Art Teaching

"This clear text draws upon the authors' own real experiences and offers insights and guidance for those seeking to teach art in elementary and middle schools."
 Jerome Hausman, Visiting Professor, Art Institute of Chicago

"This is an absolutely essential text for future art educators as well as a must-read for current teachers who want to rekindle their creative teaching. At a time when student creativity in this country is on the decline, this book provides inspiration, tangible strategies, and—most importantly—the challenge to make the art classroom the indispensible *creative center* of every school."
 Cindy Meyers Foley, Director of Education, Columbus Museum of Art and Center for Creativity

"Bravo to both authors who provide a refreshing and much needed approach to teaching art in a contemporary classroom. The authors encourage the reader to honor the wisdom of children while allowing them creative license in the art classroom. This book provides a comprehensive view into the world of teaching art and includes nearly everything that a teacher should think about, such as meeting the standards, classroom management, curriculum planning, advocacy, and so much more."
 Kathy Danko-McGhee, Director of Education, Toledo Museum of Art

Art Teaching speaks to a new generation of art teachers in a changing society and fresh art world. Comprehensive and up-to-date, it presents fundamental theories, principles, creative approaches, and resources for art teaching in elementary through middle school.

Key sections focus on how children make art, why they make art, the unique qualities of children's art, and how artistic development can be encouraged in school and at home. Important aspects of curriculum development, integration, evaluation, art room management, and professional development are covered. A wide range of art media with sample art activities is included. Details about teaching art history and aesthetics and coverage of the National Art Education Association teaching standards are included.

Distinctive features of *Art Teaching* are its separate yet integrated middle-school section and a companion website (www.artteaching.org) with a photo gallery, sample course outlines, readers' contributions, a screening room, and more.

Taking the reader to the heart of the classroom, this practical guide describes the realities, challenges, and joys of teaching art, discusses the art room as a zone for creativity, and illustrates how to navigate in a school setting in order to create rich art experiences for students. Many textbooks provide information; this book also provides inspiration. Future and practicing teachers are challenged to think about every aspect of art teaching and to begin formulating independent views and opinions.

George Szekely is Professor and Area Head–Art Education, University of Kentucky.

Julie Alsip Bucknam is Professor of Art and Art Education at Eastern Kentucky University.

Visit www.artteaching.org for additional online resources.

Art Teaching

Elementary through Middle School

George Szekely and Julie Alsip Bucknam

Routledge
Taylor & Francis Group

NEW YORK AND LONDON

Please visit www.artteaching.org for additional online resources

First published 2012
by Routledge
711 Third Avenue, New York, NY 10017

Simultaneously published in the UK
by Routledge
2 Park Square, Milton Park, Abingdon, Oxon OX14 4RN

Routledge is an imprint of the Taylor & Francis Group, an informa business

Library of Congress Cataloging in Publication Data
Szekely, George.
Art teaching : elementary through middle school / George Szekely and Julie
Alsip Bucknam.—1st ed.
 p. cm.
Includes bibliographical references and index.
1. Art—Study and teaching (Elementary) 2. Art—Study and teaching
(Middle school) I. Bucknam. Julie Alsip. II. Title.
N350.S94 2011
372.5—dc23
 2011027003

ISBN: 978-0-415-99057-8 (hbk)
ISBN: 978-0-415-99058-5 (pbk)
ISBN: 978-0-203-83238-7 (ebk)

Typeset in Berling
by RefineCatch Limited, Bungay, Suffolk, UK

Printed and bound in the United States of America on acid-free paper
by Edwards Brothers, Inc.

Contents

5 Art Students as Artists 247

6 Professional Development for the Art Teacher 290

Dedication

Working on a book is a selfish act. Writers give all of themselves to a manuscript and expect everyone to understand and be supportive of what seems like an eternal ride. Writing a book not only takes time, but it also steals time from a family. It is hoped that everyone might understand and pitch in and help and great families such as mine just heed the call. For example, my wife Dr. Laura, who was up with me for my 4:00 a.m. writing sessions, making sure oatmeal was on the stove, and all commas were in place. Dr. Ilona Szekely, my oldest daughter and colleague, soon followed to critique each chapter. A good book is backed by a great family, and I am thankful to my family of outstanding teachers—Laura, Ilona, Jacob, and Ana, who freely shared their thoughts about the art of teaching.

George Szekely

With immense love and gratitude to Randy, Sarah, and Samuel Bucknam, and Ora and Carol Alsip, who have helped me to pursue and realize so many of my dreams and who have so liberally given such absolute and unconditional love to me; and with continued appreciation, respect, and reverence for Richard Deane, George Szekely, Linda Levstik, and my professional family at Eastern Kentucky University. In the midst of this steady diet of generous portions of motivation, inspiration, love, and support from such amazing family, friends, students, and colleagues, I feel as if I am the luckiest wife, daughter, sister, professor, colleague, dreamer, artist, and author in the world.

Julie Alsip Bucknam

Preface

These are extremely exciting times to become an art teacher. After years of relentless emphasis in education on "academics" and their assessment, educators have finally realized that schools have to reflect the total needs of society. In a nation that is no longer a producer of things, we are realizing what we do best and embracing the fact that our survival as the leaders of a free world rests in our students' ability to be inventive and creative producers of great ideas. The recognition of the importance of art in education is on the rise as never before in our history. It cannot be denied that the buzzword of the day, that was long *shunned* by art educators themselves as something abstract and immeasurable, is creativity.

In the subtitle of every convention is the word *creativity,* and public education establishments proclaim creative thinking to be among their top priorities. Committees across the nation labor over creating or refining strategic plans, and it would be difficult to find one that does not include the word creativity. Universities are getting in on the act, declaring that their primary goal is to create graduates who are proficient, critical, and creative thinkers. Publications are filled with articles on the subject, and museums are opening up centers for creativity. Which classes, if not art classes, are best prepared to carry the torch and fly the banner of creativity? In preparation to move into their first art room, future art teachers can begin work on a bold sign to be placed above their door, proudly proclaiming it to be the *School's Center for Creativity.*

The overriding theme of this comprehensive textbook, dedicated to the education of future art teachers, concerns creative means of teaching art, and methods that invite and inspire students' creative development. Teaching art is about making art, designing art experiences, setting up varied environments, and utilizing the objects and many canvases that make up an art room. An art lesson is not created as a lecture or a PowerPoint; it is sketched, drawn, and initiated by creative individuals as a guide for what might be seen and experienced in an art class.

This book speaks to teachers about the critical call to set the stage for meaningful acts of inquiry, exploration, idea formation, mistake making, inventing, and the creative development of the young players who enter the magical arena that we call the art room. It is the beginning of the teachers' challenging, yet extremely fulfilling, performance that will involve the orchestration of rich and inspirational environments where teachers guide and young artists feel safe to learn to set and solve problems for themselves.

A creative act cannot occur on demand or be triggered by the assigned command written on a chalkboard; just as to be happy in school cannot be brought on by smiling faces posted on the board. Students have to be invited to participate in special activities and enter magical spaces, into which ordinary schoolrooms can be transformed. They have to sense the freedom and excitement of playing and exploring a special place that allows for their creative contributions. The art lesson plan is just a beginning. It is the appetizer that we, as art teachers, dish up in order to prime students' appetites by allowing them to shop, imagine, experiment, ponder, and play in the art room; and we help young artists to feel free to bring their ideas, favorite finds, and unique contributions to the art class.

The art room can be thought of as a curtain that opens for students to enter a creative world, transporting them to the opera, park, playground, carnival, or to an airport where magic carpets or hot air balloons (balloons tied to a classroom chair) await eager travelers. In the art room, all of the unexpected things that are not supposed to be in school can appear, such as a tent for camping, or pull-toys to

initiate a parade as students march forward in their creative development, gaining confidence in and utilizing their own inventive ideas, as they separate their ideas from the teachers. Every art lesson set up in the room can yield a thousand visions. Art teaching is creating marvelous treats for the creative palette that break with school routines, frames of mind, and moods in which children can be children and creative artists again.

Past, present, and future art teachers need to shake the roles of playing teacher long enough to be able to model a free and creative human being who is able to be funny, good-natured, light-hearted, and play with children on the floor. If you have never played with children on the floor then you have not felt the *full* extent of the great privilege and creativity-riddled joy of a teacher in an art class.

Let's face it, art teaching is not the most financially lucrative profession but it does have great rewards, many of which are shared throughout the pages that follow. This text does not suggest the simplest and cleverest art projects with which to arm you for teaching. Elementary- and middle-school students who learn to simply look towards the teacher's diet of lessons and correct answers will not maintain their roles as artists in the long run. That is not how artists work in the art classes that are the most useful.

To prepare students for creative experiences, future art teachers have to consider ways to open art classes so that various levels of thought and creativity can occur, and so that students are just as well prepared for creative and critical thinking as are their teachers. Art education is both humbling and exciting for the teacher when students come up with and communicate their best thoughts and dreams. Indeed, the art teacher is fortunate to be wrapped in the young artists' uninhibited and creative ideas and dreams, the impact of which, consequently, keeps alive a cycle of teacher–student motivation for new ideas and art that can last a lifetime.

WHAT A TEXTBOOK CAN AND SHOULD NOT DO

A traditional textbook is not a substitute for figuring out things for oneself. This one is a bit different; it asks the reader to engage in the quest … like the art teacher asks of his or her students in hopes of empowering them by providing as many questions as answers to the subject. Each page of this book is a challenge to you, the future art teacher, to think and plan with creativity and self-confidence. This book sets the stage, describes the history,

and hints at the possibilities, but it does not pose definitive rules; a list of how-to's, or correct answers to teaching art or managing an art room.

While there are many "how to" books out there for making art as well as teaching art—books of lists, and recipes and web sites for art lessons—this is not how art works; nor is it how creative art teachers should exemplify art to others. An artist does not just go to a museum and pick out a painting that they want to emulate, and neither should an art teacher be in the business of collecting sure-fire art lessons or methods of art teaching. Art teaching is sharing where art can come from, and how everyone needs to search for it. A how-to-make-art-lesson diminishes the excitement of teaching art for the creative teacher, but more importantly, it sends a poor message to students of what art or teaching art is about. Art teaching is a demonstration of creativity that has no short cuts or formulas, that cannot simply be handed from one artist to the next.

When we work with classroom teachers, all students are artists in the class; everyone is treated as colleagues and asked to fully immerse him or herself in the art experience. There is no "art light," or a less serious art class; to receive an art education one has to be fully involved. A classroom or art room becomes a studio while art is taught. Everyone in this book is addressed as an artist. It is a sign of respect for individuals involved in creatively preparing to be teachers.

YOU ARE AN ART TEACHER

You are an art teacher if you are planning to teach in elementary school. All elementary teachers work with art and with children who love art. You are an art teacher if you plan to be an art specialist in elementary or middle school. This book is addressed to future art teachers who might be taking one "methods of art teaching" class or who are part of a program that entails several art courses.

Art making and art teaching is something one continues to learn about beyond a single course or experience; it is truly an example of lifelong learning. Please enjoy and grow accustomed to being called artists and art teachers in the pages of this book. It is meant as a high compliment and to welcome you as a colleague. The best teachers, who stand before a class of students and teach math, feel that they are mathematicians. When one stands before a class teaching art, one needs to exude a love of art, recognizing that we don't know all there is to know about art, but we take great joy in the subject and we are immensely devoted to sharing it with students.

Each page of this book is a celebration of children's art and the artists we all used to be, reminding every future art teacher of a missing part of their résumé. It is not how many art classes you take, or what degrees that you hold, but instead it is the wonderful artist you were as a child and how that memory and confidence can become a key ingredient of teaching art. This volume hopes to immerse every reader in the wonders of the child artist, and assist the future art teacher to bring their most imaginative and youthful artist selves to the teaching task.

Passing the matchbook "draw-a-face" test or the often cited "being-able-to-draw-a-straight-line" test are not prerequisites for using this book. Animated stick figures can be just as exciting as fully inflated ones. Art teaching is from the heart and, as you will read, it is a pleasurable and creative task that does not require a formal art skill inventory, or an informal self-appraisal of one's art-making ability. You are an artist if you feel like one. No paperwork or previous grades or judgment of others counts. This book is the one to inspire you to teach art and always give you joy and confidence so you will never worry "Am I good enough or skilled enough to make or teach art?" You will be an excellent art teacher if you read, and hopefully return to re-read this text, which hopes to keep the fire of creativity, playfulness, and yes art, alive within you—the star of this text, the future art teacher.

Acknowledgments

The authors wish to express their sincere gratitude for the time and expertise so willingly shared by colleagues at Eastern Kentucky University: Ilona Szekely (Art Education), Dr. Gay Sweely (Art History), Dr. J. Jeannette Lovern (Assessment), and Dr. Jeanie Goertz (Gifted Education). We are very fortunate to have had the wise and patient Naomi Silverman as our editor at Routledge; she was a great supporter and enthusiastic fan from the original proposal to the final details. We also express our deep appreciation to Nan Hathaway and Diane Jaquith, co-directors of TAB (Teaching for Artistic Behavior Inc.), for their suggestions in shaping the final drafts of this book. A special thanks to Kentucky's beloved poet and writer, Jonathan Prasse, for accepting so many luncheon dates at the Good Foods Co-op to discuss this project.

From Theory to Practice

A successful man is one who can lay a firm foundation with the bricks others have thrown at him.—David Brinkley

Section One A Brief History of Art Education

VIEWS AND VALUES OF CHILDREN'S ART

Children have always played and created art. However, the art produced by children has a history of being placed on a lower artistic shelf than art produced by adults. Ask a museum guide to see children's art and you will be directed to the basement education department, to view reproductions of what is upstairs, presented in a child-friendly, interactive way. The history of art education has been about how adult art principles, systems, and ideas about art have been taught to children. Children could be taught art principles, but their own strivings were not historically worthy of display or preservation. Although children obviously have been making art as long as adults have, they were not recognized as artists; their playing and creative actions were thought to be frivolous, unimportant, and only distantly related to "real art." Starting in the 1950s, children's art appeared as a developing story, displayed to illustrate stages or as progress toward the art of adults. Developmental displays of children's drawings in textbooks suggest that all children's art is the same, emerging in predictable stages. Unique qualities and individual expression were not worthy of mention until the late 1950s, when modern artists claimed children's art as a source of inspiration and something they were striving toward.

In writing the history of art education, the emphasis is on how art came to be included in the public school, as if children did not explore art before it was taught in school. Drawing as an aid to improving penmanship was first to be included in public schools in America. By 1875 some form of drawing was taught in most schools. It was not until the next century when a strand of progressive educators—starting in Europe with Johann Pestalozzi

and Friedrich Froebel and followed later in America by John Dewey's progressive education influence—that creativity and children's play were truly valued by the art establishment.

The story of art education in America began, and to some extent still exists, as one of two persuasions. One, stemming from the notion that art is something an adult teaches children, often for reasons other than art, such as to advance penmanship, morality, school studies, thinking skills, or simply to appreciate adult works. The other, second viewpoint, is that play and art are natural and valuable children's expressions, that art is a child's unique expression, interest, and mode of learning. The child is an artist and a creative player whose art is to be built on and not diminished by art instruction. The authors of this text hope to engender the notion that despite its historical positioning, art created by children should be recognized as art.

The study of the history of art education needs to be about recognizing and discussing issues that art teachers still deal with today. A historical view is what art teachers need to establish, a bigger picture of how the field evolved. Discussions about the history of art education are not just about learning names and dates but following the flow of significant issues that continue to demand a contemporary response. This section is a special walk through the history of art education. Based on what is known about the evolution of the field, the journey takes the reader into schools of different periods, giving an impression of what it looked and felt like to be in the room with our forbearers. Teaching styles and materials used are described as if the reader were a visiting colleague. Key characters and issues of the past are also brought to contemporary and sometimes personal light, in a history to remember and perhaps to enjoy.

Journeys from Europe to America

As one official story goes, Boston school leaders visited European schools in the middle of the nineteenth century and were awed by the quality of student handwriting. The fine hand control appeared to be a result of manual drawing lessons prevalent in European schools. Boston schools adopted German and British drawing manuals, which featured lettering exercises supported by line drawing. These how-to instructions were unrelated to the natural ways children draw or learn about the world using art by connecting play and awareness with the experimental use of objects and materials. Walter Smith, a well-known British professional drawing teacher, was brought to Boston to supervise the training of teachers in his manual drawing system.

In a recent biographical animation for art teachers on educational television, George Szekely's character explains,

> I didn't bring European education with me when I came to America from Vienna in 1959. However, I am a product of the old European drawing system that has not changed from the time it was studied by Boston's educators. I had the scars from my manual drawing teacher's ruler for the lines I missed, and I vowed never to take drawing again in school. I arrived in America in the midst of the greatest artistic change in the New York art scene, the birth of the first truly American and internationally recognized art movement known as Abstract Expressionism. The new American art brought with it a departure in the schools and deviated from my Viennese art teachers, who had no respect for children as naturally expressive artists.
>
> In my Viennese school, each class could be characterized by perpetual lectures, followed by student recitation. Readers were our primary source of learning, and there was a book for every subject, including a strictly adhered-to manual for drawing. In a tightly restricted environment even hands had to be kept out of sight, behind our back, raised only in a specific way, to a specific height, in response to questioning by the teacher. In Dr. Herr Manfreda's drawing class, the school model was just as unnatural. All drawing was done on graph paper, following Manfreda's manual, and drawings were enlarged from his bible onto the board. Initial sessions were spent on proper pencil-sharpening techniques. We moved to properly ruled lines, with precision enforced by hits from Manfreda's ruler. Uppercase letters had to be carefully rendered and practice writing was part of all home drawing assignments. Manfreda, like our other teachers, considered students as blank slates, with no prior knowledge, aptitude, or interest in the

subject. All that was to be learned about drawing came from Manfreda and his stick.

Students in American schools in the early part of the nineteenth century wrote and drew on slate boards and not on the graph papers used in Herr Manfreda's class. Otherwise, drawing assignments during the middle of the nineteenth century in America were not substantially different than those in Vienna in the middle of the twentieth century. In early American drawing classes, students copied line assignments modeled on the board onto individual slate boards. The Museum of the City of New York houses a wonderful collection of materials such as early drawing manuals and slate boards.

Knowing how children love to draw on chalkboards, one can assume that many inventive drawings were also inscribed on slate. Free art was not called for in school, and what children drew on their own was not considered something important, so there are no traces of their art. Did children playfully draw in between copying, or were there some unsung teachers who encouraged children's drawing inventions? The answer remains erased.

Copying from drawing manuals, classical casts, and masterpieces sums up the early history of our field. Even though children like to copy pictures, everyone today knows not to copy in art classes. To experience the history of art education in a memorable way, art teachers can follow a lesson in an old drawing manual or from a new one, still sold at any art supply store.

A Visit to a School in Boston, Drawing on Slate Boards (1868)

A basket of chalk sits on the floor. A darkly framed chalkboard covers the wall opposite the main door. In the general classroom the teacher is in charge of the drawing lessons. The top of the board is lined like a music sheet; parallel lines are spaced in five equal intervals for lettering. Below, a chalk drawing of a cylinder is bisected at different points and neatly lined on both the top and bottom. Joseph Mann has been teaching drawing for two years, ever since the Boston school mandate.

Upon our meeting, Mann right away clarifies that he is not an artist, nor an art teacher, but like other teachers he attended Walter Smith's free drawing workshop. During the visit Mann speaks convincingly about his views regarding the importance of drawing for his students. "Artisans and students who will be involved in mechanical labor

need the benefits of knowing how to draw accurately," he says. "With our growing American industry we cannot afford not to teach drawing to future cabinet makers, printers, or silversmiths, who depend on patterns and drawing for their livelihoods." Mann stresses drawing as a practical advantage to the many mechanical trades. Introducing his teaching to elementary and intermediate students, Mann describes his drawing lessons as teaching the outlining of forms, measuring, emphasizing proportion, accuracy, and the laws of perspective.

For drawing lessons students use The Chautauqua Industrial Art Drawing System; a roll-up, cloth-backed class display hangs on the wall. On the chalkboard, Mann enlarges sample sections of the drawing system for students to follow. The teacher draws parallel lines vertically and horizontally, using different spacing. The parallel lines turn to rectangles and squares. Students follow each step of the drawing on individual slate boards. Mann urges patience and precision as he turns the parallel lines into arrow feathers, then a rake.

The next drawing lesson is geometric shapes, starting with a circle, divided into halves and fourths. The segmented shape on the board is then opened into patterns and designs based on a circle. What looks like an enjoyable experience involves drawing animal silhouettes—a donkey, a squirrel, and a rabbit. According to the wall chart, later line lessons cross into weavings. The final assignments use the parallel line practice to be drawn as fences surrounding previous animal silhouettes. The same chart illustrates "Draftsman Capital" letters and the proper positioning of hand and chalk to be used in display lettering. The Boston drawing course illuminates important lessons that are a hallmark of future art teaching.

Working on a slate board is holding art education history in hand. Art teachers can share the experience by purchasing a variety of slate boards online or at antique stores, or work over slate tiles from a lumberyard. Slate boards are wonderful items for art teachers to collect.

Efficiency became an issue from the moment drawing and art were placed into the school curriculum. Drawing systems offered a way to efficiently deliver information about drawing to students. Students followed clear instructions demonstrated by the teacher. Personal investigation and interpretations required a great deal of time. The "correct" way to draw was demonstrated by the book and enforced by the teacher. All students needed to do was follow a prescribed path and copy correctly. No class time was wasted talking about beauty, or searching for the new. Systems for teaching art were sought after, and drawing

masters published their manuals with sequential exercises. Picture study and art appreciation were later added to the subject; like drawing, they had their own manuals and directions for the teacher to follow. And like drawing, picture study was efficient, it required no personal probing of art, and like most docents in museums to this day, all one had to know about the artwork was explained. Later, initiatives to integrate the arts with other subjects, or to use art to enliven school learning, also saved time by not requiring art to be taught separately, while assisting general education. But one concern started to be clear: How could the richness of the art experience, the journey of artistic investigation, be included in schools that had little time to spare?

Another concern that began with mid-nineteenth-century drawing instruction was the notion that anyone could teach art. In early drawing lessons, succinct manuals guided the teacher and students through specific steps. It was assumed that anyone who could learn how to write could draw. From the early history of art teaching, some still believe that with the proper workbook and logical steps, later called skills and principles, there is no need to hire art specialists. Future art teachers need to demonstrate that they bring more to the table than teaching steps of how to draw. They need to prepare contemporary arguments for the value of having an artist-teacher teaching art in schools.

Early drawing classes also raised the question of presenting art as copying. Art students to this day need to be reminded that art is not copying, reproducing drawings outlined by experts. Early drawing classes were clearly based on following rules, proper measuring, copying as the way to see the truth. Some drawing experts suggested copying drawing manuals; later the emphasis was on copying art masterpieces, and casts of classical figures. Another path in early drawing lessons was to copy nature.

Some art classes today still copy magazine photographs, or reproductions of adult art. It has been a long journey in art education to move from copying and imitation to interpreting what the artist sees and feels.

A Manual-Training Drawing Class in Saginaw, Michigan (1912)

Passing by rooms with motor-driven lathes, band saws, and boring machines, one can meet with Mr. William Mason, the drawing teacher in the Saginaw school. Mason studied art and manual training at Pratt Institute in Brooklyn, NY. Before coming to northern Michigan, Mason taught manual training at the Pennsylvania Museum and School

of Industrial Art. While sitting behind his handsome Arts and Crafts style desk made by students in the school, Mason speaks of the close cooperation between art and manual training in the practical-arts courses offered at the school. He explains,

> When drawing was first introduced into the public schools about 30 years ago, it was wholly on the plea of its practical value, benefiting the growing industries of the country. As industrial drawing, it took its place in the school curriculum. The foundations were geometry,

he says as he picks up a black compass case.

> Methods were overly scientific and analytical. Expression was formal, stiff, and I would say colorless. Let's say the hand was trained at the expense of the eye. Our teaching neglected observation and focused on linear execution. Manual skills out-ran visual insight. Linear treatment permeated every phase of the subject. The result was students who had achieved mechanical excellence but not art appreciation.

In 1912, according to Mason, there were major changes.

> Now we include training in aesthetics through all forms of nature drawing and color study and its applications in design, including the study of art masterpieces. There is a balance now. It is not only teaching the skill of the hand. When I started it used to be dry, analytical drawing. I called it the skeleton method. It was unsatisfying to teachers and uninspiring for students. It neglected nature, the child's birthright. Our teaching is now based on nature rather than the abstraction of geometry. It is not manual dexterity at all cost. We are starting to think about more than just teaching useful and efficient citizens.

Mason suggests the establishment of art appreciation as a new emphasis in drawing classes. He sees drawing classes as contributing in other ways to society besides their recognized industrial role. In the past, the study of "fancy art" was only for the wealthy, the nobility who were not inclined to do manual work. Wealthy private schools taught the appreciation of art, while the manual arts became a public school subject. Art appreciation came to be seen as a symbol of democracy, soon to become the cultural capital of every citizen. Great museums were built in American cities with the mission of educating public taste; the appreciation of great art could be the great equalizer. Good taste was said to be a necessity to compete in society. Throughout the history of art education there was an emphasis on studying art and learning to appreciate art, beginning with the picture-study movement of 1870, to classes in art appreciation, the study of environmental art, arts and humanities courses, and the study of visual culture in contemporary schools.

The battle between teaching art as a hands-on subject through art making and theoretical learning from picture study, slide lectures, museum visits, or PowerPoint presentations has been a continuous debate. Considering some of the reasons for teaching art in the past and in the present, such as moral education, education of taste, a study of cultures, an appreciation of the humanities and of beauty, may not require actually making art in schools. The old roots for drawing instruction were a practical matter, training the hands and the eye and not making art. When art claimed to promote higher intellectual thinking it no longer claimed to be the practical arts. The emphasis on appreciation, the study of world culture, and aesthetics, further de-emphasized making art. Hands-on art was not for the wealthy, not for the academic student, or intellectually gifted. Art making from the start had a social stigma and is still considered by some to be for students who cannot do anything else. Future art teachers need to formulate their opinions regarding the contributions of both making art and appreciating art to public education.

An Industrial and Applied-Arts Class in Cincinnati, Ohio (1925)

In a Cincinnati, Ohio, public school in 1925, the hallway leading to the main office is a gallery for darkly framed reproductions from the Great Art Series. A new trend is to display art in schools, and among works in this school is an illustration of the Lincoln memorial by Augustus Saint-Gaudens; "The Gleaners," by Jean Millet; and "The Windmill," by Jacob Ruysdael. Walking toward the last hallway of the school, one can hear sawing and hammering from the children's woodworking class opposite the drawing room. Art classes are now separate from industrial-arts classes, yet they still share the old manual-arts hallway, away from the mainstream of school life. The display of student work on the bulletin board is entitled "Complementary Colors." Stenciled color shapes in the style of arrowheads are cut out and placed onto their complementary color background.

In the art room is Georgia Wilhelmina, an applied-arts teacher. Heavy oak tables with drawers and tilting tops conceal students sitting behind them. Fourth graders are quietly rendering nature with a pencil from depictions of nature on the board. Three "proper methods" of nature

drawing are illustrated. The first drawing is of a flower form, presented as drawing of mass to suggest values. Some students are already on the second, called "accented outline drawing," illustrating a large leaf on a branch. The third nature drawing requires students to use white chalk to show milkweed pods on small gray papers. Wilhelmina encourages students to continue at home by making mass pencil sketches of trees as they appear in autumn, "showing their 'truth of structure.'" She reminds students to use three values and remember good pencil technique. Displays in the art room are neatly mounted classroom assignments such as "Civic Beauty," featuring drawings of a garden gate. On trays at the side of the room are stacks of stencils and cut paper for teaching drawing.

The fifth graders entering the room will be working on civic art. Wilhelmina changes the garden gate drawing on the board to a more complex drawing of a home from colonial days with a vine-roofed pergola. The sample drawing is signed by A. L. Guptill, a well-known illustrator of art manuals. Wilhelmina reviews the picture and points to the jar of plants in the foreground and the mass of trees in the background as an example of creating a balanced design. She asks students to first draw the picture with a fine pencil outline. Then students are asked to plan the colors they wish to use and paint in the outlines. "First paint the sky, then the ground. Wash green over the trees and plants. Color the columns by adding red and yellow to a thin gray."

During a lunch break, Wilhelmina shares samples made from her yearly curriculum.

> The lessons you saw will be followed by a lesson on free-hand letter drawing, and another on poster letters,

she explains.

> After students master their free-hand letters they will use them to make notices for the junior Red Cross meeting in school and to copy mottoes and quotations. The lettering will emphasize careful spacing.

She shows how a wooden stick was whittled down to a flat point to use as an ink pen for the posters. The poster and letters introduce school clean-up week. Upper alphabet characters are drawn on fine pencil-lined five-by-eight-inch spaces, divided one eighth of an inch apart. Other posters for school use cut letters from dark papers. Wilhelmina clarifies how the lettering learned will be practiced in future lessons such as poster designing, where students will be making posters for a poultry show. Lettering and stencils will be "well arranged decoration" for a portfolio

design. "Our art will also be applied to several exciting projects to include a birdhouse and designing a kitchen for the home."

Wilhelmina takes time to explain the final projects of the year.

> Students will study the habits of different birds, like the wren, who likes a house with a small entrance. The fourth and fifth graders will learn to draw front and side elevations, and to draw plans that represent exactly the size, shape, and arrangement of parts.

For the kitchen, students work on ready-made prints of kitchen walls, copying outlines of the door and windows. The kitchen lesson includes the study of the paneling of doors, different ways of placing windowpanes and arranging curtains.

> If the effect is pleasing, students will copy their ideas using fine, even lines and add the necessary lines to the cabinets. We will study pictures of well-arranged kitchen furniture.

Wilhelmina has learned to express and enforce basic rules of art with certainty. The notion that art can be broken down to small, teachable components suggests a single and proper way to study art. Contemporary art rules are stated as "basic design principles" and started with a demand for school accountability in the 1980s. Many art lessons are framed as "standards" to this day. To be a legitimate school subject, drawing, and later art in general, had to be presented as easily defined lessons about what was known. Some art teachers to this day prepare demonstrations and handouts for the proper way to draw a face, demonstrating drawing trees, or using painting systems as the correct model. In the mid-twentieth century, the conflict in art education emerged between those intent on teaching the content of art, emphasizing art techniques, styles, and principles of design, and those seeing art as self-expression and searching beyond what was done before. Future art teachers need to discuss ways to strike a balance between teaching art and students discovering art.

In reviewing past drawing systems and how the teaching of drawing has changed, future art teachers can discuss how they were taught drawing and to trace where the "system" came from. In drawing instruction, what principles and beliefs will guide new art teachers?

Before art was taught as its own subject, schools displayed a social and moral message through the display of framed art. It was thought that great art would inspire students to admire the great accomplishments of humankind.

Most reproductions from the past displayed the ideals of hard work, the purity of nature in pastoral fields, and inspiring portraits of great leaders. The presence of art was thought to have the power to humanize, uplift spirits, and transmit society's core values. Future art teachers who will hang the new art displays in schools can consider the past as they formulate their ideals of what should adorn school walls. What is the status of displaying the work of the old masters or contemporary art in school? Should adult art be displayed or only student work? If adult artists are represented, who would be the artists, and what is the message of their prominent display?

Horace Mann, secretary of the Massachusetts board of education in 1837, was a pioneering activist for education for everyone as a means of transforming society. Mann was also an advocate of drawing in the schools and held the belief that art was a useful tool to enliven the school climate. Mann was to become the harbinger of the arts-in-education movement of the 1970s, integrating art with other subjects so that students could become more interested in the general learning of other subjects. Making art is primarily a hands-on experience, and educators have long recognized that hands-on experiences make education more meaningful. Today we talk of art as developing visual intelligence, critical thinking, and helping visual learners struggling with math or science. Future art educators need to recognize this longstanding attitude and discuss the flip side of the argument—the danger to art in school from taking on a supporting role. In other words, they must consider how art can be successfully integrated in schools where art teachers are asked to work with other teachers, and they must think about ways that art classes can keep their own identity and value.

Art came to schools as manual arts and vocational education for industry. From 1890 to World War I, art education went through a transition. It changed from a subject limited to drawing to a wider designation of art as art appreciation, design, and crafts. Industrial education transformed itself to vocational education and separated itself from art. But the original industrial purpose for art education survived in the form of handicrafts and the ideals of the Arts and Crafts movement. The Arts and Crafts movement did not change production processes, as was its intent, but like picture study, it did contribute to the cultivation of taste and the appreciation of the beautiful. With the industrial mission of art education lost, art teaching turned its focus to the teaching of appreciation of art and natural beauty. The lack of a utilitarian mission reduced the importance of the subject to an elective status in secondary schools.

In the historic roots of art education in American schools, art was not included as the study of the fine arts, derogatorily referred to as the fancy arts. In our past, school art was expected to make a direct contribution to commerce, industry, and society. On the other hand, today's art teachers are trained in college art departments focused on fine arts. Many art departments make no room for such subjects as commercial art or graphic design. Other art departments exclude crafts, calligraphy, and typography from the program, and as a result it is difficult for today's fine arts graduates to be sympathetic to the historic emphasis on commercial art, crafts, or manual arts in schools.

When you have computers in every home, every business, and every art class, is using your hands to make art still valuable to teach in schools? Art itself has become more conceptual. It no longer has to be made by hand, or made at all. Future art teachers need to consider how changes in society and the art world change school art. What can art contribute to today's schools?

Progressive Education, from Europe and America

As described in the first paragraph, children's art was not considered significant in the nineteenth century. The public did not pay it much attention, nor was it a factor in the new drawing classes that started in schools during the middle of the century. Children were considered to be "little adults," dressed to look like adults, and their art was not considered polished or up to the standards set forth by adults. So the first act in the story of art education implied a devaluation of children's art. The second act deals with paths toward recognizing children's art as valuable and significant enough to be invited to school.

The first strand of art education in America was Common School Drawing, tied to industry, therefore justified as a legitimate subject of study. Before looking at a second strand of art education, progressive education in America, we again have to go back to Europe, this time to study with Johann Pestalozzi and visit Friedrich Froebel's Kindergarten.

Visiting Johann Pestalozzi's School (1820)

Visiting Swiss pedagogue Johann Pestalozzi's school, one finds poor peasants and many orphaned children, students who are generally excluded from education. In what was

formally an old palace, now crowded classrooms are filled with great activity and plenty of hands-on things for children to do. In this school there are no long lectures followed by student recitation, typical in other schools. There is no sense of fear and the customary reign of pedagogical terror. Instead the children are happily obedient, responding to the respect shown for their humanity.

Even though his drawing strategies are anything but natural, Pestalozzi speaks about a "natural education for children, where an innate desire to learn is nourished and the child's curiosity is unfettered." Pestalozzi's method for hands-on activity is called Anschaung, or object lesson, based on children's straightforward and concrete observations. Pestalozzi's classroom and actions are far less rigid and theoretical than his writings about drawing. The master teacher emphasizes the capabilities of youth, the personal experience of children, and supports it by loving encouragement.

On Pestalozzi's modest desk sits *Emile*, by Jean-Jacques Rousseau (1762), a book he has read many times starting as a child. *Emile* is a widely read attack on French child-rearing and urges parents to learn from nature as it tests and excites children to activity. At a time when play was dismissed as an empty waste of time, *Emile* urges a love of childhood, encouraging sports, pleasure, and children's playful instincts. Pestalozzi feels that it is most important for his children to be happy.

Look at the children, he says, "In no other part of life will they be so busy." Pestalozzi is animated by the lessons from *Emile*. "The teachers described by Rousseau were not information dispensers, but guides, and the child's willpower acted as an agent of education. Children learned by doing." In *Emile*, books are described as repositories of secondhand opinion, to be avoided in early education. Learning how to read too soon merely interferes with learning how to learn and reason. Pestalozzi reinforces this idea by repeating his well known phrase: "First from the mind and then furnish it." Pestalozzi compares the development of the child's mind to a tree:

> Just as nature creates the largest tree incrementally from a single seed, the teacher must make gradual additions to a child's knowledge in every action taken. This allows each new idea to become an extension of existing knowledge, and can be understood, accepted, and compared to what is already known.

Pestalozzi frames his notion that to be meaningful, all human activity (such as art) must be self-generated.

Pestalozzi recognizes "children's natural taste for drawing." The next visit is to Friedrich Froebel, as he encourages children's ability to play and respond to simple play objects as a way to formulate ideas and interpretations.

Welcome to Froebel's Kindergarten (1840)

Join the children on the floor, playing with rainbow-colored, hand-crocheted balls on strings. Some children drop, others hide, roll, and swing the ball, discovering the uniqueness of the object and what can be done with it. Froebel holds a red ball, adding sound effects, making believe the ball is a dog jumping over a hedge. Children demonstrate to Froebel the springing ball as a bird in flight, or showing how their cat jumps for a ball. The simple ball embodies a myriad of children's everyday life events, eliciting action and stories. The balls in the hands of children appear as other found objects in which children discern uniqueness while discovering their own individuality.

Froebel calls the ball "the first gift, because it is a perfect form, an expression of stability and motion." In subsequent playing, berries, seedpods, and a cabbage lead the children through the realm of nature. In children's hands balls also become heads, eyes, and as the knowledge of form is discovered, they also find independent expressions. Children love to receive gifts, and they find them in each lesson. They play with wood spheres, cylinders, cubes, and simple geometric wood blocks. On different occasions Froebel distributes other gifts such as colorful parquetry shapes, linear sticks, rings, and slats, as well as colored paper to fold and weave and modeling clay.

Sitting at a small children's table with Froebel and his twenty gifts, the master kindergartner shares fine ink drawings in personal booklets, demonstrating uses for each gift. Parquetry blocks become abstract flower designs, colorful bridges, steeples, and architectural forms. The linear sticks move from simple geometry to overlapping patterns, stars, and complex grids. In an idea drawing, Froebel's sticks, which look like long toothpicks, are connected with cork, allowing the linear structures to be lifted into the air as puppets or used as geometric structures. The handsome three-dimensional structures drawn by Froebel are reminiscent of early Buckminster Fuller sketches. What better program with which to rear a future abstract artist? Fuller's mother, like Piet Mondrian's and Paul Klee's, were all proponents of Froebel's Kindergarten.

Froebel is said to be a romantic alternative to the rational system of learning that characterized the enlightenment. In Froebel's founding of the Kindergarten, children are not passive receivers of adult impressions but active organizers of

their perceptions in order to understand the surrounding world. Using simple play items, the kindergartener's mind reconstructs the world in alternative forms, creating beauty and a heightened sense of morality. The arts during the romantic era are regarded as a source of great moral insight, rather than just ornamental accomplishments. Froebel believes that children's minds can receive intuitive knowledge that goes far beyond the limits of perception. In his Kindergarten, Froebel organizes instructional materials as gifts, which yield activities to stimulate the mind. Gifts also help to transform art education from sterile drawing to using a variety of manipulative media. The self-activity advocated by Froebel foreshadows progressive education in America, to be emphasized in mid-twentieth-century schools.

John Parker and the Cook County Normal School (1890)

The best place to meet John Parker is at an outdoor classroom, the scenic lakefront of Chicago. March is still a bit cold, but the children on their nature study walks don't care. They are engrossed in picking up treasures, drawing the objects tossed from the water. Parker greets all visitors by pointing to children attending to their surroundings, saying, "Every child has the artist element born in him. You see how they love structuring with sand. Give a child some rocks and their fancy runs riot." Parker discusses a student's charcoal drawing and turns to talk about art as a way to secure meaning in the world. Parker came to the Midwest from his native New England, abandoning the standard curriculum based on textbooks and rote learning in favor of nature study, which he calls "trips to the neighborhood."

Following Parker and the small band of students along the shoreline, one witnesses a passionate teaching experience. Parker is also mindful of visitors, and while strolling he disperses bits of educational wisdom. "Children can only learn what is meaningful to them in daily life. Meaning is rooted in children's own experiences. We are here at the lake gathering experiences from nature and objects in the daily environment. Learning is about attention and expression." By attention he means looking, listening, and touching to stimulate intense imagination, expressed by students through words, discoveries, and pictures. Memorable thoughts of meeting Parker should crop up each time one sees an art class exploring the environment, or visiting a mall. Parker's thinking about education also influenced the teaching ideas of the more prolific writer John Dewey.

A Visit with Mrs. Dewey at the Lab School at the University of Chicago (1898)

The smell of fresh rolls fills the hallway. It's Friday and the students are baking. Although John Dewey is the philosophical director of the school, his wife, Mary, is the principal and is in charge of visitors. After offering some tasty bread, Mrs. Dewey explains how the students handle all kinds of raw materials like flour, or wool to do their weaving, or wood in manual activities. "Art in our school is not taught as subjects but in conjunction with occupations," she explains. "The children have the satisfaction of shaping each material to their own planned ends."

The Lab School has a large gymnasium, several manual training rooms, and art and textile rooms in a large attic space. As in Froebel's Kindergarten, students look happy to be here in what feels like a nurturing, cooperative community. Mrs. Dewey explains how regular schools are isolated from the world, and how learning has to be based on experience. "If play and occupations are interesting at home, why should school be uninteresting?" The Lab School introduces school subjects as firsthand experiences to children, so learning has real significance to students. Mrs. Dewey clarifies that "art is not taught as an isolated subject but in conjunction with an occupation." The Deweys believe that when students engage in their work experiences, or occupations, they are also having a genuine artistic experience. While Parker found the artistic in nature study, John Dewey looked for it in manual occupations, in the day-to-day tasks of the real world.

Ponderable In the history of art education, art existed by hitching a ride on the coat-tails of other subjects. Drawing began in America by its virtue of improving handwriting. Later art was said to be generally enlivening to the study of other subjects. More recently art claims to improve critical thinking, scientific reasoning, and is touted to improve standardized test scores. The history of art education is one of art having to sell itself as being useful and not frivolous in education, attaching itself to subjects that society values. Others have argued and tried to demonstrate that art has its own unique and intrinsic value in educating a total human being. If art is to become a sustainable subject of study in public education, its values cannot be sought outside the field. What would you as a future art teacher argue to be the significant merits of an art education?

A Progressive Art Lesson in New York (1907)

From the archives of the Field School, a private elementary school in New York City, imagine meeting with one of the school's earliest art teachers. Sara Hale helps to reconstruct art teaching in a progressively minded school at the turn of the twentieth century.

A hand-lettered sign in the art room says: "Color is Important in the Child's Development of Mental Powers." Hale explains that her color training provides students an opportunity to analyze and appreciate the elements of color. According to Hale, "Watercolors provide the largest range of possibilities to accurately represent nature and design." Entering the Hale classroom, students are making design finders, L-shaped cardboard cutouts providing an opening to find the best design arrangement. Students handle the L's as a rectangular viewer placed over a picture. Hale explains that everyone has brought to class tall growths of grass and placed them on paper. Using the finders, students close in or frame the best design to draw, trace, and then cut out. Hale reminds the class that "nature holds a fascination for artists and holds all truths in art."

Drawings are made from sedge and seed heads brought to class, by means of a direct pencil stroke, following the direction of the growth. Students collect the plant samples and Hale provides instruction in what she calls "pencil painting." Her secret formula to nature drawings is the swinging movement of the pencil with an effort to get the desired tone all at once. At the end of the formulaic lesson, students are asked to collect clover leaves in their garden.

Students work from nature and also imagine nature. Hale instructs students to use a few strokes of red crayons for sunset effects. They use black crayons to add trees in the foreground against the sky, to create distance. Hale shows every visitor her bulletin board display, how each drawing exercise is applied to useful things. The landscapes students have completed are cut to make calendars, and the cloverleaf drawings become stencils for party invitations. Students also work from objects placed before them, drawing a large watering can that will be cut into stencils for the cover of a gardening book.

Pets are welcome in this art class; cats, dogs, or rabbits inspire quick drawings using what Hale terms "leading lines" to suggest movement. The animal shapes are used as cut-outs for daily living items such as decorative folders and book covers. Art is not made for art's sake, but as occupations turned to crafts items for the home. Nature study—bringing to school plants and animals—is a progressive view of art teaching. Hale endeavors to integrate the children's interests, home life, and the handmade into art education.

Ponderable Artists and art teachers often share strong opinions about their way of making art or teaching art as the correct way of seeking the truth. In the history of art education, the claim was made that nature study yields all knowledge. Students copied nature drawing from the board and collected sample grasses from their backyard to study in a drawing class. Others claimed that deciphering the masters and copying classical casts defined all you needed to know in drawing. There still remains a strong view that all lessons in art can be found in the human figure; drawing the figure will inform you about all of nature and all of art. Truth was defined in terms of rules and accomplishments in the past. Today, questioning and rejecting old ways have become the way of artists. School art in some cases has remained the preserver of the past in art and teaching methods. Are there still some aspects of truth to be revealed by rules in today's art class? Without acceptance of a universal truth, what can today's art teachers subscribe to as valid teaching philosophies in an art class?

Leon Winslow's Integrated Arts Program (1935)

It is exciting to join Leon Winslow's class in their study of the color red and fire safety. Leon sports an old fireman's hat and students draw pictures of fire trucks, covering them with the most brilliant red they can find in a magazine pile. In a wrapping paper booklet, students draw fireman at the scene of a fire, as Leon demonstrates how to draw figures of policemen directing traffic and a patrol boy. Winslow shares another aspect of fire, by showing the children a beautiful southwestern night painting lit by campfires.

Art is related to transportation in Winslow's class. His lessons use toy automobiles. Winslow plays on the floor with his students, demonstrating how pieces of scrap wood can be used to make automobiles. Students compare an old car with the newest streamlined models. The teacher shows a collection of fine transportation advertisements that inspires one of the students to draw a milk wagon.

In his lesson about art in relation to home and community, Winslow brings to class beautiful old canning jars to show the children. In the lesson, the students talk

about how canning is done and use labels and wax crayons to design labels with good lettering forms for their families' canned goods. In the canning lesson Winslow talks about conservation of natural resources. His students are able to name most of the wildflowers the teacher has brought to class. Students will paint greeting cards with the wildflowers they are studying and learn to letter them. Winslow asks the children to make a booklet of trees in their neighborhood and asks the students to "carefully observe the beauty of line, colors, and forms before drawing."

Among Winslow's favorite lessons is teaching safe-street crossing. In this lesson the students also study the colors of buildings, and how to construct cardboard neighborhoods. Winslow's teaching of color theory, composition, and art appreciation is in the context of learning about safety, family, community, and democracy. Art in relation to democracy starts to become an important subject in school art as the currents of war start to stir. Students study uniforms of various men and women who serve the community. They help to decorate the room with flags, and draw pictures depicting girls and boys saluting the flag. Winslow teaches about color and pattern by the study of state flags.

Winslow's integrated art program was a blueprint for art teachers and classroom teachers who saw the value of art in teaching elementary school themes. As a forerunner to interdisciplinary art instruction, Winslow's teaching tried to stay true to the subject of art. Later, interdisciplinary attempts often used art but made art teaching of secondary importance. In contemporary adaptations of Winslow's methods, classroom teachers often became lead planners, or simply use art in class without the guidance of the art teacher. In many contemporary situations, art in the regular classrooms and art in the art class are separate entities. Leon Winslow inspired a balance of art teaching and general education.

Ponderable Today art is most commonly integrated into the elementary school with math and science concepts. Winslow applied his art instruction to subjects he felt to be already more visual and picturesque. For example, a major theme in Winslow's fifth-grade classes was the Middle Ages. You can see in the school hallway a display of family coat of arms, designed and cut from cardboards. On display is a large tapestry of a royal feast hall depicting typical food items the students researched. Illuminated manuscripts from student scribes surround the large cloth work. Future art teachers need to observe and discuss how integrated art lessons are similar or different from Winslow's classes.

Art and Democracy, a Vermont Art Class During the War Years (1943)

Even before the war years, art was said to serve democracy. From the earliest drawing classes in schools it was believed that everyone could be taught to draw. Drawing was said to be important for citizenship, elevating the taste of every citizen. A school art class was a model of democratic ideals, where students coming from different lands and backgrounds could work together. No language was necessary; everybody could make art and be successful in an art class. The art class was the true melting pot, where all who spoke and could not speak the language shared the joy of a successful experience. During the war years, the integration of art and other subjects centered on problems facing the nation.

Visiting the art class of Ms. Sylvia Green, an elementary art teacher in Montpelier during the dark days of World War II, one can witness a lesson in art serving society. Green, sitting before a display of War Bond posters, speaks about her teaching philosophy.

> Whether in war or in peace, the main objective of education is the teaching of democracy as a way of living. There is no better way to teach democracy than through art. Art teaches balance and harmony, the ability to work with others, respect for other people's work and ideas, resourcefulness, development of judgment, and emotional stability.

According to Green, art results in inner satisfaction and calmness that come from a piece of work well done. Art in itself is the democratic way of living.

Walking around the large art room, one sees many patriotic themes. Drawings illustrate a man marching in an Armistice Day Parade. Paintings are titled "America the Beautiful" and "The Star-Spangled Banner." There are inspiring pictures of boys and girls saluting the flag and showing the Boy Scouts placing geraniums on a soldier's grave.

Speaking about the shortage of art supplies, Green optimistically suggests that appreciating art can be taught without any equipment; it is something that is free. "I teach children to be art conscious. We look from the window at the sky to view all types of weather, to be conscious of all the beauty around when the children come to school each day." When the children can see and appreciate their beautiful surroundings, they can look at the beauty of pictures and handiwork like buildings and furniture. Before the children enter the room Green adds, "Every

child needs to become an intelligent consumer who insists on beauty in personal needs, in the home and community in which the children dwell." From looking at one's home, city, and nation, visiting historic districts and architectural wonders, environmental art education continues to be of interest in the field to this day. The current study of visual culture can include anything from shopping centers to art at the airport to music videos.

Victor Lowenfeld, the Father of Modern Art Education in a Pennsylvania Lab School Class (1949)

After World War I, American artists flocked to study in Europe, to immerse themselves in the great European art of the past. World War II had a different effect. A great immigration of artists brought modernism to America. Among them was the master art teacher Victor Lowenfeld.

With his head low and close to the children's art table, Lowenfeld carefully observes art being made by the side of the student. He is not up at the chalkboard explaining his system of drawing but is characteristically listening to children as they make art. Visitors to his art class hear about children as being masters of their art. Lowenfeld explains that children have their own system of art and don't necessarily need adults to show them how to draw. Freedom rang out across the nation after the war that was to end all wars, and it led to an artistic rebellion against academic rules.

Outside the classroom, American artists were preparing for an avant-garde declaration of ending old academic traditions. In his gentle manner, Lowenfeld is not leading an art rebellion of children, but more quietly demonstrating how children are capable of making their own art. In his art room, Lowenfeld simply offers children the time and space to make art, and in doing so, he shows a natural progression of stages in their artistic development. In this room there is no question who is the artist, and Lowenfeld works to create an environment where each child can feel creative and uninhibited. For the first time during our tour through art teaching, we notice that Lowenfeld avoids the imposition of adult ideas on children. As an exemplary art teacher of the modern period, he tells stories, looks for ways to stimulate children's imaginations, and allows them the freedom to draw and paint, recognizing the importance of self-initiated tactile and expressive work within an academically oriented school.

Creativity Grows in Mr. Williams' Art Class in Brooklyn, New York (1963)

During the first wave of a new American art that anointed New York City as the capital of the art world, many artists not only expressed themselves but referenced children as the freest of all artists and expressionists. Visitors to Jerome Williams' junior high art room may check twice before entering, to make sure they are in the right place. Loosely separated tables are covered with red-and-white-checkered oilcloth. The music heard is rock 'n' roll played at pizzerias. Williams quickly assures any guest that the restaurant-style tablecloth is not just to keep the tables clean, but some students even use the backing, which feels more like canvas, for their poured paintings. The "young artists" Williams points to are agitating and pulling their drip marks with beads and white plaster doll hands and feet. Class artists walk by freely, checking off completed artworks on a list on the wall and proudly heading to put the dry pieces up for display. Students are addressed as artists, and Williams encourages everyone to "dig deep into their imagination to be creative." There is a free flow to art in the room, which Williams calls "a depiction of the artist's journey."

Williams makes his rounds to see everyone and encourage them to trust themselves, their intuition, to close their eyes and trust their feelings. He shows paintings from *Art News,* and shares the most recent shows of the abstract expressionists. Everyone is painting over different surfaces, such as photographs, advertisements, and flattened cereal boxes. A class artist sitting with a cast on his legs paints over his blue X-rays. Someone is gluing together records and record covers, preparing a canvas. Even as the art world is still in the abstract expressionist mode, in Williams' class the winds of Pop Art are already stirring.

In the nineteenth century the adult artist was viewed as a redeemer of society, giving form to a collective vision of humanity. In Williams' 1960s art room, the child-artist is expressing universal truths in unifying symbols of what is now referred to as the collective unconscious. "My students see the future of art; they are the founders of all new art worlds. You can see things in this art class that will be standards in museums of the future." The child-artist has become the savior of art.

Knowledge of the progression of school art is valuable to know and to teach students in all grades. It's important for them to appreciate the freedom of being able to participate in many decisions and open discussions about art and to have license to choose artistic paths in ways not always

permitted. Everyone who picks up an art tool to freely pour paint should know that this was not always allowed.

Ponderable An important strand in the history of art education recognized children as artists and the value of children's art. But how and what do you teach someone who is already recognized and appreciated for being an artist? Future art teachers can discuss the changing roles of art teaching in a child-centered art room, an art room respectful of all artists in class.

By the middle of the twentieth century public schools had art classes and art teaching developed to be the fine arts. Drawing, painting, printmaking, and sculpture were made and studied in schools using the art references of the day. Narrowly defined fine arts reigned as the way art was made and studied in schools. Adult architects, graphic artists, or industrial designers studied their profession in special art schools and their lessons seldom crossed paths with public schools' art.

A Discipline-Based Art Class in Los Angeles, California (1975)

A rocket and a little dog catapulted the Soviet Union into a leading role in space exploration. Where was the United States? The public demanded accountability and wanted to revise our systems of education. In a Los Angeles art class where self-expression reigned a decade ago, the art teacher, Katie Cox, demonstrates a more rational path to art education. Her principal is now preoccupied with objective observation, procedures, measurement, and quantification. Success of her art class, as in all others in the building, is measured by the quantity of knowledge the students acquire, defined by how much of the teacher's knowledge was passed on to students. Cox argues that her students are gaining insight, invention, and making discoveries through art, but that does not appear to be enough. The intellectual freedom Cox tries to provide her students are not trusted to achieve socially valuable results. There is no room for the artist-teacher or the artist-student.

Picasso must have been at Cox's school because the hallway looks like he signed autographs. The large signed Picasso banner in the hallway is the work of a youthful forger, experiencing a discipline-based art class, supported by the Getty Museum. In Cox's school, one walks through a pantheon of art history illustrated by the children. Although children painted the oversized art, there is no children's art in sight. Entering Cox's room, one sees that the students are in the midst of a discussion, comparing a

projection of a Matisse and a Picasso portrait with proper terminology. The room is filled with large art posters from the Getty Museum under a sign of art appreciation and aesthetics, the new emphasis in art classes.

Cox's class is preparing for a trip to the Los Angeles County Museum of Art by studying the museum's collection through its brochures. The students offer opinions and fluently use the language of art in refuting opposing views. The study of aesthetics, criticism, and art history is firmly embedded in the curriculum, and less time is spent on washing brushes, since the portfolios on Cox's art rack have more writing samples than pieces of student art. In Cox's art room students learn about how to look at, talk about, and appreciate adult art. Cox says that her students "will be comfortable in any art museum. They know how to inquire into art and their art elements and principles." While self-expression is interpreted as freedom from pedagogical restraints, discipline-based art teaching is structured and sequenced.

Ponderable Cox's class demonstrates how the history of art in the schools is a pendulum that swings back and forth, as seen in scientific rationalism that began in the 1890s and asserted itself as the scientific movement between the two world wars. Then the avant-garde artist became a cultural hero, with creative self-expression on the rise to counter the scientific mood. As creativity and art production were gaining, as seen in Mr. Williams' class, we see art classes that have been influenced by ideas emanating from science and general education. Art as a discipline became again the study of adult art as the model for children's art. If the child was not an artist, fewer hands-on art projects are required to nurture them, and more time is spent on learning about the "real artists."

Ponderable Can art-class time be balanced between making art and studying art appreciation, aesthetics, and art history? Schooling has traditionally been the transfer of information and knowledge from teacher to students. Is art education about children's art or adult art? It is the adult who has to teach art to children, or do adult artists need to learn from children? Should we view children's art as a unique art and is teaching the value, uniqueness, and beauty of children's art our goal?

An Arts and Humanities Class in Houston, Texas (1998)

As the twentieth century is sealed, a new educational model is initiated in many secondary schools. The arts and

humanities class is a general history of culture, exemplified and compared through some common threads illustrated by different art forms (art, dance, drama, music). This educational decision was prompted by a lack of faith in contemporary artists and the fast-paced and often provocative contemporary art world that became a problematic role model for school art. It was also an economic decision to have one arts teacher in school rather than representatives of all the arts.

In Houston it could be described as an unusual Texan welcome to enter a school lobby and see students in paper folk costumes performing a loud Csardas, a Hungarian folk dance. Was it to honor a Hungarian visitor, or just part of arts study connecting dance and European history and culture? In a few minutes, exuberant dancers circle the visitor's chair, demonstrating a variety of Eastern European inspired steps. Expanding on a unit on staging and lighting techniques, several tech students enhance the dancing moves with mood lighting. It is fun to watch and is certainly not a conventional art class.

During a lunch break, Mr. Young, the art teacher, explains in his Texas drawl about his supplementary education. "This Fred Astaire took five dance lessons during a local public-television-sponsored arts and humanities day." Reading manuals from all the arts, combining art music and literature history, Young creates interesting concoctions from his sources. He has an art studio and an art education degree from a prestigious university but never dreamed he would be dancing or teaching about theatrical lighting. While textbooks were often put away in art classes emphasizing hands-on learning, in arts and humanities class the textbook serves as the students' and the teacher's principal guide. Young's art background sometimes displays itself in a multimedia production, but he mostly reminds students to open their books and pay attention to their reading assignment.

While idealized classical and romantic art provided lasting symbols and accepted ideal forms that were welcomed in schools, modern art in its early days was not just misunderstood but mistrusted by educators and a vast public. When he was hired, Young was clearly told that he cannot teach just art. Art education, which started out to be a handmaiden of democracy, became a threat in Young's school and his students only read about modern art up to the Impressionists as a form of history.

Ponderable Some communities and schools still feel art to be too free and challenging to the structure of rules in education. Future art teachers need to discuss how a visual nation that loves objects, collecting, films, and,

yes, democracy has come to question the importance of school art.

Adopt-a-School Art Class in Lexington, Kentucky (2008)

In hallways of an urban elementary school in Lexington, Kentucky, from the main office branching out to every artery, art is visible everywhere. It feels like a continuous art gallery, with well-lit white panels on the wall. The art teacher, Mrs. Shaw, organized the current exhibit. It is an all faculty show, displaying the art and crafts of not only the classroom teachers and specialists but also the principal. She proudly points to his painting, which is a portrait of his father.

Beyond the teacher's works, there is plenty of student art on display. There is no demarcation between works done in the children's classroom, at home, or in Shaw's room, called the school's art studio. It all looks like children's art and not art manipulated by adults. They are all very different in style and theme, images that are not the obvious responses to a mass assignment. The works are displayed with the help of the children and not the usual display censored by adult selection. Some pieces are even in funny frames made from Lego and baseball cards, topped with stickers.

On the art class door is a drawing by Shaw and several announcements of her video art shows. The door sign reads 302: Mrs. Shaw—Artist in Residence. Next to the door is a painted can, a drop point for found-object donations to the art class. During the early morning hours there is a line of students and parents dropping off a wealth of interesting supplies. On the wall is a schedule of open art workshops for the staff. Art is obviously alive and well in this school, where everyone is involved in the art program.

Students come to school with surprises sticking out of their pockets and backpacks. They carry unusual items in boxes and shopping bags protected by Shaw's labels that say Top Secret Art Finds. Standing with Shaw in the hallway, she remarks, "In our school, it is not just the art teacher who prepares for class, but as you can see everyone comes with materials, objects, and ideas to share." You see students who not only happily greet the art teacher but cannot wait to show her their secret stash.

Students come to the art room and find a place to sit on carpets painted by the children. Prime time, or the beginning of the art lesson, is not wasted with attendance, announcements, or a declaration of the art teacher's plans. The art class starts with students' enthusiastic sharing of things, their presentations, ideas, and observations. Students talk about art and show what they noted in their

idea books. Shaw encouragingly listens and looks at everything as a supportive audience.

There is a museum-style banner across Shaw's studio class, declaring that browsers and shoppers are welcome. The art room is set up as an exciting open market. There are lots of drawers to open, parts boxes to look through, and old trunks with found art supplies. Shaw talks to her students about serving themselves, being independent, and using the most interesting finds in the room. Her motto is that "real art ideas cannot be assigned, and real art works are not art exercises." She states that "art has to come from the most profound observations, interests, and finds of each young artist."

At this school, art is not secretly made behind closed doors. Students can be seen working in the hallway, watched by interested teachers on their planning period. One of the teachers says, "If you miss the hallway art, Shaw is always the warm-up act at our faculty meeting, and we all get to do the latest art lesson."

Ponderable There are art teachers today who still use handouts and prescribe to art formulas for students to follow. Future art teachers can discuss who has to have the vision in teaching art; does the art teacher have to come to school with a system, knowing art and teaching the art they know to children? What is your view of the role of the teacher in an art class, in the school? Having walked through art rooms of the past and witnessing art lessons of their colleagues in history, future art teachers need to consider their art class and ways to approach art teaching. A new art teacher has to visualize the next step: the future of art education. Creative art teachers don't want to just fit in, or accept everything from the past or what they currently observe in classrooms. Each art teacher has to navigate their own path and, as any young artist, they must bring fresh energy and visions required of new leaders and agents of change.

Concluding Thoughts to Ponder

Studying the history of art education is not just recalling dates and events but grappling with basic questions. First, one must try to pin down art in a fast-changing world in which definitions, views, and art forms themselves are constantly being transformed. When a student's future art world cannot be predicted, what will they be taught? In the history of the field there was an assumption of certainty, a standard for drawing, an acknowledgement of what was great art, worthy of study and presentation to students.

What is considered art shapes the way that it is taught, but how do you teach art in a world that keeps redefining art or is constantly looking for a new one? After searching through our common past, future art teachers need to discuss the future and consider the art teaching that is still valid and beneficial to the inheritors of a new art world.

A second issue is how to look at, interpret, and make sense of old art-teaching practices to help future art teachers in formulating their plans. We have all experienced immense empty rooms in a museum filled with great paintings that many just pass by on their way to crowded rooms of contemporary art. It is common to dismiss old art, even to admit a disinterest, while future art teachers scorn the old systems for teaching art. Yet the art teaching of the past continues to inform the practices in today's art rooms.

Simply teaching art and not looking at the past is not an option. Discussing major issues in the history of art education, trying out old tools, and comparing old methods to new practice helps to make informed judgments. As part of teacher preparation everyone observes current practice. Historic roots, however, have informed the practices one observes today. What might look familiar to future art teachers from their own childhood art classes goes back further in history. To study art education history—old values, old standards, principles, and systems—helps to make informed judgments about art-teaching choices and to understand what is really new, relevant, and potentially innovative art teaching. See Plate 1.1.

I come to school every day because I love art class.
—Sarah (age 9)

EXAMINING BASIC BELIEFS AND WHY WE NEED ART IN OUR SCHOOLS

Building Basic Beliefs

"Art, our first language," begins a 30-second commercial. In public service announcements created by such organizations as Americans for the Arts, advocacy has itself become an art. Advocates have mastered the art of sound bites and the use of timely slogans to influence public opinion in favor of arts programs in the schools.

As the history of art education demonstrates, slogans of advocacy change with the needs of the times. Art classes rolled up their sleeves, acting as a melting pot for immigrants to help them become part of our common cultural heritage;

they offered manual and design skills so immigrants could join the democratic work force. "Art went to war" and students made banners to support the military and instill national pride during two world wars. Later, society called upon educators to return to the basics of learning, and since art was seldom included in the basics—defined as reading, writing, and arithmetic—the response was to promote art education as teaching basic visual literacy. In today's environment of testing and accountability, advocacy adapts itself to the reform of the day. No wonder the most recent slogan of art advocacy is "support the arts as critical thinking."

Art teachers should be aware of the important role of advocacy groups and hone their skills as advocates in their communities and schools. Their advocacy at the public school level, however, is not based on slogans but on the teachers' well-defined personal beliefs. While advocating for the arts is important, the importance of an art education is also a personal matter, to be discovered by each art teacher who explores why the field of art they are committing their life to is essential.

Art teachers spend their training in enchanted studios, perhaps for the first time fully dedicated to making art. While finding ways to articulate their art ideas and learning about the theories and practice of teaching, art teachers are often too busy to pose such basic questions as: how can I be an advocate for what I do? Why is it important for me to be in the field?

Art teaching is not just a job; it is a serious commitment. Slogans and even the statements of experts are not enough to help people understand its importance. Art teachers need to hear from all their constituents—from students, parents, and other teachers, including those with opposing views—to find meaning that carries them through an art-teaching life.

Advocates for the arts are everywhere. Art teachers need to listen to their voices in order to enlarge and empower their own thinking. Collecting the sentiments of children, colleagues, and everyday advocates will help to engage those views in discussions about formulating teaching goals and developing advocacy skills. This section is a sample blueprint for art teachers embarking upon the search for their own answers in hopes of articulating the importance of art instruction in every school.

Do Your Own Research and Ask Everyone

Art teachers cannot be satisfied with slogans or their own intuitive answers: they have to listen to everyone who talks

about the importance of art in the schools. The answer to why art is important to children and their education is a local tapestry to be woven in each school, by the community. Researching and assembling basic beliefs can be one of an art teacher's most exhilarating and useful projects.

Ask the Students Everyone who intends to teach art should experience the pleasure of asking young students, "Who wants to be an artist?" The question is invariably met with a celebration of cheers and waving hands. "Who wants to go to art class?" Just the suggestion receives applause. But to be an art teacher is also to encounter dissent. It is vital to the profession that art educators develop an understanding of why art is important for children to experience, even in the face of discord. Beyond the rousing and unforgettable cheers for art, teachers should always keep notes of memorable student comments that build a strong case for art in the schools. Building such a file is the best narrative an art teacher can have handy to support his or her own dedication and persuade those who question the value of art.

The following are examples of one art teacher's collection of student insights:

- *"I come to school every day because I love the art class"* (Sarah, age 9). Check with classroom teachers about absentee rates on art days. Coming to school with joy makes a great difference in the child's school day and the child's feelings about education.
- *"The art class is the only place I can imagine making things and actually make my own things"* (Josh, age 7). The value of the art class can be found in how different it is from other classes.
- *"In the art class I just think of all the things I can make for my room and family, and how I can make everything around me more beautiful"* (Emilie, age 8). Not bad for a second-grader expressing her opinion about the value of art.

Art teachers collect many things, but collecting comments and ideas reflecting on the importance of art teaching is a precious collection. Teachers should always pay attention to student comments; take notes to be shared with everyone willing to hear them.

Art teaching is not only teaching students to make art but teaching them to understand the importance of an education in art. The students in your class who had a memorable art experience will be the people who insure that others in the future have the same. It is our students

who will build new museums, fund new art programs, and lead in shaping the future of art. If your students feel the importance of art in their school and in their lives, they need to be able to say it. Art classes at every level can address the point of an art class and the importance of art learning in order for the students to clearly understand why they are there.

Ask Experienced Art Teachers As art teachers you will be asked on many occasions about the importance of art in school, so you constantly need to sharpen your answers. We all have feelings about why art is important and the value of art in our own schooling, but to speak about it convincingly to others is a skill to develop. After you assemble your research about the value of art teaching, practice talking about key points to others.

Talk to experienced art teachers about what they feel is valuable about what they do. Learn from art teachers you admire and who are passionate about their work. Hearing art teachers formulate their ideas helps to build your own voice. Being an artist and art teacher can be a very solitary endeavor. It becomes vitally important to engage in exchanges with colleagues.

As one art teacher suggests, "Listen to students. They have so many great ideas and few people take the time to listen and pay attention." Another advises, "Call your students inventors. An art class is the only studio-laboratory set up for discoveries left in school." The art class is important because it celebrates new ideas and encourages futurists who are interested in all that's new.

A veteran art teacher sees

mostly homogeneity in schools. Assessment has prompted an unprecedented emphasis on efficiency in teaching and conformity in learning. The sameness in school is enforced by tests, homework, expected behaviors, and dress codes. The climate of conformity cannot breed the innovations required to continually improve our nation.

Our culture depends on places like the art class, where the emphasis is on innovation, self-reliance, and independence.

Thinking about his students in general, one art teacher notes,

Be careful about the kids who teachers never complain about. The ones who always follow instructions and come home to do their homework but then they don't know what to do. As a child, I used to make things, and I always had an art project I was working on. Through art I discovered my interests and

loves. While it is important to follow instructions, I want my students to be independent thinkers.

Not new to the profession, one art teacher refers to her class as an art team.

I notice in my art class that when students participate in group art activities, individual students learn to work creatively. An art class just lends itself to collaboration and not competition. It's important because our students will be a part of many collaborative-creative-teams in their life.

Ask the Parents An art teacher often hears from parents why art is personally important to them and why they consider it to be vital to their child's education. For one parent art is an important communicator.

When my child brings home art, we talk about it and get into great discussions. He learned to intelligently discuss art, talking about the design of things. There are so many things that I learn about my son's fears and fantasies from the art. These feelings are so hard to communicate in our busy family life. I pay attention to what he says about it.

People's feelings are communicated to others by the art forms they create. This is important at home but also in a school where we rush to educate children and don't really have the time or the means to pay attention to them.

A parent who is also an architect explains,

My daughter comes home and says that she did nothing in school. She is not interested in telling me about her day except for her art class where she feels safe to express her individuality. Few places encourage self-awareness in school—obviously this is a genuine concern. In the art room she says that her ideas are recognized and appreciated. I want her to take art so she can be the idea person, to feel that her contributions count.

Other school classes primarily work from assignments, being told what to do and how to do it. Art is an important time to work on your own projects and ideas.

One role of the art teacher is to rally support for art instruction. Parents are often the art teacher's biggest advocates, and therefore it is important to foster solid relationships with them. As an art teacher, listen to parents who recognize the value that art plays in a good school. Conduct an ongoing survey about what parents attach importance to in their children's education and what they consider a first-rate art program. Follow such leads, and keep notes when parents praise an art teacher.

According to one school's PTA president,

> The art class promotes good taste and caring about the environment. We raise money to support the art class because our students are the best dressed and our school is the most beautiful place anywhere. Look at the children in the hallway with their decorated lunch boxes and art hanging from their shoelaces and backpacks. Our kids know they have good taste because the art teacher asks them to decorate classroom doors, windows, and bulletin boards. My son now comes shopping with me, because he feels he has a special eye for beautiful things.

The school crossing guard with two children in the school notes,

> I see children walking by with great projects, and they love to show me. Making things by hand is such a basic human fulfillment! Since my daughter was little, she helped me to work on the family car; now the art teacher always tells me how talented she is with her hands. Except in the art class, students don't make things anymore at home or in school. Children need to feel confident in being able to make things with their hands.

A parent who volunteers as a docent in the art museum says,

> Art teaches patience for enjoying beautiful things. The hardest thing to do is to slow down young visitors. They have little patience to stand before an artwork, to look and get to know it for any length of time. They would love art in the museum if they would stop long enough to converse with it. Students who have had an art class come to the museum better prepared to see the works of other artists.

A cab driver who's a former art teacher says,

> I was born in Bombay and drive this cab in New York. It's a beautiful city. The tourists just rush with lists; they look at the meter instead of looking out of the window. I used to be an art teacher. My best lesson was to see the sky and the ground—the art in everything. Art is learning about nature and all that is beautiful around you. Today it is also very important to teach students about television and motion pictures.

A parent who works as a magician has interesting views, saying,

> Magic is my art. I create the illusion of changing one thing to another, but my children do it better. When they play and create, they turn everything they find into toys, gifts, and decorative things. Art is real magic. School is full of abstractions, and children often don't understand why they learn what they are taught. To work with real materials and complex ideas and be able to transform them is practicing the power of creative thinking that only an art class provides.

Ask Others in the School Ask classroom teachers in an elementary school that has a great art program about the contributions the arts make to the school. It is stirring to hear a classroom teacher remark,

> This is what our children need more of. Our art teacher makes sure that the children think and get to create their own things. At a time when all we do is prepare students for testing, art is an important reminder of what learning should be like.

> Creative play is vital in a technological world,

notes a fifth-grade teacher.

> All my fifth-graders own a video game system. They talk about video games and gaming heroes all the time. The art class is the real play-station, with abundant materials and found objects for children to discover and shape. Mesmerized by video games, students need the art class to use their minds and imaginations more than ever.

The school secretary says,

> We get packages in the office with great pieces of foam. I send anything interesting to the art room. Art is creative recycling; it is seeing the extraordinary in everyday things.

The school guidance counselor has her basic beliefs:

> Art is the last shield against school pressures, testing pressures, and life pressures. Even the most difficult children I see do well in the art class. Those who are silent or bored in school discover their voice, their individuality, and humanity in art. I see the art class as an oasis where facts are not forced on kids; tasks are not done under pressure or threat, but because the children want to do them.

The custodian sees plenty of mess when he comes to an art class, but he says,

> The art room is my toughest job. It's always messy, but I know kids are working and making important things. I am not a teacher, but I see that a quiet and neat classroom is not always the best. I can walk into the art room anytime and see children working like they are real artists in an art studio.

By the way, the custodian is the one who brings to the art class his collection of Mexican pottery, explaining the cultural significance. He says the art room is a wonderful place to explore the differences in the home art and culture of students, and to acknowledge and teach about cultural differences.

The school library media specialist notices that when students come to her from an art class, they are able to work more cooperatively and function effectively with their fellow students.

> Art provides an important social education; children who come from the studio are socially competent. Perhaps the art education field needs to tout their interest in developing the quality of individuals who are socially competent, more than just being able to discern the quality of things. It is wonderful to see the seriousness that students come in with to research art ideas, or to find pictures of artists they are interested in. In a global society our children look at museums and art from all over the world. Art has changed this school, and it can change the world.

In a school that is the beneficiary of a good art program, whole communities can sound like the people cited above. Their quotes can be used as evidence of the importance of art in the school.

The principal who supports the arts like the one quoted here can be included in the art teacher's collection of advocates.

> The art spirit enhances all areas of learning. In our art classes the children learn about all aspects of visual thinking: planning, problem solving, interpretation, and the process of abstraction. What they learn is not only about art, but science, math, and life skills. Since we began focusing on the art program, it has substantially boosted our test scores. I require all my classroom teachers to have art as part of their lesson plans. This insures that the value of art and the joy it brings to learning become part of every subject. It is also important to note that technology and our emphasis on academics and memorization has deprived our students of direct sensory contact with basic tools and materials. Students in school seldom make things and participate in the full cycle of production: planning, roughing-out, refining, and working towards a finished product. We can see this even in the loss of students' involvement in their regular classes where students are not involved emotionally, intellectually, or physically in their day's work. In an art class, however, you see students who are completely involved in their task. Art activities stand alone in permitting students to regain a sense of wholeness.

The importance of art in the school is not self-evident. Adults tend to forget the importance of their early plays and love for art making. Don't assume that being hired to teach art in a school means that everyone understands your role or recognizes the importance of what you are trying to do. From the moment you start teaching you become a spokesperson for art education, finding every opportunity to show colleagues, parents, and administrators the importance of your subject. See Plate 1.2.

PRINCIPLES AND STANDARDS FOR SCHOOL ART PROGRAMS

It is crucial that as a future art teacher, you define your personal mission before looking at the mission statements and "standards" of others. Ask yourself, what do you want your students to learn, to become, to behave like when they finish your art class? How can you promote the above through your class? If you are still working on defining your own mission statement, here are some things you can do. Decide what it is that you want students to accomplish and know, and the attitudes you want them to have before they leave the art room. What is important to you? You must decide what it is about being an artist, a creative individual that will be most useful for students to continue their artistic journeys throughout life.

Once you have a clear picture of your own standards, you can begin to think of ideas for experiences and lessons that students will need to fulfill those standards. After formulating your vision of art for your students, check the national and state standards to make sure that you are working to meet those guidelines. The standards you are given are not meant to control great lessons, but to help guide the art-teaching journey.

Creating Your Standards

As an art teacher it is important to reflect on what you learned on your way to becoming an artist, and how you learned it. What do you consider important in order to love art and appreciate beautiful things? In other words, write and discuss your own experiences, what helped you to be the creative person you are. In recalling creative experiences in school and at home, with teachers, parents, and on your own, what do you feel are particularly valuable skills and insights to gain for your students?

During such a personal search, also look at the principles devised by states and the national standards, but realize that a life in art teaching will span all kinds of reforms. Seek to discover what is timeless in teaching art, and what needs to change with the times. Learn to question and be critical in looking at change. As you envision the art teacher you want to become, you are setting your own standards. Art teaching is maintaining your artistic questioning and fierce independence as a creative thinker, not an untested acceptance of standards set by others.

To develop your own standards you may want to *begin* with a brief outline, responding to such queries as:

- *This is what I believe in …*
- *This is what I want to accomplish …*
- *This is what I want to teach …*
- *This is the freedom I need …*

Extract key phrases that clearly describe teaching goals and move them towards a standard style phrasing. For example: I believe that children should learn from every art experience, that they have great ideas, and can come up with wonderful art on their own: *Standard 1: The goal of the art class is teaching artistic independence.*

Understanding the Debate Over State and National Standards

State curricula and local guidelines for every subject have been drafted and will continue to be revised. Since the 1960s groups of teachers have been called together by arts administrators to develop curriculum guides. The intention is to legitimize what is taught in the field, coming up with a clear and generally agreed body of knowledge that can be distilled and organized, articulated and assembled by many state school boards. The word "guide" in curriculum guides made the venture of organizing the knowledge of a field seem innocent at first, appearing to be a helpful service for new teachers. The curricula that developed were often called "suggested," implying a helpful option, a starting point for new teachers to think about the content of their presentations. However, suggested curriculum guides eventually became standard and, along with testing, became a threatening force in teaching, especially in art; creative teachers were told what to do and how to do it, lest students perform poorly on standardized tests. Standards became strict and legal in their terms, and later

the word "national" was added: national standards. They seemed to carry the weight of the Constitution or be the embodiment of "truths" in the field. All art teachers must carefully and critically examine the pros and cons of what they will encounter in today's schools: the standards that are already in place.

Moves to Standardize the Curriculum

We have arrived in the twenty-first century as a nation dissatisfied with its educational system, calling for standards that can be weighed, seen, and measured, and teachers who can be held accountable for what they teach and how effectively they teach it. Standards are a call to supervise and regulate school learning. Whether a school has met the standards can be measured and demonstrated to the taxpayers paying for education.

Standardizing the curriculum shows that a school subject has a body of knowledge that can be uniformly conveyed to students. To be accepted as a legitimate subject in the schools along with other fields, art educators have tried to formulate standards showing that art can be taught and assessed in an organized fashion. To make what was learned in an art class testable, it had to be in step with state and national standards.

Standards theoretically allow the public outside the school and any administrator in the school to supervise an art teacher, to view an art lesson, and know whether the standards outlined are being met. In theory, supervisors or parents untrained in art would know what to look for in an art class. Key phrases used in a lessons presentation, confirmed by signs posted around the classroom, help observers confirm that the teacher is teaching the required standards.

While the standardization of art education curricula has indeed presented art teachers with obstacles, it is important for art educators to learn how to navigate such policies while remaining true to their personal philosophies.

Standards as Open as the Sky

Right now, state and national standards for art teaching are appropriately broad, serving as a useful reference. These standards respect the richness of art and the creativity of art teachers. For art teachers, the national and state standards are not tasks to be completed or lists to be filled in.

They are useful references, possible models for organizing what the art teacher wants to accomplish. In other words, they don't impede what you want to do or erase who you are. To demonstrate the broad stroke of standards, pay particular attention to those drafted by the National Art Education Association (NAEA) in 1999 (see Tables 4.3 and 4.4 on pages 236 and 237 for more detailed lists). The NAEA has two listings. One is called Content Standards and includes the following:

Students will:

- Understand and apply media, techniques, and processes.
- Use knowledge of structures and functions.
- Choose and evaluate a range of subject matter, symbols, and ideas.
- Understand the visual arts in relation to history and cultures.
- Reflect upon and assess the characteristics and merit of their work and the work of others.
- Make connections between visual arts and other disciplines.

To accomplish the Content Standards, a second listing provides the Scope of Learning Experiences that schools should provide. These experiences vary for different grade levels and different students. The art curriculum should provide experiences in the following:

- Examining extensively both natural and human-made objects from many sources.
- Expressing individual perceptions, ideas, and feelings through a variety of art media suited to the manipulative abilities and expressive needs of the student.
- Experimenting with art materials and processes to understand their potential for personal expression.
- Working with tools appropriate to the student's abilities to develop manipulative skills needed for satisfying aesthetic expression.
- Organizing, evaluating, and recognizing work-in-process to gain an understanding of the formal structuring and expressive potential of line, form, color, shape, and texture in space.
- Reading about, looking at, and discussing works of art and design from contemporary and past cultures using a variety of educational media and community resources.
- Evaluating art of students and mature artists, industrial products, and home and community design.

- Seeing artists and designers at work in their studios and in the classroom through the use of technology.
- Engaging in activities that provide opportunities to apply art knowledge and aesthetic judgment to personal life, home, and workplace.

The above standards are reiterated with some variations by the useful standards set forth by the Kennedy Center in Washington D.C.

Critically Viewing Standards

There are many state and national standards that can be examined. Start online, comparing your state's standards with other states. Mark similarities and differences you find. What is missing; what would you add? Compare state and national standards. What would you rephrase, delete, or add? This research will help you develop an informed opinion and formulate your own standards. Build a composite from editing, reshuffling, sorting, and adding your own art teaching goals.

Standards like those above can open doors for art teachers, as they don't disregard all the forms of human activity feasible in a school art program. The teaching of art remains to be determined by the different needs, interests, and abilities of students and their teachers.

Standards Protect Jobs

To the outside world the art teaching profession has to dress in style. As a profession we need to keep up with current trends in education, appear similar to other academic offerings, and abide by prevailing laws. To save a place for art in the schools and retain respect and job security, art teachers must set general goals and abide by standards.

Standards are a practical matter within a school, and they can be utilized to create legitimacy for the art teacher's work. Someone has to be hired to teach art, to cover the art standards. Ask any practicing art teacher how often he or she is asked to do things in concert with other subjects that don't have art as their focus. For example, "We're studying Eskimos in Alaska—could you make igloos with my students when they come to art?" Having art standards to meet, the art teacher is backed by an official declaration so that projects cannot just be thrown at the art teacher from other subject areas. Teaching art for art's sake has a respected place in the school.

Testing for Standards and Problems Presented

Kentucky was the first and only state to create testable standards for art, and then it became the first to abandon the process (1990–2010). In the Kentucky experience, the broad and open standards became more specific and narrow as art teachers were ranked, graded, and rewarded in pay if their students scored well on standardized testing. To meet state demands, art teachers joined the ranks of other educators who were teaching to the test. The point was no longer to prepare students to study art history beyond Western art traditions, but to prepare them for an upcoming question about West African art of a certain period. To the detriment of art programs, studios showed few signs of art making as teachers became consumed by preparing students for the subjects tested. Now that Kentucky art teachers (and students) are back to making art, hopefully the episode will serve as a reminder of the potential hazards of standardizing art instruction.

Debating Standards in a Class of Future Art Teachers

Even though the word "standards" implies a certainty about what students should learn in art class, art teachers should feel free to discuss and debate standards. Just as the justices on the Supreme Court discuss our sacred Constitution in order to interpret and reframe issues according to contemporary society's needs, art teachers must be comfortable discussing and questioning art standards. This can be an important part of teacher training, helping teachers, as inheritors of standards, sharpen their views. Standards are constantly being revised, and one day the future art teacher might be asked to sit on a review panel, having to contribute to that important process. The following describe some possible scenarios to begin discussions:

- Throughout the history of art education, art teachers have looked for inspiration and guidance from the environment. Studying casts of classical sculpture, the human figure, nature, and the built environment have all served as models for art learning. What should students observe, study, or perhaps copy today?
- Standards for art classes have also come from outside of art. Values for art teaching can connect to the educational mission of the school, the goals of a community, or the hopes and ideals of a nation.

- School art can reflect the state of the art scene: what is dominant, what is new, what is stressed by contemporary artists filters down to the public school art class. How can we look at the art world and find a context for school art? What are some of the methods and concerns of today's art scene that suggest the formulation of new art standards?
- Art teaching in the past has been slow to change, and the old ways are still evident in art education today. Standards have traditionally been based on art making, art criticism, art history, and art appreciation. Is that breakdown still useful? In a contemporary art class, what can be added, removed, or emphasized from the above? Which standards are still relevant today? Which ideals, best practices, or methods of the past are important to look at in formulating contemporary standards?
- Artistic behavior and practice have also determined art-teaching goals. In the profession of an artist, what aspects of working life—tasks, routines, work space, studio life, working styles, attitudes and practices—can be looked at as useful models for school art? Can standards for school art be drafted to highlight artistic behavior?
- There are many art professions that contribute to the make-up of the visual world. Can there be one standard to accommodate all visual art fields? Art teachers can develop standards to cover different career paths in art.
- Throughout the history of art education there has existed a belief that drawing could be taught by rules, while painting and other 2D art forms should be studied through principles. In surveying state standards, there are some that list rules, design principles, and art formulas. In view of the "rule-breaking attitude" of contemporary artists, are standards based on teaching design principles still useful?
- Some states describe the mastery of specific techniques and art media in their standards. It's interesting to look at the inclusions and omissions in techniques and media recommended for study. When standards specify media and techniques there is room for debate as art teachers can assess the needs of contemporary and future artists.
- To a degree, standards constructed for art education depend on the level of "seriousness" one is striving for. Do students need to be involved in the art process, in actual art making, immersing themselves in artistic behaviors and trying on artistic roles to learn about art? Is art education intended to make sure that everyone can participate in art making to some degree? Should standards focus more on students becoming appreciators of art, making certain that everyone in a democracy has

a basic knowledge of a common artistic heritage? Do we construct standards for a lifetime of enjoying art or what it might take to make art, paving the way for some to choose art as a profession?

• Considering children as inventors of the new art world and contemporary art as seeking the new, school art may develop its standards based on art as a search for the new. Can a standard be developed that envisions the young artist as inventor and futurist?

The Process of Drafting Your Standards

Art teachers have valuable, fresh insights and can bring their contemporary views to the profession. While critically examining standards, art teachers can create new ones. Standards can be identifiable goals for art teaching or observable student behaviors, but they derive from an art teacher's personal writings and general philosophy. Future art teachers can set goals for themselves by thoughtfully describing and analyzing the art teaching they observe.

• What will you do differently?
• What will you emphasize in your art class?

• What will be the most important goals of your art teaching?
• Describe the approach you want to practice.

Becoming an art teacher presents an opportunity to leave a unique mark on the profession. Future art teachers learn to make art, and study the history of art and art education; they are trained as observers of children and of learning and teaching situations. The study of standards can also be presented in an active participatory framework just like any other part of learning to become an art teacher.

FIGURE 1.1 Art Teacher Demonstration

Section Two The Roles of the Student and Teacher in an Art Class

In most school classes, the teacher is the one who plans and prepares. In an art class, both the teacher and students prepare for class. Students learn about art by engaging in the experience of being artists, by being independent planners, seekers, researchers, and collectors. The students and the teacher chart the course of the art experience.

The traditional teaching role is taking charge, organizing materials and knowledge for students. The art-teaching role is different; it is to promote student ideas and discoveries. In the art class, students gather materials and explore where art ideas come from and how they can be recorded, shared, and acted upon. An art teacher can demonstrate how artists work, but it is the task of the students to discover their own materials, build their collections, and keep track of their ideas.

The art teacher's job is to empower students, allowing them to take on significant roles as fellow artists. Art

teachers recognize students' ideas and opinions, becoming important listeners as teacher and student learn from each other. The role of the art teacher is not to pretend to have all the art knowledge but to recognize that there are other artists in the room and create a forum for students' ideas and plans. For students to have a significant role in the art class, the art teacher must abandon the position of sole art authority, or master artist with student apprentices.

The Art Teacher as a Mensch (a Good Person)

The word "mensch" is an old Yiddish expression for a kind and decent human being. Menschlichkeit, the qualities of goodness, can be taught to art teachers. As children and adults are taught to be wonderful hosts in their home,

teachers need to learn to become wonderful hosts in the art room.

From the moment students enter an art room, warm caring should envelop them. But how often, instead, does one see children ordered to their seats while being firmly reminded of classroom rules? Art teachers should rethink the way they greet students coming to class. Consider a few greetings like, "Thank you for coming to this art class!" or "I am so happy to share this art time with you!"

Memorable impressions are created not only by great art lessons. In the pantheon of great art teachers, it is often their humanity and caring, and the ability to express these qualities that stay with students. The great art educator John Michael used to say to his future teachers,

> First you have to love people, and second you have to love your field. People are among the most important things. People who teach subject matter only are half teachers … My students are my friends.

Love for students is the most important piece of art teaching. Art teachers need to be inspired to express their love of children in writing, to study the wonders of the child artist at home, and to play with children as a prerequisite of art teaching.

In all conversations with and notes to students, art teaching is making every artist in the room feel important. When visiting art teachers, one should notice the chalkboard. The tone of the writing on the board reflects the art teacher's attitude toward students. Writings on the board or handouts can read like a list of orders: "This is what I want," "What I am looking for," and "What I expect." On the other hand, a board that says, "Welcome to our class" or "Would you like to be a color magician today?" demonstrates the humanity of the art teacher and his or her respect for young artists.

There is fragility to young artists as they invest themselves in their artwork. Art teachers need to be aware of the quality of their response to students—including humility, respect, and kindness. Art teachers should be taught how to receive student art, how to speak to students who are sharing their "investment" with an art teacher. Good art teachers know how to place everyone around them at ease. An art period would be incomplete without a kind word being said to each student. Making students feel comfortable is the important art in art teaching.

It is valuable to talk to former students about what being in our art classes meant to them. One might hear that teaching art skills is not the real gift of an art teacher. The immediate results of our lessons may be less significant than what our students will recognize and value later. Art teaching is a helping role—helping facilitate students' dreams and ideas. In a climate in which the public is impatient with education and administrators only watch test scores, art teachers still need to develop a long-term art vision, considering which lessons or experiences will make a lasting impression on students. One art lesson might not change the world, but one art teacher who is a mensch can make a lifetime of difference.

Issues and Practices of Teaching Art

In the history of the field, art has tried to fit into the framework of the public schools by making itself resemble other subjects. But the value of art is that it provides "missing components" to the school. Although children begin their creative lives as independent artists, schools foster dependence on the lesson, the textbook, and the teacher. The role of art teaching is to preserve children's artistic independence during the school years.

We know school subjects. Content is clearly laid out in textbooks, formulated in terms of standards, and sliced into curriculum segments, with mastery demonstrated through testing. But we don't know art! Art is change; attempts to create systems or neat packages to represent it ignore its basic nature and richness. Art teaching requires an open curriculum that will always be at odds with the way schools categorize knowledge. The role of the art teacher is preparing students for new art worlds that have yet to be imagined.

In school, children are often handed supplies and learning is defined for them. Learning is seldom based on the children's environment or experiences. As environmental artists, children often find their own supplies and design creative settings. The role of the art teacher is to provide opportunities for students to explore the environment, set up studios and creative spaces, and search for materials in class and at home.

In schoolrooms, learning is usually a tabletop activity. Students sit at desks to listen, read, recite, and take tests. Jackson Pollock's use of the floor in his painting was a major step in the history of art, but children have always claimed the floor as their studio, just as they've always played under tables. The role of the art teacher is to move art away from school desks and promote activities on all surfaces and in all parts of the room.

In the classroom all eyes are on the teacher as students wait for information and knowledge to be presented. But children don't learn art directly from the teacher. The role of the art teacher is to provide appetizers for creative exploration, settings for adventure, and opportunities for creativity and investigation.

Throughout the history of art education, adult art has been used as the model and standard for children. Following adult examples, techniques, and systems was the way art was taught. Children have been taught to appreciate art by studying the masters along with other examples of adult art. Reared on the greatness of adult artists, children don't see their art as valuable, or even as art, in comparison to what is held up as art in school. However, children's art is art; it's not merely a step towards "real art" to be measured against adult work. The role of the art teacher is to celebrate children's art ideas, unique finds, art materials, subjects, and techniques. Art teaching is teaching children to have confidence in their art forms and inventions.

There is little discussion about art between children and adults. A good example is how docents treat children on a museum tour as if children don't understand anything about adult art. Presentations about adult art are lectures, as if absolute truths about artworks must be learned from the experts. The role of the art teacher is to let children know that they have valuable opinions and insights to contribute when looking at adult art, their own art, and any aspect of their visual environment.

School subjects are considered serious learning, requiring a sober frame of mind. Yet an art lesson should be fun. Humor and laughter, life and liveliness in the art room contribute to the significance of art making. The role of the art teacher in planning is to envision an art lesson that will be a fun experience—fantasy trips, imaginary play-acting, joyful dancing, make-believe plays, and making faces.

Children study in school to get good grades. Learning is impersonal, and children can't always see the connection between school subjects and their lives. Art, on the other hand, is closely intertwined with children's ideas and feelings—it is personal and often useful. Art can be a gift to others; it can be about making toys, creating art to wear, decorating one's school supplies or room. The role of the art teacher is to discuss why art is made, the connections it has to students' interests and experiences, and the contributions it makes to others.

For most subjects learning is designed to take place in the classroom. Homework is used to verify school learning. Because art is a full-time pursuit, classroom time is only one part of being an artist. The role of the art teacher is to prepare students to bring art ideas and collections between home and school, preparing them for art at home and in the classroom.

In a typical classroom, the teacher is the expert and learning is presented as fact.

Art teachers recognize that there are no simple truths about art, and even a lifelong practice does not provide absolute solutions for everyone. The role of the art teacher is not planning lectures on cue cards; it is providing comfortable settings and "tea" for discussions to brew. The distinct feature of an art class is its liveliness; everyone feels free to contribute, and not everything derives from a lone source. The joy of teaching art is being a part of the student's discoveries.

School subjects are taught and students commit them to memory, but not to the heart. Art teachers help move students through unforgettable sights, sounds, impressions, and amazing beauty. The role of the art teacher is preparing a daily museum to expose students to beautiful things to see, objects and sights they would not experience anywhere else. The daily query of an art teacher is not "what can I say?" but "what can I show students that will inspire them for a lifetime?"

Art learning is often limited to learning from adult artists and art. Great art reproductions are flashed before students; the teacher challenges students to create something similar, and later claims that students were "inspired" by the other art. Art learning, however, is broader and more encompassing, with ideas coming from students and from any aspect of their environment. The role of art teaching is to invite students to rummage around the neighborhood, to take notes in stores and from daily events, including mining the inner self, to find their art.

Shopping for ideas needs to be done by every participant in an art class. From setting up art rooms as shopping places, to learning to see the environment as the world's largest art-supply store, students need to lead the class. The role of the art teacher is to ask, "Whose art lesson is this?" and "How can I include the students and make it their experience?"

Contemporary reforms in education emphasize the importance of clarifying and ordering school subjects. Art followed with its own attempts to systematize its content in the schools. While the search for art can be logical and systematic, art's opposite nature is perhaps of more interest for young artists. The role of the art teacher in public school is to balance the rational, transformative, and illogical qualities of art. Art teaching is demonstrating the magic in

art, giving students a space to dream and playfully break away from ordered, logical, and pre-planned paths.

Learning in school is based on lectures and assignments, demonstrations of problems followed by the revelation of solutions. Art teaching has often borrowed the strategy by offering demonstrations and solutions that in fact misrepresent the nature of art. The role of the art teacher is to portray art accurately and to use each art period for students to experience the full nature of a subject that has more questions and mysteries than simple solutions. Art lessons might have no answers or guarantees. Every art experience includes an individual search, working through uncertain solutions, sorting through untried, unlikely, even accidental possibilities to travel an unchartered course. The reason to study art is to experience another side of learning.

Lessons are planned in schools that are supposed to work for everyone. The foundations of school learning have little to do with the students' experiences or interests. Art is a personal response, something that individuals have seen and experienced, and something that matters to students. Art teachers are devoted to show-and-tell, listening to students' stories and sorting the ideas that lead to their art plan. Art classes are not mere assignments and exercises, preparing students for art to come later, when students are ready, and children's art is not divided into exercises and real art; it's the real thing, the expression of real fantasies and real experiences. The role of the art teacher is to help students tap into real experiences, to connect their art with their lives.

Students keep many notebooks, being asked to record everything they are taught in class. Busy keeping records of other people's ideas, students don't always have time to keep track of their own. The teacher keeps a plan book, detailing all that end up in students' notebooks. Students, however, don't have plan books detailing their plans for class or idea books to safely keep their best thoughts. The role of the art teacher is to include students in the planning process. Art teaching is conveying to students the crucial role of planning in making art. While in some art classes students keep sketchbooks for assignments, art teachers can make sure students have a place to keep the valuable records of their own observations, finds, and art plans.

In school there is frequent repetition. Students perform what the teacher has taught by recitation and through homework assignments and tests. Artists in all media, including the visual arts, require rehearsal, but in art class the repetition and refinement is fueled by students' own creative plans. The role of the art teacher is to make available opportunities for students to try out their art ideas on many surfaces and in many spaces via different art projects. Art teaching can help students recognize that the visual arts are not a birthright, or a freak occurrence of talent, but that each inspiration requires regular rehearsal, dedicated practice, and intense hard work.

The role of the art teacher is to ensure a realistic art experience, where even the youngest students ask, why do I want to make art? What do I want to do? How will I find ideas? How do I plan my space and find materials? How do I develop the techniques and skills necessary to complete a project? This cannot wait until later, as we see that students raised on teacher-prescribed exercises can't function without them.

An art class cannot be run by art lessons alone, without appreciation of the unique art of children. The practice of art teaching needs to be listening to children's ideas and plans and not overshadowing their dreams with a prescribed art lesson. When no one asks for the children's ideas, they soon forget that they have any.

HELPING STUDENTS TO BE COMFORTABLE IN CLASS

An important role of the art teacher is to create an environment that moves children away from school stresses and allows them to be comfortable making art. Children become relaxed when they understand that art class is different from other classes. Students must be assured that they are not working for the teacher's approval—that in this class they are in charge of their own work.

Space

Creating a sense of free space that's reminiscent of playing at home might require taking off shoes and moving to the floor. Opening windows and letting the outdoors in adds to a feeling of comfort, light, and airiness. Studying children's art making spaces in the home offers other possibilities to alter space to facilitate creativity in school. The art teacher might change the detailing of the room by placing toys or displaying children's collections on the windowsill. An art room can feel more comfortable by adding children's art to the displays of great masters and posters of art concepts. The goal is to create a space that feels open for playful investigations and illuminates the unique interests of young artists.

Attitude and Interaction

Art teachers step away from the front of the room and find a comfortable space to engage with the children as a guide. To create a comfortable interaction with students, art teachers should imagine how they would be at ease making art, for example, not always standing behind kids as they work but giving them room to breathe, to take chances, and to experiment. Art teaching is shifting the conversation in class from prescriptive rules to permissive guidance. Being a patient listener and showing genuine interest in children creates a comfortable art making environment.

An art class is comfortable when children are allowed to be children—to be playful, to move, to talk, to joke. An art class is comfortable when children are having fun, when they can get up to browse, to set up their own work sites, to have some control over the progress and outcome of their art. Art teachers can set up plays, adventures, performances, and improvised dances to begin class with a fun activity that removes the children from school fears and the academic mindset.

Preparing for Art Class

Future art teachers should never hesitate to pick up items that strike their interest from the backyard, the neighbor's trash, or a flea market. Every show-and-tell item demonstrates to students that beautiful things, innovative items, or futuristic forms can be found anywhere. Some teachers walk or ride their bikes to school. Art teachers are lucky if they can get all their stuff into a car. According to one art teacher,

> I save exciting objects to share with my students all the time, and I figure out ways to pack them into interesting containers. My studio is always stacked with little piles of objects, clippings, or books—things that I made, found, or bought at different places. It's exciting to unpack all this before appreciative students who enthusiastically examine each special find.

Art Openings

Art teachers can use the same care in wrapping finds to bring to art class as they do preparing a birthday present. The most exciting "openings" are at children's birthday parties. Children open beautifully packaged items with great anticipation before an enthusiastic audience. The excitement of opening presents is a yardstick in preparing to show collections and finds in class. Items can be brought to school in beautiful hat boxes, vintage toy carrying cases, old doll trunks, and the latest in character suitcases. Preparing for a class in this way makes students feel as if they are at their own birthday parties, unwrapping one surprise after another. Everyone wants to be the magician's assistant, revealing what's inside the show-and-tell package each day.

SHOW-AND-TELL DIARIES

Art teachers constantly plan for art class by always looking for, gathering, and sharing the best things found. An art teacher's show-and-tell shares a varied art world of multiple dimensions, inviting students to participate. "Here is what I saw; what did you find?" Show-and-tell, which ends way too early in schools, continues to flourish in the art class as a means of sharing beautiful finds with observant artists.

An Art Teacher's Show-and-Tell Diary

Excerpts from a teaching diary, or art journal, reveal the many types of art examined through the teacher's and student's finds. Diary entries are a clue to the complexity and excitement of preparing for an art class:

10-3-10: *It's Sunday evening and everything is piled up on the couch for tomorrow's art class. After a weekend of shopping at garage sales, Goodwill, and used bookstores, I don't want students to miss any part of my adventures. Monday is a dreaded back-to-work day for most, but for me it's the most exhilarating day in art teaching.*

10-4-10: *I took all my packages to school to share with students. Loading the car was a challenge. I envy colleagues who can fit everything into their briefcases. Some days a U-Haul would not be big enough. With the antique stick horses in the back seat, I had to ride with the car windows open.*

10-8-10: *And how did the students prepare for class today? James removed fierce creatures from his lunchbox. Crocodiles and hippos stretched into colorful handles of a plastic utensil set. With sound effects, he animated the delightful super-market finds. Another market-art observer said that the new utensils had matching dishes. Children always find the latest and present their show-and-tell as performance art. I shared my interest in children's place settings and made a*

note to bring in my antique tin fairytale dishes. Sharing a love of beautiful objects is art teaching.

10-11-10: *I started "prime time," the beginning of our art class, with what a student brought to class. Although I was just as anxious to show my things, I wanted to demonstrate that student ideas and finds are more important. Emilie carefully unwrapped her treasured collection of miniature turtles before the class. She said the first turtle was a present from her grandfather and explained how she began collecting the others. Everyone handled Emilie's miniature sculptures with great care and listened intently to her stories. Students saw the art class as a place where discoveries are welcome, where children's visual interests are respected.*

10-13-10: *We started class with the largest package first. David shared his dad's old Lionel trains. Everyone was interested in the old train catalogues and in his dad's sketchbook for layout ideas. I liked the Lionel railroad stations, and I showed photos of the great old stations I visited in Hungary this summer. Students proudly show the art their parents collected and preserved. Everything shared today was presented from the heart! The children talked passionately about trains, creating a bond between artists in class.*

Show-and-tell turns an ordinary art room into a special place that welcomes students' finds and ideas and is open to student art. Presenting finds and talking about them leaves everyone feeling that they have great ideas. Show-and-tell is a sharing of one's creative life that brings artistic self-awareness and confidence to every presenter.

THE ART TEACHER'S AND STUDENT'S VISIONS

The art-teaching dilemma can be described by the following brief story told by an art teacher:

> An electrician works in our home and leaves a present of a huge box of assorted wires. Excited, I think of all the things I can do with it. Of course the wires will be for my students, and the next day, with ideas still fresh in mind, I go to class. The temptation is to explode and roll out all the great ideas that the box of wires sets off within me. Even worse, one idea seems to subsume all the others—yes, my very best idea for the wires, the one I want to share in class. Wouldn't my best idea also make the best art lesson for the class?

As an art teacher, it is important to respect that there are 25 or more artists in class. They all come to class with their own experiences and everyone has great ideas that they can't wait to share. It is their art class. Patience, self-control, and respect for the other artists in class suggest that the art teachers with the wired-up ideas wait their turn. This does not mean that art teachers should not recount their exciting ideas, but that it is not the *only* art idea. The box of wires will still be there after the art teacher has listened to the students' ideas.

Art teachers can be described as pied pipers for curiosity, showing an interest in all kinds of things and using their stories and finds to inspire these qualities in students. This helps to build an art class where all students confidently share or act on their ideas, becoming art experts and their own art teachers.

Preparing Students for the Art Class

Everybody needs to be prepared to make art. In an art class both teacher and students need to be prepared. An art lesson should not be a total surprise to students. The question an art teacher working with children should ask is "how can I prepare my students for each art class?" Students can come to an art class with their own ideas and some of the materials to realize their art.

Preparing students for an art class might involve the following:

- Each art class can end with a discussion of where to look, where to "shop," and what to prepare for the next class.
- Starting with the first art class, in the youngest grades, teach students that this is the place to bring art finds and ideas. Make student preparation a priority, routinely supporting and rewarding students who arrive prepared.
- Students can be encouraged to search for ideas by leaving each art class with collection bags labeled "secret finds" or "my treasure bag" (for outdoor collecting, secret treasures, beautiful kitchen finds).
- Inspire students to get out of the house to look for things, take notes, and collect souvenirs.
- Offer safe passage for students to bring the unusual and the personal to an art class. Offer convenient morning drop-off times for students bringing larger treasures.
- Encourage students to keep idea books with records of trips, observations, and plans for art making.
- Start art class with a show-and-tell of object finds and share students' ideas.

There is an art to welcoming a prepared young artist to class, being a great receiver of student finds, without overshadowing your own lessons and plans.

Planning Together

Explain to students the many ways they can participate in the art class. Describe to them what they can do at home and in class to search for art and materials, and how they can work to advance their art ideas and love of art. Generally teachers have it all laid out. They consult the curriculum, look at the previous years' plans, add some new components, and they are ready for another year of teaching. Unlike other classes that come prepackaged, with the teacher providing all knowledge and information, the art class is a joint venture in which the art teacher and art students shape the class. When you sit down to plan with your students, explain how an art class is different than other classes, how one artist (the art teacher) cannot predict the art of another artist.

ORIENTING THE ART PROGRAM TOWARDS THE NEEDS AND INTERESTS OF STUDENTS

Adults make up résumés in preparing for jobs. What knowledge, skills, and unique aptitudes do children bring to the art class? What can be put on *their* résumés? Collector, designer, inventor, display artist, home chore artist? Art teachers can ask children to give examples of their experiences as players and artists and to consider what should be listed on their art résumés. Résumés clarify children's experiences and help teachers understand the unique qualifications and wide range of art interests children come to school with. By studying children, art teachers can focus their programs on their art.

A Different Kind of Teacher Preparation

Art teacher preparation requires more than university coursework. One cannot learn about teaching art to children if isolated from children. You cannot teach art to children without having played with them, knowing their interests and rediscovering their many art forms. While school visits are valuable, they are not substitutes for learning from children, spending time on the floor, and creating with them.

Teacher preparation includes working with children in camps, volunteering for child care, and studying the creative play and development of children in one's own family. An important class trip for all art teachers is visiting children's rooms—their home studios. Here teachers learn to make a smooth transition between home art, the play-based art of children, and a realistic school art focused on children's creative interests.

Visiting Home Studios

Opening the door to children's rooms, one immediately notices how creative activities take place on the floor. While furnishings may hold clothing piles or serve display purposes, art is on the floor, beneath tables, or under beds. On the floor one might find Barbie aerobics classes ready to exercise or little ponies going to school. Children's playthings merge with their own gatherings of household objects, creating environmental art with changeable performing elements.

ARTISTIC FREEDOM AND BEHAVIOR MANAGEMENT IN THE ART ROOM

In gauging the climate of the art room, it is helpful not to sweat the small things. In other words, expect paint to spill on occasion without swearing never to have the class paint again. Just figure out how small classroom issues can be resolved—how students can be covered, floors protected—and move on. In an active art room accidents will happen, but they are never as bad as the teacher fears. You should feel that you can handle small matters with calm and logic while demonstrating care for the students. Don't worry about handling things "the right way." All small issues in an art room are rectifiable if not spun into the status of major problems.

One should not expect the art room to look like other classrooms. The typical classroom set-up might not be the best model for the art room. Art making is not like the synchronized activities in other rooms, where all children follow the teacher's ideas and instructions, all doing the same things at the same time. Sameness in art is seldom a good sign. As an art teacher you already know that your students will not be doing the same thing, in the same place, in the same way, at the same time.

Sameness dictated by the teacher does not lead to artistic independence. A sign of students becoming more creatively independent, for example, is that they ask less permission from the teacher. With inner discipline students learn to respond to their artistic voices, and you hear less "may I do this?" Students behave more independently, making their own decisions as artists, instead of constantly asking, "Is this all right?"

While silence might be valued in school, free conversations in the art room are encouraged and important. Students of course need to respect when other artists like the art teacher speak, but talking in the art room needs to remain spontaneous and not only in response to the teacher's questions. Art views and ideas should be freely expressed and debated among class artists. After all, that is one of the advantages of sharing a studio. To be able to describe one's own work or to respond to someone else's involves talking about the artistic process. The freedom to speak in the art room promotes the freedom to act, and to test art ideas in words and in gestures.

Young artists should feel free to get up and walk around in the art room. Students can look at what others are doing or search for the supplies they need. Limiting students' moves and behavior also restricts freedom in art moves. It leads to artistic ideas being isolated rather than shared. Students gain ideas from their own art as well as from other artists working in the same room. It's important to promote personal freedoms, movements, and opinions in the art class without feeling that this will lead to the collapse of school order. Doing so allows the students to become independent, self-reliant, and self-disciplined.

First-Year Teacher Expectations, Colleagues, and the Principal

Each day many classroom teachers escort their students to the art room. Every teacher and administrator that comes to the art class has their own concept of discipline, including how an art class should look and how students should act in the art room. Matching, or at least understanding, the perspectives on discipline of the many teachers who walk through the art room door is the task of the art teacher. Part of that task is recognizing basic school policy and keeping the art room's energy and the consequent mess, or appearance of disorder, within school boundaries.

"Art room fever" is the amazing outpouring of excitement, joy, and relief children demonstrate coming to make art, but stampeding into class will not work. One solution is to start and end the art class on the rug, a carpet painted as a clubhouse, with spaces for cushions decorated by the children. The students should know to meet you at a special place on the floor, on a magic carpet. At the end of the art session, on the heels of an unbelievably exciting art-room experience, the children are dying to share what they created with their teacher, so they can once again return to the exclusive meeting place on the floor to prepare for being picked up.

As you work your way into the heart of the school and the good graces of the faculty by displaying your students' wonderful art throughout the building, you can ease students into having more freedom and control of their space. At this stage there can be informal discussions with colleagues about the special requirements of an art studio. Opinions about the "new art teacher" are often formed superficially and can be difficult to reverse until you gain everyone's confidence in the art program. As the new kid on the block, take the opportunity to introduce yourself. For now it's show time, when colleagues and administrators enter, let them see that there is such a thing as organized chaos. Students may be out of their seats or creating on the wall, but they're completely absorbed in their work and well-behaved.

Driving Without Brakes

Scary? But you are not alone—the most common nightmare of all teachers is losing control of the class. Every teacher, even the most experienced, has had the dreaded dream of standing before a class and losing his/her voice or not remembering what to say or being unable to stop a fight. The nightmare should not be confused with reality, since none of the above is a common school occurrence. As you calm yourself it is good to know that there are brakes, "classroom tricks" or planned controls that every teacher can access. Knowing the brakes are there if needed offers a sense of security.

Study the school customs—what your fellow teachers use to establish classroom order. Some teachers may flicker the light switch. Others may ask students to go back to "level one," a school-wide motto for lowering your volume. Art teachers can also use original ideas for fast responses that are educational and fun. Do you know the difference in stance between an Egyptian and a Greek sculpture? Students who have practiced sculptural posing do. You will be proud to see students freeze in a silent sculpture pose

selected from art history when you call for silence or attention.

As a background to what is accepted in the art room, one can gain insight to school norms by observing hallway manners and behaviors in other classrooms. Granted, some norms have to be altered because of the nature of the subject, but "dismantling" general school rules needs to be done with consideration to those rules, balancing them with what is necessary for art.

There is a gradual period of change as the art teacher becomes more experienced and relaxed, allowing the students also to gain freedom. It is important for the art teacher to gradually let go of the reins of control so that students learn about the nature of self-discipline practiced by artists. As students seek autonomy to steer their art, the freedoms granted should be focused on art; those freedoms are not there to pose a challenge to the art teacher's authority.

Involvement in Art Brings with It Its Own Sense of Discipline

When students are involved in making art, you can feel an intense labor of love throughout the art room. This offers a very different experience from trying to control a disinterested, uninvolved group of students who don't want to be there. One can walk out of a bad theater performance. In school the teacher has to keep students in the room no matter how bad the show. This forced attendance can create various discipline problems, but these are notably fewer in an art class.

Freedom and discipline are not contradictions. Art teachers provide freedom in art classes to instill self-discipline in students. In the art class a different relationship has to be built between teacher and students. The art teacher is not a boss, a dictator, a ruler, but someone who is a disciplined fellow artist, a mentor who instills a sense of pride in self-discipline when it comes to making art with students.

The art teacher is a model of what it means to be an artist, demonstrating how artists are focused and extremely hard-working. Art teaching is realistically involving students in the art process. This includes discussions about the patience it takes to make an artwork and telling stories about dedication and hard work in artists. What does it take to make great art? Discipline and hard work are held up as high ideals through art teaching.

A mission, a compelling idea that is important enough to dedicate all energy, time, and self to, centers an artist. Likewise, students become disciplined by having a voice, feeling a stake in an art class, by participating in planning and formulating their own art projects. When students feel that the art lesson is about their concerns and interests, they go to work with great dedication.

You, as an art teacher, should always think about how to involve students in the art class:

- How can students gain a sense of purpose and freedom to make decisions over their own art making?
- What choices and decisions will help students to understand what being an artist is all about?
- Which decisions must be made by the teacher and which are best decided on by students?
- What say can students have in art planning, in the process, and in ending a work?
- How can students prepare for individual art sessions?
- What planning roles that are usually done by the art teacher can students take over?
- How can students take charge of their own artwork and art making space?

Understand Your Comfort Level

How much noise in the room are you comfortable with? Are you okay with students listening to music on headphones? At the start of art teaching it is useful to consider every aspect of one's comfort level. Be honest about the level of action and activity that you're comfortable with in the art room. Test how much organization you need and how much mess, disorder, and noise make you uncomfortable. Students stealing, destroying materials, or insulting each other's art are things you cannot accept! Share your list: let students know about your feelings. Draw the line to what is not acceptable.

Envision New Teaching Roles

The reward of art teaching is the daily inspiration you gain from the children. It is not about you, the art teacher—your art knowledge, your art interests, your art taste, or your art judgments. Teaching must not be accepted as an act of controlling, being in charge, or playing the only lead role in class; it must not be taught as a way to merely present information and knowledge, handing it down to students

because they will quickly learn to turn to the teacher for all their needs, all their questions, problems, and solutions. Art learning needs to flow both ways, from the teacher to students and from your artists to you. To feel free and behave well in an art class, students need to feel that the art class is about them.

As an art teacher, you can see yourself as helping students become their own art teachers and promote freedom for students to experience what it is to be an artist. You, as the art teacher, should view your task as a sharing role. You set up an art room that belongs to the students. You can envision art teaching as sharing plans and ideas with students, instead of giving assignments or telling them what to do. As an art teacher you will be sharing your artist self with others in the room. As an art teacher you will be in charge of encouraging young artists to demonstrate their artist selves.

Expanding Freedoms as a Class Progresses

One art class, in a very small art room, offers free shopping for materials at the table. During the period the art teacher brings to the table other containers to examine. In another class, however, students are encouraged to move beyond the table and to open drawers and cubbies, because the art teacher has already worked with the class on tabletop shopping. In all circumstances where freedom and choices are available, freedoms can be expanded over the school year.

Setting Up Space To Be Disciplined Yet Free

Art teachers should consider how to set up a student-friendly art room, where supplies are not locked and students are not chained to desks. Envision an art room that is organized to be "self-serve," open to students making choices about their work space and materials. Art rooms of all shapes and sizes can allow for freedom in a controlled studio. For example:

- In setting up space for independent action, give students a choice of pillows or chairs, which allow for different movements and levels of privacy. Headphones can be made available for students who prefer to work with sound, using their own selection of music brought to class.

- Multiple work sites can be offered to students by ensuring free access to covered walls, designated floor segments, or even space under tables. Each work space selected allows for different moves, sights, and relationships to the art and other artists in the room. Moving tables and chairs aside, opening floors for art making, and valuing breathing space promote the students' artistic freedom.

- Allowances for shopping require free shopping zones in the art class. Organized cubbies and interesting drawers and containers can be used to give the feel of a store, a market, or a treasure hunt. Shopping sites can be organized yet fun to browse for materials and art inspiration.

Rethinking the art room—moving away from the idea of a sea of tables and chairs acting as barriers to movement—is a start. Allowing individual students to stake out work spaces, creating access to shopping zones and to seating and standing areas, help create a working studio setting.

Sharing Responsibilities

Your students can learn not only to enjoy the freedoms an art room offers, but also to take responsibility for its organization, upkeep, and general appearance. Being in charge of one's art requires sharing responsibility for the space where the art is made. In other words, taking a personal interest in the art room, having pride in the room, demonstrates a sense of co-ownership. Students can work to improve the art room's storage capability or add their material collections and finds to class shopping sites. Helping to beautify the art room by contributing a student-made clock or a decorative trash can shows that the occupants take pride in the studio. Having specific clean-up tasks for each student and volunteers who care enough about the studio to clean and organize on their own time shows that students value a school's art studio.

Working in a Studio-Like Atmosphere

One of the questions most frequently asked by new art teachers is "How do you get there? How do you go from controlling an art class to offering students a place they can perform independently as artists?" Following are some suggestions offered by art teachers.

Understanding What Is Held in High Esteem

Art teachers should make certain the students know what is held in high regard in the art class. This is accomplished by what the art teacher emphasizes and rewards. Praise student cooperation wherever you see it. Congratulate students who are ready to help each other and who respect each other's work advances freedom in an art room.

Art talks about sharing and helping are an essential part of teaching students to work cooperatively in the studio. When young artists become responsible users of the art room, there is a sense of ownership of the place. Pride in the art room leads to pride in individual artworks. To stimulate freedom and self-discipline in any art room, there has to be a sense that the studio belongs to students.

Balance

There's always a balance between disciplining and providing freedoms. Students can never be completely free in a school setting, but they can experience a class that offers increasing amounts of freedom of choice. The balance goes back and forth as students demonstrate by their actions that they can handle the freedoms available to them.

Negotiation

Art teaching is constant negotiating, providing freedoms as rewards for students who demonstrate the ability to take the lead in the art process. While work is assigned for class and for home, students recognize that it is all negotiable, gladly substituted by their own proposals.

Trust

Art teaching is trusting that students have great ideas and are able to act upon them. While this is true, the art class has to provide opportunities for students to express their own ideas, to share and discuss dreams, to take notes on ideas and plans. It is common for students to say that they aren't inspired or can't think of anything to make. But these are statements of fear and uncertainty from children who are unaccustomed to sharing their own ideas, which are seldom asked for in school. Art teaching is not giving up,

but patient exploration with the students about their observations, collections, and possibilities.

Discussion of the Nature of Life in an Art Studio

Art teachers should re-evaluate what makes an artistic community work. How many art rooms have you visited with an oversize poster of classroom rules? Does a new crew of young artists review and adapt the rules each year, or does the yellowing laminate suggest that the rules have been on the wall for quite a while? Which rules actually benefit the artists in the room?

Students may discuss:

- How art studios preserve concentration and promote privacy, allowing artists to work in their own unique ways.
- Some artists prefer noise, music, and company, while others like quiet.
- One artist prefers a cluttered and busy space—others want nothing in their studio but bare white walls.
- Some artists like to have space to move around, but others sit motionless at tables and computers.
- Group studios have room for art making in cubicles and conference spaces in which to confer with colleagues.

Can some of the above findings be incorporated in thinking about your art class? Students can participate in intelligent rule-building that will allow everyone the comfort and privacy required to respect individual and group needs in the studio.

A Few Final Thoughts

An art class is like an artwork itself—always a work in progress—and like an artwork, results take time and careful planning and will not materialize without some problems. Paint will spill, there will be arguments between artists, but as an art teacher you will always be thinking about how to adjust the art room to make things better for everyone who comes to make art.

A sign outside an art room reads "Beware: artists at work." The art teacher is reminding everyone in the neighborhood—passers-by and visitors—that this is a studio. It may appear messy or noisy, active with children doing unusual things, but it is a room not to be judged by ordinary standards. The art room and its occupants need

space to do things differently in order to produce ground-breaking art. One of the signs that an art class has a good balance between freedom and discipline is that students feel the place is their own and treat everyone and everything inside with pride. Teaching art is teaching students to value their time in the art room as a unique opportunity in school.

Characteristics of Highly Accomplished Art Teachers

Who were your best art teachers and what did you learn from them? If you understand the art teacher you want to become, you can begin to plan your course of actions. Learning from good people and observing and identifying with great teachers helps to guide your path and provide personal goals.

By the time you become an art teacher, you have received many art lessons and been observed in many art rooms. There are a few—the special art teachers, the greats—who perhaps inspired your choice to become an art teacher. The people who motivated, nurtured, and supported you are role models; they are the art teachers you are striving to become, the art teachers to honor with your prologue.

Creative and Innovative

Art teachers need to be role models for creativity. They can be found most often creatively showing instead of lecturing in class. They are able to set up the art room as a stage, enlisting all classroom surfaces and objects to speak about color, transparency, and light, or to use objects and events to set a play stage or tell stories. Being in class with a creative art teacher is like being in a great studio watching an artist at work.

Creativity in art teaching is sometimes defined as being able to see art possibilities in everything, to set up a Broadway show using just classroom furnishings. Creative art teachers recognize the many lives and uses for all spaces and objects. They have a free sense toward incorporating ordinary school supplies, kitchen tools, or inflatable beach toys to contribute to architectural wonders.

Creative art teachers are described as doing things differently than other teachers in school. Some take attendance by drawing with the children on the board, others design hall passes, paint handouts, illustrate the cover of their grade book, and wear decals sharing their new art over T-shirts. Creative teachers know how to use ordinary things to make everything around students beautiful. Instead of smiley face stampings, creative art teachers have stamper sets cut from their drawings to share with fans of stamping.

Legendary art teachers give playful instructions, are known for their playful hands, constructing, wearing, and animating with unexpected objects in class. In their way, they are living the art process—trying out everything and exploring the many possibilities in all things around them. Creativity is being able to stage a lesson, possibly arriving in one class on a raft fabricated from rolled newspaper, accompanied by a childhood teddy bear, the only speaker during the entire introduction to the lesson. Teaching is a living art, demonstrated as a creative teaching performance. Creative teachers take care not to allow school life to turn into endless routines—they are the pied piper for doing things differently.

Energetic

Art teaching is not a desk job. Great art teachers wake up students from their slumbering school daze and energize them to be children again. An energetic art-teaching performance includes being on your feet, being where the action is, circulating about the room, and moving and acting as a lively performer.

Another aspect of energetic art teaching is demonstrating passion for the subject. Good art teachers are clearly enthusiastic about art and teaching. They are alive in class and they excite students because they want to give and share everything they can with their students.

Relates Sympathetically to Students

Teachers who are well suited to work with their students are like a good marriage partner. Some teachers are in a good relationship, they are wonderful with young children, while others are at their best in middle school. The relationship that works best for each art teacher has to be explored.

Good art teachers are in touch with their own childhood and spontaneously respond to the interests of children in the art room. Such art teachers talk about children in class and the wonders of their inventions, and art ideas. They take cues and use examples from children's playing and art making, sharing it by means of personal stories, photo albums, collections, or freely introducing their childhood

toys in art class. An essential part of good teaching is keeping the art world and the meaning of art open for everyone in class.

A good art teacher has the energy to learn about children's "stuff," what they care about, from the latest toy to the coolest cell phone. Shared art interests are a means to form a relationship with students. Teaching art is a matter of taking detours, entering new aisles during shopping to examine what's new in children's toys, school supplies, or inside or on the back of cereal boxes.

A passionate art teacher can speak eloquently about art but is equally devoted to listening to the student's art plans and finds. An extensive adult knowledge of the subject can be balanced by a devotion to learning new things from students. The art teachers who are most frequently remembered are the ones who showed genuine interest in children and their ideas.

Patience

An art teacher's moves, attitude, and words set a pace and speak about having time to make art. A good art teacher will encourage students to take their time. Where does one hear that in school anymore? In the rushed life of children, there is little time between ballet class and soccer practice. In school everyone is rushed to cover materials mandated by the state and to be ready for the next test. In a deadline-driven school, art requires patience, something schools, teachers, and children are not accustomed to. A good art teacher will say "Let's sit down and talk" and "What do you have in mind?"

The art teacher's patience instructs students about another way of life, of the necessity to learn to manage one's own time and to make time for important things. Who has time in school to sit down with students to plan and think? A good art teacher exhibits patience so that every student feels it, and so that young artists themselves are able to take over the natural flow of the art.

Someone Who Makes Art

Good art teachers make art and frequently share their art with students. They share their personal art making, their own childhood art, and the work of adult artists who motivated them. Sharing the love of art making translates to inspiring students. Good art teachers continue to make art while teaching, so that students can have the special

experience of meeting and working with an artist in class. The experience of making art enriches the conversations in class. Art teachers remember seeing pictures of their art teacher's studios, their sketchbooks, sampling new papers, and hearing about the hard work that it takes to complete each series.

Art teachers often refer to the experience of fearing the white canvas. Outstanding art teachers talk about art fears, and sympathetically discuss issues of perfection, expectations, and acceptance. Resolving art fears can open the way to feeling good about oneself as an artist. Liberated students move art into the cherished column of subjects that they feel they are "good in." Students feeling that they are good in art is one of the best results of art teaching.

An artist's life is a fascinating life of museum visits, travels, adventures, and discoveries in unlikely places. Art teachers don't attend art events alone; they represent their students at the events by taking pictures and gathering ideas and souvenirs to share with their students.

Art teaching is the ability to inspire students to make art beyond the classroom. Outside of the art class is where the student's own art is really made. Future art teachers can consider how their teaching could motivate students to leave an art room filled with great ideas and stimulating plans.

Appreciates Art and Beautiful Things

A good art teacher is a constant treasure seeker and an avid collector, looking for unique things for the art class. Students know when they are in the company of a special seer, someone who gets excited about finding and picking up unusual, interesting things at a flea market or the supermarket. Art teaching is constantly sharing one's interest in beautiful things with the art class.

Good art teachers are, of course, well versed in a variety of traditional art history and new art worlds such as the history of play objects. Such an art teacher is able to share and invite a pantheon of favorite artists. They can reference and compare art worlds from the history of baseball cards to the history of portraits to modern art, and demonstrate an understanding and a love for art in all areas.

To Summarize

There are many qualities in art teaching identified above, but the list is not complete. Future art teachers have to

FIGURE 1.2 Art Teacher Demonstration

complete it by looking at themselves to see what unique traits they have to offer, and consider how these qualities can be enhanced.

Good art teachers demonstrate daily to children that they have many good ideas and in fact have the best ideas. They confirm that children have extraordinary abilities to discover art, through art materials, new techniques, subjects, and ideas. The best teachers open up art worlds and possibilities for students, instilling independence in them to make art their own way.

Tell me and I'll forget; show me and I may remember; involve me and I'll understand.
—Chinese proverb

INGREDIENTS FOR A SUCCESSFUL FIRST YEAR OF TEACHING

The first year of teaching sets the tone for the rest of one's teaching life. It is impossible to define for everyone what will or will not work, but during the final days of one's first year there is a reflective state, a review of the "balance sheet" of successes and struggles. Some teachers feel satisfied in just having done it—having made it through the first year.

Beyond that, ideally one will still feel a love of art teaching. The following is the big picture to keep in mind in preparation for the first year.

Clear Goals

As an art teacher you see phone calls, e-mails, and your calendar swell with things required, demanded, and coming at you at a furious pace. It is easy to lose sight of your goals and hard to stick to what is truly important. Knowing what you consider vital for your art teaching is a skill to learn the first year. Keep in mind and even list and post your goals in a prominent place. Here are some goals that first-year teachers develop:

- I am here to help students develop a love for beautiful things.
- I am here to build students' confidence as artists.
- I am here to inspire students to bring their ideas and art to class.
- I am here to help students feel that they have the best ideas.
- I am here to teach students to make art everywhere and all the time.
- I am here to help students develop art ideas to take home and explore after class.

During a demanding school day it is frustrating to lose track of one's reason for being there. To have a successful first year, go to your new school with a clear set of goals and keep them in sight. Know what you want to accomplish, not what the principal or others want from you—otherwise the system will fill in the blanks, and you will not be happy.

The Feeling of Being an Agent of Change

To succeed in the first year, a new art teacher needs to feel a sense of *personal* mission. As an art teacher you are a reformer with good ideas and you cannot wait to try them out. This makes for an exciting first year. Teachers need to realize that they will not immediately meet all of their goals. The first year is a time for growth. Take time to draft and whittle down the changes you feel are the most important. Here are some key phrases to contemplate:

- I would like to see students come to my art class feeling …
- I would like to see students in my art class doing …

- I would like to see students leave my art class knowing…
- I would like students to realize …

Working with a sense of mission makes for a satisfying first year. "What are my goals for changing art teaching?" The personal goals young art teachers list are far reaching and have the potential to impact and inspire students long after the classroom doors close.

Realistic Expectations

You can adopt a realistic view of teaching as learning from students and colleagues and, when necessary, rebuilding and changing your approach. "During my first year I expected to do everything right," recalls one art teacher, "and when things did not go well, I right away blamed myself." One can gain an understanding from making art, knowing the ups and downs, good and bad days that challenge every artist. In art making, one has to figure things out and try different solutions. The first year of teaching requires similar expectations. Anyone involved in making art realizes that they don't know everything about art. One can have a good first year by just being a keen observer, a sympathetic listener, and an enthusiastic supporter of young artists.

Whoever says that art is all easy and fun has little in-depth experience with art making. Expect and gain strength from paint spills, unwelcome behavior, and having to constantly change your plans. Value your bad days because they force change that makes good days possible. If art making is your model, then there is a healthy expectation that art teaching can be freely explored and that everything can be altered. Be proud of your ability to bounce back from a hard day.

Understand Your Strengths and Weaknesses

In the first year it is important to be clear about your personal strengths and to use them in teaching. On the other hand, weaknesses can be creatively compensated for. We all have many public personalities and yes, you can be successful even if you are shy. You may not be comfortable in the role of a public speaker, but art teaching does not have to be a lecturing position. Tear up the cue cards and use your storytelling skills, or surround yourself with collections to relay insight and enthusiasm through your show-and-tell. As a first-year art teacher you learn to work from your comfort zone and discover the best teaching situation for your personality.

Use Your Art Interests

There are no recipes for being happy in your first-year art class, but if you share the art you love, everybody in class will feel good. Invite students into your art world as you lovingly show your favorite artists and artworks. Students should see your art from your childhood to your latest pieces.

To find pleasure in your first year teaching, incorporate yourself, who you are, the things you do, what you enjoy in each lesson. As a practicing puppeteer, there is no better performance stage and audience than your art room. If you love to beautify things, the art room can always be in bloom, filled with wonderful flower arrangements. When you are showing and sharing your art, your satisfaction with your teaching is at its peak.

Your art was formed by all your experiences, travels, or interesting jobs you may have experienced. Whatever shapes your art also enlivens your teaching. Bring your experiences to class because the subtitle of all art lessons is your growing up as an artist. As you share with students your artistic adventures, your students recognize their life in art. Dance in class if you love dancing; if you enjoy cartooning, allow your illustrations to speak in all your presentations. All your creative art forms are welcome in class.

Maintain Your Art Connections

You just began a serious studio commitment in college and it would be disheartening to bring it to an abrupt end. The start of art teaching should not be a period of mourning for lost art dreams, or a lack of art making time. Work out the time, space, and discipline required for independent art making before you start teaching.

As you teach your students to be independent artists, it is also your opportunity to begin making art without assignments, finding an art direction that is your own. As a professional you will value self-discipline, and your life will be fulfilled and you will feel good about yourself.

This is the time to get serious, make plans, and act on them. Now that you are teaching you can afford some artistic luxuries, such as the paints you always wanted, so treat yourself well. The next step is to plan your home art

studio—it may even be a kitchen table devoted to your art making. Plan to scale your art to your teaching schedule and to the available home studio space.

Art teachers must determine how to effectively blend a teaching life with an art life. For example, consider how you might incorporate the fresh student art you witness each day and use it as inspiration? Before starting your first year as a student teacher, you can prepare and test your plans. There is no waiting for later. Teachers who continue making art during their first year are likely to stay with it.

Also, you may continue making art in your own class by setting aside art space for yourself. Art teachers can playfully draw on the board and make art with and for the children. One can keep art connections by attending exhibits and talking about art, and keeping up with artist publications and friends. Your art spirit needs to be refreshed, so get dressed and go gallery hopping even after a tiring teaching week; you and everyone in your school benefits.

Develop a Bond to Your School

The first year will be pleasant if you can make the school feel like your home. One values going to school if it becomes a place you feel good about. Imagine your coffee machine perking and fresh popcorn waiting nearby. You bring in your favorite lamp, put up some of your paintings, and even without your comfortable slippers, the room has all the comforts of home.

One comes to enjoy a school when your family is there. Having a bond with the music teacher who you found a lot in common with, or the other "specials" teachers who become your friends, helps form a second family. Even the most solitary studio artists work more effectively as art teachers when they are part of a close-knit group that works well together. A good friend in school, or colleagues to sit down and talk to about school and life matters, changes everything.

Socialization is the feeling of being a part of the school, having friends, being known and liked at work. After long hours in the art room setting up and cleaning up and preparing for the next classes, you can become too tired to leave the room. With little time to go to the bathroom, it is common for art teachers to suffer isolation. As a first-year teacher a part of your effectiveness and comfort will be to make sure you break bread with the staff, sharing your meals and your art teaching with others.

Interest in the Community

It is interesting to find that teachers who take on the added responsibility of an after-school art club are more satisfied with their first year of teaching. Those who get involved with PTA-sponsored art activities also find them rewarding. When parents love the new art teacher, they also become an important ally of the art program. Art teaching is a helping role, a way to dedicate one's self to others. A satisfied art teacher is involved with the school community.

Find Support from Other Art Teachers

They may not be in your hallway, or even in the same school, but seeking the support of other art teachers makes for a happier first year. Being the only art teacher in school can feel special, but also isolating. While one has a great deal to learn from seeking out good teachers as friends one still needs the support of art teachers to compare notes, accomplishments, and seek advice. A successful first year teacher finds a strong art teacher to call and visit, entering a positive mentoring relationship. No matter how close or how far, it is important to drop by, see what other art teachers are doing, and have the necessary connections that allow one to feel secure and evolving on the job.

Take Good Care of Yourself

All the fieldwork and student teaching will not adequately prepare the first-year teacher for the marathon of guiding several hundred young and enthusiastic artists each week. Art teaching is a physically demanding job. There is frequent guilt about "flopping out" after school, taking naps and using the entire weekend to rest. One has to be ready to exercise, eat well, take vitamin supplements, and embrace a holistically healthy lifestyle, meaning being both emotionally and physically nourished. As an art teacher you have to consider how to keep fit and create a personally comfortable environment in the art class where you can sit down to have a cup of tea in a comfortable chair and unwind between classroom sprints.

It's also important to value your home time and not to let your teaching become your whole life. It's crucial that the work does not remove you from family and the things you like to do, or stop you from enjoying living in the moment.

And Finally

Success is more than surviving the first year, but in what shape did you finish? Feeling success and satisfaction in having done a good job during the first year is important. One needs to be happy and satisfied with art teaching on a basic level to successfully continue for many years.

With the understanding that there is a lifetime of room for improvement, new art teachers need to be honest with themselves in reviewing the first year. Yes, it is an unimaginably tiring and demanding job, but was the effort worth it? While they are asking about basic feelings, they need to ask: Am I happy doing this? How was this year valuable for me? Do I look forward to the next teaching year? Am I still excited about opening the art room door each morning? Not that one should selfishly measure success, but one needs to take stock of one's basic goals in art teaching, both professional and personal. The goal of the successful first year is not to burn out but to stay hopeful about the second year. See Plate 1.3.

ADVOCATING FOR THE VISUAL ARTS

So much of art teaching is about advocacy. Sharing your genuine feeling about art with students is one of the most important parts of the job. Talk with students about why each lesson is very important. Advocacy is creating a solid understanding in the hearts and minds of students that what they are learning and making in art class is significant. The teacher holds up a photo from the newspaper and says, "It would be wonderful to join these children covering the great pyramids in Egypt with their art. They want to show everyone that children making art is as old and as important as the ancient pyramids!" She/He turns to the class and says, "I believe that your art can change the world."

Understanding Your Own Advocacy Position

All your teaching life you will serve as a spokesperson for art in your school. Always clarify your views and build new and compelling arguments. Speaking convincingly and passionately from your heart, use examples from your own experience.

Students Are the First Line of Advocacy

Since each art lesson has the potential to inspire a strong future art advocate, it is important to communicate not just the subject but a belief in the significance of the subject. Behind all art teaching is a common thread, the promotion of a lifelong interest in art. Art teachers contribute to a love of art in all their students. Our students are the future of the art world, and art teaching is about inspiring tomorrow's art leaders. Our classes shape students' art views, determining their support for art in the schools, in public places, or museums. It is crucial to teach art with passion, sharing a love for art and the important place it has in our lives.

Students Share Their Art on Open School Nights

On open school nights, parents visit with the art teacher and see examples of their children's art. The art is cute, it's fun, it's decorative, but children who have learned to talk about their work can convey a hard-to-ignore impression of the value, commitment, and learning received from the art they made. Open school night becomes a significant advocacy opportunity for the children who present their own art to parents.

As contemporary artists, children learn to talk about their art, and they enjoy sharing and discussing their work with adults. Electronic presentations created by students are modern versions of the old portfolio. Sending home art that may or may not end up on the refrigerator is not enough. Advocacy is teaching students to present their art to the adults around them.

Students Talk About Art to Everyone

A young art teacher vividly recalls the elementary school principal's first informal visit to the art room. The visit seemed like it would turn out well, since all of the students were deeply engaged in creating beautiful pieces. But when the principal leaned over and asked a student, "What are you doing?" the child replied, "I don't know." You can imagine the teacher's heart skip at the noticeable displeasure on the principal's face. In school, even those swept away by the highest states of artistic rapture must be able to verbalize something about what they are doing. A school art class is not a secluded studio where work

can privately progress and meeting the public takes place later. In an art class, students must be able to voice and intelligently reflect on their creative actions at any time, since they share tables with others and are observed by unexpected visitors.

The state of creation may be uniquely non-verbal, but if people outside of the circle of art are to support the arts, they want to hear about what is being done in the art class. Artists are often told just to make the art. After the art is made it will be displayed in the public arena to be received and discussed. The artist's responsibility seems to be over, and in theory now it's up to audiences and critics to reflect on the work. In a school art class, however, classroom teachers pick up their students and want to know what they're up to; furthermore, parents and other visitors can always make an appearance.

Clues to what students are learning in an art class can be presented through signs in the classroom and displays on the boards, but the first line of inquiry will always be the students who will be engaged in conversations in class and after they take home their work. Yes, art matters in an art class, but the art class is often judged not only by the art produced but by what is said about the experience. Classroom teachers who pick up their students holding amazing art in their hands should not just see the art but should hear explanations that advocate not only for a particular project but for the overall importance of making art in school. Adults need to be educated about the art in order to recognize its importance. An art teacher therefore always needs to prepare students to speak about what they are doing.

Teaching Students to Share Their Art

Teaching students to be convincing spokespersons for their art requires practice. Students can practice discussing the art they made, speaking of the unique ideas the art represents. A student says,

> When I make art, it's something I invent. It is in my own language that not everyone understands, but that doesn't mean that what I'm saying is wrong or that the art is bad. I would like to talk to you about the art so you can appreciate it. To understand my art, you have to be willing to spend time looking and listen to what I have to say.

Writing artist statements, no matter how young the artist, helps to sharpen ideas about completed artworks. As art is

presented to a waiting classroom teacher or a parent, the artist statement, all that the artist learned and feels is important to share about the art, can accompany it. A student writes,

> It is fun to make art, but it is also important to believe that what we are doing is important. I am an artist because I invent things. My artwork is original, it is new, and the design has not been done by anyone before. This is my design for a space station.

Artist diaries are another means to share an art journey with others. A young student explains,

> Things change all the time when you are making art. As an artist I start with some idea of what I want to do. I have many choices to make. I always have new ideas while making art. These ideas are sometimes hard to explain, because the art keeps changing. During art making I think about pictures and not words. What may help you to look at my art is to see it as a story. I can explain how I started and the ideas I had along the way.

Advocacy starts in the art room, with students learning to formulate and clarify their ideas and speak about them in public. Discussing with students why we make art, why we come to art class, is part of the conversation. Our students love making art, that's clear to everyone, but to be able to continue making art the students have to participate in convincing adults—teachers, parents, taxpayers—that their art is valuable.

Hallway Advocacy, Art Notes, and Banners

Simple affirmations by students and teachers on clear banners can be powerful declarations about art. Each banner displayed in public view is both an artwork and a statement of advocacy. One such banner, created by students with bright puffy paints, crosses a busy school corridor. Children's statements assert their uncomplicated affection for art: "I love art because I can make beautiful things," "I love art because I collect crazy stuff from the street, and can bring them to class," "I love art because it shows my best ideas."

In another part of the school, it's the teachers' turn to advocate for art: "I like art because it makes my students think," "I like art because my students become observant," "I

like art because it makes everyone happy." All the heartfelt statements are signed and attributed to souls from the school population. Very soon everybody wants to have their say, their space on a banner, to proclaim their love for art.

Student Art Displayed with Informative Text

A hallway art display requires showmanship to draw the attention of a fast-moving audience. It should be fun, using such things as unusual fabric backgrounds, flags, or unique rope lights, but for the curious adult judging the learning the art provides, written material can be used to explain the art and the broad educational concepts the works encompass. Hallway displays are like storefronts for advocacy. Bulletin boards not only display the quality of the art produced in a school but create a general interest in art.

The following are examples of statements that have accompanied children's fanciful creations. There are informative signs for student reading and more detailed descriptions for adults to examine:

- *A **note for adult viewers**: In their art children make good judgments about qualitative relationships. Unlike the rest of the school day, filled with rules and correct answers, in these artworks it is the children's judgments rather than rules that prevail.*
- *A **note from students**: In my painting I learned that problems could have more than one solution. In my art making I see that questions can have more than one answer.*
- *A **note for adult viewers**: Each art assignment teaches students complex forms of problem solving. Purposes are seldom fixed, but change with the circumstances and opportunities young artist have to explore in the art room. Art learning practices the ability to respond to unanticipated possibilities as the process unfolds.*
- *From **students**: My painting celebrates multiple perspectives. In all my art I can show that there are many ways to see the world.*
- *A **note for adult viewers**: These artworks demonstrate that neither words in their literal form or numbers completely account for what the children know. The limits of the children's language don't define the limits of their knowledge or understanding.*
- *For **students**: Look closely at my art to see how small details can have a large effect. In art I learn that the world is very intricate.*

- *A **note for adult viewers**: Art helps children say what cannot be said. Young artists have to reach into their imagination and poetic sensibilities to explain what they feel.*
- *For **students**: When I made this picture I was very sad about a great loss in my family. By making the painting I really felt a variety of emotions that a human being is capable of feeling.*

When Teachers Pick Up Children

Classroom teachers who only see the art class as a planning period will pick up their students and might only inquire about how the students behaved. The classroom teacher typically clings to the door, waiting for the art teacher to dismiss and create an orderly line-up. But after an art class, the mood is anything but orderly. Students are excited to share their art. With all the art thrust before the overwhelmed teacher, parting is not about appreciating and celebrating students' accomplishments. Since the classroom teacher is such an integral part of student life, art teachers can invite their classroom teacher colleagues to occasionally come a bit earlier to see what the children are doing in art class. Even better, they should ask the teacher to participate in some classes and make art with the children. Each teacher in the school can be viewed as a potential goodwill ambassador for the art program.

A final show-and-tell of art before the children's favorite audience, their classroom teacher, can become part of the art class. Students can be prepared to speak knowledgeably about their art making and authoritatively about the finished products. Pick-up time can be turned into valuable advocacy time when the classroom teacher is provided with a written statement explaining the art that was made, its connections to other subject matters, and how its lessons might be reinforced after class through writing assignments and discussions. Teachers coming into an art room can be greeted with a summary of what happened, clearly stating the significance of the art lesson as they receive an informal flashing of art from their students. End-of-the-period art advocacy is important in shaping how the children's art is received and further promoted on its way home to a parental reception.

You Are in Charge of Art Information

The art teacher can be the messenger for all good news about art in schools everywhere. Art news from all sources

can be clipped and disseminated by the art teacher. The information can highlight new research that demonstrates the benefits of art and studies that show how art promotes writing, reading, and thinking skills. Newspaper articles, web sites, and segments from public radio need to be spread in school. Every art teacher's task is to become the source for art news, maintaining a current file of pieces that cast the arts in school in a favorable light.

Building a Library of Advocacy Materials Is a Career-Long Task

It helps to start early, collecting advocacy web sites to link to your school web site and looking for advocacy news and model strategies at every professional gathering. Collecting advocacy materials is great, but at some point you can create your own. Students and parents can be enlisted as creative forces to develop advocacy pamphlets and visuals. With high-quality, low-cost, sophisticated video recording equipment, every art teacher can create stirring 30-second public service announcements (PSAs). Local TV and radio stations are required to air PSAs and are always looking for good material to fill their FCC quotas. Delivering a PSA to the station works best. Local radio, television, newspapers, and school papers are always interested in presenting a visually rich story. What's more natural than producing art lessons for print or broadcast? Teaching parents about their children's art makes for wonderful interviews and broadcast episodes.

Advocacy at Home and Parents at the Pick-Up Line

Often it is the principal who stands outside after school, directing masses of students, making sure everyone is safely received by parents. Who would want the job? Many art teachers actually seek out this important opportunity to meet with parents and see them receiving their children's gifts of art made in class. When school artworks are carefully wrapped in hand-printed wrappers or student-decorated shopping bags, they are easy to spot leaving the building. It is great fun to follow the packages and their owners, to have an opportunity for informal conversation while witnessing the presentation to parents. Advocacy for school art is parents seeing the importance placed by the art teacher on the students' art going home.

The Art Class Newsletter

A monthly newsletter allows even the busiest parents to feel that they have visited the art room. Illuminating the art created in class and how its lessons can be expanded upon at home invites home and school art partnerships. The newsletter can prepare parents with helpful hints for home art activities based on class work, and can give them pointers on talking about the art children bring home. Columns may include advice about preserving, photographing, and displaying children's art at home. Parents may appreciate the art teacher offering advice on such topics as possible art gifts to buy, how to set up versatile home studios, or suggestions for community art safaris with children. Parents involved in their children's art education are among the strongest supporters.

Advocacy and the Art Museum

Promoting art opportunities in the community is the art teacher's job, but it has the added bonus of creating goodwill on the part of parents toward school art. What's new and exciting to see in local museums and galleries can be a regular posting on *Art Class News* online, noting the shows that are especially family-friendly and those highly recommended by the art teacher. On art teaching blogs, advice on how to make the family museum outing a success can be offered to parents. Teachers can prepare students to visit an art museum so that students can proudly serve as family guides.

Ending Thoughts

Mr. or Ms. Art, the children call you. Students who love art love you. It is easy to become complacent and not notice that everyone does not value your subject. Being an art teacher is sharing something that is close to your heart, and it is hard to recognize that everyone does not consider art as important as you do. When an art teacher learns that the school art room is being turned into a robotics lab, it's puzzling, hurtful, devastating. But dear art teacher, don't retreat to your shell, giving up on your colleagues and the school. That can impair your program and close doors to future opportunities to advocate for art.

In the midst of financial strain, schools are seldom harmonious communities. Under siege during an economic downturn, schools can become rings where adults

fight it out. Everyone looks out for their future, their jobs, and their programs. With a small pie to share, issues become magnified. Concerns over room size, money for supplies or travel, or the number of planning periods can be bitterly debated. Those who see art time as just a planning period want the art teacher to have as little time as possible. It can be a difficult climate in which to advocate for a quality art program.

Few folks feel that all subjects are created equal. Everyone wants to be valued and each subject teacher wants recognition. Everybody wants to feel that they are working the hardest and carrying out the most important mission of the school. Each person wants to feel that his or her teaching is the most essential.

Here are some final practical suggestions to advocate for the art program:

- Praise and show respect for your fellow teachers' work, just as you would like your art teaching to be acknowledged. Respect for colleagues and their work brings respect for you and the art program.
- As you wallpaper hallways with art to focus attention on the art program, don't overshadow the accomplishments of colleagues. Herald the art program without overwhelming others. Promoting the art program is a public event in a common arena. Be sensitive to a display place that belongs to everyone and the feelings of others who also want room to herald their students' work.
- Allocate part of your (often meager) supply money to support classroom teachers' needs. It is a good invest- ment to make certain that every class in school has excit- ing art supplies.
- To other teachers art seems the easiest subject to teach: you just open your paint closet and children applaud. To appreciate each other's work, opportunities can be cre- ated to trade places. Short stints in the art room lead to greater appreciation for what the art teacher really does.
- Art teachers need far more time to set up, clean up, and maintain a studio, but good relationships with other teachers are crucial to an art teacher's effectiveness. So don't eat lunch in your room. That will not promote art in the school.
- Raising awareness about art, children's art, and the art world is the task of the art teacher. This needs to be done with care, being aware of the feelings and fears of teach- ers who may know very little about art. Taking on a school-wide helping role—generously sharing informa- tion, ideas, materials, and time with everyone—leads to cooperation and respect that speaks well for the art program.
- Call yourself an artist-in-residence. Never stop making and exhibiting art. Being an artist is a powerful way to promote art in a school. If you stop making art, there is a status change: you are no longer the special artist in the school. "Real" artists now have to be invited for residencies so that students have the opportunity to work with artists. Bring your art, share your work in school, and invite young and old to the openings of your art shows. The school respects and benefits from having an artist-in-residence, someone teachers look up to as an artist.

Section Three Curriculum

CURRICULUM DESIGN IN ART EDUCATION

Art curriculums are State of the Union addresses, not by the president but by art teachers reflecting on society, looking at issues that confront the schools and the art programs within them. Since curriculums are inherited from past generations, it is important to recognize the needs of societies in the past and how art responded, what was done and to what effect. In order not to reinvent the wheel or repeat old problems, it is important to place any new curriculum on informed foundations. Art teachers can look at events in the field and the resulting art emphasis. In designing new paths, the art teacher may ask: What can be learned from the past, what is still relevant, what should continue, and what should be laid aside?

Support of General Education

As in its beginnings in the American classrooms, art today is still called on to make general studies more palatable, to

help teach academics by engaging students in an exploratory hands-on-style learning. As schools moved to constant testing, school life has become even more monotone and art used to teach academics has become a welcome relief. Future art teachers as curriculum designers now have another issue to consider: the supporting role art is asked to play in schools. An art curriculum shows everyone what the art teacher is trying to accomplish and clarifies the contribution of the art class to students and the school. It can be stated in the curriculum—whether the program will focus on calligraphy as beautiful handwritten forms, emphasize telling the stories of science and history, or post the components of art that have to be studied on their own. Let's continue the journey of the curriculum with historic stops from the nineteenth to the twentieth century.

Product Design and the Curriculum

There can still be a strong argument made for art as a tool of commerce and the importance it can play in product design. With the sharp decline of America as the manufacturer of goods, to maintain leadership in product design is perhaps more important than in the past. Future curriculum designers only have to look at Apple computers as an example of the influence and significance of product design as the art of our day. With the demise of American manufacturing, students' use of their hands and tools in an art class becomes crucial to activate bodies and minds, not to train factory workers but to educate American designers and innovators in the international dual of commerce.

Exposure to Art in the Curriculum

In the picture-study movement of the early twentieth century, inspiring art displays were mandated in schools to communicate the high ideals of society. Later in the twentieth century, art appreciation of the Masters became a serious component of everyone's general education as a way to provide equal opportunities in a democratic nation. It is more difficult to use contemporary art examples for art appreciation because they are often abstract, conceptual, and even critical of the values of society. But what future art teachers can learn from this is to recognize that students' chief art exposure is still found in the school. There are fewer museum trips, and students, especially in middle school, have a very low rate of museum attendance. Exposure to artworks may shift to the environment, to art at airports or malls, yet it still needs to be initiated by art teachers guided by their curriculum. School more than ever is the prime place for exposure to beauty and the high ideals that art represents. This can be stated in a new curriculum.

Up to the middle of the twentieth century, art had strict rules; there were dominant styles, accepted subjects, and tools and techniques for making art. One art style always dominated, studied, and set the rules and bounds for art learning. The second half of the twentieth century can be described as a time of protest. Especially in a country divided by the Vietnam War in the 1960s, questioning authority and art became central. Art came to be minimal, just imagined or conceptual, questioned and stripped to its core. Alternative art was sought and the art world supported unique and individual responses.

Today's art room is the beneficiary of the new openness in the art world, and the curriculum emphasizes a search for newness in techniques, materials, and outlook. In schools that have maintained their reliance on answers, starting and concluding education with conveying what is accepted and known, the art curriculum can still be about questioning, seeking alternatives and discovering the new. In child-centered art rooms it is no longer a question of following the teacher's lead but of opening classrooms to young investigators. The art room becomes the center of questioning, looking for new ways to make art and envisioning the future. For future art teachers, the ability to question the past and place questioning at the core of the art experience makes the task of curriculum planning exhilarating.

As the history of art education moved from art taught by all teachers to art teachers trained as artists, the new generation brought to the school not only a vast new field of study but also a dedication to art values and the importance of an education in art. Art-trained teachers have advanced the notion that art has its own importance for students and the school, and curricula can be planned to express the richness and uniqueness of art as its own subject of study. Art curricula can demonstrate that the subject is not covered by anyone else in school and that only teachers trained as artists can teach art.

The Child Artist and the Search for a Timeless Curriculum

During the advent of abstract expressionism in the 1950s and the resulting emphasis on the intuitive, no one was a

better model and spokesperson for the new American art than the child. Children's art was evoked as the art to strive for by modern masters. The child was elevated from the status of student to artist, and what they created not as something on the way to adult art, but art to admire in its own right. In an era of shifting truths, there was a search for a timeless curriculum, one that could be subscribed to in school.

What is still true, reliable, and timeless is the study of children's art. As the new in art keeps unfolding, one can always find its roots in children's play and resulting creations. The way children freshly approach art as an invention is a model for constructing new art worlds. Future art teachers can consider how children's art predicts the unpredictable, setting clues to most new art forms. A new curriculum can look to children and not just adult artists to guide school art.

Changing Times and Evolving Curricula

Curricula change can only retain their relevance as long as they respond to the educational issues of their time. Art curricula have responded to the industrial revolution by turning art classes to a study of practical design to competitively "package the goods" produced by American factories. Art curricula joined the educational revolution after Sputnik—the 1960s Soviet–American race in space exploration—by searching for a curriculum that attempted to define what are the requirements of being an artist, art historian, or critic and what precisely would be the component knowledge-behaviors required to assume these positions. The definitions of what is art, who is an artist, and how art is made also changed from the 1960s to the open art world of the twenty-first century. Using the art world, or the artist, as a curriculum model has to examine shifting ground. Future art teachers can discuss and decipher the nature of a changing society, educational trends, and the art world to keep curriculum designs current and relevant.

The baby boomers who went into teaching at mid-century, starting from the 1950s, were handed a telephone-book-size State Art Curriculum. The "phone book" detailed the art curriculum and illustrated it with sample art lessons. It was a comprehensive guide to teaching art. State guidelines have increasingly lost weight during most experienced teachers' tenure in the field. They used to be richly illustrated—not only describing a choice of curricula

but also showcasing model art lessons and the best in student art. In today's climate of accountability and emphasis on efficiency, online publications have been reduced to small sets of specific handouts, which could be easily printed from the computer. State curricula are often called "guides" and are generic, generalized, and fortunately more open to interpretation. Living within current national and state standards has in fact opened up more creative ways to teach art.

Future art teachers need to think as the innovators they are in art studio classes. In education and preparation for educating future art teachers are usually expected to tow the line, to do what is expected, and merely to observe what is in the school, without questioning or trying to make changes. Future art teachers often feel a pull between how they are raised as artists and how they feel as teachers.

There are few things in life more exciting and inspiring than our contemporary art world. Schools cannot be left out of the celebration of new art. Future art teachers can include in their curriculum an involvement in the new art world's breadth and vigor. Today's curricula can rationalize art by calling it "critical thinking" or emphasizing the importance of art by calling it Visual Studies. But art still

FIGURE 1.3 Art Teacher Demonstration

maintains the same importance to children it has always had, regardless of changing terminologies.

THE CURRICULUM PLANNING PROCESS

Why Do It?

Administrators do not request that their future art teachers come with their own curriculum. New teachers are handed the plan; a curriculum along with many other official-looking documents that seem like they were drafted by a legal department. The wealth of creativity and new ideas that the art teacher arrives to school with may have to be checked at the door? But wait, not so fast. Don't forget, you have your ideas; you are carrying plans you believe in and have carefully crafted.

The curriculum you are handed was probably drafted by a group of peers. However, you see the dust on it, and if you look carefully, the images of students or the copyright may tip you off to the guide's real age. On the other hand, you might receive a recently constructed curriculum that looks very general or broad, just waiting for you to read between the lines.

While your creative self might not be included during the first faculty meeting, you have in your heart and in your hands something special. It states why you are an art teacher, why you are here, and what you cannot wait to start doing. The curriculum you bring to school is your constitution, reflecting all your soul searching and creative thoughts about children, schools, and teaching art. It is your creative portfolio as an ambassador of art to the school.

Asking Big Questions

For art-trained individuals the planning process can be compared to the art process. An artist generally starts with "big ideas" and through the process of exploration and experience focuses creative vision. It can be useful to be open, to think big and globally about the curriculum at first. This may involve skipping the details for a moment, not to be afraid to philosophize, speak in generalities about what is to be done for a school and in an art class. The discussion can turn to such issues as what a future art teacher generally wants to accomplish; what they want their students to learn.

What to Teach Students About Art?

The process of assembling one's curriculum is one of asking fundamental art teaching questions. Every future art teacher has important experiences that shape the response to these questions and therefore shape the curriculum that represents the art teacher. The following questions may provide a starting point for other questions to be asked by future art teachers.

- What are the important lessons we want student to gain from the whole art experience?
- What are the most significant attitudes and skills we want students to have when they leave the art class?

Future art teachers' responses may start out very generally, with such answers as: confidence, independence, sensitivity to forms and objects. Others may respond by writing:

- I want students to be able to find art ideas everywhere.
- I would like my students to be free to search for art materials everywhere.
- I hope my students approach everything creatively.
- My students should know that art can be made with any tool or new medium.
- I wish that my students will recognize that art is yet to be invented, and it is to be done by them.

These important diamonds in the raw describe some future art teachers' goals. They can be further polished with specificity, clarity, stated as teachable goals in terms of what young artists can do, discussions, and experience in the art class.

Individual Art Histories

Every future art teacher has an important art history. To look at our own art history helps to define art lessons as life lessons that shaped us and what a future art teacher would want their students to learn. Future art teachers can recall and learn from their favorite art classes and teachers:

- How did you learn about art?
- What I learned from art teachers and from being in an art class . . .
- The best advice I ever received from an art teacher was . . .
- The lessons learned from a favorite art class could be summed up as . . .
- The "coolest" thing we did in any art class was . . .

- The most important art skills I learned were in grade . . .
- What I had to learn on my own was . . .

Self-Reflection

Art curriculum can define the teacher's strengths and interests. It is a statement of what a future art teacher has loved about art from the start and wants to share with others. To arrive at a curriculum one is passionate about teaching, teachers can discuss:

- What are my creative strengths, skills, knowledge, and passions?
- Where do I go to shop for art ideas, and what beautiful objects have inspired my collections and art interests?
- What personal skills, knowledge, and attitudes have helped me the most in making art?
- Who were my guides, influences, and mentors? What did I see or read; who did I talk to that made a real difference in my becoming an artist?
- What are my favorite places to encounter art; which artists, periods in art, art museums, and art forms am I most familiar with and interested in?

Insights into the Future

To dare describe the art world of your future students, the one in which they will participate, is risky but necessary. Curriculum planning is a study of change—reflecting on contemporary society and the forces of change that shape art, schools, and art classes.

How has art making changed within the art teacher's lifetime? For example, as one future art teacher notes, "Most artists who used to think with pencil and paper now note their ideas and make all art on computers." How can this be reflected in the school art curriculum? Consider the usefulness of the darkroom, developing and printing film, and how digital photography can be taught. Changes in tools, technology, media, the art world, and society all point to the importance of future art teachers engaging in serious thinking and discussions as they shape a new curriculum for the twenty-first century.

Using Art Class Observations Now to Shape Future Curricula

In addition to university classes, future art teachers have a full schedule of field work, observing many hours in public school art classes. The critical observation of school art can be a significant resource in shaping a curriculum model. Teaching approaches and curricular emphasis can be compared among teachers:

- Some teachers observed can be described as offering *an academic style* of instruction. They emphasize the skilled production of art and copying by means of appreciating the masters. They use art elements rigidly and apply art principles to everything as students typically follow directions.
- Art teachers observed may use a *practical arts* approach, a crafts or an industrial-art model, emphasizing skill development and building related drawing skills. Students are asked to follow directions and work from simple to more advanced projects.
- One may observe a *non-directed creative arts* approach, in which free expression with art media is emphasized. Creativity is encouraged as a means to individual personal development. Students learn by experience and the art teacher takes a supportive role.
- Future art teachers may observe an *applied art* model, where the emphasis is on creating and developing taste and appreciation for fashion, home goods, and designed objects.
- Art classes observed may demonstrate a *content-based* model, in which the knowledge of art, art history, and appreciation is emphasized. The class includes readings, memorization, viewing, analysis, and practice in the criticism of art, artists, and examples for select periods in art history.
- The art class observed may focus on *aesthetic education,* with the primary objective of sensitivity, and aesthetic awareness. Experiential activities in class involve the senses in the study of objects and the environment.
- Some classes observed may use an *arts education* approach, where students are involved in the learning of underlying relationships between the visual and other arts. Other subject matter is often introduced through visual art.

Many questions will arise when considering the above classes, and the answers future art teachers thoughtfully provide become a cornerstone for their own art curriculum. For example: How much unguided art making do you as a future art teacher subscribe to? How much of the art in your teaching will come from students' exploration versus the art teacher's knowledge and models of art presented?

But that's not all there is. Future art teachers as curriculum developers should know that the current practices they observe are not an exhaustive list of possibilities; many approaches are still to be developed and tried. The art world welcomes new artists with ideas, and the art curriculum is certainly not a closed subject. The following models were suggested by future art teachers:

- A curriculum to study the artist as designer of indoor and outdoor spaces
- A curriculum for home art and home play
- A curriculum for the artist as designer and maker of home goods
- A curriculum for elementary art as toy making
- Nature and urban art as a curriculum model
- A curriculum for contemporary technology
- A curriculum for traditional home arts and crafts
- Teaching for artistic-behavior model

Limitations

Every curriculum has a point of view. As a curriculum writer, the future art teacher may reflect on and discuss their personal views in terms of possible prejudices that the curriculum is bound to encompass. For example, it is important to recognize the art one considers most important or what one may not consider as art. What is prominent in the curriculum and what is possibly down-played or even avoided? It is not unusual to down-play the things one is not as interested in. But it is useful to recognize this and to invite guests with other expertise and points of view to the art room.

Being honest with oneself and digging deep are some of the most useful aspects for future art teachers to practice in designing their own curricula. After all the above conversations, notes, and discussions, the future art teacher is ready to write the preamble for their curriculum.

When?

Creating your own curricular goals has to start before your teaching. It is difficult to describe how busy you will be as you start your first job, how quickly you will be short of time and breath, and bogged down by daily demands. With initial meetings upon meetings, scores of students knocking at your door any minute, you are in survival mode. There is hardly time for lunch, or to plan daily lessons. The time for

carefree reflection and looking at the big picture is before you start teaching.

Description of the Now

Constructing the curriculum requires definition of the educational issues of our time. It is a description of how you see the school and the issues of contemporary society. It is time to define your own views and thoughts, describing the student's needs and the problems being faced in schools. It is sticking fingers into the air to check out what is blowing out there in the world and the environment; to look away from the computer screen, from what others have said or written, look around and describe the world in which you live?

Here are some examples of what future art teachers wrote about contemporary life and the art curriculum from their pre-teaching school observations:

- Today's students don't make things by hand; they go out and buy them.
- Students play hours of video games and spend a great deal of time before the television.
- Students are highly computer literate, but have fewer real experiences that are not simulated by the computer.
- Students today play less in the backyard and play fewer imaginative games in the house.
- Students today are more likely to encounter art on the computer than to attend museums.

Future art teachers can argue for an art curriculum that is relevant and addresses current needs. Based on exposure to contemporary art in one's studio studies, museum visits, gallery hops, and personal contact with artists, future art teachers can discuss the state of the art world. For example:

- Where is the most interesting art found today and who is creating it?
- What are the most notable art media, tools, materials, contemporary canvases, and processes today?
- Where are today's art-supply stores found?
- What are the themes, issues, and problems explored by contemporary art?

Curriculum Drafts

Sketching out the art curriculum is an opportunity to get down to basic beliefs, what the future art teacher wants to

bring to art teaching. It is laying a cornerstone that clarifies on paper the areas of art instruction to be covered and emphasized during a student's residency in the art class. Stacks of papers and rough drafts such as the following segments from future art teachers are extremely helpful in keeping the curriculum dream open and flowing:

- A curriculum for teaching artistic behavior may include such items as learning about how artists plan and observe how they collect objects and gather ideas. Where do artists shop and make art? The curriculum may include learning about artistic thinking skills, planning skills, habits, or use of studios. It may include learning about critical skills that artists use, or their interest in and open-mindedness to new ideas.
- A child-artist-based curriculum may need to consider what is to be the future young artist's résumé and their art-related experiences. Included would be an emphasis on artistic independence, experiences for students to find their own art, discover their own art interests, art loves, build confidence, set up home studios, and make art after school. What are the creative qualities to be preserved in children when they become school artists?
- A new-media-studies curriculum may emphasize the use of technology, experimental media, mixed media, performance art, installations, and modern dance. It may specify experimenting with video art, computer art, and cell phone art. The curriculum may study the history of technology and the subsequent changes in art.
- An appreciation of art-based curriculum may have items such as appreciation of children's home art and play inventions. Lessons may be about discovering favorite artists and sharing art knowledge and opinions. Curriculum items may define appreciation of the built environment, popular culture, art in nature, everyday objects, children's collections and found forms, and children's books.

Conclusion

The curriculum a future art teacher will design should be like other art—always in progress. It can be constantly reread and fine-tuned. One may review to be sure the curriculum is clear and precise and is not a restatement of everything that one has seen, read, or observed in schools. Checking the final print is making sure that the curriculum we write and proclaim to subscribe to represents the writer's values, hopes, and most up-to-date thinking about art.

In its final version, check to see that the curriculum designed has the imprint of an artist—that it is a beautiful book and not just a computer handout. A curriculum designed by a creative art teacher should be an object of artistic pride, including a hand-made cover and illustrated pages. It is a book that a teacher should be proud to share in school with students and the principal.

KEY DECISIONS IN PLANNING AN ART CURRICULUM

In an age when curriculum guides and lesson plans are accessed at the click of a button, who can resist just using what others have done? How can teachers be burdened, or trusted, with complex curricular issues? Can teachers think through all the complex planning issues to consider in a comprehensive plan? When schools don't trust teachers to create their own plans, they pass this lack of faith on to students, treating them as if they have no ideas and cannot possibly know what they want to do in art. The implication is that children cannot be treated as artists.

Deciding on an art curriculum requires future art teachers to try to find their own answers. It is important to entrust each art teacher to sort out their curriculum, and it is okay if they choose to look at existing guidelines. If the art teacher is not in charge of planning, the act of teaching art becomes a mindless pursuit, taught with no investment or commitment from the teacher. Besides, the questions and the responses in all their complexity make teaching art and designing the art curriculum stimulating. Instead of providing a *Curriculum Guide for Dummies*, this section proposes questions that future art teachers may ask when building a curriculum.

For example, future art teachers embarking on curriculum planning can ask themselves: What is art? What is the most important advice to offer young artists? What would be the most memorable things I want to show young artists? What crucial skills do I want to teach? What has stayed with me from my own art classes? See Plate 1.4.

What Is Art?

Everyone who becomes an art teacher needs to do some personal reflection on what is art. While it is difficult to

provide a single definition for art or the experience it evokes in individuals, it is necessary to find some personal answers for the subject that one is about to teach. For the future art teacher, their definitions shape the school curriculum. In the past the definition was simple: art is what one finds in art museums. Today the answer is more complex. Here are some future art teachers' thoughts, offered to help start the discussion:

- Art is seeing the highest forms of human expression and achievements.
- Art is an expression of universal feelings. Art stimulates an emotional response when elements come together in a satisfying way.
- Art is about objects and also the response to the object. A work of art is an object to which meaning has been added by a human being and visually drawn out by another. Artists make unique objects that stir an aesthetic response.
- Art is not just about objects but ideas. Some works are pleasurable for their analytical power—the artist's ability to analyze a form, a landscape, or a situation. Other artworks are wonderful to admire for their sense of intuition, their ability to improvise with a subject or forms.
- A work of art has formal qualities, such as shape, color, and texture, which are appealing to see and often remind one of something important.
- In seeing a great work of art there is profound sense of pleasure, euphoria, or even a sense of sadness. One comes across a great revelation or meaning for a brief period, involving the person deeply, intellectually, and emotionally. In experiencing a masterpiece there is a sense of witnessing a great innovation. It may be a great concept or an idea expressed in a new way, or using new technologies or materials.
- To observe art is being an eyewitness to the difference between imitation and creation; seeing something that is not inhibited by fear, someone who is able to respond independently or present something freshly.
- Standing before great artworks, one feels a sense of importance. They say something about people, the condition of society, and this enlightens or provides great social relevance.

What is your view of art? There may not be a universal consensus about what is art, but the curriculum can recognize the importance of trying to understand, make sense of, and make room for discussions about the important experiences that artworks provide, why art is made, and why anyone should make art.

The Student

The need for individualized instruction has been a mantra in education. Yet instruction has become increasingly homogenized since it is always easier to access everybody by doing the same thing. As all school classes are becoming more multi-cultural, students bring with them the richness of art and cultures, family artisans and different home museums of objects with which they were raised. Art teachers have vast opportunities for creating curricula that have real cultural relevance to students.

Assessing students' backgrounds and art interests is essential in developing a curriculum that will be important to them. One cannot prepare curricula in a vacuum, without learning from and learning about the artists who come to class. Future art teachers can start formulating questions to focus on their students' art backgrounds, to understand who the students are and where they come from. An art teacher can describe or ask about:

- How students participate in art outside of school.
- The nature of art on display, in collections, in furnishings, and in accessories in their home.
- What do students collect? The art they create on their own, and the interest and attitude toward art they exhibit can be explored.
- Students' artistic family members; ties to art and artistic pride.
- How much students know about contemporary American art.
- What are students' street and neighborhood art views and the exposure to art that the community offers?

Teaching art is learning about the art backgrounds of students. To plan for an art curriculum, art teachers can study their students' art worlds, art and cultural experiences, and the art they bring to school.

The Teacher

The closer the artist teacher is to the subject as a participant, the more effectively and meaningfully art is conveyed to students. Art teaching is not just presenting skills and information but is inspiring students for a lifetime love of

art. Therefore, future art teachers have to take stock of their passions and collections, experiences and interests as they prepare a curriculum that reflects their résumé. Questions such as the following can be posed and answered by each teacher:

- What is my art background and training?
- What special skills, knowledge, expertise, travels, do I have to share?
- What are my art interests, models, and heroes?
- What do I love to do most of all in art?
- What are my favorite sources and places to find ideas, inspiration, and to make art?

A foundation of the art curriculum is the teacher's art views. As artists express their beliefs through their art, art teachers state their beliefs through the curriculum. Yes it is subjective, yes it has personal prejudice. It is, however, an educated artist's vision, a powerful source and resource, a set of unique experiences that is valuable to share with students. Future art teachers need to discuss their viewpoints and clarify their beliefs throughout their preparation.

The Art World

Art teachers need to be immersed in exciting new galleries and museums of contemporary art. Teachers need first-hand responses and knowledge of what is going on in the art world, and to be a part of community art projects and the local art scene. School art is an introduction to a larger art world, not an art world that only exists in school reproductions. An art curriculum is about moving students into that art world, learning to freely question it, and seeing themselves in it and beyond it. So what does this have to do with curriculum? Future art teachers who regularly attend exhibitions will take back to their class for discussion a pocketful of questions that the exhibits inspire. These are some notes from future art teachers after visiting an exhibit:

- How is an artist like a magician, able to take common objects and make uncommon things from them? What are some of the materials and forms that represent our city, our culture? What are the media, subjects, and themes used by children and adult artists today?
- Defining the boundaries of art is a challenge today. Contemporary artists question what is art? What are

you not supposed to do in art? What do you think art is and isn't? What are some rules of art that you have learned in art classes? What are some art rules that you have seen broken?
- Based on the shows in the museums or galleries, what are some of the qualities needed to become an artist today? How can they be inscribed into the curriculum? What skills and knowledge do young artists bring to class as a starting point? What would a foundation course in art look like if you had to plan it?

An art curriculum today needs to encourage the examination of art itself, the core and the premise of art. Students need to be able to ask important questions. Art teachers and their curricula can be less dominated by a single viewpoint; it has to leave students open to new ideas and ways of making, experiencing, displaying, and thinking about art.

Child Artists

In building a curriculum that celebrates children as artists, the curriculum cannot be only the appreciation of adult art and artists. How can children's creativity, play, and art examples be included? How can children's art be looked at as art? How can the way children think about and look at art be respectfully and faithfully conveyed? This requires considering what can be done daily in an art class to present children's artworks, techniques, ideas, and interests as models and examples of art.

Some Areas to Contemplate

- To teach about the artist, will it be only adult artists and their art, or will children be included, and how? Will examples of both adult and children's art be shown? Will they be compared? Why or why not?
- In curricula prescribing art making as a series of "foundation" exercises, can one also refer to children's experiences and play foundations for making art?
- Will adult art processes be demonstrated? Which ones? Will they be compared, or shown as correct techniques? Can children's art making processes and techniques be discussed?
- Can the subject of how artists approach their work be done from an adult artist's and from a child artist's perspective?

- Can learning about art appreciation and becoming a collector be studied from an adult's and child's point of view?

And what about art history: What does it mean to children? What about it is important to learn? Should learning art history be about facts and dates, individual artists and selected works? Should children's art be part of art history lessons? How can art history be taught most meaningfully? What would you do differently?

Difficult Decisions for Teaching a Creative Subject

Curriculum design forces the art teacher to find answers to difficult questions. Art teachers have to decide on a vast array of interesting means to stimulate learning by experience. They have to decide on how to make room and make time for art to be self-taught, learned through deep involvement, experimenting with objects, and playing with possibilities.

Teaching art is teaching complex matters of self-awareness so that students can be in touch with their creative powers. The art curriculum is internalized not in a single lesson but over time, through many combined experiences in art making. It is a curriculum that holds the highest goals that requires the most difficult choices. Future art teachers can become aware of the difficulties in curriculum decisions in art without shying away from them and oversimplifying or downgrading their goals. Decisions involve maintaining a delicate balance between teaching art and inspiring independent learning about art. A great deal of art education is learning about art by being presented with examples. But an art curriculum is not only learning about consumer education, finding beauty in designed objects, but about having opportunities to discover one's own taste in art, artists, and objects. Therefore a curriculum is both teaching about good design and discovering one's own sense of design.

So What Will Students Remember?

After considering ideals and beliefs and trying out the feel of writing curriculum concepts, future art teachers need to review. Is the curriculum significant? Does it do justice to defining important aspects of learning about the artist, the study of the art process, artistic behavior, art making, appreciation, and criticism? We all remember some art classes and have no recollection of others. We recall some art projects, while others are quickly forgotten. We recall some art advice that guides and inspires us still today. It is important to take stock of all of the important experiences and learning, including memorable art teachers and teaching and the not so vivid moments. Based on personal experience as children, students, artists, and observing art teachers, will the curriculum decided upon have a lasting effect?

THE SCOPE AND SEQUENCE OF AN ART CURRICULUM

Regarding curriculum, future art teachers ponder what concepts and art media to teach and in what order. Should art media follow children's approaches to play and art making and not be taught separately at all? What new media should be taught? What skills might the students best discover on their own?

Art is a lively subject because there are so many innovative opinions on what to teach and how and when to teach it. Art teaching continues to change, thrive, and survive as it fills the various needs of society and art educators. No two art teachers approach teaching the same way, nor should they. This subject can survive disagreements, even about fundamental beliefs.

There Is Nothing to Teach, There Is Everything to Teach About Art

Future art teachers often wonder in their discussions what there is to teach, because for them making art is so intuitive. Others are overwhelmed for the opposite reason; they feel that there is so *much* to teach. The following section discusses the richness and immense possibilities for future art teachers to create their own curriculum. It is not intended to cover everything, but it is a start to organize art into a subject for school studies.

Like a tempting menu in a fine restaurant, the following checklist for a curriculum can be altered and added to:

- Curricula can suggest exploring the many makers of art objects, called artists, and the variety of forms, shapes, and performances that may be referred to as art. It may include numerous art forms and professions that have yet to receive officially recognized status.

- Curricula can imply examining the vast sources that artists use to find ideas, such as historical events, social issues, fantasies, dreams, collections, myths, materials, or technology.
- Curricula can indicate a study of different ways artists express ideas, such as reporting with cameras, drawings, or computer imagery. Artists interpret their vision humorously, with shock, ambiguity, or simplicity. Artists create statements realistically or abstractly, express them coolly, scientifically, or personally and emotionally.
- Curricula can imply a focus on the immensity of material choices and techniques used by artists, from the traditional (scissors) to the latest in technology (iPad).
- Curricula can bring to mind the study of established techniques, from animation, casting, staining, stenciling, engraving, and modeling to creating illusions, blowups, or symbols.
- Curricula can intimate the many ways artists plan, improvise, and carry out ideas, how some artists take note from nature, study other artists, or create purposeful accidents.
- Curricula items can entail the study of forms used in art such as portraits, landscapes, dreams, figures, portraits, and still life.
- Curricula can involve the study of time periods, such as prehistoric, Greek, or Byzantine, the eighteenth, nineteenth, or twentieth centuries, or pre-Columbian, Ming, Sung, Chou, or Han dynasties.
- Curricula can itemize art by geography, by studying African, European, Indian, Persian, or Japanese art, or cultures such as Celtic, Chinese, Egyptian, or Navajo.
- Curricula can emphasize the study of baroque, classical, impressionistic, naturalistic, romantic, or painterly styles.
- Curricula items can represent leading art groups or schools such as the Bauhaus, Blaue Reiter, Constructivists, Dadaists, the Hudson River School, the Ashcan School, Hard Edge, Pointillists, Venetian, or Pop.
- Curricula may include individual artists and their unique idioms such as Bergman in film, Bernini in architecture, or Van Gogh, Rembrandt, or Seurat in painting.
- Curricula may emphasize art as commemorative, commercial, decorative, moral, satirical, spiritual, political, or experimental.
- Curricula can stand for sensuous qualities, for example, color that may be advancing and receding, bright and dull, light and dark, opaque and transparent, saturated, pure and mixed, or warm and cool.
- Curricula may signify forms or shapes in sculpture, architecture, or found objects, studied as simple or complex, concave or convex, curvilinear, foreshortened, geometric-biomorphic, natural, artificial, rigid-flexible, transparent-opaque.
- Curricula items may suggest the importance of light: artificial and natural light, direct, reflected, or absorbed light, light and shade, shadows, the effects of dim, cool and warm light.
- Curricula may signify the study of movement, looking at fast and slow moves, real, virtual, and implied moves, spontaneous and controlled moves.
- Curricula may list a study of texture and surfaces—artificial and natural textures, rough and smooth surfaces, raised and lowered textures, even and uneven, course, harsh, porous, regular or irregular textures.
- Curricula may suggest the study of space that can be felt or seen in art, exploring deep and shallow space, empty and filled space, busy and open space, open and closed space, vast and seemingly endless space.
- Curricula can focus on time in art, including endless, expanding and contracting time, varied speed, implied and realistic uses in art, its present and future implications, and its long and short duration in making art.
- Curricula items can be the study of sound explored through printing, drawing, or any artistic activity, in the sounds of tools, sound in sculpture, close and distant sounds, and exploring natural, mechanical, and electronic sounds.
- Curricula may include analyzing artworks and found objects, by categorizing, choosing, characterizing, classifying, describing, differentiating, and providing reasons for.
- Curricula can treat the subjects of judgment, appraising art, commenting on art, formulating opinions, expressing approval, ranking, rating, and valuing.
- Curricula can refer to ways art is assembled, composed, displayed, exhibited, improvised, and modified.
- Curricula can specify reacting to art—empathizing, examining, handling, manipulating tracing, wrapping, smelling, touching.
- Curricula can indicate writing about art, describing, reviewing, questioning, speculating, and replying to what is seen or what was made.

Information in school can be quickly presented, but interest has to be slowly built. Children know about deep involvement and they pursue their interests for a long time. In playing or collecting, children build their skills and

expertise. Like the spirit of Halloween, excitement has to accumulate and mount. Art teaching ideas reflected in curricula needs to be built through experiences, knowledge, and time.

Curriculum Goals

To recognize the principal goals of art teaching, it is helpful to "whittle down" clear statements that can be translated to curricular items. Identifying what art teaching is aiming for, or should accomplish, is another way to focus on curriculum concepts. The following was taken from comments by individual future art teachers and is a list of examples of what kinds of students they would like to have as a result of their art instruction:

* Students who see everything around as possible art supplies and art tools.
* Students who feel they have many good art ideas and can plan their own art sessions.
* Students who have developed interest in many aspects of the visual world and are involved in collecting, preserving, beautiful things.
* Students who are comfortable making art and feel that they have ideas and skills to manipulate, organize, express themselves through different art media.
* Students who are interested in the new in everything, respect innovation, and recognize originality as an important human achievement.
* Students who have a broad base of art knowledge and are able to converse about the nature of art, artists, the history, and the future of art.
* Students who feel confident in expressing and justifying art judgments about personal objects, community life, and the environment.
* Students who are deeply involved in art and will be able to maintain their commitment, alongside competing demands and shifting priorities, as a lifelong interest.

It is useful to set one's curricular goals and then to consider what experiences the students in the art class will need to meet these goals of being educated in the visual arts.

The curriculum section of this book emphasizes the importance of future art teachers engaging in their own curriculum design. The lists and examples provided are not intended to include all possibilities, nor serve as prescriptions for individual plans. They are intended to be browsed and used as other art-shopping opportunities that inspire individual creativity in planning.

Sample Curriculum Concepts

The guiding principles of the curriculum can easily get lost in complex phrasing. In order to create a clear curriculum and make its implementation practical yet open to a variety of interpretations in daily art plans, future art teachers can practice writing clear curriculum concepts that start with kindergarten and can be continued for each grade level. The following concepts drafted by future art teachers are intended only as examples of how an individual curriculum can be drafted using simple terms and building on art ideas that can be expanded through the grades.

The Elements of Art

Kindergarten The environment is made up of a large variety of shapes, textures, and colors.

Grades 1 & 2 There are many shapes, textures, and colors to be found in a natural and built environment.

Grades 3 & 4 Knowledge about art elements enriches one's understanding of art.

Grades 5 & 6 The use of design elements in creating and enjoying art involves the individual's knowledge and sensitivity to their use.

Grades 7 & 8 Artists are like composers with design elements, creating an individual concept of beauty.

The Nature of Art

Kindergarten Art is a source of enjoyment

Grades 1 & 2 Art helps people enjoy color, texture, and shape in the natural and man-made environment.

Grades 3 & 4 People enjoy the various forms of art and their uniqueness.

Grades 5 & 6 Freedom to make choices, try out ideas, and search for new ways to communicate visually lead to satisfying experiences.

Grades 7 & 8 The desire for beauty is inherent in people and heightens their sense of well-being.

Openness in Art

Kindergarten Artists create in many different ways.

Grades 1 & 2 Art can be made from all materials.

Grades 3 & 4 Art can be made with all tools.

Grades 5 & 6 Art can be made on all surfaces.

Grades 7 & 8 Art can be made using all processes and techniques.

Play and Art

Kindergarten Children and artists use their imagination and invention in playing.

Grades 1 & 2 New art ideas are discovered in playing.

Grades 3 & 4 Artists play with tools and materials.

Grades 5 & 6 Artists learn from putting things together and taking things apart.

Grades 7 & 8 Creative people can create art by playing with every object and every idea.

The Art Process

Kindergarten Artists observe things that are beautiful or unusual.

Grades 1 & 2 Artists take pleasure in collecting all kinds of beautiful and unusual forms and objects.

Grades 3 & 4 Artists take notes on what they observe and record ideas and experiences in many media.

Grades 5 & 6 All artists rehearse, improvise, and try numerous possibilities.

Grades 7 & 8 Artist use different media and methods to plan their art.

Art and Ideas

Kindergarten Making art starts with an idea.

Grades 1 & 2 There are many sources for art ideas.

Grades 3 & 4 Art sources can be shared and ideas discussed.

Grades 5 & 6 Art may be made as collaborations, with ideas contributed by a team or a group.

Grades 7 & 8 An idea can be art.

Art as a Language

Kindergarten Art communicates feelings and ideas.

Grades 1 & 2 Stories can be told through art.

Grades 3 & 4 Art communicates inner thoughts such as fantasies or fears.

Grades 5 & 6 Artists express opinions about people, events, and society.

Grades 7 & 8 Words and symbols are used in visual art.

Art, Nature, and the Built Environment

Kindergarten Art stimulates the enjoyment of nature and the built environment.

Grades 1 & 2 Art and nature have many things in common.

Grades 3 & 4 Many artists find their ideas in nature, while others look to the built environment.

Grades 5 & 6 Artists interpret nature and the built environment using many techniques and new media.

Grades 7 & 8 Artists work with natural elements—earth, water, or wind, and explore building sites, materials, and walk city streets.

The Importance of the New

Kindergarten Discovering new objects and collections is part of making art.

Grades 1 & 2 New materials inspire new art.

Grades 3 & 4 New inventions inspire many artists.

Grades 5 & 6 New science and technologies can be applied to art.

Grades 7 & 8 Creative people are interested in the latest fashion, style, and trends.

Artists, Professions, and Careers

Kindergarten Artists are many people who do many different things.

Grades 1 & 2 The environment showcases the works of different artists.

Grades 3 & 4 Some artists make things by hand and others use computers.

Grades 5 & 6 Artists work in diverse settings and display art in many places.

Grades 7 & 8 Artists receive different preparation and education for what they do than people in other fields.

Prioritizing

What can be taught in art is vast, and class time is short. Planning a curriculum is constant prioritizing. What is most important has to be decided and constantly examined and re-examined, such as: Is this the most important piece of an art curriculum? Is this curriculum item the most

beneficial in illustrating and practicing artistic behavior? Is this how children make art? Does the curriculum portray what artists do and how they do it? A curriculum is a point of view, a narrow selection, configured with the understanding that art is a lifetime of study. A curriculum is an abbreviation of many experiences that provide insight into what art is and what artists do and can be applied to future art studies.

Curriculum Design for Everyone

Every art teacher needs to be a curriculum-involved person, not just a creator of daily plans to fit a curriculum laid out by someone else. The scope, sequence, and items to include in the curriculum are open to art teachers to determine. As future art teachers sort out their views and priorities and play with possibilities, an individual curriculum starts to take shape. Having a global plan of one's own design allows the art teacher to be in a better position to formulate daily lesson plans that are in harmony with their own beliefs.

EVERY ART TEACHER IS A CURRICULUM DESIGNER

Art teachers have to be passionate about what they teach. The passion cannot be there if the art teacher is reciting someone else's lines, using someone else's curriculum. Future art teachers having learned in many teacher-training courses and observations what has been done, how art has been taught, they as artists need to find their own voice by making their own art—in this case, building curriculum models.

Starting to teach art should not be a rush to gather all existing curriculums; studying the past is only encouraged to set up models for the future. New art teachers with their recent exposure to the art world and emergence in studio activities, gaining fresh views of art teaching are at an ideal juncture to conceptualize fresh views of teaching art. This unique opportunity to invent the field according to their own views should not be missed. Art teaching for the first time should be started with fresh ideas and new views of how it could be done. Doing it differently and wanting to make a change is a prime motivation for art teachers. Art teachers have to enter the field as reformers and agents of change.

Each art teacher is a philosopher, and the nature of art and teaching art as a school subject becomes the luxury of looking at the big issues—formulating them for oneself and finding one's own answers.

Future art teachers can practice by playing consultants who look at schools and their overall art programs. They can role-play being curriculum designers and draft the art programs they would want to be a part of. They can bounce around big ideas such as the following:

- Is it all about making art? If not, then what is a school art class about?
- Is it all about studying adult artists or meeting the artists of today? If not, then who should be emulated?
- Is art teaching about appreciating beautiful things? What could be a plan to accomplish this goal?
- Is it simply about a love of making beautiful things? If not, then what is left, or left out?
- Is teaching art a demonstration of a variety of tools, techniques, and media?
- What is art, what is this subject for which we are about to define a curriculum?
- Is our mission to broaden knowledge of art past, present, and future, and perhaps discover something new along the way?

This is not a book of answers. No textbook in art education should pretend to be one. In the above section and in all parts of this volume, there are as many questions as answers. Learning to teach art has to involve the richness of individual creative thoughts, which lead to open, full, and joyful discussions. What are your views? Listen to what your students say and plan together.

Evaluating the "Ready-Mades" You Are Handed to Use

There is no doubt that as an art teacher you will participate in orientations and walk away with piles of handouts you will be expected to read and implement. After all, with all the new teachers being oriented, there is no time to debate. It is wise to come with your own preliminary curriculum plan before you arrive at the starting gate. As you sit at orientation meetings, you may want to read what you are handed, make notes on it, and consider such questions as the following:

- When was this curriculum designed? Check the expiration date.
- Does it offer a philosophy, rationale, explanation, or is it just lists?

- Does it read as though someone familiar with children and art wrote it?
- Is it accurate and current in view of your reading of society, the art world, and students as you have observed them?
- Does it suggest or dictate? Does it leave the door open, assuming partnership with its users?

A Statement of the Problem

Unfortunately, first-year teachers are more susceptible to seeing and doing only what the standards say and the tests require. Instead of seeing state guidelines as an open framework, first-year teachers get the state guidelines and find the old tests, throwing up their hands to say, "No art will be taught in class, just information that's on the exam." Many art rooms are swelling with supplies because they are seldom removed from storage. The curriculum is not the impediment, but the art teacher's decision to shape course content towards standardized tests. Teacher education has to make sure that first-year art teachers come to school prepared to teach art, and have developed in their repertoire a strong sense for their own curricula or what each individual teacher feels is important to teach about art.

In an age of accountability, it is more important than ever to prepare individuals to be independent and confident curriculum planners. Coming to a school with one's own ideas is necessary, otherwise the art teacher's talent will never be utilized, and their view of art teaching will be formed for them, making for an unsatisfying life in the profession. Teacher education has to be a shining beacon of how to fulfill institutional guidelines and maintain the values of art teachers and art.

Making your own art curriculum is seldom asked for in your first job, but how can you start without it? Open discussion of art curricula or standards will not be officially sanctioned in your school, but it has to occur if you are to be an effective art teacher and the curriculum is to reflect your beliefs.

School is about keeping things nice, tidy, and uniform, for all classes and art teachers, and in all of the district's schools. It just keeps things simple to avoid oversight in a large school system. The notion of individual art teachers having a say, shaping and teaching multiple art curricula, is a dreaded thought and fears are that this cannot stand up to district- or state-wide accountability.

This is what the curriculum of the district is for all teachers. The sameness, efficiency, and accountability that sometimes works for other subjects works against the creativity and the most valuable qualities that art and art teachers can offer a school and its students. The freedom of an artist to make their own art is obvious, but for art teachers to formulate their curriculum teaching art is not easily accepted. A unified curriculum sounds good, but it disregards an art teacher's basic views and philosophy about teaching art. It removes art from the artist and what is unique and special that art teachers bring to schools and offer their students.

In many ways the new teacher is in the best position to offer new ideas, change curricula, and update old ways of doing things. Art teachers are creative people—just what is needed in curriculum planning. Asking art teachers to use someone else's curriculum is like asking teachers to implement someone else's art.

New art teachers can be productively wrestling with the most important new issues in art teaching. They have strong feelings about what is good and what is wrong with art teaching and have a passion to change things. Can their voices be squelched by what they are told should be taught? Art teachers should come to the profession with a license not only to teach but to innovate and the desire to shape their own curricula. The new art teacher is well qualified to be an enthusiastic theorist about the future of art. See Plate 1.5.

Section Four The Art Lesson Plan

THE UNIQUENESS OF ART PLANNING

Art planning should differentiate art from the rest of school. Planning for an art class means having a unique vision of learning that emphasizes students and their valuable creative experiences. Unlike other school subjects, art can be a departure from the routines and restrictions of school, finding new possibilities for exploring students' ideas. An art period is a time to see students as individuals, to listen to their ideas. Planning an art class is designing special environments and imaginary places

where it is safe to risk, to dream, and to explore the extraordinary.

Art is about uniqueness, and lesson plans can express this quality in a concrete form. Plans can say that the art room will be filled with surprises, things one would not expect in school. An art lesson plan can design unusual things to do, to say, or to wear. The art class can be planned as a unique setting, entered by imaginative openings, experienced by magical instructions, performed by the teacher together with students.

The Art Lesson as Appetizer

The lesson plan is generally the principal guide detailing how knowledge and information are to be conveyed from teacher to students. Art lesson plans are different in that they do not assume that the teacher holds all the knowledge to be doled out to everyone. Art lessons are appetizers, designed to inspire students' individual searches and discoveries. The lesson plan is a design for an appetizer that will further the student explorations that are the main course in the art room.

An art lesson plan is designed to whet students' interests but not to carve out a single path for everyone to follow. A lesson plan offers up the teacher's creativity as a sampler, including designs for fantastic stories, imaginative settings, adventures, fun shopping experiences, and active performing that invite students to discover something of their own. Art plans are starting points: a play, a show-and-tell, a story to imagine.

While traditional lesson planning attempts to define the whole story of a class, art plans only describe the start of a lesson—the set-up, the initial phase before the students reformulate the lesson. At the point the students take over, the art teacher's role turns to improvisation: responding, supporting, and helping students navigate their own plans. Starting points provide opportunities for students to make discoveries and find their own paths. The art lesson plan invites students to keep going independently, to experience a realistic artistic journey that does not have a single or simple solution set by someone else.

Planning for Possibilities

In school it is generally assumed that the teacher holds all information; the lesson plan describes how it is to be conveyed to students. Art planning, on the other hand, involves setting up students to look for knowledge and information themselves. The assumption is that art has to be found and created by individuals. The teacher's plans are discovered and then reinvented and altered by each student. The outcome of an art plan is to be determined by individual artists. A successful plan opens up possibilities for students to respond to in their own ways.

Generally teaching plans have predictable results, knowing what everyone will learn and master at the end. In an art lesson the results are unknown; as students investigate, the results will vary and become surprises. Art planning recognizes that the teacher's preliminary vision only takes one so far. To travel beyond the vision, plans have to be abandoned and everyone has to be open and free to search. Planning in art is to devise a process to inspire the artist, allowing students to consider many possibilities, multiple results, or finished works.

Plans for Full-Time Art Making

Planning for art class should also consider home art. How can the students' plans be supported by their at-home play? Students can only experience the full-time nature of art when school art continues at home. Plans for an art class should have students coming to class with ideas and leaving class just as inspired, with many more plans and ideas. An art class is always to be continued at home. The uniqueness of art planning is that it is not only planning for what goes on in the classroom, but planning for events after class and before the next art class. Art teachers can plan beyond the art period, envisioning connections between children's activities in and out of school as necessary preparation for art.

An Art Session as a Series of Events

The art teacher plans an introduction and also sees a series of unfolding events. For example, there is an entrance plan for students coming into the room, then the plan turns to what students will see and experience in the room, to be followed by creative activities.

Accenting the Visual

In other subjects students generally listen to planned lectures, but an art teacher plans visual presentations. After deciding on the theme of the lesson, art teachers picture how the lesson can be made visible in class. Plans for an art

class are designs for unique environments, sights and actions that inspire students toward playful investigation. Art teachers can consider using all surfaces of an art room to inscribe a lesson and encourage student responses. A plan can be a piece of environmental art—students invited to navigate a room of spider nets, a crossing of Day-Glo ropes, strings, threads, and other lines. Art lessons can be multi-sensory, setting up the room in silence or with strategically placed sounds, providing for darkness or changing lights.

Planning to Share Beautiful Things

The art lesson showcases beautiful things for students to see and touch. Currently on exhibit: an amazing button collection, a display of antique and contemporary board games, and old doll quilts. Art planning involves constantly building exhibits of children's objects, both old and new, transforming the art room into a living museum of beautiful things. Art teachers can begin gathering objects that are not seen anywhere else in school.

Art teachers can consider interesting ways to share with students their art world, completed artwork, favorite artists, and their many unique art loves and interests. Art teachers might create plans to share recent finds and lifelong collections, describing their impact on their art. Art plans are unique in that they can bring the art world to students through the teacher's work. The teacher's art in various incarnations—in planned sketches, early stages, or completed form—can be part of an art lesson. An art project does not necessarily inspire in the way that an art teacher who loves to make art and collect beautiful things can.

Plans for Premiering the Latest

A lesson plan constructs a blueprint for students to explore the latest in art, design, and all fields, from a Hubble telescope photo of a new star to new countertop patterns and color samples. Art teachers can plan to recognize their students as futurists, providing a platform for sharing the new. Art lesson plans can emphasize a search for the new, thus suggesting that everything is part and parcel of the artist's business, broadening ideas of what art is.

Plan for Sharing Plans

An art teacher's planning book provides an inspirational guide for students, showing them how to become artists and artist-teachers in their own right. Each art lesson plan

can reveal its sources, ideas, steps, and the changes that went into its creation. A close review of the emerging lesson plan coupled with its final execution demystifies the art process. Students gain understanding when they share in plans that surprise and inspire them in an art class. Students can witness how art teachers record the creative process and connect it to their teaching. Transparent lesson plans draw students into our experiences and observations. Art teachers can highlight the role of spontaneity, revealing why a street find, an item in a store, or a parade can influence classroom activities. Opening planning books to students makes the art lesson a shared experience, one that is rightfully the property of everyone.

The Plan for Students to Star

In most school classes, the teacher is the planner and the leader, in full command of the troops at all times. Imagine a class where students star, where their plans, collections, and ideas are seriously regarded. Art planning starts with trusting students and believing in their ability to come to class prepared with great finds and ideas. Art teachers can plan to highlight students' notes in idea books and discuss their collections and new finds. Planning for art sessions can include creative ways to show children's art, to draw attention to student artists, instead of only pointing out adult accomplishments.

Art class planning can ensure that instead of being handed everything, classes begin with shopping, allowing students to research with playful hands and open minds. A plan that simulates how artists look for and find their ideas may take the form of classroom treasure hunts, adventures of unearthing, unwrapping, and finding surprises. Auditioning objects, trying them on, entering and wrapping forms are all playful ways to demonstrate how artists explore their materials and objects. Plans to start class with shopping encourage student discoveries.

Plans to Go Out, Open the Door, Loosen the Hatch, and Seek New Worlds Outside the Classroom

Generally lesson plans are for in-class activities. Art class plans are for getting out in all kinds of interesting weather, at unusual times of day, to observe changing views of the environment, to experience fresh snow or its unusual wrapping of forms. Taking walks, going on digs and city safaris, inspecting car washes, making art at fast-food stores:

these are all part of the search that can only take place outside. Art planning is unique in that it plans for direct learning experiences, discoveries that need to happen in nature or on the street outside.

Plans to Showcase the Uniqueness of an Art Room

Art planning involves the constant clearing of spaces, changing settings and adjusting furnishings to transform classrooms for movement, shopping, and dreaming. It is okay for students to create a mess: the art room functions differently than the rest of the school. Art teachers can consider plans to create exploriums, interesting, beautiful, and inspiring spaces that represent the nature of art.

Plans for Dressing to Teach Art

In what other subject would the planning include what to wear? What the art teacher wears not only sets the mood for the lesson, but also exemplifies creativity, showing the importance of dressing up and playing in art. Wear your art

on a hat as a billboard. Show an example of your painting on your watchband. Art teachers can consider in each plan how a costume or a special item of clothing can support a lesson's presentation. Children love to dress up, and they appreciate adults who share this spirit.

Concluding Thoughts

Planning for an art class is having a unique vision of learning, emphasizing the importance of the students and belief in their vast creative abilities and what they bring to class. Art planning is creating special places and occasions for creative players to flourish. Lesson plans in art encourage independent thinkers and confident idea people. Art class plans include making time for students to share their ideas and finds. Art class ought to be a time for students to freely move, playfully explore, and function independently. The art class should also be a catalyst for students' creative pursuits after school, creating a commitment to art beyond the classroom.

It is the uniqueness of the art experience that provides significance for the school. Schools are generally operated

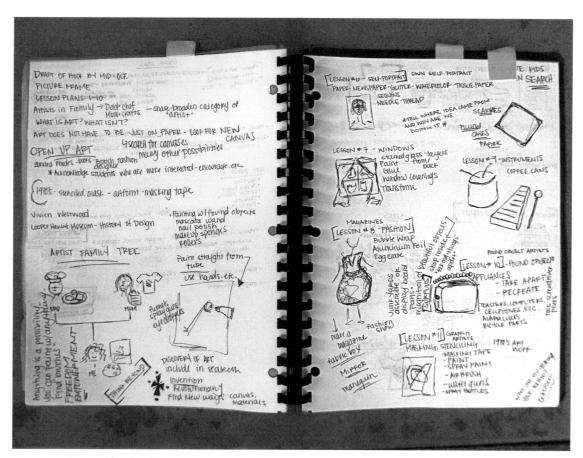

FIGURE 1.4 Lesson Idea Book

to teach in the most efficient way possible so that students meet standards and perform well on standardized tests. The art class remains the time to see students as individuals, to take time to sit with them and listen to them. The art period is a time to hear students' ideas and to discover their interests and dreams. In a studio setting, students can shop, play, experiment, and act on their ideas. Art plans can work toward providing the confidence and skills for independent research that promote a love of learning.

VISUAL AND WRITTEN LESSON PLANS

"Be prepared" is not just a scout motto but also a way of life for art teachers. Ready with a camera, a favorite Sharpie, or freshly sharpened pencils, art teachers sample, collect, and take notes on everything. If you see someone taking pictures of a fruit-crate label in a grocery store aisle, it may be an art teacher.

Art class introductions show an art teacher's special way of seeing the world. A constant readiness to plan is an important part of art teaching. Art planning uses all media and objects to present life lived as an artist in notes and pictures. Ideas are constantly recorded and exciting plans are circled from a lengthy list of possibilities. Lessons may be freshly discovered, and in order to maintain their freshness are presented immediately. Other lessons may linger in the art teacher's idea book waiting to be re-visited later. Future art teachers can start to plan and record ideas and then select from a rich storehouse of visual and written notations.

Visual Plans

Future art teachers are trained in studio classes to think visually and to plan in sketchbooks. Visual planning also helps to envision an art lesson, to plan for spaces, views, and events to take place in the room. Drawings of classroom tables can describe a tunnel, a cave, a playhouse, or picture other transformations over and under the table. Class furniture arrangements are used to set up imaginary places, adventure sites, and performance staging that can all be envisioned in pictures. Travel plans for runways and flying carpets to board can be richly detailed in sketches and diagrams, before anything is altered or planted in the art room.

Preparation for art teaching is not like preparing a speech. Art plans focus on the visual—all of which will be seen by students entering an art room. Art-lesson plans are visual designs for imaginative settings, beautiful objects, and art for students to hold. Art lessons are multisensory plans, setting up the silence and sounds, darkness and light, planning for places of interest and actions that inspire students toward playful ideas and investigations.

The Idea Book

The idea book is the art teacher's plan book. It is not the typical-looking black book with boxed dividers used for other subjects. The idea book is a multimedia-planning center, which includes the art teacher's written notes, visual observations, and collections. Using an idea book suggests a different kind of planning, one that accompanies an artistic search and reveals many aspects of a life in art.

Art students who are used to living with a sketchbook by their side feel comfortable with an idea book as a creative-planning partner. An idea book expands a sketchbook, to become both a visual and written plan book, covering lists of possibilities and ideas to more finished drawings for the look of an art lesson. Unlike sketchbooks that may plan for a personal series of paintings, what goes into idea books are intended to frame different art lessons. Idea books enrich the future art teacher's choices in keeping records of their observations, finds, and experiences by offering a choice of media and styles in creative record keeping. It is also useful to have one's sources of inspiration in the same book as the resulting art lessons they inspire. Idea books become filled with notes and sketches for art lessons. Some will be immediately refined and used in an art lesson while others await a future calling.

Since both the student and the art teacher make use of plans in an art class, it is important that both keep idea books and share them with each other. Idea books are constructed as works of art, with interesting handles, straps, carrying cases, cover and interior materials that are illustrated and decorated. It is designed as other personal artworks, to keep. The idea book can have many content sections such as the following:

A Diary of Observations

Future art teachers can write freely in an idea book, especially if it feels like a familiar art surface. For example, they can write about children's home art inventions, stories of childhood playing, or highlights of conversations with

students in a home art studio. Future art teachers can record students' questions and concerns about art and art classes. The teacher's notes can be plans to demystify art for students, noting plans for important topics of discussion between artists in class.

Field Notes

Preparing for art or art teaching requires getting out and experiencing the world. A visit to a tire store inspires a fresh view of printing, examining the exciting feel of tire pattern art, the design of rims, and the art of American hubcaps. Idea books that are designed to take along as portable sketchbooks and notepads are ready for tire rubbings, storing hubcap illustrations, and arranging tire brochures.

Art teachers say that some of their most treasured field notes come from visits to children's rooms. Ideas for school art abound in the displays and set-ups in children's spaces. Field notes flow in children's rooms, describing what children made and added to the room. Their display ideas, designs, and decorations of many surfaces are all noteworthy, to be planned for school art. Field notes are just another way to share excitement about new art forms.

A Photo Album

Thanks to the mandatory camera-carrying rule, the future art teacher has a small digital camera ready to shoot. Idea books can feature a photo album section that not only suggests art ideas to explore but also show decisive moments that triggered art ideas for the teacher. Photos bring immediacy to lesson planning, showing not just the idea for an art lesson, but also the moment and circumstances in which it was conceived. Photos in future art teachers' plan books may include personal documentaries of art, pictures of the artist's studio, and how the art was made.

A Sketchbook

An idea book is a cousin to the sketchbook, a special space where artists spend a lot of time with productive doodling and thinking through pictures. Idea books are plan books for action, the art teacher's performances, the student's playing, and movements in class that can be envisioned through drawings. An idea book is filled with colorful

illustrations using favorite art tools. Sketches make an idea book personal and beautiful, showing diagrams and drawings that allow the art teacher to see the room and the layout of props and materials. Sketches help to visualize events in detail, exploring ideas for installations and classroom performances. Sketchbooks are places to doodle, to demonstrate the importance of continual drawing in art, and where one can playfully draw and think.

By sharing idea books, the students and the teacher constantly exchange ideas and their art. Idea books, unlike other teacher plan books, can be shared with students as examples of artistic planning. Idea books filled with the teacher's drawings show the planning process and model the process of an artist who thinks visually.

A Scrapbook

An idea book is a plan book with a scrapbook section. It uses the art of scrapbooking but goes beyond the traditional task of looking back, saving and preserving the past, to also offer clues and illustrations for future art lessons. An art teacher's idea book includes an important scrapbooking component so that collections of pictures from newspapers, family albums, magazines, prints from the Internet, interesting charts, maps, advertising labels, et cetera, can become a part of classroom sharing.

A Wish Book

Although formalized in publications during the holiday season, children have year round wish books on their mind. Cutting and clipping pictures from advertisements and magazines is part of a wish book that can promote artistic shopping. Children's objects of interest and desire are important to recognize in thinking about art. And what do art teachers wish for? What are their objects of interest and desire?

Students' Visual and Written Plans

Students also have their own idea books. Their written and visual plans enrich the experience of an art class. Idea books are regularly filled with animated student writing, playful drawings that are not only plans but wonderful artworks. Students write the following: "Playing on my swing set and making up gymnastic routines is my favorite game."

Imagine the illustrations that describe this student entry: "I love riding my bike and pretending it is a horse." In idea books, children share their favorite types of play in pictures and stories that are shared and even re-enacted in the art class. Children's idea books also reflect on the creative players they used to be: "I used to make towels, sheets, tablecloths, everything into a cape. I loved wearing my capes!" Students' writings and drawings suggest classroom art but also restore confidence to young artists looking at themselves as creative players and inventors.

Lists and Lists of Possibilities

Idea books are not the traditional plan books detailing a single lesson and listing its specifics. Lists refuel idea books and more lists are constantly added as possibilities to select from.

The following are samples written and illustrated lists placed inside a future art teacher's idea book:

- List of things adolescents are interested in such as (sketches of) cell phones, (written) text messaging, rock bands, examples of eating places and shopping places
- Interview list (illustrated in class): what my students say they like about art
- A list for art discussions of students' art fears: "I am afraid it won't look like anything … " or "I want someone to like my art other than my mom!" or "I will never be the classroom artist."

Selected lists can be read back to a class, becoming the foundation for discussion. Many art teachers treasure their idea books and keep them from their first days of teaching.

Respecting Personal and Artistic Planning Styles

How do you plan for art? Do you take morning walks, all the while picking up things, looking at and dreaming about the world around you? Do you sit in a beanbag and doodle messages to yourself? Do you need to get out, shop, search the malls and stores for impressive objects? Perhaps you need to go to a museum or bookstore to find inspiration in contemporary artists or the artists of the past? Do you prepare for art while you look at the newspaper, sort though junk mail, or leaf though fabric sample books? All art teachers develop their individual style for art planning.

Gather your artistic thoughts without radically changing how you plan for the classroom. There is no singular correct way to plan for a work of art or to teach an art class. Life as an artist offers the best clues for keeping your teaching plans in the realm of art. Some art teachers walk around with a treasury of art plans in their mind. A lot of writing is disruptive to their ability to work out their vision for an art room in all its details. Others write a great deal to start a painting or produce numerous diagrams and sketches for an art lesson. Once again, planning an art lesson mirrors the unique personality of an artist when thinking of works of art outside the classroom.

Concluding Thoughts

Art teachers as artists have to value their ideas and observations enough to record them in plan books and idea books. The note-taking process enables a rehearsal of ideas using a variety of visual notations and written records. An idea book is for browsing, for looking backward and forward, for shopping through the art teacher's own ideas.

An idea book is a reserved space for art teachers to create multimedia plans, keeping visual and written records of their observations and teaching ideas. Future art teachers who keep a day-by-day idea book will not have the fear of going to school the first day, week, or year, without a lesson or teaching idea. They won't have the "teacher's nightmare" in the middle of the night of standing before a class with a blank expression and nothing to present.

Sunday evening is when many teachers write their weekly lesson plans. But in reality, art teachers must always be planning. Full-time art planning can look like a trail of notes, stacks of photos, sketches, souvenirs, and special collections. Inspiration is an important part of art planning, and it cannot be turned on once a week or only Sunday nights.

Improvisation in Art and Art Teaching, Playing Jazz While Teaching Art

An orchestra is a well-oiled machine directed by the composer and conductor's vision, detailed in a score or a lesson plan set before musicians to follow. An art class is more of a jam session, with some tracks laid down but much more being improvised by experienced group

members. Players come together to listen and respond to each other's cues.

Art teaching is a creative response to an inner world of ideas and fantasies and everyone and everything in the art room. An art lesson becomes a creative jam when everyone begins to play and participate and moves away from a preconceived policy.

Improvisation is playing with everything in the art room, creating playful introductions, unexpected pauses, and funny endings to a lesson. Improvising during an art lesson can be demonstrating new ways to use a brush and be carried away by the occasion, bowing and asking the brush for a spin on a paper dance floor. Creativity in trying the unusual, doing things differently cannot always appear in a lesson plan, but it is an important improvised ingredient in the lesson.

Doing things differently than what is done in other classes reminds students that in an art class rules can be changed, new ways can be tried. What the art teacher improvises demonstrates the kind of freedom offered in an art room.

Art teaching always has to be a balance between planning and improvising. A detailed lesson plan can make it difficult to be in the moment or to come up with ideas on the spot. The art teacher brings in objects and creates a setting; students come in with found objects and stories, playing with school supplies in ways that no plan can foresee. By trying to stick to a plan, it's hard to listen to one's creative inner voices.

Plans That Promote Improvisation

Improvising requires that individual planning styles are accepted, and going off a lesson plan is expected. An art teacher who draws plans on the back of a cereal box will more likely feel free to depart from the plan and build fancy cereal towers than someone filling out standardized lesson plan forms.

When an art lesson is thought of as an act of improvising, an open-ended performance without a script or written dialogue, what students see is creative action. Open-ended plans and pictures without stories make room for classroom anecdotes and lively observations that reveal the core of the art process itself.

Future art teachers can practice by pretend auditions for improvisational theater gigs. They can rehearse making up their own stories for lessons instead of reading books to children. Let other teachers read stories, an art teacher can

improvise them. Detailed planning can be a hindrance to unleashing the art teacher's full imagination.

Freshness in Art Teaching

On Broadway, no performer is expected to do more than two shows a day. For a creative art teacher to do seven is extremely difficult. In order for the experience to remain fresh and interesting for the teacher and the students, the art teacher has to have room to be creative with each lesson and make each class feel different. It is the art teacher's ability to improvise that changes art lessons as they are presented before different audiences.

How do you keep yourself interested after the first class, knowing you have six more? To avoid dreaded repetition, the art teacher needs to make constant changes, improving and customizing with each audience of different students and circumstances. An early morning lesson will bear little resemblance to one in the afternoon. Future art teachers need to recognize that they are not purveyors of a single product derived from one plan. Improvising allows a planned presentation to stay fresh and interesting for each class and performance.

Knowing Your Planning Style

As an art teacher, it is useful to know how much and what types of planning you require to be successful in class. Understanding the kinds of preparation your artwork requires is a clue to your needs and strengths, the planning you may need for art teaching. Some artists chart their art journey on paper in great detail with much precision. Others pride themselves on their intuition and the ability to respond to different situations set up for each artwork. There are artists whose final piece deviates very little from their well thought out preliminary sketches, while others are known to have never owned or used a sketchbook. There are art teachers who make long-term plans and commitments, while others need the thrill of the unknown. You may have seen art teachers who plan during class, preferring to wait and be free to listen and respond to the students coming in.

As a new art teacher you will probably be more cautious in planning. Your style may not feel like what you would do when making art. Planning styles, however, can change with experience and comfort level in both art making and teaching art. Neither art nor planning lessons should be standardized.

Dressing Up

Many of the more joyful, inspiring, and memorable aspects of an art lesson cannot be noted in advance. It is useful and fun to note in a lesson plan what the art teacher will wear. But a lampshade helmet, or cup holder mask that an art teacher may informally pick up, try on, or model during the lesson is difficult to predict.

Simple Object

Young children naturally pick up and play with everything, but future art teachers need to work on it as they demonstrate that playing with objects is a way to begin many works of art. An art teacher needs to practice picking up any object in a room and starting to play and create with it. Holding an article makes a new teacher feel secure. A prop is like clay in the art teacher's hands, which can take on many roles. While file-cards encourage sticking to a lecture, a folding ruler turned into a marching figure demonstrates the many lives of ordinary objects and shows art being made.

The wealth of possibilities in testing objects in the art room is difficult to predict or write about in a lesson plan. A single object can be performed in multiple roles; it is what children do when they play with an action figure or an old picture frame. In playing with and discovering the potential of everything in one's hands, art teaching can convey an experimental attitude toward all tools, objects, and surfaces.

Free Movement

All art teaching takes place on a stage before an audience. The art teacher is a performer who wears sneakers to freely move to show how improvising is done. Future art teachers need to be able to bounce around, jump, hop, and fly, to show the importance of freely moving bodies and tools in an art class.

Art Tools, Supplies, and Techniques

The purpose of planning art demonstrations is to show that all art tools and materials should be discovered, played with, and used experimentally. Years ago, the principle theme of art teaching consisted of demonstrations in the proper use of tools and materials. The thinking was that before students use art tools or materials, they have to be shown how to use them correctly: "You don't just give a tool to someone without teaching them how to use it." While this may be true for a ticking time bomb, art tools are flexible and everyone can use them differently.

Conclusion

Children throwing a ball to each other are engaging in a creative dialogue. The back-and-forth improvisation is a volley of creative ideas. Imagine art teaching to be such a stimulating exchange. Every planned improvisation in class is followed by an equally playful and imaginative response. Dunking a ball in colors and rolling it out on paper is responded to by a dip and bounce, using the ball as a paintbrush in an exchange of playful improvisations.

Following a bouncing ball tossed between children is a way to think of the many possibilities of creative improvisations involved in art making and teaching art. The first throw slides off a phone book before falling into the recipient's hands. Followed by laughter, the ball is rolled back under the legs of a chair. The next response is even more elaborate, as a child serves the ball with a grilling tool. The students applaud as the ball flies into the safety of a laundry basket. To expand thinking about art, future art teachers can plan on playing with tools, demonstrating skating moves with markers, and making a ballet out of toys or balls.

PLANNING TO START AND END AN ART LESSON

Introductions to an art lesson are multifaceted and make use of variety, surprises, and fun. Creative starts are more than an exhibition of the teacher's ideas; each creative start focuses attention on a creative act, which invites students to think, play, and perform. Creative starts do not provide ready-made solutions or demonstrations of known techniques to be strictly followed. Introductions are in fact planned to be buffers between a teacher's preconceived ideas and the students' proven ability to search. Introductions can be designed to rehearse methods for finding art ideas and making art, providing opportunities for students' discoveries, including the exchange of plans, thoughts, and objects. The start of a lesson sets the stage and forms an important initial impression.

Inner Plans

There is an inner process to creating lesson plans. The art teacher goes over the introduction to a lesson many times, replaying it in his or her mind. Quick sketches with brief notes complement the art teacher's complex mental calculations.

Art teachers could write a book about each lesson's start, but to simplify matters many art teachers use brief notes, like shopping lists. These have to be practical and easily decipherered—a list of what needs to be done quickly to prepare the room for the students waiting to enter. There should be no guilt because there are no paper trails with in-depth explanations for each lesson's start. With all the physical preparation necessary for an art class, there is no time for a lengthy and complex plan to decipher. There is an understanding, however, that more complete plans have been drafted at home, and on the car ride to school, the lesson has been visualized and organized in the creative mind of the art teacher.

An Appreciation for Unpredictability

An art lesson's starting plan can become simplified if it is not viewed as a prediction or a guarantee of what will happen during the class. It does not contain behavioral objectives ("students will do this" and "they will do this next") that try to shape the students' total art experience. A comprehensive and time-specific prediction of what will occur in class is not the purpose or even a realistic goal in planning the beginning of a lesson. While an art teacher makes tremendous personal contributions to each class, to do justice to all that the teacher will do, the complete story would have to be written after the fact.

Plans for starting a lesson cannot be so prescriptive that they misrepresent the spontaneous nature of art or interfere with the students' many possible contributions to the beginning of each art class. An art plan can read as a list of possibilities; offer choices and ways that every class artist can be encouraged to participate. If the plan is appropriately open, students can respond, join in, adapt, and alter it by their participation.

Clarity and Relevance

A starting plan needs to be clear and to make sense to students. Clarity occurs when a lesson is able to make connec-

tions with students' past and current interests. When an art class is tied to children's creative play experiences, the lesson has a comfortable familiarity; it is not far removed from what children know as their art. Plans that explore childhoods relate to students' collections, inventions, and interests. They are about dressing up for birthdays, or the joys of constructing a tree house. Timeless and familiar play activities form a clear grounding to start an art lesson.

Who Starts the Art Lesson?

Who starts the art lesson? In most classes it is understood that the teacher plans and initiates each lesson. In the art class there is a choice and an important decision in planning. The first few minutes of class set the tone for the rest, but perhaps more importantly, they are recognized by all participants as key moments. Minds are fresh and sharp, and everyone is at the height of attention. To yield this prime time is a big deal, and the students know it. If students start the class, the lesson plan needs to indicate how they will be prepared. Will they be sharing a cherished place from their idea book? Or will they start the class with something they are eager to show and talk about? A general theme in art teaching is letting students be aware that they have many good ideas and that the art class is preparation to make use of them. Trusting students to start the art class underscores that they are being treated as artists and colleagues.

Everybody Plans and Contributes

Both the teacher and the students prepare to contribute to an art class. This is a fundamental difference from planning in other classes. For clarity, everyone needs to understand the nature of each other's preparation. The following are examples of the art teacher's planning and the students' planning.

- The art teacher plans an introductory story and preliminary play experience.
- The art teacher develops a setting to inspire student fantasy and invite participation.
- The art teacher plans for a show-and-tell and invites students to share their finds and ideas.
- The art teacher looks for interesting ways to encourage student planning and to welcome student ideas. For example, the art teacher might provide interesting bags

or unusual boxes to safely collect and transport students' items to class. The art teacher encourages the making and sharing of student idea (plan) books.

The students prepare for an art class by discovering ideas in many forms and being ready to share them in class:

- Students tell stories and relate observations of after-school trips, found treasures, and collections.
- Students come to class with ideas, plans, and object finds.
- Students discuss their art plans, the materials and processes they would like to use, and what it will take to accomplish their goals.

Imaginative Lesson Starts

A palette of infinite possibilities presents itself in imagining the start of an art lesson. There is no correct way to begin. Each start is an embodiment of the art teacher's creativity, invented and channeled through his or her creative vision. Let's pretend! Let's imagine! How can your inventiveness be expressed through art? Dramatization and playful fantasies grant a direct entrance into imaginary places and ideas.

Art teachers, as innovators, are familiar with the process of seeking out the unthought-of, the unexpected, and performing a little magic. A creative plan awakens "tube watchers" and passive listeners in school. "All aboard!" "Fuel up!" "Let's move out!" Passive, silenced school bodies need to be electrified. Students who might hide in the audience at school activities can become active participants when an imaginative invitation is produced. Here are some possibilities for creative starts (but the best plans are still to be invented):

- An imaginary travel start: taking a trip in the classroom as a drive, a flight, or a blast-off. Consider the art room as an airport, a launch site, or a pier, where students dock waiting for an adventure.
- A treasure hunt by archeologists who unearth hidden objects from a play pool or the schoolyard.
- Tell a story with props from childhood or create a mystery with clues and footprints. Children happily join in and prolong an exciting story using their own words and images, floating farther away from normal school frames of mind.
- A piece of mail can suggest a ceremony of opening a package or be a notification that a contest has been won.

Art room mail can be marked "fragile" or "top secret" for students to decipher its unusual sounds and scents. The mail might include a special mission, secret, or assignment. It might arrive in a bottle or be printed on an old telegraph form. It is always "special delivery" when mail starts an art class.

- A browsing of catalogs reveals the latest trends. Children are excited to review and clip from catalogs that adults consider junk mail.
- A lesson can start with a play in which students perform with play figures and found objects, or act as performers on a stage or a runway. Turn up the lights, add voices, make-up, and pantomime during the start of a lesson. Bypass a lecture. Unobstructed by words, a lesson can be planned to start with a dance. After all, children's creativity at home does not start with the day's objectives or verbal instructions.
- A lesson can begin with a creative display of play figures or grocery items, or by arranging drawers or dressing a mannequin. As set-up artists demonstrating great originality, students carefully arrange and display the food on their plates or toys on their shelves. The set-up of objects and displays in class can be used to interest students in all kinds of creative acts. Through creating store displays or playing school, students begin to tell their stories.

The start of an art lesson requires the preparation of mind and body. Creative fantasies and movements lead to ideas and further exploration. Lessons inaugurate touching, handling, playing, observing, selecting, and shopping for objects. Lesson starts are not uniformly triggered from a starting gun. They do not rush to art making and preconceived projects. Creative starts seek to develop the students' thoughts and investigations. Art lessons can be designed to provide questions, not answers. Creative starts are set up as choices, trials, and journeys into art. They can be verbal or they can be expressed through sounds and movements and shared as dreams. Lesson starts are artworks that take into consideration the use of surprise, magic, and invention. They illustrate artistic preparation and rehearsal, the act of searching, and all that is part of art making at its inception.

Plans for Ending the Art Lesson

There is no correct way to end an art lesson. The art process includes a continuous flow of activities and events.

Choosing when and where to stop is a significant artistic decision. A completed piece contains each artist's ideas, hopes, and clues for subsequent art. Art is the most important teacher. Learning from it is the essence of art education at all levels.

Why do artists spend a long period looking at their completed work? Why, in school, is so little time spent by students in viewing their finished art, in a rush to clean up and move it out of the way at the end of class? Art teachers can design active and playful encounters to prolong the time spent focusing on finished art. This reflection might involve different media, performance, or writing; it might involve speaking, listening, or visual notation.

School bells signal the end of the time designated for artwork. "Brushes down," the teacher might say. Everyone must finish at the same time, which, artistically speaking, is impossible. Art is collected and stored in portfolios. Cleanup details urge efficiency in getting both the tools and works quickly out of sight. Art is mailed in envelopes or portfolios for impartial grading. Monitors pull the art out of hands, and the conclusion to the art lesson is given little importance or recognition. The following sections describe other ways to plan for ending an art lesson that benefit the students as artists.

Plans for Nearing the End

Teachers typically focus on the beginning of the art lesson. But equally important are creative endings that invite learning from one's art and send students into the world with their new art experiences. Review and reflection integrate the components of a work, and they need to be planned for before nearing the end of allotted class time. It is helpful, for example, to announce the time remaining during a period, at reasonable intervals, to help set inner clocks and pace artists at work. Kitchen timers or other audible timers are fun to use. Methods of editing and reviewing art can be encouraged so that students stand up, step back, and get distance from the work. Play plans can include rotating the art or looking at it upside down to gain a fresh view. With most elements in place before a work's completion, some of the following strategies can be talked about:

- Simplifying the work can include cutting out, erasing, whiting out, or merging areas of line and color.
- Clarifying the work can involve reworking areas of forms or accenting certain places.

- Altering the work can range from minor changes to daring reworks.
- Taking time for thoughts helps students move away from the active place in which the art was made. Students' inactive states also need to be seen as being productive; time out is useful towards the end of class, allowing the artist to step back and away from the work. This time can be used for students to view their art outside of themselves, from the perspective of the audience.

The plan might be to simply allow students time to be alone with their completed art. Plans can be made to share the art, to look at it with others or to explain it to someone else. Plans might include moving away from the art— standing up, placing the work somewhere else. Students can also have fun, parading, animating, or performing with the art. Plans can be made for students to interview each other about their completed pieces and their ideas about them. Songs, poems, writings, and photos can be planned. Creative endings help students to play and think with completed art, to prepare exhibits, performances, and celebrations to honor finished pieces. As students handle and present their art to others, they also learn about what they made.

Flexible Endings

Making an artwork, as opposed to performing a classroom exercise, means being in charge of deciding when and how to start and when the work is finished. Each artwork has an infinite number of possible endings, and an individual's decision regarding when the art is finished shapes its results. The teacher's plans can ensure that students decide when an artwork is completed, even if it requires continued work beyond the class. Art teachers ought to create ending options that allow students to conclude their art early, take it home for completion, or work on it further during class. Art plans should clearly remind students that they have to decide when and how to complete each piece.

Students often finish their art either before or after the time allotted by the teacher. Some young artists naturally work with great speed and finish in record time. The tendency is to coax them to go on until "the finish line." "What else can you think of, what else can you do?" But this may indicate a wish to fit the art and the artist into a designated time frame. The pace of an artist reflects an inner timing, a balance of both creative patience and

impatience that has little to do with the quality of the results. Planning to incorporate flexible endings is more realistic.

When a student declares that he or she is finished, that artistic decision should be respected. Both quiet and active reflection time can be planned for as productive endings. The student and teacher can build a personal list of choices of activities, exercises, or reflections. For example, an exercise might challenge students to work fast, to be the "fastest drawer in the West." These exercises can help students experience work places other than those with which they are comfortable. Flexible endings might include finishing work at home, working on several artworks at the same time, or completing a series of short pieces.

Ending Choices

To continue or not to continue? Unfinished art is not bad. Art is not a speed contest. Incomplete works hold great promise. Having students finish artworks might require individual planning and discussion so that students are aware of the choices they have for completing work. For example, plans can be made to keep art in a holding file to be returned to when time is available or new inspirations arrive. Works might be taken home to allow more leisure time and privacy. Planning with students means considering all options and developing a satisfying plan to complete the art.

Living with their art allows artists to get used to it and to imagine different versions of the work. An artist's views change regularly, even when considering the same work over a period of time. These views can change by moving the work to new spaces in the room or out of the room. Taking art on a journey allows it to be seen in a new light, against different backgrounds. Plans can include keeping the walls of an art room open, welcoming informal displays. Parents can be advised to provide space at home—on doors, corkboards, or in high-traffic areas—to promote casual yet continual viewing of artworks. Perceptions of art change as we live with it.

Plans can be made to engage different audiences to help bring about the satisfying completion of a work. Art teachers can discuss with students how at home, a different and often more supportive audience combines with an additional range of tools and opportunities to help expand a piece. At home there is the luxury of time and the availability of a studio. Seeing works in daylight or with new audiences on the school bus can also promote other

views. Informal public sharing can affect the artist's decision as to when a piece is ready to be formally shared with an individual or larger group. This needs to be the student's choice.

When is it time to retire, store art, or be away from it? As long as it is in sight, one continues to reflect on the work. There is one time a particular artwork should not be seen: when its presence is a distraction and the artist cannot come to it freshly.

Disposing of art, an important artistic prerogative, is one many students arrive at prematurely. Art teachers can discuss throwing out art as a step in the learning process, even if it seems like a drastic choice. Recognizing that no one can keep everything they make, students might not want to keep pieces that don't represent their best efforts or ideas. Disposal is a useful cleansing act and is sometimes necessary for a fresh start.

Ending Talks

Words help to summarize and carry ideas from one artwork to another. Words alter our thinking and focus the ideas upon which we build our art. Hopes, fears, and self-clarification speak through presentations to others. After completing an artwork the student is also transformed, and interesting ideas flow through words. Art teachers can create opportunities for students to express thoughts about their art and their hopes for its future. Students can take a microphone, stand on a podium, or face a camera to answer questions, giving interviews or supplying explanations.

Clean-Up Plans

All acts in art making are significant to the art process. When cleanup is not a speed rally, it can be a time of learning. Areas and surfaces to clean are portraits of the art process and art making styles. Art teachers can plan to check with students the space and surfaces they worked on, the changes in tools. Whether the work surface is messy or extremely neat, the moves used to make an artwork are inscribed on every surface. Do you go beyond the edge of the paper and do your marks know no bounds?

A student's mixing tray may not tell his or her fortune, but it is visible evidence of choices and mixing styles. There need be no rush to discard it! Before throwing out table or floor covers, look for clues about what they say about the art. Art teachers can help with the study of all surfaces

before washing brushes or hands. Check for drips and blotches while unraveling an artwork's colorful past. Look at tool handles to describe how tools were used.

Before students are asked to collect all scraps in sight, they can gather cutouts and cutaways in order to learn about the forms created. Can a new piece be built from the scraps, and how would it relate to the original? Plans can be made for students to become art detectives at the end of the period, by reviewing and writing up clues to the completed artwork. Art teachers can plan a display of items such as mixing spoons, sticks, and trays, or the best spills and finest drop cloths.

Plans to End Art with Art

All art is made in a series, as one work inspires the next. Plans can be made to study art through drawings, diagrams, photographs, videos, or computer images, to learn about the art making process from the artworks themselves.

For example, plans can be made to play with finished art, to move it, spin it, turn it, or drop it. Sections can be blocked with hands or papers in order to focus on details and unique elements that pop out when viewed separately from the whole work.

Plans can be made to copy by tracing, photo copying, or sketching from the original. Art teachers can suggest ways to alter the reproductions. Copies can be cut, torn, drawn over, or scanned into a computer. These changes create new impressions to carry over into the next piece.

Plans can be made for performing with completed art: using it as a script, a score, or a costume. Art can be held and carried in new ways; it can be worn and performed, and young artists can talk through it. Ending with a show expands students' visions and ideas about their pieces.

Plans can be made to frame a finished work. Frames created from scrap wood, silky ribbons, socks, or feathers change the appearance of the completed art, suggesting new meaning for it. Placing completed pieces in see-through boxes or plastic bags gives the finished art a different look and feel on the wall.

Plans can be made to wrap up work in special covers or folders. Special shopping bags can be made for it: an art bag with new handles, so that a work can be carried in a different way. What would the gift-wrap look like if your work were wrapped up for a special person? Art teachers can consider that all creative work employing a finished piece, reveals a new side to the completed work.

Taking Home Plans to Make Art

Not just artwork but art lessons need to be taken home. It is useful to recognize when planning that art begins and ends at home. School art can support home art as it rekindles students' art interests in bringing fresh new ideas home. A lesson plan can emphasize what happens after class. It is a strategy to invest in home art, even helping to provide materials to be used at home. Planning can include considering what students can do after each class, what objects and materials they can use to be independent artists at home. School art can never be considered the total art making experience, but a good art lesson ignites art making at home and works toward full-time art, the experience of being an artist.

Why consider planning in school for art to be done at home? Art made at home represents students' ideas and not the teacher's art lesson. Home art uses students' material choices and inventions. Art at home is typically less hurried and not limited by time constraints. Art made on one's own is not made to earn a grade or complete an assignment, but because it is of interest and even urgency for the artist. Home art is a response to personal and authentic art interests, an artist's reason for making art.

Sharing students' home art in class can become a planned part of each session. Students appreciate praise when they start art projects at home and bring work done at home to the art class. Plans can include the art teacher sharing works in progress from home, inspiring students by example. Art cannot take root in students' lives if they only participate in it once a week, in a 45-minute class. The art class should inspire students to go home with art on their minds.

Plans for the Next Class

Plans for the end of each art class can include determining what will be next. This can include plans for what can be done at home and preparations for the next class. Plans might involve suggestions for field trips or sites to search at home or at neighborhood stores. The end of an art class is also a reminder for students to be prepared for the next show-and-tell, sharing their finds and ideas in class. Each art experience fuels the next; the plan for ending an art class is also to inspire students to get out and be actively engaged in looking, collecting, and taking notes to find possibilities for the next session. Goals can be formulated with students to research ideas, take trips, and gather notes. Students might receive special artist passes allowing them

to bring unusual items to school, with guaranteed safe passage to the art room. Welcoming a prepared artist to the next class is an art, practiced by a teacher who is an enthusiastic listener to student plans at the end of each class.

The end of an art class can encourage students to embark on a great beginning outside of class. Ending plans can suggest rewarding beginnings for young collectors, players, designers, and inventors. Constructive endings leave students with more than the memory of isolated art projects or skills. Art lessons can nurture a sense of optimism about a student's identity as an artist and the world at large. An ending can promise the beginning of new work to be done.

Future art teachers can build in time between the art experience and ordinary life out in the hallway or in the next class. Good art planning considers ways to reach beyond the art period, to extend its meanings, applying art learning and encouraging further exploration in daily life. The lesson's ending is an opportunity for students to think about what they have discovered so they can use it outside of the class. As they walk through the art room door, the lesson's ending can be instrumental in empowering students to be artists in life.

Reference Books and Resources to Read, Look At, and Share With Students

In this first chapter, the foundations, it is our feeling that books should introduce the field from the giants. There are many volumes listed that might be very old and obviously not available in your local bookstore or common online vendor. They are, however, worth searching for. Some were our textbooks as new art teachers and they still transmit words of valuable wisdom. Others are part of our common heritage as art teachers, items that future art teachers may seek to come across in their lifetime, or actively want to own during their careers. It is not always true that new books are the best, and have more to say about art education as it exists today than some of the older volumes. Often going back to our roots reveals the present, how we got here, and ideas that are just restated by new authors. So we urge you to read and to own many of the volumes below, enjoy adding your favorites to expand the list and share with your future students.

Amburgy, Patricia M., et al., eds. The History of Art Education: Proceedings from the Second Penn State Conference. Reston, VA: National Art Education Association, 1992.

Arnheim, Rudolph. Thoughts on Art Education. Los Angeles: The Getty Center for Education in the Arts, 1990.

Brosterman, Norman. Inventing Kindergarten. New York: Harry N. Abrams Inc., 1997.

Broudy, Harry S. Enlightened Cherishing: An Essay on Aesthetic Education. Urbana, IL: University of Illinois Press, 1972.

Chandler, Barbara E. The Essence of Play: A Child's Occupation. Bethesda, MD: The American Occupational Therapy Association, Inc. 1997.

Chapman, Laura. Approaches to Art Education. New York: Harcourt Brace Jovanovich, 1978. Chapters 1, 2, 3, and 6.

Cottrell, June. Teaching With Creative Dramatics. Skokie, IL: National Textbook Company, 1979.

Cremin, Lawrence A. The Transformation of the School. New York: Random House, 1964.

Day, Jennifer. Creative Visualization with Children: A Practical Guide. Boston, MA: Element, Inc. 1994.

Day, Michael, Elliot Eisner, Robert Stake, Brent Wilson, and Marjorie Wilson. Art History, Art Criticism, and Art Production: An Examination of Art Education in Selected School Districts, vol. II. Santa Monica, CA: The Rand Corporation, 1985.

Dewey, John. Experience and Evaluation. New York: Simon & Schuster, 1938.

Dewey, John. Art as Experience. New York: Putnam, 1958.

Efland, Arthur. History of Art Education: Intellectual and Social Currents in Teaching the Visual Arts. New York: Teachers' College Press, Columbia University, 1990.

Eisner, Elliot. Educating Artistic Vision. New York: Macmillan, 1972.

Eisner, Elliot W. and Michael D. Day. Handbook of Research and Policy in Art Education. Reston, VA: National Art Education Association, 2004.

Feldman, Edmund. Varieties of Visual Experience: Art as Image and Idea. 2nd ed. Englewood Cliffs, NJ: Prentice-Hall, 1972.

Gandini, Ella, Susan Etheredge, and Lynn Hill. Insights and Inspirations from Reggio Emilia: Stories of Teachers and Children from North America. Worcester, MA: Davis Publications, Inc. 2008.

Gardner, Howard. Art, Mind & Brain. New York: Basic Books, 1982.

Gardner, Howard. Art Education and Human Development. Los Angeles: The Getty Center for Education in the Arts, 1990.

Gardner, Howard. The Arts and Human Development. New York: Basic Books, 1994.

Golumb, Claire. *The Child's Creation of a Pictorial World.* Berkeley, CA: University of California Press, 1992.

Herbeholz, Barbara. *Early Childhood Art.* Dubuque, IA: William C. Brown, 1982.

Hurwitz, Al and Michael Day. *Children and Their Art: Methods for the Elementary School.* Fort Worth, TX: Harcourt College Publishers, 1995.

Jackson, Philip W. *John Dewey and the Lessons of Art.* New Haven, CT: Yale University Press, 1998.

Lark-Horovitz, Betty, Hilda P. Lewis, and Mark Luca. *Understanding Children's Art for Better Teaching.* Columbus, OH: Charles E. Merrill, 1967.

Linderman, Earl W. *Invitation to Vision: Ideas and Imaginations for Art.* Dubuque, IA: Wm. C. Brown Company Publishers, 1967.

Linderman, Marlene. *Art in the Elementary School: Drawing, Painting and Creating for the Classroom.* Dubuque, IA: Wm C. Brown, 1955.

Logan, Fred M. *Growth of Art in American Schools.* New York: Harper & Row, 1955.

McFee, June and Rogena Degge. *Art, Culture, and Environment.* Dubuque, IA: Kendall-Hunt, 1980.

Michael, John, ed. *Visual Arts Handbook.* Princeton, NJ: Kraus International, 1993.

National Art Education Association. *Quality Art Education.* Reston, VA: National Art Education Association, 1986.

Plummer, Gordon S. *Children's Art Judgment.* Dubuque, IA: Wm. C. Brown Company Publishers, 1974.

Rayala, Martin. *A Guide to Curriculum Planning in Art Education.* Madison, WI: Wisconsin Department of Public Instruction, 1995.

Read, Herbert. *Education through Art.* London: Faber and Faber, 1943.

Rushlow, Bonnie B. *Purposes, Principles, and Standards for School Art Programs.* Reston, VA: National Art Education Association, 1999.

Sarason, Seymour. B. *Teaching as a Performing Art.* New York: Teachers College Press, 1999.

Smith, Peter. *Learning About Art in American Schools.* Westpoint, CT: Greenwood Press, 1996.

Smith, Ralph A. *Excellence in Art Education: Ideas and Initiatives.* Reston, VA: National Art Education Association, 1986.

Smith, Sally L. *The Power of the Arts: Creative Strategies for Teaching Exceptional Learners.* Baltimore, MD: Paul H. Brookes Publishing Company, 2001.

Soucy, D. and M. A. Stankiewicz, eds. *Framing the Past: Essays on Art Education.* Reston, VA: National Art Education Association, 1990.

Stewart, Marilyn G. and Sydney R. Walker. *Rethinking Curriculum in Art.* Worcester, MA: Davis Publishing, Inc. 2005.

Suzuki, Shinichi. *Nurtured by Love: A New Approach to Education.* Smithtown, New York: Exposition Press, 1981.

Szekely, G. *The Art of Teaching Art.* 2nd ed. Boston, MA: Pearson Publishing Co., 2000.

Szekely, G. *How Children Make Art: Lessons in Creativity From Home To School.* New York: Teachers College Press with National Art Education Association, 2005.

Wachowiak, Frank and Theodore Ramsey. *Emphasis: Art: A Qualitative Program for the Elementary School.* Scranton, PA: International Textbook Company, 1965.

Wygant, Foster. *School Art in American Culture 1820–1970.* Cincinnati, OH: Interwood Press, 1993.

Zemelman Steven, Harvey Daniels, and Arthur Hyde. *Best Practice: New Standards for Teaching and Learning in America.* 2nd ed. Portsmouth, NH: Heinemann, 1998.

Art in the Elementary Grades

Anyone who says you can't see a thought simply doesn't know art.—Wynetka Ann Reynolds

Section One Where Art Ideas Come From

CHILDREN'S ART IDEAS ARE DIFFERENT FROM ADULT'S IDEAS

Adult artists' ideas are often focused on the study of the art world. Their concepts for art are based on knowledge of art history and a dialogue with other artists from the past and present. Children see art freshly, removed from traditions of style, art movements, and history. They discover art and invent art, finding the future of art in nature and in their environment. Through play children find their ambition for art, make art for pleasure, and as a gift for those they care about. Children's ideas come from firsthand experiences, from making and decorating things, discovering creative ways of approaching household tasks. Before entering school and being taught what art is, there is a golden age of self-discovery.

Art is understood instinctively and practiced without fear because children don't think of their many creative actions as making art. Children's art finds come from such sources as the figures they play with or the nail polishes they collect. Children start creative life with boundless ideas from opportunities to create with toys and all household objects. Dreams and ideas derive from fun and playful inventions. The art ideas found in playing are not high art or low art, nor are they divided into separate media. Play ideas demonstrate an interest in trying out things, in the fun of carrying objects and trying on curious finds. Ambitions to be inventive come from pocketing the unusual and making beautiful things to surprise everyone.

Children acting as landscape artists demonstrate their different attitudes towards art. For children landscapes are not an interpretation of the environment, they are real places to be explored. In an outdoor landscape painting class, some adults bring along children. While the adults

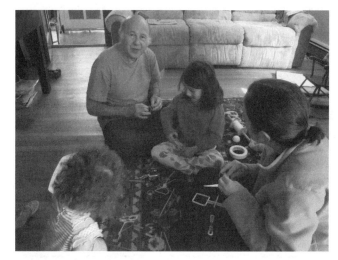

FIGURE 2.1 Art at Home

are setting up easels and making sketches of the views in the distance, the children are busy scouring the landscape, picking up beautiful petals, twigs, and rocks from the ground, making trays of play food. Art plans are made while playing with water and sand, building with pine needles and creating displays of leaves tucked into one's socks. In other words, art ideas are not abstractions to represent something else.

There is paint before paintings, play set-up before picture making. Children play and experiment with objects and materials, while adults develop a technique to represent a likeness, a picture of the landscape they see in the distance. Children's art is intuitive. Adults generally don't dip into colors before they have an idea. Kids not only dip but completely immerse themselves in playing with paints. Just the love of paint drives the act of painting and propels the joy of touching and spreading colors over any surface.

In school, art inspirations come from the art teacher, who may refine them from standards and from the

curriculum, which in turn represent adult artists and art history but not children. At home, art ideas derive from children who are still confident that they have art ideas of their own, and adults are generally willing to see and listen to them. Adult art and concepts can interfere with fertile periods of artistic playing. Art teaching is appreciating children's freedom to just make things from their many sources and ideas.

Future art teachers need to be cautious in applying their studio training as the standard of art, and not confuse the importance of learning art from children with a teacher's notion of art. Care needs to be exercised as to whose notions of art are being taught in an art class, and whether children's ideas are being recognized. What teachers and adults think of as art might not be the children's view of how they practice art.

One generation plants the trees, and another gets the shade.
—Chinese proverb

Art Ideas Without an Art Teacher

Children have many art ideas without art lessons, art classes, and art teachers. Those independent plans need to be looked at in determining what children's art truly is. Future art teachers who are taught to plan lessons for children need to step back to consider whose idea is being taught and practiced in an art class. Is it the child's idea? Art classes can be run purely on teaching plans, over-riding the many ideas that children come up with on their own without adults putting themes and lessons up on the board.

There can be no comprehensive listing of children's art ideas; such a listing would have to be updated daily. Art teachers, however, benefit from taking notes on art ideas expressed by their students. Categories and patterns of original thoughts are useful to construct, so that art teaching is always about children and insuring that it is their ideas that are the basis for planning the art class. An art room is an idea-sharing place, where everyone learns from each other. Opportunities have to be available for children to discuss their plans and concepts, goals and ambitions. Children can share secret shopping places, favorite idea sources, and recent discoveries.

Art is about ideas, individual reasons for wanting to create. Unlike other subjects, art is not a series of standardized exercises, representing only already discovered art principles. Art teachers need to believe in children's ideas as the foundation for the future of art. Teaching in the field is pro-

moting student goals and encouraging them to search outside and in class, all the time and everywhere. Art teachers are not only promoters of their own ideas, but also enthusiastic fans of children's art. The following segments explore some of the many sources for children's play and art.

Art Ideas from Presents, Birthdays, and Fun

Children's art ideas often come from happy moments, or recollections of fun experiences. Where are the smiles in school? Fun, play, and happiness are part of discussing joyous subjects. Playing and pretending exudes smiles and laughter; that is a hallmark of an art class. In art, students remain children, celebrating birthdays and planning fantastic parties for stuffed animals. What makes children happy is an important source for ideas. Birthdays make children happy, and the measure of a good art lesson is that it should be as much fun as the best birthday party. For example, a little girl carries a cake made from a Frisbee, decorated with candles of pastel-colored shuttlecocks, and asks everyone to sing "Happy Birthday" to her art. Or, a sponge cake made from sponges and held together by painted twigs posing as birthday candles demonstrates how found objects become surrogate canvases.

Thoughts of wonderful birthday parties suggest interesting themes, settings, and architectural cake sculptures. The well-known artist Christo, who has wrapped islands, bridges, and town halls, could testify as to how he loved to artistically wrap birthday presents. Many artists have admired children's unique gift-wrapping art, preparing presents for friends, and festively wrapping up their own birthday gifts using unique stickers, ribbons, and customized gift wrap. Examples of children's gift art are not in museums yet but need to be proudly displayed in an art class. Future art teachers should scrapbook observations of the unique parties, cakes, and gifts children create. What gifts can a child give without cash or a credit card? Plenty! Children's gifts are their unique art ideas.

Creativity takes courage.—Henri Matisse

Adapting to Fears by Way of Art

Art ideas often derive from children's fears and desire to gain control of them. Children make the most wonderful masks and beasts to scare off the furry monsters that haunt their life.

A student who recently arrived from Ashkelon, an Israeli border town, draws fighter planes to guard his sky. When air raid sirens punctuate childhoods and underground bunkers are referred to as playgrounds, drawings of well-armed fighter planes offer protection. American children pose as superheroes, draw action figures, and paint armed robots for their defense. Fears coming from an attic, a closet, or from the sky call art to arms. Uncertainties are responded to by calling on art to be the child's protector. Battle scenes in space, in the skies, and on the ground are an important part of children's art. Images of fighting are frequently frowned upon and even denied to children as an art theme. While society accepts pictures of war in daily newspapers and on television, it frowns upon the child's portrayal of fighting, which is not only therapeutic but often a source for powerful images.

Art Ideas from How Children View Their Future

Adults often see themselves in terms of their job or profession. Children also begin to fantasize about what they will become as adults. Children on a baseball team think about sports heroes and picture themselves as future ball players in artwork. When attending after-school ballet classes becomes a dominant activity and tiaras and tutus fill the closets, a ballerina's dreams become their collections, their ideas for decoration, for their plays and art. Children who ride and take care of horses create vast equestrian play worlds and strong art pieces around their interest. As children pose ideas and portray individual dreams, future art teachers need to pay attention to what children are involved in now and how they envision their future.

Ideas of Placing the Self in the World

The play figures children acquire and make act as ambassadors of themselves to the world. Many art ideas come from posing, dressing, animating, drawing, and setting up environments for action figures, fast-food figures, and dolls. Children construct playgrounds and schools, circuses and parades in which they participate. Teddy bears dressed in foil and plastic act as astronauts for planetary explorations, the roads children cannot yet travel.

Children's entrepreneurial spirit opens up many stores. Their figures are employed in the post office and in banks and in restaurants made from trays and pillows. Many drawings and paintings follow the path set out by toy figures and vehicles moving through imaginative constructions. With the action of play figures children test out many worlds, developing ideas for detailed backgrounds and stage sets. Plays in castles, forts, or garages are situations that yield ideas for unique buildings, interior design, and drawings.

Ideas and Wonderment

Children often invent entire stories for their pictures. The stories are in the present, yet in their imaginings they are timeless. Exciting drawings and constructions deal with such images as the tooth fairy, supported by wonderful tales about the secret life of teeth under pillows. Although children's art is already unique in appearance, the ideas behind the work deal with important wonderments such as the appearance of heaven or an attempt to grasp an image of God. Although children more often choose everyday themes, such as traveling, a visit to grandmother, a wedding, or a familiar game, children seem to express their sense of the divine in the ordinary, the common places and events around us.

Children's speculation about how things work leads to unique inventions and designs for pulleys and tree houses, experiments that display amazing solutions to everyday problems.

Ideas from Shopping

Children discover many ideas while shopping. Supermarkets where children can freely roam suggest ideas in every aisle. On the way to the check-out-line there is a common negotiation between young artists and their parents. Children tightly hold on to an object as adults fire objections: "Why do you need that?" "You already have enough junk in the house!" "You have a million things like that at home!" The barrage leaves little room for a child to interject. Parents would be surprised by the flow of original ideas readily accessed for using every found object. Art teaching is about listening to children's ideas and being open and interested in their thoughts and plans.

Adults shop with lists, while children dream of creative ideas. In a supermarket, children find plans for the business cards, bag ties, and paint samples they've collected. The supermarket trashcan is a vast reservoir of discarded labels, carton dividers, and displays. Discarded free stuff intuitively conjures up plans for play constructions. Visiting at

least a store a week is necessary to provide the young shopper with ideas.

Future art teachers need to consider how to set up art classes as shopping sites modeled after garage sales, a memorable attic shopping adventure, or a special dollar-store visit. Children in every store are idea shoppers, finding unusual uses for all objects. It is important to encourage idea shopping online, in stores, and in the home as a primary preparation for an art class.

Joy and Art Ideas from Art Materials

When an art teacher opens the paint closet there is applause in the room. Before painting pictures, or learning of painters and painting techniques, children love to unscrew the paint jar, squeeze a paint tube, and get their hands into each color. Art starts with love for paint, a joy of stirring, pouring, and mixing water and colors. The interest is not in naming or charting colors but discovering and blending them. Children pocket dry color chips and seal interesting samples in plastic bags. Children's art ideas come from the pure joy found in paints before they are turned into a picture or a painting. Children find ideas from being able to freely play with media, mark surfaces, and paint faces. Children have great ideas for substituting brushes, by simply moving paints from one container to another. Children are inspired by the endless possibilities of the media and its instruments.

Future art teachers need to observe how children play with art tools and discover ideas by taking them for a spin. Children invent new tools for art making, new handles and extensions to existing tools. They think of ways to extend their reach by using found objects such as antennae or fishing poles. Tools extend children's reach and ideas, as they discover dancing with mops as brushes, plungers and umbrellas as marking tools.

There is great satisfaction for a child to be in control of a tool, being able to move or go anywhere. Young artists find ideas by "driving" markers and brushes before they can drive a real car. Children dance with a crayon on paper as if the paper were an open field, and move an art tool on a seemingly endless road.

Ideas from the Insignificant

Children don't have to be invited to see, but their creative visions need an encouraging audience. Because children see possibilities for art in the most unlikely places, art teaching is an appreciation and validation of their ability to find art in the smallest things. Future art teachers can showcase children's art finds in such unlikely media as Band-Aids, pencil shavings, lint, hair, and nail clippings. Children's specialty is looking down, picking things up, pocketing interesting finds that others abandon. Young artists point out possibilities in lost, neglected, and forbidden objects.

Future art teachers can build on new paths charted by children. As children find art ideas in old hair curlers or the latest in colored metallic paper clips, art teachers can legitimize their students' finds with special containers to display them and by illustrating how small ideas have led to big ideas by artists of all ages. Children will continue to discover their own art ideas as long as there are encouraging parents and art teachers who appreciate youngsters who scour the floor.

Ideas from the Kitchen

The kitchen houses the most interesting art tools and supplies; no wonder it is such a popular idea-gathering site for children. Before young artists are blamed for every misplaced kitchen utensil, there needs to be an understanding that the kitchen is the best place to find art ideas, to check out tools for printing, painting, or sculpture experiments. Children who feel free to explore a kitchen use the toaster to make prints and the blender to mix food colors, applied with feather brushes and rolling pins. Children "borrow" the sink liners to test the impressions, or discover the action of funnels as a painting tool. Accounting for the missing kitchen items and figuring out ways of asking for clemency when things are missing from the kitchen has to be discussed with parents and students.

Children dream of new ice cream flavors by borrowing cones from the kitchen cabinet and vegetables from the refrigerator to sculpt a pickle ice cream cone, red tomato ice cream, and carrot ice cream shaped from a cone and a real carrot. Kitchen cupboards extend art room drawers for idea browsing. The art class is a place for debriefing, where children's many art dreams and ideas that cannot always be realized at home are shared and not neglected. When a child wants to create new colors by mixing every yogurt in the refrigerator, or test Kool-Aid stains on fine white dinner napkins, parents may be suspicious and object. An important role of an art class is to celebrate outrageous kitchen plans. Inspired young artists discover in the art class that ideas can be a form of art.

Art Ideas from Holidays

Children get deeply caught up in holiday celebrations. Special invitations and table decorations offer a multitude of jobs for young party planners before Thanksgiving. For Halloween, beauty parlors for pumpkins open up. Fanciful openings are carved into juicy orange forms and the portrait busts are complemented by make-up and original hairstyles for each client. Hearts are one of children's great form studies, rehearsed in all materials. Children cut delicate paper hearts to make modern breast-plates for Valentine's Day.

Future art teachers, however, should be aware of not just the possibility of fears about ghosts and goblins, but the religious versus secular problems associated with holiday arts. While the holidays whip up loyal art spirits, they are all related to Christian or Pagan celebrations. This needs to be a concern for future art teachers not only because of valued constitutional principles; but more importantly, they must be sure that the art spirit does not leave out children who do not celebrate the same holidays.

Another concern is the established symbols that are solidly embedded into each holiday tradition, often reinforced by images seen throughout school. In other words, there is not just one but thirty-two identical turkey hand tracings displayed on a classroom door. Even though children are motivated by the holidays to create, it is holiday projects—not children's ideas—that dominate school displays. Adult "art tricks" tend to direct art making during the holidays more than at any other time of the year. It is not only turkeys that are butchered during Thanksgiving but also children's fantasies derived from holidays. Future art teachers should not be riddled with how-to type lessons. Holiday art needs to be oriented to children's concepts of ghosts, snow, or pumpkin puppets in open-ended art that is practiced the rest of the year.

Ideas from Media Images

Today the media is such an influential part of children's experience that this section should be the largest category describing where art ideas come from. Movies and video games completely rivet the attention of young viewers, as comic books used to. In both instances there are valuable idea sources for children and art teachers. Sequenced artworks, fast-paced seeing, remote-controlled art making, and on-screen art viewing suggest a new art world, new ideas for viewing and making art. The choice is to remove children from the temptations of media, or to take a more reasonable approach, which is to involve new media arts and adapt children's technological know-how to school art.

Media dreams are a significant source for children's many gaming ideas, their animated on-screen art. Children have great experience in directing the landing of space invasions and mounting spectacular action scenes with legions of play figures, and can translate their ideas to action videos and animated media productions. Born with video paddles and remote controllers in hand, children can naturally channel their experiences into remote controlling and sequencing motion in artwork. Future art teachers have to be willing to learn from students who are on the cutting edge of technology.

Final Notes for Future Art Teachers ... Children as Artists

Art teachers need to believe that children are the artists in an art class and that they have great sources for ideas. Dreaming, shopping, and planning are the most important tasks of the artist. In presenting a realistic art lesson, searching for art ideas cannot be left to someone else. Each young artist needs to arrive in class with collections, idea books filled with plans, and the excitement to show and tell about it. Future art teachers need to understand that children have unique sources and reasons for making art that are different from adults.

Children as Confident Contributors

When students know that their creative ideas are sought after they become confident contributors to an art class. When students are not asked for their ideas and their contributions go unsolicited, there is the risk that they will lose interest. If future art teachers can look away from art lessons for a minute, step back from their own art and training, from adult notions of art, they will become supporters of children's ideas and art sources.

Art Ideas

Every art class is a demonstration and sharing of how and where ideas are found and how they can be used in art. Art teachers may list students' ideas on the board, which will

demonstrate their importance. Before art is made, art teachers can work to: Get ideas to flow, share ideas in public, acknowledge each student's ideas, listen to all possibilities and, remind everyone that no idea is silly.

Idea Auctions

"Idea Auctions" can be played with students to consider art ideas stemming from the familiar or mystery objects. The auctioneer simply holds up and demonstrates the object. Students consider:

- How can this object be turned into something else?
- How can it be made into something to wear?
- How can it be made more beautiful?
- How can this ordinary object be made extraordinary?
- How can it be redesigned to make it more fashionable or contemporary?
- How can it be made into art?

Through idea auctions and similar play, students learn to dig deeper to come up with the most unusual, unheard of, unlikely, and even silliest ideas.

Art Thoughts

Art thoughts come to those actively searching for them. Future art teachers need to go idea shopping at the supermarket with children. With a child, one learns about the nature of children's art idea shopping, as opposed to ordinary food shopping. Keeping a diary of this important experience demonstrates children's broad idea sources and willingness to look at everything, touch, and pocket all that's interesting. A teacher's list of supply ideas from his trip with a child might include: plastic fruit underlays, berry baskets, bag ties, printed flower bags, and hand-ground coffee bags.

The Latest Ideas

Future art teachers need to keep up with the latest ideas. Art teachers should visit toy stores to study how kids interact with toys and games, to see what inspires their wishes and dreams. At the toy store the art teacher can find the latest in computer painting games, printing, building, and performance supplies. There are no part-time artists—finding art ideas requires full-time seeing, observing, and collecting on the part of all class artists, both teacher and students. Art teaching is figuring out how to encourage what all artists do—looking for ideas everywhere. See Plate 2.1.

TESTING THE WORLD THROUGH PLAY AND ART

The seemingly insignificant play acts of children are loaded with meaning. Momentary play, often annoying to adults, develops future notions of art. It is in play that a sense of design, taste, and art interests are born. Through play children begin to discover their future in art; they test potential tools, surfaces, and find new perspectives that sustain a lifetime of art making. Adults learn by observing children in acts of discovering art as they play in the school cafeteria, in a bathtub, or in their room. In directly observing children, future art teachers can discover a timeless path for teaching art.

Artists of all ages explore the world through play and art. Acting on curiosity, children immerse themselves in firsthand exploration of their physical environment. Play is a means of interacting with objects and forms, testing materials, experiencing surfaces, and entering spaces. In play children create manageable models of the world so they can make modifications and restructure what exists. Playing allows for independent exploration and creates avenues to see things in fresh ways, to discover and invent. Play is a voice and a feeling that there is room for individual contributions to art and to restructuring the world.

Between play and art, play is the less recognized art form. Children themselves don't refer to the many acts of arranging, decorating, constructing set-ups and try-out performances as art. Even though painting and drawing are called art, play continually challenges and opens up the notion of children's art to many yet to be officially recognized art forms. Children use play as a rehearsal for painting and drawing and also as a way to independently discover new media. Familiar art tools and supplies expand the possibilities of play investigations and provide permanence to fleeting creative acts. Children's playful investigations and discoveries open new art ideas, ways of creating, practicing design, finding new art tools, and setting a foundation for imaginatively exploring things around them.

With play allowed and sparked in an art class, art is made through children's initiatives, in their way and in their media. Play differentiates the art class from school. There are blocks, trains, teddy bears, and toys in an art class, some

brought in by their caring owners, others made in class. There is movement, messiness, and noise, as everyone is not working in the same way, in the same place, on the same clock or time frame. Each art lesson needs to begin with preliminary play that is a rehearsal for art, and sometimes the art itself.

Preliminary play starts the art class with children's own investigation, separating their ideas from the teacher's plans. Each preliminary play leads to a thousand ideas for children to start a class. Each play contains and suggests the seeds of great ideas for further creations, constructions, paintings, and performances. As children grow up investigating through play, they bring this expertise to the art class. Children's play is not only their art, but also their means of discovery. Play is where art in life and in an art class begins.

Testing Objects by Playing and Animation

The story of figurative sculpture in children's art is intertwined with a child's relationships with figurative objects such as dolls and action figures and their ability to animate these inanimate objects, bringing the figures to life. Future art teachers need to study children's playing and changing relationships with play figures. The special relationship children have with their dolls and teddy bears is partly a development of animation, and of course the development of love, attachment, and caring for others. In playing with their "babies," children not only become aware of the figure in sculpture but how figures are made to portray people—themselves and their family. In experiences with animation, they learn to act out their own life, their hopes and fears. They learn to animate baby to take a nap, dress up, and experience arranging a figure in multiple backgrounds and settings. Children form an early attachment to figurative sculptures.

All kinds of artwork can be made for play friends; clothes from paper towels, beds from boxes and pillows … A new repertoire of movements is added. Young sculptors always carry their models with them. They look to the outside world for new scripts, scenarios, and story ideas. As the child's movements become more sophisticated so are their dolls'; the child's figure-handling skills grow. Baby's discoveries relate to the child's discovery of their body and its moves. By the time children enter school they enter as skilled performers, ready to pose any figure and animate any object in the art class.

Testing the World by Wearing Everything

Build-a-Bear is one of the fastest-growing mall chain stores. Children pick their teddy bears from a dozen available models and can watch the teddy bear being "born" or stuffed and dressed in the outfit of their choosing. While building your own suggests creativity, there are few choices to be made in the bear. Yet children start their play experimentation by dressing scores of play figures and wanting to choose their dolls and their own clothes. Picking out their own clothes at age two is part of a creative yearning and an early start in exploring fashion arts. In doing so, children are making personal and artistic choices, in style, color, and fabrics. Children who are active in dress-up play will dress up their pencils and pets, wrap a plaster outdoor deer in jump ropes and cover its antlers with badminton birdies. Children explore sculpture by wearing it, putting on an unusual found container, trying on hats or modeling baby blankets. Before children learn to make masks in school, they have tried on many objects, covered themselves in many materials, wrapped themselves in foil and paper towels and invented clothing and masks from everything at hand.

Art is encouraging freedom in expression and allowing a reprieve from standard fashion rules and adult dictates such as matching "appropriate colors." Future art teachers need to be experts in children's costumes and dress-up play, using the art class to further their efforts to make their own clothing and wardrobe choices. Art class can have regularly stocked fabric trunks, dress-up corners with mirrors, and opportunities to make and try clothing on resident play figures. Designing art ideas related to the body is similar to choices made over other canvases. The art class is the place to build your own bear and make its own outfits to explore fabric colors and patterns, and to try on everything as a way to test objects and art ideas.

Testing the World by Fixing It

A child walks over with a marker and exclaims, "I broke it!" Seeing the inkwell and bright red color drippings, the adult is unsure if it was an accident. Nevertheless, it's clear there is great interest to discover what is inside the marker. Before getting angry, adults have to step back to consider what children learn from an experience. Children explore objects by taking them apart and seeing how they work. Before labeling a child destructive, the need in artistic

learning for dissecting, looking inside, and even breaking something that works to gain access to its parts has to be considered. Sometimes it takes a screwdriver or even a hammer for a young artist to investigate. Art teaching is about encouraging playful looks at exterior surfaces and views, but also allowing for going inside and pursuing the mysteries that lie beneath the skin of a worm or the locked interior of an alarm clock.

To be a sculptor is to admire engineering and the beauty of interior structures and mechanical parts. Future art teachers need to stock up at Goodwill stores for old typewriters, phones, and alarm clocks. Every child needs a toolbox and an art room to use it in; they need to fix things by taking them apart, and boxes to collect parts in. Tool belts are exciting for playful investigators. There can be many opportunities to save, sort, and trade parts, showcasing and arranging them in see-through containers. Operation is an art game of basic sculptural fantasy, of pulling parts and ideas from the inside of things to appreciation of the forms and their workings. Assembling and disassembling, constructing and destructing are important acts in building artworks in any medium.

The familiar building and kicking over of blocks to experience the fall is a basic play act and a valuable art study. Children are not destructive in turning things upside down; dumping things out from the inside allows them to admire the accidental. To see how objects fall is an important learning experience for architects, sculptors, and engineers. Surgical masks, scissors, and tweezers promote operating and dissecting in an art room. The "patient" may be an apple, an egg, or an old cell phone. Old artworks may need fixing and artworks in progress are always in need of repair. Future art teachers need to create opportunities for children to see the nature of art as something that is continually being built and sometimes taken apart.

Supplies to Test the World

Children's creative supplies are not limited to traditional art supplies. Any supply with which children frequently play can be considered an art supply to be explored in the art class.

Water Water is a child's most basic art supply. Playing in a bathtub-studio or at the beach provides investigations in pouring, funneling, straining, soaking and also allows children to study drips, experiment with waves, create waterfalls, or play with bubbles. School paints are wet, flowing water and colors. Experienced water players exhibit a free painting spirit. Water play conducted in the art room enhances painting experiments and ideas. Instead of a sink or the bathtub, an art room can substitute trays and play pools, and funnels to explore playing with water and colors. Color can be added to wet sponges, squeegees, hoses, and turkey-basters to animate water in tubs as students perform on soft canvases and household papers. Future art teachers need to study the way children play at the sink and at bath time, using it as a model water-play site.

Glue Children pour, scribble, and freely draw with glue. They pour glue from containers, through their fingers, on their hands, and playfully make circles over any surface. Children put their hands and heart into glue playing, making glue sandwiches by attaching papers with surprise inserts. The slimy, sticky surfaces are an artistic way to join all kinds of household objects. For many adults it's just a waste of glue and paper, instead of children's poetry. They desperately try to intervene, teaching children how to use the glue correctly instead of encouraging an important inventive act. Children learn that they can join any form to any other form; that leaves can be joined with candy wrappers to make art. Long after art materials are used in a controlled way as other school supplies, future art teachers can still distribute bottles of glue to promote playful scribbling and drawings and the fluid joining of objects stuck together like fly paper. Adding color to white glue, squeezing ketchup, or enlisting new dispensers are ways school art can expand glue play.

Tape At home there is tape everywhere, yet never a fresh roll to be found. Young children acquire artistic power from being able to use a tape dispenser and by displaying anything, anywhere around the home. The discovery of tape is a big art and design step, as things start to be taped all over doors and windows, as children discover the many available home canvases besides the refrigerator. Tape becomes spider nets suspended around the home, providing a creative way to join and wrap any object. Tape makes all children's art wearable and leads to a love of all kinds of sticky decorating like covering bodies in Band-Aids or stickers. Future art teachers need to be sensitive to children's art-material interests and their preferences for materials that have playful qualities. The most important children's materials may not be in art-supply stores or catalogs; they may have to be gathered by everyone in class.

Play-Doh Dough can be shaped into any play food or take on the appearance of any play figure-friend. Play-Doh demonstrates the need for flexibility and instant reshaping necessary in children's play supplies. Play-Doh and other flexible supplies are important for art class warm-up or preliminary play and idea-gathering tasks. The malleability of children's favorite play materials allows for an assembly line of instant noses, rows of action figures, or snack food ideas to be constructed before anything is drawn or painted. Play-Doh can lift any surface impression and becomes an instant explanation of texture or even help in showing what printmaking is. Like tape and glue and other good experimental supplies, Play-Doh is sticky. When they apply it to any large ball, children come up with a variety of faces, imaginary planets, and globes.

Aluminum Foil Foil is another favorite experimental children's supply and has the flexibility of Play-Doh. It is a flexible skin, instead of a flexible form. Many children's art forms of wrapping are found in foil play, such as creative approaches to diapering dolls and covering them in baby blankets or space clothing. Children experiment with new fashion trends, creatively wrapping themselves in foil. Children discover that aluminum foil instantly duplicates any toy and when rubbed against any natural surface it naturally lifts off the most delicate print. In adult terms, wrapping or covering forms leads to a deeper understanding of them, just as when waxing a car one discovers subtle curves and details. A testimony to children's interest in the magical qualities of foil is that there is never enough of it at home, so that Saran Wrap is often substituted. Wrapping is an early sculpture act with magical qualities—now you see it, now you don't. It clarifies and abstracts forms by providing a cover and a new canvas to decorate. Tape, stickers, Play-Doh, or Saran Wrap all possess similar magic.

Inventing Plays Children explore their world by inventing new rules for playing. This is especially evident in the way children make up their own rules for traditional games. For example an adult works with a young helper to set up a croquet field. After the game pieces are laid out on the lawn, there is a period of explanation and demonstrations of how the game is played. When play is about to begin the child says, "I know a better game!" She vividly describes her vision of playing croquet using two mallets instead of one, striking two balls simultaneously. Not yet sanctioned by the United States Croquet Federation, nevertheless the stakes are re-set in a circle, with participants putting from the middle of the field. Children change the rules, and art

teachers need to step aside. And so it is for playing table tennis under instead of on top of the table, or playing chess on a board set up by a child as a royal marriage ceremony. Children also change the "rules" of adult art making, or as adults perceive and sometimes teach art to children. In the art class teachers can use vivid examples and tell stories of children inventing games in a swimming pool or on the croquet field as an artistic act. Children in an art class can invent board games or redesign field games as a demonstration of how art is about changing the rules of the game and discovering one's own game plans for solving art problems.

Concluding Thoughts

Playing is a happy occasion, and that is why so much of children's play deals with parties and celebrations. Through playing children build and maintain all the essential ingredients for making art, especially the joy in art making. Parties, performing, pretending, and playing in an art class can maintain the unique qualities that characterize children's art. Children's joyful playing is a means of investigating the world and a way to begin shaping creative responses to it. Studying and taking seriously children's playful activities outside of school are important in deciding on approaches to teaching art.

Most importantly, in playing, children in an art class become children again. Playing gives art back to the experts—children who are comfortable and familiar with this art form. Players don't feel like they are in school; they are free to investigate, set up, and search for their own ideas. Play moves children out of school, in body and spirit, in attitudes and actions. As players, children lead the art class, creating non-school moods, moves, and frames of mind that allow children to pursue a child's art.

Let me see! Let me see! Let me see! Lift me up! Let ME see!
—Sam, Age 2

THE MEANING OF ART IN A CHILD'S WORLD

The Pleasures of Seeing

Children constantly ask: Pick me up, bring me closer, and show me, I want to see. Adults gradually learn to ignore;

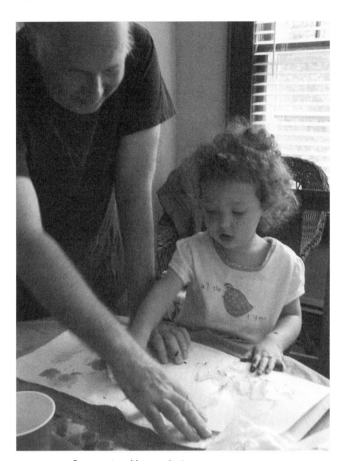

FIGURE 2.2 Supporting Young Artists

after all, there are so many minute things in the world to overlook. When a child calls, adults often don't come to share in the excitement of seeing. The meaning for a child is similar to what all artists wrestle to maintain—a sense of excitement about the visual world.

For children, seeing is a necessary part of touching, picking things up, and celebrating small wonders. Seeing is also a part of imaginatively responding, interpreting in words and actions, in pictures and fine collections what the child decides is interesting. When babies first open their eyes, everything is a miracle. Their eyes follow shadows, things that move, and kind faces. If there is something interesting the eyes will respond. So seeing begins as a miracle. The practice of art is a part of the child's noticing and discovering the world, a medium to capture what moves, making things appear and disappear, to study and explore every detail. Art is born from the pleasures of seeing and sharing the child's discoveries in objects and pictures. Teaching art is not teaching children to see, as they already do see great things. Art is a way to *sustain* the enthusiasm of touching things with our eyes and hands.

Just Pretending

Children love pretending and engaging in make-believe play. A shapely shampoo bottle becomes a doll to wrap in a favorite "blanky" to carry to the tub as a friend to join in a bath. Everything in a child's hand is a starting place for creative pretending, a basis for fantasy and action in art. Children make believe they are reading from a blank sketchpad, or pretend to sign their name before they can read or write. For a while pretending is accepted as cute, supported by smiling adults. Soon notions leading the way to what big children are supposed to do replace the child's art.

Cartoons and video games that pretend *for* you quickly usurp this basic meaning of art for children. Pretending also slows with the emphasis on reality in school, where there is often no place, and no one to pretend with, or pretend for. Make believe soon loses its allure, when it's no longer appreciated or found cute. The lines between dreaming, pretending and reality are clearly drawn as children get older and are urged to "get real."

The art room floor can be a place to sit for pretend tea parties. It is the site where store and restaurant scenarios can continue, where imagination is utilized in all tasks and seriously challenged by each lesson. Future art teachers become educated by sitting with a child to experience the richness of their make-believe world. For the hungry, unusual objects are tastefully displayed on plates and savored as desserts with an array of sounds and gestures. On the floor and sharing make-believe parties, picnics, or tea, engaged in a dialogue of fantasies, an art teacher learns to dedicate their class to be a home for the make-believe arts.

An Opportunity for Fearless Acts

A home is a place to flex creative muscles and test adults' patience with creative acts. The art room also needs to be a safe place to be different, to try things out that stand aside from ordinary school behavior. Future art teachers need to spend time with children and take notes on the many adventurous plays and fearless acts they perform as artists. With fewer opportunities in school to do things without being graded, tested, or judged, the art class needs to stand as a place where students feel that they can do what is out of the ordinary. The challenge of art teaching is to create an environment where children know they can play and be playful in both thought and action.

Look Mommy! I did it ALL-BY-MY-SELF!—Samuel, Age 3

Pride in One's Work and in Oneself

I did it! Placing stickers all over mom's new pocketbook, a child heralds her accomplishment. Without showing anger, the parent admires the stickers that are there to celebrate her new purchase. Children bring all their "significant" accomplishments in art, from scribbles to stickered pocket books, to show their most trusted audiences—parents and, later, art teachers.

I made it! This is a frequent exclamation stated with the deepest sense of self-satisfaction and pride in having produced something a child has deemed significant. There are few occasions later in life to state such self-affirmations, to express joy in unconditionally offering up one's work to the world. The enthusiasm of a caring person contributes to art being so fondly remembered by children, so worthwhile to return to again and again.

Pride develops as making art is supported by patience, materials, even tolerance for a range of actions that make a mess or invade a new pocketbook. Pride is built on sharing, as the child's actions are praised, displayed, photographed and applauded in different ways. Art teaching is not just about art but the artist's self-esteem.

As children enter school they receive praise in the form of grades for following rules and learning tasks that are initiated by others. In comparison, little attention is focused on the things they create. As occasions for making things diminishes, there are fewer opportunities to be proud of one's creative accomplishments. The art class becomes an important place to nourish pride in children's initiatives, ideas, and expressions. Future art teachers need to respond to what matters. Instead of praising the following of directions, being good, quiet, cleaning up fast, or lining up well, they should recognize that artistic pride comes from appreciating young artists for their original and creative acts.

A Way to Have Fun

School is seldom viewed as a place to have fun, but the fun that is often lost when entering school can be replenished through the lifeline of art. Many children go to school looking forward to the fun of art class. Art needs to remain a joyous experience, a place to play when it's no longer allowed, a place to bring fun objects when it's no longer welcomed anywhere else. Art teachers should take pride in and not feel less important for being "the fun class."

Teachers can make art class fun by designing entertaining places to enter, having pleasurable things to see and discover in the room, and enjoyable things to do. Art teachers need to show joy themselves in the act of creating. When children recall the best times they've had with parents, they often reference occasions of playing together and making art together. Art teaching needs to resemble the fun kids recall having had with the adults in their lives.

The Meaning of Art

To find the meaning of art is the lifelong search of every artist. It is an elusive quest because there is no single answer and it can never be fully answered by anyone. But children are originals, not molds to shape through art teaching, and future art teachers need to understand some of the meanings of art for children in order to respond with a relevant art program. Beyond some of the meanings alluded to above, future art teachers need to engage every student in their own search for the meaning of art. Art classes should be time spent on discussing important questions with students such as: Why do you like to make art? How is your art unique? How would you like to see your art change in the future? What is the meaning of art in your life and in your community? Being an artist is about learning to question art, and art teaching needs to stimulate that questioning.

Comparing Children

Parents compare their children, amazed that from the same gene pool such vastly different kids could be born. A parent knows that all two-year-olds are not the same, yet it is difficult not to compare when they see another two-year-old. There are many expectations and measures developed to compare and standardize childhood. Web sites like babycenter.com alert parents to "milestones," reminders what the child should be doing during each month of life. Children are individuals and should not be compared. Yet, children are measured against each other.

Inequalities, Standards, and Sameness in School

School jargon is filled with the implications of sameness. "Bringing students up to grade level" and "approaching grade level standards" are the current sayings describing what is expected of every student. Children are judged as

being far below grade level, approaching grade level, or meeting grade level, a comparison that sometimes spills into art testing of scribbles, vocabulary, or intelligence tests. Education is the urgency to bring children up to a level of unrealistic sameness, not the burning desire to foster uniqueness. Schools that are designed to teach large groups in the most efficient manner find that any form of individuality is just an obstacle. Sameness is worked on with a steamroller trampling individuality with little respect.

Future art teachers need to understand their role as guardians of individuality and be able to realistically appraise the forces working against it. In an art class, children need to learn and feel that they are not the same, that their uniqueness is the essence of art and the highest value to their art teacher.

The Individualist ... the Troublemaker

Dictators don't tolerate individuals who think for themselves. Only in a democratic setting like an art room can individuality thrive. But is school a democracy that nurtures individuality? A child referred to as an individual often means that they don't fit into the school mold. If parents at a parent-teacher conference are informed that their child is an individual do they go out happy and satisfied, or plan to reprimand their child for not listening to the teacher when they get home?

A challenge of an art class is to create an environment for everyone to feel free to demonstrate their unique ideas and abilities. Finding their individuality is the search of artists. Future art teachers can identify with students how the art class is unlike other classes where students are asked to respond with correct answers and solutions to problems outlined by the teacher. An art class is not doing things one way, or working for the teacher. In an art class students utilize their resources, personal ideas and approach to everything. Art classes that promote individuality can accommodate a young Miro and a young Warhol and allow a young Ilona and Ana to work side-by-side.

Schools

Schools offer instruction for everything, but do they offer time to make choices, to express one's individuality and discover one's creative voice? In general-subject areas all that is to be learned is well defined and underscored by the teacher's approval. There is a rubric for everything, just as there are instructions to follow in how to play with every new toy today. There is no time to "waste" in contemporary schools that emphasize clarity and efficiency in instructional design. The self in self-discovery, individual opinions, interests, and ideas are not all equally important.

Everyone has to fit into a school that is run like a corporation with its own CEOs. Many middle schools are honest in their intent, by dividing into teams and everyone from teachers to students is expected to be a team player. Teachers often refer to molding their class, to whip them into shape and to lose the "stubborn strains of individuality." Children in school quickly learn the game of fitting in and the penalties for being different. The better the 'fit" the more successful a student is in school. (But is that also true in life, and in the creative needs of today's innovation oriented, non-manufacturing society?) Everyone learns in a classroom by being on the "same page" and being rewarded for doing what is asked. So here we are with students who have learned to please and will work intently on doing whatever it takes to earn their grade.

Future art teachers have to explain from the start the new game plan—the importance of asserting individuality in an art class. Students appreciate the freedoms of an art class intuitively, but value it even more as they get older and discuss the fundamental differences between art and other classes. Some of the following points can be raised in art room discussions: From the ideal son, to model student, how and when do you become yourself? What advantages does an art class offer to express yourself freely? What should a student's attitude be towards the teacher in an art class? Students in an art class can discuss the nature of school and the different opportunities provided in an art class.

Testing

Testing has become the single-minded concern of administrators and thus the school faculty, shaping what takes place in classrooms. Concerned teachers, preparing students for state tests have restricted most creative learning and extracted individuality from the joys of teaching and learning. In a school devoted to testing, there are no incentives or opportunities to play, explore, and discover student's own ideas or to be themselves. There are no questions asked that may not be covered on the test, there are no answers accepted, but what may be deemed

correct, or the right answers on the test. The subject of art had to adjust to a test-taking world.

First art tried to fit in—to become a part like every subject, and then become just like any other subject. In some places 'the tests' were expanded to include art facts and art writing/analyzing art questions. To maintain a place in the school, art claimed to be the answer to improved test scores in general. In the foreseeable future, art teachers will always be playing a delicate balancing act, trying to teach for the test while maintaining the validity, and basic importance of the subject—preserving individuality and creativity in children.

Media

Blockbuster films and television shows play a role in shaping children's visual world and carrying it further by entertaining and playing out fantasies in thousands of spin-off toys and video games. Films fill in what kids used to fantasize on their own. On giant screens and small pocket media, ready-made vision appears in living color and surround-sound. It is difficult to see a frog, without calling it Kermit, or a red puppet that's not Elmo. It becomes difficult to create with generic objects or toys that are not related to a media presentation. How can children be themselves when they love Elmo? Children receive the world complete in stories, sounds and pictures; they are not part of completing it. Can there be a story or a vision left in a child? What is the need to initiate action, to have creative ideas, or to voice it in art? The most significant challenge posed to future art teachers is resuscitating individuality and imagination. Film and video needs to become the media of art classes. In a rebuilding process children are in charge of creating the imagery, writing the scripts, telling the stories and using their own voices and sound effects. Children who stop creating their own fantasy worlds and making their own play objects are also missing basic creative experiences. When presented with ready-made worlds in films, children's ability to enjoy creating, fantasizing, and making their own things is disabled. When you saw the film, played the video game, and collected all the related series in toys what else is there to do? There is no interest to make things like art.

Commercialism

Commercialism that invades childhoods at breakfast keeps making noise throughout the day. Children drink from Elmo's mugs and select foods with Elmo's face. They wear Elmo shirts and play with his toys. Going to school, children carry Elmo's lunch box and snacks in their Elmo backpack. At bedtime there are Elmo slippers, sheets, and pillows to snuggle up to. Whether it's Elmo or Mickey, or the latest blockbuster movie characters and their endless paraphernalia, children are deprived of childhood imagination and playing. Commercialism has devastating effects on children's ability to make art and the remediation required by the art class.

Future art teachers need to have strategies in place for children who cannot just play with a toy placed before them without asking who it is. What does it do? When all toys are designed to play and perform for kids, children enter an adult created world in which everything is tied to advertising. Everyone is pushed to carry and wear what the commercials offer, originality is not called for; in fact it is dismissed. Children learn that their imaginative ideas or art can never rival the characters, scenes, and adventures marketed and sold to them. When flooded with stimuli from commercials, how can children in an art class refer to their own experiences, fill their heads with their own explorations, or turn the results of their own playing into art?

Art Teaching for Individuality

A proud grandfather speaks of when his granddaughter Emilie started kindergarten and every morning began with tears. Trading the safety and free reign of her art studio for school meant leaving behind her plays in imaginary boxes converted to doll houses and doll factories. During the first day of school a doll that she made to keep her company was confiscated. Please keep all toys at home—declared a note from Emilie's teacher. When asked how Tuesday was, Emilie complained she could not play in school saying, "You know grandpa there is no art in kindergarten. Instead of art we have Spanish Culture." By Friday the tantrums did subside, perhaps because Emilie figured out how she could make secret pockets for her prized collections and sneak a paper doll to class. There is a choice to be made in schools. Will they elect to ignore, reject, discourage, and even warn against children's expressions of individuality, or will they acknowledge, praise, and celebrate it?

In many schools the preservation of individuality has been unofficially entrusted solely to art teachers. The following section discusses beliefs to consider in making the most of children's individuality in an art class:

PLATE 1.1 School Art

PLATE 1.2 Art Standards

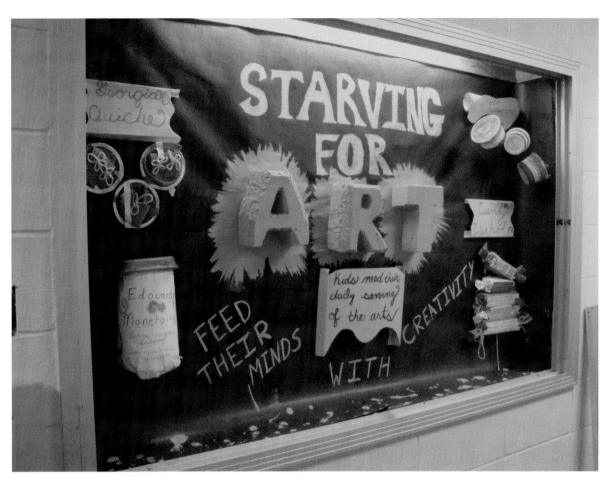

PLATE 1.3 Art Advocacy Mural

PLATE 1.4 What Is Art?

PLATE 1.5 Visual Lesson Planning

PLATE 2.1 Wearable Art

PLATE 2.2 Making One's Own School Supplies

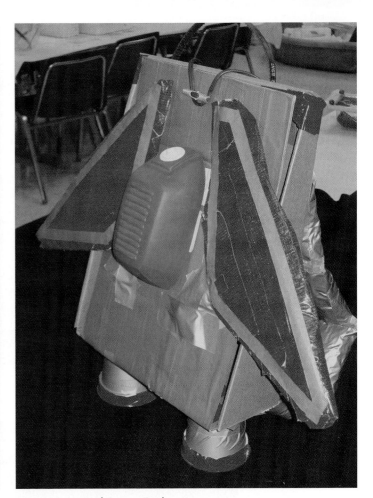

PLATE 2.3 Art and Space Exploration

PLATE 2.4 Drawing Fantasies

PLATE 2.5 Painting on Ceramic Tiles

PLATE 2.6 Painting Over Book Jacket

PLATE 2.7 Painting Dreams and Fears

PLATE 2.8 Wooden Toy Sculpture

PLATE 2.9 Dashboard Sculpture

PLATE 2.10 Clay Horse

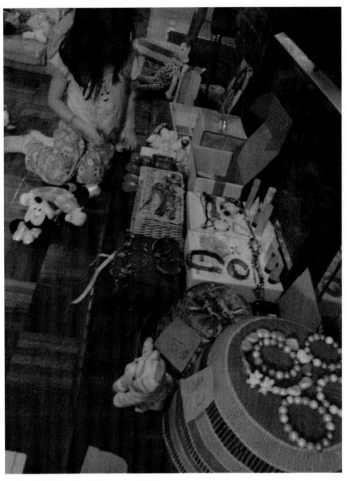

PLATE 2.11 Store Play Installation

PLATE 2.12 Water Play

PLATE 2.13 Arranging Nature Finds

PLATE 2.14 Stage Set

PLATE 2.15 *Rafters Under Cumberland Falls Rainbow* by Ora Warren Alsip
One of thousands of photos made by him in the Cumberland Falls State Park area, this original image was used in a calendar published by Cumberland Falls enthusiast and nature photographer Ora Warren Alsip of Corbin, Kentucky. (www.cumberlandfalls.org)

PLATE 2.16 *Alien World* by Mark Aaron Alsip

In this photo, Alsip uses computer technology to envision what other planets might look like. Here the surface of a moon is seen as it orbits the big planet seen in the sky. Alsip says that a lot of people don't think about the fact that just because a big planet (like Jupiter) might not be habitable (big gas planets don't have a surface to stand on and no water, etc.) the moons orbiting them might support liquid water & life. (www.AlsipPhotography.com)

PLATE 2.17 Watch Design

PLATE 2.18 Architectural Fantasies

PLATE 2.19 Architectural Sculpture

PLATE 3.1 Fashion Design

PLATE 3.2 Middle-School Art Idea Book

PLATE 3.3 Personal Narrative

PLATE 3.4 A Segment of the Berlin Wall

PLATE 3.5 Mural Study

PLATE 3.6 Collage

PLATE 3.7 Expressing Teen Emotions

All Art Teaching Is Working with Individuals

Entering an art class are children and not classes, young artists and not students. The challenge to the future art teacher is to learn about every young artist, to promote individual contributions. Learning to teach art is learning to focus on individual faces and acts, having individual conversations with children. Large classes can be redesigned into smaller studios, more private settings, where each child feels more inclined not only to express themselves in art but feel open to talk about their plans and accomplishments.

Art Teaching Is Not Setting a Single Assignment or Standard

Likewise, art is not about presenting and elevating the teacher's ideas and art preferences. An art teacher should not compare the children's artwork, and no one student should be singled out by grades or actions as the class artist who represents the teacher's taste, what is accepted, and what everyone should strive toward.

The Art Class Is a Safe Zone

Here, students are not afraid of being judged, tested, and or deemed a failure via grading. While tests and grades might be necessary, the art room climate is one in which students clearly are self-employed; they work for themselves. With extraordinary pressure on testing and comparing individuals to a group norm, the art room needs to remain a safe haven for learning that has intrinsic rewards. Future art teachers should understand how grading can devalue individuality.

Individuality Is Encouraged in the Art Room

In all media, and in all that children do, the art teacher notices and promotes individuality in hairstyles, backpack decorations, or clothing choices. When children demonstrate their own style in designing or decorating any object or surface it will be noticed and welcomed. Individual fashion statements can be the subjects of an art class. Art teachings are a battle for children to regain confidence in their taste and artistic judgment from advertising and media dictates. Art classes arm kids against media and advertising invasion usurping their visual world, taking the desire to discover ideas and make things.

Art Classes Maintain and Restore Self-Confidence

Without confidence, one cannot uphold the independent views and ideas that art requires. The essence of an art room is to empower young artists to be themselves, to plan and do things independently. Providing opportunities for students to share, to show and tell, to express their views and art plans makes everyone feel they are unique and important.

In an Art Class There Are Many Artists and Art Teachers

Every child in class is an artist to be treated as an individual. An art class is distinguished by the opportunities provided for students to search for, inventory, and share their individuality through their toys, collections, home arts, and family art treasures. Art teaching is learning from students, allowing students to take lead roles … to show you … to teach you … to share their dreams and plans.

Art Classes Emphasize Children's Research and Experience

Children learn more through their own explorations and experiences and less from copying examples set by others. Art classes need to strike a balance between being told what to do and how to do it, and opportunities to discover for oneself. Play is children's research. Starting each art class by playing allows children to approach an art problem in their own way and for individuality to be rehearsed.

Discussing Important Issues Related to Art Making and Being an Artist

All aspects of individuality should be on the top of the agenda for art room discussion. How can one look at and appreciate the art of others without wanting to copy it, or make art like them? How can one learn art from others while maintaining one's individuality? How do artists guard against being swept up by trends and contemporaries?

Some artists seek privacy and isolation, moving as far as they can from centers of art, while other artists thrive on a "café" life, having the support of an art community, colleagues, and friends. Future art teachers need to provide both a sense of privacy to make art and build a class community of artists that can show support of individual artists' interests and ideas.

Art Teachers Help Students to Have Pride in Their Individuality

Individuality may be presented in art, yet it has to be recognized by the art maker. Often students don't realize that they are doing something original. Art teaching is helping young artists to discover their individuality—pointing out individual differences, unique planning styles, and fresh invention in theme or process. When an artist is up-close to the creative act, it is difficult to clearly assess uniqueness. Clues to individuality can come from a perceptive teacher, or an interested audience of students. Future art teachers can be overwhelmed by the many artworks made in the room and need to practice focusing on spotting and encouraging the unique trademarks of individuals.

Art Appreciation Begins with Appreciation of Individuality

Art classes can demonstrate individuality by showing all art forms and media, from ice, to ice cream—that is used in contemporary art. The art class represents all art museums and in this role demonstrates to students the range of artworks on display today. What art teachers hold up and display, expresses an attitude of appreciation for individuality. Examples of individuality can be drawn from looking at the works of child artists making art in many undiscovered unique children's media. Students need to be exposed to the differences in art materials, styles, and approaches used by artists; how artists plan and execute their art in their own way. The appreciation for individuality in one's own art starts with appreciating it in others.

TEACHING FOR ARTISTIC INDEPENDENCE

For a new art teacher there is satisfaction in teaching what one knows, seeing pleasing results that satisfies one's own

criteria of art. It is like the excitement of teaching children to read their first words. There is fulfillment in spreading one's knowledge of art, in being able to present one's best lessons and to get the planned results. While it is helpful to begin with a safe connection to students, ultimately it is important to let go, so they can exercise their independence. Art teaching is not teaching how to read, showing children how and what to do, defining correct paths via perfected lesson plans.

Traditional lesson planning is for masses of students; it is not for individual artists. The concept behind the traditional planning process is that one artist—the teacher—can predict the needs of all artists in a class. Art experiences should help young children to continue feeling like artists; to think about themselves as idea people, able to plan their own art and be their own art teachers. Independent artists perceive art making as not just something one does in an art class. Future art teachers need to consider ways to encourage each student to formulate their own art plans and look to themselves for answers.

A young student goes home and proceeds to tell her parents that she had the best art class. "My art teacher has the greatest ideas!" Art teachers should be able to plan art classes where not the teacher but every student feels that they have the best ideas. School art should not simply be a long journey from kindergarten to college during which time students comfortably get used to art projects and making art to meet assignments. At the end of such a journey, students lose a sense of what it is to work independently. Even art teachers after college say, "Oh, I would make art if only I could take another art class." Teaching for artistic independence needs to start early and continue throughout every school art experience. When art classes are over, independent students should be able to continue building art collections and setting artistic goals.

An art teacher needs to be concerned about the students' general perceptions of the art class. In summing up their art class, students should not come to the conclusion that art is merely learning a series of rules, formulas, and following instructions. Students have to experience the subject as a challenging search to discover art independently. Students should not picture an art class merely as a place to acquire old knowledge, to study the masters and their art principles, but to view art as finding new problems for which each young artist has to seek their own solution. In other words art teaching can imply that art is dead and finished, or art teaching can instill being hopeful and confident that there are plenty of new things to be experienced and dis-

covered and the art world is wide open and welcoming to a young artist's many ideas.

The object of education is to prepare the young to educate themselves throughout their lives.–Robert Maynard Hutchins

Independence is the Goal of Art Teaching

During the creative period of young child artists to later being adult artists, there is a sense of an artistic life, of truly seeing oneself as an artist. When asking young children if they want to become an artist, they will frequently reply, "I already am one!" School art classes can be instrumental in preserving the independent spirit associated with the feeling of being an artist. So much of art is self-taught that moving to a complete reliance on others disables independent seekers of art.

School Art as a Facilitator

Art time in school is too brief to adequately describe the meaning of being an artist, encompassing all the experiences that art students need to have. However, art in school can inspire every creative exploit beyond the art room. For example, there is little time for students to come up with great art ideas in class, to test them, find the specific materials needed, and to act on their plans. If the class time is all the art students will have, the art teacher has to take over and plan efficient lessons with materials for everyone, brief projects that require little discussion and can be completed by all during an art period.

Once a week in elementary school, for forty-minutes, for nine weeks in middle school, how much can be accomplished? Is it a realistic time frame for art to be enjoyed and experienced? Can all artists work at the same pace? Stuffing as much as possible into every art period is not an answer. Preparing students to live and explore being artists beyond the art period is a better approach. An effective art class can make things happen in the student's day and life beyond the class, when art time is used for facilitating art before class and after class. Art classes simulate an art life—facilitating full-time art seeing, art making, planning, and thinking in realistic ways, akin to what an artist's day is really like.

School art prepares young artists to come to school with objects and ideas, plans and dreams, and to leave the class ready to start projects, to put into practice and continue their art making. At the center of experiencing life as an artist, students gain inspiration from coming to an art class. It is a place to bring art finds and discuss observations, to share art experiences and make plans. School art promotes independent art seeking and art making that takes place in and out of school.

Discussing and Practicing Independence in the Art Class, Students' Big Plans

Students bring their "big plans" to class and present their ideas and explain their decisions. Artists have many options in carrying out every plan noted in an idea book. An independent artist needs to feel excited and secure in their selection and feel confident in their ability to move toward fruition. During art class presentations students show and tell about each plan and sharpen it as they listen to themselves. Art classes are settings for students to focus in on ideas and clarify what they want to do. Art making is a series of deliberations, and every art idea a student prepares for class can be carried out in many different ways. Future art teachers can offer a taste of the creative process by assisting students in figuring out and accomplishing what they have in mind.

Art Rooms That Are Set Up for Artistic Independence

In art rooms set up for artistic independence, students choose what to work with. Students learn from fertile shopping opportunities, having available not just art supplies but toys and found objects mirroring the stuff children play with and make things with at home. Independent young artists have to feel that anything can be a toy and played with and that anything can be an art supply and used to make things. To feel free to make art one has to view art broadly and openly, to see possibilities in anything, and have the independence to adopt anything to use. An art class for independent shoppers requires opening closets and drawers, pockets and desks. Anything can be used to build with; anything can be a canvas on which to paint. Canvases can be shopped for in all sizes, scales, and shapes. Art tools can be found, made, altered, or reassigned from kitchen duty.

Diversifying Planned and Spontaneous Art Making

The art class experience can also help students diversify, to see the other side of their natural artistic temperament and broaden their experience. Students can explore making art from plans and also to try making art spontaneously. Having tried working in a messy way, maybe it's time to make art neatly so the artist can see the differences in style. Making art slow or fast, working on several pieces at a time, or dedicating oneself to one artwork for long spurts requires the familiarity of both. Future art teachers can plan discussions with students regarding their comfort zones in art making, while trying others and discovering what's most productive. Students gain insight into artistic independence by recognizing the way they play and make art.

Promoting Artistic Independence and Valuing Diverse Artistic Habits

Every Artist Works Differently. Promoting artistic independence is teaching students to recognize that every artist works differently. Teaching for independence is finding out how each artist in class prefers to work, what their needs are, and how to create the changes in an art room and at home that are necessary for individuals. Some artists will require privacy, while others thrive on working before the public outside, in daylight complete with street noise. A young artist may notice that they work better in an empty room, while others report that they are inspired by clutter and having their collections about them. Students need to chart their preferences as they chart their future as independent art makers. Art is made through a series of choices and each choice alters the work. Opening class to students' voices and plans involves enlisting their preferences in setting up and guiding the art process. Celebrating students' independence in the art class requires offering students choices in what to do and how to do it.

Art after Class

Art teachers prepare students for a life of art appreciation and art making. To prepare independent artists requires not the traditional homework but building on art interests created in the art class. Before leaving the art class, students can describe what they are planning to do at home. Students can reflect on how the art in class can be played with, displayed, or used to inspire new artwork. The continuations of art after school can be inspired by art teaching and take many forms.

School art creates a sense of excitement about the freedom of being an artist—a freedom that can be practiced at home. Outside of school the world is open to young artists with the largest art supply stores in nature, in the kitchen, in the treasures that can be picked up and worked with in every store. Students take clues from school and can even find materials to start with on their home art. Children, who love "goodie bags," are delighted to fill up with things that can be borrowed for making art at home. Supplies from the art teacher are special gifts that yield more art. Before leaving the art room students share their plans for further art making plans at home. Students should leave the art class with more exciting plans than when they entered.

Home studios legitimize an independent stature, having a place to make art and store artworks. Active and adventurous students may plan traveling art studios, designed as backpacks or lap-packs for making art on the go, in a car, or on the school bus. Home studios can be boxes finished with a studio set-up inside. Special tables can be set up for turning a part of the student's room into an art making place. Future art teachers have Internet with which to actually see the studios and art that students make at home.

The End of the Road

Look who is driving? In the art class there is no age limit, license, or degree needed. Students come to an art class with ideas and they need to be allowed into the driver's seat. The path is anything but straight, with frequent choices. It's like a video game with new challenges constantly coming at you. To assert independence, young artists must put a measure of distance between themselves and adults. This is a development that art teachers should encourage and welcome. On days students listen and follow every word that the teacher has to say, the teacher feels gratified. On days when students seem to develop strange tastes and come up with ideas out of the blue that are foreign to the art lesson at hand, independence is lurking, and the art teacher is making progress.

Creative Planning and Topics for Group Discussion, Activities, and Extensions

- Home is an important learning site. It is the source for recollections about growing up as a creative individual that can be examined now from a future art teacher's perspective. Get on the floor with children, play and make things. Find an unstructured time to be a child again, to get to know children, and how they play and create. This is important research.

- Write in your journal about your personal art experiences during your childhood. What do you recall doing? How did it make you feel then? Looking back on those experiences, how do you feel now?

Section Two Approaches to Teaching Elementary Art

I think of art as the highest level of creativity. To me, it is one of the greatest sources of enjoyment.–David Rockefeller

TEACHING THE UNIQUE CONTENT AND VALUES OF ART

Learning in school is frequently motivated by outside stimulus: grades, honor rolls, the teacher's praise. Through rewards and punishment, and more often some combination of the two, students are made to perform. Good behavior and correct responses—what is correct according to the core curriculum or beliefs of the teacher—are praised. The conventional attitude is that what is correct for the standards and right for the teacher is right for everyone.

For the art room, on the other hand, the unique content and values on which art instruction is based are intrinsic rewards for the learner. For example, a sense of accomplishment, pursuing one's own ideas, and creating beautiful objects are some of the pure joys of art that make children feel good. In an art class there are no bosses or managers, there is no final answer, and the art teacher does not teach a scientific or "how-to" method. From a supportive relationship formed with an art teacher the unique content of school art emerges. The value of art teaching is that a positive learning experience contributes to positive attitudes toward learning, teachers, and school in general.

The unique content of the art class allows students to find success and self-satisfaction in learning. Content is open-ended, which allows students to be an important part of formulating their education. Art classes should be known for being warm, exciting, and innovative, with opportunities for self-expression and problem solving. Students experience continuous self-improvement in their art, and learn that children's art—their art—is distinctive and important. The content of the art class is not art projects, but art students, encouraging individuals who are confident in their ideas and accomplishments and satisfied with learning.

Art teaching is not a response to exams and standards—it emphasizes individual ideas and not systematic learning. Art teachers offer unique values by creating playful places that support non-coercive, non-judgmental places to learn. Students and teachers in an art class have choices, share their ideas and their art, and freely talk and listen to each other. No artificial rewards are needed in a class based on making beautiful things for others and for oneself. Students should be able to understand and feel the usefulness of an art class.

As schools have become stricter about testing and taking a fast track to knowledge, the content of an art class needs new definitions. As computers bypass experiences and students use their hands less and less to pick up and touch things, to make and build toys or belongings, what is needed from an art class changes. Future art teachers have to be

able to continuously examine a changing world to understand the new art content and values they need to teach.

Art teachers have to monitor and adjust content to the ways children see and the ways that visual information is sent and received in society. Kids who spend their lives on computers at home and who go to school to get on computers require different experiences in an art class than only looking at virtual museums and making computer art. A generation of mini- and super-size screen watchers who don't play and only exercise their fantasies as television audiences require art classes with reformulated content and values.

The Unique Content of the Art Class Includes the Art Teacher

Distinguished author and creative writing teacher Frank McCourt reflects on his classroom days in a book called *Teacher Man*:

> I argue with myself, you're telling stories and you're supposed to be teaching. I am teaching, storytelling is teaching. Storytelling is a waste of time. I can't help it. I am not good at lecturing. You're a fraud. You're cheating the children. They don't seem to think so. The poor kids don't know. It's a routine that softens them up in the unlikely event I might teach something solid from the curriculum. (p. 36)

In an art class, students often meet an artist for the first time. Students have a memorable opportunity to learn about artistic life first hand. The content of conversations with an art teacher goes far beyond a prescribed curriculum. The teacher as artist can debrief about art experiences, studios, and art finds. Scrapbooks, photos, sketchbooks, exhibition brochures, and accompanying stories can be shared. Stories about a life in art are the content and media of presenting a substantial portion of the subject of art.

McCourt eloquently writes of his uncertainty about storytelling, sharing the life of an artist with students as a proper way of teaching creative writing. Doubt often stems from teachers comparing themselves to what they see in other classes, where teachers keep themselves out of the lecture and simply follow a curriculum. Art teachers frequently ask themselves: Shouldn't I be doing something else, teaching art differently? There is so much that can be taught about art that something always seems to be missing, deemphasized, left out. Future art teachers need to understand that the nature of art teaching naturally includes an element of uncertainty about how the content of art is presented.

Because of the complexity of art, stories of art experiences clash with self-inquiry about what should be "the foundations" of art and the method to teach content. After all, most courses for art teachers are filled with exercises, demonstrating elements of art, color, and design principles and are presented as required starting points to be mastered and taught in a particular way. Scores of handbooks have been written about teaching art in "proper" order. While these formulas and definitions are do-able and attractively packaged to introduce art into an academic world, they are already discovered how-to methods that can misrepresent what it takes to make art, or the nature of the artist's search. Even if mastered, the exercises in presenting the so-called foundations of art don't bring students close to experiencing the art process.

Conversing with an artist-teacher, talking to other artists and listening to their experiences in art making has a powerful effect. In the brief time students spend in art class, traditional exercises miss the important content and values of the subject—the passion required for art and the focus and dedication necessary, all of which is represented by stories that can only be relayed by the art teacher. An art teacher is uniquely qualified to present the content of art by modeling the artist and sharing one's artist self. Hearing stories about growing up as a young artist and observations of children playing and making art are often described as memorable by students looking back at art teachers who made a difference.

Creativity makes a leap, then looks to see where it is.
—Mason Cooley

The Unique Characteristic of Art Classes is Creativity

The word *creativity* has been so overused in referring to art that it has been retired from the literature of art education. Some felt that "creativity" was too imprecise for a school subject and new descriptors like "visual thinking" came to the rescue. The reasoning behind abandoning such an important word was that if creativity was so hard to define, how could goals and standards be set to mark its accomplishment? Creativity is difficult to test, although many have tried. To continue claiming that creativity is the flagship of our existence as a field became untenable in an age of accountability. But "*shhhhh*" we say quietly, just among

us, that creativity is the unique content of art classes and certainly one of the most important balances to the academics represented by many other classes in a school. Many of the important reasons for having an art class are difficult to define, quantify, specify, or even write about, but it does not make them any less important.

A creative art teacher will do everything differently, unlike other teachers in the school. Students may line up eager to take attendance by making a drawing on the board. When asked for a hall pass, children are handed an Oscar-like sculpture made by a child. Few art teachers set up easels to paint before a class, but creativity is modeled through every action of the teacher.

The stated and unwritten goal of a creative art class is to feel free enough in school to make the art room experience for students *unlike* school. Doing things differently than what the art teacher "allows," "demands," or "prescribes" is encouraged. What a difference it makes when one does not have to check with others if what one is doing is "right" or performed correctly. Children feel pride when their artwork looks nothing like anything else around. When children in an art class are referred to as inventors, and their art as innovation, they set creative goals for themselves. An important aspect of creativity is invention; in our non-manufacturing society, few job ads read "Robots Wanted." Creative people who are able to use media and tools and look at everything in fresh new ways will define our future.

Creativity allows for diverse ways of thinking and working. Few people walk around a museum, or a neighborhood, with sketchbooks anymore. They take pictures of what they want to save on their cell phone. Future art teachers have to recognize that their students will be making art with a brush or a cell phone, that all media, old and new, can be used creatively. Art can be made on a computer or fashioned by hand. Art can be a concept, or a display in a frame. Art teaching today can emphasize returning to keeping sketchbooks, while promoting creativity using contemporary toolboxes. The unique value of art teaching is that everything can be used for creativity, and we all have access to some media for expression.

The unique content of art is that it represents a different attitude toward learning in school. Most subjects in school start with the solution, tested by a correct response. Students are often still drilled to have one answer, a single solution to a ready-made path. In the creativity represented by art, students are informed from the beginning that there is a different game plan, that the teacher does not have the answers and that in higher levels of learning there are many questions yet unanswered, that remain for students to discover.

Art Class Content, Appreciation of Beautiful Things ... Past, Present, and Future

No one should take an art class and learn about art, or just complete art exercises, without being inspired to try their hand and involve their soul in the search for beautiful things found in nature, in found objects, or in works of art. An art class is incomplete without sending students out into the world to see and hold the most beautiful things the art teacher can find. The museum has to be brought to each art session, as students look at and closely examine stunning objects in all forms and media. The special content of every art class is to experience and be moved by beautiful things. Each art session can develop an excitement about the search for fine-looking objects and using them to create beautiful environments as an important part of life.

Children are taught what is beautiful through commercials, toys, and television shows that suggest an ideal beauty, as if beauty had a formula, a model to follow, or required an authority to emulate. Art teaching is partly about un-teaching the above notions and returning a sense of confidence to children who seek their own taste in what they consider beautiful. While everyone in the child's world is engaged in conveying to them what is beautiful, art teaching suggests a clean slate for students to look and decide for themselves. Art teaching offers experiences to search for and compare beautiful things in all media in order to find one's taste and what is beautiful.

Will going to museums improve recognition of what is beautiful? It is not an answer, but one place to start. A museum is one of many places to be exposed to and compared with other places, to individually shop for beauty. Beauty is often pointed out by museum guides, or selected by curators' choices. Beauty, however, is not so simple that it can be pointed out with certainty to everyone. Learning in an art class is not a subject of indoctrination, it is a place to discuss, raise questions, and express doubts. Beauty has to be sensitively conveyed as something that is perceived differently by everyone, something that changes in the eyes of the art world, in the minds, collections, and taste of individuals. One learns in an art class that beauty is not static, that what is considered beautiful now may be judged by critics to be ugly tomorrow. Students learn, for example, how fashion, trends, and the times call everything into question, as public and individual taste, opinion, and interest are subject to growth, revision, and change.

Future art teachers need to recognize that many of the important aspects of an art class, including beauty, cannot

be defined for everyone or taught directly by indoctrinating students in what is worth looking at and what is not. Yet a special flower, an antique tablecloth, or favorite painting can be brought and shared by someone who clearly loves beautiful things. Even though beauty is not easily defined or conveyed through information, it is still one of the most basic gifts and contributions that art classes can offer.

The Unique Content of an Art Class ... Confronting and Creating Change

The unique content of an art class is observing, commenting on, welcoming, and even participating in creating change. There have been different approaches to the teaching of reading and mathematics over the years, but basic academic operations have not changed. The art world, on the other hand, is constantly introducing the latest, and what is new in art is difficult to pin down. It's hard to stop its moving trajectory long enough to find ways to present it in slow-changing schools. Art ponders changes in society and therefore its representations are constantly evolving in new media and art forms. New art is nearly always controversial, seemingly out of bounds or out of reach and seemingly unrelated to school art. The art world is in motion and school is often seen as representing timeless values. The reluctance or slowness to accept the new has become a shortfall in art education.

If art is ahead of its time, how can it be taught now? Teaching in a contemporary art world has to be about change itself—how to adapt to it, to be an open observer of it, to study how change in art comes about, and how to create it. The study of art history and appreciation is a good foundation for exploring present and future trends. The education of young futurists involves a personal involvement in seeking new worlds; they need to be looking at the latest in inventions, fashion, and ideas. The art class must be a place where new ideas in all fields are gathered, examined, and even criticized. The core of art is change, a foundation that has to be individually discovered, even questioned by young artists. Art cannot be misrepresented as something defined in the past, laid out in rules that are timeless and unchanging. Future art teachers need to consider ways their students will be able to face bold new art worlds and enthusiastically participate in them.

The real value that art teaches is openness to welcoming the new. An art class can inspire students to always look for new things in their environment, in paint, or in art tools.

Artists value openness in seeing and thinking. Most people walk out of or turn off a musical performance if it is not the kind of music they are used to. Art class should teach students to be able to go to the theater, view a dance performance or an art exhibit with an open mind and as an opportunity to be exposed to a new viewpoint.

The Unique Content of Art Classes ... Teaching Innovation

In a post-industrial world the special mission of art is to teach children that they are inventors and can continually strive to innovate. In an art class it is understood that students can do everything differently and make items that are unique. The art class is a safe place to experience being innovators, for students to explore and test ideas, and present them to colleagues. It is also a place to risk being an independent thinker. The art class is a gym in which to build muscles and confidence against critics and naysayers and to sell new ideas to others.

Future art teachers need to consider how to introduce students to art and design studios, and turn art classes into research laboratories that specialize in discovering new art. It is there that students can be exposed to seeing and listening to ideas, talks, demonstrations, and ambitions of artists in all new art fields.

A Theme to be Considered by Future Art Teachers

Teaching art is a different business from what general classroom teachers do. Art teachers tote suitcases and carry laundry baskets while other teachers have briefcases. Art teachers bring their art finds, their own art, their favorite toys, a found object, or antiques to school. When students are not taken to the art museum, art is brought to them. The content of art classes is the education of taste and vision, and the development of lifelong art interests such as seeing great architecture, collecting fine design, or being comfortable visiting museums.

The content of art is taught by stories and examples; it is not just teaching but inspiring, even having students fall in love with creating and collecting beautiful things. Art teaching develops new interests, supports collectors, and involves students in experiencing aspects of leading a life as an artist.

In a changing art world, future art teachers can look for content in the study of childhood, in children's play,

creativity, and home art. They can reflect on the content of art teaching by weighing it against the art process; does the content of teaching inform students about how art ideas are found, how artists plan and work? The art class is unique in school in its ability to reflect on change, on innovation and the future as it occurs in personal lives, in media and society, and as portrayed in contemporary objects and art.

Teaching the unique content of art means insisting on the importance of art in children's lives and education. As a subject that instills important values and a passion for learning it is unequaled by any other subject or activity in school. Art teaching is a lifetime of educating, convincing, and arguing for one's subject—not with students, who intuitively love art and willingly learn its teachings, but with adults who are far removed from their own days of playing and art making and have to be reminded of the values and contributions art has made to their lives. This section on formulating the unique content and values of art needs to be rewritten by every art teacher. Future art teachers need to internalize their beliefs in order to speak clearly, discuss passionately, and write convincingly about the importance of their subject to other teachers, parents, and administrators. See Plate 2.2.

The great difficulty in education is to get experience out of ideas.—George Santayana

LINKING ART LEARNING FROM HOME TO SCHOOL

Looking at and Understanding Children's Home Art

Children arrive at the door of an art class with a rich résumé of experience and creative accomplishments. They have decorated and beautified many objects and places, developed their taste and sense of design, invented new art materials, and led the way to discovering many new art forms. Art teachers need to be aware of the art learning children come to school with for an art class to be relevant to the child artist.

Initially when children are brought to school, parents make sure their playthings, collections, and the stuff they try to bring from home stays in the car. Children soon learn that their home interests and creations have little to do with what is taught and are not welcome in classes. Bringing things to class doesn't seem to make sense; anything but

homework is considered contraband. Although children return from school with lots of things in their hand, they take little of their art or of themselves to school. So what happens to children's home art when it's not asked for in school? What becomes of children's ideas when they are not listened to and nurtured? What happens is that home art lives a separate life than school art.

The art children make at home is strikingly different than what they do in school. When school art does not reflect the art that children make at home they lose confidence. Young children say, "I'm not good in art class" and "I have no ideas," at least no creative ideas that they are willing to share in class. School art can remove children from their art and separate them from their art interests so that what is made in class as art no longer looks familiar. When learning about adult art is substituted for children's artistic concerns children lose confidence in the validity and importance of their creative acts. Future art teachers need to keep children's home art in mind when formulating school art.

What future art teachers need to do is remind children of the home artists they are and used to be. School art has to acknowledge and demonstrate children's rich home art practice. Home art and artists need to be recognized, celebrated, and referred to in every art lesson. Art teaching is to know where to find children's art at home. Adults who pack school lunches can also help pack children's home art for school. What the art teacher and the children take to share in school is important; it connects home art to school art.

Saving, Preserving, and Transporting Home Art to School

At home, children's rooms can be cleaned up and in that process there goes the art; many great collections, displays, and creative set-ups are wiped away. It is difficult to save the temporariness of children's art, the play moments that can happen in a bathtub or restaurant, and get them to school. Bringing home arts to class is sometimes preserving time and saving occasions that were not meant to be preserved. Salads are to be eaten, so how can the works of young salad artists be cited? Saving important art made from pillows and encyclopedias requires quick and creative curatorial decisions.

An important role of school art is recognizing and preserving home artists' works. It is showing everyone that children's art exists, championing all the unexpected forms

it takes. Future art teachers need to be able to look for and transport children's art finds from anywhere to be celebrated in art room openings. Future art teachers need to learn to be reporters, telling the story of the latest in refrigerator art, displayed from magnets on a refrigerator door and attending the opening of the door, witnessing a child's handsome arrangement of groceries inside. How you save and show this home art in class is a creative challenge in art teaching.

Not Every Parent Is a Trained Art Teacher

An art teacher's task is not only to show students but also their parents how to enjoy and respect his or her child's art. Adults need to be reminded that the most significant art inspiration, attitudes, and artwork are found at home. In art-class newsletters, online suggestions to parents, parent workshops, or in face-to-face meetings, parents can be reminded not to dwell on tidy rooms devoid of children's play set-ups, but to learn the importance of home studios that allow for clutter, for saving collections, and for creating displays. Like sister cities, home studios can be connected to art classrooms to bring ideas or art in progress back and forth, without customs declarations or passports.

Children's Art Arrives in School

School art displays should include both art made in school and at home. When displayed in school, photo enlargements of children decorating the door to their room, or the complex designs of home bulletin boards, make a major statement about the many forms of unheralded art created at home. School web sites can feature the art children make in school and independently at home. Display cases in the school hallway feature children's special finds on the way to school and unique home collections. Young artists can be invited as special guests to present their home art to other children. Art teachers can decorate transport cases and shopping carts they will use for moving home art examples to school.

Concluding Thoughts

Imagine wrapping artist Christo as a child and how masterfully he wrapped his birthday presents. Picture artist Judy Chicago, of *The Dinner Party* fame, setting the family dinner table as her Thanksgiving art when she was a girl. The sculptor Claes Oldenburg must have had a love for playing with food as a child, and Andy Goldsworthy probably arranged shells and sand at the beach to rehearse his later outdoor compositions. Adults might get the final credit for taking the art world in new directions, but new art really comes from childhoods spent in creative playing. Children freely explore wrapping presents, making food, and setting tables and scores of other acts that identify the future of art. Young children confidently move to take action on their ideas and change many notions of art. Future art teachers get a glimpse of what the art world will look like in studying children playfully creating at home, and it will alter their art teaching plans.

Children engaged in playful creating at home have been the envy of great contemporary artists. Their free experimenting, open view of art, and wide-ranging art interests allow for inventing new canvases, media, and art forms. It is children's home art that has inspired the imagination of modern artists.

Where does a future art teacher go to experience children's art—to a museum, or to art classes dedicated to adult artists, their techniques, and the history of adult art? Where does one learn to provide children with art models other than adult art? Future art teachers have to go home to view art that is untethered from rules and principles, and made playfully for fun and presents. There is no place more exciting to view art than in children's rooms.

It is important to revisit children's highest art states, when they still trust themselves and turn to themselves for ideas, trust their taste and choices, believe in themselves as artists. It is crucial to watch home artists in order to be able to reconnect with children at a time that art is fully theirs. In a playful home art scene, art is made from gum wrappers decorated with nail polish and worn on sneakers. At home, future art teachers gain hope that their students will be open minded about new art, interested in new ways of making art, and become dedicated supporters and audiences to the future of art.

One has to be excited by children's art to teach art. Future art teachers cannot be inspired to teach if they only experience seeing little adults perfecting their skills in school by working on adult art projects for praise and prizes. Art teachers trained only in studio methods, art history, and attending museums have not seen children's art; they are disengaged from children's art worlds. Going home to visit children playing and inventing art in all media opens awareness to a different art that needs to be the model for school art.

PLANNING ART LESSONS WITH OTHER ARTS SPECIALISTS

Elementary art teachers are part of a team commonly referred to as "specialists." The name sounds special and important, but it can also separate and isolate the arts and physical education from the academic mainstream. Experienced specialists work with the entire school and are invaluable in educating a new art teacher. Specialists are often familiar with every aspect of the curriculum in all grades—every academic cycle and all the subtleties in scheduling. They know the classroom teachers and how to best work with them. Future art teachers have to learn from seasoned, specialist-colleagues who can help them navigate the school and run an effective arts program. The team arrangement contributes to a positive camaraderie; specialists constitute an important alliance between art, music, and gym teachers, a cooperation that promotes working together and learning from one another that ultimately benefits everyone.

What Is Special about Specialists?

To plan together, arts specialists need to recognize the commonalities in their experiences and views. Specialists teach their life and who they are. Their common understanding of the importance of practice and hard work, their ability to set personal goals and the dedication to their achievement, and the importance of paying attention to early signs of art interest are shared ideals that are amplified together.

Specialists share a love for a single subject they teach and a commitment to its importance. They are united in a common bond against marginalization, being looked upon as childcare givers, scheduled around academic teachers' preparation time. Working with other specialists is not only possible, but because of shared schedules, proximity, and common interests, close ties are developed that can make working together pleasurable and productive.

Most art, music, and PE teachers have been immersed in their subject since childhood. Nearly all started life as artists and musicians and athletes, knowing how it feels to be a member of a guild, having experience performing or setting up an exhibit. Through perseverance and hard work, specialists have achieved a high level of mastery of their instrument, media, or sport. They talk and dream about their field and feel a commitment to sharing what they enjoy.

When Arts Specialists Work Together

Maintaining an informal circle of arts friends paves the way for a flow of suggestions, inspiration, and plans. When the art teacher demonstrates her interest in music, and the music teacher expresses a respect for the visual arts, specialists are working well together.

However, a basic understanding that teaching music and art is not the same needs to exist among arts teachers. While pointing out some commonalities can be interesting, they should not be the principle focus in planning. Arts teachers have to respect and value the differences between their subjects and not dwell on similarities or draw philosophical parallels. Being able to speak each other's language may involve informal referencing of common terms used in music and art (even though their emphasis is different).

When specialists plan together, they have to make sure that they don't diminish valuable music or art class time. Planning art experiences with other school specialists is most successful when it is not an attempt to integrate an entire art or music program. Planning partnerships work when the integrity of each art form is respected and when all the arts contribute what they do best, in a creative and equal manner. By just "keeping the doors open" to visitors and new ideas, specialty teachers can show an openness to learn from one another. Visiting each other's classes and having students come in to listen or see things in each other's room is a welcoming sign. Even if school schedules don't allow for multiple arts classes, informal arrangements by specialists can unlock the doors.

Planning from a Common Theme

Specialty teachers can consider using birthday parties as occasions that are celebrated in music, art, and dance. A parade and the design of floats as pull toys call for light-hearted musical accompaniment. The spirited scores in old cartoons can be the background music for imaginative improvisations and animation by children. The Winter Olympics bring out cool musical numbers and also allow the set-up for drawing on sloped canvases or skating art moves over slippery plastics. Field day in elementary school can involve running around outdoors but also teaching young artists to warm up their bodies, to stretch or meditate, to jump rope or swirl Hula Hoops in preparation for drawing, painting, printing, and sculpting experiments.

Art and music teachers and students can learn from occasional meetings in the gym in planning their own lessons.

Field Experiences for Future Specialists

Artists tend to keep the company of other artists. Art teachers in training talk to and observe other art teachers. Future art teachers need to get out of the classroom and look beyond their specialty to discover inspiring art teaching. Where do future art teachers observe children dancing under the guidance of innovative dance teachers? Where can talented music teachers be observed at work? In community arts classes, future art teachers may receive the missing link to their education. Community arts programs recommended by parents are places to start. To get the most out of working with arts specialists in the future, it's valuable to study arts teaching now.

Observing Parent and Child Classes

Observations in such places as the Little Gym yields volumes of balancing, bouncing, climbing, coordination, and movement play. In the Suzuki string method, parents become partners in the learning process. Parents can serve as home arts teachers and masters at setting up home environments for practice and listening to music. One learns from the way other arts teachers create a parent-friendly environment to sit and watch as well as participate in and support their child's learning.

Music and Movement

Teachers ask children to drive hoops as steering wheels and keep balloons in the air with paddles, building dexterity while inviting creative ideas. Clapping and rhythmic musical games are valuable resources for introductory play to loosen bodies and imaginations in an art class. Bells, drums, and synthesizers can encourage composing and improvised moving for young visual artists.

A private string lesson can warm up children's feet, fingers, and bodies as instruments for expression. From each arts teacher one learns special methods to free up movement or to master an instrument. Taking notes at the music studio or gymnasium introduces arts teachers to the methods of other specialists.

Private Ballet and Dance Schools

In dance studios, teachers offer scores of creative ways to create graceful leaps in an open space that will inspire all art teachers. Art teachers benefit from observing how children use their body with awareness and flexibility to portray feelings, forms, and stories. Learning how dance teachers present movement ideas and how children are able to execute complex movement patterns promotes ways of opening up an art room to use art surfaces as dance floors. The taps, lifts, leaps, and rotating bodies can be thought of as ways to enrich the student's art and movement with art tools. Techniques of building confidence and fortitude can be learned from a music or dance class.

Lessons from Children's Theater Classes

Drama classes provide insight into ways to help children enter imaginary roles, promoting the art of pretending and creating fantasy worlds. Performance exercises, props, and costumes that can be adapted to art teaching motivate the art of inventing and telling stories. Simple props, sets, art room stages, or lighting changes used in theater rehearsals go a long way toward suggesting creative possibilities. Each theatrical exercise is rewarded by imaginative responses from students, such as role-play and dress-up, which can be used to precede making art.

If One Can Do It Then Why a Team?

The birth of the arts and humanities teacher in elementary schools has threatened the role of the specialist, suggesting that the arts have enough commonalities that they can be taught by one individual. An arts and humanities teacher, who is charged with introducing students to all the arts, will have difficulty presenting the arts as highly specialized fields.

The arts and humanities teacher is a generalist without a portfolio of having lived the media. Presenting the arts as another academic subject, speculating on a common alphabet and elements that may help to evaluate and talk about it, is not the essence of why we immerse students in the arts. What it takes to coax a beautiful sound from an instrument, or the accomplishment required to make a great print, cannot be casually imparted. The arts require not a survey class but an in-depth experience. The arts

cannot be taught simply in theory and integrated for efficiency without losing their value as experiential education. To become an artist, a musician, or a dancer takes a lifetime of rehearsing and hard work that only specialists can share with students. See Plate 2.3.

CHALLENGES OF CONTENT INTEGRATION IN ART TEACHING

The artist's world is limitless. It can be found anywhere, far from where he lives or a few feet away. It is always on his doorstep.—Paul Strand

Art as a Source for Integration

The art that children make frequently becomes the subject of presentations, animated discussions, and writing assignments. The inventive spirit fueled by an art session does not dissipate when the class is over; this is especially evident when the art teacher comes to the general classroom. The innovative findings in art are a result of free-spirited experiments and play, but their effects on the children's life after the art is finished cannot always be appreciated during the brief time allotted to art. Integration of content needs to be looked at after students leave the art room carrying the spaceships they invented. The challenge of integration is for academic teachers to harvest students' art inventions, innovative ideas, and exciting discoveries.

The informal sharing of beautiful things between artists characterizes each art class. For example, the art teacher shares his childhood collection by reading instructions on the back of some illustrated sheets. "Directions: Moisten skin lightly, lay picture face down, then press." The mid-century tattoos spark discussion about contemporary iron-ons and the latest illustrated Band-Aids that children collect. The conversation moves to "boo-boos" and how wounds form, heal, and how new layers of skin develop. As children share their painted Band-Aids with their classroom teacher, who comes to pick them up in the art class, they also discuss the science they learned. Interdisciplinary learning started by art is characterized by a free flow of ideas that moves with the art to other classes. Art teachers need to communicate with colleagues the conversations and themes that come up in an art class.

Art can serve as a jumping off point for classroom discussions. The art teacher can share not only the art made by children, but include the conversations and original ideas suggested by students. During a space launch in the art room, retro-fitting ballpoint pens, flying marker tops, and a lift-off using a popcorn popper demonstrate new forms of space travel. Children's ideas for space flight add new possibilities to textbook discussions of space or creative writing about space adventures in the classroom. Art opens up possibilities to discuss any subject.

Learning in School Is Not Interdisciplinary

Young children naturally learn in an interdisciplinary manner, but once they come to school subjects are divided for them. Classroom teachers may devise some interdisciplinary approaches, but there are few opportunities for children to demonstrate their interdisciplinary interests. Notebooks, readings, and lessons are organized according to subjects and some subjects are even isolated by being taught in different rooms. While artists are interested in and inspired by everything, and discussions in an art class span many subject areas, the free-flowing views and discussions don't always flow beyond the art class.

By making art into just another school subject, young artists often lose out. Integrating art with other subjects becomes an effort to bolster academic learning and the fun and joy of art making are strained. Art teachers are experts in making learning enjoyable and fun, but when art is moved into academics, the joyful part of art tends to be neglected.

To Put Learning Back Together Again

It could have been a fall like Humpty Dumpty's that caused school learning to break into pieces. The fragments that often make sense only to the curriculum's designer become random bits of information to the recipients. Why study certain countries in Africa and not others, spend most of the year on one continent and leave the rest; only the state's test makers know the answer. The challenge of integration is to put the pieces together—to present a bigger picture, to see the broad context of learning by presenting to students the environment and the world in its rich complexity. Schoolrooms, classes, subjects, curriculums divide learning. The challenge of integration is to put it back together.

Art is not just design principles, bits of information or techniques, or a random study of certain art and artists. Looking at the environment as the largest and most complete art supply store, nature as the broadest resource for

materials, and one's own experiences helps to tie art and other subjects together. The challenge is to set up a whole or interdisciplinary environment for learning, yet deal with the state's required standards that emphasize the particulars in different subjects. This requires that teachers keep their eyes focused on big themes in learning and the big ideas inherent in a school subject. The challenge of content integration is to meld the current fragmentation of subjects by clarifying major themes for students that are important to every subject. In this sense all learning is interdisciplinary. Integration can breathe life into musty subjects that have been classified, simplified, and separated into teachable bits of facts.

From Facts and Formulas to Discoveries

Learning in school is knowledge and information to be mastered by everyone and recalled by all students. General subjects in school often tend to be presented as facts. Formulas are to be learned and not experienced. Learning is not set up to extend to individual interests or be the result of a personal discovery. This cannot be a model for art and cannot be successfully integrated into art teaching.

What is to be learned in art is to not know—to not know what has already been found and classified as facts. An art class is set up as an opportunity to look for things and for students to make their own discoveries. A challenge in content integration is to have students take learning matters into their own hands, to do the search and be excited about their individual ideas and finds.

Future art teachers have to consider integrating art with other subjects in order to set up for independent investigation. Art is a model for rethinking content. The search and what is learned from it are personal, individual, and thus meaningful to the student. Can social studies, science, reading be approached this way? Future art teachers need to be able to look at any subject and find visual interest in it, approaching the subject as an exploration of new content. Art teaching demonstrates to other teachers the artist's far-reaching curiosity in ideas and the desire to find art sources everywhere.

Art-Based Integration

It matters who leads content integration. When art leads, the child as inventor and visionary can be the starting point. When Frank Lloyd Wright's shaping of the Guggenheim's floating and rotating geometry engages students' calculations in a math class, more than formulas are learned. An appreciation for the beauty and creative use of mathematics can become the goal in integrating art and math. Art-based learning uses various senses—seeing, feeling, and listening—as a way to learn.

A challenge of integrating content is to retain hands-on learning in schools that beseech kids to keep hands off and keep their hands to themselves. Hands-on learning is not considered efficient and tends to be dropped when schools move to functioning in a high-efficiency mode. Students, however, recall the things they handle and often value the projects they made far above all school learning.

Art can be a model for students to look at all subjects, even those that seem hopelessly bound up in formulas and rules. Even math and science lesson don't have to start with solutions, but like art, they can be presented as questions and inquiries that call for students' ideas and inventions. Every subject has a choice to be a demonstration of mechanical or creative problem solving. In a math class, for example, students can take note of their attempts at finding solutions, noting possible shortcuts and alternatives they find, before the problem with the correct solution is demonstrated on the board. Students can set up their own math and science problems, instead of being assigned pages from a book. In a similar manner, the buildings of new art museums and sports stadiums, as well as contemporary fashion, design, and furnishings all offer clues for academic inquiry.

In a nation that takes pride in its inventors and depends on innovation for survival, art can move academic teachers to break with traditions that only teach memorization, formulas, and principles. Art challenges rules in schools that thrive on traditions and regulations. All subjects should include the search for bold inventions and new concerns. Looking at the most recent finds in all subjects, what is new and exciting in every field, is what attracts students to study any field.

Art is not a model for standardized learning. Classes are encouraged to be on the same page, to teach the same material, the same way. Schools support the kind of integration that brings everyone together to study the same content and to work on similar schedules. But uniformity interferes with recognizing individual artists and discourages teachers or students to innovate.

Natural Integrations

There are occasions in school when integration in content occurs naturally. Events and experiences occur outside the

school that stir everyone and affect everyone's thoughts and emotions. Landing on the moon or the space shuttle disaster brings together Americans and integrates learning in a school. Celebrations, holidays, natural catastrophes become occasions for everyone to come together. Future art teachers should be concerned when art across the hall is taught from clipped-out recipes. Classroom teachers need to understand that the purpose of integrating art is not just to illustrate a history lesson, or to decorate hallway bulletin boards.

Art Is Not Social Studies, Reading, or Math

A banner flies above many schools in Kentucky heralding the school score on the recent standardized test. A sign tells us that Morton school is "125.38." When all that's valued is the school's achievement on a standardized test, the contribution of every content area lines up to work like well-oiled machinery to maximize production. Each subject, teacher, and student is expected to contribute to a high-school ranking. Schools have enlisted art teachers to raise academic scores to a point when you can walk into an art class and not even know where you are.

It is important to consider what we are losing as art teachers. We risk losing our identity and uniqueness. Art teachers cannot integrate content from other subjects at the expense of art. For example, students sit before a big projection of the map of Africa. The teacher talks about different tribes, writes down key terms, and discusses tribal traditions. If a stranger walked into the room, they might wonder what class it is.

Art teachers are not social studies teachers. However, art teachers can look at any subject to find visual interest and opportunities for approaching the material in creative ways. Art teachers can be helpful to colleagues and suggest that students make their own learning materials, make their own books to read, their own watches to tell time, or their own rulers for measuring in math. However, the art teachers should not become someone else by adopting the teaching style of others.

An art class should feel like an art class. Art teachers should not forget that what children want to do in an art class is to make art, not listen to lectures or look at PowerPoint presentations. Integration has to start with the uniqueness of art. If the examination of Africa takes place in an art class it becomes a study of sculpture, architecture, and decorative textiles, or the influence that African art had on the founders of modern art.

Teachers today have precious few choices, yet many demands for adherence to requirements. Contemporary demands often place teachers outside their comfort zone. Every teacher has a distinct style; some are comfortable lecturing in silent rooms, the way they learned to teach. Some teachers are wonderful lecturers, storytellers, or skillful in gathering information and presenting it in ways that are easy to remember. Everyone is not trained or experienced to teach making things; hands-on learning may not be in their background. Integration should not be just another requirement. Art teachers can spark integration ideas, which may appeal to others who willingly participate. Art classes need to do what they do best: to inspire both students and teachers.

Inspiring Creativity throughout the School

The challenge of content integration is for art teachers to act as informal teacher-trainers, instilling the possibilities for using art in any schoolroom. Art teachers are most effective in integrating art into school life by making contacts and serving as supporters of art throughout the school. For example, art teachers can invite fellow teachers to a Lunch with the Art Teacher, keeping the art room open during lunchtime for the faculty to talk, eat, and make art together. During the time classroom teachers spend enjoying art, they can brainstorm ideas for using art in their classrooms.

There is already a great deal of isolation for art teachers in an elementary school. There is little time available during the school day to contact other teachers. Yet the art teacher needs to make time to pass by and visit other classrooms and to be someone every teacher can turn to for advice on using art in his or her classroom. A challenge in content integration is to break down the art room's sealed walls and become aware of what goes on outside.

Concluding Thoughts, Understanding Significant Contributions of Art

Art teachers informing, teaching, and creating works with fellow teachers spreads art throughout the building. Helping to insure a strong and positive integration of art in all classrooms strengthens the effectiveness of the school art experience. Informal suggestions for content integration such as having hallway discussions, circulating a series of powerful magazine photos, or sending around a beautiful

collection assists classroom teachers and encourages them to consider using art in their teaching.

Most importantly, integration needs to be approached with respect for the unique contributions made by every teacher to the school. However, to meaningfully integrate the content of art with other subjects, the unique and significant contributions of art have to be well understood.

Monthly Meetings with the Art Teacher

An interdisciplinary model that elevates art in a school has to involve every teacher. The art teacher continues teaching art, but pays attention to the art in the rest of the school, encouraging teachers to bring plans and ideas for art in their classrooms. The art teacher actively listens and looks at the art made throughout the school, learning about themes and how art is being incorporated into lessons.

Professional Development Models

First Field Trip Model A first field trip in school evokes special memories. It often forms deep personal significance that stays with the person throughout their life. The memories and details of this important field trip can be a model and standard for all field trips with children. A lively discussion can take place between the art teacher and classroom teachers as they recall their earliest school field trips and the momentum it provided for learning. The discussion provides interest in revisiting field trips taken by teachers as children, from the school's backyard to its surrounding neighborhoods.

Urban Safari Model A first-grade teacher wants to study life beneath the sidewalk, while the second-grade teachers are looking at energy and conservation. In planning a unit together, they bring their ideas to the art room. This model PD session starts with a neighborhood walk. Discussions start from looking closely at the ground, at objects, creatures, and plants living in sidewalk cracks. Teachers trace and rub outdoor surfaces and share learning ideas from their spontaneous discoveries.

Stores and Learning Model Teachers in the K/1 classroom are discussing the idea of community and neighborhoods.

They brainstorm ideas for looking at individual stores and how students can learn from labels and reading ingredients. The art teacher adds to the discussion during a PD meeting at a coffee shop. Everyone takes a moment to ponder, for example, how coffee is grown and processed while smelling the beans and learning of their journey to the coffee shop. The teachers draw up a list of important stores to be visited and possible discussions. In visiting neighborhood stores it is helpful to have a backstage pass to see how products are made. Each aisle of a supermarket has its own art and systems of display, storage, and organization. The workings of a supermarket storeroom, reading ingredients and labels, or the art of designing them can offer important lessons.

Contemporary Issues Model With major events taking place in the world, fourth-grade teachers are trying to define ways to discuss them with their students. At a PD, teachers enter the art room to the music of Pete Seeger and Joan Baez. They view images taken by the art teacher of a recent visit to a city's refrigerator graveyard; thousands of old refrigerator bodies separated from their door, stripped of their emblems, are stacked like supermarket items in various states of decay. As teachers list recycling, global warming, endangered species, pollution and other issues of our time, they receive video cameras to create their own films. Art and learning are about reflecting on the important issues of our time.

The true sign of intelligence is not knowledge but imagination.
—Albert Einstein

FIGURE 2.3 Drawing of Plays with Wood Blocks

Section Three Drawing in the Elementary School

APPRECIATION OF THE UNIQUENESS IN CHILDREN'S DRAWING

Art teachers are the greatest fans and collectors of children's drawings. Those who select art teaching as a profession are often moved to do so by their amazement in the fresh creative expressions of children. Art teachers view children's drawings as inspiring and important works of art.

There are art museums for masterpieces in painting. There are many lesser-known museums for everything from toys to toilettes, but no museum is dedicated to the preservation and exhibition of children's art. Art historians teach the story of art itself as beginning in a French cave whose walls were painted by hunters instead of starting with the drawings of children. There is not mention of children's art in art survey courses or the large volumes of art encyclopedias that accompany them. The general public has little appreciation for the birth of art in childhood, children's important contributions to art that have foreshadowed most examples we now admire as modern art. It was artists like Picasso and Paul Klee who suggested that children's art is a unique art, a demonstration of free and playful use of lines that should be the envy of artists.

Drawing with a Child

The uniqueness of children's drawings is learned from children. The experience of drawing with children has to take place before teaching drawing to children. To be able to make valid comparisons between children's and adult approaches to drawing it has to be discovered, internalized, and understood through live action research. It is an experience that changes an art teacher's life, never reverting to old ways of teaching drawing as they discover important and relevant approaches that respect the young artist and their art. After drawing with a child, an art teacher gains appreciation and can easily reflect and come to their own conclusions about the uniqueness of children's drawings.

As one future art teacher put it, "Seeing a great artist working beside me, makes me think differently about respecting children's drawings as art and now I can't approach teaching from adult constructed techniques and formulas." To understand the uniqueness of children's

drawings one has to see it being made without an assignment or art lesson. Every future art teacher should sit alongside a child drawing at home. With a pile of exciting supplies to choose from, the team goes to work. The child draws and so does a future art teacher, unobtrusively glancing at their young partner's art in progress. Studying children engaged in drawing is a lifelong lesson in understanding the unique approaches and qualities in children's art making, compared to what the adult is doing and most likely to teach. This simple learning experience needs to be repeated as often as the opportunity presents itself to be reminded of the difference between children's drawing and drawing taught in school.

Building Collections of Children's Drawings

Teachers as collectors constantly learn about children's drawing by looking at home art, drawings not made to fulfill assignments and discovering unique qualities that can be supported in the art room. Collections become a personal reference for art teaching; having children's drawings readily available to look at as a reality check, seeing how one's art teaching is related or unrelated to drawings made by children.

For teaching sessions, examples of adult drawings can easily be found in published works, but children's drawings have to be shared from the teacher's compilations. Showing books of children's drawing to other children also has the advantage of sharing the genuine art and care the art teacher demonstrates in housing the art collection.

Those Fantastic Dots

The uniqueness of many children's drawings is that it's not about traditional pictures or ways of drawing. In collections of children's drawing, one can find exciting samples of basic marks, such as drawings that consist on the richness of simply marking up a surface with dots. In some works, dots are sprinkled and scattered like confetti. In other drawings, dots may be forcefully squeezed, swirled, and drilled into place. Children's dots are not Georges Seurat's carefully grouped dots made by brush points for impressionist

illusions. Children's dots are celebratory marking, playful dotting with small points to large circles and masses, punched holes, accented with bright round stickers. There is art in children's touching the surface, tickling it with a tool, creating random patterns or the sensation of sorting dots as a drawing. Children typically try variations of a particular drawing approach over multiple surfaces.

Scribbling Inventors

Children's drawing is playing with lines. Their inventive line plays can be collected. In coloring books and on objects like restaurant placemats one finds examples of a visual battle, the required coloring inside the lines and children's powerful resistance and action marks. In coloring situations, moving and inventive scribbles fight to have their say over a controlled situation. But children come with vast experiences in drawing over ready-made surfaces and in a good coloring book page their own beautiful lines win the day.

Children don't work from landscapes and models before them; they don't naturally follow outlines, but move and invent new scribbling lines like they spin a jump rope or dance around the house. Children's bodies are fully connected to the lines used to express active movements. Fired as dots, or running and spinning as scribbles, children's line drawings are uniquely descriptive of playing and experimental action reflecting what takes place on and off the paper. Scribbles are the most immediate lines (undisturbed by images and art) that only children can make. In scribbling children find their line repertoires and their unique feel for the drawn line. Even when discouraged to scribble later in life, children continue their first love by creating unique images with glue, scribbling with staplers, scissors, in the margins of school notebooks and even in computer drawings.

The D in Drawing Is for Decorating

Children apply drawing to surfaces and containers as decoration. Taught early to make their hair pretty and pick out pretty clothes, children learn of the importance placed on making everything look pretty. When they receive markers they naturally turn to using them as important decorating instruments. Making things look beautiful becomes an important motive for marking over clothing tags, or cups and napkins at the table. Drawing can make anything look pretty, and in collecting children's drawings

one can amass numerous examples of objects that children have "Beautified."

Later children find themselves in a conceptual art world, where all art has to have an idea and just making things beautiful is not an encouraged goal. Yet it is in children's unplanned and carefree designs as drawings that they and collectors of children's art find a unique pleasure. Can children's reasons for making art to beautify everything in their world be allowed and validated in art classes? As children want to use their drawing as decoration, they also find that many surfaces have been usurped. For example when children want to decorate the presents to family and friends designer gift bags have already been purchased. There are many fine examples of children's drawings that are added to decorated surfaces, drawings made over school folders or wrapping papers.

A Unique Relationship of Writing and Drawing

For a while children use their pencils and markers to freely draw, but soon find that they have to share their drawing tools for penmanship lessons. The early transitional stage is wonderful to collect, to admire the struggle between scribbles and the written line, played out in artworks. The mechanical use of former art tools leads to great changes; fewer leaps of fantasy or scribbles and playful markings. Children's drawings become unique illustrations of a struggle for survival of the freely drawn line. In school, children who used to be line magicians and experts are taught about line in writing and in art classes. For a while there is a give and take, a wonderful period where letters and writing become a fanciful part of children's drawings. Then, writing moves out of the way to the bottom of the page to become the artist's signature. There is no doubt that learning to make controlled evenly pressed, up and down, perfectly curved lines in writing takes its toll on drawing. Eventually the controlled line wins and it becomes as difficult to freely hold a pencil without gripping it too tightly, as it is to dance with drawing tools, making free marks or lively crossings across a paper.

Accepting the Uniqueness of Children's Drawings

Watching a young child draw, adults often say, "tell me about it," explain what you are doing as they offer to write

it down (unfortunately sometimes invading the drawing itself). To an adult eye drawing cannot be just scribbles, it can't look so "unfinished," so "unreal." The question posed to many young artists is to explain what they are doing, talk about their secret language; what do you mean by this drawing? Art is communication and you lost me here. Consequently what looks like authentic children's art seldom takes a place of honor; receives a ribbon, or a place in the hallway exhibit. Essentially art that looks polished and more like art is supposed to look like: adult art, will be on display for other adults to view. Future art teachers need to be proud and confident to share children's drawings, and point out their poetry in playing with lines in motion to viewers of all ages. Children's drawings are not always about something, but they are about drawing, recorded movement, the direct exploration and composing with lines. To ask children to translate their drawings into words misses its beauty.

Final Remarks about Drawing

Children's drawings have the unique ability to make joy and play visible. There is beauty in each line, directness in gestures, inventions, and discoveries. Young artists find out all about lines by playing and inventing with them. While one may witness the excitement of children discovering a face, unwrapping a body, or finding a letter in the entanglement of lines, it is vivid lines that directly allow the viewer to enter the art process of moving, growing, and changing, that makes children's drawing so direct and powerful. Children's drawings are unique in their ability to show growing and changing. In school we seldom stop to appreciate the process. Items displayed and admired are

those that are finished, spellchecked, the completed work. The beauty of children learning to form the alphabet, or spell a word in different ways goes uncelebrated. We speak of the wonders of growing up, but in children's drawings it is clearly displayed, open to see and enjoy.

BUILDING ON CHILDREN'S DRAWING SKILLS AND INTERESTS

Children's unique drawing skills and media can be confused with seemingly destructive acts such as carving into a soft eraser, or in what looks like wasteful deeds such as pulling miles of toilet paper and laying it out over the bathroom floor. Children risk punishment and disapproval for many types of drawing. Yet as art teachers it is important to be aware of all drawing acts, to keep looking with an impartial glance, because many children's drawings are performed in non-traditional modes and media, skills practiced in action and taking place in the darnedest places.

Art teachers should keep looking for drawing clues and taking notes on line play in all media. No list can ever be complete, and it is exciting to find yet another occasion for discovering a new way to draw. Each new drawing moment that children take part in can be extended in the art class so that children themselves take notice of their wide range of drawing skills. Drawing skills and interests are closely related. For instance, children are intrigued with scissors, and while developing their cutting skills they create fantastic drawings. The following segments are examples of drawing skills and interests that are unique to children and that need to be developed and preserved in an art class.

Automatic Drawing Automatic drawing is what remains after experiences with a vast range of scribbles. It may sound like a declaration from the Futurist Manifesto (1909), or a later declaration that Jackson Pollock might have delivered, but the ability to make a line move and dance, to embark on a journey without a map or flight plan, is definitely part of children's drawing skills. Early drawings are daring, tied to emotions and a sense of adventure, very different from later drawings that often do not happen without being guided by a direct plan or forethought.

Speed Drawing Speed drawing skills are visual evidence of children as naturally active movers who are unfortunately quieted and placed on hold in school. It is easy to observe how children will skillfully produce scores of drawings in a brief period of time. Their hearts beat faster than adults,

FIGURE 2.4 Drawing of Favorite Things

their moves are more rapid, and their approach to drawing reflects their high-speed nature. The desire to move and the need for action and speed appear as unique qualities in children's drawings.

Drawing with Tape Tape drawings will thrive in a home that allows tape to be "borrowed" by children. Miles of clear lines are used each year to demonstrate this unique art skill. There is good reason to suspect that if Scotch tape is missing, it has been well used in a drawing. Some children's clear tape drawings exist as spider webs suspended between furnishings, while others are placed over surfaces or to bind objects to drawing paper. This recognition that lines are real and can be used to draw with is a child's discovery and an early drawing skill.

Peeled Lines Peeling may be hard work or even feel like punishment for adults, but a vegetable peeler is a happy drawing tool for children. They eagerly volunteer for KP, seeing wonderful line art in peeled carrots, potatoes, or oranges. Peeled lines are soon carefully shaped to order and skillfully dropped, sorted, and assembled as drawings over such canvases as salads. The reason to purchase a classroom set of vegetable peelers for an art room is because they are not available in art supply catalogs. Peeling lines however is another one of the underrated drawing skills and interests of children who may tape, glue down, trace, wear (trying on peels as masks), and eat drawings.

Tracing Interests Tracing begins as soon as children discover that they can trace their hands. The magic of tracing soon extends to the feet, other parts of the body, and all objects children wish to examine and keep. For children tracing becomes an important drawing choice, placing the shape and outline of objects onto papers to be further explored. Soon children are busy treasure hunting in kitchen drawers, expanding their tracing skills by moving around the most complicated kitchen tools. Individual tracings soon become connected, overlaid, and expanded upon with imagination, creating new forms and figures that go far beyond the original traced object. The art room always needs to have a box of challenging mystery objects that tracing artists can turn to, making them part of their general repertoire.

Cutting Skills For the art teacher, scissors need to be recognized not as an accessory but as one of children's main drawing tools. An art class can lay claim to the largest and most interesting scissors collections to choose from. Scissors of different lengths, weight, curves, and cutting edges can be collected like different types of pencils. Children become Edward Scissorhands as their moves extend into shaping the freest lines and forms in drawing.

Embossing and Puncturing

Embossed or punctured dotted lines build on children's early interest in spreading sparkles and sprinkles, making fanciful dots on surfaces. Children don't just staple but make drawings with staple marks. Few art periods go by without children asking about a hole-punch, since puncturing the surface is their extension of dotting it.

Drawing Tool Inventors

Children are tool inventors, constructing new ways to draw by inventing new tools. Children may demonstrate how they can draw by taping together a bouquet of drawing tools. Art teachers can guide students' interests and skills as tool inventors, hosting tool engineering days, and encouraging the collection of new vices, handles, and extenders used to propel drawing tools and moves.

Drawing Surfaces

Children collect drawing surfaces. Often stored in their room are fascinating napkins, business cards, unusual boxes, or wrapping paper that they've collected. No one in an art room should start a drawing without discovering their special surface. They should not have to draw on the same stack of paper distributed by a monitor to everyone.

Drawing a Conclusion

Young artists work fast and on many drawings. They are interested in collecting unusual tools and altering existing ones. For young children drawing is still play and fun, therefore as free and inventive as it will ever be. Fun with drawing is essentially what art classes can build on—a class can become a drawing party where children draw over funny faces, create masks, and make entirely new heads for themselves.

Children will find the most interesting objects, the most contemporary surfaces to draw on. Their canvas collections should begin each drawing. It is important to recognize

that children will draw with any find that needs to be tested for art. They are wonderful engineers and inventors and in this capacity they will build the most unusual drawing tools. Drawing relates to all of children's interests, joys, fears, and adventures, describing places to play and itineraries for imaginary places to visit. Teaching drawing, therefore, is a matter of constantly learning about children's drawing skills and secrets. As children reveal their drawing sources, the art teacher needs to be a source of inspiration so that children will want to continue making drawings into adulthood. See Plate 2.4.

TECHNIQUES AND PROCESSES IN CHILDREN'S DRAWING INSTRUCTION

A Technique to Understand the Adult World

Drawing allows children to figure things out for themselves. It is a means for children to understand their world by tracing, rubbing, and modeling it in pictures. There are no facts in drawing, because drawing is filled with questions and uncertainties only each artist can answer. Children have an abundance of curiosity to explore and they need a media through which to note their discoveries. Drawing is accepting that one doesn't know many things and that it's okay. It is a humbling experience and should not be responded to by teaching children tricks, formulas, shortcuts, and pretending that adults have the answers and know how to draw.

So what is teaching drawing for children who want to find out? It can perhaps be explained by this example: A child comes into an art room and, seeing the availability of drawing tools and a fresh canvas, starts to draw. "What are you doing," asks the art teacher. "I am drawing G-d," the child replies. "But no one knows what G-d looks like!" "In a minute they will," the child confidently responds. In a drawing, children discover things they hear about and grapple to understand. It is the opportunity to use a magnifying glass to look at things closely, or to gaze through a telescope to see things afar.

Future art teachers can promote the examination of any view, object, or event. Teaching drawing is not about providing a formula for perspective, but analyzing spaces and looking inside things to see how they work. It is not teaching how to shade but playing with light and being entertained by shadows. Teaching drawing is setting up art room experiments, having children play with clocks and wheels to see things move, to see the outside and the inside of things, having plenty of things to think and draw about. Children may draw growth in a leaf or change in a building. They may visit a construction site or a burned down store. Through drawings children analyze problems, picture ideas, and make plans.

Drawing from Experience

Art teachers can invite experiences by leading play journeys, flights, and adventures in the art class so that children discover possibilities and ideas for drawings. A drawing lesson may begin with an excavation, a treasure hunt, or a mystery to find objects. Drawing from experience is inseparable from one's interests and feelings, embarked on when the young artist has something important to figure out and demonstrate. In this respect children's drawings are real, even if they don't appear in perspective, or use adult devices to create pictorial realism. Teaching children drawing is not correcting their reality or ways of depicting it. While teaching drawing in the past has been about techniques of creating illusions, children's drawings show real experiences and ideas.

Teaching Dance and Promoting Activity

In classrooms where children are not encouraged to move, drawing is a way of allowing motion, at least on paper. Children think through movement. To draw, or to dance, is to think and come up with creative and dynamic ideas. Most education in school is for the head, ignoring the body that transports the head. Children express their movements and actions in drawings as well as their ideas. Fidgety children are often dismissed or punished in school when they could be asked to dance and draw. The technique of teaching drawing to children is to encourage movement in the classroom, translated into playing and dancing in drawings.

Drawing Is Not Writing

Pens, markers, brushes are all gripped tightly, while attention in school is focused on writing papers or pictures. Drawing lines need to be freed from clutched fingers, so

they can breathe and be felt as something moving and touching a surface. For drawing tools to come alive they need to be handled like toys and played with. Tools can be tickled, juggled, twirled, turned upside down and held anywhere. Arms and bodies and not just fingers can manipulate tools, while the artist pays attention to the qualities of lines created and not just the pictures the lines make.

Future art teachers may ask students to examine their comfortable writing grip by looking at the way they hold a pencil. The challenge is to find different ways to hold and move a tool, to greet each art tool freshly, discovering it as if for the first time. What would those first new lines feel like? What would they look like?

Just Doodling

Drawing allows students to fantasize and daydream in school where paying attention and staying on track are most valued. Children do many of their best drawings when they are not supposed to. To keep their secrecy, these drawings are often not referred to as drawings but doodles. Made on surfaces like hands and school notebook covers, places one is not supposed to draw, this semi-abstract and often decorative dream-like scrolling appears on many surfaces, yet they are seldom collected or appear in public viewings.

Fearless of Accidents and Mistakes

The possibilities in drawing are boundless; it is not just one thing, and it is not one correct path. Accidents are welcome, the unexpected observed and considered as new ideas. Drawing harvests the accidental, where the seeds of possibilities are sown. In the past, there were more "correct" ways to approach drawing. Of course the proper drawing pencils had to be selected. The pencil had to be properly sharpened and properly placed between fingers. In today's art room, drawing tools can be held and moved in countless ways, and students can make accidental marks that suggest new beauty and courses of action.

A technique of teaching drawing can start with the surface. Children at home will draw on practically anything. But in school they notice a paper that has the smallest smudge or imperfection and want to return it immediately. School teaches everyone to be neat, to hand in work in the same format on "perfect" paper. Drawing instruction should reclaim the messy and the willingness to draw on a paper that a bird flew over and left its mark (figuratively

speaking). Oops, the drawing paper was torn, got wet, somehow blown off the table, as the story goes, and it has some shoe prints on it. Yes, there are lots of interesting accidents to be perpetrated by the teacher or young artists and made use of in wonderful drawings. As students teach old tools new tricks, and drawing becomes experimentation and play, it is loaded with accidents and possibilities.

In Conclusion … Taking Charge of Drawing

Teaching students to take charge of their drawing is an essential art teaching technique. Possibly the most crucial teaching method is to tell children convincingly and with assurance that they can draw. A part of the confidence-building equation is that the art teacher believes that every child in class can draw without qualifying it with "I will show you how," or "I will teach you the correct way."

If asked, young children will convincingly explain why they like to draw and what they like to draw. It's important to ask and to know, because art teaching is helping students to clarify drawing problems and issues for themselves. The subject, the theme, the reasons for drawing have to be found and decided upon by each young artist.

When asked, children express valuable opinions about why drawing is important and what it means to them. This is what children have said:

- Drawing is about my play, my interests, and me.
- Drawing is tinkering, like building things on paper.
- Drawing is playing with tools and lines.
- Drawing is not facts or rules.
- Drawing is to see things, to look at them more carefully and notice things that I haven't seen before.
- Drawing allows me to save the things I like and keep them, like in a scrapbook or picture album.
- Drawing is like a friend, it helps to make me happy and it is something to do when I'm sad.

Students' enlightened views are the best guides in helping art teachers understand what drawing means to children and how they can help. When students understand that drawing is valuable for them, then it is easier to encourage them to draw at home and make it a part of their busy lives. See Plate 2.5.

Painting is just another way of keeping a diary.
—Pablo Picasso

Section Four Painting with Children

WHAT'S UNIQUE AND EXCITING ABOUT CHILDREN'S PAINTING?

Children love to paint, and their joy is evident in every piece. Even though children are ready to paint all the time, as they get older there are fewer opportunities for this during their busy school years. In addition, children are known to be uniquely messy painters, and while the beauty impresses some adults, few are willing to put up with a mess at home or in school. In many school painting experiences, the children come away elated, while teachers may privately cringe and say, "I'll never do this again." Yet painting is probably one of the most important things an art teacher can encourage.

Children's painting goes back to basics, the basic feel of paints and the suppleness at the core of the media. Painting begins with a pure love of color, colors that can make forms and extract feelings. Children's first experiences with paintings are pure painting; they are color and paint, not drawing or stories told in color. It is an expression of the love of painting different surfaces. It took a long time before modern artists discovered that same love of unpolluted color, as they revisited children's art and uncovered their own childhood. For many adults who are not artists by profession, painting often turns into a chore, losing its pleasures and the glamour it has for kids. Adults like to pick out paint swatches, then hire a painter to paint a room, or a painting for it. Children love every aspect of painting: the colors, the tools, and opportunities to cover tiny or vast surfaces and change the existing color of things.

Many adults view children's painting as an imitation of things or a step towards adult art. Children's painting is not a derivative of anything—it is the real thing. Kids are not trying to imitate adult art, although many school painting assignments ask children to paint like Impressionists or to pick adult artists and paint like them. Children's paintings don't have to be viewed in the context of adult art history. Unlike adult works on a stretcher that converse with other adult works on a museum wall, there is little art history necessary to enjoy and appreciate children's unique paintings. There are no expressions of current trends, attempts to fit in, keep up with, or reject the history of painting. Children's paintings are original in their playful handling of paint and joyous expressions with color.

Children hold numerous new color patents. They are the inventors of scores of objects tested as canvases. They constantly discover new painting tools, and use old painting tools in new ways. Children borrow painting tools and media from all experiences. A young painter may be the queen of nail polish with over one hundred nail polish colors and as many nail canvases as there are willing participants for their miniature art form, painted on fingers and toes. In the queen's room there can be also be a nail-polished phone, mug, or a brightly lacquered lampshade.

Not to be looked at through a contemporary art world lens, the new in art often starts with children's early painting. Children's painting may not look new or different than contemporary artworks only because the adult art world usurped children's many painting inventions. Today's adult art viewers cannot be shocked, but to study children's painting promotes a deeper understanding of most of the innovations in art in the twentieth and twenty-first centuries. No wonder children who encounter contemporary paintings turn out to be a sympathetic audience.

Children Invent Painting

Paintings children produce should not be compared to adult paintings, although adults have studied children's works and it is often tempting to relate schools of adult painting, or the works of individual artists, to what children are doing. Children paint with a spirit of discovery and the hope of finding new colors and new styles. Children don't paint by numbers, formulas, recipes, or theories; they paint as though they are discovering painting themselves. Along the way students pick up personal ideas, skills, things they like, and things they want to try. Children invent new colors, new ways to use paints, and essentially find their painting voice in each painting.

Future art teachers should be careful, when seeing a child's painting, not to rush to show images of adult works that may appear to be similar. The background and intent of the art are generally worlds apart, since the artist has studied the history of art and often looked at children's art to develop a deliberate style. Such comparisons can easily be misinterpreted, the young artists thinking that they discovered an aspect of painting that adults have already explored. Should students be honored by the comparison, or disappointed in their lack of originality? Should the student be painting like the adult artist they are shown? Children's painting is not an act of following a path set by

an adult model. What is unique about children's painting is that it is all new and exciting. In essence, children teach the world to paint, they invent what painting is, and that's the feeling that future art teachers should foster.

Painted by Hand

Children don't hesitate to use their hands to move the paint that moves them. They complete a painting and have almost as much paint on themselves as on the paper. Children are not removed from the paintings they make, they move right into it with their hands, handling it in active, participatory ways.

A future art teacher's task is to keep the enjoyment of paint and the pleasures of painting alive. This may mean becoming supporters of the truly hand-painted works of students. Using drop cloths, student-made painting outfits called space suits, gloves, and painting tubs and trays allows paint to be touched and painting to accommodate the use of hands and bodies in a school setting. For children, paints are alive and feel great, as students keep in touch with the media throughout the painting.

Active Painters

Children can be speed painters, as though they are winning medals at the Olympics. If paint is flowing and the surface is shiny and slick they can beat any world record. Fast painting actions are typical of young action painters—children who like to find places to move and wide open surfaces to paint.

Decisive Painters

Children are remarkably able to lead the painting process, to plan moves and steps almost instantly. Watching children paint, the observer notices that their actions are not random. They are constantly making decisions, processing clues based on the effects of their work, the flow of paints, or the colors they are looking for. Children are sensitive to change on any part of the art surface and quickly formulate new ideas about how to respond.

Art teachers need to revise their notion of what is planning in art. Since young artists often work so fast, it may seem like a random act. Filming helps to decipher what is going on and to show children's amazingly quick

ability to respond to each step of a painting's progress. Art teaching is about helping students to return to the act of painting, to replay what was going on in the act and discuss its many details.

Repainting Painters

For children painting makes things look pretty and appealing. There is a well known character in children's books called Fancy Nancy, who takes everything plain that she owns and makes it, yes, fancy. Fancy Nancy could represent the way children paint, as she wields a powerful magic tool like a brush that can cover any surface. Adults speculate and theorize about painting, but for children it is an opportunity to decorate, to make everything more beautiful. Children love to change the color of objects and surfaces and, if allowed, they would gladly repaint their rooms and everything in them. Art teachers can preserve and creatively expand upon children's belief that paints and colors are a powerful tool to beautify the world. A school, with its many corners and available objects, can provide many opportunities for color changes.

Object Painters

Children playing with paints and making new colors understand that it is about process, that painting is not just about trying to copy something. It took adult artists many centuries to recognize this aspect of painting, and a good deal of the history of painting was in fact copying what was observed. Only in the later part of the twentieth century did artists begin to refer to a canvas as an object to be painted. Before that, a canvas was a place to create illusions of reality inside the window of a picture frame. The uniqueness of children's painting has always been to use paint as paint and color as something real and not just for building pictorial illusions.

Future art teachers can demonstrate to students the differences between painting illusions and object painting. Since students recognize the reality of the painting act as one of covering concrete objects, it expresses the feeling that having paint is power. Some students will decide to paint their suitcase so it will be beautiful and easily recognized on a trip. Others will nail-polish their phone, or paint their hair, trying out different colors. When paint is left over after an art session, students may decide how to use it. Some will paint their erasers, others the apple saved from

lunch. Children treat objects as a coloring book, taking on small and big things to change and beautify.

A Final Coat

Paraphrasing the words of comedian Jerry Seinfeld, children's painting is about nothing. Young artists' work is about the reality of every moment: live action, curiosity, playful investigation. It's about everything, yet nothing. These magical paintings are different from adult paintings in that they are not responses to paintings in the past, depictions of what paintings are supposed to look like in order to be framed. Yet children's paintings contain all the seeds of paintings to come, the personal and universal future of painting.

Children start out with a love of paint and colors and the simple act of experimenting with them. It is a fragile state in that it can easily be "taught away," trampled on by noticing what adults admire, encourage, and teach about painting. As young children move on to use paint to create portraits, stories, and depictions of the environment around them, the experiences from their early painting days keep them grounded in painting. Early painting acts maintain the basic feel for color and interest in paint and the interest in using it playfully and creatively, instead of just writing and drawing in color.

BUILDING ON CHILDREN'S APPROACHES AND PAINTING INTERESTS

Children invent painting by constantly looking for new colors, canvases, and tools. They know that hands are fun to use and anything can be dipped into paint. When brushes cannot be found, children happily unearth other ways to transport paint from a paint can, or mixing bowl to other containers of paints and colors called canvases. The ability to see canvas possibilities in everything and to feel free to paint on any surface is pivotal to children's approaches to this media. A good art room confirms that all kinds of paints can be employed and all surfaces and objects can be called canvases.

Paint Mixing

Free and fanciful paint mixing is an important part of art classes. Washing out old food containers may be a bit of work, but for a painting class it makes a lot of sense. Future art teachers who witness children's color mixing joys, such as mixing fruit yogurts can make art class color mixing the tastiest painting performance. In clean yogurt containers children are excited to mix new colors as flavors they are inventing.

The Richness of Color Play Experiences

There is interesting color in so many aspects of life, and children are interested in all of them; helping adults to pick out hair coloring dyes can be an exciting shopping experience. Students develop collections of cosmetics, paint sample cards of house paints or hair colors. In paint mixing plays everyone can add samples from colors the students mix and place on sampling spoons, stirrers, or sealing in fresh color samples into zip-log bags. Painting not only expands student's interest in all colors, but also in the act of discovering and creating new colors and testing them on all surfaces.

Canvas Inventors

Children continuously search for new surfaces to paint. Many children would rather paint their face than rush to an art supply store to buy a roll of canvas. If allowed, and paint is available, children will use it to paint new uniforms on their old toy soldiers. For the most interesting canvas ideas and to preview the future of painting one may look for children's canvas finds in the painted objects in their room. Working on objects students befriend and have some feeling for, contributes a personal surface with ideas for a painting.

Mail Canvases

Children not only want to pick up the mail, they patiently wait to receive any handsome, padded envelope, stamp, or a discarded Priority Mail box. What adults call junk mail are the many disposable canvases children are not afraid to paint on.

Flooring Canvases

A canvas on the floor opens a large space to feel the physical nature of painting. Teachers can be on the lookout for

discarded doormats, linoleum pieces, ceramic or cork tiles for floor painting. After wood or brick floor installation there are plenty of left-over puzzle-like pieces to be painted and assembled on the sidewalk.

Furniture Canvases

Paintings and furnishings; allow children to paint objects for their room. Children may rescue a discarded bookshelf on a sidewalk, or an old chair on the side of a stream found on a canoe trip. Children have colorful visions for curbside canvases and cannot wait to peruse through left-over cans of household paints and get out large brushes to satisfy their dreams.

Wearable Canvases

Discarded clothes become requested by children, eager to paint a garment and offer it a new glamorous life. Jeans, shirts, pajamas, belts, backpacks, and caps, offer some of the wearable canvases young artists like to paint. Future art teachers can support clothing painters and send their students used cloth shopping.

Nominations for Twenty-First Century Canvases

Instead of everyone in class starting with the same school size, blank sheet of paper, a painting class can begin with considering uncommon and unusual canvases. Children enjoy the process of finding, collecting, or building their canvas with the feeling that their paintings will be personalized. Consideration of being the first to paint on any canvas motivates young artists. To further the possibilities of canvas invention and bringing painting into new arenas future art teachers can discuss what would be forms and materials that symbolize our present day culture? One student's response is demonstrating paintings on bumper stickers, to be exhibited on the family car.

Future art teachers can review the traditions of the artist canvas and what a non-traditional-absurd-illogical, even nonsensical canvas might be like. The implied recommendation is not to look for futuristic canvases in art supply stores. Fast-food restaurants or a tire store may be better places to locate candidates for contemporary canvases.

Brushes and Brushing

Children want to get closer to paint than a brush will allow. So, they put the brush down and touch the paint—continuing to paint by hand until an adult stops them. As paint explorers, children want to experiment with paint and colors, but school brushes are often uninspiring. Standard issue school brushes are like other school supplies, to be used correctly and not playfully. Discovering brushes allows a new relationship and fresh ways to put paint in motion.

In discovering new painting tools, children's transport of paints from container to a surface becomes an invention resulting in moving marks. Each new tool used carries different paint loads. Every tool requires different grips and moves. Tools can change the artist's distance from the painting surface. Children frequently try substituting fingers, hands, gloves, and just about anything they can dip into paint to feel it and move it.

Students can be encouraged to find brushes not intended for art use, becoming aware of the many kinds of brushing that is done daily in preparing food, used for cleaning or applying other things than paints. Brushes used for the grill, to clean refrigerator coils, to polish shoes have different shapes, bristles and handles that can be trained for art making. Existing brushes can be styled; cut and altered to make new paint marks. Students can try their hand to use found materials to make their own brushes and match them with a variety of handles. And, if there is no brush to paint with, what else could be used? Can paper towels and sponges be shaped and serve as creative substitutes? Could paint be poured, or sprinkled straight onto surfaces? New brushes instigate a new awareness of painting and allow for new paint marks and applications.

Brush Inventors

The following are examples of prototype brushes showcased before a class. Future art teachers can make the title brush inventor official, and provide students with opportunities and materials for challenging inventions. In designing the new, an art teacher can emblematically throw out old brushes, asking students to refill the class brush case with items they originate.

1,000 Brushes in One

When just paint but no brushes are found in the house, children take up interesting substitutes. Cardboards are

one such multi-use-paintbrush that children tear and shape to discover an infinite variety of tips to contact a canvas. Mounds of torn cardboard pieces represent scores of different brushes when dipped into paint leaving different marks. Paper towels and napkins are a close second to cardboards in terms of the many 'instant brush' shapes that children come up with by twisting, rolling, or crumpling them.

Restyling Old Bristles

Presented with the challenge to reclaim worn school brushes, students decorate and isolate bristles with bread ties and tapes, and by placing cotton and sponge pieces between hairs. Among the many ways children customize brushes is by creative braiding.

New Handles

Children find unexpected ways to handle all kinds of tools. Raking becomes an art of arranging the colors of large swaths of leaves. The first time a child is allowed to try the lawn mower it often turns out to be a green work of art. It's all in the brush handles and handling. When new handles are tied to a paintbrush, one can expect great innovations in tool handling and in the resulting painting field.

Dispensers and Sprayers

Future art teachers know the ban on spray paints in school and that no water guns are allowed. Ingenuity can prevail enlisting the many home spray bottles: hair sprayers, gardening spray cans, purchased at gardening or beauty supply stores that have the feel of water guns and painting with spray paints. Eyedroppers, funnels, or food-basters are excellent paint pouring devices.

Kitchen Brushes

Children consider the kitchen an art studio and a canvas source and also find it to be a primary place to treasure hunt for brushes. In a search approved by parents, students find amazing brush sets in different size spatulas or wooden spoons. By opening kitchen drawers students easily assemble a toolbox of barbeque brushes, bottle-scrubbers, and exotic scouring pads to paint with.

The Art Teacher as an Expert on Choices

Painting is not a series of principles, but rather choices that every painter has to make. Children have many ideas for subjects and themes, but how to make them into an exciting painting involves sorting through many options and possibilities. Teaching painting is allowing students to experiment and explore making colors, moving colors, finding personal canvases and inventing tools. Students can be encouraged to look for painting inspirations in all paints and colors and to shop for brushes and painting surfaces everywhere. Future art teachers can open up a world of possibilities for students to choose from and to open children's eyes and minds in considering what painting is or what painting could be.

Art is the colors and textures of your imagination.
—Meghan, Los Cerros Middle School

TECHNIQUES AND PROCESSES EXPLORED IN PAINTING SESSIONS

Shelves in most art supply stores are well stocked with books on the subject of proper painting techniques. You buy the paint and the books profess to tell you how to use them. Children however have their own ideas about what to do with paints, every young artist can write their own text. Instead of imposing adult painting techniques on children from "how to paint" books, art teachers should study the children's version and become keen observers of their painting inventions.

Most books on techniques are variations on the generic title, "Learn How to Paint" enumerating a list of proper techniques condensed from the history of painting by the author. These books express little hesitation in proposing a correct technique and no pretense that an author and expert can easily explain how to paint to everyone. After all there are plenty of adult examples to reference. Art teachers however need to be more cautious in prescribing proper techniques, not to dismiss individual inventors, children who use paints to make the media their own.

Technique books will simplify painting, "having decided to paint there are four choices." Children know there are infinite choices in every aspect of painting and that needs to be reaffirmed by every painting lesson. The beauty of painting is that everyone can freely explore and children develop their unique technique. Adult books and art

classes frequently reference technique, while painting for children is a process to engage in. Connecting students to processes of learning about painting is what takes place in an art class.

Technique manuals go on to describe choices of paints and brushes in the art store. The chapters on paintbrushes and their proper use omits examples such as fingers and the rest of children's repertoire of found and made tools, as well as the wide range of brushes children freely borrow from non-art sources. How to use a paintbrush correctly needs to be re-titled for children to "finding a thousand ways to use a thousand brushes" or "teaching old brushes new tricks." The emphasis can be on fun and educational processes that support the exploring of paintbrushes.

The section on types of painting easels seldom talks about painting on carpets or grasses, never referring to the floor, or many other places children prefer and set up for painting. The photo gallery of suitable artists' studios never depicts painting in a play pool or in the kitchen on a canvas of paper towels sloping between two chairs.

The most common sections on painting technique include a large segment devoted to color theory. Few children will embark on a painting adventure guided by color formulas. Children play with paint, unlike adults who mix colors that they 'need' perhaps using charts. Children mix colors to see what happens, while adults want to find the right colors.

Composition in painting is a universal chapter that generally starts with painting spheres. Although children will paint a rich variety of dots and circles and even create magnificent paintings of imaginary balls, these marks are a result of playing with painting tools, or juggling dabs of color. Children's compositions are purely intuitive, and derive from play experiences and executing home chores more than using prefabricated principles of composition.

Another technique that books dwell on is a broad section devoted to the preparation to paint. These chapters describe sketching for painting, and how to use photographs and reproductions, called artists references. Free references for butterflies, snows capes, or landscapes are abundantly available through recommended Internet sites, but children use snow as a canvas to paint on, and not to paint from scenic reproductions. Children who just chased a butterfly may voice it with flying paint marks. Children's painting however does not derive from stock photos and second-hand experiences.

Future art teachers should browse through painting technique books and comment in the margins as they compare what they read with what they observe in children's painting. The following humorous but illuminating notes are from some of those very margins:

- Chapter 1: How to hold a brush ... Maybe between your toes!
- Chapter 2: How many brushes to purchase and use ... How many brushes can a young painter possibly hold in one hand?
- Chapter 3: How thick should paint be? ... Perhaps it depends on how much Kool-Aid and sand children will add!

Instead of step by step demonstrations that pretend that there are concrete steps or answers to how to make a painting, future art teachers need to set up experiments to discover what painting is and could be, based on children's many painting related plays and interests. Future art teachers need to consider that before a painting becomes a painting it exists for children as colors and paints to explore. Children create exceptional art in the act of playing with colors and paints. School painting sessions can evoke the spirit of children's experimentations as they develop their own painting process and discover the techniques that will be used in future paintings as they uncover the future of the art.

Adding Stuff

"Golden" paints has pioneered additives to their line of professional acrylic paints, yet children's paint additives are nothing like what the paint company envisioned. Children have their own experiments going with less fanfare from the art world. When parents are busy painting the house children are adding fresh blueberries to the color on the paint can lid. The exchange of stories and living to tell about it is an exciting exchange about what children can think of adding to paints.

Future art teachers can promote the collection and testing of strange color ingredients by students exploring new paint textures and colors. In an old mortar and pestle students can ground fresh spring petals and save items to be mixed with paints. In zip lock bags labeled secret potions, students bring fruit juices, strawberry drink powders, and exotic Kool-Aid flavors as secret potions for mixing with school paints. Students learn new paint mixing techniques with the freedom of knowing that paint has adhesives and anything can be stirred for a secret brew of new colors and textures.

Sampling

The colors children mix can be sampled, as children find ways to make sampling into an art. Children display spoons used to mix paint with, and Q-tips dipped into their color finds as paintings. One child dipped her favorite mini-object collection into the colors she invented and exhibited them inside a clear collector's box.

Future art teachers can promote the opening of color stores for displaying color samples. In a student's ice cream store, balls and shaped sponges dunked into freshly made colors are set in ice cream cones. Students serving and displaying color finds invent exciting new canvases and techniques to showcase ice cream flavors in paints. Dunking and bathing objects in color mixing containers saves students color samples, allowing mixing adventure to be documented. Dunking with fingers, tongs, or tweezers, finds playful techniques of covering with paint all kinds of surface of forms. It's fun to try flavors at the ice cream parlor using small white tasting spoons. Children collect tasting spoons for sampling colors of paints they mixed and stirred.

Color Matches

Children are stirred by the colors of objects such as rocks and will instinctively save an item because it has a magnificent color. Paint mixing experiments are inspired by children's nature finds and pocketed treasures. Color finds are strong visions for the colors children want to make. Examples of beautiful color brought to class can become models to strive for what is stirring in mixing cups.

Future art teachers may ask children to set up the results of their portable samples all around paint mixing sites to match or document color experiences in paints made. Being moved by colors inspires collections, samples, which influence color ideas for a painting. Art teachers can encourage students to look with all their eyes, and make ordinary trips to a store, and extraordinary nature walks as things that can be put into a mixing cup and prepared for a painting.

Concluding Thoughts

Teaching painting techniques to children can be described as a series of memorable explorations to remind students of their own painting plays, paint and color interests that form the foundations for painting techniques. To learn about children's unique approaches to painting helps to appreciate the inventions that advance contemporary art, as well as understand the painting experiences, ideas, and techniques they already bring to class. Art teaching is inviting hope and teaching painting is a means to discover the new, to feel open and confident that painting is a way children are able to make contributions to their room and a changing art world.

The techniques and processes explored in a painting class involve hands-on explorations of all paints and tools that may be applied to painting, as well as finding new surfaces as unique canvases. It is playing with all aspects of paint and painting so that children maintain the courage to discover painting in all places and actions. Future art teachers can involve students in processes that encourage seeing painting everywhere, making painting with everything and exploring new visions for what painting could be. Painting processes and techniques in an art class expand upon children's experiences and painting interests as they give birth to new revelations about the future of painting. See Plate 2.6.

HOW TO SHARE PAINTINGS WITH CHILDREN

In the past showing paintings to students in school generally meant the paintings of adults, the masters of painting. Reproductions from great museums used to be projected or shared in print. Later the familiar choices from Western Civilization came to be expanded to a heritage of paintings from women and other cultures. But what paintings children were really interested to see was seldom considered, nor was children's painting added to the mix of worthwhile paintings to view.

Children need to see the paintings of other children. This sharing is important and should take place in art class, where conversations can refer to children as painters, and what they make as art. Children will be inspired by other children's art, as adult artists of the twentieth century found their inspiration in children's works. In order for children to take what they do in painting seriously, to pursue it with courage and pride, they need to see their art held up in class with the highest respect. For children not to feel that they need to become adult painters to make paintings that are important, they need to see their art, children's paintings as a worthwhile goal. When children see their art admired as great painting, they will understand the folly of adults worshipping and paying high amounts

for the works of a few children who can mimic adult painting styles. Sharing children's art with children demonstrates the differences between adult and children's painting and affirms the originality, beauty, and uniqueness of children's painting.

Children need to see the paintings of adults. But under what conditions are adult paintings shared with children? Side by side, teachers sometimes show students adult paintings that the younger artist's piece reminds them of, and feel that they would benefit from viewing. Although demonstrating good intentions, adults show children what their painting looks like, what it may be closest to if classified in adult terms, what it may derive from. This simple act can lead to great misunderstandings about the nature and intent of children's painting that is not to copy adults, and a misrepresentation of how painting is learned, that becomes hard to rectify. Children easily pick up the wrong message, thinking that the adult paintings they are shown is the art they are to strive towards, or worse, feeling that their art has already been thought of, made, and there is little more to do than imitate. Adding insult to injury, sharing adult art in class is sometimes accompanied by asking students to copy and reproduce adult paintings as a legitimate exercise.

Adult paintings can occasionally but carefully be shown to children as clear examples of how adults were inspired by children's art. In each instance it is crucial that children are made to feel that they are the originals, that their contributions have changed the course of contemporary painting. Paintings that artists declare were stirred by children's art are encouraging examples to young masters. Children can also search for and collect the works of contemporary artists who are child-like, and have interesting ties to children's paintings, discussing what adult artists may have learned from children. Students discovering adult paintings can be proud of the models they have been and enjoy the interpretations adults were able to make.

Not only children's paintings need to be shared with children, but their painting interests and expertise. Children can show their paintings recognizing them to be collectors who are seldom asked to bring paintings they collected or found to school. Showing children's painting to colleagues needs to be as common as adult art that is demonstrated to children. Paintings children feel affection for can be considered an important priority for classes to view. The paintings children show in class go beyond the already acknowledged world treasures. Some of their painting examples are painted on skateboards or contemporary T-shirts, beach towels, and flip-flops. While it took the past decades for the art world to catch up to accept the wide notion that children have of painting, the adult paintings children bring to share in class opens important contemporary areas of paintings to study.

Credentials and Recommendations

Sharing paintings in an art class does not have to be a matter of only conveying knowledge or standards of culture. Sharing paintings can be more effective and memorable as an intimate exchange between students and the teacher. The question of who are you to select paintings to share, what are your credentials can be set aside. Are you a certified art critic, a museum curator, or an art historian, is not important. Art teachers who paint, and children who consider themselves as painters, now can be welcomed into the discussion as experts.

As art teaching has turned towards building confidence not only to make paintings, but to reflect on them, everyone can bring paintings to class and talk about their paintings and art collecting. Today's art classes recognize how important it is for children to talk about their art with authority, interest, and appreciation. While the professional, the star painter, the authority on painting has a voice, children have important things to say and share about painting if someone is listening.

Experiencing Originals

There is no substitute for experiencing the original. Those who have only seen paintings in books or PowerPoint presentations are deeply moved when seeing original paintings in museums. While collecting beautiful art books is a habit to encourage in students, PowerPoint viewing completely alters the color, warmth, scale, and media feel of paintings. A virtual tour of museums cannot match the feelings that encountering an original artwork provides. Teaching art needs to concentrate on encounters with original paintings and not only be concerned with the knowledge or information that is presented by media studies of painting.

Students in art classes can come in contact with many original paintings. An art teacher generally has available a good collection of their own art and works of other artists. Students in their home not only have their own art but also the works of family artists, and collections to share in class. Removing paintings from walls at home for class experiences and discussions is worth every effort. Paintings brought from home by students and the future art teacher

arrive complete with stories and knowledge. They are treasures, not just information that makes looking at paintings in an art class a unique experience.

The Special World of Art Collectors

Being an art collector evokes images of wealthy patrons of the arts displaying their investment treasures in airy, designer homes featured on fine magazine covers. But collecting paintings and sharing it with others can be the hobby of not just the Rockefellers. Children who are often dedicated collectors of many things can easily be inspired to collect paintings, an interest that can span a lifetime.

The earlier one starts collecting paintings, the better chance that paintings will be appreciated and valued, an authority and confidence that goes with collecting. The collector can be encouraged with a classroom slogan, "Down with reproductions." Original art can be displayed in art rooms, schools, and homes that invite collecting paintings. This can be further encouraged by the future art teacher's community education. Art on loan programs initiated by art teachers and their students can be advertised and dispersed for a small lending fee, in community settings. Instead of reproductions of paintings and posters of exhibits hanging in dentists' or pediatricians' offices, they may have up original framed paintings made by students as community artists. The students' frames can be collected from yard sales and visits to artists' studios. Children are tasteful collectors of other children's paintings. Art room trades and auctions can foster selective collecting through the exchange of student art.

Meetings with Painters

Arranging meetings with painters can embrace young painters visiting artist studios. Painters meeting painters can be unforgettable moments. Studio visits are important opportunities to share paintings and every detail in their making. Students see the tools and materials used, the set up of spaces for privacy, light, inspiration, and learning about the rehearsals and extreme dedication involved in making a painting. Listening to artists talk about their painting plans, paintings in progress, and completed series presents many sides of a painting life. Future art teachers need to consider ways of creating realistic impressions about who the painter is, what they do, where they do it, all of which is not visible in a reproduction of art or even a museum visit.

While visiting artists programs are often available at a university, they can also make an impact in the elementary school. Having artists bring their paintings to school, listening to artists talk about their work, offers great insight into the creative process that ends up with a painting. Artists talking about their own journey present an entirely different perspective of painting than people who talk about it but don't paint. Inspired by the presentations of visiting artists, students themselves can learn to present their own paintings to audiences. Children may interview each other after a painting is finished, reflecting on the process and offering insight into finished works. Students can practice sharing art, taking paintings they made and presenting them on open school nights, or to adult audiences at a senior center.

Sharing What You Love

Teaching in art involves sharing the art teacher's artworks, favorite paintings, and art books. An art class can also take turns, showing what children love, their favorite paintings, valuing the painting interest of everyone. It may not be so much about listening to erudite lectures about painting as having relaxed conversations about paintings we like. It is sharing painting interests without the pressure to speak a new language, to use correct words, but to express in everyone's words and feelings what they know and like about a painting.

The art teacher and students speaking about their own painting can converse from the heart. It is personal sharing, not just talk about any object. Sharing paintings can be most powerful when demonstrating paintings that move the artist; the art that makes one smile, feel good, or even bring out the inner tears. Sharing one's own paintings can be a moving experience and often a good place to start. Painters are qualified to speak about their own art. Future art teachers may disclose major influences and momentous discoveries in their painting life.

Talking to Paintings and Talking About Paintings

Sharing paintings can be a celebration of children's curiosity and innocence instead of the typical study of art. A student writes a love letter to a favorite painting. Another narrates a journey across a painting. Sharing paintings in an art class can be a fun experience of storytelling and fun ways of presenting ideas about art. Students can sit

with paintings on their lap, instead of silently standing before a wall. Talking through the work like a ventriloquist uses their dummy establishes a playful feel for conversing with and through a painting. Paintings can be shared as creatively as they were made. Humor, silliness, even a sense of childhood mischief can be used in presenting and sharing paintings with audiences.

Concluding Thoughts about Painting

A significant aspect of being a young painter is learning to share one's art with a public of friends, family, and strangers. To learn about painting in general is to find and collect paintings in children's books and other places, to share and talk about works besides one's own. The art class is not only a place to make art, but to learn to love and appreciate all kinds of paintings.

A painting class may be the first place to notice and be enchanted by someone's art. Future art teachers may disclose their first loves, the paintings of Kandinsky, before children who are inspired to seek their own painting interests and painters they may admire. Every art class can include a creative show-and-tell relating children's painting finds, opinions, and interests. Adults often present great art to children, but children also have their painting worlds to share. The challenge for future art teachers is how to involve their students in the world of painting as collectors, presenters, and experts of art. The question can be how students can be provided with opportunities to share their paintings and art interests, their choices, likes, taste, and painting dreams with others.

Teaching painting is to maintain the passion young people have in painting, to make children's love of painting something they can share. Students need experiences in mounting painting exhibits, wearing paintings out in public, conversing widely with audiences and other painters, sharing ideas about painting. See Plate 2.7.

Creative Planning and Topics for Group Discussion, Activities, and Extensions

- Discover what the latest in children's collecting is. Look for your old childhood collections. Prepare both by placing them into new containers in order to get them ready for the journey into your future classroom. Share the containers with future art teachers as you discuss how they can be related to teaching art.

- Begin a collection of non-traditional paintbrushes (i.e. sponges, feather dusters, Nerf balls, scouring pads, toy truck wheels, etc.) and non-traditional painting surfaces (i.e. light switch plate covers, drink coasters, place mats, tablecloths, pillowcases, and jewelry boxes, etc.).

Creativity is allowing yourself to make mistakes. Art is knowing which ones to keep.—Scott Adams

Section Five Printmaking Explorations

THE PRINTING ART OF CHILDREN

Printmaking is a means by which children discover surfaces and textures. It is as exciting and natural as discovering one's face in a mirror, or the shadows that attach to one's limbs. In printing acts children extend their reach to form marks and patterns in the texture of foods and to carry sticky fingers over the high chair, printing them on walls and beyond. Children's printing may appear to be simply making a mess, yet it is a means of finding expression by getting hands into substances that feel good and extending the pleasure. As children are given spoons to eat with and straws to drink, they also receive more tools to expand their reach and printmaking repertoire to press, dunk, multiply patterns, and leave prints.

Printmaking is discovered in childhood, when every child learns to be a printmaker. The birth of printmaking is seldom an art welcomed by adults. It is confused with just

being messy, or defiant, remedied by constantly wiping children's printing hands. A child's printing is experimental, and uncharted home experiments have their limits. While there are different levels of parental tolerance in every household, for future art teachers it is important to study early attempts to make prints, including the media and various surfaces children explore to break the calm and cleanliness of house rules. Art teachers' study of early printmaking helps to identify children as artists and printmakers and to further celebrate their discoveries in school art classes. This changes the notion that only art teachers can teach the proper ways of printmaking to those who don't know how. Future art teachers may instead look at printmaking as reconnecting children to their printmaker selves by expanding on the interest of touching interesting surfaces and reproducing one's touch, and providing opportunities to rediscover and celebrate the printmakers we are.

Food Printers

Lots of printing happens on the high-chair trays of young children. Toddlers enjoy their baby foods, puddings, and mashed up bananas so much that they are willing to spread them all over the tray. Sticking fingers and hands into food is one of life's early pleasures that start in the high chair and continue by dispersing prints on tables and over tablecloths, placemats and bibs, just about anywhere there is a fresh canvas. Children will continue their first monoprints using hands and utensils because it feels good and looks interesting, even with the growing risk of disapproval. Before discovering stamp pads, children will put their fingers into food and drinks to study them by transference to a tangible printed form. We find children's hands and fingers printed on tissues, walls, or their clothing. Handprints, like many other children's prints, are unique in their multiple and playful variety. When allowed to print freely, children will make many prints of their hands in many positions, and like Olympians they capture their moving body in fast-paced marks. Vigilant parents learn to get paper ready when children are near food. Unfortunately by constantly cleaning children's hands, parents wipe out many adventurous prints over unexpected places.

All foods can be printed; in fact some, like cherries and blueberries, even come with their own inkwell. Soft printers like marshmallows are extremely malleable to create infinite variations. Mr. Potato Head was born in 1946 as a game. During that time he had many good friends including Mr. Carrot and Mr. Pepper. They would be jealous today to find out that only Mr. Potato Head is still

popular in school printing (the carved potato remains the number one school surface used to print with). When children do vegetable printing, they are equal employers, cutting and carving printers from whatever is in the refrigerator crisper bin. They extend their search to fruits and nuts, wanting to try all things in the printing pantry. When young artists gather foods for art class printing there is a cornucopia of goods, with some of the more unusual prints made with banana skin and grapefruit sections.

School printmaking can be informed by the satisfactions of finger and hand printing and the child's willingness to test all media and surfaces when it comes to official printmaking. While children enjoy blueberries, fresh blueberry prints will appear on soft white napkins along the way. If there is deep black coffee left in dad's cup, it is not surprising that it will be test printed with a stirrer and spoon, leaving fancy marks and deliberate patterns on napkins or paper towels. And so children continue to associate foods with feeling and eating with the spreading of colors and patterns. What starts out to be a side project becomes a growing interest, and children are happy to demonstrate their new proficiency as food printers.

Art teachers can demonstrate their interest in children's early printing exploits, viewing it as something valuable and worthy of preservation. Which foods can be served in the art room? Which foods are the best media to duplicate and encourage further exploits? Will a palette of Kool-Aid colors inspire young printers? Should printmaking in the art class start with hands and fingers, spoons and forks, and what other tools can home printers use and gather? Which home surfaces can be used to print on in school? While art-room prints with tea, condiments, or fresh berries can be better preserved and receive a risk-free welcome, it is important to remind students of their humble beginnings playing with their food.

Earth Printers

Nature as a vast and open depository of textures is a place to find clues to the efforts of young printmakers. Examining the dirt in a playground is like being an ancient tracker, following footprints for clues. In fine dirt one notices the remains of impressions that were left not by outdoor creatures but by playing children. When playground floors are studied after a rain, one may come upon repeated prints of rocks and pinecones and children's impressions resembling petrified bones.

There are many opportunities to make prints in the park or schoolyard, in an official sandbox, or an informal area of

dirt. Art teachers may designate printing sites with brightly colored surveyors' flags and bring out tools like pieces of wood or rulers to prepare the ground. Printed impressions in the sand are precursors to children's interest in stampers. Gently pressed against the dirt, or powerfully stamped, all fine things in nature leave beautiful impressions.

Paint Printers

Children print their feet in white snow, and use their hands to print with water, but the first color prints they make are with paint. At a birthday party in the back room of a toy store, balloons and the whiff of cake and fresh pizza welcome guests. On a long table covered with white paper the planned art project is ready to go. Every child is seated before a "pre-baked" plaster cupcake mold. Young celebrants are asked to "decorate" the cupcake using a little brush and tiny tubs of paints. With painting in progress, children simultaneously test their brushes, fingers, mom's keys, and whatever they can find around the room by pressing them against the paper table cover.

Art teaching is an opportunity for art teachers to save children's printing ideas and sites like the table cover and other canvases they use during home printing occasions. Art teaching is about importing to class the children's stories and images that represent their wide range of printing interests.

Concluding Thoughts on Printing Explorations

A good way for teachers to recapture their own first printing experiences is to detail it in a biography entitled *Growing Up as a Young Artist.* Among the first chapters there can be a personal history of the child as printmaker, since everyone has an interesting history of participation in this basic art media. Every page from such a biography can be used as a story to tell to an interested audience of future art classes. The entire book can serve as a guide for planning the printmaking experiences of students. The printing adventures art teachers participated in and discovered in childhood will ring a bell and be recognized by students as a basic printing course they themselves had.

Children arrive in school having performed many printmaking experiments, and it is up to art teachers to recognize children's home accomplishments. School print-making may appear more complex as children get older and are introduced to new tools, terminology, and printmaking

techniques. Yet it is important for teachers and their students to recognize that all prints relate to the earliest pleasures of discovering printmaking as children. Every-thing in later printmaking relates to the first discovery that one is able to reproduce one's fingers and hands, and that objects with interesting surfaces can be saved and printed over and over again.

The more printmaking becomes a formula or technique demonstrated by adults for children to emulate, the less likely that printmaking is viewed as a form of invention. So the challenge of teaching printmaking is to keep the art form alive, to feel as if it was just discovered and not to box it in with ready-made tools and materials. Printmaking for children has to carry the feeling that the door to fresh printing ideas is never closed to them.

BUILDING ON HOME PRINTING INVENTIONS

School printing needs to be related to the home printing art of children. Most school printing lessons can start at home and be prepared by students who bring their objects and ideas to class. To make the tie between home and school realistic, art teachers have to remain close to home in their studies, observations, and thinking, and not be swayed by printmaking as it has been practiced in their college studio classes. For example, the future art teacher should not be put off by silly printing deeds, funny ideas, and unsophisticated techniques performed at home. The question is always how home finds can be interpreted, further explored, and expanded in art classes. Printing lessons can always "quote" references from home printers and show examples of their works. Printmaking is most free and most open for children in kitchens and backyards. The art class needs to represent this sense of freedom and keep printmaking an open subject as long as possible for students. Home printing interpreted in school can be a series of challenges—eye and mind-opening experiences that allow printing to remain fresh and close to how children naturally practice it.

The art teacher needs to establish printing not just as potato prints but as a boundless array of possibilities, a gate of printing fantasies and inventions. Printmaking teachers should impart to students the message that all the forms with unusual patterns that they want to keep and pocket they can print. Transferring them into a more manageable print or impression of the original can save the textured treasures that they wish they had a truck to haul.

Reporting on Home Finds in Class

Art teaching can enlarge the awareness of valuable home-printing play and encourage a printer's eye for seeing printing possibilities everywhere. A valuable class activity is reporting on daily printing finds outside of school. Children who scan the ground can uncover interesting shoe prints, bike and car tire prints, or bring to class photographs of pigeon prints.

How Can It Be Printed?

Children who make prints at home don't consult a guide to techniques or tools or wait to buy the appropriate inks. When interesting events suggest opportunities, children find ways to print what they want. An art teacher can further children's open thinking without demonstrations of the correct way to print. Giving demonstrations on proper techniques accompanied by a study of vocabulary words suggest there is only one way, when in fact the process is endless. Instead, art teachers may learn to constantly ask questions by holding up objects and asking for suggestions.

Speed Printing

Handmade prints are a result of action, and children are speedy and impatient actors. It is difficult to know for sure where their knowledge of rubbings started, a most versatile and individual form of printing, but it is safe to say that most children have rubbed a coin, or had at least similar printing encounters before school. Captured by the magic of a developing image, like a picture in a photo tray, children quickly rub with the wide side of their crayon to make it appear faster. Before one can say, "Don't step on a crack …" they've already rubbed the cracks and if the paper is large enough, an entire sidewalk. With such super speed, it's easy to rub vast surfaces and even extraordinarily large objects. Children are challenged by size, draping paper over a huge boulder, or wrapping paper around a tree trunk to feel and rub its bark. As much as many children love coin, rock, or shell collecting, they enjoy keeping their favorite objects as collections in the form of rubbings, often trimming and cutting out printed impressions.

Body Printers

Our body is among our first printing tools. Fingerprints allow children to see themselves in their impressions tran-scribed as minute details. After seeing themselves in mirrors and photographs, printing extends a child's search for different ways of seeing their image. When children are asked to bring some examples of their home printing to class, there are wonderful surprises. Children will recognize a great print by seeing their mom wipe off her lipstick at night on tissue paper. When the lip prints are brought to school, they come with a story and an informative demonstration. To show how a print was made, some students are willing to bring tissues and extra lipsticks to demonstrate. Of course other students are eager to try what is sometimes called "kissing paper." Art teachers can encourage all kinds of body printing ideas from home to lead the art class. At home children will intentionally step on a wet floor, and use the wax, or floor polish, to check out the footprints that can be made all over the house. There are few things more fun and that make students immediately more comfortable than taking off their shoes in school. Foot and toe prints just feel good and are fun to create on paper-covered floors. Body printers like to be challenged and have a wealth of responses when asked, "What would be more difficult to print—an arm, a nose, or hair?" Students are willing to debate and brainstorm about original techniques for doing each one. A new form for family albums is inspired by children's first footprints that parents treasure; children constantly expand from there with their own body printing ideas. After graduating from basic training, students are eager to go home and get started with boundless ideas such as gathering family members' fingerprints as well as lip, nose, and ear prints.

Post Office Printers

Children want to go to the post office to accumulate printed labels and forms and to see the carousel of large wooden stampers on the counter. If there is no line, there can be conversation about the stampers and perhaps an opportunity to try some. After returning from the post office, children often play post office, just like they play school when coming home from school. In home post offices children print forms, make stamps from stickers, or stamp over different envelopes. With stampers in hand, children find a dancing partner, joyfully dancing over items like stamps and passports to imaginary destinations. Stamping is an important form of home printing art, yielding a bounty of ideas about printing for school.

With the availability of found objects and simple supplies, art teachers can encourage their students to be

stamping inventors. Students looking through art room bins, find ways to make original stampers by adding layers of tape, weather stripping, or designs made on cardboard with a stapler, added to a platform of wood. Many objects are auditioned, and only the students know who will get the part of the best-found object to become a found stamper.

Art teachers can support children's interest and willingness to be on constant lookout for objects such as thimbles, furniture leg protectors, or bathroom plungers, which can be used to stamp with. The art room can be a place set up for testing, trading, and displaying, student's various stamper finds. Stampers have a long visual history as toy prizes and in commercial applications. Vintage postal or supermarket price stampers and Red Rider Ring stampers are highly regarded collectibles and can be displayed in the classroom. Stamps and stampers have an illustrious history that can be given proper print art recognition by fans of the post office.

The Sounds of Printing

With music on in the car or at home, children sense the rhythm, and if they happen to be stamping, coordinating instruments is a natural extension. Often children put on their favorite music for stamping, or they may prefer quiet while listening to the percussive sounds created. All art forms are imbued with special soundscapes, and the drumming in printing is a distinct art sound. When a child stamps over an old piano roll, it's contagious; everyone watching and listening is ready to dance to their own music.

Future art teachers can "deejay" the music, or use the sampler on a synthesizer to play jazz, reggae, or rock music for students to tune into and move their stampers to. To take a stamping solo, a student draws musical lines over an EKG roll and lets the stamping rock. Art teachers may pretend to lead the band, or conduct the orchestra in a stamper's jam. Printing events dedicated to music making can feature improvised sound and visual patterns. With drumsticks, or other devices dipped into ink or stamp pads, there is no question that stampers can be the coolest of instruments.

Kitchen Printers

The kitchen is one of children's first important printing studios. All kitchen tasks are closely tied to printing techniques. For example, each baking technique and tool in which one may use a child as a helper also prepares for printing skills. Dough is printed with cookie cutters, and pasta can be printed with a bladed rolling pin. There is plenty of printing involved in making a salad, barbecuing meats, or making a sandwich.

All kitchen tools can be applied to printing in school. Under the sink, for example, there are many types of scrubbing tools, sponge printers, some sitting on top of dispenser bottles just waiting for a print. Another drawer has cookie cutters, which are already used for dough printing but can be tried as stampers in different printing modes. Spatulas and strainers make different kinds of printing tools; one may be tried as a freestyle stamper, the other as a printing screen. Even the small cork bottle stoppers in the corner of a drawer can take a textured printing turn. Out of kitchen tool trials a wealth of new images and printing ideas emerge.

Art teachers can encourage students' exploration of all foods and kitchen tools by setting aside printing days that deal only with the kitchen. It is also helpful to have students do the shopping, so that they come to class not just with tools or ingredients but printing ideas for them. The Kitchen Museum curates shows of all-important print works representing kitchen art. Exhibits that are curated by students tend to have funny names, such as The Art of Printed Pastry and Fly Swatter Prints. In an art class students can consider all home tools and chores for printmaking possibilities.

Printing Possibilities

A "big girl" empties a shopping bag filled with her old bottles and moves with unbridled enthusiasm to refill it and play baby. Children can pick up anything and use it as a toy—in this instance using the rubber nipple of a grape juice printer pressed against an old bib. Children discover printing opportunities and practice them everywhere. School printing techniques for children keep printmaking as fresh as a new bottle of juice, like a toy to explore and play with. Techniques are open to invention, and as juice flows, the future of art is discovered.

Children's prints are not adult prints and should not be compared to adult prints; similarly they should not be asked to use only adult printing techniques. New print worlds are constantly discovered at home and polished by their acceptance in school. Home attitudes, such as anything can be printed on any surface with any media, is a useful mantra in school art classes. The ideas, skills, and

FIGURE 2.5 Driveway Print

confidence gained in home printing can be caringly maintained in school. Art teachers need to believe in the young printmakers who come to school eager and ready to print. When printing is driven by a sense of adventure, invention, and discovery, students build a personal tool chest of techniques and ideas.

TECHNIQUES AND PROCESSES OF SCHOOL PRINTMAKING

Printmaking has traditionally been taught in art schools as a kind of technical drawing. A preliminary drawing is created to be inscribed on a piece of metal or wood and through technical means; chemicals and presses are used to lift the impression. School printing, on the other hand, can derive its methodologies from children's interest in discovering interesting surfaces and finding informal ways to save them.

Children print to touch a face, to become aware of the complexity of a leaf or the feel and vastness of the sidewalk. Printing allows hands or feet to dip into things and leave marks on others. Children use printing to explore interesting surfaces and to make fascinating patterns. Printmaking is not just a skill but also a valuable tool for children to collect what they cannot pocket and to share special finds with a friend. Children use printing to make copies and multiples and to find magic in making impressions on all surfaces.

Young children can be described as surface detectives, feeling everything. Before anything is "inked up" there is an attraction to a surface, an awareness that it has something special. By printing something, a child is making a sign for everyone to take note. Printing, like rubbing, helps to preview the surfaces touched and admired. School printing

can follow the path of searching for forms that have interesting surfaces and finding beautiful things with unusual textures and patterns to print.

Children print without paying attention to techniques. A printmaking session should not leave students "knowing how to print" but recognizing some of the fundamental printmaking techniques learned in childhood that offer clues to future printers. As students, children begin to refer to their surface inventions and discoveries as printing. Students leaving a printmaking session should feel a renewed interest in a subject they already had exposure to. They can leave with confidence and excitement about inventing new ways to print and searching for groundbreaking discoveries. The following segments describe some children's play-printmaking techniques that keep printing spirits open to further exploration.

Rubbing Textures

Students can be asked to look for and save for the art class their most interesting texture finds. A technique is to build a path starting from the classroom door, like a Yellow Brick Road winding through the classroom. Everyone is asked to participate in paving, using the carpet pieces, screens, and sandpaper brought from home. To experience the textures in all their rich variety, students are asked to cross the road barefoot so that they can experience the changing textures. Students can free crayons from their paper covers so they can be used long-ways like rolling pins. Students can cover the road, testing long brown roofing paper, softer rice papers, or transparent tracing papers. Rubbing is an art with many possibilities and personal variations in marking.

Rubbing Patterns

The art room tables are formed into a large horseshoe and covered with white paper. Underneath are surprises that can be felt but not seen. Students rub the mystery objects to uncover their identity. The hidden car mats, woven placemats, sink liners, fluorescent lighting covers, and doormats were selected for their unique patterns.

The search continues at home, in family closets for example, to find contemporary pattern art in sneaker soles. Students bring to school the best soles to rub and trade or to assemble into quilts. One student turns shoe prints into portraits while another takes off on the theme to create a zoo of sole creatures. Class trips expand students' interest and ability to look for new categories of patterns.

Stamping

Children amass a large portion of the world's stampers, yet they know that objects not intended for stamping can still be tried. Stamper collections grow when children are simply sensitive to the environment. Making art with stamper queens and kings may start from the beginning, with one object. With an ordinary stamp pad, students can be asked to pick any object, anything at all. A simple plastic fork, for example, can be used to print an endless series of fine impressions, each print different and generally more imaginative than the last. In a series of fork impressions students can be challenged to create some dark and other almost disappearing patterns on the page. They can be asked to build with the printed fork, to connect, intersect, and overlap them in patterns. Art teachers can encourage making stamping into an art by continuing the students' vigilance in building their own found and handmade collection and also by exploring the many possibilities of using a single object printer.

Carving

You can find test answers, poetry, and yearnings of love carved into old school desks. These carvings in school or on a park bench are notable ready-made markings that may alert a young printer to other possibilities. Soft erasers that have been painstakingly carved into or the pencils that have been gnawed by children's teeth relieve the anxieties of a school day but may also turn up as printable treasures as students are asked to look around and take stock of the carved environment. Interesting textures and patterns or complete stories can be found carved into surfaces that students identify as potential print sources. How to print an old carved walking stick can have many answers; for example, it can be painted with printing ink and rolled up in paper, or it may be used as a rolling pin with the inked surface moved over the paper.

Raised Surfaces

Inking up the raised patterns of a child's Lego table can show the fun of working with raised surfaces. A rubbing is first taken of the circular patterns to remind students how all raised surfaces can be previewed with a rubbing, before a dramatic full color print is made. Students can participate in all demonstrations, showing that they are skilled workers and reminded by the art teacher that there is no one way to print or even ink or paint a surface with rubber rollers, or brayers. Since the table is divided into four patterns, each demonstrator uses a different technique of rolling on their colors. A large paper is placed over the inked table to make the transfer. Students rub with individual hand motions and select from an array of objects to add different pressures and touch different points of the back of the paper. There are oohs and ahhs as the paper is lifted to reveal four vastly different images, printed from basically the same Lego pattern. A good demonstration may teach a general technique but emphasize the infinite options and possibilities that remain for each artist to discover.

Gathering Printing Paper and Much More

Students can constantly be on the lookout for interesting textured and printed paper and other surfaces to print on. There needs to be an array of choices to print on. When students do their own searching, they are very interested in the printed results. A young printer can contrast the textured surface being printed, or complement it. Coarse paper emphasizes a print's textures. For example, a student finds a large round and coarse floor-polishing paper and prints it on another rough surface.

The Final Sheet

Art teachers prepare and motivate students for a lifetime of interest in making and enjoying prints. Part of the experimentation and sharing of discoveries takes place in school, yet a major emphasis can be setting up home printing studios and making portable printing kits. Looking for textures and enjoying patterns everywhere and wondering about, touching, and saving them can become a young printmakers' constant activity.

Empowering students to constantly search and discover printable surfaces and bring to class the latest in metallic stamp pads are how printing ideas can be kept alive and ready to be tested in the art room. Teaching printmaking is to set up for continuous search and awareness from the toy chest with printable play-blocks and play foods, or fast cars with rubber tires. Printing activities can move to the larger world in the backyard, onto the street, or a subway stop to admire and print the patterns of old tiles on the floor and walls. Art teachers are charged with receiving surface finds and ideas from students and keeping printmaking adventurous, active, and fun in class.

In a lively printing session plastic hairbrushes with tiny ball feet bristles slide and shuffle to an old Boots Randolph song. It's fun to print with bouncing tennis balls over a fresh clay surface. Everyone is on their feet to follow the prints made by a bathroom plunger dipped in ink. The art class is the place to celebrate and applaud children's new printing discoveries.

A printmaking class has been successful when one sees children use printing for all kinds of things such as greeting cards, doll clothes for paper dolls, or preparing their own rock star road shirts. The art class can be a trading place, a printmaker's dream museum, a place to store surface finds and to borrow printing tools and supplies. Since many exciting surfaces reside outside the school, printmaking requires imaginative field trips to environmental sites, often suggested by what the students bring to class.

SHOWING GREAT PRINTS TO CHILDREN

Prints are everywhere. If children are asked to bring their favorites to class, they may present a collection of clothing tags that most adults would discard. Many children are avid print collectors, and even though their everyday prints are not what museums would seriously entertain as art, their choices point the way to many neglected areas of contemporary print art to keep an eye on. Tickets from a concert, a selection of business cards removed from store bulletin boards, contemporary shopping bags, illustrated cups saved from birthday parties are some of the prints shared in class. These prints are not made by hand or signed as art from the masters, but the mass-produced items are from influential forms of daily printing art that is valued by children.

Children's interest in collecting printed bank forms for their patterns is an important step in a print collector's life. Art teachers can ask students to show their print folios as a guide to class presentation and to learn about the broad printing interests of children.

Sharing Prints from Childhood

Art teachers most likely enjoyed a print collector's life that parallels their students'. Where to start a print show-and-tell? Perhaps by dusting off collections of stickers and stamp books. Students may never have heard of Pogs, but an album of Pogs is invaluable in demonstrating a teacher's childhood dedication to the printed arts. Pogs also demonstrate the fast pace of change in the prints children admire and collect.

Today's young collectors, who keep sophisticated 3D and hologram Band-Aids or tattoos, will be interested in the teacher's old Band-Aid boxes and soak-off travel tags. While it is fashionable today for children to save Kleenex dispensers, advertising prints in all forms have a long and

FIGURE 2.6 Game Board Print

interesting art history. It is valuable to recognize the art class as a place where collectors young and old meet to exchange the many interests they share.

Card Collecting

Children love miniature toys. They also enjoy trading objects including small prints. Baseball cards, initially called tobacco cards because they were packaged with chewing tobacco, have a rich print history. Students enjoy seeing the printed portraits of old stars illustrated in handsomely printed, sparse portraits against the saturated color background. There are also wonderful Barbie cards with the distinct look of the 1970s printed materials and the magic optical play of metallic trading cards today.

Old Maid, a children's card game with a history that reaches back to the middle of the nineteenth century, displays some of the finest printed images in the playing card genre. Vintage playing cards are still a bargain for future art teachers to own, and they are fine examples of great prints that students can hold and play with. With the advent of the automobile in the early part of the twentieth century, many fine playing card prints like Lotto were made for the enjoyment of backseat players. Collecting trading cards and playing cards is an excellent road to collecting other fine art prints.

Scrapbooking children's greeting cards is a popular American phenomenon. Fortunately this parental interest has also preserved one of the richest forms of fine prints, which can be enjoyed by all ages. Sharing the art of old children's birthday cards advances young printmakers' ideas about cutting and shaping, folding, and adding objects to the printed image. The shapes and forms of historic birthday cards, Halloween cards, and Valentines lead to lively discussion about prints and ideas about making them. Children encouraged to be greeting card aficionados may one day grow up to become curators of prints in a museum.

Showing Great Posters

One of the most familiar and interesting category of prints is advertising posters. Great circus and midway posters can be found in books and in such museums as The Shelburne Museum, in Burlington, Vermont. Posters for movies, rock concerts, chewing gum, soft drinks, or to advertise bicycles and children's board games can be brought to class. It is

important for future art teachers to look for some originals so that students can experience the layered colors, feel the size, and smell the ink. Art teachers who encourage students to become poster collectors and print preservationists can start immediately to build a folio.

Exploring Supermarket Prints

An awareness and fascination with prints can arise outside of museums. Children generally attend few museum exhibits and when they do go on a school trip, they are seldom guided to basements and back rooms where prints can be found. On the other hand, supermarkets are places children regularly attend with eyes wide open. Candy wrappers, cereal boxes, and can labels can be a good place to start enjoying the printing arts.

Art teachers can lead the way by sharing some of the history of prints featured in every aisle. To look for and build a collection of old bread wrappers is not difficult in an Internet world. There are also many books that trace the history of most prints found at the market. Teachers may want to specialize and focus their collections on masterpieces in fruit crate labels, or build a scrapbook of printed popcorn bags that will be shared, added to, and enjoyed over and over again with many students.

Showing Fine Fabric Prints

Future art teachers can begin their fabric search with children by looking for interesting fabric prints in pillowcases and sheets, vintage socks, sleeping bags, and umbrellas. Field trips to fabric stores are a memorable way to share the interest with students. Initially, students may not be happy when a teacher announces the trip to a fabric store. But once there, students are amazed at the inventiveness in patterns and engrossed in comparing prints. An art room can always be stocked with upholstery sample books or with the teacher's selection of sheets, comforters, towels, or tablecloths.

Becoming interested in patterns and fabrics enriches the stamping and printing vocabulary of students. When they hang their own wallpaper designs inside playhouses, students knowledgably converse about their influences. The Pattern House is a toy that students enjoy constructing to showcase fabric combinations and collections inside. The playhouse is a place to freely mix and match printed fabric sample palettes, to try out flooring ideas, wall coverings, curtains, and upholstery. Art teachers may

expand students' fabric vocabulary by showing the works of fabric designers. While the identities of wallpaper designers are as hidden as the backs of the paper on the wall, fabric designers like Zandra Rhodes and others have fine books dedicated to their art.

Modeling Wearable Prints

Noticing the printed fabrics students wear to school and rolling out a red carpet to model a fantastic pair of socks can start a new sense of fashion consciousness, but also an awareness of printing art. When students start looking forward to viewing the printed clothing items like the vintage Hawaiian shirts the art teacher wears to class, a new appreciation for prints that are worn is taking place. Mid-century styles can be worn in the form of printed aprons. Art teachers can look around for printmaking gear in the art they can wear.

The Final Print

Learning the techniques of potato printing and all the related vocabulary terms are not the only things that will open students' eyes and imagination to the vast possibilities that printmaking allows. Teaching printmaking is initiating students to the many possibilities of printing and uncovering the exciting vastness of printed images that surround us. Not being limited by formal processes and bound by known techniques, children are in a unique position to discover printmaking as their own art.

The task of art teachers is to look toward all kinds of prints for inspiration. Yes, there is nothing more exciting than feeling that one can make one's own prints. But along with the making, there is the seeing and discovering vastness and beauty that exist in the form of prints. Along with an enthusiasm, expertise, and confidence in feeling that they are printmakers, students should also feel that they are print seers, seekers, and collectors. See Plate 2.8.

Creative Planning and Topics for Group Discussion, Activities, and Extensions

- Arrange for a VIP tour of a child's room—their studio. Sketch and label all the things that caught your interest. Share these visits with future art teaching colleagues and discuss the implications for setting up and conducting school art classes.

- Begin a collection of gadgets that can be used for printmaking (e.g. plastic laundry soap bottle lids, toy truck wheels with texture, plastic forks, wooden blocks with textured surface, burlap, sticks, foam, inner-tube rubber, kitchen utensils, etc.).

Section Six Young Sculptors and Their Art

Imagination is more important than knowledge. For knowledge is limited to all we know and understand, while imagination embraces the entire world, and all there will ever be to know and understand.–Albert Einstein

APPRECIATION OF CHILDREN AS SCULPTORS

Sculpture was the depiction of the human figure in G-d-like poses in wood, or stone, cast in metals to stand for a fragile humanity, a sculpture was made to last forever. In contrast, children today pose ready-made action figures and create an aerobics class for Barbies as sculpture acts. Stuffed animals are arranged all over a living room in preparation to play school with a moving cast, forever changing in impermanent sculpting acts. Children's performances and animations are unique figurative creations to which they lend moves and voices.

Children's playful attitude towards found object, and the material world has also inspired adult sculptors. As adult sculpture moved off its pedestal and has joined the viewing public, other themes besides the human figure and other materials besides marble have come to be accepted for use in sculpture. Children have always enjoyed the freedoms

to play with all materials, building with sand and creating imaginative constructions assembling combs and stacking funnels. Children demonstrate a wide sculptural interest in forms and an open view of what can become sculpture. In a children's sculpture museum their transformations of the ordinary into the extraordinary steals the show.

It is useful for future art teachers who want to appreciate children's unique sculpture to compare the content and narrow technical emphasis of sculpture courses they have taken in college with their observations of children sculpture playing, making and building things. Future teachers may accompany their observations by collecting examples of sculpture children make from supermarket ties or the vehicles constructed from ice cube trays. A class in metal sculpture techniques or an advanced course studying the lost wax process is quite different than learning to teach art by observing children finding forms and making things.

American Sculptors

Children make instant sculptures from materials found in fast-food places and other American art supply stores. The modern foils and containers that form their sculptures are made not in studios but drive-in restaurants, or on a trip in the back of a car. They may not be exhibited in a gallery, but the performances will be appreciated on the road, and have many encores in playing at home. Like all-important art, children's sculpture relates to its contemporary roots, the American containers and condiments that are a part of our daily life. A wedding at McDonald's has the bride wearing white, a white fork dressed in a folded and shaped white napkin dress. The groom wears a flashy tuxedo, an ensemble of burger foils. The wedding party of straw figures is dressed up in sugar packets. Before the wedding reaches the society pages, children put their characters to rest and prepare for travel in a burger box.

Future art teachers can appreciate student's contemporary approaches to sculpture and support explorations of fast-food restaurants, supermarkets, and malls, as places to find and make art. Art teachers can welcome student's finds of modern ketchup bottles and stacking towers with Tupperware containers so that sculpture can rise from the forms of our time.

Transformers

The accessories box for the antique Singer sewing machine has been the favorite plaything for many children visiting our home. In the drawers of the sewing machine cabinet lie some of the robot assemblies made from the complex steel forms, that are still hard to pry apart.

Future art teachers can appreciate the transforming eyes of their students. As masters of seeing possibilities in found forms, students can explore mystery objects like antique oil wrenches, jar grippers used to pry open stubborned old food jars, or sewing machine parts turning them into mechanical toys and sculptures. Art room sculpture classes are gymnasiums to exercise students' sculptural hands and visions. Future art teachers can be regular shoppers at second-hand stores, buying up all kinds of mechanical mystery objects that engage sculptural fantasies.

Sculpture Spotters

Sculpture does not have to be carved, fabricated, or made in a studio. Children notice sculpture as interesting forms in nature, in a store, or in an object found on a sidewalk. Coming from school with heavy pockets, children bearing sidewalk pieces, select loose concrete, wrapping it in foil inside a sandwich bag. A children contribution to sculpture is a broad interest in forms and a selective vision able to isolate what is special from everything else.

Future art teachers can show their trust in students' sculpture finds, and use the art class to unveil and celebrate choices. Art teaching is encouraging uncensored search, digging and backyard excavations, sponsoring store shopping and city safaris as sculpting adventures. When homes are closed to the free importing of finds, students can continue to curate their special objects and transport them to an appreciative art room.

Block Players

Part of a future art teacher's education can be the observation of children playing with blocks. Notes on stacking towers, testing balances and connecting forms, creating volumes and patterns are clues to the appreciation of sculpture in an art class. From play blocks a child can construct an original camera without glue, nails, or sophisticated fabrication. Being able to fancifully create a physical world, feeling that one can make and build anything sustains the sculptural spirit. After block-playing children are confident that they can build with anything, that blocks can be erasers, ice cubes, or spools of thread. The extended freedom to build allows for discovering the sculptural possibilities in stacking dust masks, kneepads, or shoulder pads. Children observed using their 'trusty' block sets from wood blocks to found objects are ready to test the world of three-dimensional forms.

Future art teachers can appreciate block playing as the basis for all three-dimensional art. Students happily set out to discover surrogates for official play blocks, and build their own signature block sets, from soft blocks like sponges and erasers, rolling blocks like hair curlers, or large scale building blocks like detergent boxes, or storage units. To be appreciated is how students freely bring lines, like straws, planes, like trading cards, and even their figures and toys to include in block sculpting. One can reach the crown of the Statue of Liberty by stairs or an elevator, but a large pet sanctuary sculpted from packaging materials features a rope and pulley system to move toy animals to the top. Building blocks are often abandoned in school, yet they need to remain a mainstay of the art class, used to find and try out ideas in block plays. Since each block set has its freedoms and limitations it is useful for students to play with vintage toy blocks they have not tried before. The art room can also be a place to test all new block sets in stores.

Assembling and Taking Apart Sculptors

Children always seem to have their tool belts ready for items that require assembly. Adults however need to be warned that young mechanical assistants are fanciful sculptors that have no use for instructions, and are quite willing to deviate from plans to take impulsive detours. If a box says assembly required, children will be glad to use the parts, but the intended functionality cannot be guaranteed. It is not their main objective.

Children appreciate interesting parts of a shelf to be put together, or a phone they can fix and take apart. They are fascinated by the beauty of the shiny screws and washers, springs and hinges as sculpture and see in them many artistic possibilities. Future art teachers can appreciate children's interest in assembling objects and the desire to look inside forms by taking them apart.

Student's interest in construction tools, nailing, hammering, and in using screwdrivers on things has wonderful sculptural consequences. In art room shops, there can always be raw materials to assemble, there is wood, shelving parts, with amazing parts-boxes and toolboxes to foster any construction dream.

Organizing Sculptors

Children will stand and watch in amazement, even offer to lend a hand to supermarket stock clerks arranging a great wall of cereal boxes, or piling a grapefruit mound. Children come home inspired to sculpt in the pantry, with the pretext of helping to put away the groceries. Refrigerators are self-contained floors and galleries that children enjoy "straightening out," especially if they have carte blanche to empty and re-organize all the various forms in play. Everyone in a family is invited to openings of medicine cabinets, pantries, and re-organized refrigerators presented as art. In every home there is no shortage of drawers in which to practice the set-up of clean socks, or the straightening out of family jewelry. All closets and shelves can be open to design ideas and the practice of sculptural sorting, stacking, and aligning forms.

Future art teachers can appreciate their students' interests in straightening up as an art form and provide opportunities for sculptural arrangements of art supplies and items students import to class. As a constantly busy shipping department, any art room always has boxes to open, shelves to stack, and counters to arrange. Students can keep records, drawing, and photographs of special arrangements as they clean out spaces to restock and refurnish their world. Sculpture projects can use the students' passion for organizing and arranging forms as a blueprint for new forms of sculpture

Dough Sculptors

Every young sculptor has kneaded and shaped snowballs, sand, and dough in assisting parents with baking. There are few, more memorable sculpting experiences that children come to school with than shaping rolls, breads, and cookies in the kitchen.

Future art teachers can appreciate children's free handling of flour, as they distribute chef's hats in celebration of children's love for building with soft and gooey substances. Baking in the art class with soft materials evokes an appreciation of bread forms, art classes that smell from fresh baked goods, practice creative sculpting. When clay finally reaches students' hands it may not be ashtrays or coil techniques that dominate their sculpture, but the heart of free players with dough guide their hands and hearts.

Toy Makers

Children don't think of sculpture in adult terms. They play with objects and make things that are playable. The beauty in toys that children sculpt is the simple and imaginative adaptations of found objects. Instant toys are quickly made to suit a play idea or occasion. The need for a doll to sit will

prompt the shaping of an elegant couch out of folded cardboard and fabrics. When adults need a couch they look for designed objects and may even call in a designer to assist. Children still feel like designers, with the confidence of making things and arranging forms in their playhouse, or making things for their room. As long as children feel they can make their own toys they sustain a sculptor's confidence to be able to make anything out of anything else.

Future art teachers can demonstrate an appreciation for children sculpting their own toys by sharing examples and making most sculpture in the art class playable, toys that can be taken home and played with. Students can demonstrate how they made a limousine for their party-bound doll from a shoe, and turned a computer keyboard into a guitar for a rock event. Most art room sculpture can be based on toy themes, such as performance stages for which students sculpt the stage, props, and performers. Rolling sculptures may feature pull toys, circus trains, or a parade float. Future art teachers can encourage children as toy makers and set designers for playing with their toy.

Wearable Sculptures

Children are not pedestal sculptors, and in order to appreciate their works one may have to look at their wrist, at the sculptures they make to wear. One may notice the planned entanglement of scores of colorful "friendship" bracelets, woven from yarns and embellished with buttons and metallic paper clips. Wrist sculptures currently include star, flower, and animal shaped Silly Bands that children collect and add to their wrist bouquet. Like the art of flower arrangement, sculpting wrist jewelry is putting together store-bought, self-made, and found forms.

Future art teachers need to be admirers of fads and styles as they appear in class, considering how the wearable items can be further explored as children's art. Inspirations from wearable sculptures, jackets with button collections, or key chain planted backpacks filling another wearable surface children design as fashion statements. Future art teachers need to expand their definition of jewelry and art, as they learn to appreciate the unusual things students hang from belts, or are worn around the neck, or wrists, tied to shoelaces, or headbands. More original sculpture is worn to class when students know it is noticed and appreciated. Future art teachers will recognize that young students are not inhibited to try on things; to wear lampshades as helmets or get inside an air conditioner box to build a 'cool' Halloween costume. Children's willingness to

pose wearing any object and find interesting forms to tailor, allows for all kinds of wearable sculptures.

Stuffing and Inflating Sculptures

Ordinarily children's pillows are well dressed in personally selected character pillowcases. Children take their pillows and other soft sculptures seriously. They may use pillows for a pillow fight, but also to build monumental constructions to jump on, or soft habitats for stuffed animals. Like beanbags and sleeping bags, pillows are personal forms to cuddle in. Many children sculpt their pillow forms and play with the stuffing. Sculpture from 'cotton clouds' and cotton-balls are made with the freedom and abandon of jumping on soft mattresses. Children enjoy momentary soft forms such as bubbles; blowing great silvery shimmering sculptures that vanish, leaving great images and form memories. As balloon artists children love the process and changes during inflation. It has similar appeal to being allowed to use the bicycle pump to inflate play-pools or sculpt swim rings.

Future art teachers appreciate children's special relationship with soft forms; stuffing them, jumping on them and cuddling up to sculpture. Classrooms are not for sleeping, yet dream sculptures include stuffed play beds, pillows, sleeping bags, and stuffed creatures that inspire a good bedtime story. Stuffing is students' love and interest that can be appreciated by stuffing leaf-bags, shaped by hugs and by jumping on them. Collected in an art room are all forms that can be stuffed, inflated, or built with soft inserts.

Appreciation of Sculpture Inventors

Adults pose for sculptors, but young children use their bodies in experimental poses or set up play figures to become a sculpture. In children's three-dimensional creations or in their playful dress-up, or games of posing as a mannequin in a store, an art teacher can find new ways of presenting sculpture, and appreciate children's sculpture ideas. For an art dealer, children's sculpture that takes form in daily acts, ordinary and sometimes perishable materials can be problematic. While a student's sculpture from ice cubes may melt, and apple core figures may rot, the art teacher's tales and accompanying photographs can celebrate these memories and unique techniques.

In playing with play figures, found objects, and toys, children invent the future of sculpture. To appreciate

children's sculpture one needs to understand their approach to household chores, witness children as eager home-helpers and be able to relate to their many 3D collections and play interests. Children's sculpture can be appreciated when viewed as playing with dolls, setting up action figures, creating with blocks and blowing bubbles.

As Sculpture Gardens Close

In considering what could be taken to school for a show-and-tell, as evidence of home sculpture, future art teachers can begin to actively rummage around their attic and look through family albums, to see what was saved and what was lost and what may need to be replaced from childhood. There is plenty of room for an art teacher's creativity in ways to present and display, preserve and replay fleeting sculptural moments in an art class, appearing in old birthday hats, showing all the decorated cakes a parent sculpted for their child.

The future art teacher's inventiveness is required so that pretend birthday cakes can be structured in an art room, and the setting re-arranged as the parties children always dreamed of. How can elements of a classroom be made flexible to accept catering a party, simulate a fancy bakery, and to make room for students' sculptural set-ups? How can art room containers become more like toy boxes and fantastic shopping sites, to emulate home drawers in promoting a free search for forms to wrap, cakes to shape, sculptural materials to use? When home templates lead the way students become excited again about their own ways of making things that are now called sculpture.

Adult artists are inspired by their own childhood art and want to present this period of free vision and play as an important gift of inspiration to their children. As art teachers we have many of our own children in our classes. What better gifts to present to students than the magical sculptures that are the children's heritage. The home art that so many artists have paid homage to, the home sculptures that continue to inspire artists, can be the model and inspiration for school art classes. See Plate 2.9.

MATERIALS AND TECHNIQUES FOR SCULPTURE EXPLORATION

Children are interested in found materials and see sculptural possibilities in all forms. Young sculptors find impressive use for forms, regardless of their intended use.

They will stack red bricks in the backyard and call it a cake. They see the versatility in objects, using combs to build fencing for plastic farm animals, and later the same combs become a play structure for fast-food figures. When everything is free to be used as a sculpture material, there is great freedom in making things.

No one can, nor should predict the material needs of a young sculptor. An art class is a place where all kinds of interesting shapes and forms reside and await discovery. The art room can be the best yard sale, or junkyard, the most inviting shopping site that is constantly refilled by students and their teacher. Children's sculpture magic is the ability to create unusual mergers of forms that take on new meaning and usefulness. When playing with forms is unhampered, children find the best objects to make toys, try on wearable sculptures, or construct furnishings for their room. The following examples describe the ways children discover sculpture materials and the techniques used to create sculptures.

Miniatures

Miniature sculptures represent a manageable world that can be altered and played with. Sculpture finds can reside in cereal boxes, Happy Meal containers, and Gumball machines. Miniature charms, tiny cars, and Polly Pocket figures are carried in shopping bags and lunch boxes for sculpting on the go. The content of goody bags is not disposable junk, but small stuff saved from a birthday party that continues to star in sculpture set-ups for weeks. The sculpture materials used in school can perpetuate children's interest in miniature forms and the sculpture of little things.

Box Techniques

When packages arrive, children check the box, while adults look for the content. Young sculptors have an amazing eye for boxes. They select boxes that offer interesting spaces with clues for moving in, to furnish, wear, or display other forms. They see room for skylights and openings, partitions, and possibilities for expansion. With an abundance of new boxes with windows, handles, and print labels, children recognize the importance of the contemporary box. Scores of boxes pass children's viewing each day, sculptures that integrate art with students' everyday experiences.

Sculpture with Blocks

Blocks are children's way to discover balance, structure, unity, beauty, and diversity in forms and patterns. Play blocks are idea generators; teaching children to think with objects in their hands. Architect Frank Lloyd Wright's mother was an admirer of Friedrich Froebel's Kindergarten movement that emphasized the importance of children building with wood blocks. Could the circular forms of the Guggenheim Museum be so elegantly stacked without experiences in early block playing? When children start their design life on a laptop in conceptual constructions it does not allow for the tactile sensations of assembling forms. There is great value in the revival of playing with all kinds of blocks, old and new, in the art class.

Replacement Sculpting

Children's sculpture at home is often initiated by replacement; making their own version of what used to fill discarded containers. Children often find beauty and challenge in refilling with found objects empty chocolate boxes. The new forms inside may be an arrangement of the teeth they lost placed over miniature pillows and taped to cut sponges, resting each personal souvenir. Children's sculpture entails finding interesting housing for their significant collections of forms.

Future art teachers can advance replacement sculpture by encouraging the saving of interesting containers with dividers and compartments to place things in. A student sculpting inside a sushi box filling it with rubber and foam nuggets rolled up in crayon shavings responds to the sculptural container and delicious memories. Containers can hold smells, memories, and experiences, on which to build. The art room can provide safe storage and replenishing of pans and trays, plastic and cardboard sculptural containers.

Stuffing

Children work to stuff large leaf bags only to jump on them, hug and squeeze the bags, using their full body for sculpting. A collection container in an art room can be the drop off and show off point for unusual bag finds. Interesting bread bags, unusual clothing bags, and the latest in Ziplocks are all welcome sculpture materials.

In the art room students can create many sculptures by "puffing up" socks, or shaping pillows and trash bags into stuffed furnishings and sculptures. In the soft cityscape during a garbage strike, students create massive mounds and playgrounds, giant forts from trash bags.

Students may join forces to generate piles of stuffed shapes from which to select building blocks for larger sculptures. Stuffed shapes can be piled or stacked, or connected as a chain with Velcro. Like the invisible man with visible organs, clear bags allow for techniques of manipulating the sculpture's gut.

Wrapping Sculptors

Wrapping up a bicycle allows for the study of all its forms. Covering someone's face with foil is an opportunity to feel the mounds and bumps, pressing against the valleys and mountains of a landscape. Children often ask to wrap their own birthday presents to enjoy by its abstraction the forms of the gift that is inside. In an art room students can wrap themselves and anything in the room, as a sensory sculpture experience.

Future art teachers can begin collecting all grades and sizes of foil, plastics, and beautiful gift-wraps. Students can collect forms that they find interesting because of the way it was wrapped. Shrink-wrapped objects are suspended in clear plastic, a technique that can be experienced in class by placing selected objects in Saran Wrap. To touch and experience sculptural forms children cover and wrap up shapes.

Fix-It Sculpture

Fixing things is children's way of saying "I want to take something apart and look inside." Even with today's computer modeled and industrially fabricated sculptures, it is still important for the young artists to use a screwdriver and take things apart by hand. Contemporary sculptors are individuals with much expertise with mechanics from being a super fix-it-all handyman, to an engineer and expert in robotics. Young sculptors love the family toolbox and need the opportunity to take apart any household appliance. With the skills that come with "fixing things" there is also an appreciation for circuit boards, switches, the beauty of mechanical and electric movements and individual parts.

The technique of art teaching is to bring tools and tool-boxes to class with a steady flow of small appliances that need to be "repaired" or looked inside. A sign can be posted in the art room, "Wanted! Old phones, scales, toasters, keyboards, vacuum cleaners, clocks, and typewriters for tinkering inside." Required materials in the art room include

many parts boxes where the most interesting parts are saved, sorted, and traded.

Assembling things is also an art room sculpture technique. Future art teachers can search for old Erector Sets, no matter how incomplete; 75 years after Gilbert's invention, the experience they offer young sculptors to build are still unequalled. But there are so many things in boxes today that require assembly that sculpture teaching can involve bringing to the class steel shelves (which can be used like large Erector Sets) and other things that require sculptural transformation, or assembly.

Sculpture On-Site

Sculpture can take place not only in art classes but at sites where children make sculpture, such as the park, or fast-food restaurants. At a restaurant children are routinely handed placemats to color, yet if allowed their art is making things with all the objects they find at the establishment. Never mind the coloring, when there are incredible cup holders, unusual stirrers, and straws to build with. Working with the forms they find is a hallmark of children's sculpture. Unlike many adult sculpture studios filled with materials, children also go outside the studio, to make stuff from what is found on-site. If not handed pre-packaged kits children will work with what the environment yields; the largest selection of sculpting materials.

The technique is to envision art classes as places that connect students with the many places they find and make sculpture. The art room can serve as a gallery for unusual collections of lids and cups and fast food restaurant boxes and prizes. The dolls students make from napkins with forks and straws and rest on sugar pack pillows at Dunkin Donuts can be respectfully shared in the art class. Future art teachers may list the field trips students can take to fast-food places that yield contemporary art supplies and sculpting opportunities; focusing attention on the places where children sculpt and work with their discoveries is a way to build on their natural interests.

Earthworks

Taking sculpture back to nature is an important art teaching technique. Even when children are fortunate enough to have backyards, pools, trampolines, and swing sets, it is still a "big deal" to have them put their shoes on, separate them from computer games and to play outside. It is the task of the art teacher to get children, who are the original "Earthwork" artist, to the freest sculpture studios, the sand, water, and rocks outdoors.

Art teaching equipment can include pales and shovels for the natural excavating of young earthworks artists. Watering cans can be useful to construct waterways and reservoirs, sculpt paths and shelters. Art classes can mark outdoor excavation, paving, and planting sites with surveyors' flags and ribbons. Plates may be brought outside for sculptural meals of rocks and petals, using all the fine utensils provided by nature. Observing youngsters playing in park sand boxes or sandy beaches provides important insights for future art teachers.

Sculpture Possibilities

Children's sculpture is not made out of marble and its techniques don't include chisel carving. Children who use a chair to make a racecar, adding pot covers to steer it, are inventing riding sculptures and defining what sculpture means to children. Children's sculpture is different from adult sculpture in spirit, materials, and approaches, representing the active and playful artists who make it. When children build carriages, shopping carts, and carousels from laundry baskets they make sculpture as toys with which to play. To continue building with anything in one's hands is a technique that encourages sculptural fences made with combs to enclose the steel wool creatures inside. To be able to generate ones own sculptural plays with all objects and to freely entertain sculptural ideas by building with pillows, balloons, and pot covers, is a young sculptor's technique. Converting skateboards to use as carts for a parade float, making objects to pull and push become distinguished sculptures to sit on, to race, and steer. Children have a seat on anything discarded to think, and to make sculpture by converting what is under them into something wonderful.

PERFORMANCE SCULPTORS

Dancing and performing with forms is part of children's magical playing that inspires their object handling. Children's performances with objects suggest valuable sculpture ideas. With long skinny legs, fly-swatters and feather-dusters dance with dustpans and mops in innovative choreography. When positioning toys, dressing or lending voices to objects, children discover their unique talents. Juggling, spinning, animating, and talking through forms helps them take new poses and assumes new identities. Children who perform with their toys are the most familiar with them.

Art rooms become stages for children's testing of interesting forms in improvised performances. Students reach inside socks, work gloves, and knitted caps to discover

their exterior form variations. Young sculptors bring forms to life and give new meaning to them. Some of the most important performance works will be explored in the following sections.

Play Figures

Children take their sculptural friends everywhere. They dress them, tie their shoes, and buckle them in the car. Deeds and actions in figurative playing involve making props, lending voices and poses, while children develop unique skills and attitudes as sculptors. While most other toys are forgotten, children remember their favorite doll and teddy bear.

Figurative sculptures stand in for oneself. Children learn about themselves and about the object world by "sending" play figures to explore and experience it. Figurative sculptures perform in fantasies and fears. From play figure collectors and builders children become sculptors who find meaning and satisfaction in the forms they create. Children play with scores of sculpture friends they find, and many more they create. Figures children make and play with are not only movable and bendable, but their attachment to figures is a valuable lesson in learning that sculpture can be comforting and uplifting.

Future art teachers can stock the room with flexible materials such as nuts and bolts, rocks and just about any form that may be found in a child's doll factory. Techniques for figurative exploration involve making figures from found materials, dressing and housing them, and of course playing with them. This can involve creating beds, carriers, or carrying cases. Students may find roles, and occupations; create sites and adventures for their figures. Taking play figures to the doctor or the park, considering their care and needs, is a source of endless creations and performances in sculptural settings.

Sculpture of Settings

Children's sculpture art is to be able to see possibilities for creating setting with all kinds of things. Playing with figures leads children into imaginary worlds constructed as scenes and scenery. As in a movie, children create and place figures as performers into sets. The sets are made from a combination of home furnishings and found items transformed into a landscaped farm or the interior of a veterinarian's office. There are no predictable or set materials an art class needs for set constructions.

Future art teachers can keep the art room cleared and open so that students can use all furnishings and materials to build a set-up anywhere. There can be water in a play pool for a floating armada of fast-food sailors set in the middle of the room. Figures in a circus set may perform under a blanket-covered table. Sculpture is created as temporary set-ups for play, or as boxed setting with roll-up parts for students to be able to capture the mood and set-up again at home.

Rock Concerts

From years of watching music videos, children are less bashful about rehearsing with microphones than about performing on blank art papers. Creating with the lights, moves, and excitement of live rock performances urge students to create innovative guitars, sound effects pedals, and shimmering performance costumes. There is an abundance of sculptural ideas when it comes to exciting microphones, such as decorated flashlights and glowing ping-pong balls, or how to outfit a group with flashy new speaker forms and pop-up scenery for a road trip. Exciting performance events animate not just the sculptor but also enliven the forms they create for a show.

A Final Bow

Yellow rubber ducks can now change their color as they light up and quack. Even the classic in simple toys requires little playing. Yellow ducks are not immune to the high technologies inserted to make toys light up and perform for children. Performing technologies not only represent contemporary toys but also the dreams of contemporary sculptors. The art class is one of the last bastions for creative human performance, for students to play and perform with objects and not just have everything perform for them. By injecting showmanship into sculpture, students discover the performance potential and many creative possibilities in everyday forms.

As students perform a pretend sales pitch of their most fabulous ice cream floats before a convention of ice cream storeowners, they are performing live, and placing a yellow scoop of tennis ball, next to a squiggly green Cush ball topped with bright plastic worms in a shaving cream mix. In freely performing with found objects students discover extraordinary forms and generate ideas for new ways of sculpting. Performances in an art class preserve an important sculptural necessity; a sense of freedom to play and experiment with any form. See Plate 2.10.

<div style="border:1px solid black; padding:1em;">

Creative Planning and Topics for Group Discussion, Activities, and Extensions

- Look and learn about earthworks from the masters by joining them in the sandbox, or help and observe kids decorating doors, windows, or bulletin boards. Take pictures and discuss with future teachers your thoughts about learning art from children.

- Make a list of all sculpture items that could be useful in your future art room (i.e. building blocks from garage sales or the Salvation Army, empty cardboard boxes, empty cans, plastic lids, dominoes, Jenga game pieces, scrap wood pieces from a lumberyard, diaper wipe tubs, sticks, toy wooden logs, tinker-toys, etc.).

- Search online art catalogs and make a brief list of the materials that are available for subtractive sculpture methods. Describe the materials and discuss with future teachers your thoughts about issues such as possible procedures, motivation, kid connections, and safety in the art room.

</div>

Creativity can be described as letting go of certainties.—Gail Sheehy

Section Seven The Magic of Ceramics

Continuing with previously mentioned comedian Jerry Seinfeld's thoughts on children's paintings being about nothing, the same applies to clay. Children start out loving clay. When exposed to clay early on, they are sure to squeal with delight while experiencing this magical, squishable material. Without any prompting whatsoever, young people will pound, slam, roll, pinch, separate, poke, play, and create with clay. The lump of clay does not have to be become some recognizable object in order for these early explorations to be meaningful. Like painting, clay education can be "taught away," trampled on by well-meaning adults trying to force inhibitive or restrictive thoughts on the child's creative experience. It is important to allow the students to first get to know the clay and the wonderful qualities that are unique to this media. They need to pull it, and stretch it, and stack it, and rip it, and compress it, and stretch it over, and over again. An important point to remember is that children discover, appreciate, and fully understand that they can "pinch" clay, without the teacher forcing an entire class of students to mass produce pinch pots. Which would be more rewarding to students? Twenty-four mandated identical pinch pots, or twenty-four unique, creative, three-dimensional artworks? Here is a crucial point. Teachers often become pinch pot police and mandate that every child abandon their clay creation ideas because they unfortunately plan to offer a clay experience only one

time during the entire year. This can be likened to only allowing students to practice addition or subtraction one time during the school year, which we simply should not do. We must be sure to offer numerous clay experiences, and we must not remove the child from the experience. The young artists' minds should be involved in the process. The teacher can create 24 identical pinch pots without the students' participation. Students need not even be present for such mass production, thus, a more beneficial approach is to involve students in the creative process in a meaningful way. This should result in creations as unique as their creators, fine artwork that involves thinking.

CHILDREN'S CLAY DREAMS BEFORE A PINCH POT

Many successful architects have spoken of the vital role that building blocks played in their childhoods, and likewise, apple sauce and pudding play has surely been a part of many artists' or painters' early developmental years. It follows that mashed potato play is likely the precursor to later, more sophisticated clay creations.

As infants squish their new little fingers into mashed potatoes on their high-chair trays, they are in training for future clay days. If permitted to have sensory experiences

such as touching cold, smooth, mushy, clay-like dough, they will delight in that which will be drawn upon in future days. Toddlers who are permitted to make mud pies at home will be even more eager to continue the three-dimensional explorations with clay, or clay-like modeling compounds, in school art experiences. As children explore a variety of modes of communication in primary school, including art, they will benefit from consistent use of both two- and three-dimensional art mediums. As with children's drawings, clay can be used to explore and communicate the child's interests. A favorite toy might inspire a clay sculpture. A family story might be depicted in clay. A family tradition or vacation might be acted out in clay. Often a lump of clay might transform with amazing speed from one thing to many others as children work quickly all the moldable, moveable, and magnificent qualities of clay. If the content, whether objective or non-objective, is important to the child, then the clay experience will be as well.

A Word About Ceramic Molds

An adult artist has already made all of the decisions when creating the clay mold. Essentially, the brains of both teacher and student have been by-passed when using a mold made by someone else. A good rule of thumb when making such decisions is to ask whether or not the students will benefit from the experience, and in what way? Ceramic education that allows the students to think is preferable. Creative and critical thinking opportunities are abundant when students communicate via clay, or modeling compounds.

Clay Tools

The most important clay tools for elementary and middle-school art students can be found at the end of each arm. Fists can smash and dent. Palms can roll and flatten. Fingers can poke, and pinch, and prod. Hands are all that is needed to build with clay or other modeling recipes. However, other items can be useful tools for any ceramic artist. Sponges, water bottles and bowls, and buckets can be useful for keeping the clay from drying out and getting crumbly. Clay can become too wet very quickly, which the students will learn with the teacher serving in the role of technical advisor. Likewise, clay can dry quickly with body heat from creative hands, which can easily be remedied by a squirt from a water bottle or a finger dip, or two, at a time from a water bowl. Students are better served if the teacher

is the guide on the side, allowing students to learn information from each experience that will be used in future experiences. Plastic bags or tarps can be used to wrap and keep clay moist between class periods. Tools for addressing clay surfaces are endless, and mostly free. Begin a collection of items with texture such as: wooden craft or popsicle sticks, paper clips, sharpened pencils, corrugated cardboard, notched wood pieces, plastic or metal forks and spoons, plastic straws, plastic scouring pads, large beads, rocks, wire or plastic mesh, meat tenderizer mallet, sticks, tree bark, pine cones, anything with texture that can be pushed into a soft clay surface. Store in a shoe-boxed size plastic box with lid and label so it can be easily found when needed. Set the stage, and let the experimentation and discoveries begin. With clay, and clay tools, the sky is the limit!

Essential Clay Construction Skills and Knowledge for Elementary Students

All students will be unhappy if their clay creations explode in the kiln, or if they are damaged because some other piece exploded due to air bubbles in the clay. It is the teacher's job to ensure this does not happen. The teacher again becomes technical advisor, responsible for teaching necessary skills that will aide students in meeting their personal creative goals. It should be remembered that in beginning clay experiences, student motivation can be lost in the midst of a plethora of unnecessary, technical details. Young people can learn to pound out air bubbles (or wedge the clay) so clay creations will not later explode in the kiln. Having said that, it should be noted that lengthy lectures on the scientific qualities of clay particles, or at which cone the load will be fired, will surely soak the joy right out of the experience for our students. Young people do not need to understand the chemistry of glazes. They need to know that if glaze is on the bottom of their piece, it will stick like glue to places where we do not want it to stick. They need to understand that the glaze will look differently when it is fired. It is helpful to have a few examples of fired pieces to show ahead of time so they can eagerly anticipate that magical moment when artwork comes out of the kiln for an unveiling. Children can easily understand the concept of "scoring" so heads will not fall off the animals and characters they so lovingly created. Here again, a lengthy technical explanation on clay properties will not serve the students as well as a brief demonstration of "roughing up" two balls of clay, and sticking them together, explaining that all the

little rough "scratches" will grab onto each other, and help hold the pieces together as they dry and shrink. The teacher can reinforce this again whenever needed by grabbing hold of fingers of one hand with the fingers of the other, and reminding students that the fingers, like clay particles, will hold the two hands together, just like scoring a dinosaur head will help it to stay attached to the scored dinosaur body. Will students forget? Need to be reminded? Of course. This is learning. Traditional techniques can be introduced, or pointed out, through time. Pinching, scoring, coil, and slab methods are techniques that can be taught for students to utilize when needed.

Though mass-produced ceramic pieces can be purchased from stores, and though they are indeed useful, it is good for students to begin to understand the difference between their one-of-a-kind hand-built clay animal, and the one from a local department store—it being only one of 50,000 identical pieces. Invite students to pay close attention after they leave school, when they are in stores and out in their environments, to ceramic cups, bowls, sculptures, and such. Help them to become more visually aware of the world around them. Teaching children that what they have to say via clay is a valuable lesson. Their confidence will grow as they come to know that their creative thoughts and inventions are valued.

EXPANDING THE DEFINITION OF CERAMICS

For making alternative three-dimensional modeling substances, there is an endless array of recipes available. These recipes call for everyday, common ingredients that are accessible, inexpensive, or free! Recipes, such as those found in a well-known book called *Mudworks: Creative Clay, Dough, and Modeling Experiences (Bright Ideas for Learning)*, by Mary Ann Kohl, teach us that modeling dough can be made in the classroom and at home, and from common materials such as flour and water. Of hundreds of recipes in this useful resource, there is even one that calls for dryer lint! Some recipes call for baking, and or air drying pieces that young artists wish to keep. Many recipes allow for added color, straight from the kitchen cabinet, where food coloring can create a rainbow of colorful modeling dough. Some can be kept pliable for longer periods of time for added dough play pleasure, and some are even edible! On the market, one can also find numerous types of commercially available clays, in various consistencies and colors, in air-dry or kiln-fired formats, and such.

Clay can be purchased locally, or from art supply catalogs. Clay is heavy, thus shipping can be expensive. Generally, however, the teacher who plans ahead, and orders clay along with other materials, can get shipping fees waived by simply calling and asking. Clay from the ground, while free, is likely to contain sharp or unclean objects, thus, purchasing clay that has been "cleaned" by the art supplier is preferable in a school setting.

Clay History

Just as we learn about our students through their expressions via clay, we have also learned about past cultures due to surviving clay creations. Whether such artifacts are believed to be for ornamental, religious, ceremonial, or functional purposes, nonetheless, they served purposes that are revealing.

Throughout history, clay artifacts have served as a vehicle for documenting and teaching about history, and it continues to be equally valuable in this regard at present. Caution: hundreds of thousands of ceramic artists have made their mark on world history, but we would not serve our students well by asking them to memorize names, dates, and ceramic artwork titles. It is better that we give students an understanding and appreciation that excites and intrigues them, and motivates them to want to know more. Memorizing names and dates in order to regurgitate them back on a test is not learning, and is highly inappropriate for elementary art education. The teacher of art, in the role of storyteller, can impart brief and fascinating short stories about clay pieces from history. Available information is so abundant that it can be overwhelming, to the teacher, and to students, so research and share with caution.

Dipping way back in history to the Stone Age, one can find examples of sculpture (made of various materials) that are believed by some to have been created for purpose of luck. The "Venus of Willendorf" is one example, possibly meant to bring luck with fertility. Teachers of art can ask their young students why they feel that today some people might carry a rabbit's foot or horse shoe, or throw salt over their shoulder, or avoid walking under a ladder or stepping on a crack. The point is not to convince students to believe in good luck charms, or to lead them to be superstitious. It is simply to help young people to make connections between past and present as they begin to understand how people long ago might have believed the small statue of a woman would bring good luck with having a family. This,

children can understand. It would be interesting to ask your young students what they would presently create for luck and why. Write about it in an idea book or journal. Create it, and reflect on it again.

As another example, announcing to students that "Native Americans made coil pots, so you are all going to make a coil pot today (just like mine)," would not allow students to think creatively or to make meaningful connections. Having students try to imitate Native American symbols and clay techniques is not the best possible art objective. What is the goal of the lesson? If the goal is for students to understand and appreciate and experience the powerful role that ceramics can play in their lives, connections must be made by the students. Teaching children about how clay was used by early Native American tribes is not a bad thing. Teaching the coil method is not a bad thing, but effective teachers of art are careful to plan knowing that the stage must be set to enable students chances to think, create, and make it personal and meaningful. Is it better to learn and experience the coil method, and later make note that it was a technique used by other cultures. Or vice versa. We suggest that there is a give and take and that students experience meaningful visual art education—that the art experiences are genuine, engaging, creative, thought-filled, and useful to the student—and that experiences are not merely mindless activities used to punctuate the end of some other unit of study.

A Final Spin on and Appreciation for Ceramic Art and Artists

Visual education occurs when students create their own ceramic artwork, and are then further motivated to view, examine, appreciate, and even report back on interesting items they see in their environment. Have an exhibition of interesting "artifacts" they bring in from home. Display three-dimensional items, as well as photos, or magazine or catalog images they find noteworthy. An online search will result in endless interesting images to add to the display. Related books can be kept stocked in the school and classroom art libraries. Ceramic publications and NAEA are also wonderful resources for ceramic posters, images, and information. Local artists are often able to bring in a potter's wheel and demonstrate the magic of wheel-thrown pieces. Videos of the process are also widely available. A self-made video is simple to create. Local pottery sales and demonstrations can be added to the school announcements, and notes home, and advertisements on the art teacher's web site. Remind students to record ceramic observations and ideas in their journals. Allow them time to sketch ceramic ideas, and to explore, and to invent new shapes. Invite students to bring to class reflections on their daily observations and discoveries.

Most importantly, students will best understand and appreciate ceramic artwork if they get to do it themselves. As Robert Frost said, "Let me be the one to do what is done." See Plate 2.11.

Creative Planning and Topics for Group Discussion, Activities, and Extensions

- Begin a collection of clay tools in a shoe box or similar plastic container, being mindful of the endless possibilities (plastic knifes, plastic soda bottle lids, rolling pins, kitchen utensils, marker lids, pencils, forks, tooth brushes, toy car wheels, pine cones, acorns, wicker plate, etc.).

- Begin a collection of recipes for three-dimensional modeling clay or dough, such as those found in the classic teacher resource called *Mudworks: Creative Clay, Dough, and Modeling Experiences (Bright Ideas for Learning)*, by Mary Ann Kohl. Try a few of the recipes. Discuss with future teachers the characteristics of those that you try, and be ready to share ideas and recipes.

- Search local department and thrift stores for three-dimensional modeling clay/dough, and art catalogs for similar products. Begin trying them, noting the price, quality, and predicted usefulness in your future classroom.

Section Eight Installations and Setting Up Plays

The world is as many times new as there are children in our lives.–Robert Brault

CHILDREN'S PLAY INSTALLATIONS

What Is Children's Installation Art?

Children make art in their room, but also use their room to make art. Seeing opportunities in a room's many surfaces and large-scale spaces, they set out their toys and collections. Children's art is about changing the room to see the environment as something that can be creatively manipulated. Children set up performances in their room, move around furniture, create displays, and host parties as artistic creations. Children's installation art means using their room as the canvas. Thinking big, they work to mobilize everything in their studio to create play scenes. The art world has paid homage to children, popularizing their acts under such names as Happenings, Performance Art, Environmental Art, and Installations.

In comparing children's vast imaginary ventures (which take place all over their rooms) to school art, it is striking how almost everything takes place at a desk and on paper, in small and controlled settings on a page. By translating children's environmental playing to school-size surfaces and work spaces managed by adults, art becomes uniform in size, action, and materials. If making art all over their room is abandoned, young artists forfeit it.

Art teachers need to plan for students to create set-ups in art room environments instead of only asking to make works on paper. Teachers need to acknowledge that art does not have to be made only on a desk and offer the freedom of using all surfaces of a room. Art can take place all over a classroom and remain large in scope and dreams.

Another Embarrassing Mess

Children create installations by setting up play worlds, using real objects and materials and manipulating the environment for artistic purposes. Wanting to enjoy color, they set up a picnic with bright marbles set in colorful bowls, displayed on a tablecloth with bold graphics on the floor. Installations can pair toys with just about any other symbolic object in a home. Children's art is creating play sites on and under a table, a bed, or directly on the floor.

A child's room is often considered an embarrassing mess, a passageway through chaos. When carefully taking stock of each parcel of the room, however, there are elevations built from pillows and blankets laid out over small chairs. Paths between the exposition of toys and dispersed objects are often forged as part of a larger installation. With a little imagination, teachers can see that the play spaces children set up, take down, and constantly rebuild can be featured in a classroom, or a gallery.

Teachers can offer the space of the art room to create play set-ups from students' collections and discarded materials. The art room can entertain toys and even allow for children's nature collections to be spread out. With mounds of foil and passages of colored rubber bands, art room floors can also be mistaken for a walk through trash. But students' non-precious art of soft ground made from foam and mountains of crumpled newspapers are a continuity of home playing with the physical environment, a primer for adult environmental art and installations.

Untouchable Spaces

Like galleries, schoolrooms can be untouchable spaces with static display pieces conforming to gallery traditions. In children's rooms things can be touched and interacted with. Straightening up a room allows for reorganizing, moving furniture, repositioning objects and the contents of shelves. Playing house, store, and school are games that thrive on creating scenic installations by maneuvering all the things in a room. In performances, children touch and manipulate everything they want, assembling furnishings and inhabiting them with objects and toys to stage a circus or a show.

In an art room, where children feel free to use the space to shop, move, and play in, they also create imaginative play environments. A mountain made of paper towels laid over shoes can rise to surround a lake—water-filled tin trays laid out on a classroom floor. When an art room can be used and everything can be freely touched there is no shortage of children willing to move furnishings, set up toys, and create performances.

In Charge of Spaces

Having control over one's own space is an important part of taking charge of any canvas. At home, children are in control of their space. They can set up over the bed and have a favorite carpet or an entire floor to work on. Shifting things, creating set-ups on all surfaces, shaking up a room,

are all children's art. To be able to freely create one's environment is essential to raising artists who will be able to perform in all spaces and on all canvases. Children are large-scale artists; their creations often reach all parts of their rooms.

Art teachers should keep in mind that their students will not just need paper but space and the permission to use it creatively. Art rooms can be turned into play spaces for performances and for creating environments. The art class can serve both as a play space and an exhibiting environment, an informal place where young artists can do practically anything they want. In creating a store in the art room, students exercise the option of creating their own play-exhibition space. Art teachers can ensure that their students have access to space and feel that they can freely make art there.

Children's Installations and Daily Life

Children's creative installations interpret events and episodes from daily life. Birthdays, for example, are constantly celebrated, set up anywhere with a tray, a plate, and stuffed animals. Children's installations are connected to life, unlike installations in many art museums that seal off artists from audiences and from daily life. Children's installations of putting dolls to bed are not intended as a show but rather to retell a story based on a daily ritual with found objects and dolls.

Many children's installations deal with the fun of being able to do outside things inside. A child's room is set up, for example, as a campsite. There is a tent made from blanket-draped chairs, and an inflatable raft is used for a bed and river rides. Children set up indoor lemonade stands and car lots, installations that essentially remake what exists as art. Many children set up reading spaces, schools, and other play environments in closets, seeking privacy and quiet in daily life. Art rooms can welcome outdoor elements to be set up inside. Young artists can practice their art of displaying toys and street finds with symbolic objects that create a place, a scene, or a landscape that can be entered and experienced. An art room can allow for the installation of experiences and places that simulate events from students' lives.

An Art Not Made for Sale or Exhibition

Children's art installations are not items made for sale or to be admired from a distance. Their installation art is to be played with, entered, and experienced. Children's play settings are made for action and participation. When children turn their room into a space station, everyone is invited to join in the adventure. They distribute tickets for the flight. Pillows are placed into decorated and shaped boxes for the launch. The lampshades converted into space suits are art invented strictly for playing. Children tell visual stories with object finds. Art teachers can envision setting up art rooms as play rooms that can be environments, creating art lessons that are not about works for contests or hallway displays.

Wrapping It Up with Concluding Thoughts

Children play school, and with each new play set-up their room is changed. Furnishings are moved and items borrowed to set the stage for the new class of stuffed animals. Friends and siblings who want to join are always enthusiastically welcomed to participate in the school play. To appreciate children's creative environments one needs to take note of their free use of all home objects and materials. The artist, or creator of the environment, leads and participates in the performance and every aspect of the changing production. There are no audiences or viewers, because even parents are urged to join in, perhaps creating a time-out place for a misbehaving student.

Do not be fooled by messy floors in children's rooms; it is really just art that is lurking on the floor. Children's fine home installations and play environments can be resurrected in the art class. How can art rooms be prepared to welcome art inspired by spaces? When children have the space of a room available for them they spread out displays of a very different kind of art than what is traditionally supported in school. Art teachers can examine children's many installation ideas at home, considering their uniqueness and value as they ponder how they can continue them as a school art. Yes, it is sometimes hard to create art in school that takes up a room that has to be walked through, yet it needs to be acknowledged and encouraged as an important form of how children naturally work.

ENVIRONMENTS AND INSTALLATIONS THAT INSPIRE ART IDEAS

Classroom Environments That Take Flight by Promoting Imagination

The assignment is on the board. Students enter schoolrooms as spectators in a museum, to be informed and

sometimes entertained by what the teacher has planned. Art rooms, however, can feel different when they are approached as environments that stimulate the imagination and not just as places to give instructions. Set up as installations, art rooms don't prescribe one lesson or narrow the students' attention to focus on one experience, but present possibilities that engage children and challenge individual acts and responses.

Entering a room and seeing a floor covered with lettuce framed by bright red bags of carrots and potatoes creates interest, mystery, unanswered questions, and decisions. What will students think and do? Young artists' talent is to engage and participate in an art class mystery, not to stand by but to get involved. As opposed to exercises meant for specific learning and instruction, art presented as an environmental challenge stands in sharp contrast to the rest of the school day. Installations can speak without words, presenting spaces, hints of forms and places that are pure visual experiences inviting open and creative responses. Installations present an idea, a place to experience without a lecture. Art in a classroom can become visual communication from the teacher to the students, inviting them to participate in response.

Art teachers can practice setting up environments and performances to engage students. An art room installation can stand for a place, a dream, a fantasy, and not an assignment. Students can pick up anything, learn to look at any place, and ask themselves questions. What can I do with this? What can I do here? How can I use this stuff? Environments can invite playing and exploration. An art lesson can be assigned or an art lesson can be installed in a classroom.

Installations to Engage Students

The idea of an art room set up as an installation further engages students to become more active in decision-making about their art. An installation places more responsibility on students coming into the room. Planning an art lesson is not just telling students what to do and how to do it, it is involving them in discoveries and adventures, encouraging them to find things out and plan for themselves.

Shiny baking trays fill the center floor, standing in designated rows marked with floor tape like spaces in a parking lot. Empty pots and pot covers sit on tables. Various kitchen tools are inside, laid out in drawers on the sidelines. Art teachers can hold up objects and ask, "What can we do with these?" Installations are open invitations for students

to construct, paint, or draw. The art teacher can think of planning as a gesture using objects and materials that have creative possibilities.

To Be Completed

Installations leave room for completion. When students encounter paths in the art room made from bottle caps, fresh flowers, and rows of paint-sample cards, the space becomes an open puzzle. Some students collect the pieces, others rearrange them, and one child takes a toy from his pocket to create an elaborate obstacle-course test track for a toy vehicle. An installation can be thought of as an incomplete layout or a series of unfinished roads, with a job to be attended to with imagination. Inspiring elements placed on walls, tables, or floors make for a different view of an art class. Instead of handing out paper to make art, art teachers can think in terms of dividing spaces and clearing surfaces for students to be able to do their work.

Environments and installations divide spaces in an art room like they do in a museum. But unlike in museums, where installations cannot be touched or moved, in school they invite completion and change. For example, three refrigerator boxes lie on the floor, with all their loose tape and packaging materials intact. There are paints, colorful shelf liners, and cork sheets among other things nearby. What is missing? What needs to be done? This is up to each student entering the room. Depending on the students' reception, stories and perceptions of an installation can take many directions.

Architectural Installations

Furnishings in a classroom are available and can be moved, dressed, or rearranged to suggest space changes. Chairs, tables, and trashcans can build architectural frames and forms that invite children to stage plays and other performances. The small tweaking of the art room can act as installations that change the meaning of the furniture and the meaning of the room. For example, chairs separated from tables can be rounded up in the middle of the room with a balloon tied to each. Students decide whether these are festive cruise ships or a convention of hot-air balloon riders. Tables have important architectural presence when moved from their customary order. They can be linked as a long tunnel, work as freestanding lofts, used as stoves, or perceived as an indoor market.

Art teachers can look for minimal architecture and installation possibilities in all furnishings and classroom accessories as students launch stacked trashcans as rockets and follow their path on classroom chairs used as monitors. Minimal installations by the art teacher can inspire maximum dreaming with its objects.

The Surprise of Installations

Using installations to create a sense of surprise, teachers can encourage students to think inventively. Objects like refrigerator boxes and large car tires may be more common in the playground; therefore, they suggest the freedom of outdoor playing that can take place inside. An old bike, boxes of old bike parts, orange surveyors' ribbons and flags, and a garden of equally bright fall leaves all over the classroom floor may be surprising because they are unexpected in a school space.

The installation of a display can be thought of as a menu. The forms and shapes on display are appetizers to whet students' creative palettes. The objects set out are puzzling, interesting, available to be entered, painted, and changed, making a display that invites students to perform and create.

Theme-Based Installations

Theme-based installations can turn the art room into children's favorite places or events. Installations can depict a circus, a zoo, or a water-park by placing play pools and other props that describe different themes with simple objects. Sale signs, supermarket signs, display racks, and the stacking of food and detergent boxes, with markers and stickers on the floor, suggest shopping. There may be laundry baskets stacked as shopping baskets, but the rest is left to the imagination and the actions of participants using the installation.

Installations can also be inspired by current events, such as the Winter Olympics. As a class-installation piece, white paper can be angled to the wall or sloped between chairs, or draping floors can be invitations for snow-boarding, ski jumping, or cross-country skiing. Installations that bring the outside in and the inside out create great fun and challenge art teachers as designers of art rooms to supply imagination to meet students' imaginations. With leaves and branches, mulch or potted plants, the indoors can take on schoolyard realities. Using pans of water and play pools, the rivers and seas can be imported. Teachers using installation art can raise the bar in creative planning that invites Olympic-size creative thoughts.

An art lesson set up as an installation can be thought of as writing a book, creating a story and filling it with characters, scenes, and narrative surprises. In an installation environment, students can cast aside their school manners and partake in imaginary worlds, unafraid to get wet, dirty, or covered with paint as they partake in art and in life.

The Classroom is a Canvas

The wall is one of the largest canvases in the room. For different installations walls can be dressed in white or in reflective silver or wallpapered to stand out. Objects can project from the wall or be used to lean against it. Colors, stickers, tape, and pushpins can spot or divide or mark the wall. Elements from outdoor walls can be brought inside, bringing signs of outdoor walls indoors. Walls can be marked and covered to emphasize them as barriers and fences, or covered in layers of transparent materials to suggest that they can be seen through and looked at beyond the schoolroom.

The soft grid of ceiling tiles presents vast opportunities for planetary projections or for moving attention to the colors of a rainbow. The sky above the room can be opened to light shows or hanging installations. When students lie on the ground and look up at the vast ceiling and its many incarnations it can be an inspiring canvas.

When the art room floor is clear it can be instantly transformed. Doormats, runways, a red carpet, or a magic carpet suggest different movement and flight plans. Floors can be marked like sidewalks, or easily draped by many textured surfaces and materials, creating different impressions and crossing sensations. The newspaper stacks, suitcases, or signs on the floor invite students to expand and complete the installation with their own additions and ideas.

When the art room is a canvas for installations, students experience a different kind of art, such as performances and explorations that involve the room space. Future art teachers can think of ways to clear the room, open its surfaces as fresh canvases that can carry projections, dreams, visions, and stories.

Environments and installations can use the art room in a symbolic and temporary way. They can be set up and dismantled after showings. The intent is not to decorate a

room but to install experiences and make a statement about space. For a color lesson a room can be draped in color. Teaching about stained glass can involve an installation that allows light to enter the room and that filters it as it comes from the windows.

Front Lobby Installations

For installation artists the school is open for creating works in different places throughout the building. There is great excitement when students in an art class can work outside the room in public spaces such as the school lobby. Although art sometimes hangs in a school lobby, it can be made specifically for a lobby installation. Learning to make art for specific spaces is an important lesson for contemporary artists.

Hallway Installations

Hallways that typically display student art on bulletin boards are fast lanes and not places for quiet contemplation of artwork on the wall. Temporary installations provide creative opportunities for large-scale sign art, wall poetry, or long installations that keep moving with the viewer in a unique setting. Hallway installations are opportunities for creative humor, making signs to a non-existent pool, or for the illusion of escalators or moving sidewalks reminiscent of airport corridors. The temporary nature of installations allows a wide range of objects to lean against the wall, or may focus on the live art of students silently posing or distributing things. Hallway pieces create an aura of fun and celebration and turn a school space into an art experience.

Lunchroom Installations

Lunchrooms are a large thoroughfare and that provides great challenges for young installation artists to test their art of ideas with the public. There may be food served by cafeteria workers on one side and art served up in all forms by children dressed as servers on the other. A candle-lit formal dining table set up in the middle of the lunchroom is one example of an exercise in contrasting art with school life. The lunchroom's theme and activities, its space and changing large audiences make it a valuable studio for installation and performance-art ideas.

Library Installations

When students want to explore silent installations in a controlled environment, art teachers can enlist the support and sponsorship of the school librarian. While individual student art is often displayed in libraries, to use the library as a theme, a particular space, and to create with objects and furnishings in the room is an assignment for installations. The private reading places children create at home can be replayed as art, presented in new forms in the library. After researching the space, its assets, and its unique qualities, many imaginative transformations are suggested by students. Installations are created from stacks of schoolbooks placed on the floor, adding large inflatable toys to the crowd, or moving forms into unexpected relationships such as stacking car washing sponges or holding up layers of door mats, to join the books and change the environment of the room. Some of the most interesting student installations involve exchanging one thing for another, such as introducing soft and fluffy clouds in place of stiff chairs used by readers in the room.

School Installations

Passage through school spaces is generally routine and uneventful, hardly noticed by most. Children are familiar with making art objects in the art room, but installations provide opportunities to dream and build creative ideas for the largest spaces in a school building. Graduates of playhouses and arranging their own room, young artists prepare for larger challenges of planning alterations and creating interesting experiences for those who enter and use the public spaces by turning them into large art environments and installation galleries for all to encounter.

HISTORY AND APPRECIATION OF INSTALLATIONS

Environments, performance art, and installations may be relatively new concepts for the art establishment, but anyone who has studied children's rooms knows that children's playing and rearranging their rooms have existed much longer. Children's installations can be appreciated by looking at the development of adult installation art and learning about the original contributions children have made to the art form. School art appreciation has generally involved showing students adult art, without referencing the influence of child artists.

Situations and Spaces

Early environmental artists were akin to abstract expressionists in their intuitive approach to filling spaces with tires, newspaper, and other discards. Relationships between the spectator, called the beholder, and a work of art was regarded as part of a situation. A significant part of installation art moved to minimalism or so-called primary structures created by such artists as Robert Morris, who constructed large geometric forms that created architectural spaces within a room.

Children's arrangements of the furnishings in their room are seldom minimal, and their creations are rarely limited to interior spaces. Some of the most interesting situation spaces are created pool-side by covering pairs of chairs with towels to make pool-side cabanas. For art teachers home constructions can be appreciated and celebrated by replaying them in the art room. With art room furnishings and lights students can create obstacle courses to move around and tunnels and mazes to enter and navigate. Such furniture-play structures create an awareness of a room that is not a classroom but an architectural space that is open to changes.

Conclusion

The history of installations can be appreciated in relation to children's own play installations. Artworks that are hung on museum walls often had little to do with the installation set-ups and displays children created in many parts of a home and outside. When museums began to show art made from daily objects and street finds children could easily relate. With the popularity of installations in museums young artists could appreciate their own efforts of placing art in their rooms. While adults are puzzled by large installations that have to be entered to be experienced, children instinctively enjoy the spaces created and take the opportunity to climb inside and try them out. Children who create many instant restaurants and improvise birthday parties can appreciate happenings, or the "Dinner Party" installed by artist Judy Chicago. When artists pose their plaster or live figures in museums, who can better appreciate them than young artists who take their play figures everywhere to set up and pose. As children's art is appreciated in the art room, it can also be introduced to the many adult artists who work from related instincts. See Plate 2.12.

Creative Planning and Topics for Group Discussion, Activities, and Extensions

- Look for children's hiding places and installations in their closets, on and under their bed. Share your observations and recollections as a starting point for discussing children's art and the roles of adults and art teachers, with future art teaching colleagues.

- Research installation artists. Be prepared to share and discuss with future teachers the artist and artwork of your most favorite.

Section Nine Outdoor Artists and Environmental Art

INVENTIONS OF YOUNG OUTDOOR ARTISTS

Children should have many opportunities to explore outdoors. They possess a vast repertoire of outdoors experiences based on the manipulation of natural materials such as sand, snow, leaves, rocks, flowers, and twigs. By using outdoor materials their playful activities relate to creating art forms.

Designated school materials and classroom space define indoor art, while outdoor art remains open-ended. Because art in school is separated by the art teacher into specialized

techniques, media, and activities, the natural environment can maintain what art is for children and artists—a truly unique and personal experiment.

Chauffeured Children

We don't let our children walk anymore; we drive them everywhere—to school, lessons, and malls. So children forever see the world blurred by car windows orienting through landmarks and quick outside views of playgrounds and in yards and because it is no longer safe to leave our children alone there are few places and opportunities for them to investigate the outdoors alone. We "vacuum" children into our own "life pace" multiplying their after-school commitments unreasonably. We insist they need to take a course to study anything that intrigues them, or us, and nature study becomes merely another afterschool lesson that is fitted into their busy schedules. They learn on "guided tours" instead of through random roaming with friends in fields and woods and endless playing in city parks and open lots.

Nature is becoming less accessible to children and incompatible with their fast lifestyles, and many of us now drive our children to see the leaves changing colors. In urban situations, free browsing for leaves, a leisurely walk to find sticks or stones should become an organized art class experience because children no longer practice their outdoor art naturally. Outdoor plays, which are a basis of art and children's inventions, require independent roaming, spontaneous picking, and getting down on one's knees to dig. But such activities are less prominent in the lives of television-absorbed children who see everything through second-hand experiences and a camera's eye.

Spontaneous and investigative outdoor playing should become a part of art classes, revitalizing outdoor play and art preparation that children used to bring along to school. Playing with outdoor finds is equal in importance to indoor block playing, another endangered preschool-art preparation, children, of course, should neither miss nor ever conclude.

Outdoor Play and Art Needs

Children need the opportunity to freely search for things outside. They need to be able to gather, collect, and save their finds. A bouquet of leaves and branches in a child's hand is a painting—a portable art arrangement of colors and shapes. Collections (from rocks to berries or pine needles) are art sources, as both inspiration and material for play and art. Each selection is made through sensory interests and holds within it ideas, visions, and hopes for arrangements, displays, and other uses. Children attach great importance to each outdoor find and act as adult artists who have a tendency to save. Other adults feel free to throw things out, especially art that hasn't been purchased, framed, and signed. Pinecones, special feathers, and unusual bugs need a home—an art room where they can be stored, displayed, and shared.

Children need the opportunity to squeeze red berries onto bright orange leaves. Unlike adults who bring sketchbooks outdoors to record nature, children need to play with and make art from nature. Children's palettes are piles of leaves sorted out carefully in different colors; here nature is the children's media.

Outside canvases are large and open, requiring full body moves in many creative acts. Snow needs to be walked over; leaves need to be raked into patterns and piles with big tools. Mobile canvases such as baskets, wagons, and play wheelbarrows can be used to display outdoor finds; lunch boxes and interesting trays as mobile treasure chests can be used to save collections. The outdoors, therefore, can be described as larger-scale canvases, less defined by borders and edges than the canvases we work on inside. Outdoor canvases are also changing canvases; the same sidewalk may be coated with snow, leaves, or rainwater, or other fallen "supplies." The qualities of grass or ground (e.g. color or firmness) or items found on it, change with the weather, season or outdoor light. See Plate 2.13.

MATERIALS AND TECHNIQUES THAT EXPAND CHILDREN'S OUTDOOR ART

For children outdoor art studies begin as pure inventions. "Paintings" are produced by first collecting and sorting colored leaves, then displaying them over bright green grassy surfaces. Printing is reinvented by making footprints and poking in preserved blankets of snow. Sculpture is shaped out of ephemeral piles and mounds of leaves, sand and grass. Drawing and design take on form through channels, paths, and tunnels poked, scraped, and dug into the earth. Thus, the use of all art media can begin outdoors.

In self-explored sculpture, children find objects that they assemble, wrap, and construct. They do not begin sculpting with clay, paper-mache, or other traditional classroom media. Outdoors it is okay to look through natural materials or to touch and pick up things. In an

art class, students are less adventurous in spirit and few roaming opportunities exist. As scavengers, they can seek out distinctive art supplies and consider all possibilities for their use while they dig up, pick up, and pick out exactly what they need and like instead of being handed the "best" ideas and "right" materials. Fortunately, discoveries still rule the day outside.

In observing outdoor play, future art teachers learn about the potential of indoor play and about children developing their own style of art making. We note that every surface can be played on, used for displays or redesigned. Art can be created inside a red wagon, on the sidewalk, on grassy hills, or in a shirt pocket. Each found form is self-selected, played with and processed through a whole range of experiments. For example, leaves are piled, berries squashed, fruits peeled, and nuts disassembled. Search and collection of natural objects are intrinsic to children. They constantly gather, save, and use things they discover. Is this possible inside where "appropriate" materials are selected from art catalogs then shipped to the school, where they are handed to children at their seats?

To discover one's own ideas requires a sense of freedom; a feeling of space, room to search, and opportunities to move about. Art classes held outside promote free movement, as well as encourage children to hunt for and discover personal tools, surfaces, and treasures. Playing archaeologist in looking for shapes and forms or simply looking for new art making tools such as outdoor brushes provides benefits easily transferred from outdoors to indoors. Once children stop playing with pots and pans in kitchen cabinets and blocks are inaccessible to them at school, they count on the outdoors as a remaining play test site that extends beyond the school and home. They are true environmental artists. Art, for children, begins in home finds; in cribs, kitchens, and bathroom cabinets; arranging, displaying, and setting up things all over the house. Paper art comes later and art as we teach it, apart from play and children's inventions, derives from art that is relegated to school art corners. In kindergarten, the art corner is where we use only art materials; later, art is specialized to art classes with art teachers imparting special knowledge. However, outdoors, play and discovery remain an integral part of art making dependent on personal finds, sources, and resources.

As pointed out before, by the time children begin their formal education, they possess a vast repertoire of experience with primary designs using rocks, flowers, feathers, and other natural finds. And their primary architectural and construction experiences with sand or snow dwellings and tunnel digging are substantial. Around such creative experiences we can develop an initial art curriculum, because early art interests are inseparable from science and nature. Moreover, what is unique in children's works outside is that they are inspired by all sources. Watching ants and bugs in their natural habitats is approached as neither science nor art, nor do they separate architecture study from nature study. The laws and beauty of nature are studies in such far-ranging subjects as lava and butterflies and are as much art as either play or science. As art is pushed into specialized techniques, media, and activities, we can maintain outdoors what art is for children and artists: a personal experiment and interest in all areas.

Observation and Outdoor Art

Outdoors, like Marcel Duchamp, children work all the time looking for special finds to play with and often display their finds indoors. They look for art everywhere, and in fact, the younger the child, the more intense the search. Pocketing rocks, noticing an unusual leaf, is a result of keen observation, which needs to be kept honed as children begin to see art only as what is man-made by hand and conveyed to them as art projects. Noticing the smallest and most unusual detail outdoors in the complexity of nature (or perhaps stirred by its complexity), children's visions become sharper and more inventive encouraging them to see more in the busy outdoors than in the relatively quiet inside. (Perhaps, in school they are just accustomed to listening and to passively marking time during the day.) With the license to touch, collect, and move, children sense a freedom necessary for observation and intensified seeing.

Outdoor Construction

While indoor young architects construct with cards, dominoes, and Lego, outdoor architects survey pebble roads leading to leaf bridges held firm by twig structures. These crossings for small creatures and G. I. Joe travelers are part of a network comprising roads, forts, and ruins covering outside grounds. Flexible materials are abundant outside—so is space and land to claim, making the appearance of outside constructs more fitting and natural in their settings: endless winding twig fences and decorative flagpoles of twigs guard twig creatures; bigger twigs are replanted as trees. The twigs do not all look alike as children carefully select, trim, and shape distinctions from a

simple raw material. With their animator's instincts, they make any twig or outside form come to life. Stronger forts are built from rocks, and leaf-layered cakes are sold at outdoor restaurants. Towers and desserts are both molded from sand topped with grass clippings and pinecones. Pine needle mazes become marble obstacle courses as kids dig and shape the land. Tunnels for wildlife and small creatures for toy car races become paths in the sand. Children jump into leaf mounts to create circular seeded impressions since there are no bounds to outside building styles and techniques. These unique excavations and earth-shaping plays can be further promoted in school art.

Land Draping and Coverings

Something different always falls off the trees, unendingly yielding new toys with which to play. Each item is like a new surprise; becoming a fine candy to wrap up, a "tube" of color to squeeze, or a form to dissect. Silvery forms on the lawn are not from outer space but foil-wrapped forms kids created and set into the landscape. Children enjoy spreading sheets, towels, and blankets outside to draw on, feeling the bumps and grassy carpet beneath. They prefer soft outside surfaces for molding as they cover, lay on, or create unique art and find this is great fun while engaged in juggling, rolling, bouncing, animating, and draping themselves. In the home, towels quickly disappear from an outdoor clothesline only to quickly reappear as striped and flowered drapings unfurled across the landscape as beach towels, picnic sites, and landing areas.

ORGANIZING OUTDOOR ART EXPERIENCES

An art teacher describes one of many of her outdoor walks with students,

> We went to Ashland, the Kentucky home of Henry Clay, and the historic home surrounded by sweeping lawns and formal gardens. On entering the brick-walled formal garden through the wrought-iron gate, we formed a long line and began winding down the paths, each of us following the canvas: paper taped to the back of the student in front. From the window of our slow-moving sightseeing trams, we recorded all the sights. Challenged to draw from start to finish, left and right, students' eyes took in everything as they moved along. Whispered conversations traveled up and down our line as messages were passed back and forth between the crewman in the caboose and the engineer up front.

Instead of moving to a single site, students playfully explore the entire space first, getting a sense of its whole. Children collect their supplies, picking up the smallest or most precious things they can find. They bring along souvenir containers, shopping bags, for collecting. Initial expeditions may yield sticks, flowers, needles, and stones, which some students use to set up and arrange their garden plot within the garden. Someone for example finds little black pebbles that he names magic seeds, planting them and describing flowers never before grown in Ashland.

On an outdoor canvas students take advantage of the vast scale and the extensive lawns. Using white yarn, they draw trees as big as the old oaks on the property. Springing from the roots of the originals, the trees look like giant white shadows with colored surveyor's tapes and flags, the students construct play houses in the garden, exemplifying the big moves, big ideas, and big plays that the outdoors inspires.

On a hot day, students brought their own watering cans to water the plants. Spills mark the concrete and brick walks with original water drawings, which everyone rushed to sketch on paper before they evaporated. Someone had the idea of wetting large sheets of papers and continue painting with watering-can brushes, filled with colored water.

The garden is noted for its well-manicured shrubs. One student proudly announces that she is allowed to help at home in her garden by using a hedge trimmer. The art teacher plays along, saying that she brought a motorized version and, with an appropriate sound effect, pulls some scissors out of a toolbox. Students kneel before each bush and shrub in the garden and proceeded to rip and tear its likeness in papers. After creating a sufficient number of paper shrubs, they go on to trim them. As the cut shapes began to look like bugs and monsters, students noticed how the real bushes also resembled people, animals, and all kinds of things they could name

Another student suggests imagining a climb to the top of the ancient trees to be able to see and sketch the surrounding views. Other students decide to go inside a tree and be carried by its sap from the basement (roots) to the floors above. Silly play talks, gestures, and pantomimes open all doors of imagination as students draw with grass clippings and dirt, the creatures that live in the garden. As students leave the grounds each says good-bye in their own creative way; like hugging and dancing around trees, or limply swaying to communicate in tree language. See Plate 2.14.

Section Ten Children's Video Art

Children looking at their artworks and themselves on a classroom monitor cheer. They simply love to see themselves on television. Video coverage makes an art lesson into an event. Videotaping a child's art is like presenting the artist with a prize; it is like a special gallery show.

When a child plays restaurant, it involves the rearrangement of home furnishings, the set-up of play figures, drawing menus, signs, receipts, and creating make-believe foods on a suitable table setting. Words, action sequences, and creations in home media are all part of the art, which can be recorded in its entirety on video. While adults preserve their art on disks, the playful marks and gestures kids perform in home chores and active playing have to be filmed. The photographer Cartier Bresson talks about capturing a decisive moment. Still cameras record a moment and a final product. Video has the ability to follow the creative process unfolding. When an art teacher suggests a project to children, it is received as a challenge, explored as an adventure, tried on, and changed a dozen times. If not for video, a unique record of children working through their art would be lost.

Video is a wonderful tool for capturing art in other media. Children look at the LCD screen to study their art and check its progress. They contemplate completed pieces and gather ideas for new works. Children interview each other, taking turns being the video-interviewer and the artist talking about their completed art. Before the camera, children become thoughtful speakers reflecting on their work, the plans they had, and the paths a work may have taken. In videotaped debriefings, children clarify their vision of the work, which may not yet be visible in the completed art. Adults' comments and criticism of a child's work can completely miss the mark without knowing the young artist's intention and vision for it.

The message for children is clear—you are doing something important if your art is being recorded on video. Planning for a shoot requires dissecting the idea, visualizing steps, and breaking down a concept into scenes. As the steps for the shoot are built, so are deeper understandings of the art. Fresh ideas continue to surface when students play before a camera. In art classes, children are often asked to write about their art. For young artists, writing about their artwork tends to be more perplexing than talking about it and having it reflected back on video.

THE VIDEO EXPERIENCE OF CHILDREN

Video can become like crayons, one of many available media choices in an art room. And the video camera is there to be used even before the art lesson as a research tool to gather art ideas. Video updates the traditional show-and-tell—sharing kids' observations and collections from outside of school. During classes, video can be used to record art class performances, celebrations, and imaginary trips. It is a way of recording student art in progress. The video camera acts as an interested audience, an active viewer of child art. It can be used after a lesson to conduct interviews with young artists who talk about their completed art. Many artworks children create are in temporary media, made from cards, sand, blocks, ice, or ice cream. Using video in art classes is a way to explore children's free mix of creative media in playing, while keeping tangible records of the process and final product. Videotaping in the art class is an important parting shot, a final visualization of a drive-in restaurant, a circus, a birthday party in class—all recorded in detail before the artwork is put to rest.

FILMING AND EDITING IN THE ART ROOM

A video camera is a playful viewer, helping students to see artworks in new and exciting ways. Videotaping breaks the silence in viewing art and invites participation for a museum or gallery report. Students will say amazing things about art for a video. Taking the camera along to an art exhibit invites active viewing and sharing ideas about the show.

Scene 1: A student says that the piece of sculpture in the room has a nervous effect, like it would fall apart and its debris would cover everything. A shaky camera recording of the piece, sound effects along with student comments, recreates the feel of the sculpture's crackling surface.

Scene 2: Conversations about how a painting would look if it were hung in a different way clues the camera holder to film the piece upside down and try different angles of viewing the art.

Scene 3: Having a difficult time responding to a conceptual piece, the camera person decides to turn the scene into a roaming interview. For a collage of opinions, the student becomes an interviewer, asking everyone in the gallery, including the custodian on duty, for input.

Scene 4: In the final cut, the camera person is inspired to provide interpretive and creative views of an art show. Every control of the camera is exercised including blurred frames, slow closes, and views of the art in black and white. The video is recorded with a blank sound track, and everyone in the art class is invited to provide their own narrative descriptions.

USES OF VIDEO IN ART APPRECIATION

Video allows children to save their collections when no one else wants them near the house or brought to school. The video camera saves valuable visual finds and experiences as a permanent and portable record—a record that, in turn, can be brought to an art class for appreciation.

And how do we prepare today's children for a life in art? We can begin by building on existing interests. In their teaching, art teachers can emphasize student ideas and make the media they work in less important. Teachers may focus on how to think about art, how to approach and communicate one's creative ideas through any media or combination of media. Adult artists have freely followed children's lead, crossing media boundaries, and including

video as part of the artistic palette. School art can no longer consist of demonstrations of the finer points of each traditional art media. An art room has to become a young artist's think-tank.

The video camera allows a celebration of the child artist before audiences of other children. The art teacher may frequently screen great examples of children's home art for art students. Video helps in the promotion of student art-recognition that is seldom provided to young artists working at home. An art teacher can curate videos of children's play creations or unique approaches to home chores. Artists in a video collection are seen wrapping presents, playing house, dressing up, creating an outdoor café, or redecorating a playhouse. Video tapes attest to the unique media, tools, and art forms invented daily by child artists. While examples of adult art are regularly featured in art classes, through video clips, children's fleeting, impermanent, and unheralded creations are recognized. Future art teachers can come to class with exciting examples of childrens' art each day and suggests art lessons that further the unique art the children see on tape.

An art teacher always sings the praise of the innovative creations children make at home. They tell stories of home creations and occasionally bring in items kids have made. Using video in art teaching, one can more convincingly show the story of the child artist who is observant and not ashamed to browse in a trash pile, someone who has wonderful art ideas and the determination to act on them. Videotaping highlights the collecting instincts of children who are always ready to pocket or haul unusual things to home studios. Video recordings document and celebrate this talent. Videos also reveal children as visual shoppers and capture how important it is to actively search for art ideas. The best ideas surface when artists find something special on their own.

LOOKING AT THE VIDEOS OF CHILDREN AND ADULTS

There may be an artist in your family, or someone you know, who has never been recognized for their unusual art. While art teachers can have students meet artists, videos show the importance of creative people already in students' lives. Through their videos, students frequently discover talent displayed in non-traditional art forms and art acts. The subjects of videos are surprised by the attention and being called artists, often for the first time. The videos offer an unforgettable glimpse into students' artistic influences

and promote important family talks about art. Student videos of art often record vital family treasures, including antiques and collectibles the videographer feels should be noticed and preserved in pictures. Video can become a child's voice, documenting his or her own view of art and visions of the world. Unlike written diaries, which are private gestures that can be ignored, videos are public statements demanding attention, recorded for everyone to take notice. Videos also allow for special meetings with artists outside the home.

Most teachers are in college studio classes before they have the opportunity to visit an artist's studio. Children should not have to wait that long. Through an art teacher's videos, students may enter the studios of colleagues in a variety of art fields. They can visit an architect's office, go along on a photo shoot, and enter the restoration suite of a major art museum. It is fine to have artists be seen on commercial videos, but it is not the same as an art teacher making a video designed for his or her art class. Through personal videos, artists can directly talk to students and answer their questions. These video tapes represent artists who are alive, not only those existing on museum walls. Instead of looking at the works of artists in museums, the art teacher as video maker can interview and record local community artists while they set up in university galleries or at local openings. Besides special celebrations, art events also occur in many portions of daily life.

Look at the stained glass windows, not in a French cathedral, but at Joe Bologna's, a Lexington, Kentucky pizzeria. A magnificent light show showered the table and came complimentary with the lunchtime meal. The waiter explained that the windows had previous lives, inspiring Unitarians to prayer since 1890, then sending heavenly colors upon Jews when the building became a synagogue in the 1920s. Luckily, a small video camera in the phone is there to capture the light. In the narration on the video, students are asked if they know of other places in town where one could film a light show.

Later, while introducing a lesson on stained glass art, students were fascinated by the video of a familiar place. Video is a powerful tool to point out overlooked art. It can inspire an art lesson with references to familiar sights and places. Yes, one can also talk about the stirring lights of Chartes Cathedral, but in place of reproductions on paper, or commercial videos, the video lunch at Joe Bologna's makes a powerful impression. Lecturing about art qualities and elements to children only abstracts the feelings we are trying to build towards art. After studying art history and aesthetics in college classes, art teachers often give college style lectures in school. Video is a personal art about art. It not only shows artworks, but expresses an art teacher's deepest thoughts and feelings about it. Making a video focuses the artistic awareness of an audience. It translates art concepts into interesting and meaningful images. As a filmmaker, future art teachers may consider how information can be presented in a visually powerful way. While filming, a videographer asks themselves how an experience can be made unforgettable. Isn't this essential in teaching all art lessons to children?

The Video Art of Children

Children are the original action artists. Their lively moves, investigations, and animations of toys and found objects are well-suited to the action of video. Children's home plays and inventions, their artistic approaches to home chores, are art media just gaining recognition, because they are being recorded and imported to larger audiences on video.

What cannot be scheduled for show-and-tell, important areas of kids curating and collecting, can now appear in short films. One art teacher calls the class, "The Kids Television Network," where feature programming is based on videotaping children's play and creative performances at home. Video recordings look at painting by revisiting children's kitchen art, sculpture by references to kids experiences with action figures and play set-ups. Cooking shows revisit the time when children were great kitchen artists. Travel show correspondents visit kids' rooms as art studios in the house and worthy of notice outdoors. Kids' versions of the "Antique Road Show" feature authentic children's collections. Birthday party videos are the frontier of new artworks, as children create and film the parties they always dreamed about, but seldom get. Video is the perfect art media to capture the lifestyles of today's active children.

Children view the world from moving cars and school buses. All day children are chauffeured to and from school, lessons, and events. Even as kids, lives speed along at an amazing pace. With video cameras students are reminded of the joys of looking down and finding interest in the cracks of a sidewalk, the wildlife of bugs in the cracks, and the found treasures in nature and the environment. Video can be used as children's magnifying glass, collection jar, and travel bag. Art classes can prepare kids for the future by using video to make every day an adventure in seeing, every trip a safari, and every video tape a wealth of recorded finds.

There is no doubt that if you go to any museum that the art world has embraced video. Those involved with school art need to be more active in this area, helping children expand the palette of crayons and paint to include other ways of functioning as artists.

Video recordings can bring to class the latest and newest in products and designs from any store. Perhaps, more importantly, these video reports convey the artist's enthusiasm about the future and the new. During "Back to School Day" events, the art teacher may shop with the camera for the most interesting crop of folders, new pencil topper ideas, and the latest boom box pencil cases. Before Halloween, a report can be filed on Target masks, the tribal disguises of our generation. You can see it in the art class first. The video camera is there to review the newest in children's character toothbrushes, candy dispensers, and the pool toys and beach towels for the summer season. Stores come to class in video diaries, showing children that their interest in playful artistic shopping has significance. Uniquely American objects are of interest to artists of all ages, and video footage challenges art room design teams.

Ending

For the future art teacher, lesson planning is no longer just paperwork, but an active state of searching for the video footage that best inspires and explains the art lesson. Instead of planning for a lecture, a plan can be for videos to describe what the students will see and experience in the art room. Video makes it possible to share how the art lesson inspires the art teacher in the first place, leaving some of the wonderment of discovery intact. Video reinforces the act of being an observer, of finding a lesson idea and seeing it develop on its way to becoming school art. The camera accompanies each daily journey, leading to capture sights, events, and sounds, which inspire the artist,

FIGURE 2.7 Play Camera

but tend to be filtered out by school walls. The informality of the camera is a model for selective seeing, just like bending down and picking up interesting things all the time. Through videotaping, an art teacher continues to be involved in fun objects kids notice and appreciate. When videotaping for a lesson, it has the feel of planning to share something special with young artists.

Creative Planning and Topics for Group Discussion, Activities, and Extensions

- Create a sample newsletter to parents in which you describe what you are doing in the art program, and what they can do at home to prepare children for art. Write a draft and submit it to your future art teaching colleagues for online editing suggestions and discussion.

Section Eleven Children as Photographers

THE UNIQUE PHOTO VISION OF CHILDREN

In 1934, for his sixth birthday, the legendary French photographer Eugene Atget received a camera he had been wishing for. In the early part of the twentieth century, a first camera was a bulky black box that for a child was not easy to maneuver. But maneuver he did, taking some of the most memorable photos documenting a generation. In most coffee-table-size books, Atget's childhood photos are included, and stand up in quality and invention to any of his later works. Atget took his camera everywhere; it became his best friend in capturing a childlike wonderment at life's ordinary events. Atget's story is a testament for art teachers who need to be convinced of the value of introducing children early to such friends. They only need to browse through Atget's masterpieces to understand the value of one's earliest photographs.

That's Me!

Children spend time before a mirror to evaluate their own image. They may try many expressions and feel their face to find the "me." Most early pictures set out to search for the "real me," and children accumulate so many photographs, mirror images, and drawings with different expressions and views of themselves to consider that the search for the real me has to be continued. Children spend time with photographs that claim to be them in the past, without being certain how such a difference could be possible. The search for the real me is complicated by adults who look at most photos of themselves and say, "That looks nothing like me." Many children conclude that there must be many mes, and they try out different expressions and smiles whenever a camera is pointed at them.

By being the focus of so many cameras pointing at them, children conclude that pictures referring to them must be important. Parents seem to be constantly asking children to look at the camera and smile, and then they take a long time debating which picture is better. Soon there are pictures of "me" in important places throughout the house—on dad's desk, in the living room on the piano, and all over the refrigerator. There are pictures of them in all sizes. Their pictures are on holiday cards, and there are always some carried in wallets. Children learn that one not only smiles for pictures but those photographs bring out smiles in people looking at them. Photographs come to be associated with happy moments, with family, and a sense of belonging.

Many children recall a momentous occasion of stardom when they became a screen saver. Today children see themselves as soon as parents open up their computer and they begin to associate photography not just with a camera but with computers. Children see pictures of themselves in digital photo frames, and their image digitized on mugs and puzzles. Children soon view scores of pictures of themselves at different ages and in different places saved and generated from the computer.

Children feel important, seeing pictures of them sent everywhere, posted for everyone to see. They learn that after a picture is taken it's uploaded on the computer and that this is a way to share photographs. Photographs are perceived as a gift to others, something parents enjoy sharing. Not to mention the messages that come back saying, "Oh, she is so cute!"

If a child does anything unusual or seemingly important, there is a dash for the camera to take a picture of it. An early understanding develops that photography is used for important things. When a child makes something they are quick to ask for a picture of it. Photography develops from portraits of "me" being important to what I do or create also being picture worthy.

The Photo Booth

To enter that magic booth closed off by a heavy curtain was as much an American tradition as instant photography. You would enter with a loved one, insert a coin, and take a seat inside the time capsule, facing a blank screen. You'd take the vow of silence posing, and after a moment of anticipation a bright light would flash before you. After a few seconds, four little square, black and white pictures would slide down, attached like a long ticket from an outside slot. It is hard to describe the solemn fun of that old experience to someone who sits before a contemporary photo booth.

For children today every computer has a photo booth application, yet the experience is not the same. There is no longer a need to enter a magic little house, to drop a coin, or even to stay still and wait in silence. Children can act out as many silly gestures and faces as they want, money is not wasted, and instead of four precious little pictures there are instantly about fifty up on the computer screen. Little

rehearsing is required, since if anyone is unhappy with the results, erasing is just as instant. Children understand that taking computer-assisted pictures is no longer a one-time event, highly rehearsed for special occasions, but something that is casual, done without much fanfare, and can take place anytime and anywhere. Furthermore, children's earliest photo experiences are no longer about holding pictures in their hands after having waited for the results to come back days or weeks later. Instead they are seeing their image on the camera or computer screen instantly.

New Technology, New Features, and New Photo Experiences

It is almost safe to say that you cannot get a phone today without a built-in camera. In fact many things from computers to phones and now some watches come with built-in cameras. Cameras used to hang from tourists and serious photo students, but today everyone walks around with one, often unseen. Making images of course has become easier and faster, but also a more ordinary experience and a part of daily communications.

When Kids Get a Hold of Cameras

Great photographers manage to maintain their childhood curiosity, wonder about the world, and sense of humor about things that is so much a part of children's photo vision. Children are amazed by so many events that seem ordinary, mundane parts of living that adults would never think to record. Reasons for using the camera just blossom and broaden when children start using it. Photographs seem to be taken of everything, but they are seldom random shots; it's just that children are interested in so many things that are not considered traditional subjects.

Funny Photos of Oneself

Today many children start taking pictures earlier than Atget just by using the family cell phone; taking pictures of people and events starts even before children can draw. This alters all early figurative art, accelerating traditional stages of learning to draw a figure. Art teachers may consider photography as an accompaniment to enhance skills and ideas for all media studies in the art class. Taking hold of a camera has the feel of instant power, as children take photos of everything.

Opening the Camera

By opening an old camera, students develop important understandings akin to those of the notorious dissection of a frog. Since children cannot dissect the human eye, nor see inside a new digital camera, a look inside old cameras allow this important view of how things work.

Art teachers can demonstrate the basic methods of how cameras see and take pictures. A model of the human eye can be useful so that comparisons can be made. Entering the dark place may begin with an old box camera to see how light floods into the box through a small opening at one end and is focused on a light-sensitive surface on the other end.

An older film camera can be dissected next. In an older rangefinder camera, students may see how the amount of light entering into the dark box can be manually adjusted, and how the image taken can be previewed above the lens. Some cameras, like rangefinders, estimate what the camera actually sees, with helpful graphic frames used as clues in the viewfinder. Peeking into an old single lens reflex camera, an SLR, students can experience the curtains and flipping mirrors that allow viewing through the lens. While digital cameras are harder to penetrate in order to see the heart of a computer inside, the basic principles of allowing light to enter a box seeing the picture to be taken either above or through a lens can be applied to onscreen viewing systems.

Recording Images

Opening the eye of the camera or the lens to different size openings, children notice that the camera admits different amounts of light. If it is bright outside the lens squints like the eye to block the light, creating a smaller opening to the dark box. If it is dark outside, the lens has to be opened wide to admit enough light to reach the back of the camera and record an image. Pictures used to be recorded on glass plates, then on film, and now on digital memory disks.

Developing film and making prints is an exciting event to witness and experience. Visiting a darkroom, trying to load a roll of film, seeing a print pulled from a tray, and looking though a negative are magical events that add to the students' understanding of the photo process and an appreciation for beautiful handmade prints. Art teachers can set up a model darkroom in school, or include a visit to a photography darkroom as a necessary field trip for the class. Because of the sharp decline in darkroom use since photography came to be digitized, the upside is that old developing equipment can be purchased inexpensively for demonstrations, or class use, at a fraction of its original price.

Looking through Different Lenses

To experience how lenses work, a camera body with inter-changeable lenses can be set up on a tripod for students to peer through. A series of lenses placed on the camera, from panoramic to extreme wide angle, allows the experience of seeing wider than the human eye. Looking through extreme telephoto lenses that bring very distant things close up can be instructive. Students can experience a 50mm so-called normal lens that approximates human vision. Art teachers can imbue camera studies with a sense of wonderment and possibility that inspires students to consider all optical instruments as creative tools and idea sources.

Playing with Light

The interest in the timeless elements of art such as light and color can be shaped by photography. There is nothing like a camera to impart an awareness of light and all its changing effects on every face, form, and scene. Children seeking shadows at high noon, or waiting for the subtleties of late afternoon light to photograph a decorated bike, are like the painter Monet waiting for his haystacks and cathedrals to take on a different glow during the course of a day. Daring to photograph under an umbrella because the light of the storm looks so unusual is a sign of recognizing how the camera is flattered by light. What time does the sun come up? There is great excitement at home when children are asked to meet the rising sun with their cameras.

Art teachers don't have to invest in pricey studio lighting because the powers of illumination in contemporary flash-lights make all kinds of classroom and home lighting possible. New bulb technology has made lighting capabilities on faces and forms extremely portable. With the power of light in their hands students can experiment by light-ing their play figures, action scenes, or the textures and patterns of their most unique collections.

Exploring Color

Children often make decisions based on colors, picking up street or nature finds or desiring certain toys because they like the color. Photography strengthens color awareness as something beautiful to look for, to be enjoyed, and used in the art of making pictures.

Future art teachers can focus photography assignments on children's favorite colors as they exist in nature or in a home. Children can arrange colors for photo shoots, creat-ing flower arrangements and still lifes that bring together students' finest color finds. Students can be asked to wear to class their most interesting palette, or to bring an object that would light up a bland room with its color. For students who have not experienced their world in black-and-white photos or on television, it is important to see it on a digital camera screen capable of instant colorization. To physically experiment with changing black and white, students may start with simple forms such as an egg, to be transformed with colored lights, projections, and filters. To focus on color, art teachers can ask students to collect objects and arrange colors as a photo stylist would for a photo shoot.

Seeing through Optical Instruments

A camera is an optical tool with powers to increase the speed and power of human vision. These tools allow a look at the world and to explore farther than anyone in the past could imagine. Optical devices allow everyone to step out from routine and ordinary seeing and to record fantastic visions. Children who experiment with magical views can record them in photographs.

Mirror Images

If there is a large mirror in a store, then mom is generally left alone to shop while children play before it. Children offer their finest performances in a ladies' boutique, before wall-sized mirrors. Coming face to face with oneself is a compelling moment that invites dancing and uninhibited poses. Mirrors are like a camera, frames that inspire indivi-dual humor and acting.

Looking through Magnifiers and Microscopes

There is always a surprising view at the end of a lens. By playing outdoors with magnifying lenses, students build an interest in looking at nature up close. Students can look closely at their skin or the surface of plants and insects. With cameras peering through the magnifying glass, children closely examine and can save their most fascinating collections. Art teachers can look for magnifiers of different shapes, sizes, and illuminations.

To experience the extremes of closing up on small worlds, students can place found items under a microscope.

A fantastic view of snowflakes or small organisms can ignite a lifelong fascination for the visual beauty of life's basic forms. With a camera attached to a microscope, students can experience taking pictures of blood, hair follicles, or details of a butterfly's wings. After being exposed to microscopic imagery, the notion of close-up picture-taking takes on a new meaning. Art teachers can prepare slides for demonstrations, and begin the collection of ideas and striking objects to view under the microscope.

Playing with Binoculars and Telescopes

Each photo experience with students can develop an excitement for viewing things differently and freshly, like seeing through different lenses of a camera, binoculars can extend children's vision and be more accessible than working with long photographic lenses. Bird watching with students, for example, can make use of binoculars and develop an interest in viewing things far away without disturbing them.

Making Lenses, Viewers, Filters, and Cameras

Children can make their selections from the world by looking through lenses, viewers, filters, and cameras that they make. Like seeing through a crystal whose every facet provides a different view, looking through each object provides a different picture.

As students move their head slightly to look through the crystal, a vastly different range of sights is formed. The section that follows deals with the body, describing how with just a slight shift of the head, for example, everything changes in a photograph.

Looking through Tubes

Students can practice viewing the world through lenses they construct and discover. Recapturing the excitement of views through cardboard tubes, corrugated hose segments, or kitchen funnels, can be a goal for photo instruction. A familiar game for children is looking through a cardboard tube and seeing someone's eye meeting theirs on the other end. Kids laugh and have a ball using found lenses to focus in on eyes, or for circling more open vistas. Children's general interest in looking through cylindrical viewers can lead to an interest in a wide range of camera lenses.

Filter Ideas

A familiar children's game is looking through the bottom of their glass and using it as a filtering viewer after they've finished their drink. Children enjoy trying out objects placed before their eyes to look through, using various colored and shaped filters. In the kitchen they test the view by looking through the bottom of a sifter, or try seeing like a fly with many lenses peeking through bubble wrap. After watching an entire soccer game from an odd vantage point from behind the goal, a student brings to class interesting pictures of the game filtered through the net.

Art teachers can challenge students to use their own ideas of objects to look through and take pictures with. On the way home from school a student with a camera explores photos through neighborhood fences. At home the Venetian blind inspires another young photographer to take pictures through its openings. There are many colored cellophanes and screens that can be used to explore filtered views with the camera. Each photo filter breaks up the viewing lens, creating different contrasts and sharp or soft patterns. Playing with their own devices to filter views or light, students learn to use the camera as a tool for experimenting.

Looking though Frames

Children love to try on all kinds of glasses that frame their views. Students who don't wear glasses can explore the world looking just through frames. Picture taking is a process of selecting or framing desired views with a viewfinder, camera screen, or eyeglass frames. There are many geometric shapes that can be found in kitchen drawers and throughout a home that can be adopted as make-believe camera viewers. One child cleverly walks around with a small picture frame, placing everything she wants in her pretend photograph into the frame.

Art teachers can begin to consider creative ways to underscore the notion of the camera as a tool to cut away a visual selection from a larger whole, framing certain things and leaving out others. This decision of what to take in and what to cut out or exclude is a significant tool in the art of photography. In the art room students can look for and make their own viewers, including stencils, cut-outs, adjustable cardboard screens, or openings for selective framing. Shapes torn into soft paper create soft framing edges. A student who brings to class an old window with divided panes, which he saved after a home remodeling, proposes framing photographs through windows. The class enthusiastically responds

with related suggestions of a car and a school bus window, as well as store windows that can be tried in framing pictures.

Making Play Cameras and Cameras That Work

Students can transform interesting boxes, such as ballot boxes, mailboxes, and jewelry boxes, into cameras. Building fully equipped play models, complete with flash, tripods, lenses, timers, filters, and viewing screens, becomes a hands-on way to learn about camera parts. Film can be simulated by drawings on adding machine tape. Promoting the design of futuristic cameras can help children learn to visualize extending the present limitations of the media. Children's responses have included cameras that dispense portraits in three dimensions, like a jack in the box. Others suggest cameras capable of producing three-dimensional wedding scenes inside, or cameras that can be used in the bathtub for underwater photography.

In addition to fanciful models, art teachers can use pinhole cameras with students. Using the basic black box, a pinhole opening is made with a removable lid. Light sensitive paper is stored inside the camera, to be exposed by a momentary opening of the lid.

The Body and the Camera

Photography sometimes involves sitting still, posing in silence, or holding the camera steady. It can also be the opposite, an expression that requires moving and action from the eyes to the hands to the entire body.

Many photographers wonder and walk endlessly to find their decisive moments and subjects. Others look for action in a football game to photograph. Watching a body (or being a photographer) in motion requires constantly seeing new images and finding new framing possibilities. A camera in motion can paint and blur images. In moving, a photographer experiences new angles and discovers new views.

Photography on School Field Trips

Students often take school trips, and the advantage of inexpensive digital photography is that students can interpret and reflect on these experiences by including a camera. No one knows when and where interesting things will be found, but having the camera in hand heightens awareness and motivates the creative search. Using a camera in an art museum, for example, allows pictures to be seen upside

down or sideways or can focus in on a single brush mark. Future art teachers can stress the message that all their trips for school and outside of school require taking a camera.

Future art teachers can consider such practices as following an art museum visit with having students share photos of their favorite works, discussing the art they would want to hang in their room as well as examples of "questionable art." This can provoke intense class discussions. The photographs that art students accumulate after a visit add immeasurably to the memories of the museum trip and the art they have seen.

Children in the Newsroom

The news is only for adults, or so it is said. But in a media-saturated society events don't escape kids' attention. Children are in fact exposed to and affected by newscasts and images in newspapers that make their way into homes. While adults listen to commentaries and post their blogs, children have few avenues to deal with and respond to the news. Art teachers can teach children to put their camera into action, to be observers, reporters, and investigators.

Children Making Family Photographs

There are public news events and also news in every family. Home events may not make headlines or be touted in school, yet they are important in the life of children. Drama and celebrations are played out in homes and children are aware and listening but don't always have ways to respond, to create keepsakes, or share them with the outside world. Art teachers can work toward making cameras available for home, to be used silently, unobtrusively, and faster than other art media. Many notations of home events can be kept over a period of time in a small memory stick inside the camera.

Children's Sports Photographs

One of the most powerful subjects in photography has been sports. In magazines or newspapers, sports photographs are some of the most memorable visual documents. Children, who participate in sports and spend a great deal of time in locker rooms, practicing, or on the sidelines, are uniquely prepared to take pictures. In children's photographs the pictures of a wildly enthusiastic coach or a disappointed parent can sum up the drama of youth sports.

Children's Portrait Studio

Whether it involves going with the family to a portrait studio, or just the experience of sitting for school photographs, children know what it is like to have formal pictures taken of them. But great pictures are taken when a child creates their own backdrop, gathers lights, and directs the costume makers while playing portrait photographer.

Children as Fashion Photographers

Fashion photography is often viewed as the glamorous art, but for children who play both in front and behind the camera, it is a lot of creative work. Dressing up in borrowed clothes or wrapping oneself in towels, scarves, or blankets presents unique opportunities for modeling, posing, and performing before a lens. At a school dance, a photo-booth style area set up for kids becomes the most popular place to pose before the camera. Starting at home and continuing in school, fashion photography can become a recognized children's art.

Children as Nature Photographers

Seeking beautiful things is an occupation in itself. On the way to the store in the morning a child carefully looks at the flower buds that opened since last evening. She selects the most beautiful flowers of the day to pick and bring home. At home she takes her time arranging the flowers in a vase, getting her camera and taking several pictures. Nature photography for children is seeking pure beauty to pick for a vase or to put inside the camera.

Digital, Online Portfolios

Photos of completed art made by students not only build a convenient portfolio, but also act as a means to examine and learn about one's art. Having an online photo album means easy access to old works. One's art is the best art teacher, and online portfolios are useful tools for comparing old and recently finished pieces. Digital portfolios are easy to sort and arrange and are always available to look through and play with.

Getting to know one's art is an important part of being able to guide its path and future. Photo folios taken by children help them to recognize the qualities that are unique to their art—their style and preferences. Art teachers can put student artwork on a class web site instead of paper portfolios stored in the room. These portfolios can be maintained, updated, and of course photographed by the students themselves.

Conclusion

Children are the most playful photographers when art teachers unleash children from old photo habits and rules, and allow them to take on what were traditionally adult photo assignments; children prove to be the most original and playful artists. Photography play can take place before the lens and in front of the camera. These actions may include creative posing, dressing, set design, and fantasy creations. Playful editing inside the digital camera and on computers frees young photographers to recreate the images taken. Fast and relatively inexpensive printing methods provide further opportunities to playfully create with photographs outside of the camera.

Section Twelve Technology and Computers in the Art Room

With the ever-increasing importance of technology, it might not be surprising if one day human babies spring forth from the womb into the world with the latest cell phone already in hand. Seriously, if a child is asked to draw some ideas for a birthday invitation that she might wish to create, she is just as likely to plop down in front of the home computer as a sketch pad. The computer is a tool, and accessories and software offer multiple media for artists of all ages. Many children live and develop in homes and schools where technology exists in such abundance that its use comes naturally at a very young age. Likewise, in extreme cases, some students might not have a home computer, or access to any technology at home. In either case, the school has a huge responsibility. Future teachers must be prepared.

HIJACKING THE HOME COMPUTER FOR ART

School assignments, projects, and challenges are often completed at home, and frequently with aid of the home computer. Children, who might ask dad if he minds giving up his computer time, often find themselves deeply engaged in artistic behaviors. "Please move over Daddy, I must have the computer to make art!" It should be noted that before most children ever step foot into a school building, they are actively involved with computers, the latest software, computer games, digital cameras and video recorders, cellular phones, personal game devices, and other technologies at home. Many children have barely learned to walk before they begin to learn computer mouse skills that they will carry with them through life. Tiny tots become quite accomplished with extremely durable digital cameras, such as those currently made by Little Tikes toy company. Please note that computer systems, software, and games are updated with such rapid speed that it would not make sense to even try to list many specific names in this chapter, for surely all will be outdated and/or updated before this book goes to press. The important thing to remember is that technology plays an important role in many homes, and it will continue to do so in school years, and all throughout life.

Many important skills are learned and practiced via computer software. Numerous games involve artistic action, often allowing for "side trips" during adventures where the child focuses solely on drawing, painting, creating, altering, and often printing their own original images. Without yet knowing technical artistic terms, young home computer artists are often thoroughly engaged and entertained as they experience and learn about texture, color theory, line, line weight, value, tints, shades, intensity, famous artists and artworks, composition, artistic style, shape, form, and such. It is crucial that elementary and middle schools do not drop the ball, or allow any sort of pause in these early artistic experiences. When young people enter school, they are eager to continue making art, including computer art, and art that is assisted by means of technology.

I never let my schooling interfere with my education.
—Mark Twain

EXPANDING CHILDREN'S COMPUTER PLAY IN THE ART CLASS

Computer usage, begun at home, must continue when children enter school art education programs, where computers and technology can play an important role. Schools lacking in technology present a problem for students who are then forced to home-school themselves in this regard. Young people are highly capable and resilient, and they often enter school knowing more than their teachers do about the newest technologies. Mark Twain said, "I never let my schooling interfere with my education." In regard to technology, most elementary and middle-school students seem to be well aware of Twain's declaration. Appropriate support, via funding, professional development, and thoughtful scheduling are all crucial for teachers and schools to remain current. There should be no technology gaps when children go to school. Ideally, students' technology usage transition from home to school should be seamless. The teacher might arrange a few computers or a small computer lab of 5 or 6 within the room, where students can choose to use the computer as a tool, while others are free to simultaneously utilize other media. Additionally, visits to the school computer lab where each student works in front of her or his own computer are an option. Most schools have roaming computer labs, or stations that can be loaned out for any length of time, and in some instances, students bring their own laptop computers with them each day to school. Michelangelo, an Italian Renaissance artist, said that "man paints with his brains and not with his hands." First and foremost it should be remembered that children will primarily use their brains when they paint with their imaginations, and that the tools—whether they be computer software or brush and tempera paint—are tools to be made available for creative play, experimentations, and creations.

How does the teacher know what art software and art games to make available to students in the art room? Ask the students. They know. At conferences, and in other teachers' rooms, and in nieces' and nephews' homes, sit down and try out new games and software whenever given the chance. Try to view the experience with children in mind. A game that does not seem interesting to an adult might be viewed by children in a completely different way. In a drawing program, for example, a "bomb" icon that, when clicked, causes the image to explode, as an alternative eraser option, could be really fun from the perspective of a young, uninhibited mind.

Art teachers might collaborate with Student Technology Leadership Program teachers, or state visual art association conference planning committees, or other art teachers. Student groups might set up a booth at a local teacher conference, or parent meeting, or fall festival, and offer original artwork created at the computer, or a page of

personalized business cards printed on the spot. In preparation for this entrepreneurial adventure, students could plan for their booth design, logo, business name or corporate identity, and even their own business cards (possibly with the school art program web site, and of course with no personal identifying information connected to children other than a first name).

Most state sponsored and national art competitions offer a computer art category, that is, art that is completely computer generated. Some allow use of existing images as long as they are altered with copyright laws in mind, and some only allow original, made-from-scratch artworks by students. Many also offer a digital art category, where it is permitted to enhance and alter existing images using tools that do everything imaginable—changing appearance in numerous ways (texture, value, style, media appearance, color, etc.). Additionally, digital photography is a common category, where rules will allow varying degrees of manipulation to original or altered images. Art experiences can be increased by providing information, skills, and knowledge to students regarding such opportunities.

SCREENING AND DISCUSSING COMPUTER ART AND DIGITAL GALLERIES

The list of spectacular digital art web sites is unending! Digital, or computer generated, art can be viewed as part of small or whole class instructional experiences, in the classroom, or school computer lab, or at home as out of class challenges or assignments. As with computer art software, web sites are also in a constant state of change, and many will be altered, updated, or even deleted before this book goes to press. However, we would be remiss if we did not mention at least a few tried and true sites that have already proven that they will possibly exist for a long, long time.

One such example is the International Children's Digital Library (childrenslibrary.org), which offers copies of thousands of children's illustrated books from over 100 cultures in 20 languages, such as the charming book, *Belly Button of the Moon*, written in Spanish and English by author Francisco X. Alarcon and illustrated by child artist Maya Christina Gonzalez. Valuable links can be found, such as the International Child Art Foundation (ICAE).

We want to motivate students to think and ask questions, and ideally we will arm them with the ability to find answers to questions. If using ARTLEX (www.artlex.com), for example, to look up the definition of "collage" a student

will encounter a list of related processes such as bricolage, coulage, femmage, frottage, fumage, marouflage, montage, parsemage, and photomontage. Whew! Though some of the art terms might be familiar, this is a fabulous resource for introducing young art researchers to new terms that might guide their interests down paths that might not have otherwise been explored. References such as this art dictionary are for artists, collectors, students, and educators in art production, criticism, history, aesthetics, and education. Here, the viewer will find more than 3,600 art terms, useful index, and shortcuts list. As a teacher, the pronunciation guide will also prove to be useful, so the teacher will know, without a doubt, how to pronounce chiaroscuro (Kee-ahr'oh-scyoo"roh).

Another interesting resource is offered by the International Association of Astronomical Artists (www.iaaa. org). A visit to this site's digital gallery will reveal a variety of media that has been used to express various artists' visual messages about space. One of the reasons they are so important is that we've discovered almost 500 planets outside our solar system but imaging technology is not good enough to show us what those planets look like, and it won't be good enough for more generations than we can count right now (and the ability to travel to them is far beyond our reach). So the only way to see these planets is

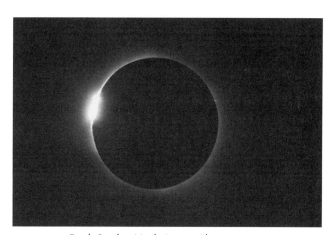

FIGURE 2.8 *Dark Sun* by Mark Aaron Alsip

Captured in northwest Mongolia in 2008, this artwork is by computer programmer, photographer, and total eclipse enthusiast Mark Aaron Alsip and titled, "Dark Sun." This particular moment during a total eclipse is referred to as the "diamond ring." It is a big burst of white light at the 9:00 position when sunlight is streaming through mountain ranges on the edge of the moon. The pink spike near the 3:00 position is called a "prominence," which is a flare leaping off the surface of the sun (that is behind the moon). Alsip talks about this event with such excitement that listeners are on the edge of their seats when he shares that, "The impressive thing about the prominence is that it's larger than the Earth!" This type of excitement leaves students ready to learn more about astronomy and fine art photography. (www.AlsipPhotography. com).

through the eyes of artists. The art is used by NASA and all the publications you find on your local magazine stand to illustrate stories. In this case, where words just are not enough, it is the art that keeps the public inspired enough to fund science programs, and a lot of important discoveries that help people in daily life because of what results from the research. As we know, the space program gave us a lot more than just Tang! Many photographers and astronomy enthusiasts turn their digital equipment skyward, following and photographing amazing astronomical events as they occur, such as those who faithfully follow total solar eclipses.

While students will benefit from looking at the artwork of other artists via computer, they can also gain from creating, and/or being highlighted in their own digital art gallery. The teacher can earn understanding, support, and recognition of parents by running a digital art gallery during PTA meetings, school festivals, local television stations, and other community events. Students will enjoy creating the electronic galleries of their own work, and will most certainly wish to serve as narrator or digital docents when the audience arrives. A video or disk can be looped to run on televisions or computers in local stores, restaurants, doctors' and dentists' offices, hospital waiting rooms, and such. Whenever possible, background music and added text can be an added enticement to hook, and keep, the viewer's attention. What a great way to advertise a quality art program, highlight student artwork, and boost student's motivation by giving them an opportunity to share their creations.

Without leaving the comforts of the art room, students can begin their journey into a different art gallery or museum each day of the week, such as the work of nature photographer Ora Alsip (www.cumberlandfalls.org). While such tours cannot replace the rich experience of seeing the real artworks, there is no doubt that this is the next best thing. These virtual visits will introduce to elementary- and middle-school students the wonderful world of art museums that they are sure to want to visit in person as they mature in their visual education throughout life. Many digital "tours" allow the viewer to take a "virtual" tour, where they can actually walk (visually) around a sculpture, seeing it from all sides. The teacher should first view web sites, and will have no problem constructing a good age-appropriate list for students to use. Many museums and galleries have created kid-friendly web sites, or art education teacher resources such as: The National Gallery of Art (www.nga/kids), and The Museum of Women's Art (www.nmwa.org) in Washington, D.C.,

The Art Institute of Chicago (www.artic.edu/aic) in Chicago, IL and the Metropolitan Museum of Art (metmuseum.org/explore/museum/kids) in New York City. See Plate 2.15.

DISTINCTIVE COMPUTER IMAGES CREATED BY CHILDREN

Artsonia hosts one of the largest student art galleries on the web (www.artsonia.com). This kids' online art museum is a place for art teachers to exhibit their students' art. Additionally, it allows children worldwide to view hundreds of thousands of K-12 artwork. Here, the viewer may search by school name or artist screen name, or simply enter the digital museum. Parents and students can view international art, as well as visit Artsonia's wonderful art-related links (NAEA, art contests, VSA Arts, etc.) and can also visit the gift shop to purchase items with their own children's artwork. Why not send invitations to students' homes announcing quality digital exhibitions that they can visit with their parents via the home computer?

As previously mentioned, the computer is a tool. As such, it can be used as any other art medium to make creative and unique artworks. Instead of grabbing a colored pencil or crayon, a child might decide he or she would like to exercise their rights as an individual and utilize the computer for a particular art experience. Young people can be taught that some well-known artists have used existing images as a springboard for their visual message, such as Marcel Duchamp's use of Leonardo da Vinci's painting *Mona Lisa*. Students can benefit from learning about copyrighted images in the art class, just as they must know about plagiarism regulations in the language arts class. Using and altering existing images requires that copyright laws must be followed; however, web sites continue to appear that offer students the chance to create their own artwork using an array of techniques (www.nga/kids). Albert Einstein said that, "Imagination is more important than knowledge." In every possible instance, students will benefit from using their imaginations, thinking critically and creatively, and being given a license and necessary support for these actions. Why require all students to create identical foam ball solar systems, when they can instead visit space (iaaa.org) and be inspired to construct something new from their knowledge—something rich, meaningful, personal, and lasting? American author John Kao said, "The crucial variable in the process of turning knowledge into value is creativity." See Plate 2.16.

Section Thirteen Designed by Children

OBSERVING CHILDREN DESIGN WITH HOUSEHOLD OBJECTS AND TOYS

Children are play designers and find many design opportunities by participating in home chores. Few adult designers work as freely as children, not bound by assignments or specific commissions provided by clients. Children don't look at what they do as an occupation, or think of themselves as design professionals. Children's motivations are different than adult designers, and recognizing the differences can help to shape school design experiences.

Children at home design by themselves and for themselves. They are the freest of freelancers, finding design challenges in nature, or arranging a hallway cabinet. Adults work in offices, or design studios, envisioning design solutions for clients. Students can visit design studios and consider the demands, limitations, and solutions of different design specialties.

Young designers are interested in all that is new, they follow design trends in play objects and find interest in many things, from the latest soccer balls to new pencil toppers. Most adult designers are highly specialized in particular fields such as packaging design, warehouse-storage design, or home interiors. Young designers may take on interesting design challenges in a dollhouse paralleling adult design specialties, yet they are generally not aware of their adult counterparts. The creator of a figurative performance inside a lunch box is seldom familiar with the works of stage designers.

Children work for free and freely. They can allow their imagination to take flight in designing a chair from bags of leafs. They are not compensated or tied down by clients' demands, their taste or specifications. They are not only self-employed, but design for pleasure and to test the media. Adult designers create within the framework of a client's needs, budget, and approval. They often work in design teams, solving problems as a group. Young designers can join in pretend simulations, or join a team to solve a problem identified in the school or community.

Most children design by hand as their principal tool, playing with found objects or home finds as their materials. Adult designers employ technology and specialized computer programs to model design ideas. The means may differ, but designers ask similar questions: How could it be more interesting? Work better? Look better and appear more pleasing? For children, the answers come to them by playing with real objects. Future art teachers can pose questions and promote discussions similar to what may occur at a design firm.

Adult designers create samples to be manufactured in quantity by others. Children serve both as designer and manufacturers, making one-of-a-kind design pieces. A car designer may use special tools and processes beyond the scope of children. This does not mean that children are not great vehicle designers with the objects they find and assemble. For example in designing a school bus, the child may use a toothpaste container and search through the family button box. The child designer borrows not only objects but freely exchanges the object's intended use, adapting it to their plans. A pencil can become a car, an umbrella turned into a rocket. Children's personal designs are not prototypes for manufacturing, but designs for play, gifts and gift-wrapping for special occasions and for things to be used at home.

Young designers don't hesitate to put together seemingly unrelated forms to design a new one. While adult designers work within the framework of design history, adopting design philosophies such as "form follows function," children's designs freely borrow existing or designed objects to make something new. A child's design of a train put together from slippers changes all game plans and design traditions. Edible play blocks, a phone from a banana, or an inflatable car from balloons takes leaps and liberties in designing. Future art teachers can consider how to bring in the exciting accomplishments of child and adult designers to art classes. See Plate 2.17.

Observing the Artistic Life of Young Designers

Every design career can be studied in children's studios—their rooms. First-hand explorations of such home studios can help to construct an understanding of children as design artists with candy "blocks" or little ponies. A visit to the studios of children demonstrates their creative collecting and playing and how they design, display, and decorate the surfaces and spaces they investigate. A sense of taste, resourcefulness, as well as an interest in old and new forms develops at home. There is an early awareness that one's environment is a canvas for fashion shows and each

opening between pieces of furniture is a space that can be furnished.

If allowed by parents a child's room is a place to design and experiment in without interference. It is a safe place to transport collections and a storeroom for unusual objects, where self-discovered treasures can be arranged, set up and displayed. Children frequently use objects and furnishings as props and scenery with which to stage plays and fantasies. Children's rooms are important teaching resources to be approached as archeological digs; they offer opportunities to witness and gather insights into art teaching.

Creative sites in different stages are found throughout children's rooms, with eye-opening opportunities to see children designing set-ups and arranging articles. Having a place to play, build, and fantasize, is a lifelong artistic foundation and a valuable model for school design experiences. Art learning which takes place in children's rooms is important to preserve in the art class so that young designers may continue their calling long after kitchens and most rooms in a home come to ban fanciful designing.

Ending

Future teachers can study the many design arts of children to learn about the broad range of design decisions and choices kids make in their playing, getting dressed in the morning, or setting the breakfast table. School art lessons can offer more time and focus attention to the importance of home design experiences and the interests they lead to. The art class can expand dressing dolls to become respectable as fashion design, or creating settings for fast-food figure shows as scenery designs. School needs to be a place to take young designers and their budding interests seriously, to call it art, to secure its continuation, with some early references and meetings with adult practitioners.

DESIGNS OF SPACES INSIDE DRAWERS, REFRIGERATORS, AND DOLLHOUSES

Children usually begin their design careers on flat surfaces, with cutting and pasting, activities such as gluing squiggly worms (rubber bands) on a plate. Design art may migrate to arranging pictures on the door, to greeting card displays on home bulletin boards.

With increasing awareness of living in a three dimensional world, and access to playing with pots and pans and fast-food figures, the scope of design expands to three-dimensional objects. Practicing design by setting up toys and found forms, children also learn to make play objects, designing models for play beds, star ships, and alternative worlds.

Discovering a wide range of household objects that could be drafted to build and stack, children design settings for playing school or create scenery to place their figures. Making and directing scores of play objects soon moves to distinctive spaces in which to model brave new worlds.

Designers of Spaces

As children feel in charge of the designing arts of arranging play objects, they become more selective in scouting out and seeking control over their art space. They look for special and unusual places for their figures and objects to inhabit. To get the space they like to move into and set up in, children are willing to clean out messy shelves, closets, and drawers.

Designs for Pets

When a goldfish named Alfonso comes to live with a family, children design the aquarium, furnishing it with plastic toys and decorative scenery for the glass walled exterior. The life of a pet fish can be exciting when children constantly fabricate new landscapes and playgrounds to explore. In artistic nurturing, a fish can feel like the Riviera, surrounded by props and environments caringly designed. In acrylic sweater storage boxes and see-through fast-food containers underwater worlds can be modeled in the classroom. Creating artistic environments for all types of pets below the water or above ground is always a welcome challenge for students.

Opportunities to Handle and Share New Design

Art teaching can encourage students to constantly browse and pick out design innovations. Instead of waiting for what is new in art to be displayed in a museum, an art room can be the sponsor of showing great design selections. Through studying magazines and newspapers students can preview the famous furniture shows in Milan. They can look for the latest in paper clip designs in local stationary stores, or have fun trying out new designs in digital drums at a neighborhood music shop. Community convention centers that sponsor car shows, boat shows, tool, or

electronics shows are festive art-places to take a class to sample new designs.

Initiating a weekly search, each student staking out a store in the community they wish to study, they can bring to class photos, drawings, brochures, and other souvenirs for a discussion of the latest in thin 3D television monitors, or the most exciting design finds in a sporting goods store. For example, contemporary art museums have a treasure trove of gift shops (that can also be visited online) presenting the latest in subway map carpets, or the most unusual paper gift wrap and many other outstanding design examples. The appreciation of new design is a personal experience, enhanced by students' individual searches. A student bringing to class a new series of kitchen gadgets designed by Phillipe Starck from Target demonstrates awareness and a willingness to participate in life's little visual pleasures in finding great designs.

Signature Design Lines

Inspired by a sharing of innovative old and new fly swatters, art class designers can go to work creating a new summer line for a home goods trade show. Creating a single new product, or an entire "line" with variations on a theme, can be a classroom design challenge. In a world of sameness, to design one's own toy, own school supply, or start simply with a memorable chair establishes a designer's practice.

Placement and Making Room for Designers

Students not only learn from making changes in their artwork, but by making changes in the art room. There is no need to wait for a new paint job for the art room to be rearranged. Students need regular practice in re-setting furnishings, designing studios, play spaces, hiding places, secret places, and displays in the art class.

Art teachers can provide opportunities for students to rearrange counters and shelves, to create new designs for art displays and to set up art supplies in closets and storage units. Windows and windowsills, ceilings and walls, can be cleared for young designers with plenty of home experience, to try new ideas in temporary displays. Experienced bulletin board and door design artists can have many school doors and display arenas left open to practice the design arts. Students are not only excellent helpers, but great designers when it comes to placing things on walls or windows, deciding on the design of what can be put up and where, even in forgotten parts of a school.

Teaching design issues to children is not just about consumerism, but also preservation and recycling. Children create their play worlds by repeatedly demonstrating that something can be designed from anything. Student designers can continue the tradition in school art and use rescued objects to design new uses. Children may not recycle corn to make bio fuels, but they can use just about anything that would be discarded in a fast-food restaurant, and bring it all to school for supplies. Working from a classroom-recycling bin or from all things discarded in school, students can formulate new forms.

Concluding Thoughts

Through design there is a sense of ownership of the object world, or a place, something that "I selected," "I arranged where it should go," "I re-designed it to become what it is now." The importance of a design education is for students to view the world as "theirs" to take possession of it, by designing it.

Student designers can feel like magicians, having a wand in the powers of design to change things. Art-class designers make changes in clothes to wear, in the clock on their wall, and any item in their room or the environment. It is for young designers to change the world and this can be put into practice in an art room.

PRESENTING THE HISTORY OF OBJECTS DESIGNED FOR CHILDREN

Children are designers whose works reflect what they see in the environment created by adult designers. A parent, who purchases a new iphone, leads the way to a child's interest in technology and design. In an art class students can be guided through the drawing portfolio of Jonathan Ive, Apple's chief product designer. They may try their hands inventing playful visions of technology and handle vintage toy phones that exhibit the story of the media.

Adult designers are often inspired during childhood; dressing dolls and creating interiors in playhouses they become fashion or interior designers. Informal lessons in design history can be part of an art class where students are encouraged to shop for designed objects and develop personal areas of interest to be shared in the art room. In a "marketplace" where students contribute designed objects, the future art teacher has an opportunity to point out historic associations; connecting students' finds to the history of designed objects. See Plate 2.18.

Section Fourteen Young Architects

CHILDREN'S EARLY ARCHITECTURE PLAYING

While adults create separate fields of design and construction, children's early building play has few boundaries or specialized career tracks. Children make no career commitments when they freely build with blocks and just about any object. The possibility of becoming future sculptors or architects is open according to children's early enthusiasm for creating structures that are taller or sometimes longer than they are. Children are also interior designers, considering the time they spend in playhouses arranging furniture. Architects or interior designers who work for clients start with the challenge of a problem to solve and work differently than children, who build freedom towers that may also be places to park small toys. They respond to any object's unlimited possibilities.

Children's architectural achievements are seldom taken seriously because their experimental approaches are not the same as adults', and their interesting found materials are usually not from the building section of a lumberyard. Yet a handful of the most visionary architects do remember their childhood and use forms and materials only dreamed about by children. For children, the Great Wall of China can be made of cereal boxes. If allowed by parents, children are designers and builders with many of their best works found on kitchen tables, in backyards, or floating in a bathtub. A bathtub boasts futuristic palaces built on flip-flops, visualized in sponge forms. Their masterpieces are temporary constructions made from play blocks and everyday materials, which may not look like the buildings of our time. Children build the future of architecture from skyscrapers made up of stacks of CDs.

Children's architectural freedom is to manipulate interesting forms and materials and consider unusual containers to play in and places to move into. Children identify secret spaces and create private nests and shelters for themselves and for play figures. They are interested in exploring inside closets, crawling into a new box, or discovering openings in bushes and trees. Young builders look for privacy and unusual places to set up toys and places to hide from parents. While being an architect may not enter their thoughts, their creations lay the groundwork for future architects.

Children learn to design by volunteering to "set up" the dinner table and explore architectural relationships between dishes over placemat "plots." Daily objects become children's building materials and daily events their sources of inspiration. When kids are allowed to touch and play with everything, playful hands discover all kinds of unusual building materials. Children who view their environment as a vast building-supply store inherit great construction opportunities.

Within children's play spaces and structures lies the seed of significant architectural ideas in need of encouragement. Art teachers designing an architecture curriculum for the classroom can benefit by an examination of children's architectural practice outside of school. Each art class can have a building site, stocked with many household forms and play blocks, with a changing bulletin board displaying photographs of home constructions. And if there is no time to fulfill all construction dreams, art teachers can organize an after-school building club.

YOUNG ARCHITECTS LIVE IN CHILDREN'S ROOMS

Children live in buildings and pass by architecture all the time. It is not unfamiliar, yet it is one of the art forms that is most taken for granted. Besides playing with blocks and found objects, the earliest recognition of playing with architecture starts in ready-made playhouses. Children spend many hours furnishing and rearranging forms inside carefully selected dollhouses, castles, and garages. Playhouses are memorable addresses, and they are also important because they move children's interest to creating their own play spaces. From entertaining and fantasizing inside a store-bought playhouse, children expand their sites to boxes and drawers, finding their own places in which to set up and decorate. Children expand their interests to seeing possibilities in all containers that could be made their own. In the transition, children become more aware of architectural forms that exist everywhere and that can be transformed.

THE CHALLENGE OF TEACHING ARCHITECTURE IN AN ART CLASS

In the art class students can design inside historic playhouses or move under classroom tables while expanding on

the many pleasurable memories of playing under dining-room tables. Art teachers need to find a delicate balance between introducing students to architecture that adults create and continuing architectural dreaming inside laundry baskets and suitcases, freshly looking everywhere and building with anything.

As children continue in school they are exposed to many sights, going to new places and experiencing new architecture. The art teacher needs to empower children's expanding journeys with a greater awareness of the building environment and to appreciate it as an art form. Architectural awareness from the playhouse can be expanded to looking more carefully at places students shop, their own school, and the architectural features of their own home. With the study of the familiar, the art class can become a place to share unusual architectural experiences, such as a football game in a dome, a concert in an outdoor tent, or the fantastic architecture at an amusement park. The goal of art teaching is to maintain excitement about constructing in new places with new forms and sharing stimulating architectural experiences.

Art teachers can acknowledge and empower students by recognizing the fantasy buildings they create as an important contribution to the art of architecture. This may involve comparing children's many building fantasies with the dream works of great architects from the past such as the Spaniard Gaudi or the contemporary magical structure of museums and concert halls by Frank Gehry. It is important for children to continue thinking of architecture as an art of imaginative playing with forms and new materials instead of sprawling developments that litter the world.

Young Architects' School Practice

Young architects who set up their first practice in home studios can branch out in schools. Here their unusual ideas and architectural inventions can become legitimate and public. Home architecture playing can turn seriously to building new worlds as described in the following experiences in school.

Turning the Art Room into Other Places

While schoolrooms are generally immovable, children rearrange their rooms at home all the time. If students have some say in the space, art rooms can be arranged to experience the flexibility inherent in all spaces. Using what is available, students can create streets, or partitions that suggest rooms, and build in the art class a museum, or an airport with a handsome control tower. Students can warm up their design spirit by playing with everything in the room, describing and explaining the new scenery and changes they've improvised.

Models of Familiar Places

Children draw many interesting plans for their ideal room, but they also dream in three dimensions, creating models for a built environment the way they like to see it. Children draw many fine views of their home, and in the art class they also like to create models of their "best nest." In school models children voice feelings and ideas about their home's interior and exterior, always prepared for additions, renovations, and other changes. As artists who turn the ordinary into the extraordinary, children can give home models a rooftop planetarium or change the scary places in their houses, like attics and basements, into secret gardens and swimming pools. See Plate 2.19.

APPRECIATION OF ARCHITECTURE

Children invent architecture to house their play figures like soap pads or magnets, sheltering them in buildings that are not founded on tradition or historical styles. To encourage children to continue building freely while urging them to look more closely at existing buildings in their environment is a delicate balance. The following section looks at architecture appreciation as supporting children's understanding of buildings while maintaining this momentum to build freely.

Playful Appreciation

Classes in architecture in college classrooms often include looking at slides and listening to lectures about historic details, correct terms, and stylistic classifications. Children's experiences need to be playful, involving students' imagination, sense of humor, and active minds and bodies. Children become interested in architecture when they can feel it and imagine wrapping it up to take home and play in it.

Children can tell which building would make the best playhouse or castle, or they might nominate one to the haunted-house hall of fame. Instead of looking for historic

styles, children can look for architecture that would be wonderful to portray in gingerbread, detailing it with candy for their birthday.

Appreciating Architecture

Appreciating architecture is about experiencing its changes from the past to the present, being entertained inside fine play homes or visiting old World's Fair pavilions by handling old fair souvenirs. Following their own taste in building styles and finding hands-on methods for experiencing them, students can learn about the history of amusement park structures, or Barbie's dream homes. Teachers can start by building collections to make architecture kid size, finding objects for young appreciators, from historic playhouses and architectural building blocks.

LOOKING AT ARCHITECTURE WITH STUDENTS

Architecture is one of the most fascinating examples of public sculptural works that men and women add to the environment. Buildings create a visual setting, a background for movement and activities. Architecture creates and controls environments by defining space, light, air, and sound qualities. Buildings serve both as visual and physical settings. Architecture is as individual as all other artworks; buildings are created from the personal views of the designers, the clients' unique needs, and the changes made by those who continue to care for them. Buildings function as shelters in which activities are organized within a space that is a major influence on people's senses, feelings, and moods.

Art teachers can organize architectural visits that involve students in observing, listening, and touching. Each visit can be designed as an adventure, a treasure hunt, and a playful discovery. Art teachers can encourage students to be free to find new sightings without being exceedingly concerned about architectural classifications, historic identification, or the opinion of experts. Students on a field trip are the experts. Great buildings speak to each visitor about something exciting and new. When everything to look for is assigned, students don't really experience the buildings and lose the opportunity to make their own discoveries. Individual observations and the things students notice have lasting value.

The Experience

The experience of innovative buildings is at the core of architectural studies. For children to be captivated by a building it has to be touched, walked through, and the elevator buttons have to be tested. Spaces have to be entered, paths walked, and life inside a building experienced. Each structure has unique sounds to be heard, incoming light that can be felt, and smells that can be sensed. Art teachers can encourage playful encounters that include students mapping and recording diaries of their visits. Interpreting one art form into another, such as drawing, rubbing, or photographing helps in looking more closely and experiencing buildings more completely.

Reference Books and Resources to Read, Look At, and Share With Students

Each art library is a portrait of its owner. To some degree these books are portraits of our interests and our students, a description of our many combined years of experience sharing classrooms first with children, then future teachers. What you like to see is what you share. The following books are what we like to read, return to browse, and enjoy sharing in an art class. We would be honored if future art teachers will expand this list. Go ahead, write below your favorites, the new volumes you elatedly discover.

After a quick perusal, this may look like an unusual list for an art education text. But these are the books that future art teachers not only read, but really enjoy looking through with students. These are books to learn from as teachers, but also to have in a future art class. Art teachers don't live on a narrow diet, their interests in books, as in everything else, is wide ranging. The books represent the art teacher's extensive interest and their openness to look at everything, and learn from every subject. Future art teachers should start collecting interesting books now. It is the fun and the tradition of being in the field. Seldom do we enter an art-teaching situation

without some of the books below in hand. Since there are few collectors' books of any kind that school libraries are willing to invest in, the books that future art teachers will need and cherish sharing in class have to be imported and set up in a classroom library. The books below are items that would be a great start for any art teacher's professional collection and wonderful to start an art room library.

DRAWING

Church, Marilyn and Lou Young. *The Art of Justice: an Eyewitness View of Thirty Infamous Trials.* Philadelphia, PA: Quirk Books, 2006.

Dyan, Nellie. *Beautiful Doodles.* Philadelphia, PA: Running Press Kids, 2007.

Edwards, Betty. *Drawing on the Artist Within: An Inspirational and Practical Guide to Increasing Your Creative Powers.* New York: Simon & Schuster, 1986.

Eric Carle Museum of Picture Book Art. *Artist to Artist: 23 Major Illustrators Talk to Children About Their Art.* New York: Penguin Young Readers, 2007.

Fein, Sylvia. *Heidi's Horse.* Pleasant Hill, CA: Exelrod Press, 1984.

Hannas, Linda. *The Jigsaw Book: Celebrating Two Centuries of Jigsaw-Puzzling Round the World.* New York: Dial Press, 1941.

Heimann, Jim. *May I Take Your Order? American Menu Design 1920–1960.* San Francisco, CA: Chronicle Books, 1988.

Pfeiffer, Bruce Brooks. *Frank Lloyd Wright Drawings.* New York: Harry N. Abrams, Inc., 1990.

Spiegelman, Art. *Maus 1 and 2.* New York: Penguin Books, 1986, 1991.

Steinberg, Saul. *The Inspector.* New York: Viking Press, 1965.

PAINTING

Alloway, Lawrence. *Roy Lichtenstein.* New York: Abbeville Press, 1983.

Callaway, Nicholas (ed.) *Georgia O'Keefe One Hundred Flowers.* New York: Alfred A. Knopf, 1989.

Cathcart, Linda L. *Nancy Graves: A Survey 1969/1980.* Buffalo, New York: Albright-Knox Gallery, 1980.

Cooper, Martha and Henry Chalfant. *Subway Art.* New York: Holt, Rinehart and Winston, 1984.

Elderfield, John. *The Cut-Outs of Henri Matisse.* New York: George Braziller, 1978.

Lenclos, Jean-Philippe and Dominique Lenclos. *Colors of the World: The Geography of Color.* New York: W. W. Norton & Company, 1999.

Pacovska, Kveta. *MidNight Play.* New York: North-South Books, 1994.

Stafford, Clif. *Brush.* New York: Pointed Leaf Press, 2006.

Waldman, Diane. *Mark Rothko, 1903–1970 A Retrospective.* New York: Harry N. Abrams, 1978.

Wilkin, Karen. *Frankenthaler: Works on Paper 1949–1984.* New York: George Braziller, 1984.

Wilson, William. *Stuart Davis's Abstract Argot.* San Francisco, CA: Pomegranate Artbooks, 1993.

PRINTING

Akers, Kevin. *All Wrapped Up! Groovy Gift Wrap of the 1960's.* San Francisco, CA: Chronicle Books, 2005.

Bruce, Scott. *Cereal Boxes & Prizes: 1960s.* Chamblee, GA: Flake World Publishing, 1998.

Gallo, Max. *The Poster in History.* New York: American Heritage Publishing Company, 1972.

Gifford, Denis. *The International Book of Comics.* New York: Crescent Books, 1984.

Hofmann, Werner. *George Braque: His Graphic Work.* New York: Harry N. Abrams, Inc., 1961.

Melnick, Mimi. *Manhole Covers.* Cambridge, MA: the MIT Press, 1994.

Pearlstein, Ira. *Playing Cards.* West New York, NJ: Mark Batty Publisher, LLC, 2005.

Spies, Werner. *Max Ernst Frottages.* New York: Thames and Hudson, 1986.

Steele, H. Thomas. *The Hawaiian Shirt: Its Art and History.* New York: Abbeville Press, 1984.

SCULPTURE

Baal-Teshuva, Jacob. *Christo.* New York: Prestel-Verlag, 1993.

Beardsley, John. *Earthworks and Beyond: Contemporary Art in the Landscape.* New York: Abbeville Press, 1984.

Beardsley, John. *A Landscape for Modern Sculpture: Storm King Art Center.* New York: Abbeville Press, 1985.

Brouws, Jeff. *Readymades.* San Francisco CA: Chronicle Books, 2003.

Buhrer, Michel. *Mumenschanz.* New York: Rizzoli, 1984.

Carandente, Giovanni and Alexander Calder. *Calder.* New York: H. N. Abrams, 1979.

Carter, David A. *White Noise.* New York: Simon & Schuster, 2009.

Friedman, Terry (ed.) *Time Andy Goldsworthy.* New York: Harry N. Abrams, 2000.

Hopfengart, Christine. *Hand Puppets.* Bern, Switzerland: Hatje Cantz, 2006.

McShine, Kynaston (ed.) *Joseph Cornell.* New York: The Museum of Modern Art, 1980.

Nevelson, Louise. *Dawns + Dusks.* New York: Charles Scribner's Sons, 1976.

O'Brien, Richard. *The Story of American Toys.* New York: Abbeville Publishing Group, 1990.

Pacovska, Kveta. *Unfold/Enfold.* San Francisco, CA: Chronicle Books, 2004.

Pape, Donna Lugg. *The Book of Foolish Machinery.* New York: Scholastic Inc., 1988.

Rose, Barbara. *Claes Oldenburg*. New York: The Museum of Modern Art, 1970.

Rower, Alexander S. C. and Holton Rower. *Calder Jewelry*. New Haven, CT: Yale University Press, 2007.

Schiffer, Nancy. *Baskets*. Exton, PA: Schiffer Publishing Ltd., 1984.

Sharp, Charles Dee. *The Wonder of American Toys (1920–1950)*. Portland, OR: Collectors Press, 2002.

Szekely, George. *The Study of a Community: Staten Island Architecture and Environment*. Staten Island, NY: The Staten Island Continuum of Education, Inc., 1980.

Tilden, Scott J. (ed.) *Architecture for Art: American Art Museums 1938–2008*. New York: Harry N. Abrams, Inc., 2004.

Willner, Dian and Patty Cooper. *Antique & Collectible Dollhouses and Their Furnishings*. Atglen, PA: Schiffer Publishing Ltd., 1998.

DESIGN

Bosker, Gideon and Bianca Lencek-Bosker. *Bowled Over: A Roll Down Memory Lane*. San Francisco, CA: Chronicle Books, 2002.

Epstein, Diana and Millicent Safro. *Buttons*. New York: Harry N. Abrams, 1991.

Goodman, Lizzy. *Lady Gaga: Critical Mass Fashion*. Bellevue, WA: Becker & Mayer, 2010.

Holland, D.K. *Great Package Design: Creating the Competitive Edge*. Beverly, MA: Rockport Publishers, 1992.

Karp, Marilynn Gelfman Karp. *In Flagrante Collecto (Caught in the Act of Collecting)*. New York: Abrams, 2006.

Ledenbach, Mark B. *Vintage Halloween Collectibles*. Iola, WI: Krause Publications, 2003.

Marks, Ed. *Ice Cream Collectibles*. Atglen, PA: Schiffer Publishing Ltd., 2003.

Meccariello, Bryan. *Plastic Cup Collectibles*. Atglen, PA: Schiffer Publishing Ltd., 1998.

Murray, John J. and Bruce R. Fox. *Fisher-Price 1931–1963*. Florence, ALA: Books Americana, 1991.

Pridmore, Jay and Jim Hurd. *Schwinn Bicycles*. St. Paul, MN: MBI Publishing Company, 2001.

Rathbun, Robert Davis. *Shopping Centers & Malls*. New York: Van Nostrand Reinhold, 1992.

Webb, Michael. *George Nelson*. San Francisco, CA: Chronicle Books, 2003.

Young, Lucie. *Eva Zeisel*. San Francisco, CA: Chronicle Books, 2003.

ARCHITECTURE

Allen, Joseph. *Sandcastles: The Splendors of Enchantment*. Garden City, NY: Doubleday & Company, Inc., 1981.

Anderes, Fred and Ann Agranoff. *Ice Palaces*. New York: Abbeville Press, 1983.

Dupre, Judith. *Skyscrapers: A History of the Most Famous and Important Skyscrapers*. New York: Black Dog & Levethal, 1996.

Hatton, E.M. *The Tent Book*. Boston, MA: Houghton Mifflin Company, 1979.

Sheard, Rod. *The Stadium: Architecture for the New Global Culture*. Singapore: Periplus Editions, 1998.

Stille, Eva. *Doll Kitchens 1800–1980*. Westchester, PA: Schiffer Publishing Ltd., 1988.

PHOTOGRAPHY

Arbus, Diane. *Diane Arbus Magazine Work*. New York: Aperture, 1972.

Baeder, John. *Gas, Food, and Lodging: A Postcard Odyssey, Through the Great American Roadside*. New York: Abbeville Press, 1982.

Cohen, Michele. *Public Art for Public Schools*. New York: Random House, 2009.

Emanuelli, Sharon K. *The World Is Round: Contemporary Panoramas*. Yonkers, New York: The Hudson River Museum, 1987.

Lacy, Paul. *Brooklyn Storefronts*. New York: W. W. Norton & Company Ltd., 2008.

Leibovitz, Annie. *Olympic Portraits*. New York: Little, Brown and Company, Inc., 1996.

Schneider, Ira and Beryl Korot (eds.) *Video Art*. Philadelphia, PA: Institute of Contemporary Art, 1975.

Smith, W. Eugene. *Minamata: Life—Sacred and Profane*. Japan: Soju-sha, 1956.

Szarkowski, John. *William Eggleston's Guide*. New York: The Museum of Modern Art, 1976.

Wolman, Baron. *Classic Rock & Other Rollers*. Santa Rosa, CA: Squarebooks, 1992.

NEW MEDIA

Barker, Claudia. *YaYa! Young New Orleans Artists and Their Storytelling Chairs (and How to Ya/Ya in Your Neighborhood)*. Baton Rouge, LA: Louisiana State University Press, 1996.

Barreneche, Raul A. *New Retail*. New York: Phaidon, 2004.

Bishop, Claire. *Installation Art*. London: Tate Publishing, 2008.

Chicago, Judy. *Holocaust Project: From Darkness Into Light*. New York: Penguin Group, 1993.

Mack, Kathy. *American Neon*. New York: Universe Books, 1996.

Marci, Roxana, Diana Murphy, and Eve Sinaiko (eds.) *New Art*. New York: Harry N. Abrams, Inc., 1997.

Oldenburg, Claes. *Store Days*. New York: Something Else Press, Inc, 1967.

Reiss, Julie H. *From Margin to Center: the Spaces of Installation Art*. Cambridge, MA: The MIT Press, 1999.

Sollins, Susan. *Art: 21: Art in the Twenty-First Century*. New York: Harry N. Abrams, 2001.

Middle-School Art

When my daughter was about seven-years-old, she asked me one day what I did at work. I told her I worked at the college—that my job was to teach people how to draw. She stared at me, incredulous, and said, "You mean they forget?"—Howard Ikemoto

Section One Middle-School Students as Artists

ART FROM ELEMENTARY TO HIGH SCHOOL AND BEYOND

Typically, elementary-age children (preschool to fifth-grade) make art at home, in the art room, and in their classrooms. Children's art extends free-spirited playing and is welcomed as a miraculous act with much support and little adult interference. For the art teacher it's a wonderful experience to stand by their students who are excited to make art, try all materials, and think highly of themselves as artists. Before a supportive audience of parents and teachers, a young child has a great start for a life in art.

Middle school is often characterized by a sharp down-turn in students' artistic activity, accompanied by declining confidence. In middle school, students encounter new scholastic challenges and priorities. Creativity is not required for school success, and there are few art classes and little time to make one's own art. Parents often move out all the play and art-related items from home to make room for serious studies. Students clearly understand adult expectations and their lack of interest in youth art and culture. Further removed from their own creativity and personal expression, adolescents, in the few art classes they take, are taught adult techniques and formulas in preparation for high-school art. High-school art divides the dabblers from the serious art majors who decide to pursue college art, or art as a career. See Plate 3.1.

As students move into high school they want to be treated like adults in order to feel that they are making mature art. While the high-school student yearns to create adult art they are often stuck with traditional "school" projects—another turn around the color wheel and exercises culled from college foundations' programs. For future art majors, high-school art often becomes a rehearsal for the next step of portfolio preparation, still removing them from a real artistic engagement of finding their own path, or learning to function independently as artists.

A few adults in college fully dedicate themselves to the study of art. Many more reject art, citing their earlier experiences, "I was never good at it." They exaggerate their school trials with such comments as, "In high school, I could not draw a straight line, a face, or even a stick figure." With decades of not making art, those who are asked about it will gladly demonstrate their lack of skills, which they obviously have not practiced. While arguments of incompetence would not be expected from pianists or dancers who don't rehearse, adults' self-applied visual arts test negates practice. The thinking goes that either you have it and are blessed with a natural gift, or you just lack art talent.

Some adults who had inspiring art history classes in high school or college turn their focus to appreciation and perhaps collecting art, but shun the making of art. Others continue to make art that is not called art, engaging in scrapbooking that they only secretly refer to as a creative act. A few adult artists who choose to make art on their own fondly recall the freedom and lack of inhibitions of the elementary years that they never forgot, and set originality and childlike freedom as their goal, while others dedicate themselves even more to an academic path of mastering the masters.

Middle school, therefore, is a pivotal step in sustaining a life in art, continuing art in high school and into adulthood. If middle school can create an environment where art flourishes, then elementary school will not be the last time that individuals have made their own art, felt good and confident about their creations, and experimented before a supportive audience. Middle school can be the conduit to

continuing in art and nourishing one's creative side, or the juncture that convinces students to take a permanent leave.

Adult attitudes continuously shape the path of school artists. When children are still considered delightful and their art is revered, adults respect it and marvel at the results. Teachers refrain from leading or interfering. A youngster is recognized as an artist in class and adults as audiences respectfully view their work. Originality, individuality, humor, and fun are evoked as cherished traits. Parents and teachers allow for maximum freedom and seldom trample over young artists' ideas or techniques. For lucky children, everyone waits for their art to happen, following their lead, responding to their art without trying to shape it.

Adults often think middle schoolers are confused, potentially troubled, and above all that they need discipline in school and in art. They expect middle schoolers to act grown up and let go of their childish ways, including their art. The mission of middle school is to set students on adult paths, to be molded and taught everything about every subject.

Art becomes assigned exercises and projects separated from personal meaning to the artist. Art instruction and resulting artwork become academic, as prescribed by teachers and reinforced by criticism. In middle school, art teachers tend to take the reins and shape the students' experience and art. How students respond by accepting or rejecting these changes in art teaching can predict their artistic future. Middle-school art is no longer tied to children's birthday parties or play interests; it involves serious studies to prepare for high school and college art.

If middle-school students feel that they have the skills to cut it, and the ability to follow art assignments and receive good grades, then they might continue in high school. Students from middle school to high school and college want to know from the teacher how to make art, how they are doing, and if they have what it takes to make art. Values of self-expression, art as personal invention, the creativity and confidence used to express ideas, and the joys of independent art making are long forgotten, left on elementary-school desks.

Many art teachers who come out of college preparation in studio art are eager to apply their learning to "serious" classes with older students. No wonder students in middle-school art can often be such perfectionists. One teacher described middle-school artists as "little men with big erasers." They draw a line and immediately erase it.

There are many theories for why such free-spirited elementary-school artists later become so uptight about their art. Some say having learned to play the game of school, middle-school students become more realistic; they want to know what teachers want, and play the game of how to please them. When it is all about grades in secondary school and college, the will of many artists in a class is easily manipulated to the will of one artist—the classroom teacher. Students want to draw and make art "correctly," and as in other subjects, they come to learn the rules. The notion that art is not like other subjects has to be an important part of all future secondary-school art teaching.

Elementary art teachers are important in offering students their first taste of being independent young artists, building an indelible feeling of joy and confidence in making art. Middle-school art teachers are important in advancing and not neglecting students' valuable elementary-art experiences to further promote artistic freedom.

Middle-school teachers can consider ways to enhance confidence and assure students that their art ideas are being heard and that their unique voices matter. There is a rush, since in a few weeks of middle-school art students often make the decision whether they want art to be a part of their future. All students have to maintain an ability to play, independently explore, and investigate, utilizing their fantasies and experiences to make art their way. The joy naturally present in elementary artists needs to be encouraged all the way through high school. More play and creativity, and not less, are necessary for students as they become further removed from these opportunities. The work of child artists and the contemporary art world that it inspired need to be guiding spirits for art classes on all levels, beyond the elementary grades. See Plate 3.2.

CONCEPTUAL DEVELOPMENT IN ART DURING THE MIDDLE-SCHOOL YEARS

Preadolescents (ages 11 to 14) become dissatisfied with stock adult answers to their questions and set out to seek their own. In a search for independence, children explain their newly formulated views on just about everything. As young artists, preadolescents rely on independent observations and are interested in recording the results in their own visual and written notes. Eager to make personal judgments and to invent, they are at an ideal juncture to study and develop their own answers to significant questions in art. The desire of students to independently assess the world and form their own views is a significant consideration in teaching art.

A way to approach the increasingly curious and independent preadolescent is not with stock answers and ready-made art formulas, but to engage them in artistic investigation. Instead of presenting them with easy solutions to complex artistic issues, art teachers can create opportunities where adolescents can investigate and find solutions. For example, instead of presenting students with a way to depict space through linear perspective, the issues of space can be investigated from many dimensions. Students can set up objects to observe at varying distances in a classroom, or go outside to study the same pieces set up in outdoor spaces or in the street. First-hand observations allow students to draw and paint depictions of space with insight and to describe their inventions of creating the feeling of space on a flat surface.

Verbally skilled middle-school artists are able to articulate their observations and also compare different ways that contemporary artists have depicted space in painting and in sculpture. Teens understand that the picturing of space and other problems in art are questions and artistic challenges.

Middle-school artists embrace art because it is something that is still open to investigation, a subject that welcomes fresh insights. So much of school learning is pre-packaged as a series of adult answers and solutions that are already completed show. However, middle-school students are not just eager to make art, they are interested in discussing and debating it, formulating their own views and opinions.

Middle schoolers are eager to make their own mark by developing plans for important things like what they want to do in art and how they want to do it. They are seeking a voice in their learning—an involvement in decision making that can take place in an art class. Ready-made art lessons conflict with their style and appear just like other classes.

Planning for an art class and coming to class with ideas is a true presentation of how artists work and it is also pleasing for students seeking independence. Idea books and preliminary sketches are invitations for students to make choices, develop their own path, and guide their art. Coming into the art room with a thousand sketches, and as many ideas, is appreciated instead of entering another classroom situation in which one has to keep silent and keep opinions to oneself.

Verbal middle-school students can speak about art as ideas, explaining their thoughts about art and views expressed in the works of others. Making objects by hand is not their only art form. When young artists are eager to share their visions and their inventions are overflowing, art lessons cannot be used to just keep students busy with old exercises. For adolescents who are ready and eager to change the world, their way of doing things is their art. Their views need to be communicated during each art period. Art teachers can find ways to adjust the conversation; middle-school students love to be asked about what they think needs to be changed, what could be designed more cleverly. Teen artists can be encouraged to define artistic problems and suggest solutions.

Preadolescents can be multi-dimensional observers, providing detailed facts and opinions. They like to study their world and express their feelings about it. Middle-school students can start keeping diaries and writing wonderful poetry and songs. The many ways middle-school students use media to record and comment on their life can become the essence of the art class.

In all their growing up and gaining independence, middle-school students also mourn the loss of their childhood perks. The fun of being able to dress up for Halloween, being read to, allowed to go outdoors for recess and play, or have their teddy bears and toys is not really lost in spirit. Middle-school students have many childhood dreams they carry inside. Being considered little adults has its problems in that students miss their childhood and to some degree are still children in spirit. The art class can help in its approval of playful investigation and reminiscences of childhood interests, helping students hold onto a creative childhood longer than they can in other classes.

PHYSICAL AND ARTISTIC CHANGES

Adolescents carefully check their own appearance, fascinated, surprised, and scared but more aware than ever of changes in their bodies. Selecting make-up and the perfect hairstyle means appropriating the family bathroom and being more attached than ever to its mirror. Body image is constantly checked by standing on a scale, with awareness of all changes in size and height especially in comparison to everyone else. The new interest in bodies and a willingness to observe it closely leads to unhappiness in how the preadolescent is able to draw people. No longer happy with stick figures, they want to draw the human figure with more perception and detail. Faces and figures become favorite subjects to draw, and for self-critics of this age, it is also the greatest challenge.

People-watching becomes an official sport, so preadolescents can check their progress and see beyond themselves. Adolescents can analyze all body types, describe what is wrong with anyone's make-up or style, and

criticize the appearance of everyone including parents. Their detailed commentary of physical appearances becomes a unique art in itself. Of course their most critical statements are about themselves, easily producing long lists of what's wrong with their appearance, how they want to look, or the stars they want to look like. Preadolescents scrutinize people and faces and start to draw them in great detail. It is not unusual to spend an art period just on hair, never mind the rest of the face. Students become interested in photos and film, especially used for portraits depicting themselves and their friends. When offered stock photos to copy ideal faces from magazines in an art class, or handouts of correct ways to draw portraits, their new skills of observation and critical viewing are undermined by the ready-made images.

Art teachers can make use of students' interest in taking a deeper look in the mirror and using their ability to analyze their face and body. Yes, people are beautiful, but in the eyes of adolescents they form ideals and are quick to notice deviations from them. It is a good opportunity for the art teacher to have students sculpt bodies in all media, but also to look at famous sculptors like Giacometti, Degas, or Gaston La Chaise, who used art to exaggerate, alter, and build a new awareness of the human form. Students enjoy drawings of the great caricaturists Al Hirschfeld or Saul Steinberg, and photographers like Diane Arbus, who highlighted extraordinary faces in a crowd. The depiction of the human body and face is an important vehicle for artistic expression and not just an exercise in skillful rendering.

Art teachers can encourage adolescents to look at family albums. They can discover family traits and resemblances as they draw, paint, or photograph family members. Teens' deep caring for people is expressed in their relationships with friends and some of their most endearing art is a result of their depictions of them. Team portraits or drawings of ballet groups and class portraits done by students are a favorite subject in art. In scrutinizing appearances, middle-school students write poignant and humorous descriptions of their teachers, artfully detailing their nails and make-up, and describing their mannerisms and style in many art media. Art teachers, who are often role models for teens, can also become art models to sketch or photograph. Adolescents, who develop a keen eye from closely monitoring their own physical changes, show their expertise in their artistic depictions of people in general.

A child can ask questions that a wise man cannot answer.
—Author unknown

THE AGE OF CHOICE, OPPORTUNITIES, AND OBSTACLES TO MAKING ART

Middle-school students are looking for answers to many of life's tough questions, including who they are. In trying to define themselves, students are seeking their individuality and independence just as the gates of school are more tightly shut, controlling individuality more than during any other stage of schooling. They are looking for choices and a place to safely test their dreams and opinions. Into large and largely impersonal classes, students are herded and bombarded with rules, threatening tests, and sometimes dress codes. In the art class lie opportunities to be open, to hear and listen to students, to see them as young people with big ideas.

During private times when they are unstuck from the crowd, teens learn to play the guitar and compose moving lyrics. While their writing is required to be formulaic for classes, preadolescents write fine prose and original poetry in personal notebooks. Teens are devoted music fans, make personal choices in cinema and jeans, and are loyal to their adopted sports teams. The students who are so clear about their favorite songs and film stars may not have yet selected their favorite artists or know little about their choices. While preadolescents express strong taste in film and fashion, they are still looking for artistic clues and passionate art interests. Teens' art life waits to be informed and explored in an art class that is open to their adventurous spirit and opinionated ways. The way art is presented and taught to young artists can make all the difference.

Teens seek full participation and involvement in an art class. Listening to art rules and the teacher's opinions and art judgments about their work is not the way to respond to middle-school needs. It is also true that some students crave the safety of some structure and feel comfortable with rules as they are applied in all other classes. Consequently a simplified art that emphasizes simple techniques has its audience. In the art class, however, students can learn to figure out how to break rules in a safe and supportive environment.

An art class based on choices and soliciting the ideas and opinions of students about artistic matters satisfies the urge towards independence in self-seeking youngsters. Future art teachers need to consider how the artistic search and decision-making process can involve students at every step. Easy solutions and ready-made art handed to students is not the satisfaction for which they are looking.

When school and home activities diverge sharply, as they tend to in middle school, private worlds where creativity can be expressed cannot only exist in a student's room at home. The private worlds that art moves into when it is not a major emphasis in school need to be tapped by art teachers who care about bringing art into the mainstay of students' lifetime pursuits.

Middle school equals the start of serious studies. Students are pushed to compete for grades and score high on tests. The countdown to college begins, accompanied by worried students who just want to get good grades. Some art teachers give in and offer short cuts, formulas, and step-by-step art instruction that is easily scored and what students really want. Yet, dangers lurk in giving in to what students seem to be comfortable with and expect from middle school.

While scores motivate students, at the same time another story unfolds inside adolescents, an inner life of emerging realizations and strong desires. Personal views and emerging opinions, a need to feel and be true to themselves is a competing feeling to what is experienced in most school classes. Growing up means becoming yourself, but where in school, if not in art classes, can this happen? Art provides the opportunities and tools for individuals looking to themselves for answers.

Adolescence is a period of rapid changes. Between the ages of 12 and 17, for example, a parent ages as much as 20 years.
—Author unknown

MATURING AS A MIDDLE-SCHOOL ARTIST

A serious studio approach to the study of visual arts supports healthy adolescent development. There are benefits to studying art as connoisseurship. Recently art classes for teens have emphasized appreciation and examination of art history in the framework of arts and humanities offerings. Courses studying art in theory and history, or dabbling in art exercises set by the teacher don't have the same effect on the maturing adolescent as taking part in the serious pursuit of making art. To seek the most beautiful art one can make requires an intensive study aiming toward mastery that involves every fiber of the preadolescent's self.

The art room as a serious studio becomes an unmatched learning environment with important clues that can help inspire middle-school students. Middle-school artists are studying just about everything there is to be learned; they soak up everything in art class, not just what the art teacher consciously presents. They learn from the quality of interactions among themselves and with adults, and by observing every gesture of those around them. Learning how to be an adult makes use of the whole environment in which the preadolescent lives, and when it comes to life in a studio, preadolescents learn the vision and work ethic that one finds in making art in a community of artists.

Unlike academics, or studying art as an academic subject, getting students' hands and minds seriously involved in art making develops a larger vision of what is possible for them in the world. Nowhere else but in an art class that is run as an artists' studio can students have the opportunity to go beyond what has been prescribed, outlined, or defined for them by school. Involved in art making, teens have an opportunity to dream and plan ideas. In the studio middle-school students can be motivated by their own dreams and learn to "go for it," using a level of hard work and persistent commitment that it takes to carry through a project and keep a dream alive.

The values that involvement in art has always provided are needed in middle school. The challenge for preadolescence is moving from dependence to mature independence by developing a secure sense of identity. Education should mirror the changing motion of life; there needs to be a connection between what students do in school and what they are trying to accomplish as people. Middle-school students are trying to find themselves in a confusing world and an art studio is a school laboratory in which to do this.

Unfortunately some middle schools squash the qualities that contemporary adolescence needs the most. Qualities such as impatience, defiance, questioning, and risk taking are hard to deal with in classes and therefore not considered mature qualities. Middle-school students are constantly told in academic classrooms to grow up, which they are desperately trying to do. Students are warned to act their age, when that is precisely what they are doing. While working as artists in a studio class students' passion can be turned into meaningful work, their risk taking into learning, and their defiance into engagement.

Relationships with the Artist-Teachers

Elementary-age children see adults—especially their parents—as all-knowing people who can answer all of their questions. To be able to grow as individuals and let go of

others having the answers to everything, middle-school students find the same adults who were all knowing and wise to be annoying and not so smart. To establish themselves and find their own knowledge, it's natural to have these changing feelings. Middle-school teaching can continue in the old parental role, by providing guidance and all the answers, or it can allow students opportunities to find out for themselves so that they feel accomplished.

Since they are just on the brink of breaking away, middle-school students become increasingly driven by fantasies and dreams about what they are going to do and who they are going to become. As adults start to mistrust adolescents as dreamers without a sense of reality, art teachers who work with adolescents find young dreamers charming and value a pre-teen's desire to become a rock star and come to the art room to craft rock tour shirts. When middle schoolers need to push away families in an attempt to establish their independence, having positive relationships with other adults becomes very important.

The relationships young artists form with their art teachers fills a unique need. The art teacher can be someone a young artist identifies with and wishes to emulate. The middle-school art teacher might know his or her students better than others do because of the openness of a studio. Art teachers must be interested in the whole student if they are to motivate them to use their art to reflect on their life. The sense of being seen as a whole person by an adult is always important in learning, but especially so in middle school, when the ego seems so fragmented. During periods of intense art making, students are asked to bring all aspects of their being to the task, and share it with a supportive adult.

Teachers can appear as dreamers, free and independent and able to see the world in new ways. Teaching by example is what art teachers do best; it is the most natural way for them to teach. The fact that a young artist's teacher is also an artist exposes the student every day to an adult who they admire and want to emulate, an adult world they are eager to join. The artist model is attractive to students at this age and gives their life a model and a purpose. It is artist-teachers who are able to teach students the most important task at this age—to teach themselves.

Building an Identity as a Creative Individual

One of the most significant characteristics of young artists is that they go from seeing themselves not as teenagers with few positive attributes and not so flattering connotations in our society to seeing themselves as young painters, designers, or filmmakers. Art teachers can work toward calling their students "artists" and treating them as such. The feeling of worth is raised in being young artists, especially when these feelings are based on real achievements: artwork, exhibits, and portfolios. Adolescents want to be taken seriously. By working as artists, it allows young people to identify themselves as artists, giving them a framework in which to grow, providing dignity, respect, and a worthwhile challenge. For middle-school art students to assume the identity of an artist might not be a final career choice, but for now it provides a positive place from which to negotiate the delicate path from dependence on the family to interdependence as a mature member of society.

Finding a Place

Every artist needs to be alone yet feel connected to an art community. Peer relationships are one of the central dilemmas of adolescence—how to be part of a group and at the same time be seen as unique, special, and singular. All middle schoolers have a desire to be part of a larger group. A community of artists can satisfy the need for belonging. Because artists are often perceived as marginal in this culture, young artists can identify with a community of artists and feel separate from society at the same time. This combination of being part of a group, but a group that is questioning, commenting, and seeking change, is like the preadolescent who wants to belong and also be a rebel. Art teachers can consider ways that an art class can project the feeling of belonging to an art group. An attractive group for students at this age would be one that questions, protests, and sometimes rebels against the culture.

A Search for Meaning

Art teachers who raise middle-school artists need to see the many positives of their age. For example, adolescents have a strong sense of idealism. Theirs is a longing that is particularly strong for the good, the true, and the beautiful. Their desire for greater meaning in life is an impulse shared by all artists. What is often felt in art classes is a spiritual impulse to connect with universal meaning; adolescents feel this deeply and want to express their emotions appropriately and with authority. Teens want to make art that speaks to others, that shapes the feelings of passion and idealism. Because middle-school artists are idealistic, unrealistic, and demanding, we need their spirit and art in our cool and disconnected culture.

Middle-school students are often portrayed as being uninvolved in school, bored, and just plugged into their music, video games, and phones. When teachers are unresponsive to the needs and interests of adolescents, students can become very rebellious and easily misunderstood. Adolescents in an art class are in fact passionate and involved, they show boundless enthusiasm, a strong sense of self-competition, ready to tackle the difficult tasks involved in being an artist. Art teachers need to plan for art experiences initiated by teens, and studio time that arouses participation and evokes meaning and passion in art.

Growing Vision and Imagination

Middle school is generally not associated with playful experiences that challenge the imagination. Academic classes may be rigorous and demand hard work, but few ask teens to play or experiment in different media with an open mind and heart. Teens yearn to participate in the excitement of creating new knowledge, to search for the next new thing; this can come in the form of understanding a new painting problem or searching for a new design solution.

Central to the work of middle-school artists is to maintain their imagination. Art classes need to be richer, more experimental, and more active and hands-on than others. It is in the imagination that new ideas are formed. Preadolescent imagination can be used to move people and culture forward to the next new thing. Artists never stand still; they grow and are excited about new visions and ideas.

To focus middle-school students only on pursuing the right answers and correct solutions to old problems wastes their youth.

Art teachers can consider their studio class as a place to find the right questions. No art lesson should be presented as something that is concrete or something that is in need of a predetermined answer. Experiences that resist easy closure and that keep the complexity in artistic questions provide challenges that engage students. To seek out open questions, to live with ambiguity, and to be comfortable with chaos are life lessons from an art class that can help students develop and be part of a contemporary world.

Conclusion

The arts have the potential to save middle-school students by helping them to grow up. Middle schoolers are the most attuned to many aspects of contemporary society. If you want to know about the latest in consumer products, social networkings, or popular trends, then ask a middle-school student. In some respects, middle schoolers will always want to go along with the crowd. They have a lack of confidence in their own ability to create their own trends for fear that they might be ridiculed. Part of this stage is developing a confidence in one's ability to create and recognize the powers of the individual to come up with new ideas. To understand preadolescents' worldview and art view and how they are different than those of other age groups is a critical part of the middle-school art class experience. See Plate 3.3.

Creative Planning and Topics for Group Discussion, Activities, and Extensions

- Practicing art teachers might not have all the answers to teaching art in middle school, but their combined experience is a significant lesson to discuss. Not only observing schools, but having coffee and informal talks with art teachers offers many subjects to further thrash out with future art teaching colleagues. Ask three art teachers about their middle-school rotation structures. Discuss with your future colleagues how middle-school students are scheduled to take art and the ways the art teachers manage their rotations.

- Citing the opinions of practicing art teachers, what are their important objectives for students to accomplish and take away from the brief middle-school art experience? With your future art teaching colleagues put together a list and categories of different interview responses and discuss the range in middle-school art goals and philosophies.

A child seldom needs a good talking to as a good listening to.—Robert Brault

Section Two Crisis and Art During the Middle-School Years

PATHS TO ADULTHOOD, STRIVING FOR PERSONAL AND ARTISTIC INDEPENDENCE

At a time when preadolescents seek to make sense out of life, it seems that school just continues on its own path, forcing students to do things. Middle-school students want to know why they are studying algebra; what can it possibly have to do with their intended career as a baseball player? Why learn math, or formulas for art techniques? A part of the search for personal independence is to question. Students are seeking answers and a degree of control over their learning. Middle-school art teachers have to consider that their students are also striving for artistic independence. Art teachers cannot just tell students to do projects anymore without explaining the purpose and possible benefits of the art lesson.

Being presented with choices and making decisions are at the heart of being an artist. This can be accurately represented by how learning takes place in an art class. Middle-school art can support an emerging independent adult by offering the experience of artistic independence. An art class should not be like so many other school subjects that students enter unwillingly, where they are told exactly what to do. It is a unique place where students come enthusiastically with ideas of what they would like to do.

Teaching art to this age group is about building a sense of ownership of the art class. The important challenge is to find ways to involve students by offering a stake in the space and to let them have a part in deciding what takes place there. Art teachers can repeatedly remind students that it's *our* class, *our* studio, and *our* supplies to use and investigate. Students can learn to take notice of their abilities to observe and take notes on their many good ideas, bringing them to each class as important records, kept inside uniquely made idea books. Students cannot just be assigned art; they need to be involved in the search. They can experience the discovery of materials and techniques, and demonstrate them to others. Middle-school students want to be involved in examining the environment and the art world, sharing their sighting of art and artists and discussing them in class. Even the seemingly quiet students enjoy giving presentations, being involved in discussions and art debates in which they can express their views and opinions.

Art teaching can demonstrate how artists are independent people, self-employed and motivated to define their own problems and find solutions. Middle-school art teachers can think of teaching as a question mark that requires students to think and creatively respond. Everything can be phrased as questions and not as absolute truths, or substituting the teacher's answers for the students open exploration. What can we do with these objects? How can you wear it? What is the most unusual idea for using this object? Promoting students' search for answers can become a way of life in an art class.

Future art teachers can passionately portray and share their respect of personal art ideas by showing their own idea books. They can describe how important it is to exercise the freedom to put down individual creative plans. Respecting and collecting one's own ideas allows a sense of personal pride and the motivation to act on them. Unlike any school notebook that students come across or use, a special hand-crafted idea book is filled with rich entries of photos, clippings, doodles, diagrams, and plans. Acknowledging that each student has many great ideas worthy of recording and keeping is an important step toward fostering creative independence.

Middle-school students can describe in great detail their artistic past. They like to talk about the creative things that they did and connect them with the things that they still want to do. They are honest in enumerating their creative assets, what they are good at, and the skills and abilities in which they take pride. Reflecting on personal artistic assets allows young artists to make the best use of them.

An art class in middle school can start by recalling students' experiences and affirming that they have innovative thoughts and sharp observations. Every art class can embrace student opinions, favorite art media, and discuss important achievements. Middle-school art teachers can start each session with what students do well. Students discussing their art, and telling their art stories, can be the highlight of an art class.

Considering middle-school students' history helps us to understand their desire for artistic freedom. For example, one student fondly recalls being a young child with fashion dreams, fancifully dressing Barbie dolls. Preadolescent fashion experts discuss spending their time at the mall looking at clothing and watching *Fashion Runway,* their favorite television show. Students complain about being

overruled by parental fashion opinions and censored by dress codes in school. Deciding what students can wear is symbolic of other strivings for creative independence that can be explained and responded to in an art class.

While clothing choices become an important issue and a cause of friction with adults, in an art room fashion can be considered an art form. Recognized for being great shoppers with a keen sense of fashion, students can engage in lively fashion talks and design the next season's *Fashion Runway*. Middle-school students who are becoming more environmentally conscious are wonderful critics of all the design arts, and their design views need a place to be voiced and accepted.

A middle-school art teacher describes art teaching for this age group as "doing a lot of listening." Many new middle-school teachers have had the experience of coming to school excited about their art lesson, only to find that students couldn't care less. After the lesson is presented, the students look tired and bored. Art teachers need to consider how to get students to come to school passionate and excited to talk, participate, and present. Art teachers can practice stepping back from traditional teaching roles in order to empower preadolescents' interests. Instead of generalities of what this age group needs and likes, listening to them explain their own passions weaves a solid fabric for activities in the art class.

When few children of any age are considered safe to play outside, and are instead escorted everywhere, their world is in lockdown mode. Opportunities to explore by oneself are limited. Middle-school students who seek independence find that life is organized, chaperoned, and adult directed. They have a teacher, a coach, and a museum guide for learning. Self-directed learning of the artistic kind is not the way most of the day is spent. More and more the road map to success is perceived as pleasing others. For preadolescents many things become "uncool," yet to be an artist offers the feeling of being independent and retains coolness. To teach middle-school art is to establish that students are indeed artists.

A characteristic of the normal child is he doesn't act that way very often.—Author unknown

PEAKS AND VALLEYS IN MIDDLE-SCHOOL STUDENTS' DAILY LIVES AND ART

Middle school is frequently described as a roller coaster. For elementary children everything seems to move along just fine, but in middle school there is a distinct feeling of being confused, lost, or along for a rough ride. For many students the art class provides a respite from the highs and lows, an opportunity to clarify the anxious ride.

Expanding Bodies with Uncomfortable Hands

For the clumsy middle-school student in the burst of physical development, art can be an opportunity to regain their balance. Some find success in sports, others discover grace and beauty in dance or gymnastics, or fine-tune themselves by playing a musical instrument, but many find their skills in art. Art teachers need to find an important balance between opportunities for hands-on skills requiring art and art discussions.

A Need to Move

One can often feel the restlessness in students who appear uncomfortable in their new bodies. It is a legitimate restlessness resulting from growing that can be exacerbated with marathon sessions of being squeezed behind school desks. In the art room there may be a rug and a couch for work, and students are able to get up, move around, work on the floor, and shop around the room for materials and ideas.

An Amazing New Self

Preadolescents spend long periods before the bathroom mirror, on a scale, or just helplessly watching their bodies and appearance change. The preadolescent might appear overly absorbed in their appearance, but with such changes, who can blame them? Art can focus not just on accurate self portraits but self awareness and creative ways to look at one's self. The art room can offer cameras and lighting devices, video cams with editing opportunities to create scenes and backgrounds, and stage events in which the "real me" is the star.

The Chosen Few

Middle-school students have greater powers of observation; they can "read" people's actions. What they read, however, might not be helpful since students are quick to notice how

teachers respond to their art and who receives the title of class artist. If they are not among the chosen, students might wilt, since young seekers of independence still depend on adult and peer confirmation for their art abilities. It is not easy to be an independent middle-school artist. The future art teacher's sincere and equal support for every young artist is important.

Artists and Peers

It is true that middle-school artists are more observant and aware, but they are also extremely self-critical and fearful of criticism from others. Students want to explore and spread their wings, but being more peer-aware, they often hesitate to leap. Middle schoolers start dividing into groups and cliques. Being popular is one thing, but being good in art can be another goal.

There are highs of being accepted into a group, but it has its price of fitting in, and in the case of art, one can be limited by doing only the work for which one is "famous." Future art teachers must be aware of these issues and formulate strategies that unite, and not pull apart a "creative group" vs. others. Opportunities to work together and to contribute one's efforts and ideas to a team are valuable to students at this age. Contributing one's art as a gift to the school and community and working for causes that are greater than oneself are also motivating factors in middle school.

Teenagers complain there's nothing to do, then stay out all night doing it.—Bob Phillips

Excited but Bored

Middle-school students are notorious for their excitement but also for their ability to act bored. In class, there can be an excitement about art yet boredom with rigidity and adhering to inflexible instruction. When the middle-school art teacher involves students in shaping the art class, students become excited. When the class is about the students' art idea, no one acts bored.

New Models and Roles

Middle-school students are busy growing up and changing. There are changes in what is important to them, and they demonstrate a need to give their allegiance to something, or someone. Students try on adult roles, contemplate professions, and need someone to look up to. They frequently attach themselves to the art teacher and the artistic traits the teacher portrays. As youngsters experiment with risky behavior, they can also get their high from art. Art teachers presenting themselves as artists with connections to the art profession can serve as an important role model.

Fears and Misconceptions

While students come to the middle-school art room with expectations of relief, they also start to fear art in ways they never have before. Understanding middle-school students' art fears is important for art teachers in deciding on helpful responses and conversations. The following fears and reservations about being "good at art" are the most common.

The growing fear of middle-school artists is that there is always someone who is better than they are. As students make comparisons, others appear more talented, others can draw anything on demand, and their work is always on display. Pre-teens place great power in the hands of their audience, and that judgment can hurt. Yet the same students have little resilience or practice in fighting back or standing up for their art. Creating a supportive environment in the art room is important, even if it might not always exist in the real art world. Future art teachers need to chime in, discuss art values, and work in the face of uncertainty in general. Art teaching is heavily dependent on the teacher's ability to reference their artistic fears and show that they understand how students feel.

Middle-school students come to the conclusion that art is for the few who are talented or for those who take to it easily. For some, art is a "piece of cake" and for others it feels hopeless. The truth is that making art is difficult and art teachers need to consider discussing the difficulties of art making and how to deal with it. Expectation of middle-school artists needs to be accurate, recognizing that art requires tremendous practice and dedication. Discussions need to be truthful in describing the total immersion required by art making. Learning art can be compared to the persistence required in practicing any instrument. Art, like preadolescent life, has its ups and downs, its highs and its great disappointments. It's a love-and-hate relationship with artwork that changes from moment to moment. Art teachers should be prepared for frank and sympathetic discussions.

Fears abound about not having ideas, or not having great ideas, but also there are uncertainties about not being up to the challenge to execute them. It is a fear of not having the fortitude, or know-how, to follow through. While art teaching can arouse big plans, doing it is another matter. Students should know that even the most experienced artist battles uncertainty. For example, while an artist might have a fine idea, art often has its own. Art can always move in unplanned directions. Does one follow the path of art or stick to one's original plan? Navigating the many choices and obstacles during the art process is a required conversation. Art teachers can speak from experience about fears of losing control and the blessed surprises that may trump initial art plans.

Middle-school students want to be taken seriously and for their art to be respected. Fears of not being recognized, however, haunt all artists. Middle-school students wonder if their art will be ridiculed. What if it is not considered good by anyone? The student who draws cartoons of space invaders wants to know if they will be supported. The artist's drive to follow their instincts is admirable, but risky, since vocal critics to anything different in school are easy to find. The fear is like that of not being picked for the team. The fragile middle schooler is expected to place a personal item like art into the public domain. Art teachers need to consider the issues of recognition and how they will respond to art critics in the form of other students.

Children are thrilled to make art, but in middle school students raise the issue of talent. Fear speaks when middle schoolers wonder if art can be learned, or if it rests on a talent randomly dispersed among some and not others. Preadolescents are guided by vivid memories of how people responded to their art; they recite disappointments and negative comments. Becoming an artist goes hand in hand with preadolescents' search to find and accept themselves. The middle-school art teacher has to be ready to offer a battery of logical arguments for everyone having the potential to become an artist.

Students want to do their own artwork yet please everyone around the table. Middle-school colleagues tend to like what they understand; students risk rejection, then, when they venture into experimentation or want to explore new art worlds. For teens, acceptance can be the primary goal. The more art teachers understand and can sympathize with students' fears about not getting this, the more they can become an effective buffer between student seeker and their critics. This is especially true when it comes to group critiques, which heighten fears of judgment.

Students often learn to feel safe in the art class by making art that is safe, reverting to old habits and familiar ways of making things. While known and tested answers to art are appealing, the challenge of middle-school art teachers is to have students try new things, to push their ideas and dreams further instead of being satisfied with the status quo. While art is about invention and change, for middle schoolers it is safer not to change. Class critics can further hamper the student's willingness to change and take risks that lead to growth and independence in art.

But the person who scored well on an SAT will not necessarily be the best doctor or the best lawyer or the best businessman. These tests do not measure character, leadership, creativity, perseverance.—William J. Wilson

THE SEARCH FOR INDIVIDUALITY IN A LARGE CLASS

The traditional art room, with its tables and chairs for students to sit around, has a long history. It made sense to accommodate large groups of students all focused on one source—the teacher and the chalkboard—for their art making cues. As middle-school students search for independence somewhere in the school, the art room they inherit may not feel like an artist's studio. For many middle-school artists it is uncomfortable to make art around a table under the watchful eye of not only the teacher but within the critical fire of tablemates. Besides, before they have come to the art class, they've already had the experience of sitting and learning in a lecturing mode. If there is any art to be made, students have to feel that the art room is unfinished and open for them to complete. The more the art teacher can envision the room as a studio, the more welcoming it will be to artistic behavior. An artist's studio, like an easel, has infinite adjustments, different ways of moving in, setting up, and relating to one's work.

Even a small space has to be reinvented to feel larger in order to accommodate the needs of students looking for materials and privacy. For individuals to be able to work on individual projects there needs to be a place where they can set up in a corner or on the floor and not feel like they are in a sweat shop or art factory.

The contemporary middle-school classroom can be organized around media centers, interest groups, or divided into large and small or public and private places. Students who share a common interest in a particular art form or media might want to work together, making art and

discussing art-related matters. Some students might prefer working at a table, individually, or in design teams. Others might need more privacy or a larger floor space. Art teachers support individuality based on the set-up of their room, encouraging ideas to be executed all around the class.

ART, SOLITUDE, PERILS, AND POSSIBILITIES

Being an artist requires the ability to be alone. Artists spend a great deal of time in the studio and in quiet contemplation outside. Middle-school students might not be afraid of monsters in the attic, but they are reluctant to be alone without being on the phone, Facebooking friends, or watching television. To really be alone in a quiet, meditative and art making state requires time, practice, and discipline. An important challenge for art teachers is advocating for *productive*, quiet times for their students.

A taste for quiet times can be introduced in the art room. Students can experience brief moments that can be called quiet segments, in which they're alone with their thoughts and idea books, engaged in dreaming and planning art. Instead of art rooms with constant music and other group-calming techniques such as listening to lectures or looking at computer screens, art teachers can encourage some quiet time. Students can organize their place and schedules for quiet art moments. Distractions abound in students' home lives, and there are many disruptions in a classroom. However, there are ways for students to regularly experience medidation and to just be working alone.

Being alone is often equated with getting into trouble at this age. Parents' and teachers' strategies for middle schoolers are to keep them busy, occupied, and out of trouble. Middle-school students also fill in the quiet with music and noise, friends and distractions. If the loud music stops in their room, parents want to know what the matter is and immediately investigate.

When things feel out of control in a student's life, art can be experienced as a quiet retreat. Art is something that needs to be watched as it unfolds each day. It is something that needs to be returned to at one's free will if it is to grow. Students can learn to watch their art as a growing plant, unfolding day by day, even if students don't have art each day. School art can offer a sense of what it is like to build ideas daily. What works for oneself as an artist can be discussed in school and tried at home. Art teachers can plan with students to experience art unfolding over long periods of time, not artificially started and stopped by bells or school schedules or someone else saying go.

Middle-school students can build the courage necessary to be alone, even in public spaces or in the woods developing art ideas and making art. A Walden Pond experience, where time stands still, is difficult to replicate in an art class. But middle-school art learning can point out how art time can be lengthened and adjusted to the requirements of each artist's work by including home time. The art class serves to facilitate art plans and art making opportunities that go beyond the official art period. Students can decide on the place and time they can make art, to feel comfortable working on their own clock. Students can learn to take visual ideas by taking pictures and sketches and found materials from one place to another, from class to home and back. If one is comfortable in one's own space making art, whether it's a private or public space, one is never alone.

CONVERTING CHALLENGES TO ENJOYMENT, KEEPING ARTISTIC INTEREST AND CONFIDENCE

Textbook wisdom says that art in the middle-school years declines, and there are important reasons for this in the accelerated life of middle-school students. However, art does not have to die out; it needs to be searched for and noticed in many aspects of a student's life. Middle-school students' self-initiated art might not be before an easel, or using formal art materials. Its best examples might not even be in middle school. Therefore, art teachers need to make home visits.

At home there are many clues to preadolescent creativity that might never be seen or mentioned in school. A future art teacher reports the surprise of being invited for coffee and cake proudly served by an adolescent who has been studying pastry creation. During the visit the student shares her collection of cake-decorating tools and sketches, while they taste beautiful desserts. After dessert, the student proudly shares her art by bringing all the scrapbooks she has been working on to the table. It is easy to dismiss students at this age and mourn their loss of creativity in school. Yet time and time and again, home visits indicate that art is well and alive in students' homes, taking shape in projects done alone or sometimes including a parent.

It is perhaps more important during the middle-school years for students to feel assured by being spoken to as artists than during the confidence-filled earlier years. Art teaching during this period needs to seek out students' art interests and be open to accepting their many art forms that are shunned in more traditional circles. A

student detailing cars for his dad who likes to fix up old automobiles experiences great satisfaction in the garage instead of the traditional art studio. If not for a home visit, the art teacher visiting the vintage cars might not have been aware of the young artist's masterpieces. Middle schoolers trying to fit in and go along with traditional schooling don't often share or brag about their own interests. They look at the art class as unrelated to the pastries, scrapbooks, or car models they are working on at home.

One of the essentials of middle-school art teaching is to find out about students' art before unfurling new art lessons in class. The preadolescents themselves need to learn the many ways creativity can be expressed and feel comfortable that they are working with an art teacher who is open-minded and not myopic about what is considered art. Future art teachers therefore need to look in the back of notebooks for signs and scribbles, and make an effort at asking, investigating, and welcoming all signs of middle-school creators.

A different attitude toward art and being an artist occurs after an invited presentation in class of a student showing the dresses she has designed and sewn at home with the help of her mother. Interests such as this may be practiced for the rest of the student's life and might provide the satisfaction that allows for new art to be created.

COMPETITION, COMPARISONS, AND CONCERNS

What students think of their art and of themselves as artists, while comparing themselves to others, becomes a middle-school concern. Middle-school art classes can be highly competitive. Competition is supported by a society that dwells on grades, awards, and contests; preadolescents still rely on artificial competition and for the teacher's attention and praise. Obsessive competitors equate their rankings in class with their art, even with themselves. The task for middle-school art teachers is to help students achieve an inner peace with their art. Art teaching must support not just classes but individual artists and their unique interests and self-initiated plans.

Competition is part of everyone's make-up, but competing with oneself is perhaps a better way to present art and shape life in an art class. In a healthy environment artists are not in competition with each other but focusing their efforts toward their own best work. Competitors always wish to know where they stand in the pack; they constantly are checking against each other. Picking up and showing the best students' work as models for accomplishment defeats individuality. Art teachers can warn against false yardsticks and unnecessary disappointments by such comparisons.

The art of art teaching is to move everyone along individual paths. To achieve individuality in a class, teachers can instruct students to listen to their own instincts and judgments, to follow their ideas as guides and believe that they are the principal experts over their own art. Each artwork talks to its maker; it is truthful and says what it needs. When an artist is lazy, holding back and hesitating and not committing to the work, it shows. The artist is the most knowledgeable master of his or her own work. The art teacher's task for middle school is to help students believe in their art ideas and judgments. The outside world may be neutral, or not care about what an artist does, but art class audiences respond vocally. Learning to be true to his or her own art is perhaps the most important lesson for a student to learn in middle-school art.

Creative Planning and Topics for Group Discussion, Activities, and Extensions

- Ask middle-school students what they feel is their "real" art. Ask them for examples of their creative strength and interest that few people know about. Listen to what they consider artistic. Share the many art-related interests of students you uncovered with future colleagues in class.

- Empty and save items from a middle-school art class trashcan at the end of the day. Bring your collection to class and discuss what was discarded and what might be useful to learn from this exercise.

Art is a shadow of what a person is thinking … a small glimpse of what they hold inside. Little secrets, regrets, joys … every line has its own meaning.—Sarah, Los Cerros Middle School

Section Three The Social Dimensions of Art

THE ART ROOM AS AN ART COMMUNITY

Art has played a friendly role in the life of most art teachers. They grew up believing that there was something democratic about art. After all, making art gives us the feeling that a human being can change. Through art one has the power to say and think what one feels. To be able to make art is so attractive that one often becomes an art teacher just to be able to share these wonderful experiences in school life with others.

Many adults have fond memories of elementary-school art classes, recalling art teachers as supportive, creative, and enlightened people. They stand out as mentors who wanted to pass on something special to the next generation. Early art rooms are often remembered as harmonious places, accepting of children's ideas and welcoming even their strangest finds and collections to show in school. Many teachers remember visiting the art teacher before school or staying for after-school art classes. Art is remembered not just as a class but an exciting community.

This unique feeling toward art can continue in middle school, where students spend less time in the art room yet yearn for a similar sense of comfort that a studio community provides. In the larger grounds of middle school, students rush from class to class, yet art is still looked at as a safe place where students are encouraged to be themselves. Where a good art teacher presides, there is always someone who is willing to listen to students' stories, experiences, and viewpoints.

In middle school, students who are insecure about life and the part they will play in society can meet someone with great commitment and a depth and passion to their work in the studio and in the school. It is an important meeting that leaves the impression that artists are free to speak and examine, observe and comment on the world. In an art room students find an adult who doesn't direct from the sidelines but shows a genuine interest in students, engaging them in partnerships and collaborations and who is not in school simply to tell students what to do and how to do it.

Art communities can be rich and diverse, a real haven for middle-school students during this time in their lives. An art class that is a studio community inspires students to work together with dedication and to set goals and assist each other. In art communities students experience what it is to be an artist, not just a spectator or consumer. Students can formulate their own plans, make their art, write and illustrate their own words, make music and essentially nurture their soul. As students enter middle school and try to find themselves, art can sometimes become the only place to search.

Partnerships between students and the art teacher have the possibility of being authentic, honest, and mutually beneficial. Art in middle school cannot be a dictatorship presenting only one view and insisting on singular ways of making art. It has to be a partnership based on shared values, students understanding that there is not one answer to questions about life or art.

As elementary students happily raise their hands to proudly confirm that they are all artists, in middle school this needs to be again reaffirmed in the minds of students, who are less likely to raise their hands. Most are called to art, but older students are more reluctant to answer. While art offers preadolescents the freedom of a bird that can get out of the cage, art teaching needs to repair the wings and offer the courage to soar. Middle-school art teachers can build a special community in the class where students learn from each other and not just the teacher, and at times reach out to an art community to mix with artists in all fields of art. Frequent meetings with community artists can enrich artistic life in a middle school and encourage a connection to a larger art community.

Middle-school art classes can start with groups. When it's no longer cute to put on a show for the family, students still love to perform and create artistic circuses and dress for a masquerade ball. Creating art performances glues participants together. Middle-school classes can be like the Futurists, the Blue Rider, and other legendary artist groups working together for an ideal. Art organizations can be formed in class and student groups can be renamed as design teams or art cooperatives. The power of art for middle-school students is in their ability to flex their muscles and create change. But first there must be community building, where students get together and work comfortably on projects, as the following segments suggest.

It is easier to build strong children than to repair broken men.
—Frederick Douglass

MAKING A DIFFERENCE AND CHANGING THE WORLD THROUGH COMMUNITY ARTS

Art has the ability to create positive changes in society. For students who are searching for meaning in their own life, it is important to view their engagement in art as something that can make a difference. In middle-school art classes students can begin to ask what it means to be an artist in their city and an artist in the world. Young children are reminded to eat all their food because there are hungry people in the world. Middle-school students in an art class can ask how they can use their art to feed the hungry. Bringing art to diverse communities can be an important mission of an art class.

Young children make art for loved ones and want their art to be received with love. Middle-school students want their work to be important, influential, and helpful, and therefore it has to go public. Art projects need to be more than refrigerator art, or art made to hang on school bulletin boards. They need to get out to the community and even to the world. In middle school the art class can be the place to plan and prepare stirring art that calls people to action and improves lives. For example, art can become a student's response to disasters in the world; mailing teddy bears that were created by students for the children affected by tsunamis or earthquakes lets those who are in need know that there is a community of caring art room citizens. Middle-school art students can get together as a board of their own relief organizations, to make adult decisions about how they can help. Art can dwell on fantasy but it can feel fantastic when it's made with others and for others, dedicated to a mission that is bigger than the goals of an individual artist.

Artists organize for many important purposes. Art teachers can gather examples to show the many ways artists rally for causes—for example, giving their talents to Farm Aid in order to help small farmers in the U.S. Their actions can guide artistic middle-school students to consider to whom their art can speak and what it can say. Lessons on drawing techniques are not the only way to approach middle-school art teaching. Instead of art as exercises, a real art that contributes to real causes can be the art teacher's focus. After all, students are intent on becoming adults.

Chairs and other home-furnishing items boldly painted by middle-school students are displayed at a neighborhood coffee shop. It is one of many outlets or art markets that students can contribute to with their work to make money for real causes. Items placed in a community business can become art stores that feed the hungry and elevate the actions of the art class. It is a different art room when students work with their heart. The art class is no longer part of an institution but becomes a dedicated family.

Middle-school artists are ready for a connection to the art world. They want to see and know what is out there and what other artists are doing. Art teachers can concentrate on helping to make introductions and connect students with other artists. Art exchanges with students all over the world are of interest at this age. With today's technology it is easier to facilitate correspondence and art exchanges with art students from the most remote regions of the planet. Such sharing motivates students to be part of a larger art community.

In their desire to be part of a group, preadolescents are interested in other community artists, adults who work in the neighborhood. Taking part in studio visits and gallery walks can be an introduction to many working artists in different fields. Artists representing many specialties can be warmly welcomed to the school, as students envision themselves being architects and graphic designers, enlarging their view of art and moving past the realistic drawing challenges that can become a self-imposed test of talent at this age.

A day dedicated to allowing students to meet and candidly speak with artists from the community makes powerful use of the brief amount of time middle schoolers spend in art classes. Middle-school students can be raised by art teachers to become artists of the world, advocating for the artist's commitment to good citizenship and significant causes. By bringing the art world to middle school and middle schoolers to the art world, teaching creates a series of significant coming-out events for the art world. See Plate 3.4.

It is the mark of an educated mind to be able to entertain a thought without accepting it.—Aristotle

UNDERSTANDING MANY POINTS OF VIEW THROUGH GROUP ART ACTIVITIES

Students can be in the middle of a classroom yet still feel alone. While there is need for privacy in making art, middle-school students want to be with friends.

In school, students learn in groups, most sports are played in groups, and kids hang out with groups of friends. Therefore, group art can also be a good choice because it is comfortable and familiar. Art learning in this case takes place by students interacting and seeing the results of their interaction with each other. The art class can take advantage of having many artists with ideas and different skills in every room.

Sitting around the school tables pushed together to resemble a conference table, students can share their thoughts, maintaining visual contact, and feeling safe to share creative ideas. Structured groups that plan art activities that revolve around a theme appear like a well-oiled comedy-writing team for a television show. Group art that allows for the forming of artistic relationships is ideal for middle-school art. Bouncing off ideas and different views, students contribute to a group that creates a design, a product, or a show. Projects can be large and dreams can be big when students brainstorm together, working toward a common goal.

Going out to improve the visual environment of a senior center for the holidays, middle-school students create elaborate plans. There is an excitement about leaving school and doing art together. With a larger purpose than making one's own piece, making art that serves society allows everyone to feel invested in the project.

During planning sessions, all ideas can be freely thrown around, uncensored. Creative suggestions are fearless since no one is completely responsible or will be criticized for freely floating ideas. Everyone's idea is respected, considered, and discussed. It seems crazy at first, but the art teacher suggests the use of her automobile as the canvas for a green statement the students are planning. They decide on every detail to outfit the vehicle as a moving billboard focusing awareness on the environment. Middle-school art can demonstrate that art can be timely and important when art groups work together.

Students who learn about artists like Jeanne-Claude, Christo, the Gorilla Girls, and Judy Chicago respect art teams that plan large projects with a purpose. In an art group there is also safety and fortitude to carry on important work, such as painting banners and printing signs raising awareness about poverty in a community. Many old bikes add up to an armada of voices on wheels when they are brought to class and retrofitted with flags and decorative symbols to lead an upcoming march against violence. As design teams tackle major issues, all media and surfaces can be used to create and disseminate art made on various scales for different public events.

Art is a melting pot. Art classes represent students of different races, religions, and backgrounds coming together. They can all work on the same team to create pins and badges reminding everyone to stand up against bullying in school. Middle-school art teachers can consider many ways to bring the fervor of young artists together, to experience art as having great power and compassion. As art used to be a young child's individual gift to someone special, in middle school art can be unselfish and not competitive, a gift for good causes.

In planning a memorial for a slain student, the art room mood becomes somber and all attention is turned to important matters. Middle-school students welcome opportunities to use their art for reasons beyond self-expression. Art can offer the power for positive involvement. Unfortunately there is never a shortage of floods and earthquakes, disasters, both close and far away, to which one can dedicate one's art.

Middle-school think-tanks can be fully geared up to discuss big issues. Debating issues such as the ways art can be used to fight pollution in the schoolyard uses the same strategies as great research teams in all fields. Middle-school art students experience the gratification of contributing great ideas to respond to big problems and social issues. They learn to cooperate and be team players in spite of an art world that used to pride itself primarily on individual feats.

Student art teams can be small or reach out for membership worldwide. With technology, group art can be global, as students in the United States can Skype to see students in Egypt and discuss wrapping up the pyramids for a good cause. Joint missions to build children's art communities in underserved regions can be a project shared with Japanese art classes, in a joint venture to design art mobiles; a network of specially outfitted private cars can serve as art studios on wheels for children who have no crayons or art rooms. Middle-school art classes can join missions and consider commissions anywhere.

It may be a positive step for middle-school artists to work together so they can get out of school desks and conduct face-to-face discussions as a group. Art groups on a mission may even be able to leave the school to work with people, with clients, or audiences, involving them in art projects. When middle-school artists work together they are neither lonely nor lowly; they are powerful and able to build relationships with other artists and society. The task of future middle-school art teachers might be described as calling all hands on deck. If art is to change the world there is lots of work for everyone.

ARTISTIC VOICES THROUGH PUBLIC ART AND MURALS

Street murals made by community artists are a uniquely American art. On a walk through American cities, a large variety of wall art created by and representing community artists of all ages is on view. Allied in spirit with the celebrated cave paintings of Lascaux, said to be the first artworks by humans, street murals also depict stories of the community, created by its members. While many old European buildings also have painted walls, professional painters used the art as decorative elements of the architecture. In totalitarian societies street murals are a political force, propaganda for the regime, with heroic depictions of their leaders. Free societies are reflected in their street art, painted by community artists in bright and joyful images to celebrate the neighborhood and its people.

For preadolescents a mural is an occasion to be counted and noticed by the community. Unlike some angry or destructive graffiti, middle-school murals are planned and approved by neighbors and created in a deliberate and organized manner. Middle-school artists want to be included in painting neighborhood murals because they offer important opportunities to be a part of the community and to create a gratifying gift. Murals involve middle-school students in something larger than themselves.

Art teachers can study the process and techniques of creating murals, from planning to execution. Art class time is wisely spent to prepare street murals, from finding sites and sponsors, to narrowing a concept and painting about such themes as community pride, community history, local heroes, or other things or subjects that reflect life in the neighborhood. Mural painting is not just transporting gallons of paint to work on the street. It is a process that involves discussions and listening, investigation and interviewing, reaching out with care and empathy to the people whose lives the artwork ultimately affects. All the preliminary steps of preparation—creating proposals, giving presentations, and gathering support for a project's acceptance—are a part of the art and students' learning. Planning and creating a mural for the public can be a serious art making journey for students looking for a meaningful challenge.

As part of a mural crew, students can identify possible locations for school and neighborhood murals. For example, students may present photos of concrete columns under a highway overpass, or a local bus stop they see as a deserving canvas. Students might advocate for painting street furnishings such as benches and trashcans or art around manhole covers. Telephone poles, fire hydrants, and other vertical surfaces may be recommended for painting contemporary heroic columns and story-bearing monuments. There might be vacant billboards to consider, naked construction-site barricades, or empty store windows that appear in need of an artistic touch. A boring concrete skate park may be noticed by canvas seekers wanting to add their impressions to a culture with which they are familiar. Art teachers can encourage students to look at the entire environment, including utility devices, as canvas possibilities.

Inside the school, a cafeteria may be conspicuously in need of a mural. Beyond the school building students may argue for working in a community shelter, or offering their services to the neighborhood YMCA. Searching for environmental sites is a very different choice and experience than purchasing a roll of canvas. Students might comment on a building's lobby, elevators, doctor's offices, and city buses as possible public places where reproductions instead of original art would work. Seeking room for murals in a world of ready-made objects and surfaces that others have filled is a challenge, but spotting canvas opportunities is a first step.

Students can participate in the act of developing proposals and submitting presentations. They can create sketches of ideas or computer-generated models. Concepts can be presented as temporary murals on boards and papers. Middle-school students can hone public speaking and presentation skills in seeking approval and soliciting sponsorships. Learning to form community partnerships may include negotiations with paint stores and banks. Even if a project to paint the neighborhood skate park is rejected, the process provides important learning for the next presentation and many life lessons.

When a mural cannot be painted on a school wall or public billboard, there are other options. Temporary art and messages can be stenciled on street floors, or made into outdoor banners. Even sidewalk chalk drawings can be done collaboratively as a serious art, with important messages. Murals are exciting, large-scale projects that reward students with a huge sense achievement. A mural garners a large audience during its creation to its final unveiling, with public praise constantly reminding students that they are artists making art. Besides personal achievements creating murals provides middle-school students with life learning experiences, such as having responsibilities as a member of a tightly organized group where everyone is counting on each other.

Murals advance the self-esteem of students in school where self-satisfaction, pride, and reward for work are all

bundled up in a grade as the only measure of accomplishment. How can grades stand up to the satisfaction of enhancing the environment? Since middle school is about growing up, art teachers need to seek murals and other public art making opportunities so that students can experience contributing to the world.

PERSONAL AND SOCIAL EXPLORATION THROUGH PERFORMANCE ART

Children frequently put on shows for the family, dress up in adult clothing, do comedy routines, imitate a rapper, or borrow the bedroom linen for a puppet show. Performance art is in children's blood and doesn't just disappear. In middle school, performance artists might need a transfusion of applause and opportunities.

Generally, adult artists blend into their studio, becoming invisible homebodies, perhaps making an appearance for a show. Preadolescents, however, often want to be seen and noticed and therefore are attracted to crossover media such as the visual and performing arts. Art can be bigger than a breadbox, and larger than an art room. It does not have to be self-contained, and as a performance piece it can be staged throughout a school, or at a mall. In subway stops and street corners one may catch a glimpse of a "guerilla art" community that generates the kind of contemporary flair and energy that can inspire art teachers and their students.

Pre-teens live on the edge of a new art world they can teach adults about. There is an authentic preadolescent art created by new young artists who are visionaries, and their best works are presented in non-traditional art forms. Middle-school students are able to present a unique perspective on art when their style is not cramped by presentations of old art. If trusted and inspired to use their fresh new voices, middle-school students have powerful artistic visions that do not box them into a single view of art or of one media.

If students are renamed and looked upon as curators of New Art, then their performances can openly straddle their love for rap, digital media, street art, or street dancing. Middle-school students have a variety of art interests that they are supposed to leave at home while they are taught about old art. Teachers as artists can work with middle-school students to create events and performances using the art room and other stages. Instead of drawing still lifes and figures, students can create real life and be performing figures in such acts as rapping while painting an improvised message on the floor of the room. Preadolescent observa-

tions, experiences, and thoughts can be transformed into songs and images and performed as public art.

When the art room becomes a performance space, students can close their eyes and escape their towns and cities, or respond to them by large-scale collaborative projects. Performances can describe hunger and reflect on homelessness, or transform violence into rap and imagery, using spoken words and painted signs. Art teachers can consider how the middle-school classroom can be turned into a performance space where students can create and be applauded, instead of storing art inside vaults like portfolios. Art class can be enriched by collaborations with community dancers, students working with rappers, and other artists in a community involved in visionary works.

Middle-school art classes can work as art groups instead of individuals, making collaborative performance pieces displayed on YouTube. Exposure to the exciting world of contemporary artists can leave memorable impressions on students. Performances in multidisciplinary creations fire up young artists and provide moments of deeply felt engagement. Adding music, lights, shadows, mime, or words to images is similar to the Guitar Heroes and video-gaming arts in which this age group is immersed. Students can document performances on video, set up open-mike sessions in class for amplified artists, or engage in found-object percussion, re-defining performance and middle-school art.

A student teacher working in a middle school, for example, becomes an impresario for Poets in the School Yard, a student group who recite seasonal poetry while wearing fragile garments woven from fall leaves. The temporary nature of performance art is an important life and art lesson, as decorated cakes are eaten, intricate face paintings are removed, and sand sculptures are washed out to sea. Yet art making continues. Preadolescents who may not like to display their traditional art love to dress up and use their body as a billboard, put on make-up, or rap while juggling flashy signs with thought-provoking phrases.

Middle-school students who are exposed to contemporary art museums and gallery shows find great meaning in performance-style art making. They like to question the art world through their art, and build online dialogues with performance artists. For those seeking independence, performance art offers many fresh ways to approach art and move beyond old notions of what artists can and cannot do. Middle-school artists working together in a performance learn to support each other. They are joyful, dynamic, and even rebellious, but their radical energy is easily channeled into art as they transform themselves and society. See Plate 3.5.

Creative Planning and Topics for Group Discussion, Activities, and Extensions

- Describe the visual environments that might influence middle-school art. Present photographs that you have taken of middle-school students at such public places as the mall, in video game parlors, and other places, to start a discussion with colleagues.

- Interview a middle-school-age family member or friend, asking him or her to describe their peers, and a day in the life of a middle-school student from their perspective. Be mindful of what is popular, and what is out-of-style in their opinion, as well as what seems to make them happy, angry, afraid, challenged, or sad. Be prepared to discuss your overall impressions and findings.

Section Four Building a Quality Art Program

CREATIVITY AND A CURRICULUM OF FUN, PLAY, AND EMPOWERMENT

In a small rural K-8 school, at the completion of an elementary lesson on water play, there is a change of scenery. The play pools filled with water are still on the floor as middle-school students enter. Now the fun is over; the pool is about to be put away as the middle-school class is about to start. From looking at students already in the room, one can sense their disappointment that the pools are emptied and they will not be allowed to play. "Why can't we have fun and do that?" A perceptive teacher notices the incoming older students' dissatisfaction and decides that instead of using the handouts for the next lesson on color, the pools will stay. Food colors come out for students to explore color theory in the water. So the pool also returns for the next lesson on watercolor techniques. There is plenty of water and lots of colors with which to experiment.

To remain fresh and open to new ideas requires that middle-school students continue to be playful. However, even words such as *fun* and *play* are seldom associated with middle school. The farther creative acts are left behind and neglected, the more rusty and in need of practice they get. Middle schoolers know how to have fun, although they often won't show it. They have learned that it is not something welcomed or rewarded in school. The middle-school art curriculum can be dedicated to reviving fun and playful activities, bringing play pools back to the art class.

An Art Program for Making Creative Choices

Being an artist and a middle schooler is an act of rebellion to be safely and productively channeled into creativity in an art room. While young children can enjoy Halloween and be applauded for dressing up for parents, middle-school students with their emergent interests in appearances have few places to test the bounds of fashion. In school you cannot wear a hat and there are strict dress codes.

As a result of a discussion about individuality, a middle-school art class decides to work toward a make-your-own-clothing day at school. After clearing the plan with the principal, who has to waive the dress code, a compromise emerges and a day is established for wearing art hats.

Students decide on the rules and procedures—that hats, for example, have to be made from items found in fast-food restaurants. Students create hats from coffee stirrers and tea bags hanging from a sculptural medley of takeout containers. The middle-school art program can create opportunities for students to test their style and taste. They can model their art finds and creations in all media.

Future art teachers can devise many ways to invite students' artistic opinions; they are eager to express their art views not only about themselves but to speak about the individuality they see in others. Students will offer their opinion about the shape of the art teacher's new glasses, or be happy to voice their vote on their choice of a new car.

Middle schoolers can deal with personalizing, customizing, and making the world reflect a changing "me." The curriculum can be an expression of *my* shoes, *my* jeans, and *my* bike, involving students in an art of customizing, personalizing, and transforming the mass-produced items that are purchased into objects of their own. Art choices may start as a personal matter, including marks that preadolescents leave on backpacks, or how they brand their ears, nose, body, or hair. The curriculum can move to public art choices, selecting the new placemats to be used in the school's cafeteria.

Creative Empowerment and the Middle-School Art Program

To feel that art is so powerful that it can create change in an increasingly complex world can be an important theme in middle-school art programs. What can be more empowering than middle-school art students holding a press conference on the school's closed-circuit TV? They are describing the new trashcans they painted to encourage a cleaner school. Before their art is placed around the building, students speak with conviction and pride, describing the good their art will do.

Art for middle school can be empowering. Students who might be lost in school, or face adversity and poverty, can find a new life and see a future in an art program designed to portray itself as hope and change. In an art program, students have the opportunity to see a future. They get to meet and question future professionals or invited high-school guests, who show how they prepare portfolios for art schools. Students involved in self-directed work have great motivation to succeed.

Future art teachers can form art classes as self-selected teams collaborating on common goals and interests. In teams students feel powerful; they coach and help each other. Middle-school art classes can be modeled after think-tanks that develop better products, more colorful pots and pans, or the next wave in architecture or music videos. Middle-school curriculums can emphasize looking through the latest art magazines featuring product design, interiors, or packaging arts. Students can also attend gallery openings so that they can discover their own art interests and callings.

A CURRICULUM THAT EMBRACES INTERESTS AND EXPANDS THE VISION OF ART

To search for freedom in their wired world, middle schoolers engage in making order of the chaos on the floor.

A white floor is rolled out in the art class. The students come in seeing an entanglement of computer wires, earphones, and discarded cell phone covers. They drag the wires to make new connections, reorganizing the haphazard arrangement and creating art from media that is not meant as art materials. An art class can present itself as a place that accepts students' technology and its implications for art, technologies that are often banned from school. Art classes in middle-school link students to new art worlds, new ways of expression beyond pencils and markers. A mission of middle-school programs is to excite students about the new in art, to demonstrate that one does not have to be "good at drawing" to engage in the many new media contemporary artists use to approach art.

Learning to see art possibilities in all media and in all places, middle-school art programs can connect students to new views of art. Students can meet with contemporary artists and be mentored to engage in all that is new and exciting in art that used to reach the schools light years later. The latest art happenings, shows, reviews, magazines, video clips can now instantly reach the art room to present a far more exciting view of art than what generally is experienced as school art.

Visiting-artist programs, common on the college level, are at the core of opening students' eyes and looking beyond school art. The programs are equally important in the search for new answers and opening the door to new art worlds in middle school. While working with visiting artists, for instance, students can go to the park and set up tables with signs offering to sketch lost pets or lost loves, in the style of police sketch artists. Students discover new ways to bring their art to people and into the environment.

An art program can connect middle-school students to living artists in the community. Artists with new ideas about art raise students' awareness of the art of our time. New media allows students to feel more a part of the contemporary art scene than any other generation of art students before. Middle-school programs can be part of the art scene and not steeped in school art traditions. Today's media-savvy students have strong opinions when it comes to a taste in music, fashion, or technology, and are eager to discover and discuss the latest in art.

Middle-school students have a variety of contemporary design and technology interests, and need to be in contact with an art world outside of school. To powerfully open a middle-school student's eyes to a new art world beyond what they know as art, classes can start with a meeting at a contemporary art center. When all students know is school art, there is a large gap in understanding art. The openness

to art making that a contemporary artist enjoys should also be felt by students who say they are not good at art.

Middle-school art programs can be about showing students that the old "draw a man" test, emphasizing that being an artist is being able to draw accurately, no longer defines an artist, nor is it the most exciting way to engage students. The middle-school art curriculum can effectively open up to students the widest approaches and infinite means of art making in history.

I love art class … Gosh I needed this today!—Sarah, Model Laboratory Middle School

Creativity and a Curriculum for Self-Discovery

To create a one-minute artist's statement, students roll the video camera and hope to do some editing. They interview each other, asking such poignant questions as, "Can you trace important changes in your art?" "What are your artistic beliefs?" Students tell their interviewer-colleague more than most art teachers will learn about them. They talk about their DVD-cover art collection, describe a belt buckle made from found objects, and the best places to look for unusual buttons. As the interviews progress, the art class becomes a place to dwell on issues of self-discovery. Who am I as an artist? In filming artists' statements or promoting students' searches for their favorite art and artists, middle schoolers focus on finding out what kinds of artists they are.

To help develop serious artistic interests, students look for great art without having it defined for them. Having an extensive classroom library of art and collectors' books, Internet access, and motivation to search, each student builds a library of personal interest and expertise in an artist or a medium that they can confidently teach to others. Discovering what one is good at, finding one's favorite media, is what middle-school art can emphasize as students begin to re-classify themselves as creative individuals.

Artists are not generalists; they constantly search for their own strengths and preferences. Students can gather around and listen to one another explaining their unusual loves and secrets. The foundation of an art curriculum is fostering students as they take charge of learning about themselves as artists. Whether it's finding interest in an art medium or profession, or building expertise related to a particular art movement, it all contributes to the middle-school student's faith in their art judgment and ability.

Socializing Creatively in the Art Curriculum

Preadolescents, who have so much to say, are constantly asked to be quiet. Middle-school students, also known as social butterflies, love to talk and are highly productive when working, talking, and feeding off of each other's ideas. Socializing is a part of the unique art of pre-adolescents, and in an art room the inherent need for middle schoolers to socialize can be embraced. In an art class, for example, students may sit on the classroom floor and make calls to each other on phones they create. The lines are always busy, because everyone is deeply engaged in discussing their most important relationships. Students share an art of social messaging that occurs in words and images. The personalized calls and phones that students make, the impromptu images attached to the conversation, are all characteristics of art that is shaped by socializing.

The common shyness in class, marked sometimes by isolation and reluctance to make art, dissipates when students freely talk. A middle-school art room has to establish itself as a different school environment, one in which students enjoy being treated as adults as they talk and work together.

Art teachers can encourage students to talk and discuss art. As members of a group such as a design collaborative, students are able to solve small and large issues in the world. Before, during, and after art making, it is extremely useful for ideas to be tested and assembled by the group. Yet most middle schools are antisocial in the sense that they discourage the free exchange of ideas between students. In the art room socializing can fuel the energy to debate art ideas.

If middle-school students don't talk about art, the subject remains unexamined, and generalities or family hand-me-downs become permanent art views. There needs to be discussions about what is bad art, or why people can't agree on what is good art. It is often said that it is hard to talk about art, but middle schoolers will talk to peers about anything. When students just get together to discuss their art, or the art of others there is a surprising flow in conversations. The art teacher sometimes needs to refocus talks on art as students describe their perceived artistic strengths and hopes, describing themselves perhaps not as artists but as rebels or fashionistas. A curriculum of socializing and talking about art yields important understanding and subjects for further discussions.

A Curriculum for the Creative Study of Cultures

While the elementary art room was a place for students hungry just to make art, middle-school students like to be engaged in discussing important art matters and to create solutions. For example, a student's collection of bumper stickers from different states has a common theme: Buy Local. The art room show-and-tell then leads to a discussion of the car bumper as America's gallery and questions what is local, or special, about our community?

When students decide to collect items from the local farmers market and share their family collections of Kentucky crafts, the art class becomes an exchange for local culture. A square of bluegrass becomes a canvas of local farms, while another student stacks lumps of coal as a monument of another reality. Middle-school students can create from their own culture before studying the world.

When examining the latest crop of Halloween masks, students can consider why masks are worn and look at masks of other cultures. From examples of home scrapbooks and family albums, an awareness of how other cultures use art to keep records of ancestors and important events can be encouraged.

Creative studies of teen culture can also begin at home and then go global, in an effort to organize a summit of texting poets and YouTube filmmakers. With today's video communications on the Internet, it is feasible to arrange international fashion fairs or show images of middle-school-age room designers and hair innovators. International art exchanges are at the click of a mouse.

As world culture is homogenized into McDonald's, Macs, and MTV, middle-school art studies can look at examples of the uniqueness of a student's home culture and tune into pre-teen visual culture around the world. Middle-school students can use the computer to compare jean ads, design cultural theme parks, and critically reflect on the general theme of the Americanization of the visual world.

A Curriculum for the Creative Care for Public Spaces

Adopt-a-Highway is a common theme for signs along the highway, naming the corporations willing to maintain a portion of the American landscape. Middle-school students can also be enlisted as caretakers of public spaces—not just to pick up trash but also to beautify buildings. Art classes can be engaged in surveying the needs of a community, decorating the windows of vacant stores or covering decaying street furnishings with art.

After children leave for school, parents are ready to seize the opportunity to clean up and change creative studios into home offices in which the kids will do their homework. Middle school becomes involved in reclaiming their space, proceeding to paint their walls purple and put up their decorations such as sports bulletin boards with the photos and illustrations they prefer. In school, middle-school students extend their environmental decorating to school lockers. Promoted by the art class, such projects as video documentaries of students gathering trash and converting it to public sculpture, designing temporary covers for an open bus stop, or creating a portable public shelter for the homeless, can become a lifelong commitment. A middle-school art program can involve students in adopting public needs.

A Curriculum for Sharing the Issues of the World

Everyone in class has been busy gathering contemporary images of conflict, the most powerful images of war for art room discussions and recycled use. Tall white cardboard tubes rise from the floor to the ceiling. A student tapes his photos around the white columns he calls victory poles. Others pose their photo collections with adjacent candles and clay figures positioned as private memorials.

The issues of the world are not only adult concerns. The middle-school art class can open up to students' finds and worldviews, to express feelings and voices not heard elsewhere. There is so much that preadolescents hear and see, experience and think about, that is not called on in school. If a middle-school art program is really about art, it has to derive from passionate feelings and meaningful experiences. The art program can provide a place for an authentic expression of feelings about the realities and powerful events that affect young artists. School art cannot hide under the guise of teaching only techniques and the basics and not the essence of art. Middle-school art is most powerful and memorable when it provides room for real expression. This requires that students tap areas of fear, shared feelings, even topics involving anger. Such a curriculum demonstrates to middle schoolers that art is a subject of caring and that the art teacher is someone who backs their concerns and cares about them.

An art curriculum that takes into account students' beliefs and newly formulated passions allows them to pursue their art with more conviction and confidence. A curriculum that also allows the art teacher to open their creative and unique insights makes the art class into a powerful sharing of principles and understandings. For example, coming back from a contemporary art center changes the students and the teacher. They can freely exchange stories and impressions, art ideas and personal revelations that both the art teacher and the students cannot wait to discuss.

With most other subjects, it is accepted that the teacher presents the basics, and students are in school only to learn the lessons presented. As middle-school students battle for their individuality, they should not have to battle for their art views. An art curriculum should not require that students duel with authority to win independence in an art class. Art teaching is not imposing art values, treating students as if the art teacher knows best and it is their duty to initiate everyone into a community of shared art concepts. An art curriculum for middle school can pre-suppose that every student is a different artist, with unique interests and fervent beliefs ready to be expressed. To flourish in an art class, students need to be able to achieve their goals, not the goals of an inflexible curriculum.

A Place to Question and Discuss the World through Art

An art class is a place where preadolescents can safely question art and discuss complex issues. They can test their ideas about art and artists, and develop individual critical abilities. With press passes made for each member of a middle-school art class, students can be on the front lines covering and reporting on all art news. Passes can open doors to art events to be photographed and reviewed on the school web site. Art museum shows, community murals, and sculptures can be questioned and students' opinions about all things visual discussed in illustrated articles.

A special online zone devoted to art room commentary can review museum shows and all aspects of consumer art. Students can write about an emerging building in the neighborhood or an electronic billboard that appeared overnight. Writing about one's own art and the art of the world challenges visual thinking, and demonstrates that an art class is not only dedicated to learning adult opinions but formulating one's own.

UNDERSTANDING THE POWER OF ART

Art is a response to critical feelings, a human response to people—not an abstract study of principles and techniques. For instance, an art class can begin with a discussion of a broken levy and the frantic events seen in every newscast. An art class is not about remaining calm or neutral but about getting involved in what could be done for the survivors of daily disasters in our world. Some students suggest an armada of small wooden toys to give comfort to children; others want to use scrap wood to build a model for practical rescue ships to be tested in the Gulf.

Art teachers can consider creative designs for a curriculum that makes a difference. A fundamental aspect of middle-school art is an emphasis on meaningful learning, doing things for others, contributing to the school and the larger society. Middle-school art should not seem like other detached learning in school but be a curriculum with feelings, active and passionate. The curriculum can be founded on the idea of building a better world.

When teachers refer to a curriculum, they discuss conveying information. Teachers feel satisfied when students can demonstrate they have mastered a skill or a technique. They can check it off and go on to the next task. Classroom teachers feel satisfaction when their students do well on a test, and feel pride when they do well on a standardized test. But an art curriculum does not have to be about the checking off of information. Learning and satisfaction can be deeper when the curriculum is focused on human issues. Middle-school art can be taught as a subject that can make a difference, brightening faces and communities and bringing beauty to the environment.

ORGANIZING MIDDLE-SCHOOL ART

The artistry in art teaching involves organizing the curriculum as a response to individual artists' posing a constant flow of fresh ideas and challenges. The art teacher in a sense can have a curriculum for every student, as they engage individuals in creative experiences and meaningful dialogues. An art curriculum can be organized after a lesson is taught, when the art teacher can go back to reflect on and organize the interaction. Since there are many artists with individual interests and ideas in each classroom, the curriculum needs to be fluid so that the art teacher can follow up on what students bring to the table. In this way it takes on a natural shape, flowing in many directions to be responsive to individuals' needs.

An art program has to be open and offer a breathing space for the gifts that come with teaching. The important curriculum in art is unstated, because it lies at the core of a good teacher responding to students. What is learned from art teachers willing to share their knowledge and love of art, their collecting and searching for art materials, or conveying the pleasures of creation is incidental; it is given freely. Narrowly specifying what has to be learned and what will be tested discourages great teaching. A curriculum has to allow for time and space for teachers to teach, to share the large body of experiences at their fingertips and to use them well. By watching students, listening to them, working with them, living in a studio together, teachers get a reasonably clear picture of how students are developing. A caring art teacher is constantly in touch, reshaping the curriculum and learning about each student.

CONCLUDING THOUGHTS

The middle-school art curriculum can start inward, responding to the inner needs and age-related concerns of preadolescents and then move outward, addressing the students' increasing interest in being counted as adults and involved citizens of the world. Art teachers can reflect on how the art curriculum can be used for students to look at themselves and the larger community. Lessons can be uniquely shaped so that students can see themselves as future members of society. Art in the middle school is not just learning facts or art formulas but is an important experience of self-discovery and looking at oneself in relation to the world. Unlike other subjects, middle-school art is a curriculum for life, a living and breathing subject that responds to students' feelings and emerging views of the planet. See Plate 3.6.

Creative Planning and Topics for Group Discussion, Activities, and Extensions

- List three art careers that might interest middle-school students. Explore your community to determine what resources exist to help teach about these careers, such as guest speakers, examples of artists' work, etc.

- Explore one opportunity that exists locally for a possible middle-school art and community partnership. Be prepared to discuss.

- Wearing the hat of a future art teacher now, things surely appear different from your own school days. Start a blog about your middle-school art experiences. How are the students, the school, and art classes you are observing different than what you recall from your middle-school days?

Section Five Teaching Art to Teenagers

These are exciting times to become an art teacher. After years of relentless emphasis on academics and assessment, educators are realizing that schools have to reflect the needs of society. A nation that is no longer a producer of goods now has to rely on creative people who are able to produce great ideas. The recognition that art is crucial to education is on the rise, and in the education world, a revived buzzword is "creativity." Publications are filled with articles on the subject and museums are opening Centers for Creativ-ity. When schools "teach to the test" and are dominated by accountability, middle-school teachers' roles become the final stronghold for students to exercise creativity. The middle-school art class has the opportunity to be at the center of this fervor. Future art teachers can start to work on a bold sign to be placed across their art room doors, proclaiming the art class as every school's creative center.

Art is the triumph over chaos.—John Cheever

REDUCING STRESS AND PRESSURE IN THE ART ROOM

The general pressures of school life plague the middle-school art room. The following section describes some of the stresses and considers ways that art teachers can prepare to address them.

Art teaching is not only about modeling creativity but about inviting students to join in and participate in a creative setting. This requires that the art teacher shows empathy for students who are engaged in some of the challenges of being in middle school yet still provide a freer and more self-directed setting. An art class has to feel like an exciting, comfortable, and safe environment.

I Cannot Draw

A stress factor that looms high above all others are students' feelings that they cannot draw. Middle-school students see drawing as a defining signal of competence and a confirmation of whether or not they are good in art. The notion goes that drawing skills are supposed to occur naturally, easily acquired by some and not by others. Middle-school students set apart drawing skills from other skills and see them as a natural disposition, unlike any art forms that require practice. The self-imposed art test of a good artist is someone with the natural gift to draw accurate likenesses of people, or heroic video game or cartoon characters. Students looking at the drawings of contemporary artists, who view drawing in vastly different ways, can be an initial step for countering these preadolescent fears.

There are other paths that art teachers can consider. One is to insist on a daily drawing diet, of anything and everything; practice, practice, practice. Students can be asked to plan art ideas in drawings, to draw everything they see, and to draw constantly in and out of school. Another option is not to make drawing the centerpiece of middle-school art.

Student views of drawing can be expanded by exposure to a wide range of drawings made by practitioners of different art professions. There is a wealth of literature by famous artists discussing variations on the following statement: I can't draw. They underscore drawing as a lifelong search, a form of personal handwriting, or just a means to an end. Students can collect and share artists' writings about drawing and compare different drawing styles. Art teachers can involve middle schoolers in a wide search for the meaning and definitions of drawing and what it can be.

I Don't Want to Expose My Feelings in Class

Middle-school students may engage in lighthearted conversations about video games or a recent movie. Seldom do they discuss feelings that can be exposed in personal artwork. Although middle schoolers certainly do talk about themselves, they have a good sense of what is safe or acceptable to divulge.

Art making that is unpredictable exposes the artist to outside opinions and can be stressful. Self-expression is more difficult to control, public reaction is unpredictable, and things can slip out. As long as art classes are about techniques, there is protection that the product will conform to an acceptable norm. The more personal the art that is made, the more vulnerable the artist feels. Middle schoolers try to avoid art that can be made fun of, thereby protecting themselves from careless comments.

Some artists expose their inner selves. Other artists reject the inner path to art making and choose subjects far away from themselves, investigating a more outward or universal subject. The two approaches describe art history and the separation of American art from European models in the middle of the twentieth century. Abstract expressionism, which dominated adult and school art, was highly personal, probing the inner self as its approach and theme. Today artists are encouraged to have their own voices—there is no dominance of a single style, and this has also freed school artists to create any way they want. As in the art world and in middle school, art can range from the highly personal to the most impersonal, without signs of the maker's feelings or hands. Art made with all media and found objects and using expressions from pop culture to social issues reduces the pressure on young artists by directing the creative conversation away from themselves. Middle schoolers now have a choice of exploring their changing self-image through art with deeply personal portraits, or of choosing to explore universal themes.

Middle-school artists can exercise a degree of control by what they make for private and public viewing. Not all art made by an artist is intended for public presentation. Many works, even in school, may remain in private collections and are not made for hallway display. Art teachers can recognize the preadolescent's interest in exploring some personal issues yet maintaining control over selecting what is publicly shown and discussed.

Students can also explore the personal in art without using their own work. To rehearse the responses that personal art faces in public, students can select the artists

of their choice. Middle-school students are ready to expand their art world by using selected artists to discuss and interpret. Students can test the waters by role-playing and expressing their own feelings through the works of other artists.

To diffuse stress in discussing personal artworks in a public setting, art teachers need to remember the privilege of the artist to remain silent about their art. Some students may be comfortable writing about their art, or by keeping discussions small among a select group of friends. Different formats to discuss finished art can be used in one art class. Some students may talk about their art with trusted friends, while others are open to television-style interviews with each other. Group art projects can also create a familiarity and trust, easing conversations among young artists.

I Hate Being Criticized

Criticism has always been a part of art classes; teachers criticize students and students criticize each other. No one likes to be criticized, but for middle-school students venturing out of their safety zone, criticism can cause damage beyond repair. Artists in a private studio decide on the time and place for their art to be viewed and critiqued. In an art room there are fewer barriers keeping out critics. Middle-school art teachers need to be sensitive to students' aversion to criticism and the difficulty of shielding art and themselves from critics. Participation in formal criticism can be made a choice and not a requirement.

A delicate act in teaching is knowing how to offer preadolescents suggestions while respecting their need to maintain some control over their art. Art teachers can make it a point to let students know that the teachers are not the ones holding magic wands of solutions for each student's art. One opinion can feel like a thousand voices, especially if it is in the form of a verdict that comes from the teacher. Since art teachers generally don't make their own art in class, they have time and power to drive students' art with words of praise and criticism. Future teachers can tread lightly in the role of the professional critic.

I Have No Talent

Middle-school art teachers embark on a constant challenge of confidence building and engaging students in discussions about the meaning of talent and giftedness in art. The work of visual artists can be compared to the hours of hard work and tedious practice required in playing an instrument. Art skills are pursued over a lifetime and not an art period. Young artists have to develop patience and understand the long-term commitment that visual artists make.

Middle-school students can be made aware that there is no blanket art talent, since everyone in the visual arts has different interests, prefers different media, and works hard to establish the skills that best suit their ideas. Preadolescents can be encouraged to understand that there is no single yardstick that can be applied to everyone. Drawing is as individual as handwriting; it varies with individuals and is modified by the ideas of the artist. Some drawings may emphasize beautiful marks, while others are beautiful in their ability to explain ideas. The more drawings students see, the better they understand that it is impossible to generalize about what is drawing or what constitutes giftedness in art.

I Don't Know What the Art Teacher Wants

By the time students reach middle school they reluctantly reach the conclusion that school is about pleasing teachers, meeting adult expectations, and doing what the teacher wants. But what the art teacher wants can be unclear and how to please them a mystery. There is anxiety when students are offered freedom and are no longer guided step by step to do exactly what the teacher wants.

As art teachers turn art learning over to students, the whole notion of what school is and how one is supposed to play the school game is turned upside down. Art teachers should understand the conflict students experience in a class where rules are not used to define everything and where one is actually encouraged to make or break rules. Students' compasses are off when they cannot figure out which direction to move in order to perform and please the teacher. When an art teacher acts as a supportive fan to students' ideas, there is sometimes suspicion that the teacher has an unstated agenda.

The essence of an art class has to be clarified from the start; this class is not about what the teacher wants. Art class is not a trick. It is not to be approached as a school game. Its value lies in the difference it provides for engaging students in their own art making. It is true that the most important qualities in learning are the hardest to define, and defining art for students is a disservice and misrepresents what art as a personal search is about. In discussions

with middle-school students, they need to feel that their ideas are welcome in this class, that they will be listened to and encouraged. Preadolescents in an art class can feel abandoned by the teacher, and in fact the art teacher has to work hard to assure students that they will welcome ideas, listen, and yes, when appropriate, give advice from the perspective of a colleague who has been through art journeys and realizes the many difficulties.

I Don't Want My Art to be Graded

As students near high school and higher education, grades become most important. Students become very aware of their abilities in academics, defining their performance according to the grades they receive. If asked how they are doing in math, for example, the answer is often an accounting of the grades received on tests. In art class the student's experience is not summed up by a test, or a grade, but some wish that art could be that simple.

Without the emphasis on grades, teachers, parents, and therefore the students pay less attention to art. Even though grading is not the issue or the reason to be involved in art, it is hard to convince students of this. In art class there is often a fear of being graded on something that one actually enjoys and likes to do. Grading also lacks the precision that a math test provides, always leaving doubts about why one received a certain grade and the hocus pocus involved. Handing in one's art to be graded can yield to a fearful uncertainty—how will it be judged and will there be an indefinable justice or injustice.

No matter what rubrics are used, grading art still remains loose and inaccurate and most of all is dependent on one adult's judgment. In other subjects students submit impersonal test items to the teacher, but the act of giving something of oneself and being exposed to how it will be received causes anxiety. Too often grading can bring about a damaging conclusion; it can even cause a student to dislike the subject and give up.

Students want answers as to how art can be graded. Art teachers privately confess to being uncomfortable with the schools' standardized ways of looking at art achievement and wishing for alternatives. Art teachers often attempt to set criteria and discuss grading, but as one student put it, "If the art teacher really wants me to express myself, how can they grade me?" Recognizing that art grades at the very least can hurt feelings but also can discourage young artists, they need to be done responsibly and creatively.

Art teachers who are creative about presenting their subject can be creative about grading. For example, art grades in middle school can be done in consultation, involving useful self-assessment by the artist. Works in an art class can be shared with students and solicit positive responses. For students in middle school who are allowed little self-rule and experience with judging the progress of their own work, art is the perfect class in which to keep a diary, to make plans and to document the artistic journey; it is a way to define for oneself how close or far one is from what needs to be accomplished. Art teachers need to find creative ways to grade in an adult manner, involving each student and incorporating the students' own views on the progress of their art.

I Am Comfortable with the Way I Work

After years of art making, middle-school students have tested their crayons and pencils, knowing what they can do to please others. Students are aware of the art that has been called good, and although they are at the age of seeking new relationships with adults, they still depend on adults and fear creating art that they are not known for. Wanting change yet fearing to take chances, middle schoolers fit into a familiar path and art-class routines.

Even though middle schoolers have the reputation of being troublemakers, in reality art teachers need to recognize their students' hesitation to make waves. The challenge of art learning is to let the student work like an artist and start taking the lead role in learning. In an art class that offers an open space, freedom can cause hesitation and discomfort.

Art teaching is not just opening new doors for students, but recognizing their hesitation and helping them walk through it. Many preadolescents need some hand-holding before they can freely use them. As students grow up in middle school, they are most convinced by action and discussion. Art teachers need to be able to demonstrate creativity and an artistic search for the new. They need to engage students in art talks about breaking with the familiar in order to seek art that is new.

Preparation for the art class can include such discussions as the necessity for getting up from the safety of sitting behind school desks. To freely move is necessary when it comes to shopping for ideas and freely crossing an art surface. For students who are learning not to touch and use their hands in school, an art class has to once again explain

the opposite side of the coin—the importance of keeping contact with the object world and sampling everything. Art teachers need to offer assurances that it is not only permitted but also important to talk in class, to express one's ideas and opinions.

I Cannot Fit into the School's Art Style

Purposefully or inadvertently, art teachers generally shape the school's art style. They define the boundaries of acceptable art by their own art, their art views, and taste. This is expressed in class by what teachers praise. Middle-school students are perceptive and quickly learn what the art teacher likes, what becomes accepted as the school's art style. Future art teachers need to be aware of their influence, their own art boundaries and taste, and not to make it a blueprint in order for students to succeed in the art class. They need to be observant of the art they pick to praise or what gets displayed or is selected for art shows. Art teachers need to self-critically peruse the bulletin boards, monitor their art picks, looking to avoid an official style and their personal artistic prejudices. Art teaching is not only accepting diversity in students but also in student views and in their art.

The art on display in a school hallway is not the teacher's art. The work is not in praise or criticism of the art teacher, but simply a representation of the variety that is produced in class. Art teachers need to learn to relax and enjoy being surprised by many kinds of student art. Schools, even more than art museums, can be guilty of expressing a single view that speaks loudly to students coming to an art room.

If we would listen to our kids, we'd discover that they are largely self-explanatory.—Robert Brault

TEACHING ART AS ATTENTIVE CARING FOR YOUNG ARTISTS

The art room is open for lunch as well as for after-school tea parties for students to get together and make art. Art teaching that is about caring about students can be demonstrated in concrete ways. When students enter, the art teacher can warmly greet individuals at the door. The students can respectfully be addressed as artists. Before art making, students can look forward to meeting in an inti-

mate circle on the floor. Instead of starting with impersonal announcements or lectures, they can just sit and talk. Like inviting good friends to a meal, students in an art class can be invited to the table or the floor to talk about art, ideas, and to share what's new and important. Middle-school teachers often complain that students can't communicate with each other: "Instead of talking they hit, push, and touch each other." Art teaching is about listening, hearing, and encouraging communication.

One teacher recalls a recent school-wide gathering in the gym on the subject of bullying.

> The students read aloud a brief essay they wrote. As individual students one at a time recounted stories of how they felt being bullied, the silence was voluntary, only broken by individual tears. They finally got it! The students were able to understand each other on a level I have not seen before.

The casual and awkward middle-school way of conversing was broken when students shared deep secrets before caring colleagues of how they had experienced being bullied. Before dismissing middle-school students as incapable of caring about anybody but themselves, and therefore incapable of art that has personal depth, art teachers can focus on sympathy, care, and quality listening.

In some ways it is simple to ask students to just tell their story and not just show their art. On the other hand, trust has to be earned, and students sitting dutifully behind desks will only open up to those they feel they can trust and will seriously listen. An art teacher has to earn the title of being a trusted person. When the art teacher and a class are engaged in truly listening, middle-school artists open up through their stories and art used as voices for expression. Art teachers can think about the many ways they can ask students to tell their stories in class and how these works can be caringly received.

A teaching role of simply being there, walking around the class, directing traffic, and posing as the art expert is not enough. Middle-school art teaching is an act of being humble, one that requires showing students care and interest in more than correct solutions or making beautiful pictures that lack what each artist is feeling or thinking about. Middle-school students are not little children; they've already had a fair share of life-changing experiences. In the right atmosphere, students can communicate significant stories in all media.

Art teachers can consider ways they can facilitate students' connection to art by acknowledging their stories, interests, and feelings. They need to demonstrate caring

about what the art students say, and what they show and propose in their stories, diaries, or favorite songs. When middle-school students make art from the heart it is beautiful, meaningful, and powerful. It is sometimes during the moments that the art teacher is away from his or her directing and performing role that the most interesting ideas can be formulated.

Art and art teaching are both personal acts. Establishing relationships in an art class is important. One hears about middle-school students as a group not having a strong sense about how to establish meaningful relationships. They are notoriously awkward at middle-school dances. Yet art can be a small element of humanity in a pre-adolescent world of chaos, a way to discover shared feelings with peers and to learn that they have many things in common to speak about.

TEACHING A RESPECT FOR ART MATERIALS AND THE ART OF OTHERS

In middle-school art rooms, the class rules are displayed in a prominent place. The rules can be read like definitions for common acts of courtesy. The word *respect* is used repeatedly in defining class regulations. In a room where there is a great deal of interaction between students, reminders are used for those who lapse into acts of thoughtlessness toward others. A respect for each other's space, materials, work, and one another sums up the common courtesy required in order to create art in a group situation. Art teachers might want students to participate in formulating class rules; it is their studio, after all.

Middle schoolers are generally sharp but impulsive thinkers who often act without first considering the effect of their actions on others. Comments about each other in art class can be hurtful. Jokers who like to get a quick reaction can cause a lot of damage to the fragile confidence of young artists. The art class is vulnerable to a special kind of bullying with negative comments. In a studio setting, students have a lot of time to interact and potentially torpedo each other's art with words and gestures that are not intended to be private, nor complimentary. Art teachers not only need to post reminders to students to treat each other's art with respect but to vigilantly enforce them, otherwise damage control is a difficult task.

Boredom is also something that can lead to thoughtless behavior. When students love and want to do art they are committed to, they are more likely to respect others who

are also working with intensity and purpose. Sit a class down to carry out a dry, technical exercise and unruly behavior ensues. When students feel that they are working as adult artists they invest themselves in the task, contributing to a strong, communal environment where everyone feels that they are responsible and professional. The best remedy for respecting art and fellow artists is to commit the art class to important and dedicated work.

BECOMING RESPONSIBLE IN THE ART ROOM

Students test authority in an art room in strange ways, such as stealing materials and seeing how far they can push an adult and get away with it. Art teachers should consider what would be a "reasonable framework" in which students can take ownership over the art room and their art experiences. For example, students may take charge of tools or plan for their own art projects. Middle-school students want to be in charge of adult tools such as glue guns. This heated, electric tool requires respectful care. If a student uses the glue gun to draw over another student, it can be admonished as unacceptable behavior and they will be asked to return to Elmer's glue. Students don't want their maturity questioned and art license to be revoked. A teacher's demonstration of trust is a powerful tool in having students act respectfully in return.

Respect for art papers and artwork can be constantly exemplified. Tables can be wiped down before students touch an artwork. Washing hands before touching good paper and working in an art class can become not only a sign of respect but also a habit. Being exposed to different qualities of supplies—for example, touching great handmade papers—builds a respect for paper making as an art. Helping to roll up students' work instead of folding it, refusing to put a staple or push pin into student art, and other issues of care and preservation can be constantly demonstrated. The way the art teacher treats student art is visible to all.

Showing children's art or the teachers' drawings wrapped in protective glassine covers exemplifies the treatment and importance of all art. When students are included in purchasing and collecting their own art supplies and are expected to come to class with plans and ideas for their use, they have more respect for art materials and ideas involved in art making.

Publicly mourning artwork that has been damaged by light, or vandalized in the school hallway, shows how fragile

the life of an artwork is and how important each piece of work is to the art teacher. Showing students that art is to be cared for and teaching preservation techniques show a general attitude of valuing artwork.

POSITIVE MANAGEMENT OF ART FAILURES, AND NOT GIVING UP

A significant aspect of middle-school art teaching is to share features of the artist's journey, especially feelings that may be of relief when they are recognized as shared concerns among artists. What advice or suggestions can art teachers offer to prevent a pile of artwork from flying toward the trash can? Some related topics that may be discussed are stated below.

Permission to get up and take a break, occasionally to walk away during the art process, is important. Except for school art, few works are created in one sitting. Artists take breaks that act as productive moments in preserving the life of an artwork. While the artist is away, ideas may surge and courage may be found. Middle-school art teachers who like to keep students seated may reconsider the rules and allow students to get up from unfinished work to stretch, stand, or walk, and return refreshed. Artwork cannot be forced into completion. Pauses are important and are not a sign of defeat.

Art teachers can consider ways to ease the pain of throwing out art and ensure that student art has a chance to be resolved. For example, a class rule may be that it is all right to start a new piece, but that all art needs to be kept. Students can keep a folder for unsolved art and not just portfolios for finished pieces. Breakthrough qualities can be scary to the art-maker, therefore it's better to save and return later to works that are hard to judge. Unsolved art folders can be regularly revisited with fresh eyes; some works can be brought back to completion, others re-evaluated and their lessons extended to new pieces. Art moves back and forth and not just in one direction. Old works guide the new and can be revisited.

Middle-school art is generally made on one paper. In many art classes, students plan, practice, and create the final piece all on a single surface. Instead, students can be advised to use several planning and practice sheets, working toward a finished paper. Artists may have many pieces in progress, all helping each other. This can be illustrated in the simul-

taneous works-in-progress appearing in many photos of artists' studios. There is relief for middle schoolers in working on a series, which gives them many surfaces to experiment and rehearse on. Working on multiple sheets allows them to view changes in their art and not attempt to test ideas and make the finished work all on one page.

One of the most unforgettable lessons is to share with students examples of the teacher's art dilemmas. Works that had to be intensely fought over in order to give birth to a new phase of art can illustrate art problems. It is helpful to see examples of the art teacher getting stuck, perhaps with pieces that were not appreciated at the time they were made.

Still, destroying art can sometimes be part of the process. It can be cathartic to destroy some works and physically create an end to a chapter. Middle-school students can also feel satisfied sorting through saved artwork and editing out pieces to clarify what they like, to find a clear path in the art they want to pursue. Throwing out works provides young artists a sense of control over their art. Art teachers can look for artists' works that illustrate momentous changes in the art journey, marking illustrations of change, detours, and saved works.

Artworks that have been substantially changed, explored, and rebuilt take courage from those who made them. Most schoolwork is predictable. However, through art, middle-school students explore with no guarantees. Courageous explorers willing to take chances turn their art upside down and tell stories about it, and they should be rewarded for this.

Concluding Thoughts

Middle-school art teaching works best by showing trust, not using a top-down teaching style where only the teacher can make assignments and rules but where the students are also expected to participate in building content. An art class is a collaboration between artists working together to organize time, involve everyone's plans, and try out artistic roles. When there is no universal art plan in place, students find the materials they need, the processes they want, and they accomplish their goals. Future art teachers need to consider how they cannot just teach art, but promote student planning and students having a voice in the art class. See Plate 3.7.

Creative Planning and Topics for Group Discussion, Activities, and Extensions

- Observe private and public middle-school art classes in different urban and suburban neighborhoods. Don't wait to get home; before leaving the parking lot, text or e-mail colleagues after observing each art class, describing the most memorable differences between each school and art class.

- Talk with middle-school children and their parents to try to determine the five most popular television shows that middle-school children watch and/or most popular electronic games that they play. Select one to research. View it, or play it, and if possible, observe a middle schooler watching the show or playing the game. Prepare a presentation for your peers describing the show or game.

- Interview two middle schoolers, asking them to describe how they spend their free time outside of school from the sound of the last school bell of the day, to the time when they go to bed. Be prepared to briefly summarize your findings, and share with future teacher colleagues in class. Be prepared to discuss the role of art in middle-school students' lives outside of school, and brainstorm ways to improve the free time art experiences for your future students.

Art is an adventure that never seems to end.—Jason, Los Cerros Middle School

Section Six Selecting Experiences for Middle-School Art

CATCHING UP WITH STUDENTS' ENVIRONMENTAL INFLUENCES

Influences and inspiration for middle-school art come from non-traditional art sources, mostly from the student's life and environment. School art needs to be aware and sometimes catch up with these influences that affect the way middle schoolers think about art.

The visual-art world is a major influence on middle-school art. It might not be the fine forms and characters depicted in ancient Greek vessels that speak to middle-school artists but the images such as the illustrations on giant drinking cups at ballparks that students notice. The design of contemporary children's drinking cups and, more recently, water bottles is an example of innovation and a story well worth examining with middle-school students who are very familiar with twenty-first-century visual forms.

Middle schoolers may not be regulars in the halls of art museums, but they do frequent cereal aisles, carefully admiring box art and paying tribute to their favorite products. Illustrated characters, new and familiar masterpieces in labels, prizes, and a world of bold illustrations cover contemporary cardboard boxes. Preadolescents have a different appreciation than their parents and teachers do. Films, video games, and cereal boxes motivate students to copy or invent their own heroic characters.

Class artists may not be well versed in framed art, but they are in contact with many arts on paper. They are aware of unusual restaurant menus, remarkable birthday napkins and greeting cards, and they have favorites among the latest creative trend in Kleenex tissue boxes. Students are participants in a lively art world on screen, in stores, or in selecting dynamic cell phone covers. There are strong visual influences on middle-school artists from the utilitarian arts of graphic and product design, among many other arts present in the larger museum of the environment.

It's better not to ask an adult or an art professor about middle-school inspiration but to discuss the matter with

middle school artists. The art that students want to discuss is not yet catalogued, but it's worn, it's heard, it's live, and students do notice it and respond to it. If not influenced by art teachers, the middle-school students do what all artists do—take things from their contemporary world and make them theirs. Middle schoolers are very much into personalizing, customizing, making the visual worlds presented to them their own.

Preadolescents grow up seeing that everything can be personalized. Customizing is everywhere; old cars are turned into "ghetto blasters" on wheels, antique furniture gets a second chance in trendy stores. The Salvation Army has a project of turning second-hand clothes into haute couture. Middle-school students' art is about discovering their own taste, and customizing provides them the opportunity. In the art class any object can be changed, especially mass-produced items can be made into something of one's own for students to alter to their taste. In the art class old things can be given a facelift, and new things can be provided with a new look, as preadolescents find their uniqueness through art.

They're My Clothes

Fashion matters to middle schoolers who might seem to all wear the same jeans, yet who are actually selecting jeans very carefully. The deceptive sameness is a yearning for uniqueness, as jeans are creatively accessorized with belts, key chains, and, of course, shoes. For middle-school students who are in between, wanting to be part of the crowd yet seeking to assert their individuality, sneakers that are *special* are very important.

Celebrities like Madonna and Lady Gaga sport incredible shoes. Rappers like DMC rap about them. Custom shoes star in music videos and fill preadolescent chat rooms on the Internet. Custom shoe designers have a following. Fashion is a major influence on middle-school art rooms, where customizing shoes, for example, is a favorite project.

Shoes have been an unofficial middle-school canvas for a long time. Students use ballpoint pens to draw on their hands, and secretly, or sometimes in full view of the teacher, on their shoes. This art might receive little recognition. Here art teachers can assist by placing a blank shoe and a marker (or paints) in the hands of students. Incredible things happen. Students no longer complain about not being good in art. Wearing art on the feet changes many things, and it also gives confidence to pre-teens who are struggling to re-enter the art scene. Art teachers need to be

immersed in youth fashion; they need to find ways to demonstrate their interest, showing off their shoe selections and creations, and condoning dynamic fashion statements by students.

As art critics, custom "kicks" connoisseurs immediately notice when someone is wearing interesting sneakers. Art teaching can broaden the study of shoes to include recent art shows, shoes in art, and shoes designed by artists. Middle-school art appreciation is taking note of art in all aspects of the environment, including collecting samples and images of sneakers and illustrated flip-flops. It is not just about shoes, of course, but all that students want to wear, dream about wearing, or decide to wear that is important.

Parties and school dances are extremely important because they are places to premier clothing choices and hairstyles. These parties are no longer the innocent birthday affairs of young children but an expression of seriousness about music and a showcase for fashion. Art for preadolescents is part of a social phenomenon which displays their new independence through clothing choices and dressing up. That many adults don't share this view or acknowledge the art in fashion choices is clear in many parents' complaints, such as, "My child drives me crazy in the morning. I give her two choices the night before, and I padlock the closet in the morning." Adults fail to see that getting dressed is not about getting to school on time. Art takes time.

It does not always matter what the designers create, because middle-school students are able to reinvent what the designs have handed them. If permitted, students can actually do their thing with fashion, creating unusual combinations of textures, wearing crazy patterns, accessorizing with tiny purses, and daring to try colorful mismatched socks as part of a new style. For students who like to dress up and test fashion ideas, the art room can provide a safe place to try out, design, and explore fashion choices beyond what's safe. Art room sculpture can be made from unusual fabrics, belts, accessories, and students can use models as they test ideas for new street fashions.

In students' art dreams expressed through paintings, they can safely explore new hair colors. In adding cyber style to fashion ideas, students can create new pockets for cell phones and use their "wire" as a fashion accessory. In drawings, students can mix and match dynamic graphics in tracksuits used for exercise classes and in second-hand clothes, as well as with toys, Silly Bandz, customized Band Aids, face paints, and accessories of intricate plastic rings and bracelets.

Art classes can offer opportunities to experiment, pose, model, and become a work of art. Middle-school fashion shows are full of creative energy. The love of fabrics, bold patterns, and mixing and matching is part of being an artist. The mundane, gray, and boring society in school or in the world can easily swallow up middle schoolers, or they can try breaking out their individuality with art.

It's My Music

Music has long been a sign of contention, a banner for the younger generation and their rebellion. The 1960s in America were the war years. These wars were fought not only in Vietnam but among youth toward the older generation. The enemy for pre-teens to teenagers were adults with archaic attitudes who were called "straight." To this day, middle-school students have idols, favorite singers, songs, and bands that depart or sharply divide their taste from what adults like to hear. The generation gap was and to a large degree still is debated and fought over through music, but also through the T-shirts worn or the pop star posters displayed in preadolescents' rooms.

The music heard in most bands, orchestras, and choral groups in school is far from the tunes middle schoolers listen to on iPods. Middle schoolers take their music seriously and understand that it can go only into their ears at home, and it is off limits in school. But music is so close to the preadolescents' world that it should be treated as an integral part of their creative choices and art interests. The middle-school art room is often the only place in school that allows students to come in and stay with their music, and with their choice in music come many uniquely creative things.

Young people's involvement in music spills over to the visual. Musical performances are their own visual culture: it is not just the music but the music scene in its totality that influences creativity in middle school. Concerts involve unique arts like staging, custom instruments, environments, installations, and light shows. This can all be viewed on music videos that are also about musicians' clothes, make-up, hair, or shoes, all of which inspires young fans. Album covers and posters also bring home the music to celebrity fans. Music moves and pumps up a middle-school art class, and art teachers can learn to move with the beat. They can invite their students to inform and initiate them into the new and fast-changing music scene. Students enjoy being involved in planning concert tours, designing sets, costumes, backdrops, and, of course, souvenir T-shirts for their music idols.

It's My Brand

Middle-school students are heavily influenced by advertising, and pick their jeans and make their food choices by brands. Art teaching needs to be able to turn around the marketing of brands so that students can again look around freely and select everything freshly, according to items they find beautiful.

Supermarket visits are important art trips, where students find the most amazing colors and forms not in a box but by leisurely enjoying the art offerings of produce aisles. The cereal aisles can be seen through television ads, or as contemporary galleries for advertising characters and bold graphic arts.

Middle-school students like their gadgets and are careful shoppers for electronics. Browsing through catalogs in the art class or taking store visits can focus on design and quality art in the high tech world. Art classes can be inspired by the design of a new generation of 3D viewing glasses and 3D images. Art class discussions, reviews, and design projects need to include the virtual world, the vistas hooked up through viewers to students' minds. Both the equipment and the change in perceptions of space, colors, and forms can be new themes for the art class. The implications of each new technology—life with Wii and gaming with "shades" on 3D televisions—are not only new gear but a major change in what is discussed and created in the middle-school art class.

It's My Place

Yes, middle-school students do leave their screens and gaming at times, but they usually go to the mall and not the museum. It is rock singers who are their stars and idols and not artists. It is up to art teachers to expand their students' places and people of interest, their stars and worlds to look at and look up to, and to make sure that museums and artists also become part of the students' pantheon of interest.

Even at their favorite malls and stores, preadolescents' shopping becomes routine and less adventurous. Art teaching for this age is less about projects than creating lasting memories and experiences that can refocus, slow down, and point out art everywhere. The malls can be revisited, this time not to hang out but to shop for beauty and art ideas. To regain the pleasures of independent searching, a kitchen supply store can be entered as a museum of beautiful things. It can be browsed freely as a favorite art supply

store with unique canvases, brushes, drawing tools, and frames.

When preadolescents speak about "their place," it's no longer the backyard, or a reference to a special hiding place outdoors. Middle schoolers spend less time alone, less free time in nature, less time picking up and inspecting things of beauty or just being lost in the wonders of the sky. As life in school and after school becomes more regimented, freestyle living and dreaming also diminishes. Fewer kids pick up fallen fruits from a tree, squash berries to make colors, or think of the art that could be made with pine cones.

Art teaching for this age group can lead students back to leisurely browsing, back to finding beauty and creative possibilities in everything, including nature. Future art teachers can begin to consider how they can take more field trips that expand students' favorite places. How can an art class rekindle the joys of painting outdoors, or look freely at the street or a favorite mall for art and ideas? Middle-school students need to regain the joys of spotting art formations in the clouds.

MIDDLE-SCHOOL STUDIO ART, AND DEVELOPING ARTISTIC SKILLS AND VIEWPOINTS

Today's art is made from all materials using all media and just about any surface. It is hand or machine fabricated; it exists in frames or in ideas alone. For the children who will inherit and advance art, new preparation is required. When any object can be the canvas and students are challenged to find art, the new middle-school studio needs to stress openness. Students need to leave the studio with an inquiring eye guided by an open mind to what is beautiful and what is art.

Studio skills and techniques cannot be generic when art can be built from anything. Middle-school studios can stress ideas—how to find them, keep track of them, and how to decide what to do with them. For example, a student interested in street finds such as storefronts, murals, signs, urban walls, or floor graffiti, may seek painting skills or want to learn video editing. Hand-making skills need to be developed alongside computer-art skills. Conceptual abilities can be balanced with the freedom to improvise. Making things can share the time with rescuing objects. Manual skills are as important as research skills. Each studio lesson is a rehearsal for an open and independent search for art.

Working with One's Hands

Middle-school students who have not worked with many other tools besides computers have difficulty hammering a nail or assembling a prefabricated bookshelf. Without home economics classes they cannot sew a button or envision 3D objects from a flat pattern. Even with video games on their wish list, preadolescents yearn to work with wood and fabrics, use their hands to shape bread and build with. Students can assemble wearable art and look forward to building sculptural furnishings and decorative items for their room. Art teachers can look beyond traditional art supplies and provide mixers and blenders for baking or mixing paints and consider decorating cakes as opportunities for students to create with their hands.

Improvisation

Moving freely and playfully becomes more difficult as students learn to occupy seats in school. A middle-school art class can be set up as a dance floor, since most preadolescents can still cut loose in freestyle dances. Studio sessions that begin with loose hands on the drums or keyboards open students up more expressively and intuitively to the sounds of making art and dancing over an art surface. Starting with performances instead of pencils, conducting, twirling, clowning, lending sounds to objects offer a wide range of moves to any art tool. Student fingers that move over a computer keyboard effortlessly and guide a mouse with the fluidity of ballet can improvise using the computer as an art instrument. Middle-school studios can start with playtime, warming up hands and bodies into a flight choreographed as freely as art.

Making Lasting and Meaningful Things

Middle-school art studios are for making real and important art. For students who want their art to have meaning and their life to matter, class is not simply about technical exercises. In the middle-school studio students want and need to know, "Why am I doing this?" Every student can find art that speaks for them and documents important events and moments in their lives. Drawing family members, documenting family holidays and gatherings, and using memorabilia or a favorite song can guide the artistic journey in personally meaningful directions.

Experiences with the Natural World

With the Internet, students view and are exposed to larger portions of their world than ever before, yet have less time and fewer opportunities to go on nature walks. Art students in middle school are led to believe that everything to be learned is on Smart Boards, so why bother to go out and search for it? However, art has always been about scouring the streets and countryside, responding to real sights, sounds, and experiences. Middle-school studios need to expand to the outside. Catching a toad, following a stream, or discovering the light on the ground is not on TV. Middle-school studios can inspire bird watching for future Audubons, finding nests to give ideas for sculpting and building, and painting from the forms of bugs and mushrooms brought to class. The palette of leaf colors collected outside just before class is the most inspiring color study. Lose the wonderment of nature, the significance of firsthand experiences, and it becomes more and more difficult to involve emotions in school studio activities.

Making Art from What's New

Middle-school studio classes can have the newspaper delivered to class. Reports of the latest in science and technology and new discoveries in all areas can be shared from newspapers. The middle-school art class can discuss all significant issues and current events, since broadening students' interest in the world is also a way to broaden their perceptions of art.

Artists have always been eager to explore the new and make it a part of their art palette. Middle-school teachers can demonstrate examples of artists who explored the new duplicating technology and used Xerox machines to make art. They can show examples of the works of Lucas Samaras, and Andy Warhol's use of the then-new Polaroid camera. iPhone art or whatever is the latest technology can be envisioned in middle-school art classes, where interest and knowledge of technology is at a peak. Media studies in an age of new media need to start early in a place where students are not necessarily specialists but are interested in all the latest in science, technology, space, gene science, or new forms of architecture and dancing. The middle-school art class has the possibilities of being the engine of a new art world, instead of just waiting and being a student of new art.

To be educated as an artist of the future, middle-school art students can practice making connections between environment and art. They can explore many contemporary phenomena such as supersized foods, oversize television screens, and room-size artworks. Students can discuss the connections between the art they find on the street such as super graphics, billboards, or graffiti, and the art presented in museums.

Teachers can work on minimizing art simply as assignments and encourage students to sort through their own interests, collections, and observations to find art ideas. Reports of what students have noticed, found exciting, and clipped out of magazines can direct the art class. A student's inspiration in scarves, tablecloths, ties, beach towels, or old aprons and handkerchiefs found at home can be encouraged to find its way into the art class. Projects in middle-school art don't have to be about defining art for students but challenging them to find it themselves. For example, they can follow paper trails by keeping business cards, clothing tags, placemats, and shopping bags that they come across during their day.

Debating Art

Today's artists are asked more than ever to explain their work, to talk about what they have created. Art in museums also appears with more explanations on the wall, more written and discussed about it. Art can be neon lettering on the wall, artists write their statements into the work, or the statements stand for the art.

There is more to talk about and debate as art classes turn to issues. Art teachers need to be prepared to offer not just art assignments and show art to students, but to discuss and debate art with students. As middle-school students hone their art skills in the studio, they need to practice expressing their ideas and views about their own art and the art they find challenging.

Middle-school debates don't have to begin with discussions of "safe art" or the masters. New art that challenges the look, media, or presentations of old art, and the very notion of what students have been presented with as art, can reframe ideas and ignite debates. Heated yet productive discussions can sharpen and recalibrate students' thinking about what makes good subjects for art.

Students can be encouraged to respond to the art world and to form an inner strength to defend the art they like. When there is not enough time for this in studio classes, the discussions can continue online as middle-school students may use web sites, create their own Twitter pages, or their own art blog. Teachers can consider ways to encourage

conversations to continue beyond the art class. Students can join student blogs sponsored by art museums, weighing in on visual art debates.

My Style

Middle schoolers enjoy browsing catalogs to decide what they like. They have private design collections that encompass many categories such as fruit slice notepads, or temporary tattoos. Students bring to school their familiarity and knowledge of many design trends, ready to set their own. Students are familiar with the latest hairstyles and like to fantasize about their version of cars, fashion, or hair by doodling over advertising catalogs and brochures. With simple materials like paper clips or produce ties, they design expressive sunglasses or innovative embellishments for the new braces on their teeth. An art class can provide students with the brash confidence to redesign the object world.

My Room

It's not unusual for preadolescents to decide to paint the walls of their bedroom purple, or to paint green patterns on their trash basket and phone. Middle schoolers are not only eager to take charge of their living environment but are interested in using their emerging design ideas to create more beautiful environments in general. An art class can become a test site and planning place for personal make-overs or for new interiors and furnishings at home, or can be a face-lift for the school or art room. Art teachers can consider ways to involve students in design projects that require design research, decisions, and the experience of creating actual transformations to existing spaces.

My City

The Manhattan skyline circa 1950 can become a source of lively conversation among middle-school urban planners, architects, and future visionaries. The photo projected on the wall over a large sheet of drawing paper can be sketched over in a planned dream work. Students inspecting a scrapbook of their parks, streets, and cities can design the future.

The challenge of art teachers is to read the papers and follow the news, to come up with actual building and renovation projects that students can take part in. Learning about plans to create an interactive exhibit of the human

brain in the local children's museum becomes an opportunity for ideas, sketches, and models. As a new children's hospital is being erected near a school, middle-school students can become part of the project by creating design suggestions for friendly and secure surroundings for patients at the future hospital. With a folder of photos, plans, and newspaper clippings, art class commissions can begin with many realistic and responsible design commissions.

My Career

Elementary students just want to be artists. Middle schoolers begin to recognize that they have many exciting choices if they want to become professional artists. The middle-school art class can be a place to elaborate and to learn about art professions via involvement in solving creative problems. Students can learn about architects, or product designers, by creating their own line of furniture, cars, and homes. Students can learn about children's book illustrators from sampling the best in the field and joining the ranks by illustrating their own books.

In the field of design, art teachers can consider what experiences would be most enjoyable and memorable for students. Middle-school students can be introduced to great designs by seeing the Kohler Museum of bathroom fixtures or the Design Store of the Museum of Modern Art. In shopping for career ideas, students can create their own design museums and show their appreciation for great art forms by curating their own shows. A student show of vintage and current paper clips can exhibit found variations on one of the most extraordinary design forms. Students can also be honorary members of design juries, selecting the top ten toys of the year, or the best sports stadiums, as they learn about prominent designers in different areas of art.

Studying Art in the Community

Few schools are located on an island, or exist without being surrounded by a wealth of talent and art opportunities in the community. It is up to the middle-school art teacher to connect their program to the community of artists and designers that are nearby. Since an art teacher in middle school represents all art professions, but is trained and often really a specialist in one, a visiting artists program is necessary in middle school art programs. To fully appreciate the workings of a design firm, an architectural practice, or a

ceramics studio, it is important that students go and see it. The art teacher might arrange brief visits or longer internships for interested students.

The art class in school can be seen as a provider of many opportunities for students to experience the arts first hand. Art is unlike some other subjects that can be taught only in theory; it is the reality of the art world that can provide a realistic view for students. Long-term interest for students can only be created by such work-study opportunities as helping out in an art gallery. There are numerous businesses in every community that are often overlooked as possible contributors to school art. Middle schoolers however would enjoy visiting a van customizing shop, or a sign and billboard design business.

Art as a business has many interesting "on the job" opportunities. Going out to estimate a job and then joining a landscape architect as they prepare plans for a client has vast educational possibilities. Helping with a store window display or coming to the site of a kitchen-remodeling project to meet with the interior designer are meaningful ways to learn about clients and their needs, to study plans and discuss choices and ideas with professionals. For middle-school students who are eager for a hands-on and realistic dimension to their schooling, there is no substitute for working with different artists.

Each community also provides a rich variety of teaching opportunities for middle-school students to share and test their art knowledge. Teaching art is about testing one's art ideas by sharing them with others. Middle-school students can teach younger children as they experience the wonders of their art and share their skills and experiences with an art-loving audience. Students who are eager to do meaningful work can discover the joys of teaching art with special populations such as the elderly, the mentally challenged, or at a children's shelter.

Art teachers can start looking for private and public arts organizations in their community and consider ways that they can couple them with school art programs. Many community arts organizations that specialize in filmmaking or ceramics have better facilities and special expertise that a one-person school art operation may not. Art teachers need to become familiar with the vast opportunities that museum education departments can offer students. At the moment museum educators are expanding their focus to include far more than elementary bus trips. They are working hard to engage older youths in hands-on museum work. Students serve on youth boards, conduct tours for younger children, and learn about the job of art preservation and restoration. From including working art

therapists in the middle-school lineup of guests, to seeing prison artists' shows, each community offers many opportunities to present a full range of art views orchestrated by the art teacher.

APPRECIATING BEAUTIFUL OBJECTS, ART, HISTORY, AND CRITICISM

Middle schoolers are verbal and can go beyond their own art to find worldly art interests. When allowed independence in an antique store, vintage clothing store, or art museum, middle-school students enjoy testing their abilities while searching for and selecting objects and artwork of their own choosing. They find pleasure in the independent search and discovery of beautiful things. Preadolescents like the freedom of being able to look anywhere and describe an interest in any object. In an art class they proudly show and talk about their favorite artwork and share their favorite stamps.

In younger children there is pure appreciation, unselfconscious hunting and gathering, and just the fun of the quest and ownership. Without issues of value or competition, this pure appreciation has hands-on gratification. Children organize an inventory such as the best in Halloween candy wrappers. This unspoiled state of collecting is difficult to maintain given the commercial pressure to collect certain Barbie dolls or the latest in Happy Meal prizes. By the time students reach middle school their areas of appreciation are narrowed and defined. Trading cards, Hello Kitty stuff, or certain perfume bottles are okay to have. An art class can support the appreciation of the unusual, and the personal. Students can look for new objects yet to be recognized, or things that tend to get lost or are headed for obsolescence, or items that are simply neglected by society. The challenge of art teachers is to encourage students to find new collections and to break new ground.

Appreciation in middle school is most interesting to students when they initiate the conversation and provide examples. Why are some pitchers collectible and admired when others are not? What makes one electric teapot a valuable gem compared to others? Students build their knowledge and expertise over objects they are interested in, recognizing that each has a rich history. They can be challenged to see how far they can look back—for example, illustrating the evolution of cups and bowls. Student presentations can define changes in toasters or fly-swatter designs that craftsmen, designers, and artists continue to transform. Preadolescents enjoy the detective work in

looking for clues, turning objects upside down for special markings and signatures, and discovering makers or origins.

Students can offer presentations on collecting old lunch boxes, show their drawings of antique pencil cases, or display samples of vintage school bags. All finds and research come with inspiring stories. Collections are about recollections. What makes finding objects and collecting so interesting are the individual stories projected on old objects that students find and can appreciate. Being able to recognize special objects without seeing them in a museum is an important statement about a young person's ability to appreciate the virtues and beauty in objects.

Middle-school students have an eye for the unusual. Student presentations have included such original themes as appreciation of ladders, featuring examples of old step stools, yacht boarding ladders, pulpit ladders, and unusual warehouse ladders. After revisiting childhood toys, one student presents a fascinating look at a ventriloquist's dummy as a unique American art. Students who share their appreciation and teach art history to others describe the journey with a great variety of interesting visuals. As a student displays his collection of old storage bins, shares his photos and drawings he made of antique rolling carts and recounts a brief shopping cart history, he is demonstrating innovative paths to teaching art in a personal way.

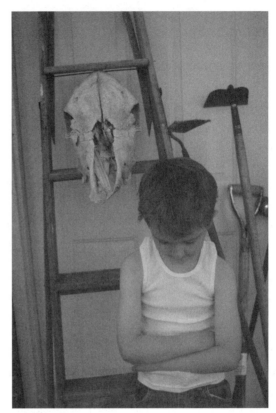

FIGURE 3.2 Middle-School Artist Sarah's Photo Series of Younger Brother: *Sam 2*

FIGURE 3.1 Middle-School Artist Sarah's Photo Series of Younger Brother: *Sam 1*

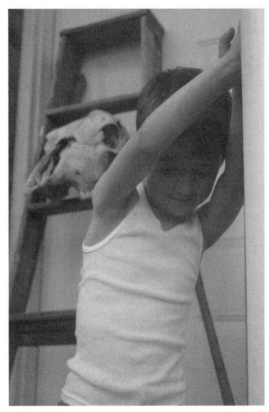

FIGURE 3.3 Middle-School Artist Sarah's Photo Series of Younger Brother: *Sam 3*

Creative Planning and Topics for Group Discussion, Activities, and Extensions

- Keep an illustrated middle-school journal reflecting on your visits to classrooms. Describe the classroom, the teaching style, the goals of the lesson and how it was implemented, the student's responses, and other things you notice. Respecting confidentiality, discuss entries from your journal with colleagues in class.

- Photograph an artist in your family or community (preferably while on the job). Bring a copy of the photo to class and be prepared to create a group display about the endless number of art careers. Discuss possibilities for having middle-schools students learn about art careers in ways that are meaningful.

We worry about what a child will become tomorrow, yet we forget that he is someone today.—Stacia Tauscher

Section Seven Preparing for High-School Art and Beyond

The middle-school art teacher receives students from elementary art rooms and in what seems like the blink of an eye, they're on to high school. Teaching art at this level is not only an awesome responsibility but one of uncertainty; what will be the future art education of each student? Some students might want to continue in high school, but they cannot schedule art because of conflicting requirements.

Instrumental music is one example of an elective that fills the small window of high-school arts opportunities. Another potential problem is that high-school art departments tend to specialize in a handful of traditional studio offerings that may not be the specialties a student wants to study. For making films, computer animation, or creating jewelry, for example, students have to be motivated to find community arts programs, internships, private instruction, or pursue their art dreams on their own.

A few decide on becoming art majors in high school, and need to be prepared for the traditional sequence of drawing, painting, and 3D courses almost like working toward a college portfolio. Without a prescribed next step, the best an art teacher in middle school can do is to develop in each student a level of comfort and confidence in art that will allow them to continue in a high-school class, or with the initiative to work on their own.

THE MIDDLE-SCHOOL ART CLUB

An important component of the middle-school art program is an art club, offered during the school day or after school. The club extends art time, allowing students to spend time with the art teacher and their chosen interest. For students who are intent on pursuing art in high school, an art club is a major opportunity to fulfill serious creative goals. Because of limited space, some art clubs require interviews, a student's written statement, or portfolio submission. If an art club does not exist, teachers have to consider the logistics of forming one in their school as an important means of high-school preparation.

THE TWO-WEEK ALTERNATIVE

Although it exists in only a small number of middle schools, the concept of students completing all "specials" or middle-school "electives" and then being able to return in the eighth-grade, before high school, to an arts area of their choice is a wonderful opportunity. For transitioning students who have decided to take high-school art, "eighth-grade arts extension" is a two-week course that can concentrate on art beyond middle school, and include many of the proposals outlined in the next sections.

TO BUY INTO ART

Art classes that prepare students to enter their high-school years are not just about making art, but making art into something that is their own. Students don't just learn to draw but find their particular art interests and media as artists (i.e. Figures 3.1–3.3). Students rave about an art or artists they like, and want to share with everyone the art

professions they find "cool." Different art centers can be set up around the art room and visiting artists can represent different art media. Before high school, students can try different art making tools and processes to find that their love is really in clay, or editing film. Before high school is a time to try everything and to learn the value of one's personal choices.

If students in middle school recognize the art that is in their future, impressions of what it feels like to make art and be in an art class become unforgettable. For students who learn that art is their refuge, the art experience is a joy, and an art class is a peaceful oasis in school life that they will seek out in high school.

TO BE WELL CONNECTED

One task of an art teacher is to be a community connector, connecting students to artists, art offerings, and opportunities in their area. It is creating enjoyable guided tours, hosting the most interesting practitioners, and being with students who may be amazed to visit a community arts program for teens who create full-length films. A visit to a stage designer's studio or climbing inside the model of an architect who creates school playgrounds can affect students more than if they were to simply work with pencils on paper.

FIGURE 3.4 Drawings from a Class Fashion Show

The period before high school is an important time for students to attend the local gallery hop and to become comfortable in entering art circles, even viewing art beyond their comfort zone. Art teachers can consider the community places and opportunities for students to visit workshops and studios where art is designed and fabricated. Art teachers needs to constantly use their connections and imaginations to find possibilities for encounters with new art and artists. Middle school is a perfect time to take advantage of the many opportunities to serve on museum youth boards, or help set up shows in an artist-run gallery. Visits may be set up at a university theater department's costume shop, or a jewelry artist can set up her table in class, as she is preparing for a crafts fair. Preparation for the next level of schooling involves introducing students to artists and art communities.

Connecting Art to Life

So that they can carry their art into high school, students need to have a sense of reality and importance to what they are doing in an art class. Art teaching has to represent artists as important contributors to society, as real people who work in the community for a living, or who devote their spare time to art. A student needs to meet, work with, and talk to artists in the community so that they may ask, "Where is my place?" Art teachers can help break down barriers between art and design, arts and crafts, fine art, high art and corporate artists, and independent craftspeople, all of whom can be role models. Middle-school students can envision themselves as photographers, museum educators or video game artists, bringing a sense of reality to their abstract notions of art and artists.

Art career explorations at the bakery, in a design firm, or in an architecture office studio can have lasting impressions. First-hand experiences from a single visit to a longer internship can be arranged. Going to high school with an art career in mind makes a difference; it provides a goal and a purpose to further studies.

I found I could say things with color and shapes that I couldn't say any other way . . . things I had no words for.
—Georgia O'Keeffe

MAKING ART ALONE

Continual support for students' art beyond the art class is an important factor in high-school preparation. Art

teachers who have a taste of what it means to struggle to make time for art can be sympathetic to what the future high-school student will need. Life doesn't get any less hectic or complicated, and the art of fitting art into one's life has no simple solutions. But teachers can offer valuable advice.

Independent art making is a project that can be initiated in any middle school. It requires art teachers to work out a long-term art project that students pursue on their own time and in their own space. It is not an assignment but a student-proposed idea, something special that they do or make on their own. The student decides on the theme and scope of the project, the materials and process, and other matters that artists consider for their work. At the end of a designated period, an exhibit celebrates these artworks that encompass the private life of the school artist.

For one such long-term project a student made an American flag, sewn on the middle-schooler's home sewing machine (he learned to sew for the occasion). The reason for assembling six months of his family's supermarket receipts was, the student explained, to show how his recently unemployed dad struggled to put food on the table, and how each receipt represents a crisis and sacrifice.

It is not one act in art teaching that can guarantee that in high-school students will fare well in making time for art, but many discussions that can help. Details of the art making habits of busy art teachers are valuable to share. These might be suggestions for drawing all the time, keeping art diaries, idea books, and when there is no time to make art, an artist can be in a planning mode, mapping out future projects. Art teachers may suggest "art pockets," showing how they may keep supplies right at hand, or designs for portable studios in a school bag or for the family car. The mad dash of high-school life can still provide available moments for art. School buses are often late; students can be ready to sketch at the bus stop, or make videos of the daily trip.

Students can also brainstorm about how they can make down time, such as watching television or listening to music, into art occasions. With ears plugged into electronic devices, students will be off to high school hypnotized by a beat or by musical dreams, finding themselves in ripe art states of mind. Restful, musical moments allow art to enter the soul. Students can build appendages to iPods and iPads for iArt.

Media controllers can inspire new commands for art making, altering art moves and actions. Moving images on a screen can alter students' views of art paper, as they learn to connect contemporary art life to new art styles. Preparation for high school involves making art part of travel, vacations, and special occasions that can fill a sketchbook or camera. Middle-school art teachers can start the habit of including

art in everything and selecting a form of media to take along. Students can begin to explore every possibility to use art to respond to events they will also encounter in high school.

TO SEE ONESELF AS AN ARTIST

To be prepared for high school, it helps if students distinguish themselves as artists. Activities such as the following can contribute to this goal. After the completion of a work of art, or putting together a series of artworks from one's portfolio, students can present an artist talk describing the intent and outcome of their effort. For an artist talk, students need an audience that is willing to participate by listening. It is also useful to enlist student videographers who can create a formal record of the event. Competence to talk about one's art is not only an important skill for the concept-based art made today, but it makes the student who is preparing for high school feel like a bona fide artist. The understanding of their art is strengthened by such a public event, and presenters learn to see themselves as the art expert, certainly when it comes to their own art. Standing before a tripod-mounted camera adds to the reality of the artist lecture and preserves a record of the event on a CD or DVD they can share and revisit. The artist talk can be followed by an on-camera interview, or a question-and-answer period played out by students.

One-person shows are an important way to send a student to high-school feeling like an artist. It is customary for the school art teacher to select student works for hallway displays and art contests. It is more important for young artists on the way to high school to stage their own exhibits. Selecting a body of work for solo shows, creating invitations and being celebrated by "fans" are important promotions from the rank of student to artist. With several shows throughout the school, or even in the community, to one's credit, the young artist moves on to high school by drafting an earned artist's résumé. At the end of the middle-school years, art teachers can insure that their young artists have a record of shows and evidence of being an artist such as public notices of exhibits, a student's own web site, and CDs of art talks to take to high school.

Cleaning your house while your kids are still growing up is like shoveling the walk before it stops snowing.—Phyllis Diller

DESIGNING AND CONSTRUCTING PERSONAL ART MAKING PLACES

All kidding aside, preparation for high school might include building a permanent place for art in the home.

Middle-school students can design and create their own home studios. To have a basement to make art is an important investment in one's art future. As one high-school student points out, "Parents stress out their kids on schoolwork, so that their kids will have a future. But what parents don't know is that their kids need some time to play and explore." Designating a place for art, a personal art making space, even a single table with inviting tools and supplies, can fuel the future artist. Having a studio in one's future insures that there is always a place for art, even when a student is not taking an art class.

An art studio may house many smaller works, art in progress, or just notes for ideas, but there is an important ongoing sense of something next, a future artwork or a dream of one to follow. As the noise and distractions of school life get louder, in high-school students yearn for private time and hard-to-find places like a studio, where they can shape plans for the future. Art teachers often dream of building home additions for a studio of their dreams. Perhaps this dream needs to be shaped much earlier, even before high school.

Specialty studios can be very important for serious pursuits in a specialty medium. A darkroom in the home, a film-editing studio, a pottery wheel in the basement all impose the same kind of discipline that a home exercise room does. Future art teachers can encourage designated art spaces and help with advice in furnishing them. There are lasting benefits to announcing, I am an artist in my own studio. To cope with the upcoming high-school pressures, there is the promise of one's own space. Having established a place to go to, a place not ruled by bells, schedules, and assignments; to enjoy being alone and making things by oneself, is the best investment in the next step of schooling.

Middle-school art class can be part of building an early foundation for high-school art, having staked out a place where art interests can be sustained. A student who created a stained-glass studio in his laundry room says, "While other people like to sit and talk after school, I like to hang out in my glass studio. Other friends stop over and look at my work. They like to help, and often join in to help complete a project." Some high-school students begin to feel that if they are not doing homework, they are wasting time, but their interest in beautiful things serves as a reminder that they're not. A studio owner says it perfectly, "What others call wasting time is the most meaningful part of our day." Making room for art before high school is not wasting time but creating opportunities and investing in students.

Much education today is monumentally ineffective. All too often we are giving young people cut flowers when we should be teaching them to grow their own plants.—John W. Gardner

ACTING ON INDIVIDUAL ART INTERESTS

The art experiences offered in middle school have to remain as an art compass for students going to high-school campuses, where students can get physically lost and uncertain of their individuality. In the urgency to do everything for teachers, for college, and the future, students repeatedly overlook the present, ignoring, postponing, or hiding their creative thoughts. Students have to be prepared not to neglect their interests and ideas even if they have to be pursued on their own.

During the course of middle school, students can be weaned away from total dependence on the teacher's art lessons, moving toward an independent art life in high school. Students can be asked to take notes and bring to class not only their object and material collections but also notes on feelings and observations, and unique ideas that need further art exploration. The most memorable school art is always based on something a young artist cares about, notices and really wants to do, such as middle-school artist Sarah who communicates the importance of her younger brother in her life via photography as seen in Figures 3.1—3.3. When high-school studies turn to copying out of books already written, knowledge already found, students have already experienced art as something they discovered and that is important to them.

While universities offer a smattering of independent study opportunities, for students unaccustomed to an

FIGURE 3.5 Drawings from Teen Car Designs

independent style of learning, it comes late. Independent study is important as students head to high school. Middle-school independent study programs can use contracts, or specially designed forms that invite sketches and models to narrow down and clarify what the student wants to accomplish. Independent artistic preparation is important for future studies that become even more academically specialized and information-driven in high school.

Creative Planning and Topics for Group Discussion, Activities, and Extensions

- Study the outline of this chapter and consider what you could add or topics that you would change if you wrote your own book. Gather your middle-school writings and thoughts to assemble into a book. Life as a middle-school art teacher will be very busy and it will be difficult to be an author of books, so start now. Keep writing and adding your experiences and ideas as you enter the profession. Nothing is more complimentary to the authors, than to inspire art teachers to write their own books.

Reference Books and Resources to Read, Look At, and Share With Students

It is often said that middle-school students are a mystery, or difficult to understand. That might not be true, but learning about preadolescents (10–14) needs to be approached from multiple perspectives. The books below represent the views of art educators, artists, psychologists, parents, and words and pictures by the students themselves. As future middle-school art teachers you should not be afraid or hesitate to look closely at art education resources and all other sources to build your library on the subject. This is not just a list of books to underline for a report, study, or a test, but is a suggestion to build your own library at home, in your studio, or your classroom. These books are not just information; not only do they hold useful ideas for middle-school teaching, but they are books to return to. Most are enjoyable since it is fun to read about the kids and their art. Many of the books can also be taken to class to share and start a meaningful discussion about middle-school art or about being a middle schooler.

Barrett, Terry. *Talking About Student Art*. Worchester, MA: Davis Publications, 1977.

Bayles, David and Ted Orland. *Art & Fear: Observation on the Perils (and Rewards) of ARTMAKING*. Santa Cruz, CA: The Image Continuum, 1993.

Capacchione, Lucia. *The Creative Journal for Children: A Guide for Parents, Teachers, and Counselors*. Boston, MA: Shambhala Publications, Inc. 1982.

Clandinin, D. Jean, Annie Davies, Pat Hogan, and Barbara Kennard (eds.). *Learning to Teach, Teaching to Learn: Stories of Collaboration in Teacher Education*. New York: Teachers College Press, 1993.

Coleman, John C. and Leo B. Hendry. *The Nature of Adolescence*. Third Edition. New York: Routledge, 1980.

Congdon, Kristin G., Doug Blandy, and Paul E. Bolin. *Histories of Community-Based Art Education*. Reston, VA: National Art Education Association, 2001.

Diepeveen, Leonard and Timothy Van Laar. *Art With a Difference: Looking at Difficult and Unfamiliar Art*. Mountain View, CA: Mayfield Publishing Company, 2001.

Hickman, Richard (ed.). *Art Education 11–18: Meaning, Purpose and Direction*. New York: Continuum, 2000.

Kroger, Jane. *Identity in Adolescence*. New York: Routledge, 1997.

Michael, John A. *Art and Adolescence: Teaching Art at the Secondary Level*. New York: Teachers College Press, 1983.

Portchmouth, John. *Secondary School Art*. New York: Van Nostrand Reinhold Company, 1971.

Wexler, David B. *The Adolescent Self*. New York: W. W. Norton & Company, 1991.

Classroom Organization and Assessment

Section One Art Room Design

Albert Einstein said, "There are only two ways to live your life; one is as though nothing is a miracle and the other is as though everything is." The art room can be organized with this thought in mind. Art teachers have the privilege of setting the stage for daily miracles, or magic. What might seem common to the adult, such as glitter, ribbons, glue, clay, or dress-up items, will most certainly seem remarkable to young artists. Magic markers may have lost their magic for some, but the magic is still very much alive for young art students. Daily art explorations will be new and fresh to young people, and those experiences should be viewed as though each and every one can be magical. Gathering supplies and organizing the art room in such a way that will make these miraculous moments possible is an ongoing effort, which can be a team effort, and an enjoyable one at that. Some reflection and pre-planning concerning art room organization can go a long way in helping teachers of art in elementary and middle schools.

THE ART ROOM AS A CANVAS

The art room is the teacher's canvas on which ideas are showcased, the curious are challenged, and responses are invited. Art rooms should not be ordinary rooms. They ought to be full of color, collections, images, supplies, tools, and visuals that will entice and motivate young artists to imagine and think creatively. Gone are the days when the teacher is the only one who gets to use the jars full of tempting tempera paint. In today's art classes, the students are the players, and teachers help set the stage.

Just as a successful painting involves inspiration, planning, creative decisions, and artistic effort, so it is with the art room—the art teacher's canvas. Many college education classes focus on various areas in the field, such as human development and educational psychology, but it is important to give thought to how one goes about organizing and structuring the classroom, or in this case, the space for making, investigating, experimenting, and thinking about art.

Likewise, adequate time is required to effectively develop a painting, and so it is with the process of developing and organizing the art room. The process does not happen overnight, but rather over a span of time, probably the entire length of one's teaching career. Similarly, as with a painting, it is important to step back, examine, reflect, and take a good look at the art room as a canvas. Reflect, question, and make note of what is working. What might be added? What might be altered or restructured?

DESIGNING ART ROOMS TO INSPIRE ART LESSONS

First, visit as many art rooms as possible. As Harry Wong (2009) suggests, rather than reinventing the wheel, if you see something that is working well, try it out, "borrow" the idea! In *First Days of School*, Wong (2009) maintains that the greatest compliment for a teacher is to have someone copy an idea. Make the most of pre-teaching hours spent in the field. Become an investigator, thoroughly analyzing each art room visited.

Be mindful of details. How are supplies organized? What type of shelves and storage containers are used? What is visible, and what is stored or locked away and why? How are containers/items labeled? Pay attention as teachers open

cabinets, closets, and drawers. Where is the paper cutter situated? Is it positioned for teacher access while being out of reach of curious young people's hands? Where is the kiln? How has the teacher managed to have adequate access while ensuring that inquisitive youngsters will not accidentally touch or get burned by this oven that reaches dangerously high temperatures? Are other potentially dangerous items stored out of young artists' immediate reach, and how so? How are students interacting with and/or retrieving materials, tools, and resources? Consider how materials, such as easily tangled yarn, can be arranged, stored, and made easily accessible to young artists who will be shopping for art supplies in your room. Reflect on and make note of that which makes sense and works best.

On the other hand, and equally important, ask yourself, "What does not make sense, and what does not seem to work?" Take notice of all aspects during observations, including that which might seem stale, ineffective, or in need of restructuring. What arrangement could work better? What changes might result in a more user-friendly, inspirational, and magical learning environment? What freedoms might be afforded to students to help them to be more independent and to improve their creative experience? While observing in other classrooms, for example, it might be noticed that the simple act of obtaining a pencil is overly time-consuming and cumbersome or that students have so little freedom to act on what they need that it seems to be a barrier to the creative process. Decide what you might do differently to make the art experience more effective for your future students.

Make note of these observations and reflections. File them away for the exciting day when you will design, organize, and stock your own art room. As another example, one future art teacher might note during an art room visit that a long potato chip can is observed to be the perfect size for storing and carrying rulers or colored pencils—it is portable to take out doors and easy to distribute to various groups of artists in and around the room. This person might decide to start saving cans. However, in a different observation, if it is noted that a teacher spends an extraordinary amount of art time distributing and collecting drawing pencils sorted by class in long potato chip cans with labels (so Ms. Jones's class does not use Ms. Smith's classes' materials), the observer would clearly file this away as a practice that would not be wise to copy. Keeping art supplies separated in such a manner serves no purpose and is a waste of precious art time.

In another example, young artists are observed spending 10 minutes or more with their hands up in the air, waiting for the teacher to grant them permission to approach the pencil sharpener. Ask yourself some important questions. What purpose does this serve? Is this practice detrimental to, or aligned with art program goals? Would you allow this in your room? Hopefully not. Once identified as such, how would you correct problems that you notice? The art room and every object and practice within it should support, motivate, and inspire art students, and not hinder them or the creative process.

REFLECT, REVISE, AND REPEAT

Careful observations and trial and error, coupled with a healthy dose of reflection, can go a long way in helping to create an art room that is conducive to learning. If you note a constant concern that students will spill ink on the carpet, get rid of the carpet. (Tile or linoleum floors are best for art making spaces, and area rugs are inexpensive, easily replaced, and can add extra color and comfort.) If it is noted that water containers topple over too frequently, they are probably top-heavy and/or too tall. Find wide-bottom, short, plastic (not glass) water containers for young artists (16-ounce butter bowls are perfect when using watercolor brushes, or a sleeve of new 32-ounce round containers, easily purchased from the local deli, when using longer-handled brushes).

If students' drawings are inspired by your flea-market finds, keep them alive by seeking additional unique items. Before long, young people will begin bringing in items to add to the community art supply pool and even starting their own collections! If students spend too much time in line at the pencil sharpener, get additional sharpeners, and/or have a student or parent volunteer to help pre-sharpen pencils before/after classes. Is art time too precious to spend standing in line at the pencil sharpener? The answer is absolutely! Is the student wasting time by waving his hand and waiting for permission to approach the pencil sharpener? Again, the answer is yes, and once such a problem is identified, the solution is simple.

Does it make sense to store the paint, water containers, paintbrushes, and paper towels near the sink? Yes, absolutely. Faithful reflection on teaching will reveal practices that are working, as well as those that, if altered, would better serve the students. In other words, the effective teacher of art should keep three steps in mind: reflect, revise, and repeat.

STUDIO PERFORMANCE SPACE FOR YOUNG ARTISTS' ACTION AND INTERACTION

While the floor covering, size of the art room, and available furniture will vary from school to school, tables (rather than individual desks) are an ideal primary flat work space for art activities. At times, the art teacher might also move the furniture out of the way and utilize the best flat surface that money can buy—the floor! In the absence of tables in a new art room, individual desks can be pushed together to create small groupings or student communities until tables can be found.

Furniture can be re-arranged as needed for various lessons. A long row of chairs can temporarily play the role of a train, ready to take eager young passengers to an imaginary destination where a unique type of art will be experienced. The paper-covered under-side of the tables pushed together might serve as a long cave to which young explorers might travel back in time to visit and draw upon the walls as did their ancestors long ago.

A common table arrangement is the "horse-shoe" or "U" shape, which offers an opening that can be effectively used as a space for students to perform and/or show work and for teachers to also demonstrate or perform. This creates a community where the teacher is the facilitator, one where the teacher moves around and guides, encourages, and nurtures. It enhances the students' ability to have creative discussions, bounce ideas off one another, view demonstrations and performances, etc.

Some students, especially younger/shorter individuals, might be more comfortable standing at tables or sitting on the floor. In an organized art room, with the teacher serving as the "guide on the side," an art class can run smoothly with some students sitting in seats, some standing, and others sitting on the floor. Too much freedom can seem chaotic and hinder creativity. Too much structure can have a negative effect. The goal of the effective art teacher is to find the perfect balance, to allow action and interaction, to allow students to experiment, practice, and present ideas—a handy life skill on many levels!

ART ROOMS THAT INVITE SHOPPING, CHOICES, AND THINKING

The art room is a place where young artists are free to create, communicate, and actively investigate. Some supplies and artifacts should be stored away for when needed, so that they can be brought out or "unveiled" to renew interest and intrigue and invite curiosity. However, not everything should be hidden. Supplies that are used often should be visible and easily accessible. A wide variety of supplies that will enhance creative choices and individuality should also be easily accessible and visible to young hands and eyes. Before long, students will be familiar with the space and how they can utilize, move through, and interact with it.

Again, Harry Wong (2009) offers fabulous advice for effectively utilizing the first days of school, some of which can be helpful to the beginning art teacher. A brief teacher-guided introductory tour of the special art room space on the first days of school is a must. In the art room, students should become familiar with supplies that will be commonly used and where they are located, which spaces are okay to visit without teacher permission (i.e. pencil sharpener, paper shelf, sink, unique items for reference, embellishment, and brainstorming), and which spaces are off limits to students (i.e. paper cutter, kiln, teacher's desk drawers). In such a space, students must be free to make choices, within reason, without having to ask for permission.

Time should be invested at the beginning of the school year, teaching and assuring students that they will have the freedom to make certain decisions in art class. If a piece of paper is needed, or extra paint is called for, or suddenly, a hole-punch is required, students will soon learn that they can attend to these things on their own and that indeed the teacher has given them license to do so. A few reminders from the teacher at the beginning of the year will go a long way to help the art classroom be a magical place, while making the most of the allotted time.

By allowing student choice and freedoms, such as those previously mentioned, teachers save time (resulting in added art time for students) and also send the very important message to students that *their choices are valued.* This improves self-concepts and increases confidence levels, which are characteristics that are directly related to important art and life skills.

Not only should students be permitted to retrieve their own materials when possible, but art materials can be organized, stored, and displayed in such a way that students might shop for unique materials that might serve their purpose.

In their efforts to be helpful, new teachers might mistakenly dictate materials that will be used by each student in a sculpture, for example, but in doing so, much of the "magic" is missing from such an experience. Permitting students to have a hand in selecting materials, whenever

possible, multiplies the possibilities for high levels of creativity.

In a lesson, such as mono-printing, where the "sky-is-the-limit" in terms of supply/tool options, the freedom can be both a pro and a con, depending on the situation. Without ever being given the opportunity to make choices, a new student might be overwhelmed with the sudden freedom, and this could inhibit success with the art experience. Decision-making skills can be taught only by allowing students to make decisions. If the teacher allows and plans for them, students will feel confident and comfortable with creative and critical thinking.

This is crucial. Expression, one of the many purposes of art, occurs on the part of the students when they are given opportunities to communicate via art, think, decide, select, choose, and shop for their own ideas and materials. Given possible constraints such as schedules, space, and budget, the art teacher must maintain some sense of order, and it is clear that some students will require more time and reminders than others as they become accustomed to having the freedom to think and value their own decisions in school. The teacher will help encourage and guide as students become confident with their creative thoughts and actions. Otherwise, there would be no need for the art teacher.

For the certified art teacher, a 60-minute art lesson, once per week, for example, will require pre-planning, organizing, and facilitation. Making 1,000 items available for a sculpture project would most likely be overwhelming for young artists, but an array of plastic containers and found objects that offer choices is possible.

Likewise, mono-prints will lack pizzazz if every student uses the same slice of carved potato, paint color, and paper. In contrast, individuality is invited in an experience where the teacher makes available trays with a variety of items from which students may choose (potato masher, rubber shoe bottom, wheels of a toy truck, plastic lid, fork, halved onion, lemon, ear of corn, toy blocks, wooden shapes, corrugated cardboard, etc.) and when students are then encouraged to bring in their own printing objects. The teacher must allow time for the students to think, ponder, try out, experiment, analyze, reflect, revise, repeat, make mistakes, and have genuine successes that they can claim and own, and of which they can be proud.

Cookie-cutter art lessons, in which the teacher makes all of the decisions, will prevent students from having any ownership in the process, essentially rendering the students useless. The art experience is enhanced when students make choices. Important art making and life skills are learned when students are permitted to imagine and solve problems in the art class. Remember, students will be better thinkers and decision makers if they are consistently engaged in opportunities that involve thinking and decision making.

PLANNING FOR PRIVACY IN ART MAKING

In all honesty, teachers would not enjoy their work environment quite as much with someone constantly looking over their shoulder, and neither do the students. Likewise, though group or committee work often leads to positive results, some tasks are better tackled by only one person. In both cases, the same is true for the creative process. Elementary- and middle-school art rooms should provide adequate space for students to work in small groups, while also accommodating individual work space as well. Sometimes, students want and/or need to work alone. This should be honored.

Without planning, on the part of the teacher, students will often create their own, personal, individual "cubicles" in which to work. Such spaces are often easily constructed by impromptu openings of hard-back books. When stood upright on the table or desk, they essentially create a V-shaped area in which the student can work in private. At times, it is comforting to be able to communicate via undisturbed drawing and/or writing. Some people, young and old, even find the act to be therapeutic. Students often create such a space with a book on their desk in this way, behind which they seek the private moment to temporarily work undisturbed. In such a case, the only action required of the teacher is to "not" act; just let it happen.

A private or personal work space can also exist in a room by simply allowing the student to physically move from an occupied table to a less crowded area of the room. Boxes can be turned sideways to create instant cubicle spaces. It would not be wise to insist that all students work in this manner, but it makes sense to honor student's privacy in times when the easily granted wish will lead to more effective communications and creations.

METHODS OF ORGANIZATION AND STORAGE, AND THE ROLE OF VOLUNTEERS

In order to accommodate student artists as they shop for tools and supplies in the art room, it is important for

materials to be visible and easy to find and that they be stored at a level where students can reach them. Clear boxes are ideal for helping students to identify the contents. Tools/supplies that are frequently used (crayons, glue, scissors, markers, pencils, rulers, hole-punches, etc.) can be accessed with greater ease if stored in containers without lids.

Discount stores have aisles full of unique storage containers. Restaurant-quality disposable carry-out containers, shoe boxes, oatmeal containers, restaurant-sized pickle buckets, and many other containers that would otherwise spend their last days wasting away in landfills, can be really valuable in the art room and are often inexpensive or free. Labels help. Stackable is good. Transparent is nice. Various sizes are needed to accommodate an assortment of materials. Most-often-used materials on waist-high shelves better serve our shorter, younger customers as they shop, search, and reach for art materials.

Experienced teachers know two secrets that will now be revealed. First, students love to help. Second, if a kind person shows up at the art room door with arms full of possible art materials, such as beaded car mats, and asks, "Would you like to have these?" the immediate answer should always be "Yes," even if the donated item's potential usefulness to the art room is not apparent at first. Later, the 101 ways that the donation can be used will be discovered (usually by students). Art room student helpers can dismantle and prepare such free gifts for art room use with amazing speed, and they will be more than happy that the teacher expressed confidence in them by selecting them to assist that day. There are no laws against sharing with students such duties as washing tables, rolling balls of yarn, or cutting beads from donated car mats. In fact, such experiences will be enjoyable, useful, and even educational to students.

Many parents and members of the community would love to volunteer in the art room; often, they need only be asked. A sign-up sheet displayed by the classroom door during open house is a good way to recruit volunteers. A letter sent home, with a volunteer form at the bottom to cut off and return to school, will also drum up some help in the art room.

A phenomenon (about which many college methods courses might not teach) is that often, the lower the age of the student group, the higher the parental enthusiasm and eagerness to volunteer. This is valuable information for the elementary art teachers who will make sure that the parent letters and/or newsletters make it home in backpacks of younger students.

Communications via art newsletter and/or web site are also good tools for announcing specific needs (i.e. help needed with the annual art fair, rotating an exhibit, cutting paper, helping carve pumpkins, stitchery needle threading and knot tying, filling glue bottles, balling and organizing yarn, unpacking supplies, or supervising hot irons or glue guns, etc.). Some parents even prefer to receive communications via text messages and will gladly agree to have their cellular phone numbers added to the lists of the children's teachers. Message delivery is easy via text messaging. Calling all parents: *"FYI IDK how, but we r in need of black yarn again! Ud think the kids are eating it :) LOL! That's all Atm Gtg Ttyl!"* Never fear, students will gladly translate the meaning for any parent who has fallen behind with current text language (Translation: For your information. I do not know how, but we are in need of black yarn again! You would think that the kids are eating it—insert smiley face—Laugh out loud! That is all at the moment. I've got to go. Talk to you later!). All communications, regardless of the venue, will help the teacher to be more organized, efficient, and prepared, which will have a positive impact on student success.

PRESERVING AND SHIPPING ART HOME

A 9"x12" drawing is easier to send home with students than an architectural structure made of icing, graham crackers, cereal, and candies, but both artworks are important to their creators and, as such, should be valued by teachers. The role of the art teacher includes the responsibility of teaching students to value, transport, store, and care for art.

Teachers can help students to be successful in reaching their homes with the artwork intact, as well as teaching ways that young people might display and store artwork once it is at home. Art teachers must be mindful that each lesson will require a bit of thought regarding how the artwork will accompany the students as they leave school each day, and the young artist's work needs to be stored safely until it goes home with its creator. Consider utilizing window seals/ledges, floors, drying racks, lawn, clothes lines, school fences, etc.

Likewise, with some preplanning on the teacher's part, artwork will fare better during the ride home if it is appropriately stored. A damp tie-dye shirt can be sent home in a recycled plastic grocery bag. A fired clay piece might be better off wrapped in newspaper, paper towels, shredded paper, or recycled bubble wrap before going into the back-

pack. A ginger-bread house or sculpture might be happy to ride home in a shoe box or recycled fast-food container.

Two-dimensional pieces can be sent home on a regular basis, and/or kept in cubbies or handmade portfolios (manufactured or handmade from cardboard and designed by students). A portfolio can also be created for home storage.

Parents and students might be thrilled to see a special delivery arrive in the mail—postcard or business envelope sized artworks can be mailed home to highlight young artist's work and/or possibly draw attention to an upcoming event. Designing the package, envelope, box, and/or shipping label could be an interesting and valuable art experience involving graphic design.

Images and/or announcements can also be electronically "shipped" home. This free and simple manner of sharing fabulous images with the click of a computer button is a deal too good to pass up. With the aid of an inexpensive digital camera, artwork can not only be electronically shared, but it can also be preserved and archived by the students and/or teacher. Students can sit at the computer and visit the collections of artworks from all over the world, but they can also visit their own artworks, as well as those of fellow classmates in this manner. Paying special attention to art by preparing it for an exhibition via the World Wide Web or for the creation of an in-house electronic gallery reinforces the value of art for all onlookers, both young and old.

Creative Planning and Topics for Group Discussion, Activities, and Extensions

- Visit at least one elementary art room. Draw a detailed diagram of the room, paying special attention to the furniture, sink area, posted rules, tables/desks, storage spaces, floor spaces, light (natural and artificial), flat work space, exhibition space for two- and three-dimensional work, white/chalk boards, drying space, teacher desk, art books and art resources, basic materials (i.e. paper, pencils, scissors, glue) and how/where they are stored, items suspended from the ceiling, other materials and tools and where/how they are stored/organized, spaces for group work, restroom location in relation to the art room, exits, visuals/displays, location of any potentially dangerous materials/tools (i.e. liquid paper, bleach, sharp cutting tools, kiln, paper cutter), hall space near the room, etc.

- Describe and reflect on the completed diagram from the item above. Discuss what seems to work and why? What might you do differently in your own room, and why? What did you learn from the visit? Examine various types of storage containers in classrooms, art rooms, discount stores, and in your home and surrounding community. Bring a unique storage container and idea to class. Be prepared to share ideas.

- Visit at least one elementary- or middle-school art room for at least three art classes, paying close attention to how students move throughout the room (obtaining supplies, watching teacher or peer demonstrations, disposing of trash, sharpening pencils, visiting the sink area, art making, and such). Describe, and then reflect on, your observations. What worked well and why? What might you try differently?

- What is the favorite art lesson you recall from personal past experiences? From beginning to end, what role did *you* play in the process? What decisions were made by the teacher? What decisions were made by you, the artist? As a future teacher, would you change the lesson in any way? Explain.

Section Two Art Supplies

Similar to the food orders for the school cafeteria, art supplies are often referred to as "consumable," since they, unlike books, are gone once used, and they must be replenished. Therefore, the teacher of art must plan, order, secure, organize and manage hundreds, maybe thousands, of consumable art supplies (glue, paper, paint, etc.) and quasi-consumable art tools (paintbrushes, brayers, etc.) that eventually wear out or break and have to be replaced. While school lunches might not always be that exciting to kids, art supplies will be!

EXPANDING THE NOTION OF WHAT IS AN ART SUPPLY

Finger "painting" occurs with children long before the school bell rings on the first day of kindergarten. Initial drawings appear on babies' high-chair trays as soon as they are old enough to sit and scribble in their plum puree, compliments of Gerber. Infants love the feeling of squishing, smearing, patting, and painting in pudding or baby food. They naturally create two-dimensional mini-masterpieces on the dinner plate and three-dimensional sculptures in mashed potatoes or with popcorn until gobbled up, although these artistic explorations sometimes go unrecognized as such.

As infants grow into toddlers, it still takes no parental prompting for young people to max out any creativity meter during mealtime where the child nibbles on meatball cannonballs, oatmeal quicksand, green bean log cabins, cheese cube igloos, spaghetti serpents, or cracker trains, washed down by a rainbow of magic, juicy potions.

As children grow older, they continue their natural creative communication and artistic investigations. They create, with art supplies, such as crayons, paper, clay, and paint (if given the opportunity), but they also continue to exert creative license via play.

Toy soldiers and tanks are arranged in elaborate compositions. Toy blocks are sculpted into sophisticated cityscapes. Toy dolls, dump trucks, and cars are carefully placed into intricate arrangements for upcoming special events. Children's imaginations naturally run wild and have no problem traveling while engaged in high gear.

Adolescents remain interested in games and play as they become increasingly interested in socializing, fairness, group activities, etc. These natural interests and developments can be embraced in the art room, as art teachers can utilize such objects for art and inspiration in the classroom.

Art rooms should be full of visual nourishment for young creative eyes and minds. Shelf tops can be lined with interesting objects, such as sculptural musical instruments, a fascinating vintage bicycle, uniquely shaped vases, well-traveled sticker-covered suitcases, flea-market finds, basement riches, or junk drawer treasures.

The ceiling is the perfect place to suspend more visual bait, perhaps from fishing lines, such as colorful kites, Japanese lanterns, mobiles, old record albums, inflatable sculptures, or flying machines. The apron that might be used for dress-up can double as a canvas in the art room. The material or fabric on many styles of shoes can also be a beautiful three-dimensional canvas for painting.

Consider other non-traditional painting surfaces, such as light switch plates, coffee mugs, lampshades, wooden stools/chairs, clocks, mirror or picture frames, terra cotta pots, etc. The contemporary fast-food kids' meal toys, that initially inspired children while finishing their meals, can be recycled in the art room—given new life in still-life or gesture drawings, ready-made sculptures, or installations.

STUDENT INTERESTS

Just as adults are apt to be more engaged if they are personally interested in an activity, the same applies to young artists. Children who are "crazy" about cars are likely to be more motivated or inspired by the new box of toy vehicles that the teacher has brought in, rather than the dusty artificial flower arrangement that has been in the same corner for forty years. Thus, if the curriculum is structured, as previously mentioned, to encourage individuality, choices, and decision making on the part of the student, then the art program will be best served when keeping students' interests in mind.

Are students' interests easily discovered? Yes, absolutely! Just ask them. Pay attention to cartoons, comic books, what's new in the toy department? Talk to students. Listen to students. Pay close attention. Take notes. Do these things and all will be revealed.

Many years ago, when the Teenage Mutant Ninja Turtles came onto the scene, almost all art teachers (who were paying attention to children) jumped at the chance to make

connections to these student interests. Guess why art teachers really loved this particular craze? The fictional team members of anthropomorphic turtles were named after four Renaissance artists: Leonardo, Michelangelo, Donatello, and Raphael!

Continuing with this example as it relates to art materials, it should be noted that Salvation Army, Goodwill, and thrift store shelves were suddenly FULL of Ninja Turtle figures waiting to appear in art rooms via artistic compositions, drawings, and paintings—and they were practically free! Ninja Turtle "art materials" and items galore were patiently waiting at every rummage sale, longing to be collected! Mutant mania ran rampant, and Turtle items were plentiful with posters, mugs, action figures, boxer shorts, T-shirts, socks, lunch boxes, shirts, bumper stickers, and anything imaginable hosting this theme that could be used by young people in art class. Today, turtles have taken a back seat to other fads and fantastic figures. Not sure what kids love these days? Just ask them.

Toy Stores and Pop Culture

Naturally, all humans who are more interested in something will pay closer attention to that particular thing. This also applies to elementary- and middle-school students in art class. How does the art teacher know where children's interests lie?

Visit the toy store. Carefully examine each aisle. Visit the school library. Interview the students. Watch some of the television channels that children watch and play some of the games that they play. The easiest way to find out about students' interests is simply to listen to their conversations.

Visiting a toy store and stocking up on all of the latest toys and games is not what is being recommended here. However, it is a good place to do research and to learn what motivates young artists. Once the research is complete, the teacher can find the same type of items at garage sales, flea markets, and thrift stores (as outlined above).

ART SUPPLIES AND ARTISTIC PLANNING

Some students may be so hungry for visual art experiences that a simple pencil and paper drawing can send their creative souls reeling! Planning for a wealth of art experiences is of the utmost importance, and a variety of art materials and tools can truly enhance learning.

Though this list is not exhaustive, here are some items that will be useful in teaching elementary- and middle-grade art: drawing pencils, colored pencils, crayons, watercolor paint, tempera paint, plastic paint palettes, various sizes of paintbrushes, construction paper, chalk pastels, paint palettes, oil pastels, good scissors, rulers, hole-punches, art tissue, clay, water-based printing ink, brayers, flat cafeteria-style trays, markers, yarn, scratchboard, canvas, burlap, stitchery needles, colorful age-appropriate magazines, drawing paper, wide-bottomed plastic bowls, fabric dye, buttons, ribbons, glitter, etc.

It is important to plan ahead and maintain a well-stocked art room and to gather materials in advance. An elementary art teacher in a school with 600 students can easily gather 1,200 items, for example, by simply sending a letter home to parents on the first day of school, such as that in Figure 4.1.

For art teachers, the letter should introduce the teacher and the program to the parents/caregivers. It should be positive and might make mention of the vital role that art education plays in the curriculum and in the lives of young people. This is also a good opportunity to make parents aware of what items are needed and welcome in the art room.

Classroom generalist teachers should offer daily art experiences. In most cases, they will have one self-contained classroom and, thus, will send a letter home with only their students. The result of asking for only five supplies per student for a class of 30 students will result in 150 art supplies, which will augment the school budget purchases and more than enhance art making opportunities for the year.

In the sample parent letter (Figure 4.1), the art teacher would ask each student to jot down two art items from a master list (Table 4.1). Two supplies per child in a school with 600 students will result in 1,200 supplemental art supplies for the art room! It is not necessary to use valuable teacher time tracking who brings in items, since students should not be penalized for not being able to afford or bring materials into the classroom. Consider creating a list of art materials for the beginning of the school year, such as seen in Table 4.1.

More specifically, for an art teacher with 30 classes per week, for example, this list could be divided so that each class brings in around two items. If only six bottles of liquid starch are needed (for paper mache), then only ask six students to each bring one bottle. If you predict the possible need for 60 skeins of yarn, have two classes bring two skeins per student, etc. Yes, this seems like common sense,

however, teachers often complain about the lack of budget, lack of supplies, or having to often spend their own personal money, when such a simple action can help address these issues.

These letters and reminders can also be posted on the school web site and/or ride home with students later in the month with a list of other supplies that could be useful in the art room. Make note of the sample master list of supplemental art materials that can be delivered to the art room throughout the year (see Table 4.2), which could be sent home to all parents near the beginning of the school year and again as a reminder mid-year, as well as posted on the school web site, art program web site, near the faculty mailboxes, and on any information boards in the school.

Welcome Back!!! ART ROOM News . . . August

Art Supplies Needed: Please send to art class the two items listed below. The supplies will be put into a community pool to be shared by the entire school population, so there is no need to mark the supplies with your child's name.

<u>One 4 oz. bottle of white school glue (with ribbed lid)</u>

<u>One skein of yarn (any color)</u>

Art is often messy: Be sure to send your child in play clothes, and/or with clothing that you don't mind getting messy. Supplies used in the program are always non-toxic, but some do stain (paint, ink, dye). Though the school curriculum is well-rounded and most likely all students will participate in art activities *every day*, your child's scheduled art class with the certified art teacher (when they will frequently get messy) is on the following day(s):

FIGURE 4.1 Sample Art Teacher Supply Request Letter for Parents

Table 4.1
Sample Master List of Art Materials (from which the teacher asks each student to bring two items to be donated to the art room community pool)

Bottle of liquid starch	Bag of un-popped popcorn
Bag or box of dry pasta	Skein of yarn (any color)
Bag of beans, any color or shape	Bottle of white school glue (ribbed lid)
Box of washable markers (any color)	Box of watercolor pencils
Box of colored pencils	Box of watercolor paint
Box of pencils	Protractor
Bag or package of erasers	Ruler
Box of tissue	Roll of paper towels
Container of pre-mixed white icing	Box of food coloring
Box of fabric dye	Package of permanent markers
Good school scissors (i.e. Fiskars)	Box of oil pastels
Box of chalk pastels	Package of pipe cleaners
Duct tape (any color)	Bottle of clear dish soap
Bag of beads	Plastic baggies
Box of waxed paper	Package of card stock paper (any color)
Package of printer paper (any color)	Package of Styrofoam plates
Box of craft sticks	Box of straws
Box of toothpicks	Box of wet wipes

Table 4.2
Sample Supplemental Art Materials List (from which donated items are invited year-round via letter, newsletter, web site, school mailings/announcements)

Scrap yarn	Extra buttons
Fine wire (pipe cleaners, bread ties)	Empty coffee cans
Plastic bowls (clean)	Wet wipes
Tissue boxes	Wooden beads from car mats
Plastic, glass, or ceramic beads	Art books
Beads of any kind	Used magazines
Wallpaper samples	Wrapping paper
Matt board	Flat/smooth cafeteria trays
Foam core	Still life materials
Toys	Dress-up clothes
Hand sanitizer	Hand lotion
Blocks (Lego, etc.)	Fast-food kid meal toys
Children's books	Junk jewelry
Miniature cars and dolls	Gift card to bookstore
Gift card to art supply store	Gift card to parent/teacher store

FINDING, PURCHASING, AND ORDERING SUPPLIES

It is difficult to know where to begin when making recommendations for elementary- and middle-school art supplies when, generally speaking, the "sky is the limit." Examples are plentiful of beautifully expressive elementary- and middle-school artwork, created simply with a pencil and paper.

Though children naturally create, whether drawing on paper with a crayon or on a sandwich with mustard, they will be very pleased to learn that their art teacher has skillfully and ingeniously stocked the art room with other drawing tools. The teacher of art has the challenge, and indeed the privilege, of planning, purchasing, ordering, and securing a variety of art supplies, tools, and materials that will lead to successful art experiences.

Art Catalogs or Local Stores

Product and price comparisons are easy to accomplish on the Internet. Often, the best savings come from vendors who do not charge postage when spending a minimum amount on a single order. Why spend the money on postage when it would better serve students by purchasing art supplies?

The quality of the art materials is important; however, a healthy measure of common sense and effective planning goes a long way when shopping for art supplies. Pay close attention to how well the product performs when using it. If the least expensive watercolor paint is too pale when used or just does not work, make note of this and order a different brand next time. The best practice is often by trial and error. There is truth to the saying that "you get what you pay for," but it is also often very smart, for some projects, to purchase student-grade paint or economy packages of drawing paper when the product performs well. It is also important to note that, in order for students to keep and value artworks, it is helpful if the paper and materials will survive.

Ordering or securing enough supplies to carry some items over to the next year is a really smart practice. Using all of the money in the art budget before the year's end is equally smart. "Use it or lose it" is generally the practice in public school spending procedures. Whereas school budgets usually do not allow money to be carried over from year to year, it is certain that extra materials, such as colored pencils, paper, and other art materials can definitely keep until the upcoming school year. This will enable the art room to be well-stocked and the art teacher to be prepared on the first day of school.

Non-consumable supplies must also be considered. It is likely that the art budget might not be healthy enough to allow a teacher to order 24 quality brayers at one time for printmaking, but it makes sense to order items, such as these, a few at a time each year to eventually reach the total amount desired, and then to order the occasional few items each year thereafter to replace broken equipment.

Plan to order a whole class set of paintbrushes the first year if there are no paintbrush supplies in the school and add at least a dozen every year after. Begin with a basic #12 watercolor brush and a slightly larger stiff bristle brush per student the first year and then add to the variety and collection in following years. Remember that a letter sent home to parents is likely to result in bags full of unused brushes being donated to the art room. Also, remember the numerous alternative items that can be used to apply paint (feather duster, dish sponge with handle, scouring pads, cotton swabs, etc.).

Advancements in technology and art supply quality have led to very reliable manufacturing of papers that will last a lifetime. Archival paper is not always necessary. At a young age, it is important to be able to experiment and use more than one or two papers each class. Depending on the existing budget, if expensive paper will inhibit student experimentation, it should not be purchased. If the budget is healthy enough to order the best paper, by all means, treat the young artists to a surface that will be lasting.

Some supplies should not be ordered from a catalog. The current trend for local discount stores seems to be to offer bargain prices on select art supplies at the end of the summer months, better known as "back to school sales." Art supplies, such as glue, pencils, markers, and scissors, can usually be found locally for extremely low prices if purchased during these special sales. The teacher who plans ahead will be one of the ones standing with a cart full of supplies at the cash register. A letter home during the very important first week of school, as previously mentioned, asking each student to bring in a few designated items for the community pool of art supplies, will often yield enough to last the entire academic year, will save parents' money, and will make it easier to ask for supplies.

Food

Most likely everyone has witnessed or personally experienced architectural constructions made with graham

crackers on milk cartons, embellished with a multitude of colors, shapes, and sizes of candies, all glued together with icing. The possibilities are endless when exploring ways to use edible items as art supplies.

It is not suggested that students waste food. On the contrary, a vegetable printing unit can result in fabulously creative explorations, but this experience can also be coupled with a food drive for a local soup kitchen. Every student is invited to bring in two potatoes—one for the art lesson and one to be donated to a local food bank. This might not sound like a hefty donation, but a school with 628 students, bringing in one big potato to donate, equals hundreds of pounds of potatoes to help feed those in need. (Be sure to alert the local newspaper, since there is also a great need for more focus on positive events and the power of art education.)

A smooth potato slice (cut by the teacher with a sharp knife) can be carved into a unique relief print plate by the student (with a plastic knife). The multiple series of artworks that can be created with these mini-plates (stamps) is valuable to the student and to the program as a whole, but it must not stop there.

Potatoes are not the only items that can be used to make beautiful artworks, via printing or similar methods. Invite students to bring in other fruits and vegetables and brainstorm, experiment, and think about other ways to print with edible stamps. Citrus foods, such as lemons, oranges, limes, and pineapples, work best if cut and placed on paper towels to dry a bit before printing. Foods, such as onions and apples, also have natural juices. They tend to print best if they are cut and placed with the cut-side down, on paper towels to absorb some of the juices, but this is optional and the items can still be used in an art exploration that same day.

Encourage thinking and experimentation by demonstrating with celery, for example, on its side (it will look like two parallel lines), on its end (it will look like a half-moon shape, and with the clump left after cutting off all of the stocks (it will look like a huge rose). When asking students to bring in fruits and vegetables, extend an "open" invitation and be prepared to be surprised with the sometimes unusual or less-known options that are on the market.

Promote individuality, encouragement of overlapping shapes, color experimentation, use of a variety of sizes and shapes in paper, drawing onto the print, or cutting it and weaving into it, all help set the stage. Once the ideas have been triggered, new and exciting directions might be pursued and introduced by students who are active players in the art program.

As we continue to consider the endless food possibilities, a wealth of colors, sizes, shapes, and textures can be found in unexpected places—try the bean aisle of the grocery store! There, one will find a huge variety of tiny gems that can be used hundreds of ways (such as collage, sculpture, etc.).

Pasta also provides variety and many opportunities for collage-like compositions in the art room. Noodles can be easily colored with food coloring (add a few drops of food coloring in a plastic bag full of pasta, zip, and shake).

Icing can also be colored. Whip up a batch of red, yellow, and blue icing and create an edible color wheel. Students can use wooden craft sticks for mixing and painting with colored icing. After your young artists have used these primary colors to make secondary colors (green, orange, and purple), and your more experienced students have also mixed the tertiary colors (variations of blue-green, blue-violet, red-orange, red-violet, yellow-green, and yellow-orange) on foam palettes (plates), they can continue to create edible paintings on surfaces such as graham crackers, large cookies, or cupcakes. Warning: the teacher must be armed with a fully charged digital camera and, ready to photograph fast in order to preserve these images since your artists will be anxious to eat their original artworks!

A Note About Scissors for Young Artists

Never skimp on scissors. Young people are learning to cut, and as with all new life skills, this can be a very challenging task for some. Poor quality scissors will only cause frustration; purchase only quality scissors. They do not have to be expensive. It is wise to test them for quality before purchasing because hundreds, possibly thousands, of scissor varieties can be found on the market. Some work, and some do not. Here again, this seems like common sense; yet, in classrooms across the country, one can find boxes full of scissors that should have been retired ages ago or never purchased to begin with. Students will benefit from using scissors that work and from the art teacher who plans ahead and pays attention to such simple, yet important details.

Scissors are useful for more than just cutting; they can be an effective drawing tool as well, cutting wavy lines, zigzag lines, curvy lines, scalloped lines, etc. Also, scissors now come with antibacterial handles, which could be a real perk in a public setting where supplies are shared and used from a common pool.

Some students might have limited finger/hand mobility or special needs related to the use of hands and the motor skills necessary for cutting. Special scissors are available for such instances with two sets of handles on the same scissor, one for the teacher, and one for the young artist.

Scissors have various types of tips, primarily blunt/rounded or sharp/pointed; both are useful in the art class. In the first year of teaching, begin with basic scissor purchases so that the room is stocked with at least one pair per student, since time spent waiting for a turn with the scissors is time wasted. Then, be watchful for other scissor varieties to add to the scissor collection. Teachers of art who purchase at least a few pair of scissors each year will end up with quite an impressive scissor collection before long, and this is sure to enhance the art making possibilities for students.

A Note About Glue

An important "safety" tip will now be shared—and yes, it is in regard to glue rather than scissors. Of course, safety talks and reminders will be given about scissors and potentially dangerous art tools, but the beginning teacher should also review with students what to do and not do with a clogged bottle of glue.

Here is what students need to know. The thin, hard layer of glue that dries on the tip of the bottle is razor-sharp when dry. How do most students clear this layer before using glue? They scrape it with their finger nail! In turn, this often leads to the sharp layer of hardened glue jamming up under the child's finger nail, often causing pain, blood, and tears. This trauma can be avoided. A little time invested at the beginning of the school year, showing students how to simply scrape the bottle tip on the edge of the table to knock away this thin, sharp layer, is time well spent.

Students will also often try to cut the dry glue off with scissors (which removes the "stopper"), or they might jam a pencil lead into the tip of the bottle (which widens the opening and keeps the bottle from properly closing forever). Students should be taught that both of these practices destroy the bottle and shorten the amount of time it can be used in the classroom. Again, simply scraping it on the table edge instead leads to happy young artists with fully-functional glue bottles.

Years of observations and experiences have led to another helpful adhesive suggestion. Buy, or ask students' parents to buy, the glue bottle with the ribbed lid (not the smooth one). Small hands can more easily open the textured lidded glue bottle, whereas the smooth one causes frustration for the student who cannot open it.

Additionally, glue can be an extremely versatile art supply, coming in many different colors, pens, bottles, various sizes, stick form, with sparkles and whacky scents, etc. Be sure to have plenty of regular white, liquid glue in 4- or 8-ounce bottles that are user-friendly for young hands, but also collect a box full of kid-friendly special glues. For a unique drawing or painting tool, tempera paint, ink, or food coloring/dye can also be added to glue bottles to create a thick, liquid line drawing. Simply add them to a glue bottle, shake and enjoy!

Vendors at Teacher Conferences

Hundreds of vendors annually attend the National Art Education Association (NAEA) Conference. Hundreds of thousands of art supplies, resources, tools, equipment, art room furniture, art display mechanisms, and more can be viewed, used, read, manipulated, and experimented with at these gatherings. Want to know what is new on the market? The annual NAEA conference vendors' area is the place to be, where art teachers of all grade levels are invited to try out materials, watch demonstrations, peruse books, view posters and visual aids, discuss new innovations, ask questions, join mailing lists, order free catalogs, register for prizes, receive discounts, and often take home free samples. State art education organizations also host smaller versions of this national conference, and schools will often fund teacher attendance for professional development credit. To view a list of these vendors and to request free catalogs, visit the NAEA web site.

Parent Organizations, Art Supplies, and Equipment

Prepare and update a "wish list" for art education supplies and equipment. It is no secret that school parent organizations raise money, and they often ask for requests or a "wish list" from teachers. It is wise to have one prepared and standing by.

At some point in most teachers' professional careers, a representative from the parent organization will approach art teachers to announce, "We have some extra money to spend, but it has to be spent by tomorrow." For such an occasion, the best practice is to be prepared ahead of

time. The effective art teacher is able to walk over to the teacher desk and pick up an art supply catalog with wish list items and appropriate pages already marked. Often, the parent organization is willing to purchase art supplies, tools, resources, or equipment; they need only be asked.

The justification for an expensive piece of equipment, such as a kiln or drying rack, is strengthened when the proposal reminds that all students in the school will benefit from the purchase. Need display/exhibition boards? Ask the parent organization to order a set. You may want to highlight their children's artwork via displays in the front entrance of the elementary or middle school and also host a handsome student art exhibition during the next parent meeting—complete with cookies and punch and positive recognition for students. Attendance at parent meetings will be improved because of the art exhibition, and it is likely that parents will soon offer to add to the collection of display boards. Often, the simple act of asking is all that is required to gain financial support from parent groups or others for the art education program.

Arts Organizations' Support for Art Programs

Local and state arts organizations offer the priceless support of art programs through advocacy and professional development, but they also often provide scholarship or grant money for art teachers. Bookmarking web sites of arts organizations is smart. Active membership in such professional organizations is the sign of an effective teacher, as is participating in the conferences and professional development opportunities hosted by these organizations. Additionally, many vendors often give free materials to conference participants and, similar to the NAEA, they often have numerous vendors ready and willing to show and share their best products and latest inventions for art teachers.

Parents and Family

Prepare an invitation to give to parents at events, such as open house, where you can showcase talents and introduce the idea of saving listed supplies for your classroom. As previously mentioned, send a letter/newsletter home. Advertise needs on the art web site. Most parents will gladly send two or three art supplies with each child for

your community pool of art materials to be shared and used throughout the year.

Additionally, students' family members can be the art teacher's greatest volunteers. Often, one only need ask to receive assistance. An announcement on the school web page, art room newsletter, or letter home to parents will often result in unbelievable support for the art room. One word of caution, be careful what you wish for as you will probably get it. A note sent home asking for donations of scrap yarn, for example, might yield pleasant and overwhelmingly unexpected results!

Beyond the supplies and volunteer services that a child's parents might be willing to donate to the art education program, it is highly likely that parents and relatives of students are employed or active in art-related careers or hobbies (graphic designers, fashion designers, architects, photographers, weavers, illustrators, quilters, potters, stained-glass artists, sculptors, jewelers, etc.). Invite these individuals to school.

Allow students to conduct an interview. Pre-plan some questions that will speak to the general nature of the career and allow students to become reporters for the day. Video the events to share with other classes and use them as examples in future years. Likewise, you could visit an artist in her or his studio or workplace. The field trip could involve students, either physically or electronically, via video.

Teachers and Community

Involve colleagues and the community. Not surprisingly, many enjoy finding unique items to donate to the art room once they know that there is an eager art teacher willing to accept their offerings. Here again, a good general rule, when others offer special finds, is to immediately say "Yes, thank you" and later figure out what to do with the donation. Most of the time, students will find a use for unusual items with no prompting needed. If a colleague offers a box full of buttons from a flea market, a yarn scrap collection from years of Aunt Nancy's knitting, a box full of odd wooden shapes, or a chest full of old fabric scraps, take them.

Neighborhood rummage sales are great places to find blenders for paper-making, hot plates and electric pans for melting wax, irons for batik, old game boards, marbles, clothes pins for drying, buckets, artificial flower arrangements, toys, unique still-life objects, building blocks, and an endless supply of items to add to art room collections.

While rummage sales should not be the only way that supplies are obtained for the art room, they can certainly prove to be a very effective means by which art teachers can supplement art program needs.

Recycled Materials in the Art Room

Being environmentally aware and also resourceful when gathering art supplies are two ideas that go hand-in-hand. An unbelievably long list of materials that, unfortunately, often end up in the garbage dumps or land-fills can instead be recycled in the art room.

A non-biodegradable gallon-size plastic milk container, for example, instead of residing in a land-fill for over 500 years, can spend a long life as an armature for a student-made mask. Recycled newspaper (ripped in strips), dipped in liquid starch, and layered over the milk container, results in a paper-mache sculpture that is almost free. Cut the carton in half and examine the interesting shapes that result as a starting point of a unique sculpture or mask. A young artist might decide to use the handle as a built-in nose, a long brow, or a ridge in the center of a flying machine.

In an age of convenience, bottles come in all sorts of interesting sizes, shapes, and colors that can enhance an elementary- or middle-school art program. Likewise, hollow containers, such as vitamin bottles, water bottles, shampoo bottles, small plastic juice bottles, liquid soap bottles, and any clean, empty plastic container filled with a bit of rice, can live out their lives as beautiful paper-mache shakers (musical instruments for inspirational performances to be first rehearsed in the art room, of course).

Recycled newspaper can be used in thousands of ways from protecting table surfaces to paper-mache materials, sculpture materials, and collage. Cardboard can be used for sculptures, or as weaving looms. Imagine all of the sturdy boxes that are normally discarded; in the art room they can take on a new life. Boxes can be easily collapsed, stacked, and stored—such as those for cereal, crackers, pasta, toothpaste, rice, frozen meals, soap, snack bars, etc. Only save clean boxes with no traces of food that might attract unwanted pests in the classroom. Cardboard rolls, such as those found in paper towels or gift wrapping paper, are also handy for sculptures.

Crocheting or knitting projects often result in numerous small balls of scrap yarn that can be used in the art room. Plastic bags can be cut into strips and used for weaving or crocheting. Discontinued, flat, cafeteria trays have zillions of uses in the art room. Shoe boxes or plastic coffee containers are useful in art projects or for storage. Pop the plastic lid on the bottom of aluminum coffee cans to prevent rusting if stored near the sink area (i.e. for paintbrush storage).

Small items that might otherwise be thrown away are popular art materials when placed in a collage center (buttons, paper clips, cut-up straws, plastic marker lids, paper circles from hole-punches, plastic lids from drink bottles, tabs from can tops, wire twist ties, plastic electric ties, etc.). Many similar free art supplies are also thrown away by businesses throughout the community where the art teacher might make a special request to save items.

Community, Local Restaurants, and Businesses

Consider all of the materials that can be found in abundance in local businesses and in the community that could also be used in the elementary- or middle-school art teaching spaces. The newspaper production process, for example, results in numerous "end rolls" of ink-free newsprint paper. The printing presses must be stopped before the roll runs out, so a large amount of paper is left on the roll, and is often given free to art teachers who simply ask for it. Paper cup companies often coat cups with a thin layer of melted wax (to make the cup waterproof). Such companies are often willing to donate a huge chunk of wax, which often comes in 25-pound blocks, to art teachers to use as a resist in batiks, for example, or in hundreds of other ways.

Frame shops will usually provide an endless supply of scrap matt board, which will result in a long list of ways to use it in the art class (sculpture, weaving, hand-made frames, drawing, painting, etc.). Wallpaper suppliers, upholstery shops, and carpet stores will usually donate high-quality samples of their products that have been discontinued. Grocery stores will often donate unused Styrofoam trays (which can be used for printmaking, paint palettes, sculpture, bead trays, etc.).

Restaurants are good suppliers of cups and containers that have an endless number of uses in the art room. Additionally, flat cafeteria trays, as previously mentioned, can be used in a myriad of ways in the art room. Hardware stores will often discount or give cans of paint that are incorrectly mixed. What was once the wrong color for a customer's shutters or front door could be wonderful on the palette of young artists and again often for free!

Bookstore clearance tables are often full of valuable art materials. Calendars that are outdated can still be useful to the teacher who is in search of visuals or ready-made

bulletin board materials. The diverse themes of these calendars often perfectly match the broad art curriculum, as well as other curricular areas presenting integration opportunities. Works of a local nature photographer, for example, can be used to showcase the artist, artwork/process, art career education, science, and nature, and to draw attention to a variety of topics, as seen in Plate 4.1.

Consider non-traditional painting surfaces (as seen in Plates 4.2–4.7), such as terra cotta pots and switch plate covers, and be on the lookout for clearance sales of similar items or business owners who are willing to donate them. The key is to constantly be aware of what is available and to be willing to ask for it. An important piece of experience-based advice is to always be sure to follow through with promised items. Always be sure to go by and pick up supplies in a timely manner once a business has agreed to save them. This fosters a good relationship with the community and will usually lead to increased future support.

Flea Market, Thrift Stores, and Rummage Sales

Very inexpensive, often free, items that will be useful in the art room can be found in unexpected places. In classrooms of long ago, one might not expect to see huge rocking horses, beautifully shaped old metal bicycles, umbrella collections, old musical instruments, artificial flower arrangements, interesting toys, or old signs. Items such as these can be found at little or no cost, so students and visitors should expect to see the unexpected in current art rooms.

Local community organizations often host annual bazaars where one person's junk can be the art teacher's treasure. The best time to make an offer for these unique items is near the end of the sale when the hosts are usually begging everyone to take anything and everything for little or nothing, and they are unsure what to do with the leftovers. These items can be used for motivation, play, inspiration, exploration, and for still-life drawing compositions.

Unique objects can also be found at garage/rummage sales, flea markets, and thrift stores. A box full of action figures could provide endless uses in the art room and be very inexpensive, but they could comparatively cost what seems like a small fortune if purchased new. These items can be found for free or almost free for the smart shopper. The teacher of art who invites parents to donate such supplies, with just a little guidance, will reap the benefits of an endless stream of supplies and materials that the teacher might never have found alone. The teacher of art who pays a few dollars for a huge bundle of white T-shirts (for tie-dye

or painting) at a flea market or thrift store will save a lot of money that can be used elsewhere.

REMEMBERING TO GIVE BACK TO THE COMMUNITY

In addition to asking for art supplies from the community, young art students can benefit from *giving* art supplies to those in need. For example, one art education class gave back to the community by supporting the Ronald McDonald House (RMH) Charities, which is a non-profit charity organization that serves children who are critically or terminally ill. The students purchased 12 plastic shoe-box-sized storage containers ($1 each) and hosted an art supply drive. Simultaneously, they collected canned food donations in boxes in the halls and through letters/e-mails to parents.

At the end of the semester, the college students filled the plastic boxes with art supplies, essentially creating portable art centers by theme (i.e. marker drawings, texture rubbings, sticky wick drawings, watercolor painting, color pencil drawings, paper collage, weaving, etc.). The group then visited the closest Ronald McDonald House on a Saturday where they donated the art supply boxes for children to use, prepared a lunch for the resident families, and donated three huge boxes of non-perishable food items and several hundred pounds of tabs for the RMH Pop Tab Collection Program (for more information, visit http://rmhc.org). The outcome was phenomenal. Not only did students reinforce the power of art to themselves, and the joy of giving to others in need, but the unexpected outcome was additional PR for the Art Education Program, which led to … guess what? That's right … additional support for the program.

SHOPPING FOR AND DISTRIBUTING SUPPLIES IN AN ART CLASS

As previously mentioned, art supplies should be arranged in such a way that students have easy access, making it possible for them to shop for items when needed, as well as promoting individuality and allowing student choice. At times, it is helpful to have containers in which supplies can be easily distributed to art tables, for example, where a bowl full of chalk pastels is needed at every table. Wide-bottom containers are useful for this since they do not tip as easily.

Generally, it is difficult for people of any age to pay attention to a speaker or a demonstration if seated within reach of exciting art supplies. Understandably, young artists will

be tempted to begin playing with the supplies, missing out on the verbal instructions. Until the teacher is ready for students to begin exploring the supplies, it is helpful, when possible, to have either the students or the art supplies temporarily away from the table or art making area.

Sectioned caddies with handles are the perfect home for basic supplies that are frequently used (such as pencils, scissors, glue, erasers, rulers). Once a routine is established and practiced, students can easily and quickly gather their containers when needed.

Cafeteria trays are terrific for pre-arranged introductory art stations. For example, in first-time mono-printing lesson preparations, the teacher might load a tray for each table with a brayer, paper towels, various gadgets for printing, bowls of thick paint, and one watercolor brush per student in the bowl. When demonstrations, teaching instructions, and preliminary work are all done, the teacher could call one person from each table to retrieve the pre-stocked tray from the counter for his or her table.

Likewise, water bowls can be filled (only half full) and placed on the counter by the sink for when they are needed. For traffic control ease, the towels, brushes, paint, and paint pallets should, of course, be stored near the sink. Once students have experienced printmaking, they might then be invited to the "gadget-printing museum" where the art teacher unveils a display of other unique printing gadgets, which the students will be welcome to select from and explore at their own pace. Additionally, the teacher will, of course, welcome all student contributions to the gadget printing museum for future use.

The best mode of distribution for supplies will differ depending on the situation. For a painting lesson, it would not make sense to have 24 students go to the sink area, one at a time, to fill their paint palettes. Time will be used more efficiently if a few students are assigned duties. One student from each table could retrieve water bowls, while another student could go around the room placing paintbrushes into the bowls (one per student). One student could distribute palettes, while another could place a squirt-top bottle of paint on each table.

Students who are involved with the distribution of materials will become more familiar with them and their location, and they will then be better prepared to retrieve and put them away in the future. This is all part of teaching the students to be more independent thinkers and doers. Students could have the experience of learning to pour their own paint. Yes, accidents will happen. It is the teacher's job to allow accidents. Helpful suggestions, such as "start out by pouring paint puddles about the size of a quarter," and "you can always get more paint later, but it is nearly impossible to put it back in the bottle" will teach children to use materials wisely, which is a helpful life skill.

Reminders will be needed through beginning painting experiences, but this is how children learn. Sometimes, in a different type of painting experience, however, such as a short class where every child will need a palette with five colors (i.e. for color theory/mixing), the class might be better served if the paint palettes are prepared and on the counter for students to come, one table at a time, and retrieve the palettes when called to do so. Students should be taught what to do if they need more paint: in most situations, it is okay to take their palette to the sink area and get another squirt of white paint without having to wait for permission every time—saving time and allowing them to practice being independent.

STORAGE OF ART SUPPLIES AND EQUIPMENT

Obtaining art supplies is the easy part. Organizing and storing them are a bit more challenging. If the art room is not large enough, additional storage space might be needed (an unused closet, old locker room, extra lockers, or unused basement spaces). The golden rule is that the art supplies are of no use to anyone if they cannot be found. Art rooms are unique places with unique tools, equipment, and supplies. Some things, infrequently used, can be stored away out of site, such as a potter's wheel or photo equipment. Other supplies must be kept in plain sight and easy for students and teachers to find and retrieve (such as glue, paper, scissors, pencils, crayons, colored pencils, etc.).

Students should be given a tour of what is where, what they can use and when, and all the procedures related to art supplies and equipment. For example, the young artists can get paper or sharpen pencils anytime without asking for permission but they are never to touch the paper cutter.

A word of caution: it is easy to become overwhelmed or overly concerned with organization. If art lessons and creativity are compromised because of constant and extraordinary amounts of time needed to organize, clean, take out, put away, etc., then a new system is needed. Conversely, if the art room looks akin to a garbage dump, and it is difficult to find anything when needed, a new system is also needed. The effective art teacher seeks *balance,* invests time in the beginning by organizing, labeling, arranging, storing, reflecting, rearranging, and training students and volunteers to help; then, the effective teacher steps back and enjoys the well-oiled learning machine that has emerged.

Creative Planning and Topics for Group Discussion, Activities, and Extensions

- Create a sample parent letter that lists art supplies that you would welcome throughout the school year or a list of what you would like each student to bring to school to be added to the community pool of art supplies. Construct an aesthetically pleasing letter. Use clip art, images, color, unique fonts, etc. Save this letter as a sample parent communication for your teacher portfolio or job interview packet.

- Visit a discount store, individually or as a class. Make a list of items that could be useful in the art room (i.e. plastic scouring pad for printmaking or clay textures or a potato masher for mono-printing). Prepare a list of items and explain how each might be used. Be ready to submit a copy of your list and share your ideas with the class.

- Find three resources in your community that might provide an inexpensive or free art supply (i.e. foam trays from the local grocery store produce department for print-making, clean ice cream buckets for storage, discontinued fabric from an upholstery shop, or wallpaper samples from a paint store, etc.).

- Find two to three items that might have otherwise ended up in a land-fill that could be used in art making (i.e. straws, empty and clean milk cartons, and wooden beads from car mats, etc.). Make a list, describing your ideas and be ready to share these with the class.

- Find at least two items that could be used in a collage art center (i.e. toothpicks, buttons, dry/uncooked beans, wire twist ties, etc.). Bring them to class and be prepared to share your ideas.

- Conduct an online search of art supply vendors. The NAEA web site is a good place to start (see the list of conference vendors). Create a list of at least five vendors, listing the company name, e-mail address, and a very brief description of the products available.

Section Three Displaying Student Art

In the art education world, displaying art is no more important than the act of making it, but it is a very important step in building student confidence, and it is one way to communicate to the public what a wonderful art program exists in the school. Additionally, the framing process can involve as much, if not more, creativity than the act of art making. "To frame or not frame?" can be an important question for the child artist, as well as a unifying factor, like the punctuation at the end of the sentence.

OBSERVING CHILDREN'S DISPLAYS ON HOME SURFACES

Many children have a natural desire to arrange and rearrange objects again and again. Part of the fun, when playing with dolls, for example, is setting up and creating visually appealing compositions, hair styles, wardrobe choices, and performance/play places. The "arranging" or "setting up" of displays involves creative thinking, and these acts are just as

important to the play process as what follows. The scrap piece of wood from dad's workbench becomes a doll's bed, carefully added to the arrangement and covered by the tissue that becomes a one-of-a-kind blanket patterned with fresh marker designs reflecting the latest trends in bed linens.

Likewise, part of the fun of playing with building blocks or action figures is the point at which the wonderfully interesting elements are removed from the storage containers and assigned their initial roles in the display that is created. Children are always eager to share their artworks on their bedroom walls, on the kitchen corkboards and dinner plates, and on every inch of the family refrigerator (the national gallery of art for young artists). When it comes time to display artworks at school or at home, never fear, children are eager, ready, and willing to serve as curators.

STUDENT DESIGNS FOR ART EXHIBITS IN THE SCHOOL AND COMMUNITY

When planning and providing display spaces for children's art, elementary teachers might better serve their students if they try to imagine themselves as a 3-foot tall young person. Remember that eye-level for the teacher is quite different than eye-level for young artists. Keeping the young people's perspective in mind will not only enable students to better see and interact with art created by them and their peers, but it will also aid in their interactions with, and the ability to take part in, the actual construction of the displays and performance spaces.

It is important that all children be given the opportunity to display their artistic creations. The teacher who willingly includes the artworks of all students sends a message to them that the ideas of all of them are valued. The act of including only some students in art displays (often the more adult-like pieces) sends a negative or unwanted message that only some ideas and artworks are valuable, while others are not. This could have a negative effect on self-confidence and the motivation to create and learn; at this tender age (or any age for that matter), this would be counter to the goals of educators. Our goal is to give license to creative and critical thinkers and to build up artistic confidence, not tear it down.

Of course, the familiar bulletin board provides an easy venue for pinning, stapling, and displaying student works, but there are many other gallery spaces available as well. Special adhesives are now available that allow teachers to display student creations directly onto the wall, without harming painted surfaces or the artworks themselves. Glass display cases, and window ledges, and tops of library shelves are perfectly suited for three-dimensional artworks. The playground fence wires will "gladly" hold tight to artworks hung by clothes pins or ribbons. Ceilings can be used to suspend mobiles, sculpture, and artworks that can fill space that normally goes unnoticed and unused.

Boxes, suitcases, and numerous other containers that are readily available can be transformed into tiny galleries, mini-stages, and perfect temporary spaces for displaying student creations and performances. The school parent organization might wish to get in on the act and host a rotating art exhibit by purchasing a set of frames to be used in a school "mini-metropolitan" art museum where the students are the stars, hosting their work in an ongoing exhibition throughout the school year. Parents or volunteers from the community are often willing to help change the artwork on a weekly or monthly basis, and they usually only need to be asked.

Community connections will also provide opportunities for elementary- and middle-school artists to exhibit work in spaces outside the school building. During the NAEA National Youth Art Month (March), local grocery stores often host art exhibits on ready-made canvases with built-in easels—better known as brown paper grocery bags! These can be taken to school by the teacher to be graced with students' drawings (crayon works best) and later returned to the grocery store for a large group exhibit with bags popped open and standing side-by-side along freezer top spaces, in windows, or on counters. Students will love having their art displayed in public spaces, and store owners will love the increased number of visitors they will receive due to the elementary- or middle-school students' art exhibit. Another opportunity to engage art students in service presents itself in communities with "meals on wheels" (or "meals on heels," as seen in bigger cities) programs where brown bags are also used to deliver food to the needy, who will receive an added treat if the package is graced with a child's artwork.

CREATIVE FRAMING BY YOUNG FRAMING ARTISTS

It has been said that "presentation is everything." Whether or not this is true, it is clear that a frame around a painting sometimes brings closure, ties it all together, announces completion, or is the period at the end of the sentence. Young elementary- and middle-school artists will benefit

from being involved in the framing process—from selecting it to utilizing it. Having said this, it is not suggested that the teacher take all artworks to an expensive frame shop. On the contrary, creative frames are available at little or no cost, and can also be designed and crafted by the students.

Consider alternatives to the traditional frame. Existing frames can be utilized as is, or they can be redesigned by the student. Why not try frame-like objects, such as hats, window frames, shoe boxes or lids, cereal boxes, plastic bins, metal jar lids, bamboo embroidery hoops, ice-cube trays, metal or plastic screens or vent covers, or recycled cardboard. Not all artworks have to be framed. Occasionally the piece is stronger without one, and as such, the teacher might invite the young artist to consider what the finished piece would look like with and without a frame.

PUBLISHING STUDENT ART

In addition to displaying children's artworks in the school building, many other avenues exist for possible display and publicity for young artists. The NAEA, their sponsors, and art supply vendors and companies send out numerous calls for children's artwork. Art magazines, such as *School Arts* and *Arts & Activities* publish art lesson ideas and children's artwork samples, and other education magazines often call for entries as well.

The art room newsletter and/or school newsletter is a great place to highlight children's artworks, but why stop there? Send copies of artworks to the local newspaper as well. Do remember that high-contrast (such as black and white) images print better and more cheaply than lower-contrast or multiple-colored images.

The art program web site is a great place to publish student artworks, as well as the school web site. Many students will already have their own web sites, and the teacher need only encourage them to enhance such sites with their own artworks. Artsonia, claiming to be the world's largest kid's art museum, is also a good place to submit electronic versions of artworks.

Why not publish a book of artworks on your own?

A theme could be announced, that could be as narrow (the school mascot) or broad (freedom) as the teacher desires. Broad themes are generally preferred since they promote and/or allow for individuality, enhancing the creative thinking process. Another approach would be to allow each student to publish their own personal book of artworks. Book binders with plastic combs will do the trick, nicely holding all pages. A quick online or library search will result in hundreds of bookbinding processes.

LESSONS FOR HOME STORAGE AND PRESERVATION OF ART

Teaching young artists to preserve their own artworks is equal to teaching them to respect their work. Think of art preservation in terms of how you would view saving valuables, such as family photographs. One trip to the scrapbooking section of the closest store is likely to reveal thousands of quality scrapbooking supplies. Most are archival and predicted to last many lifetimes.

So much of art is lost because of a lack of knowledge. We did not think to keep it, or we did not think to teach students to keep it. We did not know to keep it dry. We did not think of the damage that constant light exposure would do. Teachers need to remind students to care for and properly store artwork; otherwise, they will possibly look back on their early years with regret for not keeping their artworks.

Additionally, when selecting paper and art supplies, keep in mind that many are available that are archival quality and acid-free. Numerous new inventions in the art material arena will allow us to make artworks and even wrap artworks in safe materials—that is, materials that will last a whole lot longer than the cheapest construction paper that is often selected because of its price. Electronic artworks can be easily backed up for safe keeping. How does one store and preserve a painting? The children might not worry about it until it is too late, so the teacher must attend to this responsibility and, at the very least, offer advice.

> ### Creative Planning and Topics for Group Discussion, Activities, and Extensions
>
> - Make note of traditional exhibition spaces (i.e. bulletin boards, tack strips) when visiting schools, as well as less traditional spaces (i.e. ceiling tiles, windows, library shelves, architectural oddities or support poles, trees, fences, parking lot, cafeteria sneeze guards). Describe and reflect on these observations. Be prepared to discuss and share with the class.
>
> - Seek out possible exhibition spaces for children's art within your community (i.e. grocery store, hospital halls or waiting rooms, doctors' or dentists' offices, restaurants, shopping malls, indoor soccer arenas, indoor and outdoor walls of buildings). List and reflect on them and be prepared to discuss and share in class.
>
> - Conduct a search on the Internet of exhibits/galleries/museums. Describe your favorite ones, paying special attention to the type of art shown, media, site bonus features, and why it is age-appropriate (for elementary- and middle-school students).

Success is to be measured not so much by the position that one has reached in life as by the obstacles which he has overcome.
—Booker T. Washington

Section Four Evaluation of Students and the Program

THE PURPOSE OF ASSESSMENT

The primary reason for assessment is to guide educational decisions. Just as doctors conduct assessments (i.e. blood pressure, weight, heart rate, blood work) for the purpose of determining what action to take; likewise, teachers assess for the purpose of determining what action they will next take. Some examples of educational decisions that might be made because of assessment include: to re-teach, to alter plans, to provide more opportunities in a particular media or process, or to change direction of a particular art exploration. A teacher who simply assesses a task for the sole purpose of attaching a grade to it can be likened to a doctor who conducts an assessment but fails to develop a plan of action or provide any meaningful feedback to the patient. Teachers who assess students' progress, for the right reasons, will be better prepared to plan for meaningful future experiences.

WHAT IS PROGRESS IN ART?

Booker T. Washington stated that "Success is to be measured not so much by the position that one has reached in life as by the obstacles which he has overcome." When assessing elementary- and middle-school art student performance, the teacher must remember that the final destination (perhaps a product) is not as important as the plethora of accomplishments that are made en route. Therefore, when a grade is to be assigned in art, a healthy dose of formative assessment will occur. The finished product, though it may or may not be an artifact originally planned or even cherished by its creator, is secondary to all of the critical and creative thinking, discovering, creating, analyzing, decision making, singing, playing, moving, communicating, story-telling, debating, and sometimes tasting that is experienced along the way.

Young artists must feel that they are safe in their investigations and that making mistakes is a part of learning. They must learn that not only will they not be punished for making mistakes, but instead, they are more likely to be rewarded and benefit from mistakes. Twentieth-century abstract artist Mark Rothko said that, "Art is an adventure into the unknown world, which can only be explored by those willing to take risks." As young artists participate in the creative process, the teacher is the "guide on the side" who constantly analyzes, assesses, and provides feedback, encouragement, technical advice, and whatever is necessary in order to help students to sojourn smoothly throughout their artistic journeys.

WAYS OF REPORTING STUDENT PROGRESS

First of all, consider to whom the progress will be reported. Certainly students should be aware of how their art performance and participation will be assessed by the teacher, but parents or guardians must also be informed via "progress reports" or "grade cards." Likewise, administrators and members of the community are sometimes informed about what school arts programs are experiencing in the arts, possibly via state-wide assessment.

It is important to be mindful of Booker T. Washington's quote, as previously discussed, and focus more on evaluating the "journey" rather than the final "destination" or the end "product." The best way to assess children's art performances is to observe them while in progress, in other words, during the journey.

The most meaningful way of informing students of your assessment is to speak to them throughout the process, giving them ongoing, verbal assessments of their performances. Effective art teachers do not sit behind a teacher's desk during art class but, instead, circulate among students. Good art teachers often sit on the floor with students. Spend time with the young artists—really being "with" them.

Ask questions. Tell individual students what is working, such as, "I like the way the figure takes up most of the drawing; it is a strong focal point that really captures my attention." Also, tell them what is not working, such as, "Remember, when safely using a bench hook and gouge, you always cut 'away' from your hand." Give genuine praise on specific accomplishments. Ask questions to determine what students are learning, thinking, and creating.

Listen to students' stories to learn what they intend to communicate via their artworks. Make suggestions in the course of discussions to help motivate and inspire new ideas (their ideas) when needed. Students, whose strengths lie in places other than writing, might be very engaging and eloquent speakers, who are eager, ready, and willing to tell the teacher or anyone who will listen what they are trying to communicate with their artworks.

Gone are the days when children were expected to sit quietly and listen to the teacher do all of the talking. Gone are the days when children were reprimanded for talking in class. When a visitor arrives at the classroom door, it is no longer the noise for which a teacher must apologize, it is the silence. Young artists learn by talking to each other. Children who wish to tell their neighboring peer about their painting should feel safe to do so. Young artists who discover a new color will be eager to share their invention, and the act of sharing this invention with near-by peers will have a positive effect on the learning experience for all involved.

The construction of knowledge effectively takes place in classrooms where children are encouraged to think and to communicate visually and verbally. Likewise, the teacher can document the visual and verbal representations of this student progress via narratives in the grade book or journal.

In addition to dialogue that will take place between the teacher and students regarding progress, in some schools a printed progress report is mailed home to parents, and the content area of visual art is to receive a symbol on the report that reflects the child's grade in art, such as the traditional A, B, C, D, F scale or one of the many other grading systems in different school systems, such as "BG" for beginning, "DV" for developing, "IP" for in progress, "NO" for not observed, "NA" for not applicable, "S" for satisfactory, "U" for unsatisfactory, etc.

If this is the case, and a letter grade is to be assigned, the teacher of elementary- or middle-school art must communicate to students and parents the standards by which the children will be evaluated, such as: class participation, effort, disposition, willingness to complete the assignment to the best of his/her ability, etc.

Records of ongoing formative art assessment, in a school where required, might seem overwhelming to the teacher who sees over 600 students per week. Indeed, it seems a bit absurd and maybe even impossible to attempt grading like teachers of other content areas. An important point to remember is that *art is not like other content areas*; thus, if a grade must be given, the rubrics and assessment criteria will also be different, for example, than that used by the math teacher.

There are many types of assessment, such as: tests, verbal expression (aloud or in writing), analytic rubrics, holistic rubrics, checklists, rating scales, and combined scoring systems. With formative assessment, the teacher determines if the students are learning the things she/he wants them to learn, such as developing desired attitudes and skills. In other words, are they on the right track? What is working? What might you do next, or differently?

With summative assessment, the teacher investigates to what extent the students have learned what you wanted them to learn or gained the skills that you wanted them to obtain. Here again, attempting to use any of these types of assessments might seem daunting to the art teacher who sees over 600 students every five days. In such a case, it is hoped that some of these strategies, theories, and sample assessments will be helpful.

Remember that formative assessment of art progress will most likely be utilized more than summative. A checklist can be formatively used by the teacher as a tool for noting students' ongoing progress. Hundreds of discussions will take place between the students and the effective teacher over the course of one art project. Teachers' notes can be a valuable ongoing assessment tool. Art critiques and discussions, for example, are not only teaching tools, but they are also revealing. They communicate students' ideas, what they are learning, and the direction that each student might take next. This is ongoing (formative) assessment.

While the teacher cannot take the time to record every single word spoken in this ongoing analysis of student growth, he or she can utilize an assessment method, such as a checklist, which requires very little time and can even be checked while circulating among students during and/or near the end of each class. It is important that the checklist or rubric reflects that we are mindful of developmentally appropriate skills and attitudes of students' progress in terms of effort, participation, art skills, positive dispositions, and the willingness to engage in the assignment to the best of their ability as we assess their performance.

Teachers must be cautious and ever-mindful of age-appropriate expectations and goals. Second-grade children should not be graded on whether or not they can create paintings that are unified and asymmetrically balanced while utilizing at least three distinct textures and a clearly developed color scheme. Clearly, this would discourage young artists from wanting to participate in art class, and it would be detrimental to their creative growth.

In painting exercises with 8-year-old children, it is better to provide the materials, motivation, and opportunity for a rich and developmentally appropriate experience. If a grade must be given, in such a case, the willingness to participate will be at the top of the list. A grade of a "C" would be detrimental to the students' progress in art and would be meaningless to parents. If children are victims of inappropriate assessments, they might feel pressure to abandon their creative ideas so that they can please the adults. Any grade that is assigned to children's art that is based on standards that are not age-appropriate will not communicate accurate or helpful messages to students or their parents.

A discussion with students (ongoing throughout class, using the children's sketchbooks and journals) and to parents (via e-mails, letters, notes, newsletters, art exhibitions, parent/teacher conferences, open-house meetings, etc.) are much more informative and helpful when attempting to give them a clear picture of what is going on in the art class.

Again, it is crucial that adult art standards not be applied to the assessment of children's art. In a college-level two-dimensional design course, it is acceptable to assess a student's ability to understand and demonstrate effective compositions and knowledge of art theory. Students in such a class should be assessed on their ability, for example, to create a visually appealing, unified, and compositionally sound two-dimensional artwork. Elementary- and middle-school students, however, need to develop naturally through the creative process, exploring, for the first time, materials, thoughts, processes, and the art of others until one day, later in life, when they might enter into an art class that is judged on high-school or college-level standards.

Another type of formative assessment is the assignment of "home" work. Obviously, homework can involve a variety of assignments or assessments (including summative assessments, such as creating a culminating project), but in this case, the emphasis is put on the *home* part of the students' efforts. Homework is often used to give the student the opportunity to reinforce or practice the concept or skill that has been taught, and it is excellent for this. For instance, if a lesson has been taught on texture, the homework can involve having the student collect 40 texture rubbings from home such as: wicker, brick or stone walls, vents, grills, shoe soles, tree bark, etc. Thus, students will become more visually aware of textures in their environment and, hence, possibly more connected with and aware of the role of texture in artworks.

Art Fair or Evening with the Arts

Parents, grandparents, caregivers, teachers, community leaders, citizens, friends, and family can be made aware of,

and join in, celebrating the wonderful art experiences occurring in your school by attending an art fair. Send invitations. Host a punch and cookies reception. Coordinate with the parent organization for additional assistance. (The parent organization will love the resulting boost in attendance at their meetings if held the same evening.)

If rewarding students, proceed with caution, ensuring that the art fair is a positive experience for everyone. If awarding certificates, give participation certificates to *everyone* who enters. It is possible to recognize artistic talent and creative skills, especially for children who might not receive much encouragement in other school competitions, but recognition should not be given to some at the expense of others.

Train students to be docents who know how to guide their family members through the art exhibit, reminding them of proper gallery behavior (such as looking at the art, but not touching the art unless invited to do so by the artist). Collaborate with the other arts teachers (band, chorus, orchestra, drama, and humanities) and classroom generalist teachers, and make it an "evening with the arts" with school-wide exhibitions and performances throughout the evening. Then stand back and watch.

Students will display an extraordinary amount of art knowledge when serving as docents for the art fair, as they tell grandmother and grandfather all about the artwork on display. This is a superb way for students to share what they are learning, as well as a way of conveying information about the program to all who attend.

Observations and Direct Comments to the Student

One of the most common formative assessments in the art room involves the teacher simply observing the students as they work. Art teachers provide constant, formative, ongoing assessment while circulating the room, evaluating progress, and making comments to individual students or to the whole class.

The teachers' observations can be formal or informal in nature. For instance, a teacher will walk around the room while students are working on weaving and he or she will observe if students are in need of assistance. The teacher might assist the students verbally if they are struggling with weaving techniques (thus, conducting informal observations).

Teachers might also conduct a quick formal observation, especially in an extreme case (such as observed artistically

gifted qualities) in which they write down the student's name, fill out a checklist, or make notes that they later share with the student and/or with the parents of the student. The observations that a teacher conducts are varied and disparate. The same is true for what is recorded concerning them.

Proceed with caution when talking about student progress. Praising or providing uplifting comments to one student at the expense of other students can be detrimental to students' confidence, self-concept, and desire to make art. Be careful with statements about one student in the company of other students, such as bragging to an adult visitor, "Betsy is our 'class artist'… see what a beautiful painting 'she' made" (while the three other children sitting at the same table waiting in vain for praise of their artworks, are possibly thinking, "… Well, if 'she' is the 'class artist,' then I might as well not try to keep up with 'her'"). All teachers mistakenly make such statements, but the reflective teacher catches it, corrects it, and becomes a better teacher by learning from such experiences.

Self-Assessment and Defining Personal Success in Art

Art is personal. One of the many purposes of art is expression. It is important for students to be given many opportunities to convey their intent—to present, to perform, to talk about, to write about, and to help reinforce personal meaning and accomplishments. In this manner, the teacher will have clear evidence of the high level of engagement on the part of the student.

A simple checklist could be used by students, similar to the checklist that teachers use to assess students. In order for an assessment tool to fit into this category, students should be able to mark the parts that they have achieved with a checkmark or "X," or have the opportunity to write in "Yes" or "No."

Reflection is a useful assessment tool. While all self-assessments involve the students reflecting, this type of self-assessment involves the students actually writing their perception of their knowledge of a concept or ability to do a skill. This reflection can cover the spectrum, from a single sentence or a phrase to several paragraphs, or even pages, along with sketches, diagrams, and any other visual modes of communication. When reflecting, students write and/or sketch/label aspects of the information, skill, or concept that they understand, or still find challenging, as well

as their feelings related to working with the material or process.

Some students might arrive to class, sadly, with an "art phobia." They might say to the teacher, "I can't draw," or "I'm no good at art." Ask them, "If I were to ask you to change my bicycle tire, could you do it?" The student is likely to answer, "No." Then ask, "If I said that I would pay you $100 to change my tire a week from now, could you do it?" The answer will be an emphatic "Yes!" "How is that possible?" you will ask. Students will maintain that they would find someone to teach them how to do it so that they can get the $100.

The purpose of this thought exercise is to help students understand that knowledge and skills are attainable, and that if they do not feel that they have a particular knowledge or skill yet, they can attain it. This is the underlying principle of having students do self-assessment and reflection.

Sketchbooks and journals, which will be discussed in greater detail later, are wonderful tools for extracting and documenting reflections—what students are thinking and learning. Being given the freedom to write, cut, paste, draw, sketch, color, and communicate their thoughts with feelings of security and even excitement is a valuable method of assessing what students know, as well as what might come next for them.

So often, the voice of the child goes unheard in the classroom. Understandably, the teacher can only paddle so fast through an ocean overflowing with raised hands of students ready to capsize if they don't get to share their story. Encourage students to document their ideas, hopes, dreams, inventions, and images in a journal, sketchbook, or idea book. Regardless of what it is called, its important role of being there to listen to the child 24-7 cannot be overlooked.

Designing Assessments in Art

Adults, if being evaluated on job performance, would expect to know in advance the criterion on which they will be evaluated. It is fair to extend the same courtesy to children before they begin projects or tasks that are to be assessed.

Keeping age and developmental levels in mind, a rubric or checklist can be designed that will assess objectives for art lessons. Individual and whole-group critiques and discussions are also popular methods for assessing students' progress, and these can be both formative and summative in nature.

Art Critiques

Brief impromptu critiques are sure to occur in art class throughout each day if permitted. No doubt you have seen this before. One student excitedly announces, "Hey, look what happened on my paint palette!" Immediately, a few students scurry over and begin to examine and discuss the revelation. Before long, five or six young artists are discussing, analyzing, and critiquing, and the entire creative chorus is thinking in unison. Would the effective teacher allow this? Encourage this? Applaud this? Absolutely! Depending on how harmonious the group is at the moment, this might be a good time to let the students discoveries run their course uninterrupted, or it might be a good time to seize a teachable moment near the end of the impromptu elementary color theory critique and involve the whole class in a summary review.

Likewise, the teacher will initiate seemingly impromptu critiques. If the class (that has just returned from back-to-back recess and lunch) seems to be a bit lethargic, put on some soft and slightly up-beat music, stand up, take an "art walk" around the room, and look for inspiration. Ask some open-ended questions to reel in their attention. "Which artwork really stands out so far?" "Why?" "Do you see any two pieces that are the same?" "No?" "That's good." "Do you see an artwork with primarily warm colors?" "Do you see a painting that is purely mono-chromatic so far?" "Which is your favorite and why?" Then, of course, mid-project or at the completion of a unit, the teacher might hold another critique to sum up what students have learned and where they will be taken next.

Student Portfolios, Sketchbooks, Art Idea Books, and Other Evaluation Tools

Student portfolios are used as an evaluation tool in art programs. This collection of artworks, for one thing, provides an opportunity for a tangible demonstration of long-term accomplishments. In a mathematics class, a teacher might wish to see how the student arrived at a solution, and a demonstration of the thought process and the knowledge of the procedure. Similarly, portfolios and sketchbooks can be both summative and formative forms of assessment, providing both the student and the teacher with a record of thoughts, images, notes, sketches, questions, solutions, experimentations, plans, and other evidence that will appear within the pages.

Art idea books might be viewed as expanded sketchbooks with written notations of observations, environmental finds, and plans for their use and their relationship to the student's art. Some entries are suggested by the teacher, but many are independently inserted by the students. Idea books become a place to consider art in the students' lives and experiences, and also the place to record reactions to shopping, travels, plays, or performance events. Idea books are used to generate ideas for future artworks, as well as a way for the teacher to see tangible evidence of the student's individual growth.

The contents of the portfolio and sketch/art idea books are demonstrative through writings, diagrams, and artworks that require a combination of thinking and creative activity as young artists search for art ideas in various media. Each portfolio, sketchbook, or art idea book is used throughout the school year as an evolving resource for documenting artistic growth via reflection and for assessment. Again, as previously stated, regardless of what it is called, it is an important part of being there to listen to the child 24-7 and cannot be overlooked.

Art assessment is not as simple as 2 + 2 = 4. Rigid prescribed outcomes would be detrimental to students' creative growth. Students in art classes should begin to see themselves as artists, inventors, and shoppers, searching through a rich variety of art resources. There is a great rebuilding of students' artistic confidence in knowing that the art world has not been pre-invented for them and that their contributions and ideas are welcome.

Exit slips are similar to journal entries that students may utilize as formative assessments at the end of a lesson. Often, the exit slip will simply ask the students to list concepts that they learned from the lesson. The format can be completely generic and open-ended.

The formative assessment samples included in this chapter are only the beginning. Teachers (or students, for that matter) can be as creative as they wish when creating formative assessments. The only restriction is that the formative assessment truly assesses the objective that is trying to be fulfilled. Most importantly, objectives will be open-ended in nature and must always be age-appropriate for young artists as they take risks and are engaged in valuable art experiences.

NATIONAL STANDARDS AND STATE TESTING IN THE ARTS

While some states have adopted standards for visual art education and a few have tried and/or are attempting to assess the arts, a whole host of problems comes with these endeavors. Naturally, if teaching art in a state or school system with assessment standards, then the art curriculum must be aligned with the said standards. However, due to the high cost of creating, administering, and processing performance-based assessments, many attempts have resulted in resorting to pencil and paper tests. This has the potential to negatively impact on art programs, since well-meaning decision makers turn to teaching only vocabulary, taking the focus away from rich and meaningful art making explorations and experiences.

It is important to know the art standards in your school system, state, and nation. These may vary from school to school and from state to state where they exist. However the NAEA (1994) National Visual Arts Standards Task Force, whose membership consisted of Carmen Armstrong, Mac Arthur Goodwin, Larry Peeno, James Clarke, and Thomas Hatfield, is credited with the unprecedented creation of national art standards, which are sequenced by grade level, including Grades K–4, 5–6, and 9–12.

Each standard represents what students should know and be able to do before the end of each stated grade. "The Standards encourage a relationship between breadth and depth so that neither overshadows the other … and are intended to create a vision for learning, not a standardized instructional system" (NAEA, 1994).

For the sake of this text, a summary of elementary and middle-school NAEA Visual Art Content and Achievement Standards can be seen in Tables 4.3 and 4.4. The highly recommended NAEA publication, *National Visual Arts Standards*, can be found in its entirety by visiting the NAEA web site, where copies of this valuable resource can also be ordered for school systems (NAEA, 1994).

Table 4.3

National Visual Art Content and Achievement Standards by Grades K–4. (NAEA, 1994, Content taken from pp. 16–17, format adapted)

National Visual Art Content Standards Grades K–4	National Visual Art Achievement Standards Grades K–4
1. Understanding and applying media, techniques, and processes:	a. Students know the differences between materials, techniques, and processes. b. Students describe how different materials, techniques, and processes cause different responses. c. Students use different media, techniques, and processes to communicate ideas, experiences, and stories. d. Students use art materials and tools in a safe and responsible manner.
2. Using knowledge of structures and functions:	a. Students know the differences among visual characteristics and purposes of art in order to convey ideas. b. Students describe how different expressive features and organizational principles cause different responses. c. Students use visual structures and functions of art to communicate ideas.
3. Choosing and evaluating a range of subject matter, symbols, and ideas:	a. Students explore and understand prospective content for works of art. b. Students select and use subject matter, symbols, and ideas to communicate meaning.
4. Understanding the visual arts in relation to history and cultures:	a. Students know that the visual arts have both a history and specific relationships to various cultures. b. Students identify specific works of art as belonging to particular cultures, times, and places. c. Students demonstrate how history, culture, and the visual arts can influence each other in making and studying works of art.
5. Reflecting upon and assessing the characteristics and merits of their work and the work of others:	a. Students understand there are various purposes for creating works of visual art. b. Students describe how people's experiences influence the development of specific artworks. c. Students understand there are different responses to specific artworks.
6. Making connections between visual arts and other disciplines:	a. Students understand and use similarities and differences between characteristics of the visual arts and other disciplines. b. Students identify connections between the visual arts and other disciplines in the curriculum.

Creative Planning and Topics for Group Discussion, Activities, and Extensions

- Conduct an online search for a sample set of art standards for a school. Copy/print and save for future use. Briefly explain how what you have learned in this class thus far has prepared you to address the art standards. Likewise, what do you still need to learn?

- Interview a local art teacher. Ask for a copy of the art standards for which she or he is responsible. What support system exists to aid in the teaching of those standards? What constraints exist, and how does she or he overcome them?

- Compare your sample list of art standards to the National Art Standards. Are they aligned? Explain. Be prepared to discuss this in class.

- Do you feel confident that you can guide young artists in art experiences that will speak to the national standards? How so? What steps might you take to increase your art knowledge and skills?

Table 4.4
Visual Art Content and Achievement Standards by Grades 5–8.
(NAEA, 1994, Content taken from pp. 19–20, format adapted)

National Visual Art Content Standards Grades 5–8	National Visual Art Achievement Standards Grades 5–8
1. Understanding and applying media, techniques, and processes:	a. Students select media, techniques, and processes; analyze what makes them effective or not effective in communicating ideas; and reflect upon the effectiveness of their choices. b. Students intentionally take advantage of the qualities and characteristics of art media, techniques, and processes to enhance communication of their experiences and ideas.
2. Using knowledge of structures and functions:	a. Students generalize about the effects of visual structures and functions and reflect upon these effects in their own work. b. Students employ organizational structures and analyze what makes them effective or not effective in the communication of ideas. c. Students select and use the qualities of structures and functions of art to improve communication of their ideas.
3. Choosing and evaluating a range of subject matter, symbols, and ideas:	a. Students integrate visual, spatial, and temporal concepts with content to communicate intended meaning in their artworks. b. Students use subjects, themes, and symbols that demonstrate knowledge of contexts, values, and aesthetics that communicate intended meaning in artworks.
4. Understanding the visual arts in relation to history and cultures:	a. Students know and compare the characteristics of artworks in various eras and cultures. b. Students describe and place a variety of art objects in historical and cultural contexts. c. Students analyze, describe, and demonstrate how factors of time and place (such as climate, resources, ideas, and technology) influence visual characteristics that give meaning and value to a work of art.
5. Reflecting upon and assessing the characteristics and merits of their work and the work of others:	a. Students compare multiple purposes for creating works of art. b. Students analyze contemporary and historic meanings in specific artworks through cultural and aesthetic inquiry. c. Students describe and compare a variety of individual responses to their own artworks and to artworks from various eras and cultures.
6. Making connections between visual arts and other disciplines:	a. Students compare the characteristics of works in two or more art forms that share similar subject matter, historical periods, or cultural context. b. Students describe ways in which the principles and subject matter of other disciplines taught in the school are interrelated with the visual arts.

(© 1995. Adaptations of the National Visual Arts Standards: National, State, and District Examples. Used with permission of the National Art Education Association.)

ART ASSESSMENT SAMPLES

Sample journal or sketchbook prompts could be written on the board for students to respond to by sketching and/or writing in journals, sketchbooks, or idea books. Being ever-mindful that the "journey" is more important than the final "destination," some assessment samples are included below (see Figures 4.2–4.8). These can be used in schools where evidence of art assessment is required.

While some forms of art assessment are more qualitative (i.e. student narrative about progress), some are more quantitative (i.e. rubrics, scores), some are more formative (i.e. sketchbook entry), and some are more summative (behavior rubric), the teacher of art might find the resulting data to be helpful as yet another tool for communicating what students are learning and to assist with decisions regarding what direction might be taken next.

Education is simply the soul of a society as it passes from one generation to another.—G.K. Chesterton

Please draw, sketch, and/or write responses to items below.

Student's Name: _____ *Today's Date:* _____

Today in art class I:

Tomorrow I plan to:

FIGURE 4.2 Sample Exit Slip 1

Please draw, sketch, and/or write responses to items below.

Student's Name: _____ *Date:* _____

My favorite thing about art class today is:

Because:

- -

A concept I am working on is _____.

At this point, on this concept, I am: *(circle one)*

Just starting **Doing okay** **Doing well** **Doing excellent**

FIGURE 4.3 Sample Exit Slip 2

List 3 of the primary art elements and/or principles of design that you used, <u>and</u> tell how you used them in your project:

1.

2.

3.

Other comments for the teacher?

FIGURE 4.4 Sample Open-Ended Exit Slip for Middle-School Students

Self-Assessment Scoring Guide

Student Name: _____

4	• I worked on the project until it was completed, and used my time wisely. • I pushed myself to continue working even when I felt challenged, I took risks as needed, and I gave 100% effort. • I treated peers with respect and art materials properly. • I was completely successful in meeting the objectives, which were: _____ _____
3	• I worked on the project until it was completed, and mostly used my time wisely. • I somewhat pushed myself to continue working when I felt challenged, I considered risks when needed, and I put forth good effort. • I mostly treated peers with respect and art materials properly. • I was mostly successful in meeting the objectives, which were: _____ _____
2	• I worked on the project but did not use all of my time wisely. • I tried some processes or skills but when I felt challenged, I did not continue, I did not take risks that were required, and I only put forth some effort. • I either did not treat peers respectfully or the art materials properly. • I met some of the objectives, which were: _____ _____
1	• I put very little effort in the project. • I did some work on the task but then quit. • I was distracted or distracted others or damaged art materials. • I barely met any of the objectives, which were: _____ _____

FIGURE 4.5 Self-Assessment for Middle-School Art

Open-Ended Confidence Questionnaire	
1.	How do you feel about the painting you created today?
2.	How do you feel about your ability to use the painting techniques that you tried today?
3.	Which art materials would you like to try next?
4.	Which techniques did you like most? Why? Which ones would you like to continue working on?

FIGURE 4.6 Sample Open-Ended Confidence Questionnaire for Middle-School Art

Criteria	Possible Points	Points Earned
Art project submitted	4	
Project submitted on time	3	
Evidence of effort/quality	5	
Listened to and utilized the teacher's constructive criticism	5	
Treated others, and materials, appropriately	4	
Complete	4	
Total		

Comments:

FIGURE 4.7 Sample Art Scoring Guide

25	20	15	10	0–5
The student worked consistently throughout the entire class time.	The student worked during most of the class time on project.	The student worked during most of the class time on project.	The student worked during some of the class time on project.	The student worked very little or not at all during class on project.
Constructive criticism from the teacher *was* accepted, and utilized.	Constructive criticism from the teacher *was* accepted, and utilized.	Constructive criticism from the teacher was *not* accepted, nor utilized.	Constructive criticism from the teacher was *not* accepted, nor utilized.	Constructive criticism from the teacher was *not* accepted, nor utilized.

FIGURE 4.8 Sample Art Participation Rubric

Section Five Art at Home and in the Community

All teachers hope and dream that their students will continually develop their inquiring minds, even when they are not in school. No matter how much time we spend with our students, we always wish we had more, and at the end of each school year, there is always some regret that we did not have enough time to teach all that we had planned.

Consider how we might arm children with the intellectual tools to increase their knowledge—even when we are not with them. It has been said that "inquiring minds want to know." How might we tempt students to want to keep learning even after the last bell has rung for the day? What might we do to increase learning experiences and extend the classroom to the home and the community? What will it take to entice students to make connections between art education at school and art in the rest of their daily lives?

DISCOVERING ARTISTS AND COLLECTORS IN THE FAMILY

Many books have been written and numerous college classes have been taught in an effort to help students understand the definition of "art." It is good for younger students to also begin to think about how they define art and indeed, to consider in what ways art is a part of the past, present, and future. What is art? What isn't art? If it's not pretty, can it still be art? Does it have to be functional to be considered art? Does it have to convey a message to be art? What is subjectivity? Does someone have to wish to purchase it for it to qualify as art? Why do you have something different hanging on the wall over your couch than I have over mine? How is this coffee mug that I made different from the one that came from the local discount store?

If asked to bring a work of art to school from home, it is likely that a wide variety of objects will appear in your classroom once students' definition of art is initiated and expanded. In their homes, students are more likely to have examples of all sorts of art: ceramic mugs/plates/bowls, paintings, drawings, hand-made quilts, hand-made dolls, wooden carvings, woven throws or rugs, stitchery, jewelry, cross-stitching, crocheted afghans, knitted hats, hand-made kites, stained or blown glass, sculpture, woven baskets, photography, prints, painted rocks, etc.

The art teacher can help young students to be more aware of artwork that exists within their immediate environments and, indeed, in their very own homes and also that they might have artists under their roofs or even in their extended families. Young people will have a greater appreciation for a hand-made quilt once they learn the difference between it and a machine-made quilt. When we teach young artists to look more closely, they will soon learn how to know if a quilt has been machine or hand sewn.

Once children have created weavings out of paper and yarn, they will have a deeper understanding of the hard work and talent involved in weaving an entire blanket. These art thoughts will creep into children's daily lives, even without the physical presence of the art teacher, as the young artists begin to see things differently and continue to make connections within their personal environments.

We want children to think when they view and create art. Good comparisons can be made. One person might have an abstract photograph of a flower over her couch, while another has a wooden sculpture of a bird, and yet another has a clay sculpture of praying hands in her home. Are all three of these examples of art? Which one is the best art, or is one best? Why do we all have different artworks in our homes? It is fun to lead young people to an understanding of "subjectivity" and to open their minds to allow expansion of their ever-changing definitions of art.

EXPANDING SCHOOL ART LESSONS BEYOND THE SCHOOL

Students studying package design and purposes of art can easily demonstrate what they have learned by taking a field trip to the grocery store. (Ask the store manager's permission first.) Upon arrival, tell the students to spread out. They are to each find a product that they believe will sell well because of the design (composition, use of art elements and design principles). Meet back in a designated area in 10 minutes to have an informal critique. After discussing effective designs, send students back to the aisles to search for an example of "ineffective" design. Gather again and ask students to discuss why the art elements or principles are "not" effective, and what could be changed to improve the package design. Graphic design is one art

career in which people are paid to know and utilize such knowledge.

As students move through the store aisles and, at various intervals, participate in critiques, they will be engaged in one of the highest levels of thinking. The young artists will study hundreds of packages, make selections based on knowledge, analyze product packages, and justify their opinions later via group critiques. Here, the teacher is a facilitator, while the students are led through exercises that will possibly affect the manner in which they visit stores and view their home cupboards for evermore. This exercise can also occur in the art rooms if students and/or teachers bring items from home.

Similarly, students can visit a discount store and comb through the aisles for items that could be used as alternative paintbrushes, drawing instruments, or printing tools. This search is likely to help students make the connection between school and home/community. In other words, it will reinforce the thoughts of continuing to make and learn about art outside of the classroom. Again, this exercise can also occur in the art room after asking the students to discover and bring in items from their homes.

After an introduction to portraiture, the students might visit a nursing home or veterans' home where they will find many willing models to sit and pose for portrait drawings. Why not develop a partnership with a nursing home or local business?

The school building might prove to be the unique example of architecture for a perspective drawing, but there are sure to be additional landmarks in town ready to be drawn. Students constantly visit locations that will make wonderful entries in their sketchbooks, such as: nursing homes, farms, gardens, restaurants, museums, galleries, holiday celebrations, parks, beaches, swimming pools, and shopping malls. Encourage the students to document such visits, as well as their ongoing thoughts, plans, drawings, discoveries, and inventions.

In the tri-state area of Kentucky, Ohio, and Tennessee, those who travel on public roads are treated to 8′ × 8′ quilt square paintings, mostly on the sides of barns. Many of these were created by elementary- and middle-school artists who, alongside many adult artists, have now played a role in preserving the important history of quilting traditions.

Local art fairs often host hundreds of professional artists. Sometimes all it takes to get students to attend such events is to extend the invitation. Make them aware of the event by sending a show card home or post the announce-

ment on the school or art program web site. Offer extra credit or a free hand-made sketchbook (made with book binder or with other easy bookmaking techniques) to any student who attends. As proof they attended, the teacher might ask the student participants to sketch and/or interview and/or photograph the experience. Students will enjoy drawing in these locations and from real life experiences, such as the zoo, aquarium, farms, food court at the mall, restaurants, etc.

BUILDING COMMUNITY SUPPORT FOR SCHOOL ART PROGRAMS

The more visible the art program, the more support it will gain. The more support an art program gains, the more visible it will become. Such is the cycle of an effective art program when it experiences positive growth. The teacher has the privilege of orchestrating much of this circle of the art program's life, but this task will not be quite as daunting for the teachers who train and recruit assistants, such as students, parents, other art teachers, community members, local entrepreneur partnerships, etc.

First, it is important to remember that other teachers, parents, administrators, and community members might not be as "enlightened" about the important role of art in the lives of young people as we would like, but that does not mean that they cannot learn. The art teacher's primary duty is to oversee the art education of the elementary or middle school students; however, often we have to take time out to educate the adults who also reside in the school environment.

If someone does not realize the importance or the role of the art program, do not take it personally. Remember, someone who is passionate about science might not have an equal love or understanding of social studies. Someone who is a math whiz might not have a very deep appreciation of the physical education program. It follows that those who have modest amounts of exposure to the arts might need a little help in understanding the exciting and vital role that visual art education will play in their young people's lives.

As the art teacher diplomatically teaches all (the students and the adults) about the importance of art, there will be many opportunities to connect and network with those in the community. Start with a parent flyer asking for anyone with artistic skills to volunteer to share them in some way. Also leave the door open for any type of parental support.

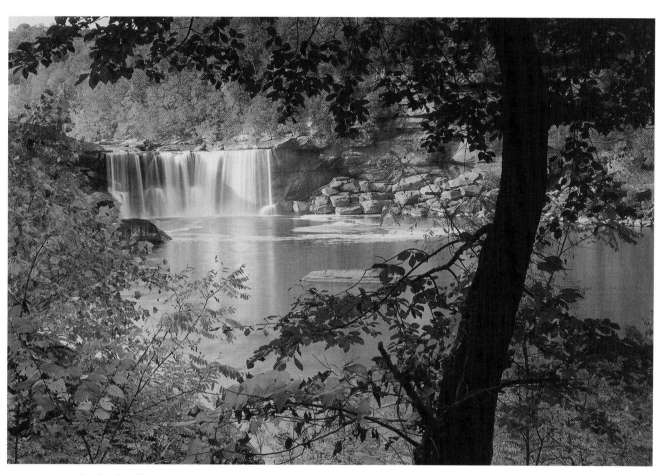

PLATE 4.1 *Cumberland Falls:* An original image from a calendar published by nature photographer Ora Warren Alsip of Corbin, KY (www.cumberlandfalls.org)

PLATE 4.2 Inexpensive Canvas: Light switch cover used as a painting surface, and embellished with permanent marker

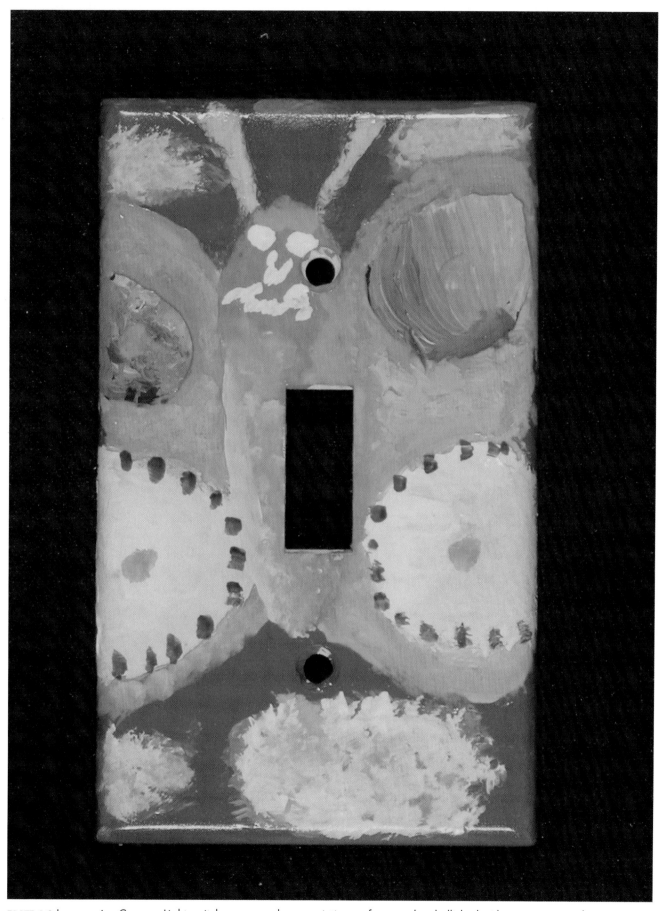

PLATE 4.3 Inexpensive Canvas: Light switch cover used as a painting surface, and embellished with permanent marker

PLATE 4.4 Triple or Double Light Switch Cover: A unique and inexpensive painting canvas

PLATE 4.5 Non-traditional Painting Surfaces: Rocks

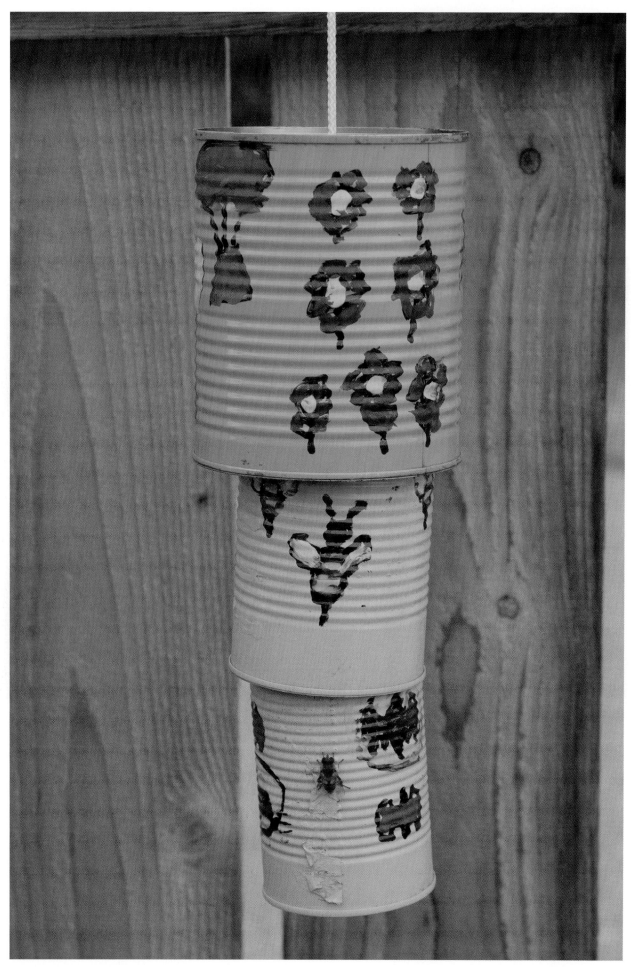

PLATE 4.6 Non-traditional Painting Surface: Painted cans

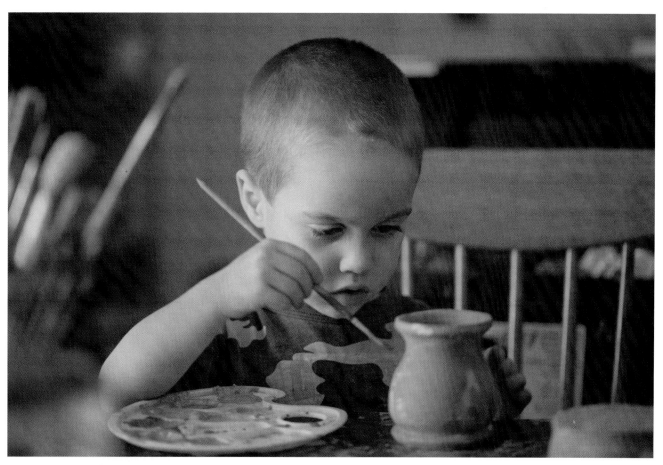

PLATE 4.7 Non-traditional Painting Surfaces: Terra cotta pots, from an end-of-summer clearance sale, accept paint beautifully

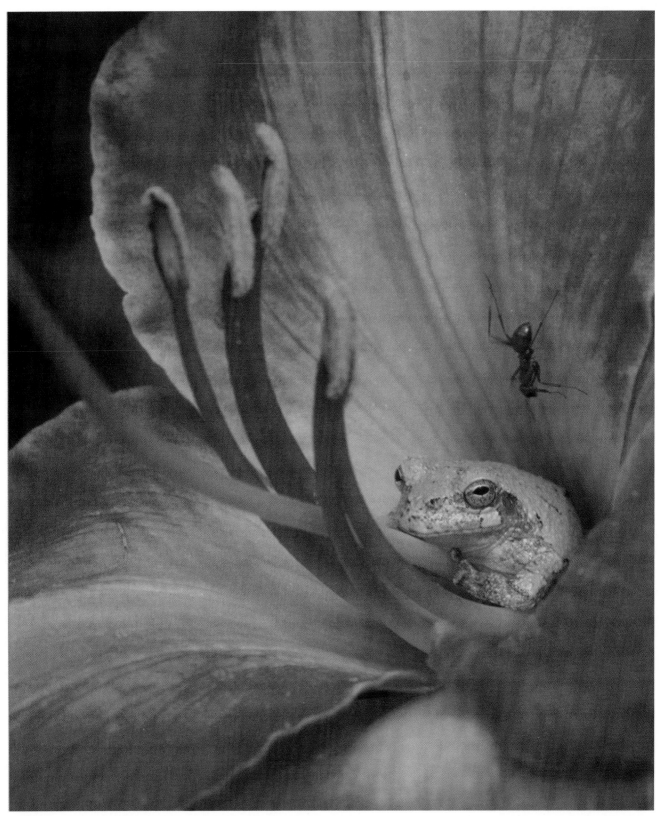

PLATE 5.1 *Frog in Lily Bloom:* Original photo captured during rain storm by nature photographer Ora Warren Alsip of Corbin, Kentucky

Often, parents want to support the teachers of their children, but they only need to be asked.

Create videos of community artists in action (printing press process, potter, weaver, painter, etc.) and invite students to do the same. Record videos of a poet or musician giving a performance and share it with art classes. Bring popcorn occasionally and gather to watch community artists in action via digital recordings. Invite a local artist to give a presentation in your class or take students into the artist's studio. Take students, with sketchbooks in hand, to a local gallery or art museum. Just think of the many, many ways that you can increase the amount of art education for young artists—who will always be hungry and eager for more.

Creative Planning and Topics for Group Discussion, Activities, and Extensions

- Bring to class one item from your home that you consider to be art. Be prepared to share it with the class.

- Photograph an artist in your family (or community) who is actively engaged in making art. Be prepared to describe her or his artwork. What and why does she or he create? What inspires her or him?

- Locate a child dinner/activity place mat at a local restaurant that you feel could do a better job to allow for children's creativity. Re-design it, providing a more open-ended task that allows children to draw, rather than merely coloring in lines that have already been drawn for them.

- Using a digital camera, visit a local grocery store, and with the store manager's permission, create 10–15 images that can be used to teach about an assigned art term (such as art principles and elements of design). Red and green peppers are often placed next to each other in the produce section, for example, because they are complementary colors, and they visually "vibrate" next to one another. Load images on a disk and be prepared to present and discuss them in class.

- From home, bring in one example of an effective package design (i.e. a cereal box that has effectively used complementary blue and orange as the dominant color scheme). Be prepared to participate in an informal critique/discussion of all products. As an extension, consider redesigning a product package and/or bring in an example of poor package design.

- Consider other items that could be analyzed and critiqued or re-designed, such as book illustrations, greeting cards, compact disk covers, book covers, T-shirt designs, wallpaper, gift wrapping paper, posters, lunch boxes, pencil boxes, umbrella surface designs, scarves, fabric designs, etc. Make a list of possible prompts that might serve as a good springboard for an elementary art student project.

Reference Books and Resources to Read, Look At, and Share With Students

Brockman, D. L. and Lanham, S. L. *Can You See the Cow? A Primer for the Beginning Teacher*. Richmond, KY: Ginormous Press, 2009.

NAEA. *National Visual Arts Standards*, 1994. Retrieved from http://www.naea-reston.org.

Wong, H. K. and Wong, R.T. *The First Days of School: How to be an Effective Teacher*. Mountain View, CA: Harry Wong Publications, Inc., 2009.

Art Students as Artists

Discovery consists of seeing what everybody has seen and thinking what nobody has thought.–Albert von Szent-Gyorgyi

Section One Art Discipline

Artists find inspiration in many places, and they benefit from viewing artworks made by other artists, as well as interacting via their senses with their personal environments. Artists might find inspiration and develop ideas based on what they have seen, heard, touched, smelled, or even tasted. However, when it comes time to put brush to canvas, chisel to stone, or pencil to paper, the moment has arrived for the artist to pull it all together, to look inward, and to make critical and creative decisions. Hundreds, maybe thousands, of stimuli might come together at one moment in time to be utilized by the artist, who ultimately is the person who decides what to do—specifically how and what he or she will create each step of the way. Indeed, it is clear that creative and critical thinking are no strangers to the artist.

Throughout the creative act, accomplished artists formulate routines in which they work from beginning to end, combing through thoughts and then possibly moving on with sketchbook entries, notes, thumbnail sketches, color studies, materials and process selection, and finally the creation of the artwork or art series. One artist might be in the habit of making hundreds of sketches before beginning the actual artwork, while another artist might be accustomed to only making a few drawings and studies in a sketchbook, and yet a different artist might prefer to skip all of this and just work it out directly on the canvas with no preliminary sketching at all. Just as adult artists develop self-discipline, we can assist young artists as they search and develop personal, artistic, and age-appropriate routines that will allow them to grow as creative individuals and critical thinkers. It cannot be denied that this will serve them well in life.

Art is the most intense mode of individualism that the world has known.–Oscar Wilde

THE SELF-DISCIPLINE OF THE ARTIST

Allowing students to have choices and freedoms, such as those mentioned in previous chapters, sends the very important message to students that their choices are valued. This improves self-concepts and increases confidence levels, which are characteristics that are directly related to important life skills. Equally important, it also opens the door for students to put on the hat of inventive, creative, inquisitive, and critical thinkers. By allowing students to try on and become very comfortable in these hats, we are essentially clothing them with experiences necessary for becoming self-disciplined artists.

It is important to note that decision-making skills can be learned only by allowing students to make decisions. The art room is the perfect place to think, explore, invent, pretend, and create; it is a place where students will become accomplished problem solvers as they wonder and ask good questions.

What materials shall I use for my print? Shall I use this rectangular shape, or do I want to change the shape of my paper? Do I need a hole-punch or a pair of zigzag scissors to change the edge of the paper? What do I prefer? What is my plan? What color best suits this plan? Does my painting need a figure, a shape? What kind of shapes? Geometric? Organic? Both? Where shall I put them? What would enhance this group of colors I've used so far? Look what happened when I dropped red paint on this yellow area and they mixed together … Hmm … I wonder if I could do that again. I wonder what yarn would look like in that area of my painting. (My art teacher is so cool to allow me to retrieve a piece of yarn without having to raise my hand and waste time waiting for her to call on me.) Should I try drawing with colored pencil or permanent marker

on this dry area of my painting? Does it need anything else? Am I finished? Shall I mount or frame this artwork, and in what way will I do this? Should I display my finished piece? I wonder what will happen if I use some of these techniques and thoughts in my next artwork.

When students are permitted, and encouraged, to make decisions, before long they will feel confident and comfortable with the acts of creative and critical thinking.

With practice, students will attempt to tackle problems on their own, without always asking the teacher for the solution. The number of times they say "I can't" will decrease since there is an increase in how often the young artist says "I can." They will discover that there is almost always more than one creative answer to each problem that they encounter in the art class and in life and that they are more than capable of arriving at wonderful solutions. Young art students will learn that the teacher is not the keeper of all knowledge or the only person in the room who can solve problems.

This process will also involve discipline on the part of the teacher, who might sometimes be tempted to take the seemingly easy route and think *for* the child or complete tasks *for* the child, rather than assisting or offering advice and then stepping back to allow the student to learn from doing and thinking. Indeed, this process involves varying degrees of encouragement from the teacher since all students (and teachers) are different. It will be a pleasure to watch children who will, at their own pace, become confident, self-disciplined, critical, and creative thinkers.

Expression, one of the many purposes of art, occurs on the part of the students when they are given opportunities to communicate, think, decide, select, choose, and shop for their own ideas and art materials. There is a likelihood that all students might not arrive on the classroom doorstep already completely comfortable with having the freedom to think; nonetheless if given repeated experiences with being encouraged to utilize their license to be unique, creative thinking will soon become part of their routine. In other words, they will become accustomed to being permitted to think.

"Ah ... now we're getting somewhere ..." and "We've moved to a new level ..." the teacher will think. This is when art becomes even more interesting, if you can imagine, because this is where teachers begin to connect with their students and learn about what they think, dream, wonder, enjoy, question, know, and want to know.

Children's art, when uninhibited, is one of the most beautiful, creative, and aesthetically pleasing things on the earth. It seems as if Pablo Picasso saw some of this beauty

when he said, "It took me four years to paint like Raphael, but a lifetime to paint like a child." Likewise, he must have understood some of the dangers of children being stripped of what makes their art so unique, uninhibited, and personal when he said, "All children are artists ..." but that the problem is how to "remain artists" once they grow up.

As student confidence grows and as it becomes routine for young artists to expect the unexpected in art class, they will become accustomed to and excited about their artistic behaviors. Indeed, they will feel free to plan personal directions, select their own materials, and express their own thoughts and ideals with broad, open-ended prompts from the teacher.

Please note that the art teacher is not totally divorced from their students' artistic behaviors. It is quite the contrary due to the fact that we, as teachers, will be busy listening to students, guiding them, advising in cases of technical difficulties, keeping them safe, discovering who they are as individuals, offering relevant insight, and applauding and encouraging their unique ways of thinking and creating. Art teachers have the unique responsibility of helping to guide students to think about their life experiences, likes, dislikes, culture and environments, and their ideas for creative expression via art.

What art teachers should not do is require students to carry out paint-by-number-style lessons or cookie-cutter visual projects that involve little thinking or spontaneity on the part of the child, ones that show no regard whatsoever for the child as a valued and unique individual, or ones where the teacher has already made all of the decisions.

Art is an adventure into an unknown world, which can only be explored by those willing to take the risks. –Mark Rothko

ROUTINES AND ORGANIZATIONAL SKILLS REQUIRED FOR ART MAKING

Schools need routines. Art classes must have some structure and method of organization. The box of yarn is useless if the classroom is so disorganized that no one can find the box, and of course, students will never know just how fine a fine-tipped permanent marker can be if it is buried under mounds of other art supplies.

The teacher is in control of the art class, and while some structure is necessary, it must be appropriate for the day's art experiences. Yes, some routine is needed so that the classroom will not be haphazard, but each student must play a role in important decisions from planning and selecting materials to the outcome of their individual art

explorations. If every step of an art experience is dictated to students, then the result will lack any possibility for students to be inventive, creative artists, and we might as well have students leave their minds at home. Yes, some routine is required; yet, the essence of art is often unexpected, unprescribed, and unpredictable. Albert von Szent-Gyorgyi, the Hungarian scientist and Nobel Prize winner, maintains that "Discovery consists of seeing what everybody has seen and thinking what nobody has thought." Art should involve the awakening of student ideas, motivation, high interest, wonder, and critical and creative thinking.

When going about the daily business of school, the teacher should be inventive, creative, and willing to serve as a role model for students. How can we expect the students to be creative if the teacher does not model creative behavior? If we wish for students to value and see the importance of reading, we should allow them to see us reading or hear about our favorite authors, illustrators, and books. If we want young people to value art, and to see that it can involve most everything in our daily lives and to gain artistic confidence, then we must model such behaviors ourselves.

Perhaps one of the greatest challenges for teachers of art is to incorporate the creative into the mundane, treating the art room as a canvas and all spaces and materials as possible avenues and vehicles for creative explorations. The teacher who treats the art class in a "business-as-usual" manner is implying that art is no different than any other subject in school.

The act of taking account of which students are present, for example, can be approached in simple, yet unique and creative ways. How we begin each class sets the tone for the remaining time. As students enter the room each day, they might be asked to sign the board or poster paper in a creative manner (i.e. a quick sketch next to their name of a favorite animal or candy, car, subject, hobby, or vacation spot). The teachers who are "facilitators" of the classroom send a powerful message about their creative personalities, even by how the room is arranged and organized or how daily attendance is taken.

I am always doing that which I cannot do in order that I might learn how to do it.–Pablo Picasso

TEACHING STUDENTS TO BECOME THEIR OWN ART TEACHERS

Every act of artistic preparation is significant. Each act is more likely to be effective if students are involved in the process from beginning to end. We know that teachers will

not be successful in teaching children to engage in critical or creative thinking if they assign predefined art projects where all of the decisions, from planning to the set-in-stone outcomes, have already been decided. Students must be involved. They must learn to judge their creations in the planning stages, throughout the process, and at the end of each process.

> What do I like about this piece? What area of this work needs to be changed? Is it finished? Was the original intention carried out? What is the work's most meaningful aspect, and should it be pursued in future works?

Children will greatly benefit from being thus engaged along the way.

Young artists need to learn to observe so that they can describe the visual qualities of the art. In order to do this, students need to develop concepts that will help them to identify certain characteristics of an artwork. They need to acquire the ability to compare and contrast the visual elements of a single work and to see similarities and differences among works. To enhance their understanding, young artists need to compare their works with the works of other artists. Students need to be able to see alternative solutions that are available to the problem posed by the work. They also need to know how they feel about their works and recognize the tastes, values, and preferences the artwork represents.

In order to do this, students must be taught to see. Too often, students are told *what* to see, rather than being taught *how* to see. Students who visit art museums are often forced to fill in answers on questionnaires. Often, the fact that students have been kept "busy," coupled with the resulting lack of discipline problems, is mistaken for the act of learning. In such instances, teachers might later check for the "correct" answers and compliment youngsters on their ability to stay busy and out of trouble, even though little to no learning has taken place. In such cases, essentially, teachers are keeping students from really seeing and experiencing the artwork. Reconsider what might be a better use of time spent in an art museum.

Teaching students to *see* in a museum or in their own work must be done in general terms; otherwise, students' responses will not be creative or personal. Truly seeing an artwork is not merely a matter of responding to questions raised by someone else but of posing relevant questions oneself.

"What is the name of the painting of a man wearing a red hat?" is an example of a question that will fall short of helping to teach young people to see. Such factoids belong

in trivia games, not in children's museum trips, since they will result in children quickly scurrying past and ignoring important artworks while they pay attention only to the "hat" they need to find.

Less energetic children might even copy the answer from someone else's paper and miss seeing the art altogether. Consider, instead, more open-ended questions, prompts, and activities that will pull students into the artworks and lead to the construction of their own questions.

With idea books in hand, young artists can learn to look at, learn from, and be inspired by the artworks of others. Consider the possible prompts for students. "While viewing the artworks, sketch thoughts in your idea book that relate to your artworks from the past, present, or future." "Write questions that you have for the teacher or to museum docents about any artworks that you see." "Which artwork do you think is the prettiest, ugliest, funniest, most valuable, most like one of your works, or scariest, and why?" These are prompts that are more likely to capture and hold the attention of young minds.

Students need to feel free to consider all questions that may guide the creation of their own artworks. In other words, teachers must resist the temptation to give "canned" questions that will lead to "canned" answers that require little to no thought and are unrelated to students as individuals.

In an art gallery or museum, young artists can partake of the visual and intellectual feast for the eyes and mind. We create circumstances where they will bring to the table what they know, and season it with what they will learn. Being permitted to examine and question in this manner can lead to delightful treats *during* the visit as discussions brew throughout the gallery.

Important dialog can and should take place in the midst of the artwork, as well as before the visit. After the museum visit, conversations can be carried into the classroom for additional, related group discussions and individual projects as well.

The teacher might ask more open-ended questions and/or give more prompts such as "Select the painting that has the strongest impact on your feelings—one that causes you to feel happy, sad, excited, or any other emotion. Describe the artwork. Explain why it makes you feel this way."

The teacher might also ask, "After viewing this exhibit, what would you like to do next to your work in art class, and why?" This line of thinking, whether in the classroom, museum, or gallery, involves the students' personal, artistic interests. Discussions can occur that will be valuable to the students' ability to practice critical and creative thinking in life and, of course, in class.

Teachers must also allow students *time* to think. Too often, teachers put a halt to student thinking by falsely accusing students of not being busy. In reality, the student is busy thinking. Seemingly inactive states often need to be viewed as possible productive periods because art making requires pauses. Changes are often made in a work without touching it. Indeed, an artwork is often made by thinking about it as much as by active physical contact.

The effective educator teaches students that they might step away from the artwork and look at it occasionally from a distance. "Seek a unique perspective. Think about it. Examine it. What do you like? What is working? What do you think? What will be your next direction?" Time spent waiting, or away from one's work, is often useful because it allows contemplation of the work's possibilities. Periods of time sitting still in front of a work, or temporarily walking away from it, are often necessary to the thought process. They may be described as periods of creative contemplation, a worthwhile art, and life, skill.

Unfortunately, creative contemplation is seldom tolerated or encouraged in schools. A pause implies being stuck, or the need for teacher assistance. Often, the act of leaving one's work, if only to think, might be regarded as an act that might possibly lead to disruptive behavior. Walking away from one's artwork for short periods should be permitted in school. Students will return to their work with a different outlook, a new approach to completing the task, and/or a new understanding of what they are trying to create.

The aim, then, is to develop students' critical and creative thinking abilities. With each new artwork, students learn to determine what is progressing well, what shows promise, and what needs to be further pursued. Each student becomes his or her own best audience. Students who regularly evaluate themselves are better prepared later to thoughtfully and knowledgeably discuss their own works, as well as the works of others.

It is likely that most of us have had to sit through college studio art classes dreading or fearing the critiques. We know there needs to be another way for young artists if we are to accomplish our mission. While it is important to talk about one's work and present it to an audience, the experience should be a positive and supportive encounter. During reviews of completed works, the child should retain the authority and tell others about plans, disappointments, and what they still wish to accomplish. Remember, it is the "journey" that matters more than the "destination."

The class can be taught to respect the artist as having the expert opinion of the work. Everyone can contribute a few kind words or supportive comments, mentioning something that they observe and appreciate in someone's art. "What I like best is the way she"; "In my opinion the most interesting part of his painting is"

Ultimately, we make only one work in our life, one artwork (a continuous process) that has many breaks or stops as it is being built. Art making is about welcoming change and fostering the ability to set directions and hopes for the next work as we become more comfortable in our role as independent, critical and creative thinkers and makers of art.

Self-criticism is an important step toward artistic independence. Outside criticism can be valuable because it encourages students to reflect about their works, but it cannot substitute for the student's own evaluation; students need to move away from total reliance on the teacher. Who best knows the student's dreams, ideas, and plans? The student is in the best position to judge where the work is coming from and where it should go.

Students simply need the opportunity and confidence to make their own choices. The art teacher's role is partly to encourage young artists to look for their own ideas and to first look to themselves for answers. We want our students to feel free to question, to invent, and even to alter our assignments. Our goal should be to create an environment in which young people feel free to dream and to create the most unusual things, to take risks, to have successes, and to make mistakes.

It is perfectly natural for some students to feel frustration or to sometimes walk away from class a bit dissatisfied with their art. As American poet Turmerica reminds us, "Frustration is the compost from which mushrooms of creativity grow." This is a positive artistic response if the student comprehends the problem and is able to devise ways to change the artwork. Reflecting on the problem by writing or sketching can help the student to sort out ideas and gain a better understanding of where to go next.

> *The best way to have a good idea is to have lots of ideas.*
> –Linus Pauling

PERSONAL GOALS, ART NOTES, PLANS, AND IDEA BOOKS

The idea book can be viewed as an expanded sketchbook, with students' written notations of observations, environmental finds, and plans for their use and their relationship to their art. It accompanies young artists, even when they are not in art class, as a warehouse for text and images that might lead to other artworks. Brainstorming is an idea-generating exercise that is practiced by writers and artists. The idea book is a perfect home for recording and savoring good ideas. As American chemist, and winner of two Nobel Prizes, Linus Pauling suggests, "The best way to have a good idea is to have lots of ideas!"

In preparation for the creation of an artwork, looking at the art of others can be useful in helping to sort out ideas. In the idea book, when art is used to learn about art, the student can imitate; vary the medium, movement, or scale; write about it, or simply examine the work through drawings from different angles.

In order to set a good example for students, the teacher should carry his or her own idea book, thus modeling the powerful role that such a resource can play in one's life. They might present it from time to time throughout the school year, demonstrating to young artists that they too can develop good habits as they learn to create and document questions, and record ideas, thoughts, and observations in their idea books.

As discussed in Chapter Four, the student portfolio will be a principal evaluation tool for the program, and the idea book is linked to the portfolio as it stirs up ideas that are used in art portfolio entries. Combined, these resources provide us with a look at students' artworks, but they also speak to the degree of children's artistic thinking and their ability to function as artists.

Some entries might be suggested by the teacher, such as: reporting on or responding to a particular school sponsored event or performance, brainstorming about what art means to the student, considering scrapbooks and collections of interest to the student, making illustrations of ideas the child might have about inventions or future art projects of interest, etc. Teachers might suggest similar topics in the course syllabi, the school art web site, handouts, daily reminders on the board, and/or art program newsletters.

Other idea book entries will be independent inserts by students. Idea books become a place to consider art in one's life and experiences, and to record reactions to daily life such as: travels, shopping, plays, performances, concerts, sports events, county fairs, etc. The idea books are used to generate plans for artworks, but they also provide a venue for reflecting, which, with time, equips students with the ability to habitually look closer, think, analyze, and create without being prompted by anyone or anything other than their own minds.

Events can be analyzed through photographs, sketches, and writings, and they can be discussed in terms of art materials, subjects, and movements related to art. Reports on favorite books, sleepovers, special occasions, family celebrations, walks, school dances, home chores, birthdays, or outdoor activities can be included. Children build early boundaries around their art views and learn to guard these fences. The idea book will be a home for discussions and observations as students form their own opinions, develop their art definitions, and expand their minds.

An illustrated self-study, authored by every class member, can appear in idea books. Young people can discuss their favorites (music groups, poems, books, holidays, or places to visit). Children can discuss their changing views of art, including the many art sources and ideas gained from the art class. This serves as one source of evidence of how students' perceptions have broadened throughout the academic year.

Prompts will be given by the teachers of art, but students will also be encouraged to make impromptu entries at any time they wish by keeping the book with them whenever possible and by pasting in bits and pieces of daily collections whenever they like (such as an original sketch or art idea on a restaurant napkin or an image that stimulated an idea found in a magazine or part of a greeting card that triggered an idea for a poem or painting, or a movie ticket or compact disk cover that they enjoy or would like to redesign).

As children become accustomed to wearing the hat of the artist, the idea book and all that it encompasses will be a multimedia documentation that encourages students to search and sample the environment through teacher-suggested research, as well as independent thought. Some collections that might make appearances in idea books are labels and price tags, rubbings of real textures, manipulated photocopies, accidental or planned photographs, rescued junk mail, flyers, brochures, movie or concert tickets, invitations or appreciation cards, scrap gift wrap paper, or unusual restaurant menus and placemats.

Children's abilities to look for and design new art ideas can be included in the idea book as students experiment with various printing tools; create an ongoing series of drawings or self-portraits using various media; try out new weaving, drawing, and painting tools and art surfaces; and investigate new building materials or color applicators. Students might try painting with a bingo dabber, try out crayon drawings on sand paper, make prints with a potato masher from the kitchen drawer, or add to their texture collection by pasting in a rubbing of the bottom of their favorite shoe.

The implication is that all art has not yet been invented. Art is not pre-defined; contributions are still needed from future artists, and there are no age restrictions for creative contributors. This is exciting news for elementary- and middle-school students and teachers of art.

The idea book entries will demonstrate, through writings, diagrams, artworks, and object samples, that art requires a combination of thinking and creative activity as elementary- and middle-school students search for art in various media and environments that they encounter. The combination of the art portfolio and idea book is used throughout the school year. It is, for one thing, a storage unit for artworks and ideas that evolve and grow along with students. Once this good habit takes hold, students will arrive on the art teacher's doorstep on the first day of each school year ready to share and bubbling over with excitement about their most recent summer entries.

The search for art can begin in elementary classes, continue throughout summers, naturally spill into middle-school years, and eventually carry into adulthood. Art classes are not offered as solutions, such as knowing how to do art, but as exciting personal adventures in learning to think, reveal, invent, and discover art. Students will begin to see themselves as artists, inventors, and shoppers who are searching through a rich variety of art sources and possible directions.

Thus, effective art teachers are ever mindful that there is a great rebuilding of student's artistic confidence in knowing that the art world has not been pre-invented for them and that their contributions and ideas are not only welcome, but that they are valued. Elementary- and middle-school art students should be free to voice ideas, tell stories, share finds and observations, and be open to noticing, and creating with objects in their environment. The idea book is one tool for teaching young artists habits of recording and valuing their thoughts.

We can't solve problems by using the same kind of thinking we used when we created them.–Albert Einstein

ART HOMEWORK AND PREPARATION FOR THE ART CLASS

If art class preparations are cradled in the motto, "expect the unexpected," then a wonderful birth of eagerness and excitement will occur among students. The art teacher has the privilege of nurturing and feeding this anticipation. As students enter the art room, what might make them

have feelings of excitement and anticipation? Certainly they will be anxious to find out what awaits them if the art teacher is not always totally predictable.

Reflect often. Has the same bulletin board been in the same spot on the same topic with the same slogan for the entire school year, or worse yet, for *years*? Are the same materials in the same place where they have been since the first day of teaching? Is the same seating arrangement that

has been used since the dinosaurs roamed the earth still in practice? As you prepare for art class, try to set the stage for an event that is not boring and mundane. Instead, strive for that which is unique, different, intellectually and visually stimulating, and appealing to young artists.

Learn from yesterday, live for today, hope for tomorrow. The important thing is not to stop questioning.—Albert Einstein

Creative Planning and Topics for Group Discussion, Activities, and Extensions

- Sketch an idea for an art bulletin board that is informative, aesthetically pleasing, motivational, and inspirational for young onlookers. In the plan, use some materials other than those traditionally or normally used for bulletin boards. Consider creating a situation where young people might interact with the display. Be ready to share ideas with the entire class and take notes to gain multiple ideas for teacher displays that can be frequently changed and inspire young artists throughout the school year. You might also consider actually creating and documenting one of the bulletin board ideas for your teacher portfolio or expanded résumé.

- Sketch out two ideas for display spaces for young people's art. Be creative. Be ready to share ideas and take notes to gain multiple ideas for student displays that can be frequently changed and inspire young artists throughout the school year.

- Begin (or continue) your idea book. You may use any structure and format (sketchbook, scrapbook, notebook, recycled book, hand-made book), but it is best to select a size that can be easily carried with you at all times. Make frequent entries but, before the next class, create a few pages that are reflective of you (likes, dislikes, favorites, music, beliefs, hobbies, etc.). Use any media and feel free to mix media (colored pencils, collage, photography, crayon, marker, paint; candy wrappers, ticket stubs, price tags, etc.). Be prepared to discuss the possible role of the idea book for you, your peers, and your future students. Although, in *future* entries, you may express *anything*, for this one assignment stay away from personal topics that you do not wish to publically share.

- "Preparing children in art is laying groundwork for artistic independence." In a small group, discuss your own art background as it relates to this statement. What experiences enabled or hindered your artistic independence? How will you utilize this knowledge in your future classroom?

- If we want young people to value art, to see that it can involve almost everything in their daily lives, and to gain artistic confidence, we must model such creative behavior ourselves. The example of roll-taking was previously given. What are three other ways that the teacher can model creative behaviors in the classroom? List and briefly reflect on these and be prepared to share your ideas in class.

The artist must say it without saying it.—Duke Ellington

Section Two Learning from Artists and Art Resources

Self-discovery will help us to better understand others; likewise, a more in-depth understanding of others will help us to make discoveries about ourselves, but best of all, this valuable cycle can be utilized by the art teacher. An understanding and appreciation of the art of others can be naturally and meaningfully blended throughout children's art experiences if dished up in a sensible manner, rather than heaped up to them in overwhelmingly large helpings of facts to be memorized, later regurgitated on a test, and then forgotten so they can memorize more.

What sparks interest in young people? It might be a momentary glance or a period of intense viewing that turns a child's genuine intrigue to a particular artwork. It might be an animated lecture, visit to an art gallery, casual browsing through an art book, or finding a card in a museum gift shop that turns young people's attention to a particular artist, art style, or movement in art. How we influence states of appreciation, or even think about teaching art appreciation, is mysterious since it deals with the hearts and minds of individuals.

Knowledge and appreciation of existing art can be made memorable, meaningful, exciting, and adventurous. A local photographer, Ora Warren Alsip, for example, shares his photographic images with young people as he tells stories about his childhood and ever-changing artistic inspirations. Once a child with eight other siblings growing up in the hills of Kentucky, Alsip connects with children when he talks about his own childhood adventures, the development of his love of nature, and what eventually led to his becoming a nature photographer.

At elementary schools, Alsip shows an award-winning photo of a miniature frog as it peeks its head out of the wet lily bloom that it has chosen for temporary shelter (as seen in Plate 5.1). "I was hiking through this lily farm in Tennessee with a small group of other nature photographers when an unexpected rain storm came thundering down on us …" he explains to young audiences. "While everyone else ran for cover, I took my camera and an umbrella and headed out … only to discover this tiny green creature hiding in this beautiful red flower bloom as if he were just waiting to be photographed by me!" With a glance at this particular photo, accompanied by the artist's narrative, a whole new level of understanding and appreciation is adopted by young viewers.

Children in Alsip's audience cannot wait to hear and see more, asking, "What else did you find?!" Young artists can relate to the joys of being out in the rain, down on their knees in the mud or grass, finding miniature treasures such as Alsip's frog, and making personal discoveries in their own little corner of Kentucky.

American jazz musician Duke Ellington must have understood this intriguing and mysterious side of art, as seen in his statement, "The artist must say it without saying it." Ora Alsip doesn't have to print, "I am in love with nature" on his photos for the viewer to notice or enjoy his passion for the outdoors. The images alone clearly communicate this.

Alsip's personal stories about the role of art in his life magnify the possibilities of elevated understanding and appreciation of his work for young students who will also benefit from investigating and communicating via the arts. As one might expect, Alsip shares how much joy he experiences by being out in nature, wearing paths into the wooded areas where he travels, and respectfully examining the forest floor, and capturing images of the smallest to the largest flora, fauna, wild life, and objects that he finds simply by slowing down, stopping, and taking the time to look and to see what other people might pass by without notice.

After a visit from a local artist, such as photographer Ora Alsip, along with rich personal art experiences, students are likely to view nature in a whole new way via trips to the outdoor classroom, school playground, park, bird sanctuary, family vacation, or existing artworks. It would be very simple to find and expose students to other artists, for example, who have also been inspired by flowers and/or nature (i.e. Georgia O'Keeffe).

Children might be asked to use pretend cameras (i.e. cardboard cracker boxes with viewfinders cut out) and pretend rolls of film (drawing paper) to capture (draw) images outside on the playground (sketching their "photos" with colored pencils on rolled paper). They might be asked to take a field trip outdoors with real digital cameras and choose a subject to photograph in as many ways as they possibly can. Students might be paired to investigate interesting ways to approach portrait photography by first taking a portrait-like photo of a flower for example (perhaps one close up, and two or three that show the flower in its environment). The teacher might present a traditional, posed portrait photo of a person and then challenge young artists to invent different solutions. It is of the utmost importance that the teacher encourages and celebrates children's willingness to think outside the box, and to explore various ways of seeing, and creating.

We involve active minds and bodies in playful investigating. We help set aside children's negative concerns about "correct" or "appropriate" responses and share our genuine interest and respect for their unique views of adult artworks. For children to experience the joys of darkroom magic, we no longer need a darkroom. To incorporate photography into the art program, we no longer need chemicals, light-tight rooms, or film canisters. Indeed, fine art photography has now become more accessible and user-friendly than ever before. With available software, affordable digital cameras, and new technology, everyone can benefit from exciting illusions, tricks, creative compositions, and unending joys that exist within this medium. A simple online search will reveal hundreds of whacky, kid-friendly, artistic ideas for playful ways to engage children in photography. Be sure to add books like *Tricky Pix* to your art library, but *proceed with caution* since exposure to this book is sure to lead to a photo addiction!

We know that we should provide encounters with adult artists and their artworks to young people, teaching them that artists are very special people who are best qualified to inspire and "turn on" others to special insights into special worlds. The artists that we invite to class, whose studios we will visit, and whose work we will see in galleries and museums, may not be famous; nevertheless, they inspire us through their demonstration of commitment and their exciting ideas. We learn about the artists' many sources of inspiration, their work habits, and the way that they care about the tasks of art making. They not only bring life to their own works, but they also show the nature of the art journey. Such visits make art a human experience—one that is within reach of young artists. We learn about artists' typical days and also about special occasions, such as the steps involved in preparing for an art exhibition. Invitations to art exhibit openings provide additional opportunities that are especially conducive to these important meetings between artists of all ages. We learn from other artists who work in different media and hold different attitudes before we encounter the art, independent of its maker, in a museum.

Where does today meet yesterday? In a museum!
—Big Bird, Sesame Street (1969)

WHERE ART AND ARTISTS LIVE, MUSEUM AND STUDIO VISITS

No appointment is necessary to visit online art galleries and museums. Expensive services of a bus driver need not be employed in order for students to visit the Metropolitan Art Museum in New York, for example. A few simple clicks beginning with www.metmuseum.org will take you there; to a viewing of Sesame Street characters in the classic film *Don't Eat the Pictures* (1969); to the many books available such as *Action Jackson* by Jan Greenberg and Sandra Gordon (2007) or *When Pigasso Met Mootisse* by Nina Laden (1998). These will all serve as unique introductions and add new perspectives. Of course, a face-to-face encounter with artworks will always provide the best opportunities for students to see, analyze, consider, and appreciate the artworks of others, as well as their own artworks. As teachers, we are in a unique position to make such trips a reality for young inquiring eyes, minds, and hearts.

Local art studios and galleries provide an avenue for a more intimate meeting with each work of art where the young art viewer can actually see all of the bristles left behind in the thick brush strokes of more aggressive painters, the finger impressions in clay sculptures or pottery, the stitches in fiber artworks, and the sometimes powerful effects of the actual size of an artwork. In books, almost all artworks are viewed in a small format. It is one thing to look upon *Sunday Afternoon on the Island of la Grande Jatte* measuring mere inches in a book, for example, but it is quite another to behold in person its grandeur at the Art Institute of Chicago in Illinois. Museum visitors cannot help but be mesmerized as they spend quite some time with Georges Seurat's masterpiece, walking up close, backing away, and walking near it again as they witness the magic of Pointillism in the painting. Guided tours are not mandatory. Encouraging the quality of the individuals' encounter with art is the priority. A fast-thinking student is not forced to slow down, and no one pulls slow-paced students along. As young eyes and minds partake of such a visual feast, each student must view, think, ponder, and learn to appreciate at their own pace—some biting off bits more slowly, while others devour the entire collection at possibly a faster pace in order to return to their favorites for an extra helping.

Pointing at an artwork is okay, even if touching is not. Fingers are allowed to share, outline, and even magically erase a drawing in the air. Children establish points of contact with the art on display through imaginary tactile connections. As fingers and hands have an important role in making art, they are also valuable in contemplating and appreciating museum studies. Our fingers draw shapes in the air, on the floor, on our hands, and even on our neighbor's back. Enthusiastic viewers point to special parts of a work. They experiment with rhythms and patterns by

snapping fingers, clapping hands, and accompanying the artwork with sound play. They may hold a make-believe brush or use an actual flashlight to travel through an artwork. Imaginary cutting and tearing of the artwork is encouraged. Children disassemble shapes and forms by tearing the approximate shapes from the paper they have in their hands. Magic erasing (hands held at a distance to cover up sections) highlights designated areas of an artwork so we can focus on isolated elements of art.

String and wire are useful for line studies. Students bend and shape simple linear materials to approximate the lines they find in an artwork. Lines are collected and playfully matched against the work in which they were found. A combination of simple objects (a flashlight, a piece of paper, and some wires) promotes playful appreciation.

Thanks to art, instead of seeing a single world, our own, we see it multiply until we have before us as many worlds as there are artists.–Marcel Proust

FINDING ONE'S LOVE BY RESEARCHING FAVORITE ARTISTS

First and foremost, please know that not all artists worth researching are dead. Artists, who might very well be living next door to students, or even under the same roof, are often overlooked. What better way to get to know artists than to speak with them face to face? When trying to understand and connect with artworks, nothing can compare to having an encounter with the real person when possible.

Teachers must make it possible for students to read in school and at home about artists, but conducting interviews with artists and seeing their studio or work space takes the quality, intrigue, and understanding to a whole new level. Yes, research via reading is important beyond description, but why not also extend a challenge to all young artists to locate and interview an artist with whom they can have a meaningful conversation? The teacher might give the students a few questions to ask but will also help them to create some questions of their own. Nurture the skills needed by inquisitive minds. Students can become reporters for the local art program newsletter, web site, or school newspaper, experiencing first-hand what it is like to be a news reporter, photo journalist, or news commentator. Create a multimedia art museum, inviting everyone, where students become the docents who will share what they have learned.

Of course, we must not forget about artworks from history, created by artists who are no longer with us, and artworks that have lasted and stood the test of time. Teach about the major, well-known artists from the textbooks, but please do not stop there. History has taught us that, unfortunately, some very noteworthy artists have been left out of the history books. Students might ask, "What makes an artist noteworthy?" One answer is simple enough. If the student is intrigued or interested in the artist, then the artist is noteworthy. Students might also ask, "Why is it that some noteworthy artists do not appear in my textbook?" The "isms" play a role in this discussion, because the teacher can teach and reinforce important lessons that we have learned and are still learning about discrimination throughout history (i.e. racism, ageism, sexism, etc.).

Gallery and museum gift shops (real or virtual) are wonderful resources when searching for a well-rounded and diverse collection of artist resources. Good resources can be collected in many places, such as bookstores, yard sales, thrift stores, parent/teacher stores, art supply/resource catalogs, toy stores, and school and university libraries. Artists are as unique and diverse as are our students. Thus, young people will connect with various artists, styles, media, and processes. The art teacher who is head-over-heels in love with the art of Vincent van Gogh, for example, does a huge disservice to students by only teaching about this one artist. Just imagine all that would be missed with such a limited curriculum. On the one hand, enthusiasm is contagious. If the teacher is passionate about a topic, chances are the students will be also. The selection of artists to be studied should be broad, for some student choice if the connections are to be meaningful.

Art does not reproduce the visible; rather, it makes visible.
–Paul Klee

READING ABOUT ARTISTS, THEIR ART, AND THE ROLE OF ART VIDEOS

Looking at and learning about the art of others can be a priceless experience. Often, as we learn about others, we also make discoveries about ourselves. By reading about other artists, students of art might also happen upon art materials and creative processes that they love but that they might not have otherwise tried. They might also realize things about themselves that they had never before thought. As Swiss artist Paul Klee suggests, art "makes visible." It places us in a unique and possibly untested

position. It allows us a view from a distinctive perspective. Luckily, there is a bountiful harvest of art books for young people, and they are ripe for the picking.

In order for a child to read books about art and artists, the teacher must see to it that the shelves are well stocked with such books. In cases where art books are scarce on library shelves, usually the art teacher need only ask to receive. Most library media specialists are more than willing to order quality art books, and they have the budgets to do it. Some might not feel confident enough with their art knowledge to make appropriate selections, while others might have already spent a very sizeable portion of the library budget on wonderful art books and resources. The art teacher plays an important role here. Lend a hand by providing recommendations, book lists, and catalog sources. Ask and you shall usually receive. Highlight an "art book of the week" (or month) by posting it on your web site, and next to the art room door. Give an enthusiastic review of the book, as can be seen on the popular children's television show, *Reading Rainbow*, or, better yet, put student commentators in front of the video camera and allow them to review a book. Present the reviews over the school's closed circuit television airways. An online search of art resource companies, such as Crystal Productions, will yield positive results, as well as art museum and gallery gift shops. Annual attendance at the state and national art teacher conventions will provide plenty of ongoing professional development to help art teachers remain informed on the wide variety, most popular, and latest highly diverse books that are available.

Using technology, teachers might create some of their own reading materials. A packet on any topic can be easily assembled. Share with other arts teachers and watch your own personal resource files multiply at warp speed. Likewise, students might be challenged to create a book or presentation on a particular topic. The school library is not the only place that houses books. The art room should have a plump art library as well. Check out the availability of good art books at local bookstores, and add them to the art program "wish list" and the art program web site in an ongoing "recommended books" section. Check with the town library to find what art books exist in their collection, and again, it never hurts to make special requests. Public library staff will rejoice when they discover that you are promoting reading, and they will not only welcome your eager young artist students with open arms, but they will fill them with art books!

Create a living book collection for non-readers or younger readers, and help set up listening/reading stations throughout the school for students to view the book as they click the mouse to advance through digital pages. Book series, such as Mike Venezia's *Getting to Know the World's Greatest Artists*, would be a good starting point (www. mikevenezia.com).

The art teacher can assist generalist classroom teachers in selections for their book shelves as well. Grant money is available for such purchases. Be creative. If a grant calls for proposals that address multicultural issues, suggest stocking classrooms in your school with art books that fit into this theme (i.e. African-Americans, Asian-American/Pacific Islander, hearing impaired, Hispanic, Native American Indians, Alaskan natives, women). If the grant calls for proposals that address women's issues, suggest a school-wide increased focus on female artists, and use money to purchase related books for the school. Research will result in thousands of female artists, but a good starting point is the National Museum of Women in the Arts (nmwa.org).

Hundreds of art books continue to be approved for, and added to, the accelerated reader (AR) book list. A simple online search will provide a lengthy AR list (i.e. arbookfind. com). Teachers might consider inventing a check-out system, like the library, so students can read art books at home. The art teacher might help serve the school with expertise by also weeding out the books that are not so good. Outdated art books, like those that call for "asbestos" as an art material, should be pulled out of circulation. Filling book shelves throughout the school with quality art books will increase opportunities for children to use them.

In addition to reading, students can also be introduced to, and deepen their understanding of, art and artists via videos or DVDs. Of course, teachers might use videos or video clips in class, but they might also host an after-school art movie once a month and/or use art videos with the art club. Additionally, the art teacher can share suggestions with the library media specialist and other teachers in the school concerning which art videos he or she would recommend (or not) adding to the school collection. A list of recommended art movies and videos can be posted on the art program web site and appear in art newsletters sent home to parents. Good art videos (tried and true) might sometimes be left for substitute teachers to utilize. Convert a section of the art room into an "art library" where students can borrow and take home art videos, DVDs, and books. Yes, it is highly likely that a video/DVD/book might be lost, damaged, stolen, or misplaced. However, in the big scheme of things, this is a very, very small price to pay considering the significant rewards of adding to students' art education experiences. Among art teachers, you will find some of the

most resourceful people on the planet who are perfectly capable of finding ways to stock such a "library" with grant money, parent organization and community support, etc. After a few years in business, the inventory is sure to be quite impressive.

This world is but a canvas to our imagination.
—Henry David Thoreau

DISCOVERING ART SUPPLY STORES AND CATALOGS

What was it like to be an artist before commercial art supplies were invented? Make-believe role-playing promotes ingenuity in finding and making things. Each adopted tool can be tested for art use, calling forth a range of previous experiences and history. When young artists are regularly challenged to find and make their tools, they eagerly participate in setting new traditions and proudly sharing discoveries. To be the first or to be an art explorer feels daring.

Could art be made without art supplies? Could we still paint without brushes? Soft leaves, bulbs, gentle moss, and a variety of twig-handled brushes can be found or made outdoors. Paper towels, cups, left-over banana peels, or a glove that wandered away from its partner—all of these may be used for painting outdoors.

Not having art supplies helps us think beyond them. As a future teacher, start a collection of "non-traditional" paintbrushes and printing devices, but plan on an extraordinary expansion of the collection once your future young students are given license to bring in their own, and/or add to your collection!

Everything can be an art supply. Discount stores can be one of the best art suppliers, but so can the kitchen junk drawer—we all have at least one, right? Hair curler racers on Life Saver wheels compete over toilet paper highways on the floor of a child's room. Why not allow inventive thinking at school as well? Playful hands and eyes peruse everything as an art resource, regardless of the intended function. These essential artistic traits will serve students well. The environment is the largest art store. Art teaching can support home researchers and broaden the notion of what are art supplies at all grade levels. Children will find important items that are often overlooked by adults.

Found objects and tools, as previously discussed, do not have to adhere to rules and routines of their previous lives. Hand tools, arm tools, leg tools, electrified tools are all part of creative retooling of original art activities. Found tools can borrow energy and motion—new grips and moves—as they are attached to or mimic traditional tools. Everywhere we walk, we move across a possible art surface. Every tool we hold has art uses. We try to regain the freedom young children have to browse through drawers and cupboards and create with anything.

Since the stage of adult tolerance to open shopping for children quickly passes and only "proper" supplies become available, it is vital that the spirit of independent art search continues in the art class. Toddlers, even those who have toy drums, often end up banging away on overturned kitchen pots or buckets. We also know that children are just as likely to play with the package in which the toy was purchased as the toy itself, and that mom's stockings might be put to work serving dual roles as they are just as likely to play the part of a hammock or volley ball net for the doll in need of rest or exercise; so it is with art supplies. Sometimes, not having art supplies helps us to think beyond them.

Feeling that we can pick supplies from everywhere and inscribe art messages on any surface frees our art spirit. Learning that all human tools, environmental surfaces, movements, and spaces are open to creative recognition and interpretation leaves the world open to the serious shopping of young artists. If everything is to play with and every tool and gesture can yield art ideas, vast new resources are open to future artists.

A hunch is creativity trying to tell you something.
—Frank Capra

Creative Planning and Topics for Group Discussion, Activities, and Extensions

- Consider where and how you normally photograph people for special occasions. Find a volunteer model and photograph him or her from three different perspectives. In other words, if you normally pose in front of the fireplace or by a certain wall in your home, try something new. Photograph someone peeking through the opening on the playground slide, the kitchen window, or from a different angle above, below,

or near the blooming rose bush. Practice looking and seeing everyday things in different ways.

- Find an artwork where the artist has created a composition that looks very much posed. Secondly, find an artwork where the artist drew, photographed, or painted a person in a unique way that does not look posed or traditional. The artworks may be any media. Examine and decide in what ways the two pieces are similar and different from each other. Based on your findings, be prepared to share and discuss ideas for making an open-ended art assignment for elementary- or middle-school students using the compare/contrast exercise.

- Find a song that you feel is similar to or makes you think of an artwork or group of artworks. Edward Hopper's paintings, for example, reflect an overall feeling of loneliness, quiet, calm, and solitude which could be fun to compare to the song, *I'm So Lonesome I Could Cry.* (Listen to versions by the Cowboy Junkies and/or by Hank Williams Jr.) Prepare approximately 10–20 images to be shared along with your song selection playing in the background. Be ready to discuss similarities, as well as employing software that could be utilized in preparing similar presentations for your future students, as well as a possible teacher portfolio entry for job interviews.

- Interview an artist. Using any media (digital photography, music, voice recordings, PowerPoint, Movie Maker, etc.), prepare a brief presentation highlighting the most interesting aspects of the artist and her/his artwork.

- Create an age-appropriate resource packet on one topic (i.e. horses, transportation, color, or drawing hands or faces) that involves both text and images. Use any format (stapled packet, spiral bound, file folder, ½" 3-ring binder, etc.). Be ready to share ideas in class.

- Read several art books that are appropriate for children. Select one and create a book review in which you offer an enthusiastic description of the book without giving away the ending. Using image or video software, offer a review that will entice children to want to read the book you review.

Section Three Children as Collectors

Anyone who has ever laundered kids' coats or pants knows that pockets are the universal savings deposit receptacles for treasures, such as rocks, bottle caps, twigs, wire, acorns, paper clips, stray candies, unidentified plastic pieces, bouncy balls, and other small interesting objects. It does not take long for parents of tiny tots to come to the realization and accept the fact that often the gift box, wrappings, bows, and cards are far more interesting to children than the gift itself.

We have all witnessed the inquisitive eyes of the young child who has stopped to exam the beauty of oil floating in a water puddle in a parking lot or the splendor of paint colors blending together as they swirl down the sink drain, or the remarkable textures made by fork tines on a mound of mashed potatoes. Children find fascinating the things that others forget to notice or appreciate, such as the intricate patterns on leaves, in spider webs, or in miniature cities built by busy ants. Even adults, for the most part,

often hang onto the unexplainable pure joy involved in the auditory, tactile, and visual excitement experienced when smashing a much-admired packing material called bubble wrap. Children notice and collect objects that, to them, appear interesting, beautiful, or aesthetically pleasing.

There are no seven wonders of the world in the eyes of a child.
There are seven million.—Walt Streightiff

A LOVE OF BEAUTIFUL THINGS

Beauty is everywhere. Paying attention to beautiful objects is as natural to children as their desire to pocket them. Noticing and saving attention-grabbing items is a simple act that may be put into practice in the art room. Saving a special rotting fruit because of its unusual colors, clipping a picture, or keeping a postcard to share its stamp are all acts of appreciation that require few footnotes in the lesson plan. A unique plastic bottle or a furniture leg of unknown origin may prove interesting to children who look for unusual forms and decide for themselves what is useful or beautiful. Talking about the sources as well as the reasons we choose to save and share special objects expands the experience and fosters an even greater curiosity.

As sons and daughters of a nation of antiques seekers and flea marketers, it is not surprising to find many interesting old objects in children's rooms. Old dolls, play houses, pull toys, miniature kitchen sets, game boards, and storybooks provide introductions to American art history that we all can build upon. Many children's rooms are rich in family histories with items, such as quilts, portraits, rugs, woven baskets, or old furnishings. Children can sit on, try out, and play with art from the past in a most personal way. Our homes are our children's first art museums, and children can participate as curators by learning our family's stories and caring for objects that we own. The childhood tendency to value and appreciate old things can be—needs to be—preserved in art classrooms.

To learn about what children collect and find beautiful, observe them inventing and creating, shopping, and collecting. Go out into the world. Journey into the toy stores and view the latest in crib toys, art toys, bathtub toys, blocks, modes of slow-speed transportation, kitchen accoutrements, and play houses. Go to parks and playgrounds to observe sandbox players, twig builders, rock sculptors, pine needle people artists, and mud-pie restauranteurs.

To learn about artistic development, go beyond the school and observe children's freedom to just make things,

play with objects, collect, and seek ideas in their environment. The understanding and respect that the students show for toy store finds brought in by the art teacher and/or the student, the way they handle them, and their sincere interest, are all demonstrative of the importance children place on beautiful objects that have meaning to their lives. The examination of children's rooms provides us with displays of inventions, buildings, and designs with self-selected objects. We see how they decorate and beautify surfaces and spaces, as well as how they animate and perform in the settings that they create. Through such home visits, we learn about children's art as it develops before and during their years of schooling; we also learn what and why they collect.

THE IMPORTANCE OF COLLECTING

Before children can learn to love beautiful things that others collect and value, they need to feel comfortable with their pleasure and satisfaction in their own collecting. Before loving what adults consider beautiful or worthy of collecting, children need to develop their own sensibilities as collectors. They must have confidence in their own searches, reassurance in their own tastes, and a love for what they treasure. Supporting young collectors is a way of supporting young artists and securing their lifelong interest in beautiful things. In supporting the child as collector, we are supporting important lifelong habits.

As collectors, children's lives change, and they see their world differently. Children who take pride in their collections are gratified with their art interests and in themselves as artists. Becoming a collector, and being appreciated for it, positively brings about lifelong art habits and influences home art and a young artist's life in art. Collectors are concerned with the quality of their surroundings; they feel good about living with beautiful things and in caring about their visual environment. They are the designers, decorators, curators, and preservationists of our future.

Young children collect for artistic reasons. They have the most direct feel for objects, making personal choices, and discovering significant new finds. They also like to be around and inspired by such objects. Children shop for objects and ideas that are important to them. We have learned through our studies not to predict children's interests and tastes.

Young collectors often encounter conflicts with adults over matters of taste and interest. Children select items with care, but they often have to work hard to convince

adults that their finds are worth keeping. Children who collect wasp or bird nests might have a tough time gaining permission from their parents. Young children demonstrate an early interest in objects that they want to keep, display, show, and talk about to others.

A child's room is an important part of the collecting process where unthinkable discards are saved, where the uncollectable resides, and where devalued objects find safe haven. For aspiring curators and future art teachers, there is no better place to begin a study of children's collections. Future teachers of art should visit the best children's museums—their rooms. Inventory different collectors' interests, see unique display sites and styles, and learn to respect children as collectors. Notice that as long as children are surrounded by their treasures, their play and home art making thrives. Art teachers are encouraged to admire children's collections and borrow ideas for setting up an art room.

Unfortunately, after the early years, children's collections can seldom be brought to school any longer, but art teachers do get to shop for supplies and ideas, and they can include children in the process. Art rooms need to reflect the notion that being around interesting objects is important. If children are to stay open to new media and art forms, they need to be involved in searching for them.

Collecting is a way for children to engage the visual world. A child's early life is an inspiring example of a collector, as the child carefully observes and sifts through the environment, pocketing its best treasures. Collecting is a way of inhaling and making sense of the interesting object world children inherit, a means of discovering, classifying, appreciating, and finding inspiration. Life as a collector is an adventure of searching everywhere for beautiful and unusual things. Collecting is what artists of all ages have in common. Children who are encouraged to collect continue to confidently explore with their hands, turning every experience and event into an opportunity for discovery. Collectors are involved students of art, more aware of details and interested in displays on all of life's "canvases."

When the art teacher is a collector, students see collecting as a valuable behavior and as an important part of being a creative person. An art teacher who is a collector is someone who has an interesting home, studio, classroom, and office. Setting an example as a collector is an important aspect of art teaching, portraying oneself as an artist and as someone absorbed in the visual world, and appreciating others similarly involved. The most avid art teacher collectors are likely to move the teacher desk out of the art room in favor of having wall-to-wall, floor-to-ceiling exhibition space (shelves) for special items ready for action—organized, categorized, and mobilized—ready to make grand appearances for young artists.

In presenting collections and the latest finds, an art teacher can vividly share the excitement of the search and the rewards of discovery. Through the act of continuously sharing collections with students, the art teacher declares the visual world teeming with possibilities, a primary source of art ideas. The teacher's demonstration of a life that values visual finds paints the artist as an explorer with discovery being the first step in art making.

Children valued as collectors will continue to turn up a rock, pocket a sidewalk piece, scout a street, or search a store for interesting things. Collectors wear different glasses and look at their day as filled with opportunities to actively look through the world. Children who are confident in their collecting skills see themselves as creative people. The sense that one is able to discover something that others appreciate builds the necessary confidence for the pursuit of art.

THE DAILY SHOW AND TELL, SHARING, AND APPRECIATING STUDENT COLLECTIONS

Children become as deeply involved in the hunt for beautiful things as do avid adult collectors. Appreciative conversations come from a variety of sources. Art teachers can take the time to look at children's stamp books, coin displays, or bouncy-ball collections. Appreciation expressed when talking to young collectors builds their interest in finding and salvaging other beautiful things.

Appreciation talks sharpen observations and confirm choices in objects. During school there might be geodes, beads, cards, key chains, stickers, rocks, Band-Aids, and rubber band bracelets—a rich life consisting of seeking, trading, saving, and gratitude for beautiful objects. Appreciation talks bring all the elements of art making together. Discussions begin with and are centered on the children's finds but inevitably expand to include others' artworks, including the teacher's own work. Art teachers must allow students to share their collections and discuss their importance. These appreciation talks stretch art viewpoints and introduce new art worlds. Art teaching incorporates learning to appreciate other voices and opinions, breaking down barriers, and thinking in new directions—as a result of caring discussions.

It is important to have young collectors take the lead in showing and speaking to other children with respect to objects about which they are currently excited. Art teachers can lead the way in encouraging and maintaining collecting as an important aspect of art in children's lives. Adults at home and in school can work together to support and preserve a child's collecting, recognizing its connections to art and ensuring that dedicated collectors will continue to preserve art objects of the future.

SAVING, SORTING, AND DISPLAYING COLLECTIONS IN THE ART CLASS

While appreciation starts early, at home, it is built upon via personal interests. This can be extended by art teachers who value collecting and who find beauty in the objects with which children are familiar or find interesting. This might come from a grand place such as in children's travels, or more simplistic environments closer to home, such as their backyards. The gift of one's artist self can be offered to students by demonstrating the importance of a stimulating environment and by how art teachers stock their second homes—their art rooms.

Appreciation is forming connections between the small, humble, and beautiful things that children find and the opportunities to feel and touch a larger world of beautiful things that one can share in the art class "museum." Art teachers who share what they appreciate touch the souls of the young collectors. Young people then begin to share their collections with the teacher and with one another. This cycle will pick up speed as each school day welcomes new discoveries, displays, and discussions, and as collectors speak meaningfully to one another.

Rich and varied interests are born simply by encouraging young collectors. Students gladly transport their home and family possessions to class and share their appreciation for new finds and selections, which can be displayed in creative display spaces. A retired refrigerator door is the perfect gallery for magnetic collections and creations where the student docents gladly guide viewers through their treasures. Art teaching needs to celebrate the appreciators as much as their finds. Young collectors develop greater artistic confidence to look at and appreciate all kinds of art. They are also more willing to question art tastes and fashion dictates and develop a more independent sense of what they like.

In art class, we can discuss children's collected items with an eye toward related objects as well as other admired items students might have noticed or wished they had in their collection. Confidence in building a category of objects allows students to expand and build new collection categories, which will easily and naturally spill into future art room experiences. With young collectors, art educators can "speak the language," using terms, such as "Deco" or "Nouveau," in describing an object's origins and relatives. By hanging around other collectors and handling objects and displaying them, children pick up the language and freely speak about styles and periods. With a little knowledge of art and design classifications, young collectors quickly advance their collections and speak like "dealers" with confidence and authority.

Collecting is an active state of contact with beautiful objects. Students' abilities to touch, set up, arrange, and display collections are part of educating them to see and learn from them. Access to collections and different sites and venues for students to display them in class needs to be an important art class activity. Art teachers who routinely share their collections demonstrate how collecting inspires their art, taste, and home and school environments—and even their interests in collecting itself. Collecting reveals an art teacher's searching, as well as where they find inspiration for art lessons. Ideas flow from each object, and with collections in hand, the art teacher has a great deal to show and tell about in the art room. Students spirited by the art teacher's finds eagerly express their own ideas.

Art requires inspiration that often has to be actively sought. Students who bring collections to class also bring great ideas along with their collections. Children encouraged to collect will not always be dependent on the art teacher's ideas for each lesson. As they see, ponder, analyze, appreciate, and select items for their collections, they are also gathering ideas in preparation for each art class (and beyond). Children who talk about, think, and plan what to do with their collections are accustomed to looking to themselves for inspiration. Those who plant great stuff in pockets and lunch boxes see themselves as people with ideas, because they readily find inspiration from all kinds of things.

Sharing collections builds a strong classroom bond, an artist-to-artist connection, and a sense of pride within students for being collectors. Children's object finds are in no way considered junk in the art room. Students see the art teacher carefully unwrap collected treasures in class, and show examples of their personal collections, whatever they may be, from trading cards to quilts to refrigerator magnets, to collections of shaving memorabilia. It is fun to reminisce and share objects with an appreciative audience.

Invite students to join in the show-and-tell about their own collections, keeping the art teacher constantly aware of the "latest." Focus on current collection trends, building their history through examples, collectors' books, and web sites. A search of web sites, such as collectors.org, will reveal thousands of collectors' clubs and categories. Their membership is comprised of enthusiasts as diverse as are our students, revealing to us current collections as well as a comprehensive view of collections of which one can dream.

Who we are as art teachers, representing creative people, is interwoven with the objects we collect and perhaps most directly communicated to students through sharing our object worlds. Whether it is a collection of beautifully illustrated children's art books or an assortment of alternative drawing tools, art teachers' careers will be dotted throughout with groupings of interesting and artful objects. Art teachers are observant, appreciative collectors of all kinds of beautiful objects. Art teaching needs to include our "loves." Students should know our favorite artists, our objects of interest, our favorite art materials, our ideal shopping sites for ideas, and our most important sources of inspiration. Collecting should be a daily diet of our teaching.

Creative Planning and Topics for Group Discussion, Activities, and Extensions

- Conduct an online search of collector categories (i.e. collectors.org) and become familiar with types of organized collectors' groups that exist. Of the thousands of collector clubs, what is the most interesting item collected? The most surprising? What category best matches one or more of your current collections? Write a brief reflection about how your personal collections (past, present, or future) might relate to your findings and how these might be used in your future classroom.

- Collect and bring to class a minimum of 10–20 different items that could be used for one of the following categories: alternative paintbrushes/tools, alternative printmaking devices, alternative canvases or painting surfaces, and/or alternative clay or drawing tools. Think outside the box: a meat tenderizer mallet or potato masher, for example, can be very useful in the art room for painting, printing, or imprinting textures into clay.

You've got to go out on a limb sometimes, because that's where the fruit is. –Will Rogers

Section Four Dealing with Artistic Problems

Problems, in the big scheme of things, are good things. Some clichés suggest that people have learned that there is value in making mistakes and experiencing problems. Most have no doubt heard variations of them. "We will appreciate the mountains having been through the valleys." "We must learn from our mistakes." One very well-respected elementary art teacher has posted a large sign above the entrance to her art room that reads, "Mistakes Happen Here!" This serves as a constant reminder to her students that it is not only okay to make mistakes, but that it is encouraged—that students will learn from their mistakes.

An equal number of quotes and clichés exist as a reminder of the crucial role of risk taking in the learning process; while risk taking often leads to mistakes, it also opens doors for important and welcome discoveries. One of the best known quotes is credited to Frederick Jezegou, "You can't ever reach second base with your foot on first." Poet T.S. Eliot was also on board when he said, "You have to risk going too far to discover just how far you can really go." Where there is risk taking, there will be trials and successes and even failures—all a part of life's lessons that lead to progress.

A ship in port is safe, but that's not what ships are built for.
—Grace Murray Hopper

THE USE AND ABUSE OF ART CRITICISM IN AN ART CLASS

When hearing the words "art critique," many college art students are likely to experience a range of emotions from excitement to extreme fear. All of us have lived through college studio class critiques and probably feared what might be said. As educators of young creative individuals, we know there is a better way to engage artists of any age in critical and creative thinking. While it is important to talk about one's work and present it to an audience, the experience should be a positive and supportive encounter for young artists. If the critique is not structured appropriately, the act of sharing artworks with others can be a very scary experience. Exposing our thoughts to others is personal, and this can lead many participants to feel vulnerable, apprehensive, or fearful. In the wrong environment, explaining our intentions, ideas, dreams, problems, and individual solutions to others can even be terrifying. Teachers must be ever mindful of this, and never knowingly insult or belittle a child with hurtful comments. It is okay to say, "I'd like to see you darken the background, which will make the foreground stand out more." Offering suggestions is acceptable, but it is never, ever okay to make discourteous comments to students.

As teachers of art, we must be willing to provide motivation, stimulate thinking, and encourage creative ideas and actions. Look for the good in all students and tell students what they are doing that you like after asking them what they like. Offer helpful observations about their art or art habits. When called upon, it is our duty to point out positive attributes and respectfully make suggestions when students encounter road blocks. Often, students can find direction by being questioned when they are at a loss for what to do next. "Tell me what you like about your sculpture." "What is your favorite part so far?" "With which part are you dissatisfied?" "What are some ways you might correct that?" As discussed in Chapter Four, such ongoing "mini-critiques" will occur more frequently than any other teaching tool or assessment method.

Knowing that students will benefit from analyzing, viewing, and discussing their works, and the works of others, teachers must create a safe and supportive place for this to happen. Some thought on how and when to conduct critiques will serve art teachers well. Likewise, be ever mindful of what we know *not* to do—what might be detrimental to young people's artistic development and creative growth.

Please know that there is no national law that mandates all critiques occur on Friday or only at the end of each project or conclusion of each unit. Rather than falling into such a rut, plan to allow critical thinking along the way. Valuable thoughts and observations will occur *before, during, and after* each artwork is created. Obstacles will reveal themselves and call for solutions throughout. Thus, students will benefit from verbalizing ideas, asking questions, sharing observations with the teacher and with each other, and receiving and/or offering constructive criticism or advice. Allowing, using, and modeling critique strategies throughout the day, every day, will soon establish this way of thinking as natural among students.

Children's critical talks can be created in playful ways. After a work is completed, call in child television crews to interview each other. Invite young artists as guests to give slide presentations of their works. Hold a public reading of original works where the children read passages from their idea books and portfolios, thereby sharing the sequence of a work's development.

Regardless of how or when the critiques take place, the teacher sets some irrefutable parameters and consistently enforces them, one of the most important ones being: everyone will demonstrate respect for each other. The teacher should demonstrate how to do this. Using an artwork, possibly not from anyone in class at first, show the students how to offer constructive criticism with comments: "I like the detail in the portrait," "I like the interesting things I see going on in this area ... where I see new colors were mixed and the paint was left thicker," or " I find the expression on the face to be extremely interesting." Ask students what they like. Students will learn critique skills and be willing to practice them before, during, and after each artwork is completed if the teacher creates an environment in which young artists feel they can safely participate.

We must not force children to offer lengthy explanations for every one of their artworks, nor can we expect them to have deep, genuine feelings about every artwork. If it comes naturally, and they have a lot to say, then we should provide the audience. However, each student will not always feel the need to give long, ponderous speeches about every artwork. As with artworks made by adults, sometimes there just is not a lot to say. Respect that.

The content and meaning of each artwork is as diverse as are the students. Usually, students *will* have lots to say, and

the teacher will only need to be the guide to ensure every-one gets a chance to speak and that everyone is listening and learning from their peers' comments. Art teachers must pay close attention to students and be sure to wait for comments instead of feeling the need to fill up every con-versation void with boundless lectures.

During summary discussions, the child retains the authority and tells others about plans, disappoint-ments, and what they will need to accomplish. As has been previously mentioned, the class, as the audience, respects the artist as having the expert opinion of the work.

You can't steal second base with your foot on first.
–Frederick Jezegou

GETTING STUDENTS TO OPEN UP ABOUT ART FEARS

Parker Palmer (2007), in his book *The Courage to Teach: Exploring the Inner Landscape of a Teacher's Life*, addresses a fact that even the most experienced teachers often forget. A certain amount of fear exists among all students of all ages at some point in their lives. It is human nature to be afraid that if we state the wrong answer, then the teacher might ridicule, offer embarrassing remarks, or that he or she might allow others to belittle us in some way. It takes courage for students to participate in discussions, critiques, and class projects. A great sense of confidence, security, and positive energy exists in the classrooms of teachers who are mindful of the fact that belittling remarks can cause major damage to the student, while more positive and constructive remarks build up students and increase the desire and willingness to participate.

As previously discussed, there is never, ever a justifiable cause for ridiculing students or for allowing any one of them to be harassed or belittled by peers in any way. However, often students arrive on the teacher's door step with pre-existing fears that have been developed somewhere else. Someone, somewhere, has done something to make them feel insecure and even fearful. Thus, as we begin to teach, we must be mindful that there exists among our students varying degrees of fear, and we, as teachers, must help build confidence. Teachers must replace the negative with the positive until students feel secure in the knowledge that they are in a safe environment where the teacher will protect them, and that they are free to investigate, free to make mistakes, and free to learn.

We know that one of the many purposes of art is com-munication and that students will convey fears via art; often, teachers need only pay attention. Through art, students might express thoughts that they would not attempt to convey verbally or in writing. Art can some-times be a good springboard for discussions. Though we should not force a child to talk about what they are con-veying through their artwork often, action-packed narra-tives will pour out of the child as they create. Sometimes only a mere, brief prompt, nod of the teacher's head, or subtle invitation is needed to launch the young artist into beautifully expressive and uninhibited explanations of their art. Here, the teacher's job is to encourage, pay atten-tion, and comment only when appropriate. More often than not, the hardest part of teaching is to be quiet, observe, and listen.

Man cannot discover new oceans unless he has the courage to lose sight of the shore.–Andre Gide

LISTENING TO YOUNG ARTISTS WITH EMPATHY AND CARE

As young art students will be free to voice ideas, tell stories, share finds and observations, and be open to noticing and creating with objects in their environment, we must remember that there is a great rebuilding of students' artistic confidence in knowing that the art world has not been pre-invented for them. As art teachers pay attention to students, they will come to see that their contributions and ideas are not only welcome, but that they are valued and sought out as an important part of the learning process.

In order to accomplish this, the teacher must learn to listen. Often, teachers might feel awkward about extended moments of silence, even periods of time that are as short as a few seconds. We mistakenly feel the need to fill the void with continuous, helping comments. Often, this robs young people of the opportunity to speak or think things through and in doing so we stifle or lose their comments, observations, thoughts, concerns, questions, and important narratives.

Often, the key to listening to young people with empathy and care is primarily found in our attitude. Students might ask a question of the teacher, for example, that has already been asked of that same teacher repeatedly by *other* students—possibly hundreds of times. The teacher, espe-cially if having a busy day, might become frustrated with

a child who asks such a question. "How dare they not know the answer to *that* question ..." or "I've only been answering that same question hundreds of times per week for twenty-two years of teaching!" the perturbed teacher might think. However, teachers must remember that the person in front of them at that moment has never before asked the question.

Inquiring minds ask because they simply need the teacher to share knowledge at that time—knowledge or advice that children do not have or they would not be asking. Young artists must be treated with patience and compassion during two-way communications. Admittedly, students might sometimes ask a question that we have already been asked thousands of times. Even better, they might even ask us a question that *they have* already asked! They ask simply because they need to know.

Here is a challenge. Observe and pay close attention at a school faculty meeting and note how many, and how often, *teachers* miss directions because they are talking to their neighbor. Teachers, being human, often whisper to one another, and even pass notes, while colleagues give reports. They sometimes even call out comments without raising their hands or waiting their turn. Teachers often disturb others due to their excitement or because they are working on a project while the principal is speaking. Is this perfect social behavior? Should teachers be put in time out? Let us hope not. Often, the principal or speaker need only employ the same strategies that we use with children to get their attention (walk close to the disruptive table and teachers are likely to immediately straighten up and pay attention).

Repeating this exercise will help teachers to have more patience with students when having to repeat instructions from time to time and to be ever mindful that our young clients are human just as we are. In each and every case, teachers must pause and be *with* the student. Be genuine. Put forth whatever effort necessary to be *with* the child at that moment. They deserve a positive attitude and a thoughtful answer.

Students ought to have our patience and understanding as they grow, and as they learn how to demonstrate acceptable social behaviors when they are excited, or when they need our attention. This is especially important for teachers of art, considering that art spaces are some of the most exciting, motivational, inspirational, and visually stimulating spaces.

Yes, risk-taking is inherently failure-prone ... otherwise it would be called sure-thing taking.–Tim McMahon

TEACHING STUDENTS WHOSE ART WAS RIDICULED AND WHO WITHDREW FROM ART

Most humans can recall a moment from early years or from public school years when a teacher, or someone else, said or did something that had a negative effect on them. Most could easily call up an instance that they still remember— one that they feel they should have been handled differently or that should not have occurred at all. We learn to be good teachers by reflecting on and acquiring positive teacher characteristics. Likewise, we sometimes learn from unfortunate incidents, or when a teacher models what we should *not* do with students.

Unfortunately, sometimes people are unkind or callous. (The reasons why will be left for professors of other classes and authors of other books.) However, for the sake of this discussion, let us at least agree that for whatever reasons, our students might have been treated very badly by someone somewhere along the way. A peer might have said, "Your art is terrible!" or a teacher might have injured the confidence of the child with an insensitive remark. Children might feel negatively about themselves and/or about art for hundreds of reasons, maybe just because of a *lack* of art experiences—the fear of the unknown. Students might arrive on the classroom door step with a very wide array of feelings toward art, ranging from "I love it!" to "I'm no good at it; therefore, I hate it!"

The worst enemy to creativity is self-doubt.–Sylvia Plath

When students arrive in art class with pre-existing fears or phobias, we meet them where they are in their development. Often, students pull into the art station with a lot of negative baggage on board. In order to engage them in positive art experiences, this negative baggage has to first be unpacked. We must show empathy, offer encouragement, and listen. The teacher, who treats students as individuals, will soon discover that the students who profess to be "no good at art" feel that way because either they have had no real art experiences or maybe because they had negative encounters. Replace these with positive experiences. Ask questions. Initiate conversations. Listen to students. Often, students will express ideas and fears through visual art in ways that they could not have expressed via any other mode of communication.

As individuality is stressed and as students accumulate positive art education experiences, they will gain confidence. In the ideal world, students would never have bad experi-

ences with art or any other content area. However, when they do occur, first-rate experiences with first-class teachers can eventually undo the damage done by bad occurrences.

I have the loftiest idea, and the most passionate one, of art … much too lofty to agree to subject it to anything … much too passionate to want to divorce it from anything. –Albert Camus

AN ART ROOM WHERE STUDENTS ACQUIRE A LIFETIME OF FAITH IN THEIR ART

It is not the job of the art teacher to teach 30,000 years of art in one academic year. This is impossible and any attempt would only involve students memorizing batches of facts, spitting them out on a test, and soon forgetting them.

Teachers who unfortunately sometimes fall into this trap will often be heard saying that they don't have time for students to make art because they have to "cover" so much art history. There is a vast difference between "teaching" and "covering" art—covering does not involve learning. An important goal of effective art teachers is to provide experiences that will lead to increased confidence, improved self-concepts, good critical and creative thinking skills, and a lifelong passion for art. A worthy goal is to help students to love art so much that they leave each day wanting more. Children can enjoy and value the role of art in their lives to such an extent that they will utilize what they learn throughout their entire lives.

Through art education, students learn to make decisions. They see that their opinions matter, and discover that their ideas are valued. They become skilled at using critical thinking skills that are useful in all areas of life, and benefit from adopting and utilizing habits that involve creative thinking and doing. They learn that art is broad and global, and like French existentialist writer Albert Camus, that the idea of art is much too lofty to agree to subject it to one thing and much too passionate to divorce it from anything.

Attitude

(By Charles Swindoll)

The longer I live, the more I realize the impact of attitude on life.
Attitude, to me, is more important than facts.
It is more important than the past, than education, than money, than circumstances, than failures, than successes, than what other people think, or say, or do.
It is more important than appearance, giftedness, or skill.
It will make or break a company … a church … a home.
The remarkable thing is we have a choice every day regarding the attitude we will embrace for that day.
We cannot change our past.
We cannot change the fact that people will act in a certain way.
We cannot change the inevitable.
The only thing we can do is play on the one string we have, and that is our attitude.
I am convinced that life is 10% what happens to me, and 90% how I react to it.
And so it is with you … We are in charge of our attitudes.

Creative Planning and Topics for Group Discussion, Activities, and Extensions

- Think about your favorite teacher. Why did you select him/her? What qualities did they possess? What role did empathy, compassion, and caring play in their classrooms and in their student/teacher relationships?

- Think about a moment in your early years when a teacher said something to you, or to someone else, that had a negative effect on you. How did it make you feel? If you were the teacher in this incident, what would you have done instead?

- Watch and summarize the video called *Fish*. Discuss how this relates to teaching art. In what ways are the Seattle fish market and the art program similar?

- Read the poem *Attitude* (by Charles Swindoll) and summarize the primary message in your own words. Then write about one example in your life when attitude played an important role in the outcome of a situation.

We are apt to forget that children watch examples better than they listen to preaching. –Roy L. Smith

Section Five Art Talk—Discussions About Art with Young Artists

If children are old enough to perform creatively, they are old enough to talk about the experience of that performance. The art class is a logical place for such a discussion since there are few opportunities for reflection and discussion at a later time. If the art class is not a place where ideas and problems are shared, the child may as well work alone.

A lifetime of interest in art can begin early in the child's education. Very young children can begin to look at art and artists as a part of their own world rather than as something to be set apart and compartmentalized. They can begin to see art not only as experiences to be assigned by the teacher but as being tied to feelings, ideas, and life. They can learn these things through conversations about artists and the art process; they can learn that many people make art and that there is an art community.

Through conversations, many of the prevalent misconceptions about art and artists, which are often learned at a very young age, can be dispelled. As a result, art can be demystified for children as they learn that ideas can be gathered from a variety of sources, and they can be formulated, visualized, and executed in a wide variety of ways.

A pat on the back is only a few vertebrae removed
from a kick in the pants, but is miles ahead in results.
—Ella Wheeler Wilcox

CHILDREN TALK ABOUT THEIR ART AND THE ART OF OTHER ARTISTS

The teacher might plan discussions around particular subjects but will also seize teachable moments for spontaneous talks whenever they occur. In either case, these conversations should be a regular part of the art class, and the children should be encouraged to participate freely.

Such discussions need not be lengthy, ponderous, or overly sophisticated; they should be based on the children's current concerns and interests and should involve age-appropriate vocabulary. Personal examples, based on the teacher's own experience, are useful not only in illustrating points, but also in allowing children to see that the teacher, as an artist, goes through processes of creation similar to their own.

Being in class implies a relationship with others as artists and as audience members—having in common some similar joys and problems. It also implies that students will not only learn from their own works and from the instructions of the teacher but also from others—including professional artists.

Where do artists get their ideas? How do they begin their work? How freely are they able to work? What do they carry over from one experience that helps with the next one? Do they have ideas that are similar to our own? How do they execute them differently? What can we discover, with the help of others, from the work we have just done? What will we never do again and why? What can't we wait to do the next time? These are questions that need to be talked about, explored, and tentatively resolved.

We have learned that we must not postpone all discussions until the end of an art experience. Rather, the dialogue should be ongoing. Plan for and allow discussions that will take place naturally, talking about art at different stages of the work. Before work begins, conversations can help us to plan, rehearse, and pre-visualize what we are about to do. Expressing ideas through language helps us not only to share them but also to clarify them. Our ideas become more concrete in form and meaning as we hear them verbalized and discussed. Also, the reactions of others to what we are doing, or intend to do, can build self-confidence.

Talking about work as it is in progress can help us to slow down its fast-moving pace and gain control and understanding so that we can direct it in a more meaningful way. As they work, children will learn that art differs from other school subjects in that finishing fastest or within a certain time limit is not the goal—artwork cannot be "timed."

Further discussion, that occurs after the work has been completed, allows us to share with others our concerns about how seldom we can precisely match the original visions and intentions that prompted us to begin work in the first place, and how this gap between intent and result can be a positive force in pushing us toward trying to find the ideal solution. Young artists who have common problems can help each other, just as we can help them, to evaluate what has been accomplished and what still must be done in further efforts. Remember, verbalizations help us to put our own thoughts into more concrete forms so that they can be recalled for later use.

If the teacher is not attentive to opportunities for conversations, students can demonstrate art skills without even thinking about the meaning of their work and their own ideas and feelings about it; it may never occur to them that they can pursue a project independently, without the supervision of the teacher. Rather than presenting unrelated exercises, the teacher, through conversation, can help the child to see art as a part of life (as a *way* of life for some people) and can help to make the work in the art class a meaningful individual experience.

Remember to ask students, "What do you think?" We want to keep them mentally engaged. Observe as students talk, question, and discuss the progression of their thoughts and actions. Pay attention. Demonstrate interest. Listen to their comments. These talks stretch art viewpoints and introduce new art worlds. Art teaching incorporates learning in order to appreciate other voices and opinions, breaking down barriers, and thinking in new directions, as a result of caring discussions.

I begin with an idea and then it becomes something else.
–Pablo Picasso

DISCUSSING ARTISTIC TRAITS AND WAYS OF MAKING ART

We know that children will benefit from learning about other artists, from talking to them, from talking about them and their work, and from seeing their work regularly wherever it may be found. Students will also be interested in the work space and work habits of other artists while they move through their personal search for particular media, skills, and artistic routines of their own, eventually realizing that they too can work independently. Young artists might be interested in the sources of artists' ideas and sources of inspiration; including places, objects, and the performances and works of others. As they learn about artworks by others, students can benefit from ongoing discussions as they are encouraged to observe and make note of everything around them, to take seriously their own fantasies and visions, to recognize beauty wherever they find it, and to act on their instincts about what may be interesting material for their art.

Children should learn that artists keep a constant record of ideas and sources in sketchbooks or idea books; additionally, when they find these sources, they change and adapt them (through abstraction or simplification and through changes in scale, viewpoint, medium, etc.) for

their own use, rather than copying them; and artists work and think continuously about possibilities for projects.

Teachers can discuss with children the continuous nature of artists' works that are in progress, how one idea or discovery may lead to another, and how artists often work in a series where an idea is pursued over a number of works in which the same concepts, media, and techniques are explored in different ways. Students will begin to understand that artists are constantly making different kinds of choices and decisions, and they relentlessly pursue new and different solutions to artistic problems before, during, and after the work. As a result, the artist's work is never truly finished because each piece becomes a seed for the work that will follow.

Tolerance implies no lack of commitment to one's own beliefs ... rather it condemns the oppression or persecution of others.
–John F. Kennedy

DEVELOPING TOLERANCE TOWARDS NEW ART FORMS AND IDEAS

As the art world moves at the speed of information on superhighways, it tends to unravel itself from its audience. Sometimes people quickly jump to negative assumptions about the value of a particular artwork. Because they do not personally like it, and/or because they have not taken the time to understand it, they immediately devalue it. Frustration is expressed not only by individuals, but also by communities into which new public art is plopped. Intolerance is voiced at government agencies that sponsor new art forms by audiences who feel left out.

There is one time where future audiences and artists meet and pass through our art rooms, and we have a brief opportunity to make an impression on each. We hope that, after students leave our art classes, they will become more tolerant of new art, and even excited about the changing art world and its future. The study of the changing art world needs to be a subject taught in every class. Young artists at every stage need to discuss, write about, explore, and consider new art worlds and their effects on future audiences.

Talking in art class is not only to be permitted; it must be encouraged, applauded, welcomed, and happily embraced. Planning for and seizing opportunities to discuss students' art, and artwork of others helps to lay a strong foundation for a lifetime of understanding and appreciation for art and for people in general.

Art is about paying attention.–Laurie Anderson

DISCUSSING THOUGHTS ABOUT PERSONAL ART MAKING HABITS

Real conversations involve more than one person. In effective art programs, the teachers are not the only ones doing the talking. During conversations, students' thoughts are valued. Young artists' minds and mouths will be actively engaged.

The teachers will wear the hats of fellow artists who share artistic enthusiasms and discoveries with the children. They will encourage originality and independence among young artists. In this way, children will be encouraged to think of art as something that extends outside the classroom as a part of everyday life, to relate themselves and what they are doing to the art world, or to think of themselves as possible future artists. Students will form good habits as they continue to practice creative thoughts and actions.

Exit slips might be utilized as another tool for triggering thoughts about personal art making habits as they develop. If used, the format should: include an open-ended question or two, be brief, allow space for teacher/student dialog, but the slips should be small enough to easily mount into the idea book at a later time if the student chooses.

A bell-ringer, quick sketches or notes in the idea book, might provide further opportunities for students to brainstorm and reflect on the development of their personal art making habits. Teachers can dialog throughout the idea books with sticky-notes, rather than writing directly into the idea book, which is sure to be a personal treasure and artwork in and of itself once the student grows attached to it.

Remember, it is not potato printing that we are teaching, but exciting ways to test our world, to choose tools to record our finds, to appreciate all "skins" and surfaces. An important consideration in art teaching is to create experiences that will be used beyond the classroom. Every art concept and technique taught can have broad implications to open students' perceptions of what art could be and to inspire individual testing of the boundaries of art after school. Each school art experience has the responsibility for broadening young artists' visions about art in their world.

If an art lesson could talk, it would ask,

> What do I inspire students to do? How will young artists be moved by my experience? At the end of the final daily school bell, have I created a hunger within students to want to do more? Will my ending function as a clue for new ideas and a seed for a new beginning?

It is important for students to reflect on their own art. They will benefit greatly from viewing, analyzing, and learning and talking about the works of others as well. The more that children understand the work habits, techniques, and creative processes of others, the more likely they are to understand their own impetus toward art and to continue working on their own, outside the classroom, directing their own ideas, and taking more charge of their own work.

Young artists might take from the classroom a few of the specific skills that they have learned but the art class's much larger contribution to them is the experience of making art, of creating something of their own. An important part of this creation is learning and thinking about art, artists, and the art process, which influences a lifetime of attitudes about art.

I can live for two months on a good compliment.
—Mark Twain

PRAISE AND RECOGNITION; POSITIVE, PRODUCTIVE, AND PLAYFUL ATTITUDES

It has been said that one "picture is worth a thousand words." We might also consider how just one word of praise might inspire a thousand pictures! Talk is cheap, so the art budget will not suffer in the slightest if the teacher liberally uses words of praise. Children who are often hungry for any kind of attention will eat it up.

An ongoing, healthy distribution of *genuine* praise is worth almost more than any act we can perform as teachers. Please do not misunderstand. Constantly saying "good" is not very helpful. If this is all the teacher ever says, the never-ending repetition of the word is as meaningless to students as white noise. A statement such as, "I've noticed that you are quite good at taking care of the painting materials … thank you for your effort," is more likely to lead to the student repeating that behavior forevermore, than if the teacher merely says "good job."

Specific, genuine praise about one action leads to increased confidence, which leads to greater success in art as well as in other areas. This positive cycle is invaluable to the art program with a teacher who is willing to utilize it. Be mindful of what you say and how often you say it. Remember, when sharing specific praise, there is an infinite number of kind words that can precede what is said, rather than always saying "good job!" such as seen in the well-circulated list "101 ways to praise a child" (www.character-kids.com) or as a direct reaction to students' work with statements, such as wow, way to go, super, you're on the right track, outstanding, excellent, great, good, neat,

well done, remarkable, knew you could do it, I'm proud of you, fantastic, super job, nice work, looking good, you're on top of it, you're catching on, now you've got it, you're an incredible artist, bravo, hurray for you, you're on target, spectacular, I like it, bingo, very creative, exceptional, fantastic job, super work, very interesting painting, look out … nothing can stop you now, awesome, beautiful work, etc.

As previously discussed, the teacher must also proceed with caution when making positive comments, being careful with wording that has the potential to uplift one student at the expense of others. For example, be careful not to make such declarations as "Jenny is our 'class artist' …" since the implication is that there is only one good artist in the class. Beware also of statements such as "This is the *best* painting in the class!" since this could be perceived as an implication that the others are not good or worthy of attention. Since such statements can be viewed as negative by students who feel that the teacher is insinuating that their work is not good or that they are not artists, the effective teachers will seek alternative ways to give the intended praise.

Children should also be shown that art is not a competition and that the presence of an artistically talented sibling or the child who is touted as the "class artist" in other classes should not discourage them from attempting to achieve their own artistic visions—in short, that there are innumerable valuable ideas and ways of expressing them.

Demonstrating an overall positive and good-natured teacher attitude is important as well. One teacher might merely talk about "making masks," for example, while another educator displays and tries on various mask options—mixing bowls, lampshades, and gift boxes—as she gives a lively description from behind her own headgear. The experience of trying on and discovering masks is illuminated by playful descriptions calling for inventive plays. Would we wear a Jell-O mold hat or an eggshell mask? Who would be willing to try it on? This promotes a different experience—one of *discovering* masks, rather than mindlessly following formulas.

One teacher opens his bag of plastic beads and says, "I brought all this junk for you to use today." A different teacher, while opening her bright red suitcase, announces the discovery of famous "jewels" found by her bus-driver spouse and says she will share this treasure with those eager to examine it. Note that the objects in both presentations are the same: a bag and jewels/beads, yet only the imaginative words in the second presentation conjure up exciting images and art possibilities.

Art ideas can be envisioned and shopped for through words that spring forth out of the teachers' positive attitudes. Performances can be introduced through open phrasing, using words that have little preconceived baggage. Instead of making kites, planes, or mobiles, for example, we can talk about objects that fly, dance, or make sounds in the air. Speaking of the wildest, funniest, shiniest, tastiest, or strangest objects becomes a challenging reference to playful thinkers. Can you make it invisible? Can you picture it so that it gets into the *Guinness Book of World Records*? Can you think of it in a way that no one can resist looking at it?

Playful conversations constantly expand art. With what supplies can art be made? Where can it be found? What tools and techniques can be used to make art? Language challenges us to reach out to new approaches; it stimulates creative thought and leads to artistic productivity.

One picture is worth a thousand words, and one word
of praise can inspire a thousand pictures.
–Julie Alsip Bucknam

Creative Planning and Topics for Group Discussion, Activities, and Extensions

- Practice critiquing an artwork. Look for 5–10 things you like about it. Be specific, using comments such as, "The warm reds, yellows, and oranges seem to express a joyful mood." Now, list a few things that you might have done differently if it were your artwork.

- Bring to class a work of art that you display in your home (painting, photo, wood sculpture, hand-made jewelry, ceramic bowl, hand-sewn quilt, poster design, etc.). Be prepared to share it with the class, explaining what you like about it and why, and explore similarities and differences in objects, the meaning of art, and the definition and role of subjectivity.

> ● Interview an artist. Prepare a brief presentation to be shared with the class regarding what inspires the artist, why and how he or she does what they do, where they work, what art habits and routines they have developed, etc. Pictures and/or video clips can be utilized to make the presentation more effective and interesting.

I've learned that people will forget what you said, and people will forget what you did, but people will never forget how you made them feel.—Maya Angelou

Section Six An Art Class for All Students

Many would understandably argue that there is no one content area within the school curriculum that is more important than any other area for all students. In fact, no one content area can replace what all children will miss if the art program is neglected or absent from the curriculum. Visual artists especially, will testify to the fact that their lives are made whole via art in ways for which there is absolutely no other substitute. Consider the magnitude of these statements for students in schools with, or without, a strong art program.

Unless they fully support a high quality visual art program, no school system can ever honestly claim to leave no child behind, nor can they honestly declare to be meeting the needs of all children or that they have permitted none of their students from falling through the cracks. In a school where art is missing from the curriculum, how could anyone claim to meet the needs of all students? Children arrive at school with unique personalities and their own special mixture of dominant learning styles, tastes, and interests. In order to effectively teach all children, all children must participate in a visual art program designed to include everyone. No exceptions.

We all know that diversity makes for a rich tapestry, and we must understand that all the threads of the tapestry are equal in value no matter what their color.—Maya Angelou

MULTICULTURAL ART EDUCATION, TEACHING ART FROM A GLOBAL PERSPECTIVE

Both teaching and learning should be full of acts of discovery, sometimes planned and sometimes pleasant surprises,

that are permitted, nurtured, applauded, and encouraged. Art experiences can be structured so that students will make discoveries about themselves and, in turn, about people and cultures other than their own. The effective art teacher will be in tune with students' distinctive needs, unique personalities, and individual contributions that can be brought to the table we call "education."

If planned for, a natural cycle can occur via art experiences as children learn about various cultures. As young artists study art and characteristics of cultures they can begin to more deeply understand their own. The teacher might consider planning experiences with masks, for example, as this is just one of many art forms that play an important role in various cultures around the world. A young artist in Kentucky might connect masks to Halloween, a costume party, a wall ornament, or to the theater. Similarly, a child in New Orleans might immediately associate masks with Mardi Gras while a child in Mexico might think of masks in connection with the Day of the Dead celebrations. Likewise, a young artist in Zaire might associate masks with spiritual ceremonies. Students might see masks from around the world and be asked to consider the role of masks in their own lives. As they enter into a rich personal study, in turn, students will gain a greater understanding of the meaning, materials, and art processes in other cultures and, indeed, around the world.

Remember not to fall into the trap set for teachers who often offer flashy pre-packaged experiences that do not allow for creativity. If a teacher gives each of her 24 students a commercially produced kit so they can all assemble the same mask, how will children benefit from this experience? Instead of such a cookie-cutter experience, consider the wonderful discoveries that will occur if the teacher shows various masks from other cultures via posters, video, the

World Wide Web, and/or real masks from her or his personal collection. Students will benefit far more if permitted to design, think about, shop for their own materials, and create their own masks. Discuss the endless possibilities for mask-making materials and processes and allow students to be involved in selecting what best suits them. Along the way, there is likely to be a bit of thought, coupled with a great deal of excitement.

As students begin to bring in buckets, bowls, sticks, branches, leaves, beads, necklaces, junk jewelry, interesting plastic recyclable objects, scrap cloth, yarn, acorns, buttons, shells, junk found in their parents' garage, and wonderful finds from the kitchen junk drawer, they are well on their way to a wonderful art journey. Through such acts, the student will become more able to relate to artists thousands of miles away who also make use of items from their surroundings for art making. As young artists allow themselves permission to be influenced by their own environment for school art experiences, they will have a better understanding of the role of inspiration and motivation in the lives of artists globally. In other words, when the child asks himself why he selected a turtle shell, fishing lures, deflated football, photos of family and friends, or swim goggles as a dominant element in his artwork, he learns something about himself. Additionally, when he presents his mask to the teacher and to peers, he uses art vocabulary and content that is meaningful to him.

The audience will also learn a great deal about diversity, as they see, hear, and discover 24 different solutions to the mask-making challenge. It is exciting to watch as students discover aspects of art with which they can make personal connections with their own art, the art of their peers, and the works of others from around the world.

The arts can speak across race, class, and cultural differences.
–Linda Levstik

The beautiful cyclical nature of learning occurs as students learn about self, others, self, others, and so on. Understanding and appreciating seasons the cycle of discovery as the art teacher points out, comments, questions, reminds, encourages, shares information, and positively reinforces students' artistic behaviors as they learn and grow.

While the finished artwork is treasured by the student, this is not the most important component of the overall experience. Remember, it is the "journey" where the learning takes place and not just the "destination" that is important. Instead, the focus should be to help students to become independent, confident, and passionate about art,

and about what it can teach them about self and about others. Many teachers frequently announce goals such as, "We must finish this mask by Friday so we can move on …" It is often implied that not only is *finishing* the issue of importance, but that they must finish making one thing so that they can move on to making another thing.

Do not misunderstand. Most students will thoroughly enjoy the act of art making, and of using their hands. This is important, but we must also instill within them the joy and power of creative and critical thinking. It is hoped that each day, when students leave the school building, they will do so wanting to go home, make, think, or learn more about art. Our expectations for them should be that they will be excited about returning to school each day where art will be a part of their everyday lives; and that they will eagerly seek out opportunities to see art in museums, galleries, art fairs, books, magazines, artist studios, and on their home computers and cell phones.

Students need time for art education—often more than the school administrators allow. It is better to allow proper time for art experiences where hundreds of important skills and concepts will be learned and practiced, rather than to allow only one day or one week with the simple, flat goal of quickly making a mask.

Teachers who pay attention will see signs that art is often therapeutic for children. When a fifth-grade child announces after art, "Wow … I needed that!" the adult would be wise to pay attention. Remember the fast-paced nature of many cultures in which our children live. In only a few minutes time, the whole family can have a bagged dinner in their laps by simply pulling the family car up to a window. Many meals are eaten in such a way by our students while still in the car. Many of us live in a high-speed society with decreasing attention spans since we often do not have to wait for things.

A favorite pastime, watching television, offers us multiple breaks; thus, young people seem to have a need to practice real life without always getting a commercial. They need to be able to enjoy being deeply engaged in an experience without feeling pressured to complete it fast. Once they realize that they can spend time pondering, analyzing, questioning, commenting on, sketching ideas, etc., they often express to teachers of art that they want, need, and appreciate such opportunities. Art class is not a race. Grown-up artists do not have to stop all work on their art at the sound of a bell. This is not to say that the more "laid back" student should be permitted to sit the whole year without ever picking up a pencil or uttering one word, of course, but teachers will help find balance and set a good

pace so that students can have time to help set, understand, struggle with, and accomplish their goals.

The teachers who best know their students will be better prepared to help them to make connections with various cultures. Because art is a means of expression, the observant teacher will learn endless interesting facts about students. We will learn who loves to bake, read, run, draw, talk, swim, visit, debate, fix, invent, climb, and tell jokes. Who has siblings? Who travels? Who exercises? Who spends a lot of time alone? Whose pet cat had kittens the night before? Ask a student how his piano recital went the night before and watch as the child's face lights up! The fact that the teacher takes the time to pay attention and make students feel special will help children to become the kind of citizens who respect others. They will be more apt to go out of their way to respect, learn about, and appreciate others. The art room is the perfect venue for such life lessons.

As our world becomes increasingly more diverse and seemingly smaller, art teachers can play an important role in the lives of children as they begin to understand and appreciate special qualities in themselves and others. With an appropriate amount of time spent on experiences, such as the simple one described above, students will make valuable discoveries about art, about themselves, and about others. Rather than fearing people or things that are different, students will learn to understand and appreciate the uniqueness that makes up the world in which they live. Diversity is one thing we all have in common; we must celebrate it every day.

Good art is art that allows you to enter it from a variety of angles and to emerge with a variety of views.
–Mary Schmich

THE ART EDUCATION OF URBAN MINORITY STUDENTS

Once upon a time, there was a shy, insecure, bright-eyed, round-cheeked beautiful six-year-old African-American boy who, after drawing a self-portrait, timidly asked his elementary art teacher for *permission* to paint the skin on his portrait brown. Other students around him were busy using a peach color for their skin, and he honestly questioned whether or not maybe he should also use peach. This unexpected question was viewed as an opportunity to gently and lovingly teach the young artists not just about painting but also about pride in one's skin color and heritage. As the child came and went in and out of this art room

over the years, the teacher seized such teachable moments and began a long history of many discussions and helpful comments.

When children enter public school and they are surrounded by all sorts of people with seen and unseen differences, they begin to look, compare, and question. The child in the example above discovered a lot about himself while in art classes. He also learned to be a proud, confident, creative, and critical thinker. He began to learn about and understand himself and others. The art teacher enjoyed many brief conversations with the boy for six years, until he moved on to middle school. The intrinsic rewards she received as she watched his self-concept and confidence levels begin to soar could not be matched by any other reward.

Also noteworthy within the above example, is that during the impromptu, informal conversation about skin color, a few children nearby joined in the discussion by revealing their observations that their skin did not match the peach paint from the bottle and that, indeed, the brown bottle of paint did not match any brown skin in the room either. Before long more students joined in a genuine quest to try to mix paint to match their different skin colors. Children all around the room were mixing paint colors by adding to, darkening, lightening, studying, comparing, altering, and repeatedly analyzing each action. They were sharing ideas, asking questions, and occasionally dabbing a bit of each new color mixture on the backs of their hands or holding up a loaded brush next to their cheeks and asking the advice of peers ... "Does it match?" "Does this look like my skin color?"

Throughout the room, impromptu mini-critiques rolled through the students' eyes, minds, and mouths with peers helping each other: "I think you should try adding a bit more yellow ..." and "Try adding just a dot of red ..." and "I think you got it, how'd you do that?" One girl announced, "I'm painting my skin green, because that's how I feel today" While another student challenged, "No you can't 'cause you're not green!" and yet another reaffirmed the art room philosophy by announcing, "Yes, this is art class where it is okay to do stuff like that ..." meaning that they are permitted to think, analyze, seek advice, give advice, and make choices—all extremely valuable life skills.

In this one brief example, which is a true story, one can see that a wonderfully exciting and meaningful color theory exploration occurred. Students learned a tremendous amount about color mixing and paint characteristics. Equally important, students learned about themselves.

They learned to understand, respect, and appreciate commonalities, as well as differences in others. Due to the unique nature of art, children can be given valuable and rich experiences. Will students notice and comment on the fact that they are a minority in a particular setting, or that minority members of the class are different from themselves? Of course they will. Will there be related questions, comments, analysis, discussions, and explorations? Again, the answer is absolutely yes. Will the art class serve as a perfect stage for such acts to play out—again the answer is a resounding "yes!" In a class where the art teacher is the director and the students are the actors, rich art experiences will make up the script with a story line written and played out by the young artists.

The teacher can structure art experiences that will promote self-discovery. One Kentucky art teacher/artist, when discussing the importance of searching for self by looking at one of the driving forces in her life—her grandmother Ida—shares these related thoughts,

> Remembering what my grandmother Ida taught me is important. Without her, I might not appreciate things like the richness of uneven stitches in beautiful handmade quilts, or home-grown and fried green tomatoes, soup beans and cornbread, hand-woven rugs and chair seats, the act of caring for and tending flower gardens, the joy of making good use of the soil and watching vegetables grow, singing and dancing at family gatherings, or the unique scent of bed sheets that have been dried in the fresh air of the outdoors. Only recently have I realized how much her love of and deep connections to nature have influenced my thoughts, art making, and life. If provided opportunities to make such connections, students might gain a deeper understanding of self, as well as an appreciation for others. (Bucknam, 2001)

Buchoff (1995) suggests that " … we should be challenged to reproduce our own life stories and that if we do not, the recollections may in time be lost forever" (p. 233). Self-discovery is important for artists of any age in gaining understanding, confidence, and pride in the role one plays in the home, school, city, state, country, and world.

Visual art helps to bring about understanding and appreciation. It is a tangible record of each student's history that helps preserve their rich and diverse heritage. If offered opportunities to share family stories at an early age, many children might keep and continue such acts of discovery into their adult lives. Sometimes, the stories swell into extensive series of artworks, coupled with numerous idea book sketches and entries! Students might share parts of

their histories during group discussions as they work on individual projects in the hallway or before and after class. If students' family stories are valued, encouraged, and collected, children will benefit as they grow and make self-discoveries. Understanding one's self is helpful in understanding others. In preserving the past, we can learn about and understand the present and set goals for the future.

One obvious perk of teaching in an urban area is that students generally do not travel as far to and from school as do those in rural communities who might spend hours each day riding the bus between home and school. In many urban schools, students live within walking distance of the school, which is a huge plus for the teacher who wants to utilize some of the precious after-school and/or before school hours. Imagine for a moment all the rich experiences many students could have if the art teacher arrived a little early and/or stayed a bit longer after school. What might students accomplish if the teacher's art library were open 30 minutes before school each Monday, Wednesday, and Friday? Just think of what students would learn if an "art movie" was shown on the classroom television every morning or maybe scheduled for showing once or twice per week. What might students discover in an after-school art collage club, art news team, weekend illustrators' workshops, tie-dye night, or after-school trip to a local museum, gallery, or artist studio? The newest art teachers are full of energy and ready to save the world! A good piece of advice is to focus on ways to not lose this enthusiasm and passion. Be careful not to make the job unrealistically hard (i.e. working 20 hours every day). Find ways to do what needs to be done to make the art program successful.

Teachers who want to be effective until the day they retire must be careful not to contract the horrible disease called "teacher burn-out." Ah yes, throughout your career you will encounter a few of these infected souls who have become negative people—worn out and ready to retire yesterday! In the teachers' lounge, they are easy to spot since these infected speech givers will constantly reminisce with hundreds of stories that begin with "When I was younger." "When I was younger, I took students on annual trips out of state!"

> When I was younger, we spent the night in the museum … invited guest artists to speak after school … visited the local artists' studios … slept over night at the zoo to draw … and the aquarium for painting … and we visited the National Gallery of Art in Washington, D.C.!

By the end of the day, these same dreary souls are already backing out of the school parking lot as the last bell rings.

They are experiencing "teacher burn-out" (which is a topic for another book), and they have it bad. All good teachers, especially teachers of urban minority students who arrive early and stay for special school art programs, cannot afford to be burned out.

To be fully engaged in the activities that students need, the teacher must take care to plan, but also let the students plan; organize, but let the students help; gather and save, but with the assistance of students, parents, peers, and the hundreds of available community resources; and spend quality time with students before, during, and after school—all the while making sure to maintain a healthy, happy, and fulfilling life during school and in the hours spent for and with students.

Find help. Become good at making lists and delegating. Recruit volunteers. Remember that quite often students, parents, and citizens in the community want to help, and they only need to be asked.

Sometimes, teachers have trouble letting go of some of the jobs that need to be done. As previously discussed, students will gain confidence, and learn important life skills if the teacher trusts them to assist. The teacher, who tries to attend to every single detail, without any help at all, will most likely fall prey to the teacher burn-out disease. Sometimes, it is simply a matter of habits, such as accepting students' offers to help, calling parents and asking for volunteer chaperones for an after-school visit to the art gallery a few blocks away, having a cup of coffee while watching a morning art movie with students before school, reading the morning paper in the art library with students while they read your art books before school, and being ever mindful of the need to take care of yourself. "Hire" a few art library helpers to organize books, water plants, restock the paper towels, wash paint palettes, and weed through old magic markers. Their "salary" can be drawing paper, art materials, or a nifty pair of winter gloves from the thrift store. Give students the gift of modeling good behaviors and giving them your personal time. These are gifts that are sure to come back to you.

What lies behind us and what lies before us are tiny matters compared to what lies within us.–Oliver Wendell Holmes

WORKING WITH SPECIAL EDUCATION STUDENTS, TEACHERS, AND PARENTS

For all students, including students with special needs, teachers must focus more on what students *can do*, and less on what the student *cannot do*. Since all students have different abilities, when the inevitable day comes, will you feel a bit under-qualified or under-trained to teach a student with autism? Who does not see? Who has no arms? Who spends each school day in a wheel chair? Who writes with his or her feet? Who does not speak? What about those who cannot sit still, or those who just will not stop talking?

As future teachers, you will read books and journal articles, take college courses, attend professional development programs, join professional organizations, and learn by talking to other teachers, but the "real" experts are the parents! On the very first day of life of the baby born with a disability, most parents begin their in-depth and very personal study as they explore and analyze every quality that is unique to their child. Parents, who want the very best education for their child, are usually more than willing to tell you anything you wish to know. All the art teacher needs to do, in most cases, is ask. "Tell me about your child." "What does she like?" "What do I need to know to make the most of his time with me?" "What type of art experiences has she had, or does she prefer?" "With which tools, materials, or art processes is he already familiar?" It is likely that valuable information will also be revealed by simply asking and/or spending time with the child.

Many parents state that they prefer their child's teacher's to focus on the *abilities*, rather than the disabilities, of their children. For example, rather than dwelling on a thought such as, "he cannot see the clay," focus plans around the fact that he can "feel" the clay. Rather than overemphasizing thoughts about how she cannot hold the glue bottle in her hands, spend time finding ways for her to glue with her arm, foot, mouth piece attached to the glue bottle, or use a helper to assist with gluing. If he has sensitivity issues with the wet feel of clay, but loves the feel of foam shapes, then foam sculpture it is! If she puts everything in her mouth then try painting with pudding, oatmeal, mashed potatoes, or icing. Add food coloring and/or use various foods to create diverse experiences.

No one class or book can fully prepare future teachers for every possible experience that will be encountered in the real classroom. All children are different. All children are special. No exceptions. All children have different personalities, likes, dislikes, talents, fears, dreams, and abilities.

Oscar Wilde said, "Art is the most intense mode of individualism that the world has known." Through art teaching experiences, teachers will learn new ways to teach

and meet the individual needs of young artists with individual, unique, and special needs.

Many helpful art tools can be found on the market, such as scissors with extra grips that allow the teacher and student to simultaneously control them. They have two sets of finger holes—one set for the student next to a second set for the teacher's fingers. Many online forums exist for parents and caretakers, which can serve as the perfect place to ask questions or gain ideas. A simple online search will also reveal hundreds of items that will be helpful in arts experiences; start collecting now, and make it a goal to annually add to this collection.

Approximately 7 million people throughout 51 countries participate in arts events sponsored by a well-known and highly respected organization called, VSA—The International Organization on Arts and Disability (vsarts.org). They promote the following beliefs:

- Every young person with a disability deserves access to high-quality arts learning experiences.
- All artists in schools and art educators should be prepared to include students with disabilities in their instruction.
- All children, youth, and adults with disabilities should have complete access to cultural facilities and activities.
- All individuals with disabilities who aspire to careers in the arts should have the opportunity to develop appropriate skills (VSA, 2010).

Inclusion teaches us that all means all. Everybody.
No exceptions.—VSA

TEACHING ART IN AN INCLUSIVE CLASSROOM

The four VSA guiding principles listed above focus on the fact that "all" means all. Inclusion means all. No exceptions. All means everybody. The VSA "invites people to leave familiar territory, to explore new answers and seek new questions," maintaining that the arts offer a means of self-expression, communication, and independence, and that by learning through the arts, students become lifelong learners, experiencing the joy of discovery and exploration, and the value of each other's ideas." The VSA, an affiliate of the John F. Kennedy Center for the Performing Arts, is committed to education, "changing perceptions and practice, classroom by classroom, community by community, and ultimately society."

Looking at inclusion, from another perspective, including "all" students sometimes means addressing the unfortunate existence of bullying. Bullies often isolate or exclude their victims. It is the teacher's job to constantly be aware of such dynamics in the room and to consistently address them without hesitation. The art class lends itself to being more social than other classes and, as such, is a good place to work through issues for the bully and the bullied. There should be a "zero tolerance" policy for bullying in every classroom, including the art room. Here, the teacher is in the best position to stop unacceptable behavior and to help students work through issues. Likewise, in art class as students develop an understanding of and appreciation for those who are different, they will begin to open their minds and hearts and celebrate diversity.

Creative Planning and Topics for Group Discussion, Activities, and Extensions

- Review and reflect on one of the following resources. In what ways might this resource assist teachers in teaching children of all abilities? Additionally, list any other resources of which you are aware to help children of all abilities learn. Be prepared to discuss your one selection in class from the following: VSA: The International Organization on Arts and Disability (vsarts.org), Learning Abilities (learningbooks.net), National Institute of Art and Disabilities (niadart.org), Hope Light Media (hopelightmedia.com), Kinder Art (kinderart.com), Organization and Management of an Autism Classroom (omacconsulting.com), and/or Education by Design (edbydesign.com).

- Read and reflect on the following quote, and discuss how it relates to what you read in this chapter.

... we can say that the journey inward becomes an ongoing process that leads to a more complete understanding of the human condition. Self-understanding is not merely a reflection on what we are but on what we are in relation to the world. Self-understanding comes to us via our unique perceptions of the world, which are dependent on our inherent individual abilities as well as on our particular socio-cultural histories. (Krall, 1988. p. 467)

- Search catalogs for tools and resources that might be useful in art for students with special needs. Bring information (source, cost, description, possible uses) on three to five good inventions/tools/products and be prepared to share this in class (i.e. chubby or triangular crayons).

- Find a sample of a "permission slip" (i.e. for staying for an after-school art club, or going on a field trip to an art museum) to share with the class. If needed, alter the content, and/or revise it to make it more visually appealing.

- Brainstorm ideas for art-related experiences that could occur before and/or after school. Discuss the logistics of each, considering who would be involved (other than students), and what resources would be needed.

- Read "Welcome to Holland," by Emily Kingsley. In a small group, discuss what it might be (or is) like to have a child with various types of disabilities. What are some personal or related experiences you have had that you can share? How do you think parents of special needs children feel about the well-known poem?

It is the supreme art of the teacher to awaken joy in creative expression and knowledge.—Albert Einstein

Section Seven Gifted Students

Ironically, a student's giftedness is often what leads teachers to pay less attention to or even ignore the child's needs. The opposite extreme would be schools where only artistically gifted students receive art education experiences. Both extremes are examples of what we do *not* want for our children if, in public schooling, we wish to help young people to be well-rounded citizens who are informed critical and creative thinkers. It bears repeating that, according to a leading advocacy group for students with special needs, " ... all means all. Everybody. No exceptions" (VSA, 2010). "All" must include artistically gifted students who have very special needs that often go unmet.

The U.S. Congress offers a federal definition that relates to teaching gifted and talented students that includes visual arts as one of six vital areas. Furthermore, a definition is offered: "Gifted and talented children are those identified by professionally qualified persons who, by

virtue of outstanding abilities, are capable of high performance ..." (Marland, 1972), and programs in the area of visual art must be provided for these children (Goertz, 1999). Art experiences will "... provide emotional outlets and a medium for expression that words and numbers cannot ..." and the "arts also provide a new means of understanding and explaining the complex phenomena of human endeavor and human motion ..." (Seeley, 1989). It makes sense that an art curriculum is essential for those who are artistically gifted. Otherwise, talent is likely to go unrecognized.

The visual arts are not the domain of the privileged or the talented, but they belong to everyone. Art education is for all children, just as math education is for all children. The uniqueness of each child's talent must be nurtured and developed to full potential whether it is in the visual arts or other content areas; the arts must be recognized as basic to the curriculum.

When the arts are realized as intelligences that are *basic* and *invaluable* for children and adults in creating new ideas, concepts, and skills, then the study of the arts will be required of all (Goertz, 1999). The arts then will be recognized as basic, and the outdated cry to focus only on the traditional "3 Rs" will have to move over and make room for an important "aRt" that we cannot afford to ignore. Many experts in education believe that creative work presents problems without any one right solution and that, with the capacity to extend thought visual art can bring a whole other dimension to the education of gifted students—one that cannot be achieved in any other way.

The National Art Education Association (NAEA) helps support expert opinions within hundreds of their publications and statements, such as this one:

> If all the art in the lives of our children were to be removed there is no way that adding more mathematics, increasing reading programs, requiring more science, mandating more tests, or scheduling more computer classes could ever replace what they have lost. (NAEA, 2010)

It is important for the teacher to encourage students to recognize their individual talent and to emphasize self-expression through art experiences rather than an over-emphasis of technique. Outside of the art room, it should be noted that incorporating art as a necessary part of learning units encourages more choices for study and greater originality in student presentations of learning. We must be ever mindful of artistically talented students' interests and encourage them to write about, reflect on, and discuss their artworks.

As part of the art program for the gifted and talented child, include visits to art galleries, museums, artists' studios, and invite local artists to visit the classroom. Consider a mentor for fostering the individual art interests of students. Meet art students and art professors at the local university and develop a network of those in the community who are willing, and sometimes rewarded for, visiting your school and/or sharing their expertise with young artists in your program.

As artistically gifted students develop good art habits and confidence, it is important to encourage them to be responsible for solving art problems, as well as for finding art problems and working through them. Effective visual art education programs and gifted programs should provide unique opportunities for gifted children to think innovatively, to integrate the rigors of skill with the flexibility of imagination, and to extend their analytical and creative powers in new directions. Students with special talents

in visual art need to be identified and valued as worthy of our attention and support. Otherwise, they will recede into the background like so many other invisible and underserved gifted populations.

The crucial variable in the process of turning knowledge into value is creativity.–John Kao

DEVELOPING AN UNDERSTANDING OF ART AND ART MAKING

We must go beyond the teaching of skills to the sharing of ideas and attitudes via informal discussion, mutual exploration of exhibits and ideas, and the sharing of collections, sketchbooks, artworks, other artists' statements, etc. Conversations with the gifted child are as important as actual work on projects; this assists with the development of serious attitudes toward art and high personal standards, as well as with work-related frustrations and triumphs. Such ongoing dialog must be sought out since it will help artistically gifted children to develop an understanding of art and art making.

Creative work is performed in the mind before it gets to the canvas; preliminary investigations, preparatory plans and exercises, and both verbal and visual exchanges are extremely valuable and necessary parts of making art. Often, because of lack of time, these preliminary steps are not emphasized in most elementary- and middle-school art programs. The art teacher can help the gifted student to classify the different kinds of decisions that artists make before and during the work and to explore more of these decisions for themselves.

An important aspect of working with gifted children is that we present a broad view of who the artist is and what the artist does, recognizing that career interests in the design arts, architecture, or fashion industry might arise as early as interest in and commitment to the fine arts. The children's projects might extend to redesigning the school's interior spaces or playgrounds; creating murals, outdoor classrooms, or outdoor sculptures; or designing a special school publication.

Through example and through discussions of the work of other artists, teachers introduce to students the ways that artists think, work, and live. Children's views are expanded through increasing familiarity with art history as well as contemporary artworks.

I used my imagination to make the grass whatever color I wanted it to be.–Whoopi Goldberg

IDENTIFYING TALENTED YOUNG ARTISTS

Not every gifted child is identified by perceptive teachers or parents. Consider, for example, the children of artist parents who generally live within environments that would be perfect for most artistically gifted students. Children of artists tend to be extremely creative for a good reason. In the age-old "nature versus nurture" debate, one cannot deny that artists' children are likely to receive unique and enriching experiences that foster creativity. Growing up with an artist in the home, young people are surrounded by art and art making, a climate of experimentation, and a wide range of art supplies and collections of visually interesting objects. The artist-parent is likely to frequent museums and to take the child along.

Even in the simplest daily activities, the parent will point out interesting visual finds to the child as a matter of course. Even if artists do not instruct their children, these children learn about the life experiences and the work of the artist through the pores, and their own creativity is given interest and attention. Every gifted child cannot, of course, have the same advantages as the child of an artist, but special programs in our schools can go a long way toward setting the budding artist's feet on the right path.

We must dispel the picture of a gifted art class consisting of super-talented geniuses who are screened by placement exams. While in some gifted programs we must use some sort of screening process, the main requirement for a gifted program should be the child's expressed and demonstrated interests.

Generally, the interested child submits a body of work, both from school and from home, in the form of a portfolio that is evaluated by a panel or committee that might be comprised of, for example, a visiting college artist/professor in consultation with parents and teachers. The portfolio demonstrates the child's special interest areas and abilities and gives personal insight to those who will work with the child.

Teachers and parents are also asked to state their recommendations. Handouts to classroom teachers, such

Table 5.1
Checklist for the Identification of the Artistically Gifted

Does the child demonstrate the following characteristics:	YES	NO
1. Sustained involvement in creating or in viewing works of art?		
2. Interest in reading about or collecting arts related materials?		
3. Multiple arts interests?		
4. Interest in the sensuous qualities of artworks?		
5. Interest in keeping visual records of written plans of arts ideas?		
6. Unusual powers of observation and recall of visual detail and overall structure?		
7. Imagination, exhibited in a wide range of new ideas?		
8. Advanced technical skills in art medium?		
9. A highly developed capacity to organize artworks in various media?		
10. Awareness of a medium's possibilities as well as its limitations?		
11. Adaptability from one creative situation or medium to another?		
12. Ability to execute self-initiated problems and see them through to conclusion?		
13. Ability to explore freely, experimentally, and playfully?		
14. Satisfaction in challenges of creative problems and difficult tasks?		
15. Displays capacity for organizing creative ideas?		
16. Tolerance of difficult moments in creation?		
17. A capacity for self-evaluation and the setting of high standards?		
18. Realistic appraisal of present achievements and positive plans for future action?		
19. Willingness to assume leadership in the arts program?		
20. Interest in entering a profession in the arts or in becoming an artist?		

as in Table 5.1, can help them to identify art talent without basing their judgments solely on their own preferences for one type of artwork over another. Two kinds of pupils are usually recommended by classroom teachers: those who have above-average skill, who are advanced in terms of developmental stages in art or who can draw convincingly realistic images (hopefully without reliance on formulas or copying); and those who might exhibit less skill in image making but who are full of original ideas, inventions, and innovations in their artwork. Both groups are equally good candidates for the program for young artistically gifted students, particularly if they have demonstrated the ability to work independently.

Rather than looking for one test to identify artistic talent, procedures for identifying artistically gifted students can include a panel of experts to observe and recommend the student. The parents are the experts regarding their children—most knowledgeable about their own child of course. The generalist classroom teacher will most likely know her or his students' unique interests and talents very well. As is the nature of public schooling, they often end up spending as much (or more) time with the children than do their parents. The art teacher and teachers in special community arts programs can often offer valuable insight. The school decision makers need to set a policy on admission to the gifted program that encourages everyone interested yet takes into account the sometimes limited resources available for the program during each academic year.

Hurwitz (1983) noted that certain characteristics are evident for the artistically talented student: interest, precocity, ability to concentrate, ability to work on own time, tendency to draw for emotional reasons, fluency, and communication. He recorded the characteristics of the artworks of the visual-art child as: (a) realistic representation, (b) use of detail, (c) visual and kinesthetic memory, (d) use of variety of media, and (e) improvisation (Hurwitz, 1983). With these characteristics of young artists and their artworks, a checklist can be developed and a process established to determine visual art talent as well as art potential. An artistic ability and talent assessment, such as in Table 5.2, is an example of one source for recognizing

Table 5.2
Artistic Ability and Talent (Goertz, 1998)

Name:	Grade Level:	Age:		Date:	
A list of statements is given below. Please read each statement and circle the one that best describes how the statement applies. Explain, give an example, or describe behavior in the "comments" section after each statement. Optional: attach a sample of artwork.					
Observes changes in environment	Always	Frequently	Sometimes	Infrequently	Never
Comments:					
Exhibits curiosity	Always	Frequently	Sometimes	Infrequently	Never
Comments:					
Experiments with art materials	Always	Frequently	Sometimes	Infrequently	Never
Comments:					
Draws realistically from memory	Always	Frequently	Sometimes	Infrequently	Never
Comments:					
Draws to explain ideas	Always	Frequently	Sometimes	Infrequently	Never
Comments:					
Draws with detail	Always	Frequently	Sometimes	Infrequently	Never
Comments:					
Spends long periods of time making art	Always	Frequently	Sometimes	Infrequently	Never

(Continued)

Comments:					
Spends time making art at home	Always	Frequently	Sometimes	Infrequently	Never
Comments:					
Uses imaginative ideas in artwork	Always	Frequently	Sometimes	Infrequently	Never
Comments:					
Critical of own artwork	Always	Frequently	Sometimes	Infrequently	Never
Comments:					
Wants to be an artist	Always	Frequently	Sometimes	Infrequently	Never
Comments:					
Completed by: Parent, Self, Peer, Teacher, Artist (Circle one) or Other (define):					

1998 Goertz

talent and potential talent in the young artist. Having students prepare a portfolio is helpful for the examiner to see and review student artwork first-hand. Additionally, the attentive art teacher will be well aware of potential, gifted candidates from regular observations of art performances in class.

We must be mindful that the portfolio for those not familiar with the child's regular art performances can be somewhat of a disadvantage if used alone because it only represents snapshots of "actualized talent" rather than "potential talent." Students with consistent experiences in a rich art environment (including art classes) will have an advantage in preparing an art portfolio. An interview

might be conducted with the young artist to respond to open-ended questions that allow the student and interviewer to begin a dialog that encourages individual responses. The interviewer might elicit information that indicates the student's desire and passion for art, as well as motivation and persistent interest in art.

When possible, students should be observed in the art making process by an art teacher who will be able to see good indicators of visual art talent. A sample interview format can be seen in Table 5.3.

Children are the living messages we send to a time we will not see.–Neil Postman

Table 5.3
Interview for Artistic Talent Assessment (Goertz, 1998)

Name:	**Grade Level:**	**Age:**	**Date:**
Tell me about your artwork.			
What do you like best about working with art materials?			
With what kinds of media do you like to work?			

(Continued)

What do you do at home when you have extra time?
Would you like to be an artist?
Do you have questions for me?
Additional questions:
Completed by:

(Goertz, 1998)

TEACHING ART TO TALENTED STUDENTS

A teacher who understands the needs of the artistically gifted is most likely to be more successful in planning and implementing learning environments and experiences that stimulate the growth of their talents. Most classroom generalist teachers, if asked, can quickly point to the "class artist" or feel they can easily identify one or two, at the least, student "artists" in the class. These teachers also tend to point out too quickly their own inability to help.

Although most teachers and parents are enthusiastic about supporting special art programs, many of them *mistakenly* feel that such programs should be offered during after school hours, and/or outside the regular school setting. Some mistakenly fear that a special school art program may take away from school space, time, and materials that are felt to be in short supply and, therefore, hurting the "regular" curriculum.

Learning in art, especially for gifted children, should not be considered separate from the rest of learning and life. Truth be told, any attempt to assist children with their art can only enhance their learning in other areas. Art is extremely helpful in developing a child's confidence, concentration, willingness to learn, ability to abstract and analyze problems, and capacity to be more observant in other facets of life.

While most parents and educators recognize the need for early exposure and even rigorous training in other arts, such as dance or music, they often mistakenly state that ability in the fine arts unfolds naturally on its own and needs little special attention. Unfortunately, teachers who group students according to abilities for all other types of activities during the school day are often reluctant to make part-time groupings for art because they feel that all children should have the same opportunities to develop their talents and that groupings in the arts are elitist and undemocratic.

It is often suggested that a better choice than a special art program for the gifted would be a strong commitment by the school to the existing art program, which would promote the natural unfolding of talent in all children. Of course, it would be ideal to let children explore their talents, experiment, and play in order to develop their art abilities naturally. Unfortunately, few school art programs, even the best, challenge the gifted child and provide a full opportunity for creative talents to flow. Ideally, artistically gifted students would be served by a special art program, as well as the existing high-quality visual art program, and consistently have opportunities to be engaged in arts experiences integrated in the overall curriculum.

In developing skills and abilities, the visual arts program should enable artistically gifted students to experience the professional role of the artist. Young people should not

only create art, but they should also be actively engaged in experiences that help them to understand the role of the art critic, the art historian, and the art theorist (Clark and Zimmerman, 1984).

Goertz and Arney (2009) maintain that gifted children use both critical and creative thinking to respond to and evaluate a work of art. They develop skills needed to provide a rationale for their responses by specific aspects of a composition, and this, when using Bloom's taxonomy, can aid this process and can act as a tool for analyzing, interpreting, and judging art (p. 256). When learning about the criticism of a work of art, elementary- and middle-school art critics use creative and critical reasoning skills to determine how they feel about a work of art and, if they like it, why or why not.

This is important since many gifted children never learn to give reasons to support their arguments, and they might use their advanced language skills to camouflage what they do not understand correctly or well. Goertz and Arney (2009) suggest that we consider the intellectual aspects of art study and practice presented in increasing levels of difficulty using Bloom's taxonomy as a framework for looking at art with a critical eye (p. 257).

There is an abundance of information available to assist teachers in planning for the artistically gifted and talented youth, such as those found in a more recent publication called *Igniting Creativity in Gifted Learners, K-6: Strategies for Every Teacher* (Smutny and Fremd, 2009). One of the greatest gifts that a teacher can give to those gifted in visual art is to be ever mindful that the "artistic domain offers a creative bounty" that teachers and young artists will be "hard pressed to find anywhere else" (Smutny and Fremd, 2009, p. 243).

> *The future belongs to those who believe in their dreams.*
> –Eleanor Roosevelt

The Gifts of Confidence, Risk Taking, and Self-Discipline

The creative child needs to develop self-confidence and enjoy what she or he has accomplished while, at the same time, realistically evaluating what is still to be achieved. The future artist learns to set and work toward high goals, exploring various skills, abilities, and styles. In setting high standards, the gifted child might be prey to excessive doubt when these standards are not immediately met.

Some children gain confidence from becoming knowledgeable about a particular medium or a particular artist, especially if they have an opportunity to share their expertise with an appreciative audience through exhibits and oral or written presentations. While becoming specialists, these children must also be encouraged to become generalists. The teacher needs to arouse children's interest, opening up new vistas through the exploration of different media, materials, styles of working, etc. A delicate balance must be struck between the full development in the area preferred by the child and broadening challenges in new areas. A child who has had success with a particular talent or ability might not want to venture beyond that area that has brought her or him acceptance and recognition in the past and might sacrifice creativity for facility. Young artists must develop a great deal of self-confidence to go beyond the safe limits, to endure uncertainty, and to risk failure with the unfamiliar.

Self-confidence in art is developed through continuous art experiences, constant self-evaluation, and progress toward personal goals that give a sense of inner stability and control even if the goals seem infinite and even unattainable. With the teacher's help, the child can gain confidence in setting goals and sorting out interests, perhaps abandoning some in order to concentrate on others and learning about the combination of patience and courage with which the artist must work.

Self-discipline in art means making choices and taking risks, which is a natural process in creative growth, a means of deciding who one is and what one means to do. With this self-discipline comes the self-assurance that allows the child to confidently experiment in new areas.

The Gift of Independence

With repeated experiences involving self-discipline and self-assurance, comes the valuable ability to become independent, creative thinkers and doers. Creativity is *intensely individual*, and even the budding artist in the elementary school must learn to sometimes work independently. Some gifted children are already independent in their work, whereas others might need help in learning to work on their own. From the outset, children in a gifted program should be taught that they are working for themselves: that the time, effort, and initiative put into the work are to be their own reward.

The teacher can stress the importance of setting personal directions and goals. Children may learn by collecting ideas from objects, reproductions, photographs, or new slants on their own work. Teachers might help gifted children to

explore materials and ideas through visits to museums, art supply stores and flea markets, and through environmental walks—the possibilities and resources are endless. With the teacher's help, the child can learn to document ideas, keep a continuous record of observations, make notes of ideas, formulate plans for new uses of familiar materials, and envision the incorporation or transformation of objects that are unusual or of special interest.

Young artistically gifted students can learn to act independently on their noted ideas, to view their own progress, and to decide how to carry challenges and their newly learned skills from one project to the next. As children become aware of different materials and styles and of different preparations for, and techniques of, working, they can make more and more of their own decisions regarding each aspect of the work. Over time, they can gain more control over space, materials, and skills and consequently over the outcome of the work itself. Art class is not about teaching skills; its boundaries are limitless, but among the numerous positive outcomes of quality art education experience, we find children learning to be more independent.

… we have focused too much attention on basic skills testing to the detriment of problem solving and critical thinking. We have focused too much on remediation of skills in math and reading to the detriment of a full, well-rounded curriculum that includes art, music, health, physical activity, social studies and science. We have pulled students from engaging in courses like music and art to provide skills training.
—Terry Holliday, Kentucky Commissioner of Education

The Gift of Challenges

According to Victor Lowenfeld (1979), if a great deal is expected from the young artist, a great deal is achieved (p. 376). Many have supported this line of thinking under the label of "self-fulfilling prophecy." In Hildreth's view (1967), the aesthetically gifted students have to be challenged if their natural facility is not to turn into glibness, a means of avoiding in-depth artistic problems.

In the middle of difficulty lies opportunity.—Albert Einstein

The experience of children who are gifted in art should be as close to that of the adult artist as possible. For example, they should work with the tools and materials used by artists, and they should have an opportunity to search for and select tools and materials that they feel are the most

suitable to the expression of their ideas. Teachers can broaden the child's awareness of what is available and of what wide varieties of materials have been used by contemporary artists. Similarly, through visits to artists' studios and through photographs and recordings, the gifted child can become aware of the different kinds of places where artists personalize and design their space to create the kind of environment in which they best work.

The child's work habits and attitudes are also of utmost importance. Teachers can help the gifted child to arrange for a continuity of experience, and to develop a regular work schedule, which is the first step toward recognizing the need for a sustained effort in creativity. Such a schedule requires the opportunity to work outside school hours, as well as during school, so that art may become a part of the child's total lifestyle.

Some children might already be active in visiting museums and galleries on their own time, while others might benefit immeasurably from unchartered territories and expeditions with the art teacher. Some students might have easy access to interesting materials in the home, and others may have interesting after-school chores or hobbies into which art may be incorporated. The program for the gifted can be individualized according to what can be accomplished at school, what facilities are available at home, and what supplementary activities might be planned for the art teacher to experience with the gifted students.

No bubble is so iridescent or floats longer than that blown by the successful teacher.—Sir William Osler

The Gift of Support

Perhaps the most difficult part of being an artist is the feeling of isolation from non-artists or, in other words, of being different. This feeling can be particularly painful for the gifted child who also has the "normal" problems of growing up. The tyranny of "sameness" imposed by peers (and by adults as well) is particularly strong in childhood, even before children have had an opportunity to develop a sense of self as an artist. As a result, gifted children might withdraw and become almost reclusive or they might even redouble their efforts to be "normal" and deny any special talents that label them as different.

One of the most important functions that the teacher serves is to teach gifted children that it is okay to be different, that they are not alone, that others have the same dif-

ficulties, and that there are people who understand and share their concerns. By fulfilling the role of understanding mentor, the teacher might make it possible for the gifted child to strike a balance between the seclusion needed for creative thought and the work and harmonious relationships with peers. The teacher can help the gifted children to understand why they are different from others and to accept the fact that people who choose to move away from society's norms and standards are often misunderstood.

Gifted children need the chance to be comfortable with at least one person in talking about their ideas, frustrations, and worries: a person who tends to their unique abilities and problems and who takes their intuitive creative thoughts seriously. Gifted students need to be provided the opportunity to focus on an idea or project until it is completed to their satisfaction without having to move on to a new assignment in each art session. This helps protect them from premature outside evaluation and fixed standards of propriety or excellence and allows them to build away from predetermined solutions toward experimentation and innovation.

Gifted students must be provided with time to work alone and also with a circle of similarly interested friends as well. Part-time groupings of such children allow them to share concerns and ideas and to support each other's goals and, whenever possible, the child's work should be shared with regular classmates as well as through exhibits, demonstrations, etc.

The art teacher can also help gifted children by finding a wider, more knowledgeable audience for their work. The audience might include people who are willing to look, listen, and fully appreciate the gifted child's efforts (i.e. special programs, seminars, workshops, art weekends, etc. are offered by government agencies, arts organizations, universities, arts advocacy groups, etc.).

Parents' support is also essential. Although initially some parents fear that "academic" work might suffer or picture the stereotypical image of the artist as someone that they do not want their child to become, they may be reassured by being kept informed of the child's interests, plans, and progress. Parents may well benefit from a discussion of appropriate and supportive reactions to their child's work. Similarly, parents should be encouraged to participate and to help by providing time and space for the child's art experiences, as well as storage and exhibition space in the home.

They might assist by acting as models, by gathering interesting props, by being supportive critics of the child's work, by encouraging steady work routines at home, and by taking children to art exhibits, festivals, demonstrations, and other related art programs. Parents might want to share an art-related hobby, such as training the child to use the family camera, or they might invite the child, as an artist in the family, to participate in such activities as selecting room color schemes, arranging home furnishings, or choosing decorative art objects for the home. Parents will appreciate teacher advice on the kinds of art materials available for fostering the child's artistic interests.

The support of the PTA (or school parent group) can be a great asset to art education for the artistically gifted. They might be able to provide art supplies, additional space, or artworks and art books for the school's collection. They might also be able to help with building a school ceramics room, computer art lab, special facilities, saving materials for a particular art project, arranging for exhibition space outside the school, etc.

Support from the school administration and governance committees can result in major contributions to a program for artistically gifted children. They might allot flexible time so that the child-artist might regularly work on art investigations and projects. It should be pointed out here that the freshness of the morning hours, which are often devoted to the "academic" subjects are equally important to nurture the creative spirit. Generally, the school needs to recognize that like any other art form, the visual arts require routine and regular practice if serious work is to be accomplished.

The school decision makers might be willing to provide exhibition space for the program outside the classroom. Ideally, the art program for artistically gifted students would provide areas that could be individualized and compartmentalized toward creative physical privacy and an opportunity to design one's own work environment as far as possible—an "advanced" studio space if you will. Having a corner where unfinished work can be stored, one's own wall where favorite reproductions can be pinned up, the choice of working on the floor instead of on a table, or the freedom to experiment and make as much of a mess as necessary can add immeasurably to the success of such a program. For this purpose, the school leaders might make available such spaces as storerooms, stage dressing rooms, the stage itself, or the gymnasium when not in use. Some pupils (like some artists) need familiar and quiet spaces in which to work. Others perform better when exploring unfamiliar places in active surroundings.

The school administration might also provide a more liberal allowance for travel to exhibits, stores, shopping malls, farms, and other neighborhoods so that the children

can incorporate more of the real world into their art than would be possible from within the classroom. The artist needs the freedom both to experience and explore in a public setting and to retreat, think, interpret, and visualize in a private setting.

The school might be able to expand its library collection to include art magazines and books, art image collections (both hard-copy reproductions and digital formats) to make them easily available to the children and their art teachers. Aside from funds for visuals, money may also be given for special tools and materials or for special projects, such as the production of posters, brochures, a school catalog newspaper, an art "backpack program" with packaged art items ready for students to check out for home use for short periods of time. Such small-project grants from the school are tangible support for the art program and the child-artists in the school.

Gifts from the Art Teacher

The art teacher will provide ongoing assistance with the individualized plan for each gifted child. In addition to differentiating learning experiences and helping to incorporate art throughout each artistically gifted child's school experience, just imagine what young artists could do outside of the school day if art becomes an around-the-clock part of their lives. This is very likely with some help from the art teacher who might:

- Provide art materials for art making before, during, and after school.
- Provide advice on where to obtain additional art supplies.
- Introduce children to art supply stores via field trips, whether in person or via video/photographs/online (and during every art experience, tell young artists where to find unique art tools, materials, and resources).
- Communicate on a regular basis with parents of gifted students via e-mails, snail mail letters, art web sites, school web sites, school newspapers, art program newsletters, informational handouts at parent meetings, etc.

- Make available films on artists and art making processes that students can view outside of the art room (at home, in the school library, in all regular classrooms, etc.).
- Make available art "packages" that students can temporarily borrow (i.e. for printmaking, a backpack might be stocked with tubes of water-based printing inks, brayer, printing tray, paper, etc., or yarn, cardboard, and scissors for weaving).
- Allow students to check out laminated art prints to hang in their bedrooms.
- Make art prints available for purchase by sharing resource information or via fund-raiser.
- Print student's original artwork on a large format printer for them to have/display at home.
- Provide an independent work space in the art room where gifted students might spend time (and assist other teachers in doing the same) before or after art class.
- Invite guest artists to the school (for talks after, as well as during school).
- Take field trips to art museums and galleries in person and/or via technology (web sites, videos, DVD, books, etc.) and communicate suggestions to students and parents so that they might engage in similar activities outside the school day.
- Take field trips to artists' studios and work spaces in person and/or via technology and communicate suggestions to students and parents for additional places to visit.
- Provide exhibition spaces in the school where students can work after or before school to display art of their choosing.
- Arrange for exhibition spaces in the community and assist students in displaying their artwork (i.e. hospital or doctors' office waiting rooms, coffee houses, shopping malls, offices, banks, public libraries, churches, community centers, restaurants, daycare centers, nursing homes, gyms, etc.).
- Provide sketchbooks to gifted artists and/or give online prompts to stimulate ideas and encourage the continuous recording of ideas, thoughts, questions, investigations, sketches, inventions, etc.

Creative Planning and Topics for Group Discussion, Activities, and Extensions

- Review again the list in the above section, "Gifts from the Art Teacher," and brainstorm other ideas. In what other ways might teachers of art assist in making art a daily part of the lives of artistically gifted students?

- Interview a local artist. Using digital photography, video recordings, audio recordings, or other appropriate media, prepare a brief presentation on the artist that can be shared with young students. Be prepared to share with the class and gain ideas from each other.

- Describe one art "package" that the art teacher might prepare and make available for students who are gifted or highly interested in a particular art media or artist to borrow. The tools, information, and/or materials must be able to be stored, checked out, and carried in a regular-sized student backpack (i.e. for printmaking, a backpack might be stocked with tubes of water-based printing inks, brayer, printing tray, paper, etc.).

Reference Books and Resources to Read, Look At, and Share With Students

Alsip Photography. Cumberlandfalls.org, 2011.

Buchoff, R. Family Stories. *The Reading Teacher*, 49 (3) (1995), 230–233.

Bucknam, J.A. Express Yourself: Beginning at Home with Family Stories. *Art Education*, 54 (4) (July 2001), 38–43.

Character Kids. *101 Ways to Praise a Child*. Retrieved from http://www.character-kids.com, 2010.

Clark, G. and E. Zimmerman. *Educating Artistically Talented Students*. New York: Syracuse University Press, 1984.

Goertz, J. Searching for Talent through the Visual Arts. In J.F. Smutny, *Underserved Gifted Populations: Responding to Their Needs and Abilities* (pp. 459–467). Cresskill, New Jersey: Hampton Press, Inc., 1999.

Goertz, J. and K. Arney. Looking at Art with a Critical Eye. In J.F. Smutny and S.E. von Fremd, *Igniting Creativity in Gifted Learners, K-6: Strategies for Every Teacher*. Thousand Oaks, CA: Corwin Press, 2009.

Greenburg, Jan and Sandra Gordon. *Action Jackson*. New York: Roaring Brook Press, 2002.

Hildreth, G.H. *Introduction to the Gifted* (pp. 206–209). NYC: McGraw Hill, 1967.

Hurwitz, A. *The Gifted and Talented in Art: A Guide to Program Planning*. Worcester, MA: Davis, 1983.

Kingsley, E.P. Welcome to Holland. Retrieved from http://www.autismnetwork.co.uk, 2010.

Krall, F.R. From the Inside Out: Personal History as Educational Research. *Education Theory*, 33 (4) (1988), 467–479.

Laden, Nina. *When Pigasso Met Mootise*. San Francisco, CA: Chronicle Books, 1998.

Levstik, L.S. and K.C. Barton. *Doing History: Investigating with Children in Elementary and Middle Schools* (pp. 75–192). 4th ed. New York: Routledge, 2011.

Lowenfeld, V. *Creative and Mental Growth*. 6th ed. New York: Macmillan Publishing Co., Inc., 1979.

Marland, S., Jr. *Education of the Gifted and Talented* (Report to Congress of the United States by the U.S. Commissioner of Education). Washington, D.C.: U.S. Government Printing Office, 1972.

National Art Education Association. Retrieved from http://www.naea-reston.org, 2010.

National Museum of Women in the Arts (nmwa.org).

Palmer, P. *The Courage to Teach: Exploring the Inner Landscape of Teacher's Life*. San Francisco, CA: Jossey-Bass Inc. Publishers, 2007.

Seeley, K. Arts Curriculum for the Gifted. In J. VanTassel-Baska (ed.), *Comprehensive Curriculum for Gifted Learners* (pp. 300–313). Boston, MA: Allyn & Bacon, 1994.

Sesame Street (1969). *Don't Eat the Pictures: Sesame Street at the Metropolitan Museum of Art*.

Smutny, J.F. and S.E. von Fremd. *Igniting Creativity in Gifted Learners, K-6: Strategies for Every Teacher.* Thousand Oaks, CA: Corwin Press, 2009.

Swindoll, C. *Attitude.* Retrieved from artlex.com/artlex/a/ artquotations, 2010.

Venezia, M. *Getting to Know the World's Greatest Artists* book and video series.

VSA. Retrieved from http://www.vsarts.org, 2010.

Weed, P. and C. Jimison. *Tricky Pix: Do-It-Yourself Trick Photography.* Warwickshire, England: Scholastic UK, Ltd, 2001.

Professional Development for the Art Teacher

Let such teach others who excel themselves.—Alexander Pope

Section One Continuous Professional Growth for the Art Teacher

Aside from earning a diploma in a university teacher education program and gaining teaching experience, what other actions will lead to the improvement of art teaching, knowledge, skills, and attitudes? We know that art teachers must take care to find balance and avoid over-extending themselves, while at the same time being active enough to have a genuinely positive impact on students. Art teachers must do all of this while also finding ways to keep alive their personal love of art and teaching. Choreographing such a performance is exhilarating and essential business.

AVOIDING TEACHER BURN-OUT

Teaching art to young people will be an intensely rewarding, yet sometimes fatiguing job. Most would agree that the career is extremely pleasurable and fulfilling. Those who long for an endless stream of intrinsic rewards are likely to be very happy and successful in elementary- and middle-school art teaching positions, but those who seek a fully predictable, daily routine or who lack motivation need not apply. Anita Voelker declares that, "Teachers can't burn out if they aren't on fire." J. Oswald Sanders wisely notes, "Fatigue is the price of leadership … Mediocrity is the price of never getting tired." Consider ways in which art teachers can maintain their passion of art and teaching, avoid burnout, and find balance between hard work in their schools and in their art studios.

ART EDUCATION PUBLICATIONS

Novice art teachers sometimes skip attendance at their annual state art teacher conventions, declaring that they are too tired to attend, while the master art teachers have learned that active participation in these important events will result in newly-found levels of positive energy, ready for direct application in their classrooms and art studios. Professional development is necessary for art teachers who strive for long-term success and effectiveness, avoidance of teacher burn-out, or fatigue-riddled mediocrity.

An ongoing familiarity with historical and current art education publications is one way to develop professionally. An enormous amount of literature is alive and well from various sources, including the National Art Education Association's (NAEA) offerings. In addition to the recommended books listed throughout this text, it is wise to keep abreast of current publications, such as those available in the annual conference NAEA store, conference vendors, or year-round online sources, such as naea-reston.org.

Libraries, both real and virtual, tend to stock thousands of art publications, just waiting for past, present, and future art teachers to check them out. Keeping abreast of current issues in the field is also made possible by subscribing to appropriate publications and growing a healthy personal art library, being sure to include journals and magazines, such as *Art Education, Arts and Activities,* and *School Arts.*

ART MUSEUMS AND GALLERIES, MEETING WITH OTHER ART TEACHERS

Frequent visits to art museums, galleries, and artist studios are considered worthwhile behaviors for the teacher-artist in order to grow in the profession. Artist demonstrations, seminars, and lectures will provide inspiration, motivation, and education for the lifelong learner within the artist and art teacher.

Meeting merely one time each month with other art teachers in the county and/or region will provide priceless opportunities for brainstorming sessions that are beyond compare. There is no need to wait for someone else to call a meeting. Zip off a quick invitation to local art teachers and put on a pot of coffee. No budget is necessary for the act of sharing knowledge or touring others' art rooms and studios. Invite each guest to share favorites (materials, publications, speakers, storage tips, art gallery and museum programs, art collections, art material suppliers, community resource ideas, etc.). Show, and tell, about the exciting objects that live in the art room.

Take turns meeting in different art rooms throughout the region. Strangely enough, this seems to be one of the most overlooked sources of professional development. New art teachers have the opportunity to jump in and begin a wave of new professional families that will reap positive rewards.

Probably one of the most important ways to experience professional growth as an art teacher is to be an active artist. Continuation of creative activities in the evenings, on weekends, and/or during summers might be likened to running; one might feel too tired after a long day, week, or semester of hard work, but once started, it is clearly worth it.

Creative Planning and Topics for Group Discussion, Activities, and Extensions

- Interview an elementary- or middle-school art teacher(s). Discuss how they maintain their passion for art teaching and art making, avoid teacher burn-out, and find balance between hard work at school and their own art studio. Summarize your findings and be prepared to discuss, with the class, at least three things each art teacher enjoys about his/her job and at least three helpful hints or words of wisdom for future art teachers.

- Select and review one art education publication and summarize at least two of the most interesting and useful things you learned. Be prepared to share with the class.

- Create a list of topics that might be useful to address in a meeting of local art teachers. When interviewing an art teacher, ask what professional development experiences have been most beneficial to them. Be prepared to share in class.

Teaching has given my art life great traction.—Bob Ragland

Section Two Uniting the Roles of Artist and Teacher

Teachers must be ever-mindful that the acts of practicing and teaching art have fundamental similarities. Maintaining one's artistic self while teaching should be a principal goal of art education. The ability to harmonize one's creative powers in teaching *and* art making should be one of the foremost competencies of each art teacher.

Artists' creative talents will be naturally applied to teaching, and the inspiration that results from teaching will feed into new discoveries within teachers' personal artworks. This cycle must continue if the artist-teachers are to be as effective as possible. The relationships between artistic development and growth as teachers of art must be recognized. The field of art education is unique in this way since progress in one area generally leads to a heightened awareness of the other.

THE ARTIST-TEACHER IN SEARCH OF SELF

It is important to engage in self-discovery, regarding the relationship between artist-self and teacher-self. Throughout one's career, the teacher of art must reflect on and

assess his or her own competencies as both a teacher and as an artist.

The artist-teacher is someone who continuously grows, both as an artist and as an educator. The creative individual who is able to combine the artist-self with the concerns of teaching has a great deal to offer. With one's involvement in art comes excitement about creative acts and the flourish of new ideas that might be translated into art making and art teaching.

It would be wise to keep the idea book always within reach. The artist-teacher, who has performed or painted the previous evening, maintains a high level of interest and creative ideas, which serve as readily available references for art teaching. The closer the sources of inspiration, the nearer one feels to the art world and the deeper one's insights will reach into the art process of others. Although, in most cases, the spark of creativity is transmitted instinctively to one's teaching, this process can be enhanced if the teacher makes a conscious effort and is constantly on the look out. In other words, the transmission of one's artist-self to a class should be both planned and intuitive.

During the school year, it becomes progressively difficult for a teacher to continue personal artistic pursuits. The demands of the job, to which many art teachers "give themselves completely," in their creative personalities, often leaves them too physically and mentally exhausted to pursue a professional art career.

Maintaining the Artist-Self

Sometimes, when art teachers enter the public school systems, they find themselves gradually removed from the idea of being productive artists. Determined to do well in teaching, year-by-year they see the hope fading of being a productive member of the art world, and they might resent this. Unfortunately, many art teachers only dream of adventures in the art making world that they *might have had* or the goals they *could have reached*. They stop making art and come to view the teaching profession not as another area of creative fulfillment, but as a hindrance to personal creative ambitions. This serious problem seldom receives enough attention: how to maintain oneself as an artist while teaching or, more importantly, how to combine art and teaching during one's lifetime needs a great deal of thought and discussion.

Effective school administrators encourage the art teacher to pursue creative growth as a productive artist. The art teacher's work outside of the school is not just a private matter; it is directly related to his or her responsibilities as an instructor. What, in fact, has to be realized is that the teacher's artistic productivity outside of the school is one of the most important preparations for the performance in class. Without support from the school's decision makers, art teachers lose sight of the natural connections between the development of their art and teaching.

Creative muscles are exercised when acts of planning for teaching and art making merge. The teacher who has been inspired to creatively formulate an art lesson presents something of great value. The teacher who supplies only experiences straight from a catalog, or from "recipes" of others, lacks the understanding of the need to create meaningful art experiences for the student.

DRAWING ON KNOWLEDGE OF ARTISTIC EXPERIENCES

Artists who are continuously involved in creative performances can draw on the specifics of their own work and explore the problems they may have in common with other artists, as well as the issues on which they differ from them. These might include discussions of sources for artistic inspirations, their views of time, work space, means of planning, relationships to their audience, and personal qualities, such as patience, determination, independence, and self-assurance.

Art teachers will be able to recognize essential personal traits that they have as artists and explore these factors in the development of their pupils. Referring to personal insights allows art teachers to be sympathetic observers and supporters of other artists. Teachers who are working artists can address themselves to their students as they would the other arts practitioners and be systematic to all problems of creativity. The artist-teacher provides great insights, knows where to assist students, how much help is required, and when to stop assisting. They are familiar with the difficult issues of beginning a creative work, of going beyond obvious solutions, of trusting one's intuitions, and of being able to take advantage of accidental occurrences—often called "happy accidents."

A LIFELONG INTEREST IN ART

Effective artist-teachers consider their own artistic development to be a lifelong process. Consequently, they might view the teaching of art not as a series of art projects but

as an inspiration to others to also pursue a lifelong interest in art. Artists who face the daily struggles of their own creative work learn qualities that will be important in their teaching efforts, such as inquisitiveness, humility, and patience. The artist-teacher can best understand that there are no uniform solutions or single answers and that the role of the art teacher is to help students discover individual tasks and their own unique ways of working—to recognize the existence of problems and alternate paths in solving them.

Artist-teachers are able to converse about significant issues and about the fears, responsibilities, challenges, dedication, and sacrifices that accompany their careers. The high standards that artists must impose on themselves and the struggles and possible failures can be openly discussed from the standpoint of personal experience. The teacher who is willing to reveal and reflect on these issues might also be perceptive and sympathetic to the struggles of students.

It is wise to meet with other artists within the school, county, region, state, and nation in order for such diverse and helpful conversations to occur outside of the classroom. It is in becoming an artist-teacher and also inviting the student to become part of one's creative world that some of the most significant aspects of art teaching occur. It is in this regard that students develop an understanding and respect for artists, who they are, and what they stand for. Thus, young artists will gain more insight into their own work, which would not evolve by merely looking at artworks in an exhibition.

ORGANIZING THE VISUAL WORLD

Competent artist-teachers have to be aware of the many ways that they present themselves to young people. Creative actions might be visible through the instructor's selection of materials, setting up the art room space, displays, classroom management, personal dress, gestures, demonstrations, and practices in the classroom. The confidence with which an artist handles materials, uses tools, and solves problems reflects one's competencies as a teacher as well as an artist. It is partly the artist-teacher's inspiring presence, personality, points of emphasis, and mannerisms that make the art class a special place that constitutes a unique experience. This is an important part of the job description that cannot be overlooked.

The ability to formulate a personal philosophy relating creative efforts to instructional methods is also a key for artist-teachers. Individual teachers have to discover these relationships for themselves and apply them in such a way that one stimulates the other. The artist who brings total dedication to a task cannot consider teaching and art making as separate activities or independent endeavors. The artist is the central source of creative power, regardless of the media of expression. The displays, in fact, might materialize in a variety of media, such as painting, photography, and teaching.

Art teaching involves a catalyst that can elicit ideas and emotions from the artist as well as the art viewer. When the artwork has the response of an audience, or the art lesson presented meets the involvement of the class, the artist's message is confirmed. Here, the teachers transcend their own sense of self, their own interests, and even their own performing capabilities. Such messages are designed to involve and inspire. Artist-teachers have the ability to transcend the artist, step out of their ego, and draw attention away from the instructor to form and encourage a close connection between media and students. It is by removal of attention to self, whether through teaching or other creative actions, that artist-teachers recognize the essence of their mission.

The task of the art teacher is the organization of a visual world; the aesthetic experience turned into a new universe for the involvement and comprehension of others. Art teachers, just like creative artists, produce communications through the structure of their lessons, the organization of ideas and visions into a unified whole. The message can be verbal in its thought or visual in its format. By learning to order one's experiences on a canvas, sketchbook page, printing plate, or a photographic composition, the artist-teacher receives the best training or insight into ordering the art experiences of others.

ART MAKING AND ART TEACHING PERFORMANCES

Art making and art teaching both involve performance. The difference between artists and their audience or between the art teacher and the audience is the rehearsal and preparation. The artist, like the teacher, has to be able to view creativity as a continuous preparation or rehearsal, tuning oneself and sharpening one's skills. If well done, both spheres require the same ingredients of concentration, discipline, and perseverance.

Great "performers" or great artist-teachers are sensitive to the life cycles of repetition, indicative of typical human actions. They see art teaching or art making as a means

to break this repetition in order to involve oneself and others in a movement towards change. This is the essential value of the artist, be it as a teacher or as a productive creator of art.

Producing art is a process of sharing—being part of a community where the audience is an essential part. Creative acts are performed in the spirit of giving part of oneself to another person, to a group of people, or to society at large. Artist-teachers recognize that they are not merely relaying subject matter in class, but they are sharing as well as giving their creative self as a model to others. It is by absorbing others into one's creative performance that the essential communal experience called "art" occurs.

Through their work, artists can control visual and emotional distances between their creation and the audience. People can be drawn near or pushed far away in experiencing an object. These distances are created through visual order, scale, color, subject, or meaning set up in the artwork. Art teaching permits similar possibilities of building distances or close relationships as teachers influence audiences in their classrooms through control of their attitude, actions, dress, time, space, materials, etc.

An essential aspect of creativity is not being afraid to fail.
—Edwin Land

CHALLENGING SELF, CHALLENGING OTHERS, AND PROMOTING INDIVIDUALITY

Artist-teachers must be able to challenge themselves and create a high-level intensity of experience for themselves and their work in order to translate this ability into challenging others. Artists do not begin their work or pursue the creative process with known answers and solutions. They must have the ability to project new solutions and ideas. The artist-teacher has to share the process of discovering possible ideas and solutions with students.

Artists pursue major problems closely related to the art world in their own work. While at school, however, art themes are often trivial and have little to do with creative concerns. For example, " … boys and girls, today all of you will color a pumpkin, just like mine … now, sit quietly while I distribute the pumpkin-color sheet where you are

to color the pre-drawn pumpkin orange—just like mine!" This example is not representative of the creative process that artists experience. Artist-teachers must be able to resolve conflicts and work out their concerns through and with their students, and to do this, experiences must be more open-ended to allow creative and critical thinking.

One of the artist's distinguishing traits is the ability to question life through the process of creativity. The artist-teacher should be a continuous questioner and examiner *in front of the class,* rather than the authority or the one who presents "the truth" to the class. How marvelous it is for a young person to watch an adult work through a problem or for them to work through the problem together. Minds will be in the "on" position when in this type of art room!

The job of the artist can be likened to that of a critic—critic of oneself, of the works of others, and of the artworks in general. The artist-teacher brings this critical examining attitude into the classroom.

I enjoy this part of the print because … I'm not particularly fond of the way this was done because … I don't like the characteristics of tempera paint as much because … I think I'll try mixing oil pastels with color pencils … I think I'm finished … I'd like to see more contrast in value … I'm not happy with it yet so I think I will … I wonder what I should do next.

These are examples of statements that can be practiced by student artists as they learn what it means for artists to reflect on work, what they like, what they want to change, what inspires them, and in what direction they will go next.

Artists are rarely ever fully satisfied with themselves or their accomplishments, certainly not to the extent that they can stop making art all together. There are always other ideas to be explored, further messages to be communicated, and other media to be investigated. In art class, the artist-teacher must be able to implant these qualities in students and cultivate them in each member of the art program.

Many would argue that it is impossible for art teachers to reach full competence without continuing to practice their own artistic medium. If we wish to keep the art in art education, we must value the creative performers in artists-teachers and ensure continued active performances in their own studios while teaching.

The most effective teachers embody the teaching they give out. –Maharishi Mahesh Yogi

Section Three Sharing Ideas, Writing, and Talking About Art Teaching

Discussing and writing about ideas can be very exciting, rewarding, and an integral part of an art teaching career—a way to share thoughts, plan artworks, and observe children and their own worlds. Writing is another creative media that longs to be explored by artist-teachers. As observers, players, inventors, and investigators with great ideas, children and art teachers are well qualified to write. As a matter of fact, among our colleagues in the education community, the artist-teacher has the most solid credentials to practice the art of writing when it is kept close to one's art teaching, creative ideas, and art making. The computer screen is just another canvas for the display of creative observations, stories, and fantasies that encompass our teaching of art. As an artistic media, writing daily in and out of the classroom can lead to many successful and helpful art education publications.

The reflective artist-teacher will generally take notes in multiple formats such as: sketches, graphs, doodles, charts, narratives, journals, etc. Piles of notes will be accumulated via sketchbooks, idea books, personal journals, post-it-notes, backs and margins of faculty meeting agendas, and restaurant napkins! Essentially, the article is almost written when one compiles all of these notes.

REFLECTING, BRAINSTORMING, AND SHARING THE ARTIST-TEACHER IDEAS

It is important to regularly record, comment, and reflect on experiences in the art room. In this way, the articles and

books that will result will be real and alive; they will capture the essence and flavor of the children and their art experiences. Making notations of our ideas is one way of teaching children to value theirs so they too can be reflective, observant, and inquisitive lifelong-note-takers in their own idea books and sketchbooks.

Artist-teachers are trained observers. They are visual. They notice beautiful things; they see more and often more deeply. They sense the uniqueness of objects and are open to discovering and freely conveying the excitement in events. Many artist-teachers might claim, "I am not a writer," or "I am not a workshop presenter or a convention speaker." This could not be further from the truth.

Art teachers are observers, photographers, keepers of creative stories, performers, guardians of young creative minds, and collectors of interesting things to talk and write about. Teachers, especially art teachers, are storytellers. Each day we perform in front of a very lively, enthusiastic, and spunky audience—children! As storytelling becomes a natural part of the art teacher's repertoire, it easily translates into writing.

It is known that teachers of art should attend regional, state, and national art teacher conferences, at which they should also share with peers as a professional obligation a small token of appreciation for the myriad of things that they will learn, in turn, from others. Similarly, it is also understood that art teachers should meet with other local art teachers and should host meetings in their own school system, county, and region—especially if no one else is

doing it. Invite a local artist to come to perform in the art room, not only in front of young students, but also before a room full of local art teachers.

Elementary-, middle-, and high-school art teachers in the same school system should meet together on a regular basis, to network, and share ideas and resources. Not only is this worthwhile professional development, but many teachers experience an incomparable intrinsic reward for their willingness to give back and to make a valuable contribution to the field, in addition to teaching their students. Teachers who are professionally engaged as such, will reap endless rewards as they share ideas, brainstorm, and professionally grow along with like minds.

Our art training can serve us well in the study of children and their art and, subsequently, in writing and speaking about it. Building on existing artistic skills, it is wise to get involved, and to study through a variety of media, including personal art forms with which teachers are already comfortable.

Elementary- and middle-school art teachers are uniquely in touch with childhood ideas and have a feel for art processes, artworks, objects, and experiences that will be appreciated by children. Planning an effective art lesson or museum field trip, or writing about art education in children's lives requires a strong sense of what is real including insight into childhood ideas, and what to do and not to do with children in art education. Because elementary- and middle-grade art teachers value children and are so close to the joys of childhood, it is indeed a pleasure to read and gather inspiration from what this unique group of educators has to say.

WRITING POSSIBILITIES, TELLING STORIES, PRESERVING OUR HISTORY

Writing, like any other art media, requires innovation. Unlike a beginning English composition class, formats, style, and presentation are more open in art class writings that encourage creative thoughts and personal styles of expression. We use many sheets of paper to promote the free brainstorming of possibilities. As in drawing, there is room in our writing for improvisation, building and, changing, since impressions can be quickly erased or altered, cut and pasted, copied and moved, ripped, loosened, tightened, scattered, or blended.

Experiences in art have taught us to look beyond the surface, draw upon different sources, and dissect and analyze events and objects in depth and from diverse angles.

Our trained eyes have prepared us well to write about ideas to which we are committed.

Artist-teachers constantly describe objects with words. They are aware of the jubilation in creative activities and can translate this into writing. The art room can become the breath of fresh air and the perfect environment for creative writing for the teacher as well as the students. Teachers and students who write together and openly share their writings can inspire each other.

Writing with or about children involves noting their many creative media, such as drawing, playing, and story-telling. A vast majority of today's young artists seem to have impressive collections of electronic devices in which, in tandem with their idea books, they might record notes and ideas for artworks, articles, and assignments. Can we teach young art students to write and make note of ideas, observations, questions, and inventions by modeling these behaviors? Absolutely.

Whether writing an article for an art education journal or magazine, planning a local art teacher meeting, conducting a workshop at the state art teacher conference, or presenting a session at the NAEA conference, art teachers who are active in this manner will experience first-hand the undeniable, unending benefits. These professional perks will be welcome to the teacher who sometimes feels alone in a school.

Being the only art teacher can sometimes seem difficult. As art teachers it is not uncommon for us to be dispersed in isolated settings where nonetheless we have our unique work cut out for us. As representatives of visual art, we educate parents, colleagues, administrators and, of course, our students. Through writing, discussing, and sharing, one feels connected to colleagues, whether across the hallway, across town, or abroad.

The more active one is in sharing, the more opportunities there are to be invited to present ideas and exchange thoughts with others in the field. Sharing information with like minds, whether it be verbal or in writing, at a conference or in the teacher's lounge, helps us to become part of our art education community.

As art teachers, we might never have great financial wealth to leave to others, but our lives spent as witnesses to extraordinary events, such as the births of new and future artists played out daily in our classes, offer unique perspectives that deserve to be preserved. Art teachers should write about what happens in their classrooms.

Forgetting for a moment about the confines of college education class mandates and jargon, art teachers may *write and talk about the sites and sounds of children*. Teachers of art

can feel free to set aside the confining style of some writers, whose writings are sometimes merely a guided tour of others' thoughts instead of their own, and put genuine ideas, observations, and discoveries on paper as one way to preserve and share revelations with colleagues.

It is wise to discuss topics that deal with children's concerns, interests, collections, and fantasies as they will always be the most enjoyable to read. A lot of writing is carried out by those who have not been part of the story or participated in children's artistic lives. More writing in our field needs to be centered upon children and their art. No previous writing experience is necessary. Art teachers must tell their stories, preserve them in history, and allow others to learn from and be inspired by them.

Creative Planning and Topics for Group Discussion, Activities, and Extensions

- Review art lesson ideas on kinderart.com. Find and summarize one lesson idea of interest that could be adapted to maximize the opportunities for individuality, creative expression, and critical thinking on the part of children. Explain what could be done differently (materials, theme, motivation, visuals, teacher costume, location, method of presentation, music, art tools, altering the environment in some way, etc.) and why this would allow for more open-ended problems and diverse creative solutions.

- Make an entry in your idea book regarding an art topic about which you feel passionate and you might one day feel confident about giving a presentation to colleagues in the profession. Brainstorm a list of points to be made and creative presentation possibilities. Prepare visuals and be prepared to share with the class.

You teach best what you most need to learn.–Richard Bach

Section Four Art Education Organizations and Their Purposes

Effective teachers often wear the hats of chief learners in the classroom as they are daily taught, via consistent reflections about art classroom experiences. However, the teacher who works as a recluse, never venturing outside her or his classroom for inspiration, will soon fizzle out.

or international groups of educators. The effective art teacher is involved in such opportunities for professional growth, proudly supporting art education efforts to advocate, research, teach, and write in the field.

DRAWING INSPIRATION OUTSIDE THE CLASSROOM

Art teachers need to spend time in the company of other artist-teachers for rich and meaningful professional growth. At each meeting of individuals whose business involves art and teaching, artist-teachers turn ordinary spaces into extraordinary events, whether the professional gathering is comprised of members who are from local, state, national,

DRAWING INSPIRATION FROM ART EDUCATION CONVENTIONS

Art teachers, who are some of the most resourceful people on Earth, are often the only art teacher in their schools, so there is a need to look beyond the campus in an effort to network with others. However, put two positive-thinking art teachers in a room for two hours and prepare to be amazed at the extraordinary number of ideas that will be generated and shared. Multiply that by a few hundred to

see what one might find at state or regional art conventions. Now multiply that by thousands to gain an idea of what might be experienced at an annual national art teacher conference.

The NAEA, for example, hosts an annual conference where artist-teachers and colleagues from around the globe join together for a premier professional growth opportunity. Each 4- to 5-day gathering consists of over 1,000 sessions that bring together practical research and teaching strategies, hands-on art workshops, special exhibitions, and tours of major art-rich cities. Every NAEA conference session is 100% focused on the professional development and growth of visual art educators.

Founded in 1947, the NAEA is the leading professional organization exclusively for visual art educators, and other arts education professionals. The NAEA mission is "... to promote art education through professional development, service, advancement of knowledge, and leadership" (NAEA, 2010). Art teachers' membership and active participation in this organization is a must.

An art convention is the most ambitious undertaking of any state art education organization and requires much time and energy to plan and host. Conventions are the principal bond for a state art education organization. It is where art educators in a state, or neighboring state, all gather, receive most of their in-service training, discuss their common concerns, and establish lifelong professional ties. State conventions are important meeting grounds where future teachers meet new teachers and experienced art teachers are nurtured by a wise force of retirees. It is a crucial introduction to art education as new teachers make important decisions about their chosen careers.

Many state organizations depend on this yearly face-to-face gathering. It is the glue that carries educators through the year of e-mails, newsletters, and thin threads of communication until they meet once more. Just as with a great art exhibition, an art teacher convention can leave one with the impression of being uplifted and transformed.

Creative Planning and Topics for Group Discussion, Activities, and Extensions

- Review the NAEA web site. In your own words, describe the mission of the organization and the member benefits. What is the annual cost of membership for active members and for university student members?

- Review your state art education association web site (or membership information in the absence of a web site). Describe the mission of the organization and the member benefits. What is the annual fee for active members and for university student members?

- Review web sites of other state art education associations. Select the one that is the most helpful, visually appealing, and user-friendly. Briefly describe the site and list the member benefits.

- What other arts organizations exist in the town, region, and state in which you live? Find one and be prepared to share a brief description and benefits in class.

Section Five School Rules, Procedures, and Legal Issues

Rule A: Don't. Rule A1: Rule A doesn't exist. Rule A2: Do not discuss the existence or non-existence of Rules A, A1 or A2.–R.D. Laing

Psychologist R.D. Laing offers a humorous twist on the seeming insanity and confinement of rules. He probably understands that if students are asked to list their favorite things about school, the resulting answers are not likely to ever involve school *rules.*

Rules and procedures can also appear confusing or overwhelming—especially in the classroom of the slightly overzealous teacher who posts the billboard-sized list, "Ms. Smith's 101 Rules!" or the classroom where the teacher has rules but only shares them with students *after* they have broken them, or the teacher who posts rules but does not reinforce or even mention them except on the rare occasion.

THE HUMAN FACTOR IN ELEMENTARY- AND MIDDLE-SCHOOL ART EDUCATION

Out of all the possessions of parents and all of their acquaintances, many are likely to state that their children are the most precious. It is for this reason that during the first days and sometimes weeks of school, a line of weeping parents can often be found in the halls outside of the kindergarten room entrance. Handing over a child to a stranger, even one with a teaching certificate, is a tough task for many parents who have spent years serving as the child's keeper. Rules must exist if teachers are to properly care for children that parents entrust to them.

You don't really understand human nature unless you know why a child on a merry-go-round will wave at his parents every time around–and why his parents will always wave back.–William D. Tammeus

Generally, parents have an innate desire to treasure and protect their children. Indeed, it is quite difficult for many parents to "let go" of their innocent, young child to attend school when the time comes. Understandably, parents want to feel confident that their children are safe, properly cared for, that their rights are respected while at school, and if they learn something in the process, that is even better!

Teachers are given the distinct honor and pleasure of not only teaching these young individuals but also of being responsible for them. It is the seemingly overprotective or overly-involved parents who can, at times, seem to be the greatest gift, the greatest challenge, or oddity to the busy art teacher.

Art teaching requires patience and constant tending to the *human factor* of our students and their caregivers. The parent who calls three times during art class to check on her child's rash is also the parent who is likely to help with the art fair.

OTHER Rs IN EDUCATION—RIGHTS, RULES, REGULATIONS, RESPECT, AND RESPONSIBILITY

Effective art teachers create an environment that is safe and one where there is mutual respect among all who enter and all who entrust their children to the school faculty. Effective teachers of art respect this relational triangle and happily accept the obligation to protect the rights of, care for, teach, and inspire young minds.

Everyone has to follow rules. Though rules are not always fun to think about, they are necessary. If teachers are caught speeding in their cars on the way to school, they are likely to be penalized via fines or, at the very least, with official warnings from law officers. This process leads to safer roads. This can be easily understood by adults and students of all ages. In every school system and in every classroom, where every person has rights, students and teachers have to follow rules. Usually, there are consequences for infringing on the rights of others.

Rights, rules, regulations, and responsibilities are usually outlined in faculty and student handbooks. These local rules and procedures exist to protect and ensure safety and fairness for everyone within the school. It is the teacher's responsibility to be knowledgeable of all of the rules, regulations, policies, and laws that would or could be relevant to their position within the school. Additionally, it is also the teacher's duty to make certain that students are aware of all of the rules and procedures that apply to them.

Art teachers must fully understand all school policies, school-wide rules, and procedures, and must model proper behaviors, as well as teach them to students. After all, it

would be unfair to hold students accountable for infringing on the rights of others if they have not been made aware of the rights. This suggestion might seem a little mundane at first, but consider the instances where the knowledge of proper procedures, policies, rules, or laws might be applicable.

The nightly news showcases a plethora of unexpected issues that knock on classroom doors, such as current topics of interest within the American Civil Liberties Union (ACLU). Policy-related and legal issues involving students' rights are likely to arise in every school at some point in time, thus, art teachers need to be alert, and ever mindful that students' rights are protected. Many unexpected issues will arise during every art teacher's tenure.

What are the legalities involved in taking elementary- or middle-school students on a field trip to an art museum? Is it okay for the teacher to "friend" a student on FaceBook? Should art teachers utilize social network web sites while at work? Is it permissible for the teacher to e-mail or send text messages to students? Should teachers wear logo T-shirts to work? Is it acceptable to give a student a ride home from school or to offer an aspirin if the student has a headache? Is it okay to take a photograph of a student under the age of 18? Can you post student photos on the school web site? Is it legal to talk about students with other teachers? Can you talk about students with their parents or with parents of other students? What role will the teacher play in preventing harassment or cyber-bullying? Could the teacher ever be put in a situation to protect a student's freedom of speech? What should teachers know about students' Fourth Amendment rights?

Making the decision to have a child is momentous. It is to decide forever to have your heart go walking around outside your body.—Elizabeth Stone

While these questions can seemingly be answered by merely using common sense, one look at the newspapers, television news stories, court cases, and the ACLU literature or web site sends a very clear message that not everyone is clear on the definition of common sense and that not everyone would give the same answers to these questions.

Many state branches of the ACLU have highlighted the need for advocating, protecting, and teaching others about student rights. The ACLU of Kentucky, for example, has published a 45-page handbook entitled *You Have Rights, Too: The Rights of Young People in Kentucky* that is free and available in hard copy (info@aclu-ky.org) or electronically at http://aclu-ky.org/content/view/34/103/ (ACLU, 2006). This handbook was written especially for young people in

order to help them understand their constitutional rights and freedoms. It addresses issues, such as freedom of expression, freedom of religion, freedom from discrimination, student privacy and school security, and sexual health and reproductive freedom. The sources used to highlight student rights are the Bill of Rights (contained in the first ten amendments of the U.S. Constitution), state statutes, and court case decisions (which often lead to the creation of new laws) (ACLU, 2006). It would be wise for art teachers to remain well-versed about such legal issues as they strive to be effective and informed.

Teachers must be mindful of the difference between rules and procedures. They should make students aware of art room rules and procedures, offer reminders, encouragement, and opportunities for students to practice them until the rules become instinctive and the procedures become habit. Be patient. Be consistent.

To talk too much and arrive nowhere is the same as climbing a tree to catch a fish.—Chinese proverb

Students should be invited to come up with art room rules. After all, it is their art program. Additionally, the art teacher might have a few rules that need to be followed in order to "keep peace." As previously discussed, all teachers have a "comfort zone." Having too many rules can overwhelm or confuse, which can hinder the effectiveness. Keep it simple. Rules should be easy to understand and remember. An elementary- or middle-school art teacher might have three *rules*, for example:

1. Respect Art Materials
2. Respect Others
3. Respect Yourself

Rules should reflect your teaching personality, and protect rights of all who enter the art room. Remember, students might wish to add a few rules of their own. If given the opportunity to be responsible, they will demonstrate great pride in helping to make the art room a wonderful place to be.

Art teachers will also explain, demonstrate, and expect students to learn art room *procedures*, such as: "Only one pump/squirt of paint at a time … you can always have more, but it's tough to put unused paint back in the bottle." To be more specific, the teacher might explain and demonstrate a suggested procedure for how to wash and care for paintbrushes. One elementary art teacher explains her "no tapping" procedure as she shows young students how to "bounce, bounce, bounce" bristles on the bottom of

the water bowl, and then "touch, touch, touch" the bristles on the inside of the bowl or on a paper towel to drain the excess water. Here is the part that kids love. She also demonstrates what "not" to do—zealously banging the brush on the rim of the bowl, sending clean water drops spraying all over—hence, the "no tapping" procedure, which helps first-time painters to see how to clean a brush, how not to spatter dirty paint water all over the artworks of nearby painters, and how to respect materials and classmates who are sharing the studio space.

Kindness and consistency on the teacher's part will aid in the students' ability to be independent learners and to utilize materials and tools in a way that will make them last longer. A little more direction on the front end of the trip will equip students with the knowledge that they need to make a more independent journey through the art program, and into their art making studios at home.

Additionally, this direction facilitates students in demonstrating their respect for others and for the art materials. It helps them to utilize precious time while attending to their ideas in art, rather than having to use dirty water or lingering endlessly with their hand waving in the air as they wait for the teacher to give them permission to do something that they were perfectly capable of doing on their own, minus the wait time.

Other procedures that are unique to art programs involve safety issues. Much research and attention has been wrapped around this topic, especially in high-school art programs. A quick online search will yield a surplus of information, making it possible for informed art teachers to offer safer art experiences for the young and old.

Elementary- and middle-grade art teachers need to make their students' safety a high priority. Items such as hot irons, warming plates, paper cutters, kilns, liquid paper, spray fixative, hair spray, rubber cement, alcohol-based hand sanitizer, scissors, stained glass, needles, electric blenders, wood-carving tools, hot glue guns, and even *sharp pencils* can cause serious injury in the blink of an eye! It is necessary for teachers to give timely safety talks and frequent reminders and to keep a close watch on all interactions between young students and art tools, equipment, and materials.

Years ago, the list of possible dangers seemed shorter. Who would have thought that young people would ever "huff" or find dangerous ways to use spray paint, liquid paper, hand sanitizer, or hairspray? Yet today well-informed teachers know that some students have abused these materials, leading in some cases to tragic fatalities (even at the elementary level). This information is not meant to scare future art teachers but only to lead to knowledgeable, attentive, and caring educators who keep abreast of children's thoughts, fads, hobbies, and sometimes dangerous trends or actions.

All art teachers, students, programs, and situations differ, but, in general, it is wise to position the paper cutter (with a long, sharp blade) and the kiln (that usually reaches dangerously high temperatures of 2,000-degrees Fahrenheit) *out of children's reach*. Additionally, it is wise to keep any toxic materials in a *locked* cabinet or to not have them in the classroom at all.

Sharp instruments, such as scissors and pencils, will be used daily and therefore, students must demonstrate their ability to safely use them. Other sharp art tools, such as carving tools for wood or linoleum cuts, should be numbered, tracked when in use, and locked away when not in use.

Tools, such as a hot iron, might be safely used in many elementary- and middle-school art rooms, as with most tools. The teacher, for example, can set up an "ironing station" for explorations, such as fabric crayon designs, batik, melted crayon artworks, etc. Having two to four irons, at one large table where students come to use the iron when their artwork calls for it, can be accomplished more safely, while the teacher stands at the table and oversees the iron's use.

Many safe alternatives exist in the art world today. Furniture polish is often used on fired clay pieces and in some printmaking techniques. Printmaking surfaces exist that are more easily cut. Almost anything that the teacher can dream of using can probably be found in a non-toxic version.

Low-temperature hot glue guns have made the older high temperature glue guns obsolete in elementary- and middle-school art rooms. Though the low-temp glue guns probably will not cause burns as serious as their high-temp ancestors, it is still wise for the teacher to set up a hot glue "station" and keep a close eye on its use. As with anything in life, constant use of a little common sense can go a long way.

Experience and watching other effective teachers will reveal many procedures that are never mentioned in the textbooks, nor could they be in their entirety because the list is endless and often based on individual situations. In a room with a sink, six-year-old artists can easily take a container with dirty water to the sink (holding it with two hands, looking down and straight ahead like they are driving a car), and refill it (only half way), and return to their seats without missing a beat—and without involving the art teacher. The teacher only need show students one

time and offer a few reminders, of course, along the way when needed. Always reflect on what is working and what could go more smoothly. Revise procedures as needed, practice them whenever needed, and reflect on them again. Reflect. Revise. Repeat. Introduce, remind, and reinforce rules and procedures—those that are uniquely meant for the art room, as previously mentioned, and those that relate to the overall school culture.

Bullying, harassment, and various forms of discrimination seem to be at an all-time high in the public school systems. Teachers want students to be independent, confident, and competent problem solvers, but bullying in elementary- and middle-school classrooms is not an area where teachers should stand back and allow students to "work it out" themselves. There is no gray area here. In an art teacher's classroom, it is his or her responsibility to ensure that students are not bullied, harassed, or discriminated against. No exceptions.

Cyber bullying is demanding serious attention but has not been adequately addressed yet. Ironically, most schools have polices against cellular phone use by students while at school, for example, yet many teachers seemingly do not enforce the policy. This is puzzling because, meanwhile, surely some of the same teachers must see television news reports each evening. Nationwide, we wonder how on earth students have got away with creating such personal, hurtful, and even destructive photos of peers in locker rooms and school restrooms, and how such images could have so easily been posted on the World Wide Web.

Future teachers must decide. Do we enforce school policies and protect students or not? The decision should be simple. Future teachers can only control what students do while they are in their keep; however, an attitude of "NOT on MY watch" would go a long way in protecting students while at school and, hopefully, having a positive influence on them each day after the last school bell has rung.

In all schools where there is, or should be, an enforced "zero tolerance" policy for bullying, harassment, or discrimination of any kind, it is the teacher's duty to keep his or her eyes and ears open and to be prepared to act on any breach of this policy. In the unfortunate classroom where the teacher tolerates such offenses, learning is negatively affected, but more importantly, the ugly gap between the bully and the bullied students grows wider, since the bullies feel more confidence, control, and power over the bullied who feel powerless, unprotected, unsafe, and afraid.

PHOTOS, AND FORMS, AND FIELD TRIPS, OH MY!

On a lighter note, but also important, is the need to be aware of the school policy for actions or events such as photos and field trips. The school might require the use of a specific form, but if not the art teacher who wishes to take students to an art museum, gallery, or artist studio can find numerous samples to borrow, use, or adapt (such as the sample in Figure 6.1).

When taking students off school grounds, a medical form containing pertinent information (such as the sample seen in Figure 6.2) is also generally required. In attending to such paperwork, minimal effort will be required, and it will be well worth it. Whether the teacher is taking students across the street to an artist's studio or gallery or across town on a bus to the art museum, teachers of art must plan for the unexpected. Accidents happen, and when they do, the teacher is in charge of how each incident is played out.

Likewise, a photo release form (such as the sample seen in Figure 6.3) should be given to each student at the beginning of each year, since the teacher might wish to use photos of artistically engaged students in publications or on the art program secure web site, in school displays, etc. Generally, if teachers post photos of students or students' artwork online or in hard copy format, he or she only use the first name of the artist. The art teacher who sends hard copies home in student backpacks, through the mail, and also posts forms online will increase the success rate of signed and returned forms.

If not careful, a teacher might accidentally betray the confidence of their most valuable customers—their students. Teachers, parent volunteers, university observers, and any visitor who steps into a school have the responsibility to keep private all that they hear and see.

Many school policies require that everyone, without any exceptions, receive confidentiality training each academic year and that they have a signed verification form on file in the school office before they are permitted to volunteer, observe, or visit in the school environment. Some statements go a bit further and address natural characteristics of children to sometimes tell things that their parents might have preferred that they kept private, such as northstar4kids.com/policies/confidentiality, where this statement is found:

Young children have not yet developed a sense of judgment about the difference between information that can be shared about their families or information which properly stays

within the family. Very often young children are the source of much gossip and conversation about the private lives of their families. Teachers and caregivers unwittingly become the receivers of shared confidences both from children and their parents. It is critical that children's and parent's confidences are not repeated to other teachers, to the caregiver's friends or families. We agree to respect the confidentiality of verbal and written reports of children, families, and teachers within our classrooms, the center and in our non-work environment. (NorthStar, 2010)

(SAMPLE) PERMISSION FORM FOR FIELD TRIP
Please complete and return this form to your child's teacher no later than: October 10

I give permission for my child to participate in the following school-related student trip:

Destination: Aquarium

Departure Date: October 15

Departure Time & Place: Meet in the art room no later than 7:50 a.m.

Return: Pick up in front of school. Bus should arrive at approximately 3:30 p.m.

Special Notes: We will spend the day learning, drawing, and painting at various indoor locations throughout the aquarium, and aquarium gallery. Please dress appropriately. Bring $5 for lunch. Healthy snacks will be provided. More details will follow. As always visit the art program secure web site for up to date information before, during, and after this exciting experience.

Student Name:	**Homeroom/Class/Grade:**
School:	**Parent or Legal Guardian's Phone Number:**
Signature of Parent/Legal Guardian:	**Today's Date:**

FIGURE 6.1 Sample Permission Form for Field Trip

(SAMPLE) MEDICAL RELEASE FORM
Please complete and return this form to your child's teacher
no later than: _____

Student's Name:

In the event of an accident or sudden illness while on the school-related student trip, I authorize school personnel to contact the physician(s) listed on my child's school enrollment data forms and authorize those physicians to render such treatment as may be deemed necessary in an emergency for the health of said child. In the event physicians, parents, or other persons designated by the parent cannot be contacted, school personnel are hereby authorized to take whatever action is deemed necessary in their judgment for the health of said child.

Signature of Parent or Legal Guardian:	**Today's Date:**
Name of Child's Doctor:	**Doctor's Phone Number:**

FIGURE 6.2 Sample Medical Release Form

(SAMPLE) PHOTO RELEASE FOR PERSON UNDER 18 YEARS OF AGE
Please complete & return to your child's teacher no later than the
end of the first week of school.

Instructions for parents: For each child you have who attends (name of school) and for whom you are legal parent or guardian, please complete one of these photo release forms. Return completed form(s) to (name of art teacher) no later than the end of the first week of school.

I hereby grant (name of art teacher), the right to photograph my dependent and use the photo and or other digital reproduction of him/her or other reproduction of his/her physical likeness or reproduction of his/her artwork for the school art program web site, whether electronic, print, digital or electronic publishing via the Internet. I understand that in the event of such publications that my child's last name will never appear.

Student Name:	**Homeroom/Class:**
School:	**Grade:**
Signature of Parent/Legal Guardian:	**Today's Date:**

FIGURE 6.3 Sample Photo Release Form for Students Under 18 Years of Age

Creative Planning and Topics for Group Discussion, Activities, and Extensions

- Find two to three samples of permission slips. Be prepared to discuss the components of the documents and design one of your own.

- Find at least two samples of photo release documents that are meant to be used to gain permission from parents or legal guardians of students under the age of 18. Examine the components and be prepared to design and create one of your own. Be sure to make clear the intended use of the photos (i.e. such as on the art program web site, in the art newsletter, for submission to the state or national art teacher publications, in a student teacher's teacher portfolio, etc.).

- Visit the ACLU web site (www.http://aclu.org). Find and read one article about a case that involves a person under the age of 18 and a school in some content. Summarize the article and be prepared to discuss it and its implications on education.

- Consider ways in which an art teacher might communicate with parents. Make a list and be prepared to share them in class.

- Define "confidentiality" and its role in schools. Who should receive confidentiality training? Can you think of a time when you witnessed a breach of confidentiality? Consider and discuss how you perceived each involved party, including the victim. (Do not mention any names or identifying information of any person involved.) What steps can teachers take to help ensure confidentiality?

Reference Books and Resources to Read, Look At, and Share With Students

American Civil Liberties Union of Kentucky (March, 2006). *You Have Rights, Too: The Rights of Young People in Kentucky.* Louisville, KY.

Art Education, National Art Education Association. Reston, VA.

Arts and Activities, Publishers Development Corporation. San Diego, CA.

NAEA. *Art Education.* Reston, VA.

NAEA. *Studies.* Reston, VA.

NAEA. *NAEA Mission Statement.* Retrieved from http://www.naea-reston.org.

NorthStar. *Confidentiality Statement.* Retrieved from http://www.northstar4kids.com/policies/confidentiality.htm.

School Arts, Davis Publication, Inc. Worcester, MA.

Index